KU-736-404

Marketing Modernism
in
Fin-de-Siècle Europe

■

Marketing Modernism in Fin-de-Siècle Europe

■

ROBERT JENSEN

PRINCETON UNIVERSITY PRESS

PRINCETON, NEW JERSEY

Copyright © 1994 by Princeton University Press
Published by Princeton University Press, 41 William Street,
Princeton, New Jersey 08540
In the United Kingdom: Princeton University Press, Chichester, West Sussex
All Rights Reserved

Library of Congress Cataloging-in-Publication Data
Jensen, Robert, 1954–
Marketing modernism in fin de siècle Europe / Robert Jensen.
p. cm.
Includes index.
ISBN 0-691-03333-1
1. Modernism (Art)—Europe. 2. Art, Modern—19th century—Europe.
3. Art, Modern—20th century—Europe. 4. Art—Europe—Marketing—
History—19th century. 5. Art—Europe—Marketing—History—20th century.
6. Art criticism—Europe—History—19th century. 7. Art criticism—
Europe—History—20th century. I. Title.
N6465.M63J46 1994
709'.03'4—dc20 93-50184 CIP

This book has been composed in Linotron Janson

Princeton University Press books are printed on acid-free paper
and meet the guidelines for permanence and durability of the
Committee on Production Guidelines for Book Longevity of the
Council on Library Resources

Printed in the United States of America

10 9 8 7 6 5 4 3 2 1

Contents

Acknowledgments vii

INTRODUCTION 3

CHAPTER ONE
"This painting sells" 18

CHAPTER TWO
"The circle of dealers" 49

CHAPTER THREE
Rhetoric from the Battlefield: Innovation and Independence 81

CHAPTER FOUR
The Retrospective 107

CHAPTER FIVE
The Juste Milieu International 138

CHAPTER SIX
Secessionism 167

CHAPTER SEVEN
The Rise of the Impressionist *Weltanschauung* 201

CHAPTER EIGHT
Der Fall Meier-Graefe 235

POSTSCRIPT
1905 264

Appendix 277

Notes 279

Index 349

Acknowledgments

Since beginning this project I have mourned the deaths of my mother, some close friends and advisors—L. D. Ettlinger and Lawrence Steefel—and a colleague whom I did not know but whose work has deeply affected mine, Nicholas Green. My gratitude cannot be expressed. But I would like to thank those institutions that over the years have supported this project, beginning with the University of California, Berkeley and the Social Science Research Council, whose grants enabled the dissertation research out of which this project has grown. Recent summer travel grants from Washington University enabled me to take the project in new directions and the Andrew Mellon Fellowship at the University of Pittsburgh gave me time to write. I owe particular debts to the libraries and staffs of the University of California, Berkeley, the Robert Gore Rifkind Foundation, the New York Public Library, the Library of Congress, the Zentral Institut für Kunstgeschichte, Munich, the Kunstbibliothek, Berlin, and the Bibliothèque Nationale, Paris.

I owe much to Peter Selz, who guided me at the beginning of this work and to Molly Nesbit whose early criticism had a decisive impact on all that came later. For her continued support and constant criticism, no one could have a better friend and colleague than Kristine Stiles. Patricia Leighten gave me much needed support at moments of crisis (and there have been many). Beth Irwin Lewis and Joan Weinstein read early versions of this manuscript and this book owes much, I hope, to their criticism. But it is above all Jane's patience and endurance that made this book possible.

St. Louis, August 1993

vii

Marketing Modernism
in
Fin-de-Siècle Europe

■

LIVERPOOL JOHN MOORES UNIVERSITY
Aldham Roberts L.R.C.
TEL. 051 231 3701/3334

Introduction

To MARKET MODERNISM ARTISTS, their dealers, critics, and historians required above all to establish its historical legitimacy. This historiographic enterprise was as much a part of merchandising Impressionism as the increasingly refined practices of art dealers to promote not only individual paintings, but whole careers, and to do so not only through conventional publicity, but through carefully constructed exhibitions and a mode of personal persuasion that variously appealed to the speculative and/or connoisseurship skills of the potential client, the art *amateur*.

Aesthetic modernism therefore produced not only a body of work, the "isms" that stretched from realism to suprematism, but also a body of institutions, a matrix of practices that, unlike the art, was absorbed almost without resistance by the European and American public for art.

Consider the example of the 1903 exhibition of Impressionism organized by the Vereinigung bildender Künstler Oesterreich [the Vienna Secession].[1] It was a modest show compared to earlier, sensational, even scandalous exhibitions devoted to such artists as Gustav Klimt, Auguste Rodin, and Max Klinger. But its title, *Entwicklung des Impressionismus in Malerei und Plastik*, attests to ambitions that in fact exceeded the vision of all their previous shows. In the late winter of 1903 Impressionism did not belong to a pre-established history of modern painting and sculpture. Not in Vienna, nor in Paris, nor anywhere else in Europe. This was an exhibition that took itself, and particularly its academic pretensions, very seriously. Lectures on modern French art by Richard Muther and Julius Meier-Graefe, Central Europe's two chief authorities on modern art, were intended to drive home the exhibition's historical lessons. For the show was anything but commemorative. In fact, its persuasive use of history as argument set a great precedent for the large public retrospectives of modernist art that dominated the art world before 1914: the 1905 Impressionist show in London, the two "Post-Impressionist" shows organized by Roger Fry in London in 1910 and 1912, the Cologne Sonderbund exhibition of 1912, the Armory Show in New York in 1913, to name only the most celebrated.

The Vienna retrospective, like the ones that followed in its path, represented a powerful alliance of commercial galleries, celebrated collectors, and a public, ostensibly altruistic, exhibition society. Through its overriding argument about historical legitimacy the exhibition masked its dependence on the art market and the commercial value accrued by such displays.

3

It also told an exceptionally linear story, offering a narrow track of artists who for three centuries it claimed had pursued an anti-classical (anti-academic) style and whose art had evolved into its triumphantly modern manifestation in French Impressionism. The first rooms were given over to artists such as El Greco, Velázquez, Vermeer, Goya, Turner, Constable, and the French Romantics. Next came a remarkable collection of Impressionist paintings largely derived from the Paris gallery of Paul Durand-Ruel. Besides Édouard Manet and the canonical Impressionists, six paintings by Paul Cézanne were present.[2] In the following section were those artists set to benefit from the Impressionist canon: they constituted the Secessionists themselves and their international brethren, whom I will henceforth call the international *juste milieu*. Next, in an inevitable pedagogical move, came a collection of Japanese prints (albeit of minor quality) sandwiched between "Impressionism" and the final group, which bore the title "Übergänge zum Stil" [Breakthrough to Stylization], and included paintings by the Nabis, and a few Vincent van Goghs and Paul Gauguins.

Wilhelm Bernatzik, the president of the Secession and an "Impressionist" painter who had spent most of his professional life in Paris, organized the show with the aid of the commercial connections and historical vision of Meier-Graefe, the critic, dealer, and prophet for the modern. They intended, in essence, a systematic demonstration of the Secession's claim on French Impressionism. But Meier-Graefe's theoretical and historical understanding of French modernist painting gave the exhibition a sweeping, totalizing agenda that transcended the ambitions of the Secessionists. He subsequently codified these ideas in his enormously influential *Die Entwicklungsgeschichte der modernen Kunst* (1904).[3]

The Vienna exhibition constituted the fruition and institutionalization of the rhetorical defense of modernism that had begun to be articulated in Paris in the 1860s. It had been, for example, the habitual practice of French apologists to employ a genealogy of "neglected," pre-Impressionist masters whose "opposition" to the bankrupt classicism of the European academies prefigured the misfortunes of contemporary "geniuses of the future."[4] Painters such as El Greco, who had only recently been "rediscovered" and subjected to intense commercial speculation, made particularly relevant forefathers.[5] In such company the impressionists were presented to the Viennese public as an historical *fait accompli*. The exhibition naturalized art that had heretofore either been entirely unknown or radically unfamiliar. Cézanne most notably was publicly canonized in Vienna long before the French cultural establishment so honored him.

By opposing Impressionism to classicism, its German apologists not only

4

constructed what they called an Impressionist *Weltanschauung*, they also substituted one borrowed culture for another. Since the days of Winckelmann German intellectuals had linked national cultural identity with the Greco-Italian tradition.[6] Now Impressionism was to be de-nationalized in order to signify modernism itself. Under its banner they claimed both social and cultural progress. There was a sense of urgency to this search for a trans-national cultural identity, an urgency grounded in the alienated, pessimistic cultural politics that dominated Central European thought at the fin de siècle. Friedrich Nietzsche's searing indictment of German culture, undertaken in the aftermath of the Franco-Prussian war, now began to resonate with the politically and culturally disaffected elites. Meier-Graefe evoked those ties in his famous 1905 polemic, *Der Fall Böcklin* [The Böcklin Case], modelled on Nietzsche's denunciation of Wagner's music, *Der Fall Wagner*.[7] Attacking the artist most Germans regarded as the greatest painter since Michelangelo, Meier-Graefe wrote "all of them—Böcklin, Klinger, Thoma, and the rest, with their cheap, barbaric "anthropomorphism"— succeed only in proving that Böcklin's case is Germany's case. What these men lack is culture, and so does Germany."[8]

If a pan-European, Impressionist *Weltanschauung* was to be inserted in place of a bankrupt Germanic culture, however, it had to overcome two factors: the obvious political opposition, especially in Prussia, to all things French, and the less obvious, but no less important problem that before the very end of the century extremely few paintings belonging to the canonical Impressionists were to be seen in Central Europe. Instead, *Pleinairismus* had long been understood only at the level of theory and only under the umbrella of literary naturalism. What paintings most Germans knew by the canonical Impressionists belonged to a handful of unilluminating reproductions in the pages of Muther's *Geschichte der Malerei im XIX. Jahrhundert* (1893–1894).[9]

Into this vacuum stepped the *juste milieu*, artists who commandeered certain aspects of Impressionist technique and subjects and who won international renown through their ubiquitous presence at the international art exhibitions that flourished in the 1890s. The *juste milieu*, like the public that attended their shows, believed that they were the legitimate heirs to the French Impressionists.[10] In 1903 in Vienna they were gathered in the section bearing the elusive title: "Der Ausbau [Construction] des Impressionismus." Here were such Central European Secessionists as Max Liebermann and Max Klinger, French painters such as Albert Besnard and Charles Cottet, and artists from the English-speaking world such as James McNeill Whistler and John Lavery. They were joined by the French Neo-

Impressionists (including Georges Seurat)—because at that time the Neo-Impressionists were understood to belong to the aesthetic left-wing of Secessionism. Together these artists were to represent the international dispersion of the Impressionist *Weltanschauung*, transforming a specific French phenomenon into a far-reaching cultural and social articulation of modernity.

And yet, even with the presence of the *juste milieu*, the Vienna exhibition described a point of rupture, where the secessionists' pluralist, contiguous, and continuous model of international Impressionism would be cast aside in favor of an exclusionary, disjunctive model of modernism in which "movements" succeed and cancel out their immediate predecessors in a linear march to an ever more perfect, more modern art. Treating Impressionism as an inevitable monolithic manifestation of social and aesthetic modernism, the Impressionist retrospective helped initiate the process whereby national and regional styles were swept away in favor of a hegemonic, unitary history of modern art. Paradoxically, the rupture that it anticipated within the European artist community and within art historical writing which Roger Fry later coined "Post-Impressionism" also decisively shaped the Impressionist canon we have today. The "end of Impressionism," by redefining who and what mattered through the lens of avant-garde painting, rescued artists such as Manet and Claude Monet from the embrace of the *juste milieu* and finally separated Impressionism from literary naturalism in Central Europe.

Bernatzik and his colleagues could not have anticipated that the Vienna exhibition would usher in an anti-Secessionist, Post-Impressionism or that French Post-Impressionist painting would flow so rapidly into Central Europe as to undermine Impressionism itself. In Vienna in 1903 Post-Impressionism was only latently present; by 1905, it had swept across Central Europe.[11] Cézanne was an Impressionist in 1903 and a paragon of Post-Impressionism in 1905. While there were to be many affinities between the generation of 1905 and their Impressionist "fathers," the Post-Impressionists would oppose the social conditions of modernity that the Secessions had praised as synonymous with an Impressionist world view: a humanistic individualism, positivism, and thus a positive valuing of objectivity, scientific rationalism, and urban life. They also reintroduced the potent theme of national identity against the Secessions' determined internationalism.[12] Finally, in Germany, whereas those committed to the Impressionist cause had rejected the Greco-Italian roots of the neoidealist art that flourished in the 1890s, the new generation sought to overthrow both these recensions of how Germans should understand their culture, turning

6

neither toward Italy, nor toward France. The Expressionism that character-
izes Central European art by the end of the first decade was thus heir both of
the international art market that introduced younger German artists to the
French Post-Impressionists and a counteraction that sought out a wholly
German, yet modernist culture.

So far I have been describing a situation of enormous import for Central
European cultural history. But this book attempts more. The German
experience may reflect on French modernism in ways that recast basic
conceptions regarding its reception history, particularly the institutions
and means by which French modernism was legitimated at home and
abroad. The literature on the reception of Impressionism in Central Eu-
rope is rapidly growing.[13] That literature has been virtually unidirectional,
concerned only with what Germans thought of French modernism and the
resulting differences between state policy and the oppositional affiliations
of artists and intellectuals. I would not suggest that this account fully re-
verses that direction. The French on occasion did pay attention to German
artists, writers, and intellectuals. But such attractions were almost imme-
diately made French. An extremely important role, however, was played in
the development of French culture by the sustained admiring gaze of the
foreign public. I propose that French modernist painting developed a his-
tory with a leading cast of characters and became the hegemonic way of
elucidating modern aesthetics when, at the fin de siècle, the history and
theoretical armature of modernist painting began to be written about
abroad. I also propose a fundamental relationship between this historical
enterprise and the discovery of a market for French modernism abroad.

Since this book was first conceived, numerous, local studies of French,
German, and British art institutions have been published or are underway.
The international scope of the modernist art market and particularly its ties
to the emergent art historiography have remained virtually unexplored.
This book is offered not as an alternative to much-needed microanalyses in
the fields of late nineteenth- and early twentieth-century French, British,
and German art history, but as an argument about the larger frame in which
modernist art was consumed in fin-de-siècle Europe. It argues, above all,
that the critical reception of modernist art centered around not one, but
two poles: Paris *and* Berlin.

The history of French modernist art created by its foreign admirers was
perhaps not one that many French artists and intellectuals preferred. It was
too exclusionary, too singular in its evolutionary project, to benefit the vast
majority of artists flocking to Paris. It also effaced or defaced the richness

and complexity of the art in relation to its time and place of creation, in favor of a blandly uniform, if more powerful, description of categorical advances made from "realism" to "Impressionism" to "Post-Impressionism" to the post-1900 "avant-gardes." And these categories were each presided over by an ever-decreasing handful of luminaries: e.g., Courbet, Manet, Monet, Degas, Cézanne, Matisse, Picasso, etc. French critics, while playing an instrumental role in setting out the discourses under which French modernists came to be consumed, were bit players in writing the histories of modern art. The enlightened, comparatively unselfish French *amateur* was dwarfed by his speculative brethren. A booming export business—some called it a catastrophic diaspora—sent French modernist art abroad.

It was of course the Americans who "rescued" the Parisian modernists by being among the first to buy their art, and to buy it for high prices and in volume. And just as significantly, most American collectors then ceded their collections to the new American museums. Their financial muscle and the prestige they lent to favored artists stimulated the final collapse of the French Salon system and ensured the lasting preeminence of commercial galleries within the modern art world. But Americans greeted the arrival of the French Impressionists largely uncritically, accepting the products of the French cultural machine, whether official or unofficial, as "art." American critics and artists contributed little to the evolving understanding of what constituted modernism in art. Germany, on the other hand, led by Berlin, was second only to the United States in purchasing French modernist art, despite—and in its own way, because of—the long-standing political and cultural enmity between the two nations. Its commercial galleries, *Kunstvereine*, and Secessions took direction and sustenance from French models, which they projected into every Central European town or city that could present itself as a *Kunststadt*.[14] More importantly, German critics and scholars led the way in the formation of the historical exegesis on modernism, the codification of aesthetic positions, and the entrenchment of a canon of artists with a modernist tradition.[15]

If the French are obviously to be credited with the "invention" of modernist painting, the institutional structures of modernist art—among them, the modern art gallery and its means of publicity and enlightened self-promotion, the enlistment of critics, and other such strategies I will treat—were generally first developed in Britain. Its long commercial history perhaps led the British to mix less tendentiously the business of making art with the business of selling it. Yet the British market showed very little interest in modernist French art or modern art of any kind. Despite three decades of

8

informed British art criticism, British collectors bought Impressionism very late and at very high prices. In Germany the situation was quite different. The German art world absorbed the traditions and methods of the French art institutions alongside French modernist art. It was for this very reason, I believe, that in Germany, from the 1890s through the tragic years that constituted the Third Reich, the apologists for modernism could never uncouple its commercial dependency from its aesthetics. One of the greatest, and most tragic, paradoxes of this era is that the German Expressionists, who wrapped themselves in the banner of German nationalism, were unable to fend off the perception fostered by the political right that modernism was a distinctly Franco-Jewish import, imposed on Central Europeans by art dealers, that the Expressionists were but bad imitators of French fashions.

Because the German reception of French Impressionism was enacted in a political and social environment where positions were always articulated in extremes, arguments for and against modernist art were expressed in dramatically polarized rhetorical forms. The era produced numerous blanket oppositions such as modernist artist versus the bourgeoisie, connoisseur versus philistine, young versus old, city versus country, internationalism versus nationalism, healthy versus degenerate art, tradition versus fashion, masculine versus feminine aesthetics. However reductive these constructions are, they nonetheless infuse the literature on aesthetic modernism from the pronouncements of the most radical artists to the most sober writing of German academic art historians. This book therefore proposes to examine some of the ruling structures and discourses, what might be called the central cliches, of modernism. In another context, Pierre Bourdieu has called these cliches the *habitus* of practice:

> the strategy-generating principle enabling agents to cope with unforeseen and everchanging situations . . . a system of lasting, transposable dispositions which, integrating past experiences, functions at every moment as a matrix of perceptions, appreciations and actions and makes possible the achievement of infinitely diverse tasks, thanks to the analogical transfer of schemes permitting the solution of similarly shaped problems.[16]

For Bourdieu, the *habitus* has its own internally coherent logic, the logic of practice that operates on such simple and therefore endlessly flexible and adaptable dichotomies as high and low, good and bad, male and female. Whatever the general truth of Bourdieu's observations, such dichotomies clearly characterize the critical discourses of the European fin-de-siècle art

world, where, for example, young versus old or commercial versus non-commercial operate on a level of mythic speech that imagines rather than describes social reality.

I have found no polarization more exemplary of modernist rhetoric than the endlessly voiced distinction between authentic art and commodities, an opposition central to the definition of "avant-gardism." Elsewhere I have argued that the commercial gallery system and the historical discourses that served it have become inextricable from the very concept of the avant-garde.[17] In my view, the commodification of art represents only a mythical fall from grace. What I hope to demonstrate—in opposition to Peter Bürger's distinction—is the ubiquity of market discourses in the ideological defense of *both* aesthetic modernism and avant-gardism, discourses bound to modernist art from its inception to its demise.[18] In my view, "classic" alienated artists, like an Egon Schiele, would have learned by 1910, if not long before, that alienation sells, that to be alienated was as much a role, a way of establishing a professional identity, as occupying a position in the academy.[19] Indeed, professionalism brought the modernist "left" together with the academic "right." Since the institutional business of distinguishing oneself from the crowd had a life of its own, independent of aesthetic or political causes, a confusion of loyalties was inevitable. From widely differing aesthetic positions, the leaders of the official art world and the "avant-gardes" might converge, each, as a professional elite, seeking the signs of authenticity through the denial of commercialism. The "alienation" of the artist was, at least as far as the market was concerned, largely a fiction that served rather than denied the commodification of art.

The dialogue of money and art is manifest in the language, in the institutions, and in the actions of modernist artists and their audiences. It is a discourse that is at once narrow and wide, that invades and colonizes many discourses, while in many respects remaining singular and untouched by them. This protean relationship has become so bound up with the rise of modernism and its accompanying discourses that they can never be separated. The attempt to separate them is itself one of the central tropes on which modernist criticism has been based. The narrative about art and money is just one of many possible narratives, but one that I hope elucidates the manifold nature of the dialogue, or better perhaps, the aporias of art and money within the context of the rise of modernism. The two partners remain alien to one another, though always, endlessly intertwined. The commercial benefits of the Vienna Impressionist exhibition, for example, were considerable, but they were never admitted into a discussion of what the exhibition represented. Vassily Kandinsky was a tireless promoter of

modernist art but never permitted a discussion of money to enter his writing. That we have continued to insist on this division, even while ever escalating the domain of money in the world of art, has been an essential feature of modernism.

Consequently, I will only distinguish between avant-gardism and modernism in order to define an historical change of consciousness that attends modernism as a "history," which came into being around 1905. It will not be my business here to measure the differences in fact—as opposed to the modernist discourses about them—between modernist and centrist art, the *juste milieu*, or between the *juste milieu* and the *pompiers* and the academicians. These terms obviously describe an ever-fluctuating continuum of aesthetic, institutional, and social positions, relative to the position from which they are viewed. What separated the *juste milieu*, for example, from those who adopted a more committed oppositional position was simply the pursuit of official honors. After all, an artist like Manet, who never exhibited with the Impressionists, engaged in a lifelong pursuit of official honors—that were finally, grudgingly, granted him in the last years of his life. As professional insiders rather than radical outsiders, the *juste milieu* was a quintessential phenomenon of social and cultural, but not aesthetic, modernism. As a group they tended to reflect the growing sentiment for international cooperation, comparable to other institutions that sought international footing in the second half of the nineteenth century—in areas such as industry, communications, medicine, practical and theoretical science. The *juste milieu* generally believed in social and artistic progress and represent as a class, therefore, a different kind of modernism than the sense that normally dominates twentieth-century art criticism and historiography. They embraced almost every aspect of modern capitalist, democratic, and materialist culture, even if they continued to insist on the uniqueness of the artist and the work of art vis-à-vis society.

However, the fin de siècle was to be characterized by the countering effort among modernist apologists to systematize and label aesthetic doctrines, to take sides, and to authorize what mattered versus what did not. Eventually, this historicizing process led to the overthrow of the *juste milieu*. The discourse that emerged was precisely characterized by its arbitrary aesthetic criteria, its exclusionary historiography, its heroes and heroines, its victims and oppressors. These distinctions mattered, then, and they still very much matter now. They labeled the horizon of opinion that circumscribed artistic creation and public consumption.

Norma Broude writes in her introduction to *World Impressionism: The International Movement, 1860–1920* that in the name of "postmodernism"

she wants to recover an international definition of Impressionism and thereby to destroy the "falsely linear and chronological view of the development of modern art."[20] By redefining, or rather, expanding, the geographical and the ideological terrain of Impressionism, she would employ Impressionism as a lever, a touchstone of artistic achievement, to raise in stature artists previously cast from the modernist ranks, to restore, as it were, the Secessionists to their proper place in Vienna in the late winter of 1903. But in so doing, the project of the post-1900 art market and its accompanying critical discourses to delimit Impressionism's representatives and to identify Impressionism's proper successors is overthrown. Modern art was not "falsely linear"; modernism was self-constructed in a progressive, linear fashion, which is what gave it its force. Breaking the canon (by expanding it) without understanding either its origins or what the canon represented to the *Kunstpolitik* of fin-de-siècle Europe merely reconstitutes in a different form the mythologies of the past.

Kunstpolitik—a word favored by German writers and artists of the fin de siècle to describe the bickerings and the struggles over professional identities, over juries, art school appointments, and so on—may help us rethink the artistic events and polemical discourses of modernism, because it was a term so clearly detached from a concept of political or independent art (a tradition Central Europe lacked until the closing years of the century). As it was then used, *Kunstpolitik* expressed what we might find as a surprisingly tolerant view of artistic affairs, for it announced the strife among artists as independent of the real business of making art—at worst, it was a distraction. Unlike the politicized French understanding of the struggle for publics, *Kunstpolitik* does not define an inevitably fatal conflict between opposed aesthetic positions. Instead of a truly ideological contest, it implicitly accepted as inevitable the demographically engendered competition among artists. Commerce was essentially what *Kunstpolitik* was all about. Lovis Corinth (a significant player in both the early Munich Secession and the Berlin Secession) argued for this distinction in 1912 when he wrote that although the greater the individuality of the artist the more he is misunderstood by the public "the greatest and most famous artists have actively participated in the game of intrigue. One need only to read Vasari or Benvenuto Cellini."[21] Just as characteristically, however, Corinth vigorously denied that *Kunstpolitik* had in itself been responsible in any way for his or any other artist's success. Indeed, Corinth, by tacitly granting aesthetic diversity to the notion of *Kunstpolitik*, offers us precisely the conceptual rationale of the *juste milieu*. *Kunstpolitik* gave way to our more familiar picture of modernist triumphs and capitulations when the paradigm of a

politically and aesthetically independent art gained ground in Central Europe at the very end of the era I consider here. The German Expressionists were thus the first generation of Central European artists to come into so decisive, so personalized, conflict with their artistic "fathers."

The rigidification of the competition among artists was profoundly abetted by the rise of a modernist historiography that served to market modernism throughout Europe and America after 1900. This historiography, however, was not always, and did not have to be, rigorous, theoretically minded, and substantially argued. Deeply tied to the contemporary art market, the early retrospective writing was far more often polemical, imprecise, saturated with received ideas, often paradoxically or unquestionably joined with seemingly incompatible positions. And in fact the post-1900 modernists constructed their aesthetic positions within the competing demands of naturalism and idealism, the two poles of fin-de-siècle critical thought. They had much to sort through. Consider how Meier-Graefe came to know modernist art.

> In 1890 the inside of our heads looked like an emergency railway station in wartime. It is impossible to conceive how riddled with holes our mental communication system was. Toulouse-Lautrec, Vallotton, Odilon Redon, Axel Gallen, Vigeland, Beardsley, Gauguin and Munch, Puvis de Chavannes and Whistler were our main sources of awareness apart from the German romantics. . . . I knew Bonnard before I knew Manet, Manet before I knew Delacroix. This confused state of mind explains many of our generation's subsequent mistakes.[22]

Although Meier-Graefe played an instrumental role in creating our normative perception of the developmental history of modern art, he did so by the radical act of defining the history of modern German painting through a history of French modernism. The Vienna exhibition, like his own *Entwicklungsgeschichte*, inverted this order and put things "right," but, in the process, covered over the very complexities and the tolerance for aesthetic diversity that shaped the views of the Secessionists and their critical defenders.

By the 1920s, the employment of modernist history and criticism pioneered by Meier-Graefe and some of his contemporaries as a corrective to the errors and confusions (and eclecticism) was normative. In 1926 Roger Fry summarily dismissed a paragon of the *juste milieu*, John Singer Sargent:

> When I look now at the thin and tortured shapes those lily petals make on the lifeless green background, I realize that what thrilled us all then [in the

13

1890s] was the fact that this picture was the first feeble echo which came across the Channel of what Manet and his friends had been doing with a far different intensity for ten years or more.[23]

Fry's certitude of conviction, the quality of his dismissive prose, anchored only in his knowledge of the other, "authentic" art of "Manet and his friends," only fulfilled his own convictions, re-rehearsed his own conversion to the modernist faith. Sheldon Cheney opened his *A Primer of Modern Art* (1924) with the assertion that before an Oscar Kokoschka self-portrait, "lovers of Whistler, Sargent and Zorn will find its technique deplorable." Cheney's target, the taste for the *juste milieu*, was no more programmatic and no more open to self-criticism than Fry's.[24] This act of "straightening," dismissing the false from the authentic, was obviously circular. In a trenchant critique, the artist group Art-Language attributed the circularity of this critical system to the transcendent character, the asocial, apolitical nature of *l'art pour l'art* high modernism.

> If we seek to identify the aims and objectives which might be satisfied by that change in art which Manet's work is taken to be the occasion, the Modernist's answer is likely to be restricted to what he feels about the effects upon himself which those changes have occasioned; i.e., the answer to "Why *these* changes?" will be "In order to produce effects such as those I experience."[25]

Although there is no doubt that circularity within the history of modernism has enjoyed a long life, the historical moment in which this rhetoric was largely shaped was the fin de siècle.

Marcelin Pleynet asked what I take to be the central question for the early history of modernism:

> Why then the production of so many histories? From Delacroix, Ingres, Courbet, from impressionism to postimpressionism and right up to our own day, we have seen them multiply: histories of cubism, of fauvism, of analytic cubism, synthetic cubism, futurism, expressionism, and surrealism, not to mention the recent histories of op art, pop art, etc.[26]

Where Pleynet sought the answer in individual artists and their engagement with the self-construction of systems of art-making, this book takes a strictly institutional view, outside artistic practice, to account for the compelling presence of "histories" in the history of art since Impressionism. In the discourse of art and money I propose to argue that the control over the market for art meant the control over history. The market lies behind what

Pleynet describes as "on the one hand the hierarchy of the 'passage' from tradition to impressionism and on the other, the productive negation (the rupture) so fiercely sought after by impressionists, preimpressionists, and postimpressionists alike"[22]. Economic forces surely are not the exclusive cause behind the historicist consciousness that infuses modernism, but neither can they be disentangled from any other motivation, so profoundly are they intertwined. Moreover, the use of the term "avant-gardism" arose out of the historical moment in which competing modernisms (most significantly, the replacement of Impressionism by "Post-Impressionism," "Fauvism," "Cubism," "Expressionism," and "Futurism") divided heretofore indivisible modernism into factions. These "isms" are not just the great creative flow of a generation, but a mentality, haunted by the need for originality, by the need to supersede one's competitors, by the desire to get a piece of the market share, to be discussed.

To treat the marketing of modernism I have extracted a series of what I think of as symbolic systems. I begin with the commercial dynamics of a rhetoric of exclusion or neglect and subsequent vindication. Then I consider the ideological refashioning of the commercial gallery, which transformed galleries from the equivalent of book dealers and antiquarians into rivals of museums. Against the rise of the ideological dealer I examine the commercial utility of the construction of a group identity and the employment of a rhetoric of independence in the context of the Impressionist exhibitions. I trace the trajectory of the Impressionists' career path into the gallery system where I look at the retrospective as the primary site of the canonization of artists within history, the chief intersection between historiography and the marketplace. I then turn to a discussion of the international *juste milieu* of artists who appeared in the 1880s. They played a vital role as intermediaries between the avant-gardes and the proletariat of artists, and as historical intermediaries—embodied in the European Secessions—between an art market still dominated by the international Salon system and one controlled by commercial galleries. The collapse of the *juste milieu* as the arbiters of, and chief object in the production of, aesthetic value is treated in the context of the writing of modernist history and the invention of "Post-Impressionism," concluding with the emblematic career of Meier-Graefe. These topics are arranged roughly in historical order (as each makes its appearance on the scene of the international art market) but are not confined to a single moment in time. The institutions used in the marketing of modernist art as described in this book are intended to address the historical changes each type represents and the trans-

15

formations within the type itself. These systems are so much a part of the way that modernism has been constructed as to seem transparent. Like all ideological structures they appear as natural; it seems impossible to imagine an artist's career without the canonical function of the retrospective. We have only begun to examine the role of the museum as the archive of taste and the arbiter of historical value.

The historical consciousness of modernism is manifest in everything from the style of exhibitions to the invention of the contemporary art museum to the working habits of artists. While national museums of modern art had been proposed since the beginning of the century, there were no rivals to the Paris Musée Luxembourg until the end of the nineteenth century (as for example, the creation of London's Tate Gallery). Even the Luxembourg, until the Caillebotte gift entered the museum in 1897, remained but an organ of the Salon. The museums of modern art were invented outside France, particularly in Germany. Beginning with Hugo von Tschudi's concerted effort to introduce contemporary art to the National-Galerie in Berlin, German museum men increasingly allied themselves to the most "advanced" art, domestic and imported. On occasion they were also historical apologists for the new art. More often, they simply belonged to a circle of politicians, industrialists, literary figures, and art critics who shared the conviction that modernism was not only good for Germany but necessary to raise the cultural standards, and even the commercial competitiveness of the nation.

For artists the situation was the same. Pleynet notes the primacy that painters such as Cézanne and Gustave Moreau placed in learning from museums rather than from the Salon, in learning from history rather than from fashion, and correspondingly, in learning to place oneself against history, rather than against the current market value of one's work.[27] With this habit of mind, when the Impressionists finally appeared before the public eye they did so in the context of the museum, particularly in Germany, but also in the United States, in Switzerland, and later in many other countries, finally including France. The museum represented far more than an architectural edifice, designed to display pictures. It was a horizon of attitudes, of commercial interests, of professional identities.

A final disclaimer: For what follows, although I am not concerned with art but with the processes and institutions through which the resonances of modernist art came to be refashioned into that monolithic, exclusive, and evolutionary history we now call the history of modern art, it has nevertheless not been my intention to collapse modernism back within a heterodox evaluation. I do not seek to "elevate" the opponents or rivals of aesthetic

modernism, especially at the expense of modernism, in the name of histori-
cal pluralism. From the beginning Impressionism's critics were able to
distinguish, were compelled to distinguish, the "canonical" Impressionists
from their comrades. The "truth function," or "authenticity," or "quality"
of their paintings, however one might wish to define the "aura" works of art
present to the beholder, were as manifest to the audiences who saw the work
in 1874 as it is today. I like Thierry de Duve's formulation: "A work is all the
more significant historically when it leads a greater number of its own
conditions of emergence—and the least obvious ones—to resonate."[28] If,
in naming what was "true" about an Impressionist picture, its critics misrep-
resented, or misinterpreted, what they saw, or ascribed that truth to false
intentions, or turned to the kind of reductive description that ruled the
commercial discourses of modernism since its inception, this should not
lead us to believe, as the Nazis so insisted, that it was all conspiracy, all
fabrication. I reject such arguments not because dealers never conspired to
control the market and audience tastes. They surely did. But they them-
selves were subject to the art they encountered. Durand-Ruel, for example,
would have been more personally comfortable with promoting a certain
variety of Salon art than something then so risky as modernist painting. But
he came to realize, as did the critics who worked for him, that Impression-
ism abruptly changed the paradigms of contemporary art, just as the Ro-
mantics had challenged the paradigms of David and his école. This is not to
say that these paradigms are somehow transcendent, historically immuta-
ble, but that a picture, like a revolution, is itself an historical event, and that
to the extent that it may resonate within or against the culture from which it
arises, it can qualitatively assert its identity among the competing cultural
paradigms of that moment in space and time. The work came first.

"This painting sells"

Théodore Duret made his reputation as an art critic and journalist, but he lived an equally influential life as a collector, middleman, and speculator in contemporary French painting. In a famous defense of the Impressionists written in 1878, Duret argued their worth on the two principal grounds that first they had as supporters numerous prestigious writers, including Philippe Burty, Jules Castagnary, Ernest Chesneau, and Émile Zola, and that second, their success with the *amateurs* was a sign that their's was the art of the future.[1]

> Because it is necessary that the public who laughs so loudly over the Impressionists should be even more astonished!—this painting sells. It is true that it does not enrich the artists sufficiently enough to permit them to construct *hôtels*, but in the end, this painting sells.[2]

The buyers who in the past collected Delacroix, Corot, and Courbet "today form for themselves Impressionist collections[212]". In 1884 Duret defended Manet in his introduction to the posthumous auction catalogue by again appealing directly to the *amateur*, the collector, who, unlike the public, was not blinded by fashion and asked only of a painting that "it be painted." Duret proposed two kinds of artists, those who are "avec le temps" and those who create "formes nouvelles, des créations originales."[3] The "really original painters of modern France" he wrote, were "Delacroix, Rousseau, Corot, Millet, Courbet and, in the last position, Manet." Great works of art, Duret insisted, are like the "heights of great mountains" which from close by cannot be perceived, but "from afar appear alone on the horizon."

Duret's equation of genius with market value inverted the two-centuries-old effort on the part of the European academies to preserve many of the features of traditional patronage in the face of a growing market economy. They attempted to ennoble and distance art from craft and to repress the commercial aspects of an artist's enterprise. The challengers to the French Academy used market value to demonstrate how previously disenfranchised artists (and that could mean almost anyone who was not a member of the Academy) were vindicated by later prices, consequently demonstrating

their right of place in the pantheon of great artists. Their version of the Academy's detachment from the marketplace was the vilified genius.

What drove modernist artists and their supporters into such market-oriented arguments was not simply their ostracism from the traditional venues of the Academy, its schools and its chief exhibition site, the Salon. The famous persecutions of the Salon's juries were but a symptom of a problem that transcended aesthetics or political causes: the institutional business of distinguishing oneself from the crowd. In France, as elsewhere in Europe, the state-supported Salon, with its prizes and its honors, had helped to create a proletariat of artists and a vast new audience for art. By mid-century it was widely felt that the Salon had become commercially debased, appealing to the tastes of the public rather than remaining true to the noble calling of art. With the decline of history painting, the appearance of the mass spectacle of the Salon, and the bitter disappointments of the *refusés*, it became increasingly clear that the academic system no longer worked, either from the perspective of producing major works of art or as a professional organization that could ensure the economic livelihood of all of its membership.[4] Yet by virtue of the inherent inertia of institutions, the system continued to dominate French cultural life.

Thus arose the paradox that the opposition to the Salon would deride the commercialism of the annual public exhibitions, while attempting to appear, like the academicians, to act above the interests of money. The artists who belonged to the "avant-gardes" would never see themselves, or be seen by their supporters (at least until Dada), as producing commodities. For example, in 1893 a young Dutch symbolist painter, R. N. Roland-Holst, demonstrated this unconscious duplicity in a catalogue introduction for a retrospective exhibition of Vincent van Gogh held in a commercial gallery in Amsterdam. Roland-Holst deplored the commercialization of art— "The work of art has become merchandise as good as any other, merchandise for speculation"—but declared that "this exhibition is assembled for the few people who still believe that what is grasped immediately is really not always the best."[5] The suppression of commerce in the appreciation of "true" art meant that artists were faced quite simply with the social denial of their public right to make a living from their work. Thus to draw such subtle, tenuous distinctions between commercial and non-commercial exhibitions as Roland-Holst's, modernist artists needed protection, they needed distance from the market, even as they came to rely exclusively on the market for their presence in the art world.

Compare Duret's or Roland-Holst's texts to the modernist treatment of one of their great *pompier* rivals, William Bouguereau, and it becomes

evident just how deep, how long-lived, how paradoxical this modernist market rhetoric was. The first line of argument was that Bouguereau (and all others like him) was corrupted by the marketplace. The American art historian Frank Mather, in his *Modern Painting* (1926), accused Bouguereau of having self-consciously "multiplied vague, pink effigies of nymphs, occasionally draped them, when they become saints and madonnas, painted on the great scale that dominates an exhibition, and has had his reward. . . . I am convinced that the nude of Bouguereau was prearranged to meet the ideals of a New York stockbroker of the black walnut generation."[6] Remarkably, Bouguereau, the greatest prince of the Salon, agreed.[7] In an 1891 interview Bouguereau contrasted his pre-1863 work (i.e., before he had "arrived") with what he had been doing ever since.

> Here's my *Angel of Death*. Opposite is my second painting, *Dante's Hell*. As you can see, they are different from the paintings I do these days. . . . If I continued to paint similar works, it is probable that, like these, I would still own them. What do you expect, you have to follow public taste, and the public only buys what it likes. That's why, with time, I changed my way of painting.[100]

Casting himself as a victim of public taste, Bouguereau gave exemplary testimony to the belief, so widely held then as now, that artists must prostitute themselves, that the dedication to the "high" goals of art must be sacrificed for professional survival. As the painting market began to be perceived as revolving around the nouveau-riche collector, the critical *habitus* would hold in opposition the paradigm of the aristocratic patron, supposedly defined by his innate qualities as a connoisseur, and the crass—usually American, and also often portrayed as Jewish—businessman. Art critics increasingly saw the fundamental alteration—and lowering—of the art profession in their servitude to their new clientele. P. G. Hamerton, the British etcher, critic, and publisher of *The Portfolio*, reflected popular prejudices when he wrote in 1867 that

> the power of money over art has never been stronger than it is now, and the manner of its operation, being very subtle and difficult to trace, increases the power by making it irresponsible. When a banker or speculator, some Rothschild or Pereire, goes to the annual exhibition of French Art in the Salon, and buys some picture there, he is not held responsible for the artistic qualities of the work, for which the artist alone is blamed or praised by the newspapers, as the case may be. And yet in a certain intelligible sense it is these bankers, and other rich men, who paint the pictures. They do not mix the colors and apply them with their own hands; nor do they even,

except in the case of works directly commissioned by them, offer any suggestions as to the choice of subject and manner of execution; but still, since the great majority of pictures are painted to suit what are perfectly well known to be their tastes, it may be truly said that the artists aim rather at the realization of what the rich man likes than what they themselves care for. Enormous quantities of pictures are in this way painted every year expressly for the market, with care and trained skill, but no more artistic passion or enthusiasm than goes to the manufacture of any other elegant superfluities. And the evil of it is, that unless a picture is painted in this way, with the most careful attention to the points which happen just now to make a work salable, it is not likely to be sold at all.[8]

Hamerton expressed an enduring topos of a collector no longer guided by the educated taste of a connoisseur. The new men of business and industry were understood to be dependent upon public approbation to certify the quality of the art they purchased. Since the aristocratic domain of connoisseurship was unobtainable to them, they were said to pursue the most sensational and the most decorated artists of the Salon, and to prefer the most sentimental narratives and the most photographic styles of depiction possible. Bouguereau said what he was willing to do to satisfy such tastes.

It is in this context that Duret and other apologists for French modernism invoked the necessity for a refined aesthetic sense belonging to the connoisseur (a.k.a. the buyer) to distinguish authentic art from the debased tastes of the crowd ("these bankers"). Duret explained that painting demands "an adaptation of the eye and the habit of discovery, under the process of the *métier*, the intimate sentiments of the artist . . . (it) is one of the arts the least accessible to the crowd."[9] Just as Delacroix, Millet, Corot, and Manet were misunderstood by the least refined, so too were the Impressionists. The snob appeal of Duret's remarks effectively combined the market elements of his text, the appreciations of the connoisseur, with the neglected-genius topos. In other words, the neglect was not universal, it simply took the cultivated eye of the *amateur* to recognize the artist's greatness. Duret had in mind cultivated connoisseurs like Baron Le Caze, who gave to the Louvre Watteau's *Gilles*, which he had purchased many years before for 600 francs.[10] If the discovery of the "temperament" behind a great work of art became a matter for "experts," the invitation was there for those with money to come and buy and with their purchases achieve a new kind of cultural capital, that lay not in the objects, but in the associations, the fetish gloss, ownership conferred on the buyer—marking the passage from the "rich man" to the *amateur*.

In the modernist criticism and historiography that wrote Bouguereau

and his fellow academicians out of the history of nineteenth-century art, the assumption was that Bouguereau was not merely corrupted by money but that the academic tradition as an entity was virtually corrupt by definition In 1894, the German art historian Richard Muther characterized Bouguereau as "a man destitute of artistic feeling but possessing a cultured taste [who] reveals . . . in his feeble mawkishness, the fatal decline of the old schools of convention."[11] Muther caustically described Bouguereau's religious paint-ing as "an elegant lie, like the whole of the Second Empire." Of course, in Bouguereau's own self-appraisal, given at a time when such accusations were becoming publicly popular, the artist was anxious to disassociate the commercial element of his art from his academic training. But as Muther wrote off the academic tradition on the grounds that it was convention without art, so posterity would adopt Muther's implicit formula—itself derived from the cliches of modernist French art criticism—that what is academic is commercial and what is commercial is academic.

The next step in modernist discourse was to claim that what is modern, or what is avant-garde, by virtue of its claims to authenticity as art, is inher-ently not commercial. In the modernist *habitus* an absolute split was main-tained between the motives and circumstances of an artist like Bouguereau on the one hand and the Impressionists on the other. To look at post-1860s art again, outside the lens proffered by the Impressionists, their successors, and their apologists, the boundaries between authentic and unauthentic art, between the "real" artists and their commercial rivals, appear not only arbi-trary, but fly in the face of the fact that the Impressionists were more market reliant than their Salon competitors. For many years scholars have acknowl-edged the commercial connections of the Impressionists; and indeed, even those most concerned with defending their importance vis-à-vis a dis-credited academic tradition have done much to describe the economic condi-tions of their practice. But what is still generally missing is a substantial interrogation of how their style(s), the way they organized their careers, the kinds of clients they came to possess, belonged to an across-the-board trans-formation of the relationship between artists and their audience, a transfor-mation that involved an artist such as Bouguereau as equally as a Manet.

GETTING PUBLISHED: THE ACADEMY AND THE
ENTREPRENEURIAL DEALER

As the number of practicing artists steadily expanded in the course of the nineteenth century, the social and aesthetic identities of artists were di-luted. An artist-proletariat created an inevitable institutional revolt in the

struggle over markets. Already by the middle of the nineteenth century the professional artist sought to define himself by more than the traditional desire to place the practice of art on the same level as that of the poet or philosopher. Their increasing dependence on a nameless, constantly evolving public for their livelihood forced artists, in much the same vein as their contemporaries in the fields of medicine or law, to assert their identities as a higher class of professional from that of the amateur artist, or the student, or the explicitly commercial artist. To be a member of a profession was to be "a producer of special services (who) sought to constitute and control a market for their expertise."[12] Artists sought to isolate themselves on the respective grounds of quality, difference, and the historical place of their work.

Until the last quarter of the century, however, the process of professionalism was dictated by the ruling academic system.[13] France possessed the most centralized of all European art worlds, with almost all important art activities from pedagogy to exhibitions to auctions concentrated in Paris. The French government was also the most involved in the visual arts and had committed its patronage to a single artist association, the Académie des Beaux-Arts. Although not exclusively composed of members of the visual arts community, the Academy asserted its dominance over artistic matters through the Salon. The unmatched success of the Salon system in the previous century and a half resulted in the suppression of alternative exhibition opportunities for artists—as distinguished, for example, from Britain, where the Royal Academy was itself a commercial institution in competition with other commercial organizations for its publics. The French consequently possessed, on the one hand, the most influential system in the world for the display of works of art and the cultivation of a career as an artist, and relatively negligible alternative means by which, to use P. G. Hamerton's term, works of art could be "published."[14]

Designed to train, to confer legitimacy, to provide economic support, and to create business opportunities for its membership, the Academy's unrivaled success in Paris by the end of the eighteenth century allowed the exercise of considerable influence over the subjects, the styles, and even the size of works of art shown at the Salon.[15] With the cooperation of the State, the Academy and the Salon offered a regularized system of rewards, a clearly defined professional track through which an artist could progress. Through the combination of a pedagogical system centered on the École des Beaux-Arts and a regularized system of prizes, headed by the Prix de Rome, the Academy was able to assert its aesthetic standards at both the level of pedagogy and from the vantage of the École's position as a gatekeeper to the Salon.[16] The École continued until the end of the nineteenth century to

serve, if not as gatekeeper, then at least as the standard by which the education of artists and their suitability for Salon participation was defined. The medals won at the Salons, in turn, were clear markers of an artist's rise within the system, which had as its pinnacle the almost unobtainable selection to one of the fourteen seats that constituted the Académie des Beaux-Arts section of the Institut de France. The system offered the possibility of normalizing the career path of artists in a market economy. But conversely they served to defend vested interests. As Gottfried Semper wrote in 1852, "Those lofty art academies are basically little more than welfare institutions for professors."[17]

The French academic/Salon system enjoyed, ironically enough, its greatest glory and prosperity in this age associated with the rise of modern art, reaching its apotheosis in the second half of the nineteenth century, a period that was, as Gerald Reitlinger has put it, the "golden age of the living painter."[18] Although artists such as Manet and the Impressionists benefited to some degree from the dramatically increased attention paid to contemporary art, the *Salonkünstler*, painters such as Léon Gérôme and Ernest Meissonier in Paris and their European contemporaries such as Hans Makart in Vienna, Carl Piloty and Franz Lenbach in Munich, and Lord Frederick Leighton in London, embodied the immediate rewards of an art career. They projected their fame onto the canvases of the Old Masters, portraying themselves in their self-portraits in the garb and with the demeanor of a Titian or a Rubens. The studios of the *Salonkünstler* were as flamboyant as their claims to perpetuate the classical tradition.[19] And the public was as likely to be as extreme in its accolades. George Frederick Watts was widely regarded as the Michelangelo of England. German critics noisily proclaimed the Swiss painter Arnold Böcklin to be the greatest artist since Michelangelo. Their fortunes and their knighthoods provided a gloss on the professional practice of being a painter or a sculptor that approached aristocratic heights.

These artists had a natural interest in the continuance of the Salon system and its international imitators. The tyranny of their vested interests was matched by the longevity of their rule. In France, many of the leading protagonists of the Academy, the men who dominated the Salon juries, were often quite long-lived. Gérôme, who served in the Academy from 1865 to 1903, was typical of a class of artists who began their careers before the rise of Impressionism and continued to serve right up until Impressionism's "demise."[20] Still, the enduring power of the Salon was due to more than just the long lives of these academicians. They continued to matter in public life because the Salon mattered and mattered far longer than art historians have

customarily granted, through an institutional resistance to change that has yet to be fully measured. To appreciate the power of the official French art institutions over public opinion, one has only to realize that even as late as 1914, the leading French art periodicals continued to give substantially more space to Salon criticism than to any other type of public or commercial exhibition. Long after the turn of the century the Parisian magazine *Les Arts* carried exhibition reviews of the state Salons to the exclusion of all other independent and commercial exhibitions, despite its acknowledgement elsewhere in its pages of the worth of Impressionism.[21] This is all the more remarkable because the journal was published by the prominent art dealers Michel Manzi and Maurice Joyant, whose gallery among other things specialized in the work of Henri de Toulouse-Lautrec and Edgar Degas.[22]

If at this level the Salon system worked, it was nonetheless under constant attack from both inside and outside the Parisian art world. Its critics generally followed two distinct, but interrelated tracks. The first was institutional, having to do with its inability to regulate and provide for an ever increasing body of artists. Étienne Delécluze, Jacques-Louis David's biographer and a conservative observer of the French art scene, noted in his Salon review of 1850—in what was a familiar subject in his criticism since at least 1831—the increasing disproportion between the number of Salon exhibitors and the elite, what he called "celebrities," of artists whose work could be said to have withstood the test of time.

1673: 50 exhibitors, 18 celebrities
1810: 333 exhibitors, 21 celebrities
1850: 1,664 exhibitors, 42 assumed celebrities[23]

The progressive distinction between the successful elite, the medal winners, etc., and the mass of exhibitors was, of course, a logical response to the competition for the public's attention. Delécluze believed, therefore, that the annual holding of Salons—which had been the case from 1831 to 1850—should be abandoned, because it had unnecessarily encouraged the deluge of art

far beyond the need that might be felt in France to decorate churches, public buildings, and private dwellings. After an exhibition, there is not a soul who wonders what becomes of the 1,200 to 1,500 paintings that have been (exhibited). . . . Almost all the works of painting and sculpture thus fall into the hands of the government, which, having provoked the excessive growth of the crowd of artists, is forced to pay for the uncommissioned paintings for which it is sometimes impossible to find a building.[24]

If there were not enough buildings, enough commissions, enough prizes to go around, the Academy also failed to provide for the basic welfare of French artists in a market economy. In the 1830s and 1840s alternative forms of artist organizations challenged the academic/Salon system. As an international phenomenon, the creation of artist relief organizations has never been studied. Individually the German *Kunstvereine* and the Anglo-American Art-Unions have received more careful attention.[25] France, too, possessed the equivalent, the now obscure Association des Peintres d'histoire et de genre, Sculpteurs, Graveurs, Architectes et Dessinateurs. Founded in 1844, largely under the instigation of the Baron Isadore Taylor, the Association, like the comparable Art-Unions, attempted to secure a stable, buying public for its membership and to provide old age pensions and relief assistance for artists or their families from funds derived from annual dues.[26] This and comparable institutions also raised money for its pensions through balls, concerts, fêtes, exhibitions, and lotteries. The Association's most important foray in the field of exhibitions was the 1846 show organized at the Bazar Bonne-Nouvelle of leading French artists since the Revolution, an exhibition that also included eleven paintings by Ingres, who had not exhibited in Paris since 1834.[27] Despite the deep impression the exhibition made on the Parisian art public—which led at least indirectly to the great retrospectives of many of these same artists at the Exposition Universelle in 1855—the effectiveness and visibility of the Association apparently ceased with the Revolution of 1848. The Art-Unions of Britain and America seemed generally to have enjoyed comparably short existences. Only in the German, Swiss, and Austrian *Kunstvereine* were regional alliances between artists and potential patrons—what were virtually civic clubs for the displaying and purchasing of art—effectively maintained to the end of the century and beyond.

The Art-Union/*Kunstvereine* phenomenon underlined the deficiencies of the academy system, yet, and especially in France, testified to its continued hegemony over the construction of the professional identities of artists. Whereas in Germany, and to a lesser extent in Britain and the United States, independent artist organizations survived the efflorescent Art-Union movements, in France the centralized art system discouraged the development of small, provisionally arranged exhibition societies, especially vis-à-vis the dominating presence of the Salon. The intransigence and aesthetically exclusive character of the juries under the July Monarchy made a necessity out of Baron Taylor's Association. Although a conservative critic such as Delécluze held the government accountable for encouraging too many artists through its annual Salons and related prizes, in those same

years the Salon was under the exclusive control of the academicians. Léon Rosenthal, who in his influential book *Du Romantisme au réalisme* (1914) created an enduring portrait of the rise of the modern art world in the age of Louis-Philippe, noted that while under the Restoration the great Romantic painters such as Géricault and Delacroix had no trouble passing a Salon jury composed of state officials, academicians, and *amateurs*, when Louis-Philippe handed complete control over the jury to the Academy the result was an "absurd and ferocious" jury that regularly proscribed artists.[28] Although Rosenthal essentially reproduced the accusations made against the Academy at the time, there can be little doubt that the academicians did much to earn the hatred of an important segment of the art community.

Intractable juries are, however, but flashpoints in a century-long process of institutional transformation. Both the academicians and the state through their joint efforts embodied in the annual or biennial Salons had indirectly encouraged the development of institutions that eventually undermined the Academy's place within the French art world. First the Salons gave birth to the normative practice of art criticism, which introduced a new class of professional writers to the regular operations of determining quality and taste. Standards began to be set that fell outside the control of the academicians. Artists working outside the "grand tradition" of French painting were as likely to see critical attention as those within it. The critics began to exert influence over a new, mass audience for the visual arts. Here again the Salons, joined in the middle of the nineteenth century by the great international exhibitions, were directly responsible for creating these audiences. Finally, the public entertainments offered by the spectacle of the Salon undermined the academic pretensions to "serious" exhibitions for the connoisseurs of art—if it had ever indeed truly been that.

The arguments against academicism and "conventions" steadily mounted. In 1855, at the great Paris Exposition Universelle, critics repeatedly seized upon the theme of the decline of the French tradition, on the occasion of an exhibition designed to celebrate the tradition and to announce its continued vitality.[29] In a characteristic, if extraordinarily rich review of the exhibition, the Austrian art historian Rudolf Eitelberger von Edelberg wrote a damning critique of contemporary French painting on the grounds that it had come to subscribe fundamentally to the dictates of fashion. Eitelberger had been sent to the exhibition by the Austrian government to observe French art institutions and pedagogy, a mission that foretold the spread of the institutional structure (as well as many of the strengths and limitations) of the French Salon system via the international art exhibitions. Like the Salon before them, the Paris Expositions of 1855,

1867, 1878, 1889, and 1900 encouraged the growth of Paris' international artist community, which in turn exacerbated conflicts among artists as they clamored for the fame and the rewards that could be conferred by a medal. Eitelberger held this increasing competition for publics that the French governments had done so much to foster most responsible for the decline of the French academic tradition. Artists were

> seeking not just that success which emanates from competent judges of art but that which goes along in the train of exhibitions and prizes, which echoes in the salons of the art speculators, the pretentious rooms of the rich, in the offices of journalism. . . . Why else would it happen that the most absurd fashions and the harshest contrasts are dragged forth with such intentionality, if fashion did not ever demand new food and the spoiled palette ever stronger and stronger spices? The systematic exploitation of all sorts of nudity, of all shocking objects—where can this come from other than from the morbid fantasy, from the success that similar objects achieve in that society which is in a position to spend a great deal of money for things of little value?. . . Art is art only if it comes from the spirit and speaks to the spirit.[30]

Eitelberger observed one of the most prevalent manifestations of the leveling of the Salon through popular taste (later much parodied by caricaturists such as Daumier), the rampant lowering of the moral tone, the abandonment of the idealized virtues incorporated in history painting, for paintings ostensibly without the traditional moral message. History painting declined into cinematic-like glimpses of "daily life" of past centuries or, in Bouguereau's case, empty narratives of cavorting nymphs or comely, Madonnaesque peasant girls.

The state's reasons for "meddling" in artistic affairs were often at odds with the private interests of the artist community. But direct state patronage meant money and money ensured that those who rose highest within the ranks of the academic/Salon system could achieve a strong measure of financial security and social stature even in an uncertain, market environment. Thus, in the greatest of ironies, the state was forced to conduct periodic reforms that sought to exorcise the beast it had done so much to create. It is remarkable how many thought the solution to the Salon's commercialism lay first in pedagogical reform within the art schools, broadening the rigid academic instruction and providing new technical education to produce fewer fine artists and more "useful" artisans for the respective nation's industry. This was part of a more general project to loosen the Academy's control over the Salon.

The second solution to the academic/Salon system, and the one with which I am concerned, was to reform exhibition practices. If Salon reform was the inevitable product of the sheer numbers that produced successive waves of challengers to the ruling elite, it has far more commonly been described as an ideological struggle between an entrenched conservative elite and "democratic" forces allied with the political and aesthetic "avant-garde." Yet the forces that generated the fragmentation of the French art community, and of French art, were not polar, but multivalent. In the actual politics of the Salon, where unanimity of style, of political intention, of a "public" for art were ever-lacking, Salon reform, and what needed to be reformed, had as its only constant the belief that it was necessary. But the means and the results to be achieved were never agreed upon. In the same manner, reform was never the exclusive project of the political left or of the aesthetic modernists. Indeed, there was no one among the "independents" who took so radical a position vis-à-vis the Salon as the reputed reactionary among French painters, J.-A.-D. Ingres. In 1849 he wrote

> to remedy the overflow of mediocrity which has caused the disintegration of the French School, to counteract the banality which has become a public misfortune, which sickens taste and overwhelms the state adminis-tration of the arts, fruitlessly wasting its resources, it is necessary to re-nounce exhibitions. . . . It is true that exhibitions have become a part of our lives. It is therefore impossible to suppress them. But they must not be encouraged. They destroy art, by making it a trade which artists no longer respect. The exhibitions are no more than bazaars in which mediocrity is impudently flaunted. They are useless and dangerous.[31]

Ingres' solution was untenable, too few patronage opportunities were avail-able and those went to established artists. If anything, the artistic "left" took the opposite view and subscribed to the idea of holding more exhibitions, of providing more sites for exhibitions, more honors, more rewards, etc. The "left" even sought out what was most repugnant to those who held on to pre-modern notions of art and openly pursued commercial opportunities. Indeed, where the "left" most resembled the "right" was their expressed desire to separate themselves from the bazaars of mediocrity as a matter of professional survival.

All efforts to reform the system from the inside failed, if by reform one meant either diminishing the number of exhibitors or increasing the quality of the exhibits. At odds were the two principal functions of the Salon: to provide artists with access to audiences and to act as the official arbiter of tastes through its system of juries and prizes. Delécluze, for one, thought

29

the solution to the second problem lay in solving the first. He followed the mechanical equation that an elite group of exhibitors would equal a higher quality of art. No doubt Delécluze, like many artists and critics of his era, recalled the small and eminently successful membership of the ancient workshop tradition and their nearly equally productive successors, the art academies of the sixteenth and seventeenth centuries. These traditional models, however, much like medieval workshop practices through which Ruskin and Morris hoped to reform industrial production, proved to be unworkable solutions to the overpopulation of the Salon.

Under the Second Empire, restrictive measures were employed with the expectation that they would improve the general quality of the exhibits. Biennial shows, stringent juries, a limitation on entries to three, and revisions in the system of awards to favor younger artists were designed to cut back on the chaos and the commercialism of the Salons.[32] The state hoped to accommodate younger artists and to satisfy those members of the art community who resisted the hold of the Institut de France over the French art world. Few, however, if any of these reforms worked. The biennial Salon and its juries led only to the infamous Salon des Refusés in 1863 and a new set of reforms. This pattern of constriction, followed by forced governmental concessions, was to be repeated for the remainder of the century.

The state, whose interest in Salon politics was always tied to the political utility of French art for domestic and foreign propaganda, consistently sought the solution to the diminishing returns of its academicians in physically restricting their control over the Salon. As the Academy came to be widely perceived as an exclusionary body, representing vested, factional interests over those of the art community as a whole, the state, from regime to regime, regardless of whether reactionary or republican, steadily stripped the academicians of their governing place within the Salon hierarchy. The results were often unexpected.

The practice, for example, initiated during the brief years of the Second Republic, of awarding exemptions to Salon prize winners and members of the Institute and the Legion of Honor, was greatly extended after 1863 through the creation of the *hors concours* class of exemptions (that is, if one has received a certain number of medals—the degree and number was frequently adjusted—one no longer submitted one's work to the jury).[33] Not only did this usurp the peer review role of the Salon's juries, but it decreased the amount of available space for unestablished artists. Moreover, when the right of exemption was extended to medal winners at the Expositions Universelle of 1855 and 1867, it meant that foreign artists so honored could also exhibit at the Salon without submitting to jury review.

At the same time, the state ensured that increasing room be given at the École des Beaux-Arts and the Salon to foreign artists. Although the Rome prize could go only to French artists, the Salon awarded a surprising, and steadily increasing, number of medals to foreign artists. The state also stripped the École of its exclusive gatekeeping function in terms of who qualified for awards and Salon prizes.[34] This led directly to the establishment of independent pedagogical institutions such as the Académie Julian, which opened in 1868.[35] Julian's was particularly accessible to foreign students, attracting aspiring artists particularly from Britain and the United States, but also from Germany, Scandinavia, and Eastern Europe. With virtually unrestricted admission, Julian's also offered foreign students access to the critiques of some of France's greatest Salon luminaries, including Bouguereau. Under the stimuli of the great expositions and the liberalization of art education policies, foreign artists acquired a heretofore unimagined preeminence in Paris. They formed elaborate allegiances in the cafes and in the various bohemians enclaves of Paris, and they launched their careers at home on the basis of their successes at the Salon. In the Salon of 1885 alone there were 389 foreign exhibitors out of a total of 1,284 artists, that is, over one fourth. Domestically, such numbers produced natural resentments.[36] Abroad, the internal struggle among the respective art communities over access to the Parisian Universal Expositions—and their own local imitations—engendered comparable struggles among artists over the question of national versus international exhibitions. These circumstances led directly to that fin-de-siècle, pan-European phenomenon: Secessionism.

Efforts at quality control encouraged similar factionalism in France. By 1879 the state had effectively stripped the Academy of all control over the Salon. The Salon of 1880 was the first Parisian exhibition to be run exclusively by artists, representing a "democratic" society of French painters, sculptors, architects, etc. Ten years later, the Salon governance broke apart, a potent expression of the party interests inherent in this "democratic" body of artists. It was also proposed under the Third Republic that the Salon exhibitions should be divided into two separate vehicles.[37] One, the annual Salon, would continue much as it had in the past to exhibit as much of contemporary art production as it could cram within the exhibition space. The other, governed more or less directly by the state and conceived first to be a triennial exhibition, would constitute the official verdict of the best art France had produced in the prior three years.[38] This system was soon revised to review ten years. Only two "Decennales" were staged, on the occasions of the 1889 and 1900 Expositions. For obvious reasons, official verdicts on the "best" of French art never went down well with the majority

of the art community. In short, the history of state involvement in Salon politics produced few if any beneficial results, even if these reforms were always carried out in the name of "quality," of "aesthetic pluralism," and, above all, in the name of the great tradition of French art.

NEGLECTED GENIUS AND MARKET VALUE

The fall of national barriers in the patronage of contemporary painting was to have huge international consequences. The spread of international art exhibitions in the last quarter of the century put the spectacle of the Salon on an international footing. Beginning with London's Crystal Palace Exhibition in 1851 and significantly expanded into the field of fine arts in Paris in 1855, these trade fairs stimulated international competition among artists.[39] They favored pluralism and aesthetic populism over the "high art" tradition embodied in academy-controlled aesthetics. And they shaped a vast new audience for the fine arts, which brought their own aesthetic demands and commercial resources to the art world, expanding its precincts across national borders and down the social strata. These developments were further enabled by the huge growth in reproductive prints and photographs from the 1830s on. Widespread access to reproductions of Salon notables and the ever-increasing draw of Parisian art schools brought, in spite of the apparent diversity, a new homogeneity in styles that dissolved traditional national or regional stylistic identities. By the end of the century "Bouguereaus" and "Jules Bastien-Lepages" were being turned out by American artists with the same enthusiasm that painters such as Manet and Monet found American (and British) imitators.

Increasingly the commercial rewards of a Salon career depended less on official patronage than on foreign sales. Commercial galleries became as important to the career of Bouguereau as they did to Manet. While Bouguereau's career advanced at the usual, if richly rewarded, pace—a Prix de Rome winner in 1850, a first class medal at the Salon of 1857, a member of the Institut in 1876 and a grand medal of honor recipient at the 1878 Exposition Universelle, president for many years of the Société Artistes Français—inside the commercial gallery system his career path only subtly differed from Manet's. The traditional venues of sales and publicity, auction houses and Salons, were first supplemented and eventually replaced by an emergent class of dealer whose chief product was contemporary painting, and who developed international connections and international audiences for the artists they managed. Dealers of this type were loyal neither to

national styles nor academic traditions. As Louise d'Argencourt has observed, Bouguereau translated genre painting to the kind of monumental figure painting established by Courbet in the late 1840s and early 1850s, a move that at the time was controversial, but that by 1860 was normative.[40] So while Bouguereau came to defend the institutionalized form of the academic tradition, he was far from representing its ideological substance, at least as it might have been understood in the days of Jacques-Louis David.

Like any successful painter of his day, Bouguereau had his dealer, in this case Jean-Marie Fortuné Durand, the father of the Impressionists's dealer Paul Durand-Ruel.[41] When remembered, Durand has been admired for his support of the Barbizon painters in the 1840s; the specialty of his shop, in other words, was landscape painting. But like all the major dealers of his day, he depended as much on the sale of the leading lights of the Salon as on any particular class of pictures. Durand admired Bouguereau's work at the Exposition Universelle and became the artist's principal dealer for the next ten years. Between 1855 and 1863 the gallery is known to have bought over forty paintings from the artist. This must have represented only a fraction of his output; he supplemented his income with a significant amount of private commissions in both portraiture and decorative work, and via state purchases. In this sense Durand's commitment to Bouguereau varied little from standard dealer practices of the 1830s and 1840s. The commitment to the artist is based on Salon reputation, and mediated by occasional and essentially direct purchases and sales.

Durand sent his Bouguereaus from Amsterdam to Biarritz to Manchester and London. Moreover, his son, d'Argencourt argues, was primarily responsible for convincing the artist to adapt and soften his classical style for the foreign market (under the influence of the palatable and popular painter Hugues Merle with whom Durand had entered into an exclusive contract).[42] The result was that between 1864 and 1866 the firm sold only one Bouguereau in France, while the rest went to foreign collectors.[43] When Durand-Ruel assumed control of the gallery upon his father's death in 1865, he had other business priorities—primarily the speculation in the École de Barbizon—and let the artist go. Bouguereau's next move was even more predictable; he signed an exclusive contract with the firm of Adolphe Goupil, then at the height of its international reputation.

Crossing the frontiers of national styles, dealers such as Durand-Ruel and Goupil pursued the rich new markets of the industrial elites then coming to cultural prominence in Brussels, Manchester, and New York. As a class they represented a mere handful of dealers (e.g., Goupil, Durand-Ruel, and Francis Petit in Paris; William Agnew and Ernest Gambart in

London), overtly competitors, but nonetheless linked in a cooperative net of purchases, loans, and contacts that spread from Paris to London, Brussels, and New York.[44] They reorganized their businesses in the 1850s from relatively passive concerns that exhibited all manner of art and art objects, past and present—hardly distinguishable from the antiquarian book dealer—into more highly specialized and segregated enterprises. Exploiting the market opportunities offered by the new, broadly based audience for art, they turned the business lessons learned in the print trade (with its mass-market audiences) on the now exclusive (in both senses of the word) promotion of "high" art objects: painting and sculpture. They began to supplement traditional sales methods—the selective display of individual pictures either to invited clients or the random customer off the streets—with special exhibitions, of topical or historical interest, which were intended to draw the attention of the public and the press to the gallery. Albert Boime has described this new class of merchant as the "entrepreneurial" dealer.[45]

The greatest, most representative dealers in this class were Bouguereau's agent, Goupil, who, before the 1860s, was already the largest print dealer in Europe, and the London picture dealer, and former employee of Goupil, Gambart. The two galleries, with their international branches, dominated the international picture market from the middle of the 1850s to the end of the 1870s.[46] Eminently populist dealers, working the widest possible audiences, they organized their enterprises in such a way as to suit the financial resources of a strongly disparate art public. They were unabashedly commercial in both their methods and their self-presentation, perhaps because they came out of the print trade. It was there that the fine arts first met an audience heretofore excluded from the art world: it possessed little of the gentility and the refinement associated with the academic and aristocratic tradition. And yet Gambart and Goupil were equally comfortable within the precincts of the Paris Salon and the Royal Academy. As in the case of Bouguereau, they mediated the pretensions of academic life with the rewards of an international commercial career. The rewards were great for artist and dealer alike. Gambart, like his chief British competitor, the firm of Thomas Agnew and Sons based in London and Manchester, freely mingled with industrialist and aristocratic clients alike.

Gambart's entrepreneurial practices began with the commitment to officially sanctioned reputations and individual pictures. Popular works were further disseminated by mass reproduction and by traveling exhibitions that often followed a national and sometimes international sequence of galleries. Exhibitions were arranged to favor publicity, which included,

above all, timely "benefit" exhibitions that attracted public attention and seemed to belie the commercial character of the enterprise. Finally, exclusive contracts, especially directed toward reproduction rights, ensured the greatest control possible over the art the dealer managed. On occasion they would even go so far as to control the entire production of an artist. Yet exclusive contracts were tendered at this time to artists strictly in proportion to their official successes. Through the end of the century and beyond British dealers preferred to emphasize individual pictures rather than the entire career of an artist, whereas the French found increasing value in concentrating on an oeuvre. This difference is manifested in the kinds of art they supported. British dealers generally worked the reputations of large narrative pictures, rendered with as much attention to minute detail as possible. Gambart would hold special one-painting exhibitions of works like William Powell Frith's *Derby Day* (Tate Gallery, London)—whose microscopically worked canvases forced the dealer to erect ropes to keep back the crowds who crushed around hoping for a closer glimpse. The paintings were then sent on tour around the industrial centers of Britain. Gambart also bought up the related sketches for the pictures, in addition to the reproduction rights, achieving as it were a visual monopoly over a specific work. He then arranged for a series of copies, handled in a wide variety of reproductive techniques, to suit through their size and quality the most varied audiences possible.[47] The more emotionally appealing the subject the better. The French, especially those speculating in the auction houses, while hardly immune to the attractions of Salon favorites like Bouguereau, found the market for landscape paintings and other small-scale genre work as potentially attractive as major figure paintings. The significance of the contemporary art auction for France, unlike Britain, for example, was that the chief foci of speculation, as we shall see, would not be the medal winners of the Salon, but rather artists who for thirty years had been made outcasts by the Academy or had suffered in some way from public ridicule—while at the same time receiving serious support from leading critics and *amateurs*.

Bouguereau's fortunes, generated through a Salon reputation and a burgeoning art market, like those of the other great international *Salonkünstler*, was a product not only of the economic prosperity of the early years of the Second Empire, but a demonstration of how such constructed reputations might survive the periodic checks in economic growth, the cycle of booms and depressions that characterized the European economy in the last half of the century. Survivability, indeed, might be taken as the password for the

Salon system. The Salon leadership's resistance to change, especially in aesthetic matters, exacerbated the inevitable tensions within the art community, and, in the greatest of ironies, endowed the opposition with the cachet of being both artistic and political reformers if not revolutionaries. The rise of aesthetic modernism, with its ideological and yet paradoxical stand against commercialism, had its origins in the transformed practices of the professional artist, in which modernist artists and art played, at least at first, largely a passive role. Without the Salon juries of the 1830s and 1840s, the opposition would have had much less to define themselves against. Rarely in subsequent years were the Salon juries so ideological, so exclusionary. But it did not matter. When under Napoleon III comparable restrictive juries led to the Salon de Refusés, the construction of the myth was complete. All later "avant-gardes" required the label of "refusés" whether they earned it or not.

In 1914 Léon Rosenthal reiterated the standard critical cliches of the 1860s when he derided the passing of the age of the patronage of enlightened, cultured monarchy and the aristocracy that supported the ancien régime in favor of the merely rich, and of an audience no longer composed of connoisseurs, but of the crowd.

> [The bourgeoisie] bought: they bought especially easel paintings or portraits; the tendencies that they favored were far from being completely recommendable; they encouraged the artistic production without contributing, to the contrary, to the elevation of the standards of art.[48]

For Rosenthal, the divorce between "serious" artists and the "public," this new public of the bourgeoisie, was already complete before 1848. What changed after 1848 was the emergence of what Roger Fry in 1912 called

> a band of heroic Ishmaelites, with no secure place in the social system, with nothing to support them in the unequal struggle but a dim sense of a new idea, the idea of the freedom of art from all trammels and tyrannies.
>
> The place that the artists left vacant at the plutocrat's table had to be filled, and it was filled by a race new in the history of the world, a race for whom no name has yet been found, a race of pseudo-artists. As the prostitute professes to sell love, so these gentlemen professed to sell beauty, and they and their patrons rollicked good-humouredly through the Victorian era. They adopted the name and some of the manner of artists; they intercepted not only the money, but the titles and fame and glory which were intended for those whom they had supplanted.[49]

Rosenthal, for nationalist reasons of his own, made the parallel causes of style and politics a uniquely French phenomenon.[50] But surely both he and

Fry were right in observing that no other culture before the fin de siècle managed to create this dichotomy (whether real or imagined) between the "free" artist and the "race of pseudo-artists" who "rollicked through the Victorian era" winning all the rewards the profession had to offer while the true artists labored on in obscurity. It was France that in the 1830s and 1840s gave us the ideas of the "avant-garde" and of the "juste milieu," the product of a confusion of political terms and positions with aesthetic ones.

Aesthetic tropes such as "avant-garde" and "juste milieu" are but the most notable examples of the tendency of the era to define styles as if they were points along a political spectrum, just as Stendhal's famous declaration that he held opinions in painting belonging to the "extreme left" evokes an image of revolutionary art as revolutionary politics (though it was an association that Stendhal, if not later critics and artists, explicitly denied). As Francis Haskell has argued, such usages were amorphous at best, almost always misleading, and have had an enduring life.[51] What could be more telling than Manet's remark about Duret: "It is curious how republicans are reactionaries when they talk about art."[52]

The habit of thinking of art in political terms reflects the pressures within the French art institutions that virtually compelled the formation of parties, of aesthetic allegiances and doctrines, in order, in effect, to command an audience (if not to win control of the Salon). The aestheticization of political discourse and the advancement of the "autonomous" (Romantic) artist as a heroic, transcendent figure would place any artist identified as "avant-garde" or even merely "independent" outside the problems posed by the commercialization of the art world. Conversely, the *juste milieu*, born in the 1830s, most closely correspond to Fry's "pseudo-artists," painters who, as Rosenthal described them, possessed little conviction, who smoothed away all the rough surfaces, the inconsistencies and problems of style, who created an art of spectacle for the crowds who flocked in ever increasing numbers to the Salons where they triumphed. From the "avant-garde" of 1830 (I use interchangeably the terms École de 1830 and École de Barbizon to refer to art and artists who were in reality as imprecisely defined, even to themselves, as the terms suggest) the example of the alienated moderns paired with their *juste milieu* rivals was passed down to that of 1870 and from 1870 to that of 1910. What began in the 1830s as a political/institutional struggle for freedom against the tyranny of the Academy, later became a struggle over rewards between the "authentic" moderns and their less "authentic" rivals who were so eminently more successful in the marketplace.

Freedom within the institutions of art was manifested in a rhetoric of independence, a rhetoric enacted almost exclusively in the de-politicized context of the local *Kunstpolitik*. "Independence" did not serve the political

interests of an artist's "public." The critical apparatus that supported the art market did not claim such art for the proletariat. There were writers, such as Jules Castagnary, who were never the agents of dealers and supported art for social purposes. But in the marketplace where the "independents" found themselves, their apologists defined their publics, as Duret did, in terms of an isolated elite of connoisseurs against the generalized audience of the Salon. Independence in art in the context of the art market really meant the pursuit of personal, artistic goals.

Nonetheless, the claims for the public virtues of these private victories over the "conservative" opposition were endlessly embellished, as when Paul Signac argued that by painting in a Neo-Impressionist, and hence, independent style, he was intrinsically making political art.

> The anarchist painter is not he who does anarchist paintings but he who without caring for money, without desire for recompense, struggles with all his individuality against bourgeois and official conventions . . . , basing his work on the eternal principles of beauty which are as simple as those of morality.[53]

Who this art was for and how it was to be seen by this apparently non-bourgeois public were issues that Signac did not consider. His defense of the anarchist painter was written circa 1900 at a time when Signac himself was painting pleasant landscape paintings of fashionable tourist resorts and receiving considerable attention in the international art market. Signac's ideal of anarchist painting was not so much hypocritical as it was a powerful testimony to the contradictory faith of the modernist enterprise suspended above its commercial practices.

Of course, at times the rhetoric of an independent art would be re-invested with political import, characteristically over general cultural/political issues as internationalism versus nationalism, city versus country, etc. The famous conflict between the Berlin Secession and the kaiser in the first decade of this century is one example.[54] At issue was less a matter of style per se as it was of style politicized; the Secession stood for French Impressionism in Germany, for internationalism in art politics, and for defiant opposition—which had connections far outside the world of art—to the kaiser's interventions in the affairs of artists. But the more enduring, more fundamental character of the claims to aesthetic independence was the enormous utility this topos had for the marketplace. The rhetoric of independence would endlessly be employed to overcome the prejudices against the market. In claiming to be free of audience expectations, of being above the interests of money, an "independent" art could occupy a gallery without becoming "contaminated" by it.

The contrast between the independent "Romantics" and the state-supported "academics" and "*juste milieu*" generated a powerful and enduring myth about the relationship between aesthetic and institutional revolt inside France. The myth serviced the revolution in the French, contemporary picture market, which in turn was fueled by the economic expansion of the early years of the Second Empire and by the Paris Expositions Universelle of 1855 and 1867. In the 1860s and 1870s the École de 1830 possessed the commercial advantage of being marketable as a kind of pre-1848 *refusés*, an école of like-thinking artists whose work threatened the aesthetic/social position of the masters of the École des Beaux-Arts. Through the actions of a deeply entrenched elite whose self-interests were reflected in the intransigence of the Salon's juries and hanging committees, the period between 1830 and 1848 had produced a virtual generation of comparatively disenfranchised artists.[55] One ought to be cautious about this because many artists of the École de 1830 did have admirers; were often, if not always, admitted to the Salon; and, like Delacroix, were even given state commissions. But the perception of their exclusion, when united with the revolutionary tradition in France, gave their art a symbolic capital of aesthetic/social rebellion which in the next generation had unrivalled power in the marketplace.

The vacuum left by the fall of "la grande peinture" magnified the commercial attractions of, and the pressure to be defined as, a coherent aesthetic/social movement. The characterization of a cadre of artists was passed down to the Impressionists, who, often against their will, were portrayed as a unified front. One American critic, for example, at the time of Manet's posthumous auction in 1884 claimed,

> the fact is that certain amateurs and professional dealers hope to see the day come when Manet's work will sell as Millet's work now sells, and therefore they are doing all they can to create fancy prices for his pictures . . . [Durand-Ruel] had in his hands at a time when they sold for nothing all the great pictures of Corot, Delacroix, Millet and Rousseau; and now he imagines that the future is reserving for the 'impressionists' as brilliant an apotheosis as that which Millet and Rousseau are now enjoying, hence his craze for buying the wildest efforts of Manet's brush and of the brushes of Manet's disciples.[56]

The lessons of Romanticism were consequently both aesthetic and commercial. Romanticism evoked a pattern of revolt that became normative in some circles of the Parisian art world, a way of defining oneself against the Academy, against the Salon, and against the world. But because this revolt was played out inside a newly shaped, French, commercial gallery system, it

fed the fundamental social contradictions that lie at the heart of modernism in the visual arts. Enabled by the art market, modernist authenticity hung on the thread of an independence from pandering to public tastes.

Although dealers often found it commercially expedient to hold exhibitions of living artists under a group identity, whether it be as Impressionists or symbolists or Expressionists, they reaped the largest speculative rewards from the celebration of individual "temperaments." Temperament first emerged as a critical topos in the 1860s as a byword for, or a precondition of, genius. At odds with the later political notion of the avant-garde, which stood for écoles and movements, the market value of temperament arose at a time when the notion of "isms" representing what was important and what was not had not yet entered public consciousness. As Nicholas Green has argued, the arrival of "temperament" as a component in the exploitation of the contemporary art market coincided with the triumphant arrival of the "nature" painters, the landscape artists of Barbizon "whose art works were to be read as the reflection or expression of the temperament descriptively explored in the written texts. Nature was the ground on which the plethora of creative individualities was inscribed."[57] Green suggested that the authorization for this critical *habitus* lay in its parallel to current experimental psychology and physiological theories of perception that explored the complex relation between the "objective" world and "subjective" experience. But it is also true that the nineteenth-century fascination for the individual, for the subjective experience, fed the descriptive force of temperament. The shift of absolute standards of quality—represented by the classical tradition—to the Romantic, relativist understanding of beauty, embodied in Baudelaire's art criticism, made the claims on behalf of the artist versus the individual work of art seemingly inevitable. Yet the triumph of relativism, at least in popular consciousness, was the product of a slow evolution. Genius continued to be widely viewed as a medium of transcendental experience, the history of art as the history of great men, the unity of art achieved in the unity of genius, even if in surface peculiarities of style and content much changed from one master to another.

The promotion of temperament over individual paintings did serve the market for the École de 1830 by elevating the enterprise of the nature painters. Landscape painting was endowed with the nobility of the artist's soul in an art otherwise seen lacking significant interest when compared to conventional history, religious, or even genre painting. The "sincerity" of the artist's personality was argued to be somehow inscribed in the reflection of the truths of nature (and preferable to the "fictions" of the academic

tradition). This mentality served another market benefit. The singular masterpiece gave way to the myriad productions from an artist's hand, from the smallest drawing to the most ambitiously scaled Salon entry. Each received their touchstone of value from the artist's personality, not from the specific subject, or the size, or the medium, or even whether the work remained unfinished. In 1879 the American critic William C. Brownell described the virtues of James McNeill Whistler's etchings in a way that astonishingly anticipated the language of Expressionism:

> Every one will perceive in his slightest etching an effectiveness, an impressiveness, a force which may or may not justly be called eccentric, but which it is impossible not to recognize as original. . . . It is so far from sophistication that it seems almost unreflective. It is indeed absolutely spontaneous, but it has the air of spontaneity unrevised by any afterthought, as so much of even what is justly to be called spontaneous does not. . . . His unconsciousness is so pure, and sophistication is so opposite to his genius, that he is somehow relieved of the necessity of imagining that he is reproducing a scene.[58]

The habit of reading personality through the artist's touch, and thereby measuring the value of the artist's work, would only be translated into a theoretical system with Expressionism. But clearly its practical usage was established long before.

This marvelous tool for the mass merchandising of an artist's oeuvre was not the exclusive prerogative of modernist painters. The claims of temperament became so widespread after the 1860s that they serviced Whistler as well as Manet, Bastien-Lepage as well as Whistler. The art audiences of the 1870s and 1880s became accustomed to measuring the value of a work of art in its worked surfaces, regardless of the subject. The grounds for distinguishing authentic from pseudo artists—if they ever had reality—disappeared in the banality of critical discourse. Zola, in fact, who coined the most famous phrase regarding temperament, "une oeuvre d'art est un coin de la création vu à travers un tempérament," devoted most of his post-1860s art criticism to describing the corruption of the Salon on the one hand and the lack of a great artist among the Impressionist ranks on the other. The genius of the future who would return art to the "masterpieces" of the past could not be a nature painter almost by definition. And among the "nature painters" the market not surprisingly privileged figure painters like Millet. Finally, the artist most bound up with the claims of temperament, Manet, who was also the chief beneficiary of Zola's early art criticism, was perhaps the artist most purposively dedicated—in the same years Zola

41

defended him—to the pursuit of the modern version of the Renaissance masterpiece.

In addition to the rhetorics of independence and temperament, entrepreneurial dealers from the 1850s onwards employed rich decor and a variety of fashionable entertainments, charity events, and evening soirées to attract the best class of clientele. To this mix was added in the 1870s and early 1880s fundamental innovations in exhibition practices, largely stemming from London and the singular example of the American expatriate and most celebrated (if not always respected) artist in Victorian England: Whistler.[59] Whistler transformed the agitation for exhibition reform into a fundamentally new understanding of the art exhibition as an ideological platform.

The absolute originality of Whistler's exhibition reforms has long been debated. Calls for reform in the mode of display for both Royal Academy and Paris Salon exhibitions had long been in the air. Galleries such as Agnews and Durand-Ruel had already seen the value of creating an elite ambience of well-selected, well-displayed works of art. Camille Pissarro believed that Whistler had merely imitated the layout of the Impressionist exhibitions—although he also admitted that Whistler carried out his schemes on a greater scale than the Impressionists had been able to do.[60] The massing of personal "art museums" of contemporary art which abounded both in England and the United States led another critic to compare Whistler's installations with the picture galleries of some of the English aristocracy.[61] Yet Whistler's originality was not a matter of isolated features of his method of self-promotion. Clearly the artist drew on his experiences both as a member of England's high society and as an intimate participant in the French art world, at both the official and the commercial level.[62] What fundamentally distinguished Whistler from all his contemporaries, even from other well-known reformers such as Degas, was that Whistler conceived of the art exhibition not just as an argument over how to best display pictures, but as a work of art in itself. Whistler, indeed, was the first installation artist.[63]

Combining the high-art sensibility worthy of a Royal Academician with the business sense of a P. T. Barnum, working outside and yet in close dialogue with the French gallery system, Whistler developed an exhibition "style" that was idiosyncratic, but with wide-reaching ramifications for the marketing of contemporary art. Before the word *Gesamtkunstwerk*, Wag-

ner's dream of a total work of art, entered French and English art discourse, Whistler conceived of the identity of the artist and all that he produced as just such a *Gesamtkunstwerk*. In the totality of Whistler's self-presentation, from the clothes he wore, to his manner of speech, to the letters he wrote, to the paintings he exhibited, to how he exhibited them, to the catalogues and books that excoriated his critics, Whistler conducted every action of the artist as if it were intrinsically a work of art. No other artist before the generation of the Expressionists so thoroughly conceived of the artistic enterprise as infusing every aspect of an artist's life. And no artist before the Italian Futurist F. T. Marinetti was so inventive and multifaceted a propagandist for his own art.

Whistler set the work of art in a carefully chosen and designed frame, and placed it in isolation on neutral, but pleasingly light, monochrome, white-washed walls. As best as he could, Whistler adapted the available light to create an overall diffuse lighting effect. On occasion he employed what he called a "velarium," a parachute-like or umbrella-like array of translucent fabric, that let light fall directly on the paintings alone, while bathing the rest of the room in an atmospheric ambiance. The space might be carefully articulated by a handful of flowers in pseudo-oriental vases, rush floor matting, and otherwise harmonic management of the interior decor.

Whistler extended the same care to his publicity materials, from the printing of invitations, to his exhibition catalogues, to his books. Whistler understood himself to be the foremost propagandist for his "cause." Thus, the publications in support of his exhibitions and as attacks on his critics were unparalleled in the nineteenth century. They possess a manifesto-like quality, more common to post-1900 art; but they were manifestoes composed not by the author, but by the negative orations of his critics and his response to them. *The Gentle Art of Making Enemies*, first published in 1890, was largely a compilation of critiques of his works and his rebuttals. It must rank as one of the most extraordinary books of the nineteenth century and a paragon of Whistler's aesthetic sensibility—articulated by the yellow cover present on all his published work, by the careful formatting of the page with their wide margins, and by the butterfly, Whistler's characteristic signature, which, alongside Whistler's *bon mot* marginalia, subtly rejoined the artist's critics.

Whistler's innovations in exhibition format and related promotional tools were paralleled by an equally important, but far less frequently observed aspect of his approach: Whistler constructed his artistic identity via independent commercial exhibitions. Although Whistler was not unknown at Royal Academy exhibitions, his exhibition history is largely composed of

independently arranged, usually one-person shows either in privately hired rooms or in commercial galleries. Today we take this kind of exhibition record for granted. At the time, however, it was extraordinary. The prohibition against independent exhibitions (as inevitably commercial endeavors) was not as strong in England as in France, but even in London there had always been difficulties over the self-promotion of an artist. Before Whistler, reputations were not to be made in commercial galleries. The profits later earned in the marketplace were supposed to be based on a reputation garnered at juried exhibitions. As one English critic put it, "it cannot be denied that pictures that have passed the ordeal of judgment by the Royal Academy have gained a more worthy victory than those which have pleased the taste of one connoisseur and his personal friends."[64]

When Whistler held his first "retrospective" in 1874, he had as models the famous, self-arranged retrospectives that Gustave Courbet first gave himself in Paris in 1855, in conjunction with that year's Exposition Universelle, and a second pavilion erected by the artist, alongside one belonging to Manet, in competition with the Exposition Universelle of 1867. As significant as these retrospectives were, they were nonetheless just collections of pictures. By contrast, Whistler subordinated the individual picture to the total oeuvre and placed his status as an artist over individual work. In so doing, Whistler anticipated the speculation in careers rather than in pictures. In this light one might remember Whistler's reply at the Ruskin trial to the charge that he asked two hundred guineas for a painting that took two days labor: "I ask it for the knowledge of a lifetime." While, of course, this should first be understood as an account of the experience and labor an artist accrues in his lifetime that goes into each picture, and as consistent with Whistler's ego, more strongly than any of his contemporaries Whistler articulated the value of an oeuvre over individual work.

The London critics, too, generally ignored specific pictures in favor of an account of the ambience of his exhibitions. And what an ambience. As one critic wrote

the Gallery and its contents are altogether in harmony—a "symphony in colour", carried out in every detail, even in the colour of the matted floor, the blue pots and flowering plants, and, above all, in the juxtaposition of pictures. . . . If anyone wishes to realise what is meant by true feeling for colour and harmony—born of the Japanese—let him sit down here some morning, within a few yards of, but in the secure shelter from, the glare of the guardsman's scarlet tunic in the bay window of the club opposite, just

out of hearing of Christie's hammer, and just out of sight of the conglom-
eration of a thousand pictures at the Royal Academy. A "symphony" is
usually defined as a "harmony of sounds agreeable to the ear", here, at 48
Pall Mall, is a harmony of colour agreeable to the eye.[65]

Whether this aesthetic ambiance was due to Whistler's *japonisme* is a matter
for speculation. Whistler was probably quite unaware of Japanese interiors,
save for their representation in prints. More telling is the critic's reference
to the bang of Christie's auction hammer and the thousand pictures of the
Royal Academy. Whistler realized through this exhibition a fundamental
distinction between art and its market, the quiet gentility of his exhibition
versus the "noise" and crassness of the public auction, the symbolic power
of an elite showcasing of an artist versus the vulnerability and vagaries of the
open market.

Yet Whistler could not evade the charges of personal speculation. The
radical character of his exhibition practice marked him as an eccentric.
Because his strategy was both commercial and yet seemingly noncommer-
cial, at least as his contemporaries conceived of the commercial art show in
1874, Whistler was destined to be regarded both as the creator of a sym-
phony of aesthetic sensations and as a shameless promoter, like his Ameri-
can compatriot, Barnum. Subsequent Whistler one-person exhibitions did
nothing to change this paradoxical reputation. We get another insight into
the general effect of Whistler's shows in a marvelous description of the
artist's 1883 exhibition at the London Fine Arts Society, written by a
society columnist in a lady's magazine:

> The private view of Mr Whistler's etchings of Venice took place last
> Saturday in the rooms of the Fine Art Gallery, Bond-street. Everything
> Mr Whistler does is original, even to audacity. One fault his critics cannot
> lay at his door—he is never dull. It is his whim just now to *posé* as a broken
> butterfly. A maimed butterfly has become his device. "Who breaks a but-
> terfly upon a wheel" is the motto that figures on the catalogue of these
> etchings. The catalogue is a surprise; it is entitled, "Mr Whistler and his
> critics." Under the name of each work appears a selected specimen of the
> adverse opinions passed by the press upon the eccentric genius. . . . The
> quiet rooms of the Fine Art Society were seen transfigured. They appeared
> a symphony of yellow and white. The walls yellow and white, the doors
> curtained with yellow; stands of yellow flowers, in yellow pots, in the
> corners; a footman, in splendid livery of yellow plush, handed catalogues.
> It was impossible to see the master's works for the numerous waiting

admirers congregated around them. Many social, artistic, critical nota-
bilities were present. Lady Archibald Campbell bravely sported the col-
ours of the artist who has lately decorated her beautiful house. A yellow
butterfly was in her hat of Canadian fur; another was pinned to her fur coat.
She carried some yellow flowers in her hand.[66]

The rest of the article is devoted to the predictable list of society notables
present at the exhibition. Another source adds this note: for the occasion
Whistler "wore yellow socks just showing above his shoes and the assistants
wore yellow neckties."[67]

The private view was attended, in an extraordinary event, by the Prince
and Princess of Wales, who were said to have chuckled over the catalogue
and queried the artist good-humoredly over the subject of one of his noc-
turnes. Despite these obvious signs of prestige now attached to Whistler's
exhibitions, the artist's commissioned biographers, Elizabeth and Joseph
Pennell, described the overall reaction to this show as a public debacle.

> The public laughed. The Butterflies added to the screaming farce, the
> foppery of the whole thing. The attendant in yellow and white livery was
> called the poached egg. The catalogue was worse. . . . Most of them [the
> critics] made the best of it by refusing to see in him anything but the jester.
> His humour was compared to Mark Twain's, and he to Barnum, and the
> show was "excruciatingly agreeable."[68]

The Pennells' description is a typical exercise in Romantic martyrology—
the genius misunderstood by the crowd. Dating from the Ruskin trial,
Whistler encouraged this construction, pretending to be a broken but-
terfly. Far from being a martyr, however, if anything, Whistler suffered
from his popularity. One anonymous foreign observer wrote in an English
society magazine that Whistler realized the benefits that "social and, above
all, feminine assistance may render in the establishment of a professional
reputation."[69] According to this unsympathetic critic, Whistler's dress, his
manner of speaking, the very nature of his discourse, the idea that "he
imported a novel mode of painting," were calculated to attract the favor of
society.[70]

> Society, being already prejudiced in favour of the man, now welcomed the
> artist, and saw everything which came at long intervals from his studio the
> transcendent gifts of a great original. . . . From the artist he rose to the
> oracle.[71]

Some four or five years later, Whistler's star apprentice, Walter Sickert, published an opinion in the *Pall Mall Gazette*—which Whistler significantly did not challenge—that offered almost the same judgment.

> He has allowed his work, essentially and invariably serious, and with quali-
> ties inimitable, to be presented in certain quaint garbs, and accompanied
> by certain external flourishes that could easily be imitated, and he has
> invited rather than discouraged the familiarity with it of a joyous five
> o'clock tea throng, whom the carpet and the crush of the exhibition room
> "passioned," and who would hardly notice the substitution on the walls
> of something cheaper, in queerer frames, for his "Notes, Harmonies,
> Nocturnes."[72]

It shouldn't be necessary to document the dispersion of Whistler's exhibi-
tion ideas—the Pennells argued that Whistler's innovations were the direct
source of the revolution in exhibition design initiated by the Central Eu-
ropean Secessions. In short, Whistler's exhibition reforms constituted the
most advanced articulation of the idealized space of the gallery.

Less spectacular than Whistler's shows, but more immediately influen-
tial, were the exhibitions of the Grosvenor Gallery, beginning in 1877.[73]
The show, organized and selected by its proprietor, Sir Coutts Lindsay,
featured Whistler, Edward Burne-Jones, Alphonse Legros, James Heilbuth,
James Tissot, Alma-Tadema, Watts, and Moreau, and received strong inter-
national press attention.[74] As this list indicates, the gallery was, from the
first, international in character. Second, its artists were all drawn, by invita-
tion only, from Salon and Royal Academy notables (yet not from the ruling
elite of either institution). Third, they offered sensational exhibits. As a
result of this first show Burne-Jones became an overnight sensation. He
embodied the Aesthetic Movement in Britain for the next two decades and
became an international favorite.[75] This same exhibition also marked the
occasion for Ruskin's famous slander against Whistler, his "flinging a pot of
paint in the public's face," which resulted in the equally famous trial. Far
from being hurt by the affair, the Grosvenor became *the* place to exhibit in
London for the next ten years. Its exhibitions were taken seriously and were
well attended by society figures and industrialist clients alike. Finally, the
Grosvenor fused the apparent disinterestedness, the pretense of being above
the interests of commerce, with a conveniently commercial enterprise.

The Grosvenor possessed two main galleries, with natural light coming
from a diapered glass ceiling and furnished with marble tables and Persian
rugs. One reviewer described its East Gallery's sumptuous decorations, its

"figured crimson-silk hangings, frieze painted in delicate arabesque, pilasters picked out in cream and gold, relics of the foyer of the old Paris Opera House, coved ceiling, coloured soft blue with gold enrichments, and doorways draped with stuff flowered upon a dark-blue ground."[76] Each artist's work was grouped together and an effort had been made to avoid the "skying" common even in commercial art exhibitions.[77] Henry James wrote a trenchant review that encapsulates what the Grosvenor was all about.

> In so far as his beautiful rooms in Bond Street are a commercial speculation, this side of their character has been gilded over, and dissimulated in the most graceful manner. They are the product of a theory that there is a demand for a place of exhibition exempted both from the exclusiveness and the promiscuity of Burlington House, in which the painters may communicate with the public more directly than under the academic dispensation and in which the more "peculiar" ones in especially may have a chance to get popular.[78]

Although subsequent exhibitions at the Grosvenor were never as successful as the first, elite, sensational exhibitions of already-recognized artists in a museum-like decor became the constituent elements of *juste milieu* exhibitions thereafter. The subtle difference between an operation such as the Grosvenor and the conventional commercial gallery can be measured by the seriousness with which its exhibitions were received. Even a magazine such as the *Gazette des beaux-arts*, which otherwise almost never reviewed a commercial gallery exhibition, felt obliged to consider the Grosvenor exhibitions.[79] The impact of the Grosvenor on other dealers was unquestionably great. It offered what public exhibitions could not: an exclusive, and thereby selective gentility, plush decor, a limited (and thus not too tiring to peruse) collection of paintings (and some sculpture) grouped simply and rationally together. Sometimes charging, like an academic exhibition, an admission price of five francs or one mark, the commercial gallery (gussied up like the Grosvenor) pretended to be a place where one could simply come to look, not to buy.[80] Uncluttered by a variety of goods, the galleries increasingly came to resemble the Salons and the newly emerging public museums.[81] Moreover, the ability of the dealer to function as a "curator" of contemporary art finally came to depend very much upon this image of public altruism.

■ CHAPTER TWO ■

"The circle of dealers"

PAUL DURAND-RUEL

Forged in paris in the 1860s out of the entrepreneurial class of dealers, the ideological dealer purported to be the altruistic campaigner for the public good. What separated the ideological merchant from his brethren was the claim to be dedicated not merely to making money, but to be an advocate for a particular kind of art, held above all others in the name of its "authenticity." Ideological dealers were far fewer in number than their entrepreneurial counterparts and appear to have been an exclusively Parisian phenomenon. Compared to the entrepreneurial dealer, whose example was felt much sooner and on a much greater scale, dominating the contemporary picture trade to the end of the century, the practices of the ideological dealer were not exported out of Paris until the international dispersion of Impressionism after 1897. Paul Durand-Ruel gave definitive shape to the role.

To label the dealer ideological should not be taken to mean that Durand-Ruel or any other dealer of his type necessarily held explicitly political and/or aesthetic positions vis-à-vis the artists they supported. In the case of the Galerie Durand-Ruel, choices regarding their stable of artists were hardly ever political, or at least not political in the sense that we might expect. As Francis Haskell has pointed out, Durand-Ruel's father possessed strongly conservative political views (many of which were shared by his son); Durand's defense of the École de 1830 in the 1840s and 1850s was probably not motivated by its left-wing political positions, but by the opposite. In their resistance to the École de David, they were resisting the Jacobin politics associated with the artist.[1] We should understand the ideological character of these dealers rather to rest on their speculative attitude toward contemporary art. Whereas the entrepreneurial dealer marketed artists through their contemporary reputations won through public exhibitions, the ideological dealer marketed his artists vis-à-vis a supposed historical position.

We should also be careful not to confuse the ideological dealer with the institution of the "dealer-critic system" described in Cynthia and Harrison White's landmark study, *Canvases and Careers* (1965).[2] Using the Impres-

sionists as their chief example, the Whites attributed the creation of this independent institution primarily to a matter of default, a failure of the academic system to take care of its own. As art dealers stepped into the vacuum created by an inflexible, inadequate system of public patronage, so too were art critics enlisted by dealers to help "create an ideology and an organization that would jibe with the accepted 'pure' painter role [an expression of the ideological ambitions of the Academy] while allowing an alliance with painters who needed the financial framework dealers could provide"[94–95]. Critics provided the ideological justification; dealers provided the market. Between them they effectively replaced the dual role of the Academy, that of certification of value and patronage. The Whites first observed that this system privileged careers over paintings. Their sweeping and often implicitly radical view of late nineteenth-century French art institutions has left many questions unanswered. Why could not those who controlled the Salon also come to control the "critic-dealer system"? According to the Whites, the basic reason for the success of art dealers in the nineteenth century was their recognition, encouragement, and catering to new social markets that the Academy did not.[3] If this system opened up new markets, why was it comparatively unsuccessful in selling modernist painting in France until the end of the century? Unquestionably Impressionism found most of its patrons outside of France. Why?

Despite the support of most of the best and most well-informed writers in France, modernist painting, when compared to its Salon-sanctioned rivals, sold badly in Paris. Few dealers, in fact, were willing to support artists not officially condoned. The Whites undervalued the instruments of the Academy and the Salons to control public opinion and to serve those new audiences. And they failed to recognize the most important advantage of the Academy—its official (if not actual) distance from commerce. The Salon was able to maintain its position as chief arbiter of taste and chief evaluator of talent through the thin, but enduring fiction that its system of peer review, the infamous juries, ensured that art, not business interests, determined an artist's worth. Despite three quarters of a century of criticism accusing the Salon juries of prejudicial interests, their authority remained largely intact. By contrast, every attempt made by artists and their dealers to establish the non-commercial character of their private enterprise faced the widespread public suspicion regarding their commercial motives—and thus, for a very long time gained only a mitigated success. If the Salon was seen as commercial, what then could the commercial gallery be?

The rise of the ideological dealer therefore should not be ascribed merely to a demand for markets and the failure of the official system to meet that

demand. We also need not attribute to Paul Durand-Ruel overtly conscious motivations in order to argue that he in effect invented the ideological dealer. Instead, the key to his practice—the promotion of his wares above all with an eye to the historical importance of the artists he handled—was forged in the state-sponsored auction house, the Hôtel Drouot.[4] Founded in 1852 in response to the growing market for contemporary art, this institution offered a unique coalescence of commercial speculation with historical expertise, and may well have done more to generate a "dealer-critic system" than any other factor. In a typically French pattern of central-ization, the Hôtel Drouot concentrated the action of the French art market in one place. Although Paris had hundreds of art dealers by the middle of the nineteenth century, only a small number of them achieved significant stat-ure, measured by their participation in what was to become an exclusive club of "experts" that serviced the Hôtel Drouot. The two most prominent firms before 1848, the Galerie Francis Petit and the Galerie Durand-Ruel, were installed in the 1850s at the apex of the contemporary French picture market. They and a handful of other dealers acquired extraordinary power. They assumed within the auction house multiple roles that ran the gamut from certifying the authenticity of the object, to guiding it through the hazards of the marketplace, to establishing its provenance and enlisting critics and historians to situate the artist's importance.

But this system did not have to be ideological—and the vast majority of the transactions made in and around the Drouot auctions were no doubt not ideologically motivated. It was Durand-Ruel's particular "genius," an-nounced in his ""Mémoires" as a rationale for his huge investment in the École de 1830, to recognize that "the works of artists with whom we were especially concerned, though always very much discussed, sold very badly."[5] The Whites may not have fully appreciated how personal and how specific to Durand-Ruel the "dealer-critic system" was. More importantly, they seemed not to grasp how irrelevant it was in the short term to an artist's commercial success.

Durand-Ruel was anxious not to be completely dependent on an inde-pendent press. Twice he published his own journal devoted to contempo-rary art.[6] And much more often than that, for auction and exhibition cata-logues, and for biographical monographs, Durand-Ruel enlisted a panoply of critics to write inevitably uncritical appreciations of artists in whom he traded. But using critics as surrogate spokesmen for his cause posed obvious limitations. They had their own interests to promote. And such venues as auction catalogues, and even the monograph, without the advanced admira-tion of the art public, could not win the hearts and minds of Durand-Ruel's

ideal clientele. The dealer-critic system that Durand-Ruel's publishing activities might be said to represent did not begin to pay dividends—at least as far as the Impressionists were concerned—until the end of the 1880s, or even significantly later. Yet it is also true that one first discovers in Durand-Ruel's career the integration of the promotion of "temperaments" within the rhetoric of independent and hence "neglected" artists. Durand-Ruel was the first to fully grasp the speculative potential of such artists.

Like his father before him, Durand-Ruel acted as an *expert* for the Hôtel Drouot. And like his father, Paul began his career by selling Salon luminaries alongside more independently minded artists. His career, however, took a new course with the radical intensification of speculation of all kinds in the 1860s. The highly visible successes of dealers such as Goupil and Gambart encouraged the wide-spread use of monopolistic practices in the contemporary picture market—represented by the attempt to sign artists to exclusive contracts. The fashion for monopolies, of course, transcended the precincts of the art market. Prevailing economic theories as practiced by businessmen in all industrialized nations supported the belief that a monopolistic control over a product or a resource would permit the self-regulation of prices for the largest financial advantage.

Thus, whereas Durand-Ruel's father was primarily content to foster an on-going relationship with his artists, buying work from them piecemeal, a painting at a time, after 1865, as Paul Durand-Ruel increasingly took over running the gallery, the firm began to concentrate on acquiring an entire oeuvre.[7] After his father's death in 1866, Durand-Ruel entered into partnership with the dealer Hector-Henri Brame to invest enormous sums in the Barbizon painters. They risked even the use of outside backers for the capital necessary to maintain business operations while, in effect, sitting on their stock, waiting for prices to rise at Drouot's.[8] This also meant that they had repeatedly to defend and, if possible, to elevate the prices of their artists at auction—a technique that relied on sales and resales made back and forth between a coterie of patron-speculators and the dealer.

The École de 1830 entered the 1860s earning generally lower prices at auction and at the galleries than their critical reputations would seem to demand.[9] As speculation intensified, dealers sought to corner the market in such heretofore underexploited artists. The Belgian dealer Arthur Stevens characteristically signed Jean-François Millet in 1860 to an exclusive contract covering three years of the artist's work and including all his paintings and drawings from that period. The sharp escalation in Millet's prices soon had the artist resenting these restrictions; after great effort he struggled out of his contract.[10] Durand-Ruel and Brame approached Millet in 1866,

offering the artist 30,000 francs a year if he would give them his entire production. Millet refused.[11]

They were more immediately successful with Millet's close friend, the landscape painter Théodore Rousseau, who died in December 1867. At the posthumous auction, Brame and Durand-Ruel purchased a collection of seventy-nine works for 70,000 francs, which they added to their preexisting holdings to number over 140 works.[12] Withstanding the customary lowering of prices that follows the influx of so many pictures onto the market upon an artist's death, their investment was fully rewarded in the 1870s, with the advent of an American market for the Barbizon painters. Shifting the gallery to London during the turmoil of the Franco-Prussian War and its aftermath preserved much of the wealth of the gallery into the 1870s. On one occasion at least during the early seventies Durand-Ruel doubled the sum of one investment (a Millet) in a sale to an American collector.[13]

Also at this time, Durand-Ruel finally achieved a near monopoly over Millet's work, acquiring many important paintings and drawings from the artist, including the *Angelus* (Musée du Louvre, Paris), perhaps the most widely reproduced—and expensive—painting produced in the nineteenth century. From an exhibition held in April 1872 in his galleries, we know that the dealer owned or shared ownership of other important Millets, including *Oedipus Taken Down from the Tree* (National Gallery, Ottawa), *Death and the Woodcutter* (Ny Carlsberg Glytothek, Copenhagen), and the *Seated Shepherdess* (Museum of Fine Arts, Boston).[14] In the same year Durand-Ruel bought at auction the *Sheepfold by Moonlight* (Walters Art Museum, Baltimore) for roughly 20,000 francs and sold it along with the *Angelus* to the American collector living in Brussels, John W. Wilson, for 40,000 and 38,000 francs respectively. (This sale alone surpassed the total sum the dealer spent on the Impressionists before 1874.) In collaboration with Alfred Sensier, Durand-Ruel exhibited another Millet masterwork, *The Sower* (Provident National Bank, Philadelphia), in London. This painting was included in a contingent of École de 1830 pictures that Durand-Ruel sent to the 1873 Vienna World's Fair at the request of the French Minister of Culture. The dealer purchased this picture from the Sensier collection in March 1873 and sold it within ten years to William H. Vanderbilt, reputedly for 5,000 pounds (roughly 120,000 francs).[15] All told, Durand-Ruel acquired Sensier's collection of 167 paintings and drawings by the École de 1830 for the considerable sum (though it proved later to be a bargain) of 267,440 francs, or at an average of 2,700 francs per work. This purchase included thirty-four paintings and nineteen pastels by Millet.[16] In June of 1875, immediately following Millet's death, a speculator in the artist's work,

the architect Gavet, auctioned his collection of 95 pastels for 637,450 francs.[17] That is an average of 6,710 francs for drawings alone. Within three years the value of Durand-Ruel's holdings in Millet had increased by, at the very least, two and a half times.

The success of the École de Barbizon in the marketplace in the 1860s and 1870s in turn unquestionably stimulated Durand-Ruel's speculation in the Impressionists. When *that* investment was vindicated by the Impressionists' success in America in the late 1880s, more cautious dealers began to compete with Durand-Ruel for his stable. Aspiring young dealers searched for the next generation of modernist artists. Thus what enabled the emergence of the ideological dealer as an institution was as much a product of Durand-Ruel's successful speculation in these two interrelated markets as it was the influence of his "convictions" on other dealers. Théo van Gogh, Ambroise Vollard, the Bernheim brothers, Daniel-Henry Kahnweiler, and many other dealers who followed in Durand-Ruel's wake, all owed both their altruistic "virtues" and their speculative practices to his example. Ludwig Hevesi, chief critical apologist for the Vienna Secession, in 1907 described Vienna's leading commercial gallery, the Galerie Miethke, as "our Durand-Ruel."[18]

However, whether in Vienna in 1907 or Paris in 1863, to exhibit commercially, unless preordained by an "official" exhibition jury, was to escape the review of one's peers. Even as late as 1914, rarely did an artist achieve public stature through the exclusive agency of dealer exhibitions. (Picasso is the extraordinary example of a career so constructed.) To overcome the prohibition against mixing money and art, the dealer and his artists shared the common enterprise to establish an elevated decorum through an atmosphere of serious altruism. But, as the conservative German opponents to French modernism demonstrated time and again, no decorum was sufficient to resist the accusations of dealer-managed art conspiracies. For example, in the pages of *Kunstchronik*, the respected "Beiblatt" of Germany's most prestigious art-historiographic publication, *Die Zeitschrift für bildende Kunst*, Eugen Schmidt published a review of the 1904 Salon d'Automne, in which he asserted that

> when Durand-Ruel some forty years ago harnessed the first Impressionists to his carriage, he took possession of this movement and since then it has not been delivered from the circle of dealers. In fictive sales the price of pictures were raised to swindling heights and held up there, while artists, for good or bad motives, who did not belong to the bondage of the dealers,

gave up their cause in order to earn their bread and butter. Behind Sisley, Monet, Renoir, Pissarro, Herr Durand's first Impressionists, now march thirty or forty young people, who all work for the dealer ring and who all strive not only to imitate the hacking and spittle of their predecessors, but who also overplay their parts and caricature them.[19]

Although such tactics were less in evidence in comparable French criticism (for France was, after all, the commercial—and ideological—beneficiary of these exports), the vulnerability of market-supported artists to such attacks was no less real.

Politics provided the incentive for the vitriol and the specter of conspiracy behind Schmidt's denunciation of Durand-Ruel. But by 1904 an alliance of dealers *had* occurred, an intense cooperation between Paul Durand-Ruel and Paul Cassirer had helped to smooth the passage of the Impressionists in Germany. The great retrospectives of this and the future Salons d'Automne and those of the Indépendants, as well as comparable exhibitions in the Lowlands and Central Europe, *did* depend upon the significant collaboration of Parisian dealers. Just a few years after Schmidt's review, Parisian, German, London, and American dealers *did* combine to purchase and to circulate entire collections of Impressionist paintings. The circle of dealers existed; their significant presence in the contemporary art world was undeniable. The question was what, if anything, was to be made of the impact of the gallery system and its role in fostering modernist art. That the specter of conspiracies was posed only by those opposed to or otherwise disenchanted with modernist art, speaks to the inevitable suppression of the language of commerce among artists and their dealers.

The psychology of Durand-Ruel's practice may best be explained by the dealer's efforts to transcend the image of the merchant, to be a servant of the elite call of art—the dominant theme of his "Mémoires." The thing traded, not the trade, was what mattered. Durand-Ruel's entire career depended upon his own public distaste for business. He wrote as early as 1869 that "a genuine dealer must be at once an enlightened *amateur*, ready to sacrifice if necessary his apparent immediate interests to his artistic convictions, as well as capable of fighting against speculators rather than involving himself in their schemes."[20] The statement marks Durand-Ruel's personal passage from the entrepreneurial practices of his father, to a new, idealized conception of the dealer's role in relation to modernist art. Durand-Ruel's contribution to the shift away from dealing in pictures to dealing in careers is to be measured by whom he supported and by his personal identification with his stable, projecting an image of public altruism that was initiated by his

investment in the Barbizon painters, and confirmed by his support of the Impressionists.

He advanced his conception of the enlightened dealer at the very moment he had succeeded in virtually monopolizing his investment in the key Barbizon painters. That is, in 1869, Durand-Ruel began the process of inventing himself (and reinventing his family), of converting the self-image of a man "nourished by clerics" (as Zola later would describe him) into a Medici of contemporary art—for whom commerce was an unfortunate sideline. He even denied in his "Mémoires" that either he or his father possessed any real business sense, that their love of each other and of art came, sometimes foolishly, before trade.[21] The reverse of his concern over the "lowness" of the trade was necessarily the visionary attitude.

Durand-Ruel's "defense" of the Impressionists, for whatever other motives, provided him with an identity he would never otherwise have achieved. In 1904, for example, the English painter and critic Wynford Dewhurst in the first English language "history" of Impressionism, *Impressionist Painting. Its Genesis and Development*, eulogized the dealer in what would become the standard modernist litany.

> This celebrated dealer and collector had brought himself to the verge of bankruptcy through a too generous investment in Impressionist work. He was gradually ostracised by brother dealers, buyers, and art critics. He was regarded in much the same light as the artists themselves, considered to have lost his mental balance and also his acumen as a man of business.[22]

Durand-Ruel's role as a disinterested protector of the Impressionists, not as their merchant, allowed him to achieve a special social status no other art dealer of his generation was granted. At the height of the first international market for Impressionism around 1910 the figure of Durand-Ruel came to hold nearly as much interest for foreign audiences as the artists he represented. The Berlin critic Julius Elias wrote in 1911 that "one calls him 'père Durand-Ruel,' just as earlier one spoke of 'père' Corot. And he has become, like Corot, for whom he was the first and noblest herald, almost a myth."[23] Elias, too, subscribed to the cleric metaphor when he described Durand-Ruel's heart to be open "like a Catholic church for all those who desire entry into a pure and complete artistic meditation [*Kunstgedanken*]."[24] Comparable recognition was beginning to be given to the dealer in France: the conservative French critic Arsène Alexandre wrote an essay on Durand-Ruel, published in German translation in Paul Cassirer's journal *Pan* in 1911, which described the dealer as "a man of action like the conqueror, a man of judgment like the critic, a man of passion like the apostle. (I speak

always of the apostle, critic, conqueror, and salesman in the pure, ideal sense.)"[25]

Durand-Ruel was, of course, neither Schmidt's calculating manipulator of public tastes nor the apostolic hero. The picture offered by his correspondence with his artists, or even better, by the genteel perspective of Mary Cassatt's family, is far less commanding—neither saint nor devil. In 1881, for example, Katherine Cassatt wrote to her brother Alexander about getting a Degas sold by Durand-Ruel to the Cassatt family through U.S. Customs.

> Durand-Ruel is so used to 'ways that are dark' as to bills of lading and certificates that he seemed to think any fuss about the matter was absurd but at the same time very tenacious of his standing with the American Consul here—One of the tricks I never heard of before is to make out the bill for pictures at double what they cost so that the dealer may show them to buyers who never suspects that he (the dealer) is willing to pay the extra duty in order to double his profits.[26]

On another occasion, Robert Cassatt wrote to Alexander describing Cassatt's exhibition in Durand-Ruel's gallery.

> By some stroke of Durand Ruel's financial policy Mame's [Mary Cassatt] pictures (3) were all entered in the catalogue as *not* for sale—The fact being that Elsie's was the only one that ought to have been so marked—Any little contretemps of this kind upsets Mame & makes her think anything but favorably of human nature generally.[27]

These protective letters from the family concerned by Mary Cassatt's involvement with a trade they probably thought beneath her are notable not so much because they reveal what is hidden, but that they are so normative in tone. Durand-Ruel was a businessman, he did what he felt necessary to work his sales to his advantage. The slight deceits of his practice may not have been proper for the cultivated Cassatts, but they speak to a trivial commercial reality.

In fact, Durand-Ruel probably did better than most dealers with his artists. Then (and now) there existed an inevitable, constant source of friction between dealers and artists. Commercial galleries represented short-term financial sacrifices by artists. In public exhibitions the financial burden was carried by the state, or by the exhibition society, which paid for the exhibition through gate receipts. To exhibit with a private gallery meant that the artist paid for the privilege of exhibition through the percentages owed his or her dealer. As commercial galleries replaced public exhibitions

as the overriding format in which to get published, there emerged the apparent inverse of the enlightened dealer, the parasite, who takes advantage of the struggling artist to buy low to sell high while taking a substantial commission in the bargain. In Durand-Ruel's case, it was less an accusation against him for not giving fair prices to his artists than the simple fact that he was, indeed, a man of business, looking out for his personal interests as much or more than those of his artists. Later, in a similar vein, Vassily Kandinsky and Franz Marc—who strongly benefited from the agency of their Munich dealers—sharply complained about their relationships with Hans Goltz, Brakl's Moderne Galerie, and Heinrich Thannhauser.[28] No matter what their altruistic and ideological professions, inevitably dealers would be the exploiters of their artists. The elevation of Durand-Ruel, then, was a necessary trope in the promotion of the artists he managed, a means by which to distance the association between modernist artists and their dealer from the "authenticity" destroying ambiance of commercial speculation.

That Durand-Ruel thought to write his memoirs, the only nineteenth-century dealer to do so, testifies to his fame. These memoirs in turn have provided most of what we know of the Durand-Ruel firm's early history and have largely colored the reading of the dealer's contribution to the dissemination of Impressionism (both Elias and Alexandre, for example, clearly drew extensively from the memoirs for their tributes to the dealer). This obligation to describe the history of his firm—for his memoirs are largely impersonal—is consistent with another facet of his practice: his role as an archivist. Educated by his long service as an *expert* at the Hôtel Drouot and by an equally long acquaintance with the forgeries that plague the art market, Durand-Ruel endeavoured, like no dealer before him, to keep accurate accounts not only of his stock, but also the correspondence between the dealer and his artists. Tellingly, this collection overwhelmingly begins around 1881. Perhaps only then did the dealer come to believe that he represented painters who were the heirs—and thus historically significant —to his personal favorites, the generation of 1830. These letters, in combination with the dealer's memoirs, provide the backbone of Lionello Venturi's *Les Archives de l'impressionnisme* (1939). Through Venturi's book and more directly through the firm's archives our contemporary view of French Impressionism has been shaped. Not coincidentally, the best, and indeed, most, of the modern catalogue raisonnés we have for French nineteenth-century artists have been grounded in these archives, and were either first

published by the gallery's press or otherwise produced or enabled by the heirs of Durand-Ruel.[29]

The two dominant motifs of Durand-Ruel's mature practice were the effort to influence personally the development of an audience for his artists, which he exercised as a publisher of art journals, auction catalogues, and monographs, and the documenting and tracking of works of art as they passed through his and others hands. He approached both tasks with a single-mindedness and tenacity, and perhaps courage, that earned him his exceptional stature. Besides his extraordinary inventories and archival material, the dealer kept—beginning in 1891—a systematic photographic record of paintings that passed through his shop. (The gallery saw the value of photographs early on—in 1860, in conjunction with the Galerie Martinet, it offered a ten-volume album of photographs of contemporary painting.) Later on, these photographs were to have a major impact in marketing and spreading the influence of Impressionist painting. When Hugo von Tschudi set about writing the first major German language appreciation of Manet in 1902, all twenty-four illustrations to the text came from Durand-Ruel.[30] In this case, as in many others, the photographs largely preceded the originals, providing the only sense of the new art until the, often much later, exhibitions.

Of course the most effective sales pitch was the paintings themselves. In an effort to provide a legitimizing gloss for his exhibitions, Durand-Ruel deployed essentially two separate collections, one public and one private. While the personal collection was unquestionably a product of his love of art, it had the useful business function of enabling him to promote his artists without appearing to be engaged in promotion. Often what distinguished the two collections was that the works in the former generally were sold much later than those in the latter. Because of the apparent noncommercial nature of the private collection, Durand-Ruel was able repeatedly to lend portions of it for exhibitions, not only in Paris but all over Europe and America, without seeming to act out of profit motives, but simply from the love of art, from the desire to "spread the news." An extraordinary number of paintings from his personal collection graced public exhibitions of Impressionism before 1914.[31]

In 1892 Georges Lecomte, in what amounted to an in-house publication, *L'Art Impressionniste, d'après de collection privée de M. Durand-Ruel*, described the dealer's personal collection as "the grandiose affirmation of the effort toward the beautiful that certain independent artists attempted at a given moment, outside tradition and acquired formulas. It is the brilliant repre-

sentation of an instant of artistic evolution, the museum of art of the last thirty years."[32] Befitting a museum, Durand-Ruel opened his collection to the public; the 1900 edition of Baedeker's, the one carried by countless visitors to the Exposition Universelle, featured Durand-Ruel's private collection, noting regular visiting hours and an admission fee.[33] The guidebook also advised readers that Durand-Ruel's public and private collections offered a "better survey" of the Impressionists than did the Caillebotte collection at the Musée Luxembourg. That it was *not* a permanent museum is testified to by the fact that although a number of the works illustrated in Lecomte's book remained with the dealer all his life, just counting the Manets and Monets in the collection, a notable number very soon passed from his hands. For example, Manet's *Woman Playing Guitar* (Hill-Stead Museum, Farmington, Conn.) was sold to Mr. Pope as early as 1894, while his *View of Venice* (Shelburne Museum, Vermont) went to Mrs. Havemeyer in 1895.[34] Of the seven Monets illustrated by Lecomte, by 1900 the dealer had sold three.[35]

The dealer tier represented by Durand-Ruel marks the space where the speculative practices tied more or less exclusively to the Hôtel Drouot began to give way to the money and the different sensibility of the American clientele. In the 1860s and 1870s the French market had been dominated by the auction house and by the speculation in the École de 1830. In the 1880s, however, a shift in the speculative market occurred with the steady influx of wealthy American clients such as Henry Walters eager to purchase Salon luminaries such as Bouguereau and Gérôme, but also Louisine Havemeyer, who bought the Impressionists. The need to protect artists at auction did not disappear nor was the friendly collaboration between dealer and speculative collector rendered obsolete, but the auction house ceased to be the dominant arena in the contemporary art market. American collectors were far more likely to buy from Durand-Ruel or Petit, or through an intermediary such as the American art agent George Lucas, than from the Hôtel Drouot.[36]

In his production notes for *L'Oeuvre* (1886), Émile Zola offers a curious, but telling portrait of the hierarchy of Parisian galleries in the 1880s.[37] At the bottom were men such as the père Aubourg, who bought paintings from five to twenty francs (they have little relevance for our story). At the next level was père Martin, who like Durand-Ruel had his shop on the rue Laffitte and bought from the Impressionists. He too was a small merchant: typically, Zola wrote, a man whom, when an artist would ask between sixty and eighty francs for a painting, would talk him down to forty. His method was to turn his pictures over rapidly, he would take an average of 20 percent

over his investment. He retired with an income of 12,000 francs. Beugniet came next, "un Martin en grand," who bought more well-known painters at higher prices, but who employed the same techniques. Brame, Durand-Ruel's occasional partner, occupied the next level. Brame bought dear but sold dear. And with Brame, Zola observed the practice of selling and reac-quiring a work again and again while steadily escalating its value—a prac-tice he characterized as having been borrowed from the Bourse (and which, of course, was closely tied to the Hôtel Drouot auctions). Georges Petit's gallery operated at an even grander level. He ran, in Zola's terms, "les magazines du Louvre de la peinture, l'apothéose." Petit was more ambitious than his father, Francis Petit. In his competitiveness "he wants to ruin the Goupil firm, to surpass Brame, to be the first, to centralize. And he had himself built a "hôtel" on the rue de Sèze, a palace."[38] Although he inherited a considerable fortune from his father he had domestic expenses (including the "wife, children, mistress, eight horses, the château, and shooting") that ran four hundred thousand francs a year. He would wait, according to Zola, for the Americans to arrive in Paris every May. And what he bought for 10,000 francs, he sold for 40,000. Moreover, he specialized in the "dead: Delacroix, Courbet, Corot, Millet, Rousseau, etc. Little on the living." Zola placed Durand-Ruel next to Petit. If "less grand" he handled the Impres-sionists. "I was not born to be a merchant, he says." Zola described him as a cold man, "nourished by clerics." The last dealer on his list, Sedelmeyer, was "le dernier chic." Sedelmeyer would buy a painting by Mihály Munkácsy, the Austro-Hungarian *juste milieu* artist, for 100,000 francs and sell it to a Vanderbilt in America for 300,000 francs. (It was in Sedelmeyer's gallery that the famous Secrétan collection was exhibited before it was auc-tioned: the collection contained among many other paintings, Millet's *An-gelus*, for which the highest price was bid at auction in the nineteenth cen-tury.) In all of Zola's thumbnail sketches there is a biting critique of dealer practices, unrelenting at all levels. It is an image of the middleman more concerned with profits than art, despite the public veneer of enlightened respectability. Zola was virtually alone among French critics in making the market as much a point of resistance for the modernist artist as the Salon.

Waiting for the spring tide of Americans, Petit dealt in sure things, certified by history or by the immediate reputation of the Salon. But Durand-Ruel, too, responded to the arrival of the Americans. His memoirs and his stock books are dominated by a perpetual cycle of purchases, sales, and resales until the 1880s. Then, suddenly, the American collectors brought the speculative life of a picture to its end. Once a painting travelled to New York it was likely never to return. Indeed, the most important

characteristic of the American market was the phenomenon that collectors like Mrs. Potter Palmer, or the Havemeyers, or later Frick and countless others, did not invest in art with the same speculative intensity found among many of the Parisian *amateurs*.[39] Rarely were major American collections dispersed at auction during the collector's lifetime—or even by his or her heirs. Once formed these collections habitually passed directly into public museums or were constituted as museums in themselves. The same would hold true for a new breed of Parisian collectors, who, in competing with the Americans, formed in the 1880s and 1890s major holdings of the École de 1830 and the Impressionists. The Louvre and the Musée d'Orsay owe an enormous debt to collectors such as Count Isaac de Camondo, Alfred Chauchard, Thomy Thiéry, and Étienne Moreau-Nélaton.[40] We know from his biographies of Millet, Manet, and others, that Moreau-Nélaton was particularly moved to donate his collection to the state by the diaspora of French painting to America and elsewhere. Yet there were also many important French *amateurs* who felt no such obligations—such as Armand-François-Paul Desfriches, the Count Doria, whose enormous collection of Barbizon and Impressionist art, which numbered almost seven hundred items, was auctioned off at Petit's in 1899, three years after his death.[41] Similarly, the huge Impressionist collections belonging to Auguste Pellerin and Jean-Baptiste Faure reentered the marketplace rather than French museums.

By the late 1880s the signs of this diaspora of French art became manifest everywhere. In February 1888, Millet's *Man with a Hoe* (private collection, U.S.A.) was sold for 125,000 francs to a Belgian collector.[42] High prices were reached by other artists of the École de 1830. A Troyon landscape was auctioned in New York that same spring for the stunning price of 130,000 francs.[43] The most famous, internationally celebrated auction of all was the Sécretan auction in May 1889. It was the high-water mark for the market value of the École de 1830. Millet drawings went for 25,000 francs a piece. Rousseau landscapes sold for 75,000 francs. The auction peaked with Millet's *Angelus*, which reached 553,000 francs, purchased by the American dealer Sutton, outbidding Antonin Proust, representing the state. For a reference point, the Vermeer—whose reputation was beginning to soar—in the Sécrétan collection, *Woman and Maid* (Frick Museum, New York), was auctioned for only 75,000 francs. The enormous prices paid for artists such as Delacroix and Millet provided an important stimulus to the already-growing stature of the commercial gallery exhibition. As much as any single event could, the Sécretan auction announced the victory of the marketplace over the academic/Salon system.

GEORGES PETIT AND THE SOCIÉTÉ INTERNATIONALE

When Georges Petit succeeded to his father's Paris gallery in the late 1870s he inherited a considerable fortune—according to Zola, three million francs. It was characteristic both of his social ambitions and his commercial vision that Petit sought to imitate the lesson offered by London's Grosvenor Gallery. Opening in 1882 a gallery almost as sumptuous as the Grosvenor, Petit offered annual exhibitions to a similar class of artists (many were already the heroes of the Grosvenor exhibitions), with perhaps an even more strongly international flavor than the Grosvenor, and with the quality of a disinterested exhibition society devoted to displaying the best of contemporary art. Petit was rewarded by having the exhibitions of his "Société internationale de Peinture" reviewed in the *Gazette des beaux-arts*.[44]

It is hardly surprising then that Petit should have undertaken to form this "society," which like the Grosvenor claimed an advisory board of artists and connoisseurs, but which was run in fact by the dealer alone.[45] The ostensible artist leadership for the "Société internationale de Peinture" were *juste milieu* luminaries, the Belgian Alfred Stevens, the Spaniard Raimundo de Madrazo, and the Italian Giuseppe de Nittis—the latter two recent medalists at the Paris Exposition Universelle of 1878. Both Madrazo and de Nittis had often employed Francis Petit as an intermediary and had a proven track record with American clients such as William Vanderbilt and Henry Walters.[46] Salon certified and commercially attractive, Georges Petit's artists—as at the Grosvenor, it was an invitation-only affair—were either academicians or otherwise well-established: the French were represented by Gérôme and Paul Baudry, the Dutch by Josef Israels, the English by Lawrence Alma-Tadema and John Everett Millais, the Germans by Ludwig Knaus and Adolf Menzel.

Claude Monet, for one, immediately recognized the commercial potential of such an exhibition format. Having seen the show with Pissarro, Monet wrote to Durand-Ruel to suggest an alliance between the two dealers.

> Considering all the banality and the little value of most of the paintings exhibited at M. Petit's, one can't deny that the public is captivated and that they dare not make the smallest criticism because these paintings are mounted advantageously, because of the luxury of the room, which together is very beautiful and imposing on the crowd. It was in making these observations that we had the idea of an exhibition that we would all join in

this same locale. Here, I think, is where there would be success for us and for you, if such a thing were possible.[47]

The attractions of Petit's fashionable quarters and the favorableness of the exhibition's reception strongly contrasted with the makeshift conditions of the Impressionist's seventh exhibition held that spring. Housed indecorously on a floor above a panorama commemorating the Battle of Reichshoffen, their show had failed to meet expenses.[48]

Nothing came of Monet's and Pissarro's dream of an alliance between the two dealers. The rivalry that dated to the early years of their fathers' firms was renewed by the sons. Petit's exhibitions were annual sensations, while Durand-Ruel struggled to hold on to his Impressionist stable.

Dominating the established Parisian art world in the 1880s, Petit's exhibitions demonstrated the limited power the ideological dealer, or indeed the "critic-dealer system," had to win an audience for modernist painting in France. For Guillemet/Zola in 1885 that system could hardly be said to have existed. It is telling that in Zola's description of Durand-Ruel he is reduced to that terse phrase "nourished by clerics." Moreover, in 1885 the princes of the Salon, such as Gérôme and Bouguereau, were effectively exploiting the American market through the agency of their own elite group of dealers (in Paris, Goupil, Petit, Sedelmeyer, among others). It did not necessarily appear that this class of artists would lose out to those supported by dealers such as Durand-Ruel (and later Vollard, Kahnweiler, etc.).

Petit was an opportunist, his exhibitions evolved as he experimented with different structures and different artists. The second exhibition was hardly more "modern" than the first, even though Petit managed to add to his stable Whistler, Munkácsy, and the German Wilhelm Leibl. Perhaps not yet convinced his "international society" could achieve public standing without the official stamp of the academicians, the French contingent was now represented by three members of the Institut de France, Alexandre Cabanel, J.-N. Robert-Fleury, and A.-A.-E. Hébert. Commensurate with their official position, Petit acted to give the society an official gloss.[49] The society organized a committee of honorary members that included the English, Belgian, Spanish, and Italian ambassadors, and such foreign and domestic luminaries as the collectors Comte de Camondo, W. W. Corcoran, Charles Ephrussi, the Baron Rothschild, W. H. Stewart, and Sir Richard Wallace, and such institutional figures as the director of the Metropolitan Museum, the director of the South Kensington Museum, Antonin Proust, and Lord Frederick Leighton, president of the Royal Academy of London. The intention of the exhibitions was declared in the catalogue's introduction, beginning with the annual character of the exhibitions, which

was for the first (and last) time said to be run by a society (presumably) under the name of "Peinture Internationale." The exhibitions were to have a "purely artistic character," that is, without ideological or aesthetic position, composing rather a "limited number of works by eminent painters from every country." The exhibitors were to be given enough wall space to present their work "in the most favorable conditions." Either notoriety such as Whistler's or academic standing such as Cabanel's were suitable criteria for inclusion.

Perhaps under the urging of Stevens, who was well-connected in Parisian art circles, or perhaps simply in competition with Durand-Ruel, the society abandoned its pursuit of an "official" identity (but none of its reputation) in 1884. Without the academicians, without Madrazo and de Nittis, and without the honorary committee, that year's exhibition featured the sensations of the most recent Salons, the triumphant *juste milieu*, led by Bastien-Lepage (in his last exhibition before his untimely death), Jean Béraud, J.-C. Cazin, Ernest-Ange Duez, Carolus Duran, and Alfred Roll. The foreign guests included Liebermann, Stevens, Román Ribera, and Émile Wauters.

As if to cement the legitimacy of the *juste milieu* and to take advantage of his growing reputation, Petit wooed Monet to his society in 1885, a product of over three years of negotiation. In 1883 Mary Cassatt noted that Petit was pursuing Monet "with a will" and that Petit had already bought forty of his paintings from Durand-Ruel—word had gotten around that Petit had refused to take 10,000 francs for one picture.[50] In exchange for Monet's agreement to participate in his "International Exhibitions" in 1885 and 1886, Petit received Monet's promise not to show in an independent exhibition, that is, with the Impressionists.[51]

Showing Monet alongside the *juste milieu* Petit's exhibitions blurred whatever distinction the general public was capable of making between "authentic" Impressionism and the *juste milieu*.[52] Joining Monet in 1885 were artists such as Albert Besnard, Léon Bonnat, Boutet de Monvel, Albert Edelfelt, Henri Gervex, Peder Krøyer, J.-F. Raffaëlli, and Sargent. In 1886, Monet had as company not only the French *juste milieu*, but his Impressionist comrade, Auguste Renoir, as well as newcomers, Jacques-Émile Blanche, Giovanni Boldini, and most importantly, Auguste Rodin. In 1887 Monet, Renoir, and Rodin were elevated to the society's "jury" alongside Besnard, Cazin, Edelfelt, Rogelio de Egusquiza, and Raffaëlli. Among their guests (not including previous exhibitors) were John Lewis Brown, Alexander Harrison (the American landscape painter, and a future leader in the founding of the Société nationale des beaux-arts), Carl Larsson, Berthe Morisot, Pissarro, Sisley, and a large collection of Whistlers.

Considering the large number of Impressionists represented there (par-

ticularly if one chose to include Rodin among their ranks), the 1887 show could be described as their last group exhibition (but, of course, since the show took place at Petit's rather than Durand-Ruel's it has never appeared on a list of Impressionist exhibitions).[53] Pissarro in a letter to his son reported that he had heard a lot of gossip from the writer Octave Mirbeau generally to the point that "the coming of the impressionists created great confusion at Petit's."[54] As Petit (and others) competed with Durand-Ruel for his stable, and included artists hitherto outsiders to the Impressionists' circle, the narrow, "canonical" reading of the Impressionist masters, which had been hammered out in their successive exhibitions, temporarily disintegrated, allowing the *juste milieu*—at least outside Parisian artist circles—to stand as Impressionists.

At the pinnacle of its public image, Petit's Internationale fell apart. Not until 1890 did another exhibition take place. By then the society was seriously diminished in prestige and in the rank and variety of its artists. In the intervening years, Petit experimented with another kind of front for his exhibitions, what was described in the catalogue of 1889 as the "Société des Trente-Trois." This elite exhibition structure appears to have been a direct homage to Brussels' Les XX, whose wide-ranging exhibitions made a considerable impact on Parisian art circles in the second half of the eighties.[55] Pissarro, who exhibited alongside the Neo-Impressionists with Les XX in 1887, described his participation in Petit's Internationale that same year as an exhibition of the "*French* Vingtists."[56] But there may have been more at stake in the "death" of the Internationale. After 1886 Petit faced renewed and stronger competition from Durand-Ruel for Monets and Sisleys and returned to the individual picture trade. The loss of Monet to Théo van Gogh in 1888—van Gogh was the agent for the gallery Boussod & Valadon, which was itself the heir to the gallery of Adolphe Goupil—obviously further weakened the market identity of the Internationale.

For whatever reason, the French *juste milieu* did not sell well in America. One can find in fin-de-siècle American collections *pompier* artists such as Bouguereau and Gérôme, but the paintings by Gervex, Roll, Besnard, and the rest—at least until quite recently—stayed in France. By contrast, the fashion for the Barbizon painters in the United States obviously facilitated the reception of the Impressionists. Durand-Ruel understood this and directly linked the two in his early New York exhibitions. One additional factor about the American market is worth noting. Until circa 1897—that is, with the entry of the Impressionists into the Musée Luxembourg—the Americans represented a curiously isolated track when it came to their admiration for the Impressionists. Despite the enormous sums American

collectors were willing to pay for a Manet, they were virtually alone in their enthusiasm. When German, Swiss, and Russian collectors entered the market after 1900, the competition for Manets and Monets produced a dramatic escalation in prices.[57] One result of this exclusionary relationship is that outside this particular market, the European public, and most European artists, remained unaware of the "triumph" of Impressionism until considerably later. It was not until the presence of the Impressionists via the Caillebotte collection, or perhaps not until even later, when they were included in the "Centennale" at the Exposition Universelle of 1900, that most Europeans became aware of a canonical Impressionism. In the meantime, the *juste milieu* stood in for Impressionism for most Europeans. And like the *juste milieu*, Petit's brand of commercial gallery made more of an impression outside Paris than was achieved by Durand-Ruel.

Yet Petit's commercial rivals seemed to grow daily. In the 1890s a host of new Parisian galleries started up, many aspiring to the kind of public attention heretofore reserved for Petit, Durand-Ruel, and Sedelmeyer. These new galleries identified with a younger generation of artists outside the domain of the Salons, such as the Nabis, and rediscovered older artists such as Cézanne. The nineties also witnessed the first efforts to isolate systematically the central Impressionists, both from their fellow travellers and from the *juste milieu*. The first substantial French "historiographic" accounts of the "movement" that began with Lecomte's stroll through Durand-Ruel's collection and Gustave Geffroy's book-length history was taken up in Richard Muther's *Geschichte der Malerei im XIX Jahrhunderts* and by English and American critics such as Dewhurst, D. S. McColl, W. C. Brownell, and others. Although the principal Impressionists were still not decisively sorted out until after 1900, Impressionism was increasingly constituted in these writings as both revolutionary and a *fait accompli*. The *juste milieu* could be cast then only as followers, and their legitimacy in this role would in turn be challenged after 1900 by what we now understand as the canonical Post-Impressionists. Institutionally and ideologically the rationale for an exhibition society such as Petit's was undermined and the long process of dismantling the international prestige of the *juste milieu* engaged.

KELLER & REINER AND PAUL CASSIRER

An elite and essentially heterogeneous exhibition program offered by Petit or the Grosvenor typified the vast majority of fin de siècle art galleries. In Berlin, for example, galleries of the Petit sort dominated contemporary art

throughout the 1890s. We have a vivid portrait of one such gallery from a letter written in January 1901 by the aspiring artist Paula Becker to her future husband, the landscape painter Otto Modersohn. In it Becker described an evening spent at one of Berlin's new, chic galleries.[58]

> I spent a remarkable evening yesterday at Keller & Reiner. Maidli and I were given passes and went there not expecting very much. After entering, we walked through several exhibition rooms, past elegant slender mirrors and the most wonderful Böcklins, and finally arrived in the salon at the rear. It was festively lighted by candles and shaded electric lamps which gave off a soft glow. The *crème* of Berlin was assembled there. We sat in great comfortable armchairs, all arranged quite casually. Maidli and I scurried into a quiet corner from which we could spy on the others but not be seen ourselves. . . . Then the electric lights were extinguished, and we sat in soft candlelight. There was a great cluster of candles standing on the piano, illuminating a lovely Verrocchio lady holding flowers in her delicate slender fingers. We then heard a reading from a piece by a Frenchman named Gobineau about Michelangelo and Vittoria Colonna. . . . And so I sat there at Keller and Reiner listening to music and to the voices of a man and woman intertwining and singing their love. I stared into space, then at the walls with their blue tapestries and at the beautiful candelabra, and then at paintings by the pupils of Rysselberghe, whom I don't particularly like but got along with well enough during the reading.[59]

Becker's letter signals the novelty posed by the elite ambience of Keller & Reiner, with its entertainment appeal for polite society, and its remarkable internationalism, the mixture of German and foreign art, conventional and "avant-garde" painting, which had not existed in Germany until the final years of the century. Most striking about her description is the rarified atmosphere, the way in which commerce is suppressed in favor of pedagogy and entertainment. By necessity, the commercial gallery had to appear as an anti-Salon, its juryless selectivity had to seem more elite, more cultivated than the juried products of the great public exhibitions, the ambience of its galleries more refined, more conducive to the experience of great art than anything they could offer.

Becker assumed her experience at Keller & Reiner to be normative. Indeed, such galleries were suddenly ubiquitous in Germany.[60] Every major city had at least one (except perhaps Munich—about which I will have more to say below), if not two comparable businesses. The *Kunstsalons* Emil Richter and Ernst Arnold dominated Dresden's artistic culture until the war. Thanks to the initiative of Arnold's enterprising young dealer, Ludwig

Gutbier, Dresden was the first German city to regularly witness exhibitions of modernist French art. Frankfurt am Main saw the opening (dating from the 1890s) of Schneiders Kunstsalon, Hermes & Co., and L. Richard-Abenheimer. Mannheim possessed from 1900 the Galerie K. F. Heckel.[61] Düsseldorf had Bismeyer & Kraus and a branch of Schulte's. Generally, these galleries were interconnected, particularly as the fashion for French modernism grew, so that the touring of pictures, which had already been common among the German *Kunstvereine*, entered a new phase. It was no longer a question of individual *Sensationsbilder*, but of travelling exhibitions of one person or group shows.[62] Correspondingly, a significant rise of national press attention followed regional exhibitions. The direct result of this collaboration was that an occasional Impressionist picture would begin to turn up in traditionally backwater art centers such as Frankfurt.[63]

The social prestige attached to these galleries was amply demonstrated when the Galerie Commeter joined an active *Kunstverein* and the well-established Kunsthandlung Louis Bock & Sohns in the autumn of 1900 to sell contemporary art in Hamburg.[64] Its opening was extensively reviewed in *Die Kunst für Alle*, then Central Europe's most popular, and fundamentally "middle-brow," art magazine. And its exhibition catalogue was written by one of Germany's most prominent museum officials, Alfred Lichtwark, the director of the Hamburg Kunsthalle (the presence of an exhibition catalogue for a commercial show was itself a French import, as was the concept of a "preface" or "notice" written by a distinguished art critic). *Die Kunst für Alle*'s reviewer took this association to imply a camaraderie in aesthetic viewpoints in the defense of the "modern" between the gallery and the director.[65] How modernist Lichtwark actually was in his sympathies was disputed even then. Lichtwark's participation does demonstrate, however, the typically much deeper involvement of the German museum establishment in the affairs of the art market than found elsewhere in Europe.

The success of these new galleries was so striking to contemporary observers that cities without comparable institutions soon seemed profoundly lacking. This was certainly the case with Munich. For much of the nineteenth century Munich had been almost universally regarded as Central Europe's art capital. The great annual, eventually international exhibitions of contemporary art, combined with Munich's Kunstakademie, drew artists from all over Germany and abroad.[66] The later success of the Munich Secession in the early nineties had further enhanced Munich's prestige. In 1900, so great was its reputation still that the young Picasso seriously considered settling in Munich rather than in Paris (and of course, Munich's reputation also drew Kandinsky to settle there).

For reasons both commercial and political, Munich did not develop a significant commercial gallery for contemporary art until near the end of the first decade of this century. Besides the preeminence of the annual state exhibition and the considerable number of state purchases made from those shows, the city government and the Bavarian state drew increasingly repressive in cultural affairs.[67] When an increasing number of artists, previously residing in Munich, most notably Corinth, Leo von König, and Paul Baum, relocated to Berlin, the critic Hans Rosenhagen discovered "Münchens Niedergang als Kunststadt," [Munich's Decline as an Art City]—the title of his sensational article published in 1902 in the Berlin daily *Der Tag*.[68] However controversial, Rosenhagen's polemic was largely proven right.

Only when Brakl's Moderne Kunsthandlung opened in Munich in 1904, as the gallery's name suggests, did the commercial foundation for modernism become possible and even then Munich continued to resist modernist painting. When the local *Kunstverein* held a remarkable exhibition of van Gogh and Gauguin that year, it attracted little press attention and made even less an impression on the Munich art community. The atmosphere did not significantly improve until circa 1908, when Brakl's was joined by his former partner, Heinrich Thannhauser, and by the print dealer Hans Goltz. This new commercial environment directly benefited Kandinsky, who, frustrated in his attempts to promote modernist painting through his artist organization *Phalanx*, spent much of the years between 1904 and 1908 abroad. But upon his permanent resettling in Munich, Kandinsky was able to use Thannhauser and Goltz in service of his new organizations, the Neue Künstlervereinigung Münchens and Der blaue Reiter, not only to exhibit in Munich but to send their shows on a seemingly endless tour of German cities.

Berlin, with its political and commercial concentration, superseded all the other regional art capitals and underwent the most dramatic expansion in its commercial climate. Between 1895 and 1900 the city went from having two galleries of note to eight (shortly to grow to nine), which in the context of the times represented momentous growth.[69] As in Paris, the galleries were located in one district, many on one street, the Potsdamerstraße. This concentration soon rivalled the dealers located in and around Durand-Ruel's gallery on the rue Laffitte. Between 1898 and 1900 three separate galleries opened on the Potsdamerstraße alone: Keller & Reiner at no. 122, the Kunstsalon Ribera, and the Kunsthandlung Ernst Zäslein (129–30), joining the Galerie Gurlitt—at this moment a relatively inactive firm—at Potsdamerstraße 113. In the immediate vicinity were also the Künstlerhaus (Bellevuestraße 3), the gallery of Bruno & Paul Cassirer

(Viktoriastraße 35), and Schulte's, Berlin's other major gallery, which was prominently established not far to the northeast on the avenue Unter den Linden (75/76), right by the Brandenburg Gate, at the heart of the embassy and political district of the city.[70]

Competition and the obvious lucrative expansion in the contemporary art market led Berlin dealers to branch out from displaying local or national artists, to importing them from France, Belgium, Britain, Spain, Norway, Hungary, and many other nations. The French selections were initially dominated by academic and *juste milieu* artists. However, as early as the beginning of the 1890s, the École de 1830 made significant inroads in the Central European art market, finding their way, for example, into what were then Germany's leading commercial galleries: Fritz Gurlitt and Schulte in Berlin, L. Neumann in Munich, and Ernst Arnold in Dresden. The fact that the paintings were primarily landscapes, relatable to the Düsseldorf tradition of landscape painting, made their reception in Germany, as everywhere else, much less problematic than it would be for Manet and the Impressionists. How the German art audience understood the state of contemporary French painting circa 1890 is reflected in an exhibition of photographs after nineteenth-century French paintings held in 1890 at the Arnold gallery. Among the artists reproduced there were Géricault, Delacroix, Rousseau, Corot, Troyon, Daubigny, Millet, Jules Bréton, Meissonier, Bastien-Lepage, Gervex, Roll, and Dagnan-Bouveret, that is, the École de 1830 succeeded by the *juste milieu*.[71]

The introduction of the Barbizon market initiated a pattern of relationships between Parisian galleries and their Central European counterparts that increased in intensity in later years. Not only did the German galleries cooperate with the French, but they took their fundamental understanding of business practices from Parisian models. By 1900, in the spring season that preceded Becker's visit to Keller & Reiner's, Berlin galleries offered a remarkable panoply of artists. Keller & Reiner gave one person exhibitions to the Berlin artists Ludwig von Hofmann and Walter Leistikow, to the Parisian Étienne Moreau-Nélaton, and to the Belgian Fernand Khnopff. The Cassirers held a major eighteenth-century English portraiture show, as well as one person exhibitions of the Berlin painters Wilhelm Trübner and Leopold von Kalckreuth and a combined exhibition for the Swede Anders Zorn, Corot, Pissarro, and Sisley. At Schulte's were portraits by the Munich *Salonkünstler* Franz von Lenbach and a show of the English painter Herbert Herkomer. Finally, among innumerable less consequential exhibitions, Gurlitt gave a notable show to the Swiss symbolist Ferdinand Hodler. The variety of artists represented in these galleries (even granting the

predominance of Berlin painters) was unrivalled. Most artists were well-known in Central Europe via the great international exhibitions. But increasingly shows were given to those usually excluded from such exhibitions. Paris was never so international in its private exhibitions; foreign artists got into the private Parisian galleries through their success at the Salons, but rarely were they pursued as actively as the German firms pursued their international stable. (The success of Picasso within the French commercial system must be explained by both the enduring French fascination for things Spanish and also by the adroitness with which Picasso addressed French modernist concerns and filtered them back through his unique idiom.) Berlin would become by 1905 second only to Paris as a center for contemporary art.

The intense activity of the Berlin galleries was matched by their comparative indifference to the auction market. This is not to say that auctions were unimportant; but they did not play the same role as they earlier had in France, determining, that is, the relative merits of an artist in a direct correspondence of prices. The show as a show was from the start entrenched in the German art world, with important, wide-ranging ramifications for how exhibitions were employed. Galleries such as Keller & Reiner or Schulte mirrored and fed on the rise of Secessionism in Central Europe. Schulte's Berlin gallery sheltered the artistic opposition to Anton von Werner's dual control over the Prussian Academy and the Verein Berlin Künstler—he had been the director of the Academy since 1875 and frequent president of the Verein and the Allgemeine Deutsche Kunstgenossenschaft since 1887. Until the founding of the Berlin Secession in 1899 Schulte showed its institutional precursor, the self-styled "XI," or the Eleven (see my discussion of the Berlin Secession in chapter 6 below) headed by Liebermann and Leistikow.

Werner, trusted friend and agent of the kaiser, tightly ruled the Academy and through the Verein encouraged, as Peter Paret has described it, "not the great talents but the mass of painters and sculptors, whose condition he tried to improve."[72] Much like his French counterparts, Werner sought through reforms of the prize system and state acquisition policies to respond to the increasing material needs of the artist community. Werner's institutional and pedagogical emphasis on a kind of photographic realism and subject matter conforming to the Prussian militarist and imperialist tastes of the kaiser permeated the Academy and the Große Berliner Kunstausstellung. Following Munich's example, this institution became an annual forum for regional, national, and foreign (if often undistinguished) exhibitors.

Because the kaiser vigorously opposed anything modern, and because Werner so tightly held the reigns on Berlin's official art world, the situation would seemingly have warranted the formation of an organized opposi-tional party, particularly in the wake of the founding of the Munich Seces-sion in 1892. Instead, the many Berlin artist organizations that arose in the nineties found their home in commercial galleries. For a long time these groups, like the Eleven, avoided an outright divorce from the Große Ber-liner Kunstausstellung. Thus, Secessionism in Berlin was actually delayed by the prestige and commercial viability of the city's galleries.[73] Schulte, Keller & Reiner, and the Cassirers competed to sell all the artists who were to become Secessionists. They also found easy access to the official exhibi-tion societies, in Berlin and in Munich, as well as outside Germany. Lieber-mann and Leistikow were particularly successful exhibiting internationally, in Paris at the Société nationale on the Champs de Mars and in Brussels at Octave Maus' La Libre Esthétique. Societies such as the Eleven never became, therefore, distinctly oppositional parties, but rather reflected the "Stammtisch" kind of organization, named after a table reserved for regular guests in a German bar, that is, a loosely affiliated body of friends who, independent of aesthetic or political ideology, exhibited both as a group and at officially sponsored exhibitions. And indeed, notwithstanding the opposi-tion of the kaiser and Werner, Liebermann was awarded a gold medal at the Große Berliner Kunstausstellung of 1897 and was given a virtual retrospec-tive in honor of the artist's 50th birthday.

The comfortable, commercial elitism of the Eleven was a far cry from the ideological elitism asserted after 1900 by and against the Berlin Secession. Yet both these societies and the galleries that served them articulated an exclusive exhibition policy that challenged the state's democratic approach, so that in the ideological battle between the Secessions on one side and the Prussian cultural administration on the other, elitism came to constitute the banner of artistic reform. In the same way, the international connec-tions forged by these galleries, and by the artists within these galleries, nurtured the international perspective that was the second hallmark of Secessionism. Schulte or Keller & Reiner or the Cassirers individually and in collaboration with the Secessionist organizations of the 1890s, and the Berlin Secession after 1899, provided the site where the *juste milieu* of many nations met. In this way, the dealers found themselves, particularly in Ber-lin, but also in other regional art centers, inextricably tied to the policies of Secessionism. The Central European Secessions needed the dealers as nec-essary agents to further the individual careers of their memberships. The dealers responded by relying on the Secessions to give them that prerequi-

site distance from commerce, the veneer of altruism, public responsibility, and the simple expression of *Kunstpolitik*, so necessary to the conduct of business.

Keller & Reiner shared with the Eleven the requirement of an atmosphere of non-ideological elitism, a sense that the heterogeneous collection of art in the gallery was united by quality under the noble banner of great art, and supported its selectivity and pretensions to historical seriousness by the layout and decor of the gallery's space and the corresponding entertainments and cultural activities. The modernist market in Germany cannot therefore be attributed merely to a spread of French-style commercial galleries. The appetite for modernism among the German cultural elites followed the conviction that art must reflect the course of modern business, industry, and science. What the galleries did do was circumvent the institutional hostility to modernism, just as they had in France. But with the galleries in place, they fueled the thirst for variety, for novelty, for change, for the *Sensationsbilder*, long denounced by German critics as a French weakness for fashion. Keller & Reiner, like the Grosvenor, like Petit, did not seek to become a bastion of extreme modernism. But by 1900 it was clear to ambitious dealers, regardless of personal taste, that modernist art sold, and more importantly, that modernist art was a good long-term investment. Keller & Reiner could still be modern without being modernist, could include "radicals" and "conservatives" without considering the tensions within its stable of artists.

The case of the Neo-Impressionists at Keller & Reiner is a particularly telling example of the paradoxical consequences of the pursuit of internationally fashionable artists at the expense of what was locally (witness the distaste of the young Becker) aesthetically acceptable. Their presence marks the intrusion of a different kind of art discourse, of dealer sensibility, of historical apparatus, one far more ideologically exclusive than what Keller & Reiner ostensibly stood for. At one level, to show the Neo-Impressionists —as later other dealers, similarly without a history of conviction, would show Cézanne or Picasso—alongside less problematic, commercially certified artists such as a Liebermann or a Böcklin and within such elegant setting, speaks to the potential independence of aesthetics and ideas from the galleries that managed them. At another level a gallery's reputation depended on the prestige of the artists it showed. While at still another level, to show the reputedly anarchist, stylistically "uniform" Neo-Impressionists meant the undoing of the harmonious rhetoric of great art and artists so cultivated by Keller & Reiner.

Like Petit, the Kunstsalon Keller & Reiner was rendered old-fashioned

through the agency of dealers such as Paul Cassirer, or more emphatically, Alfred Flechtheim and Herwarth Walden, who claimed modernism to be a cause, not a source of income.

At Keller & Reiner the Neo-Impressionists appeared as anomalies. At the gallery opened by the cousins Bruno and Paul Cassirer in 1898, they were part of an unmatched project to show French modernists in Germany.[74] They followed Keller & Reiner's lead in one matter: they chose the Belgian architect Henry van de Velde to design their gallery, signifying simultaneously their modernity and their desire to enter the Berlin art market at the highest echelon. From their first exhibition, the Cassirers were actively engaged in the international art market, helping to arrange the movement of paintings back and forth from Paris and even through Berlin to points east. But the fame of the gallery, particularly after Paul Cassirer took over its exclusive operation in 1901, rested on its individual exhibitions.

The Cassirers went after highly visible art. The 1901 show of eighteenth-century English portraits occurred at the peak of their international commercial demand, particularly among American clients.[75] Under Paul Cassirer's exclusive direction, the gallery exhibited other fashionable old master revivals of the era, particularly Goya. In addition to the inclusion of individual Goyas in group exhibitions, Cassirer showed a large collection of the Spanish painter's work in November 1903 and again in June 1908.[76] But even for dealers as ambitious as the Cassirers, newly established galleries found it easier to pursue contemporary artists, while, if lucky, dealing old masters on the side. The showing of old master works alongside the modernists ratified by juxtaposition still-controversial art.

Surveying the character of Paul Cassirer's exhibitions between 1898 and the end of 1909 (at which point modernist art was present all over Germany), his practice was ruled by two principal concerns. The first was the dealer's close relationship to the Berlin Secession, for which he served as secretary, business agent, and later, not without controversy, as its president. The blurring of the contours was often so great, that, for example, the Secession held its annual winter graphics exhibition in Cassirer's gallery in 1907 and 1908. A more fundamental expression of that relationship was Cassirer's efforts on behalf of a certain membership of the Secession.[77] Not every Secessionist was in Cassirer's stable, but everyone that mattered (only a few have subsequently disappeared from history) he showed. And he showed them with a remarkable consistency. No matter who was featured at the ten-odd special exhibitions Cassirer held each year, there was almost always a supporting collection of artists, usually Secessionists.

Cassirer's reputation, of course, rested more on the second aspect of his

practice, the importation of French Impressionism (and some who would later be described as Post-Impressionists). At first Bruno and Paul Cassirer had to rely on Durand-Ruel for their French paintings. In 1900 the Cassirers exhibited a large collection of Georges d'Espagnat (not to be repeated), then being pushed hard by the Galerie Durand-Ruel as a second generation Impressionist. In 1902 Paul Cassirer negotiated an exclusive contract with Durand-Ruel to show his stable in Germany. But Cassirer would rarely take again from Parisian sources an artist without a proven historical reputation, and expanded his Parisian connections to include Vollard and the Galerie Bernheim Jeune.

Nor should we assume that Cassirer deluged his Berlin audiences with French art.[78] On occasion the collections were indeed sizable (23 Renoirs in October 1901; circa 50 Pissarros in March 1904; 32 van Goghs in December 1904; 26 Monets in October 1905; 38 Courbets in February 1906; and the 72 paintings by Manet and Monet from the Faure collection in October 1906), yet they were not the rule.[79] It was rather the consistency with which he showed them, in greater and smaller collections, often only throwing in a Manet or a Monet into an exhibition otherwise dominated by Berlin painters, that asserted their presence in what amounted to a virtual measure by which all art in Berlin was to be judged.

Cassirer may also have recognized the kind of rewards achieved by Durand-Ruel came only from investing early in unknown or otherwise disenfranchised artists. This explains—again unique among his fellow Berlin dealers—his early and deep commitment to Cézanne and van Gogh, as well as his exclusive relationship with the well-established, if still sensational Edvard Munch. In his taste for artists such as these Cassirer left Durand-Ruel behind—even when it was Durand-Ruel who lent Cassirer his first Cézannes in 1900.[80] In pursuit of these artists, Cassirer not only developed relationships with other Parisian galleries, he went to its source, in the case of van Gogh cultivating a personal relationship with the artist's family. With the cooperation of Johanna van Gogh (Théo's wife), Cassirer showed van Gogh in large collections in January 1902, December 1904, December 1905 (the previous September this collection of 54 paintings was shown at Cassirer's gallery in Hamburg, then at the Ernst Arnold gallery in Dresden in November; it then traveled to the Miethke gallery in Vienna in early 1906), March 1908 (this show opened at the Bernheim Jeune gallery in Paris, which, minus Cassirer's paintings, subsequently traveled to Brakl's in Munich, then, in a recombined format, to Richter in Dresden, concluding at the Frankfurter Kunstverein), and April 1909 (an independently arranged collection of the artist's paintings toured in late 1909-early 1910: beginning

at Brakl's in Munich, followed by the Frankfurter Kunstverein and Arnold's in Dresden). Van Gogh's paintings, with Cassirer's assistance, were made available to many official art exhibitions, including some under the aegis of the Munich, Vienna, and Berlin Secessions. In its catalogue Cassirer described the 1914 exhibition as the tenth showing of van Gogh in Berlin (his count may have included the Secession exhibitions); it is still an extraordinary tally for an artist still controversial in 1910.[81] Between 1900 and 1910 he also showed Cézanne four times: October 1900, April 1904—a watercolor exhibition—October 1907, and January 1910.[82]

If they differed in their taste for Post-Impressionist art, the Cassirers strongly echoed the value Durand-Ruel subscribed to criticism. After Paul and Bruno Cassirer broke up their partnership in August 1901, the former would exhibit what the latter would publish "historical" apologies for. In this way they combined the material promotion of art with its ideological promotion. As modern as this art appeared in Germany, both the Galerie Cassirer and Bruno Cassirer's *Kunst und Künstler* almost always advocated art certified by history—even if this "history" was only just being published by Bruno Cassirer. In addition to the publication of notable German critics and historians, *Kunst und Künstler* and Bruno Cassirer's publishing house produced translations from French artists, critics, and historians. In 1902 Bruno Cassirer brought out Zola's texts on Manet, first in *Kunst und Künstler*, then republished in a complete translation of *Mes Haines* under the title *Malerei*; also published there in 1905 was a translation of Jules Laforgue's incomparable essay on Impressionism written in 1882 on the occasion of the first (and abortive) exhibition of the Impressionists in Berlin.[83] Later, Bruno Cassirer would produce German editions of Théodore Duret's book on the Impressionists, Delacroix's notebooks, an edition of van Gogh's letters (which began to appear in the spring of 1904 in the pages of *Kunst und Künstler*) and in 1908 a translation of Gauguin's *Noa Noa* (again, first appearing in *Kunst und Künstler*). Although *Kunst und Künstler* failed to review Paul Cassirer's Matisse exhibition (February 1909), it published a translation of "Notes of a Painter" in May of the same year.[84]

The Cassirers, coming to this material as they did after 1900, treated these texts as historical, rather than critical documents. That is, they saw this literature not as arguments within an on-going debate about what was or should be the nature of contemporary art. Rather, these texts functioned as concrete testimonials to the critical recognition received by modernist artists despite, and this is another familiar term in this construction, the public neglect or hostility their work encountered. For Cassirer, contemporary critical recognition in the face of a hostile public, just as Duret and

Zola predicted, certified the historical necessity of the artists defended in that criticism. In a country where the opposition to French modernism found ample expression on the floor of the Reichstag or the Bavarian Landtag, *Kunst und Künstler* presented itself as if the artists contained in its pages produced the only art imaginable for the modern era.

In 1902 Hans Rosenhagen, who had been for a decade Berlin's greatest advocate of modernist art, appraised Cassirer's contribution to the city's art scene vis-à-vis a more Petit-like gallery, Schultes Kunstsalon.

> Paul Cassirer does not have the inordinate ambition to attract the public at large to his salon; instead he wishes to acquire the applause of the amateur (*Kenner*). Under such circumstances it would be very easy to put Schulte in the shade, but apparently Cassirer disdains cheap successes and remains always bent on showing his visitors only the most stimulating kind of art. However, he therefore demands much of the art understanding of his subscribers.[85]

Clearly his exhibitions attracted the critics, who even in such mainstream magazines as *Kunst für Alle* warmly received every show. And he was equally successful with important collectors, playing an important intermediary role in the creation of the Max Linde collection in Lübeck, the Julius Stern and Mendelssohn collections in Berlin, and a good many others.[86] That is, Cassirer found an audience for his paintings in the industrial elite of northern and western Germany and within a certain class of public officials and members of the museum establishment. But even here, Cassirer sold a relatively small fraction of the paintings lent by Durand-Ruel or Bernheim Jeune or Vollard. It was not the quantity, but the quality of Cassirer's offerings that mattered most, and when a major painting was purchased by a German collector or museum it tended to matter far in disproportion to the acquisition of works by German artists.

The circumvention of institutional resistance to modernism offered by galleries such as Cassirer was a two-sided affair. If they brought modernist art into an environment that had rarely seen it, from the beginning modernism was received in Germany within a commercial context. The international competitions for markets, the sensational acquisition by American collectors of European art of all kinds, the high prices paid for heretofore almost unknown artists, made the art market a subject of intense scrutiny, producing serious institutional studies such as Paul Drey's *Der Kunstmarkt* (1910), as well as such landmark historical work on past art markets as Hanns Floerke's *Studien zur niederländischen Kunst- und Kulturgeschichte*

(1905).[87] But from an emergent sociology of art production and distribution to populist polemics was a small step.

In 1911 Karl Vinnen, the Worpswede landscape painter, edited an infamous tract, *Ein Protest deutscher Künstler*, denouncing what he described as the invasion of the German art market by French modernists at sums amounting to millions of marks.[88] Cassirer responded to these accusations in the pages of his journal *Pan* with a two-part essay titled "Kunst und Kunsthandel."[89] Cassirer refuted, correctly, Vinnen's use of statistics as absurdly misleading, arguing that the French market represented a relatively minor portion of sales in Germany. He also countered Vinnen's charge that what was seen of the Impressionists in Germany were mere studio leftovers, asserting that some of the best of their paintings were now in public and private German collections. He denied being in servitude to the Parisian dealers and described his involvement with French painting as being motivated exclusively by his love of their work and his belief that they were great artists. He also denied having a stock of Impressionists (the signifier of dealer conspiracies)—which in general terms was true, although he did own a certain percentage of the Impressionists and Post-Impressionists he showed.

In this sensational quarrel between the disgruntled artist and the celebrated dealer, both chose not to see the point. Vinnen's anxieties, even if he could not overtly admit them, were due to the standard of art being set by the French; Cassirer only confirmed those views by his ardent affirmation of their worth. In this argument, one *Execution of Maximilien* or *Dans la Serre* was as relevant, as forceful, as one hundred comparable paintings. And the prices paid for these pictures by artists who ten years before had virtually been unheard of in Germany were very high. Tschudi bought Manet's *Dans la Serre* for the National-Galerie in 1897 for 22,000 francs; but Manet's *Execution* was purchased for the Mannheim Kunsthalle in 1909 for 90,000 marks or approximately 112,500 francs.[90] Or in another comparison: in 1906 Durand-Ruel, the Galerie Bernheim Jeune, and Paul Cassirer purchased and sent on tour the Faure collection of Manets and Monets. An annotated catalogue for the Galerie Heinemann exhibition of this collection in Munich (January 1907) shows that the average asking price of the Monet landscapes was approximately 30,000 marks.[91] To take advantage of the press attention the show would inevitably receive, Heinemann also included his own collection of German painters, among them Defregger, Stuck, Lenbach, and Gabriel von Max (that is, the most prestigious Munich artists at the end of the nineteenth century). Although it is now impossible

to speak of the overall quality of the art represented in Heinemann's show, only one Defregger was valued at a price over 30,000 marks (a *Kriegsnachrichten* for 36,000 marks) and no other artist was selling for higher than 18,000 marks. Manet's *Le bon bock* bore an asking price of 180,000 marks. The acquisition, via Tschudi, of the Pellerin Manet *Déjeuner dans l'atelier* for Munich's Pinakothek Staatsgalerie in 1911 for 250,000 marks was eloquent testimony of the qualitative bench mark the Impressionists, and Manet in particular, had become in Germany. For artists such as Vinnen, the outrage was real enough. For defenders of French modernism such as Meier-Graefe, those prices were understood to be the final vindication of this art.[92]

Cassirer believed it unnecessary to apologize for these prices, nor for the prominent role commercial galleries had come to play in the contemporary art world. Although he acknowledged the difficulties for artists being dependent upon an uncertain audience, he believed that, in contrast to an over-idealized understanding of traditional direct artist-patron relationships, the market had liberated artists. Moreover, the great art patrons of the past in Cassirer's view served only their own interests, whereas the modern collector, by enabling independent artists to realize their work, served the development of art. They also possessed a sense of public responsibility that led them, pointing to the example of Karl Osthaus, to make of their private collections public museums. The dealer, by playing a comparable role of supporting artists otherwise neglected in the arena of public exhibitions, if he comes eventually to great wealth, deserves it by virtue of what he has accomplished on behalf of his artists. Cassirer found Durand-Ruel's career exemplary. He sought as much as possible to imitate the strategies of the French dealer, both in the choice of art and the manner of its promotion. Although his essay was highly defensive, unlike Durand-Ruel, Cassirer neither dismissed nor apologized for the dealer's role in the contemporary art world. He believed—and only the Nazis attempted to prove him wrong—that these market conditions were essentially beneficial and irreversible.

Rhetoric from the Battlefield: Innovation
and Independence

THE JACOBINS OF THE REVOLUTION

T HE DEFENSE of French Impressionism against Vinnen's attack published as *Im Kampf um die Kunst* rested first on the conviction of the intrinsic quality of the art.[1] Yet Cassirer and like-minded German artists, curators, and critics were no less convinced that Impressionism was the culmination of a linear development within the history of nineteenth-century painting, that it constituted a unified aesthetic, and that it embodied artistic freedom in a world still repressed by the academic tradition. Simultaneously, and without conscious paradox, the Impressionists were understood to be a collection of independent masters who defined the perimeters of the movement but were not defined by the movement. The tripartite construction of Impressionism as the party of innovation, independence, and individual temperament was to be the model for virtually all subsequent definitions of modernist movements.

What was still contested in Cassirer's day ossified by the middle of this century into unquestioned orthodoxy.[2] The process of mythification repressed the practical motives and even the real risks incurred by the Impressionists through their exhibitions. Consider the letter written by Théodore Duret to Pissarro in February 1874 on the eve of the Impressionist's first exhibition where the critic urged the artist to exhibit instead at the year's Salon.

> You have still one step to take, that is to succeed in becoming known to the public and accepted by all the dealers and art lovers (*amateurs*). For this purpose there are only the auctions at the Hôtel Drouot and the big exhibitions in the *Palais de l'Industrie*. You possess now a group of art lovers (*amateurs*) who are devoted to you and support you. Your name is familiar to artists, critics, the special public. But you must make one more stride and become widely known (*à la grande notoriété*). You won't get there by exhibitions put on by special groups (*expositions particulières*). The public doesn't go to such exhibitions, only the same nucleus of artists and patrons

who already know you. The Hoschedé sale did you more good and advanced you further than all the special exhibitions imaginable. I urge you strongly to round that out by exhibiting this year at the Salon. Considering what the frame of mind seems to be this year, your name now being known, they won't refuse you. Besides, you can send three pictures—of the three, one or two will certainly be accepted. Among the 40,000 people who, I suppose, visit the Salon, you will be seen by fifty dealers, patrons, critics, who would never otherwise look you up and discover you. Even if you only achieve that, it would be enough. But you'll gain more, because you are now in a special position in a group that is being discussed and that is beginning to be accepted, although with reservations.

I urge you to select pictures that have a subject, something resembling a composition, pictures that are not too freshly painted, that are already a bit staid. . . . I urge you to exhibit; you must succeed in making a noise, in defying and attracting criticism, coming face to face with the big public. You won't achieve all that except at the Salon.[3]

Perhaps Pissarro did not accept Duret's advice because he felt the financial insecurity that came with a sudden suspension of acquisitions by Durand-Ruel. The dealer felt the effects brought on by his already extensive investment in the Impressionists and the depression that had followed the economic boom in the first years of the Third Republic.[4] But Durand-Ruel's limited liquidity in the spring of 1874 should not cause us to overlook his very considerable and increasingly valuable holdings in the École de 1830.

The art market of the 1870s was ruled by a basic uncertainty, a constant cycle of speculation followed by retrenchment which echoed the alternative booms and busts that plagued the first few decades of the Third Republic. A surprising post-war boom allowed Durand-Ruel to buy extensively from the Impressionists and to open galleries in London and Brussels, and enabled, in effect, the creation of the Impressionists as a group, since they were first defined as a group (outside a circle of friendships) by Durand-Ruel's patronage. Assisted by the investment of the singer Jean-Baptiste Faure, Durand-Ruel effectively cornered the market in Manet. And beginning around 1871 he took similar possession of Courbet.[5] He bought his Manets at significantly high prices, in keeping with a famous, if controversial Salon exhibitor, and gave Monet and his other artist clients reasonable prices for substantial quantities of their work before 1874.[6] It has been calculated from the firm's stock books (though, as Durand-Ruel admits in his memoirs, they were not always accurate at this time) that by the end of 1873 the dealer had already spent more than 70,000 francs on these artists (excluding

Manet).[7] On Manet alone Durand-Ruel paid 51,000 francs in the two lot purchases of 1872. By 1900 each figure painting in this collection of thirty-odd works could be sold for, at the very least, 75,000 francs and often went for much higher. If the economic downturn that began in 1873 forced Durand-Ruel to buy much less and to close his London gallery in 1875—decisions echoed in the dire financial situation of artists such as Monet and Pissarro—the value of the dealer's collection meant that in the long term whatever risks he took in Renoir and Degas were recovered in Millet and Rousseau.[8] We also know from the testimony of Eugène Manet that Durand-Ruel managed to sell 180,000 francs worth of paintings in the aftermath of the Impressionist exhibition in 1874.[9] Pissarro therefore must also have known that Durand-Ruel habitually bided his time, that he preferred to sit on his stock rather even than entering into profitable commercial relationships that did not suit him. For example, he refused to send the American dealer Samuel Avery paintings on commission in April 1868, even though, as the diaries of the art agent George A. Lucas demonstrate, American clients, at least those handled by Lucas, were more likely to buy in the 1860s and 1870s their occasional Barbizon painting from Petit than from Durand-Ruel.[10]

Pissarro may not have had patience with Durand-Ruel's methods, and could not personally afford to wait, but the most interesting question regarding Duret's advice was what Pissarro refused. Duret believed that artists had to cater to two distinct publics. The specialized public of dealers, adventurous patrons, critics, and speculators Pissarro already possessed, in other words, the speculative market of the auction house in which fortunes had been made throughout the Second Empire.[11] What Pissarro lacked was not the impossible-to-define "general" public, who came to the Salon for entertainment, but rather the cautious *amateurs* and dealers, who would only recognize the validating stamp of the Salon. To succeed in the Salon, Pissarro would have had to make some adjustments, placing within his landscapes some form of narrative element to make the paintings more familiar and accessible. He would have had to moderate his style to produce pictures with greater "finish." It was not the general public, but the more timid buying public and their dealers who needed to be enlisted.

Duret's understanding of the stigma of being "in a special position" in a group or of attempting to exhibit in "expositions particulières," that is, to show in a strictly commercial context, may well have been shaped by institutions similar those of the Impressionists' that failed in the 1860s. In particular, Duret may have had in mind the gallery of Louis Martinet and

the exhibition society he organized: the Société nationale des beaux-arts. Both Martinet's gallery and the Société nationale were made viable first as a consequence of the stringent reforms that preceded the Salon des Refusés in 1863, reforms that forced artists to seek out alternative means of "publishing" their work. Martinet's effort, in turn, owed much to the English example of small, commercial exhibition societies that yet had the decorum, the non-commercial ambiance, unfamiliar to the Parisian art world outside the Salon system. The close diplomatic and commercial relationship (and competition) between France and Britain during the Second Empire encouraged an on-going comparison between their respective art institutions.[12] The British noted the commercial limitations of the Paris Salon system as a means of selling paintings, but admired the publicity value of the annual exhibitions and especially the extensive state patronage in the matter of museum purchases, the subvention of prizes, and so on.[13] Conversely the French became more intimately acquainted with the entrepreneurial practices of the English dealers and the commercial aspects of the official and semi-official artist exhibition societies (the Royal Academy itself was run as a private business). As a French critic put it as early as 1833, the French offered expositions, while the English held exhibitions. The subtle distinction rested on the view that "the first implies something free, general, official; the second has necessarily as its goal a special interest, a private speculation."[14]

The ability to distinguish between French expositions and English exhibitions, however artificial that distinction may always have been, would virtually disappear in the 1860s, as the English searched for the "free, general, and official" equivalent to the Salon, while the French explored the potential of private speculation. The artist-dealer societies organized in Paris in the early 1860s were just such an effort to create a specialized market for their art, while attempting to endow private speculation with the qualities of the free, general, and official. French dealers hoped to reconcile the commercial advantages of private exhibitions with the seeming altruism of the public exposition.

When Martinet sought (on his own terms) to join forces with artists to circumvent the rule of the Salon and the Academy, the image striven for would be of a gallery without *parti pris* and above the interests of money, a gallery with a strongly historical flavor, but one that would also be halfway between a Salon and a museum—the gallery was more intimate, more select than a Salon; more mutable, more contemporary than a museum.[15] This ambition was briefly possible because Martinet was personally and institutionally positioned between high society and the artists, between officialdom and bohemia.[16]

Martinet ran his gallery with the appearance that he was not concerned with selling at all. As with dealers such as Gambart he employed benefit exhibitions to establish the public altruism of his concern. But unlike Gambart, Martinet was interested in establishing the historical importance of the artists he exhibited. He gave both retrospectives of individual artists, recently deceased (e.g., Ary Scheffer), and historical exhibitions of an entire school (as for example his huge exhibition of the French school of the seventeenth and eighteenth centuries in Parisian collections).[17] These shows had an oppositional flavor to them, offering a challenge to the standards of taste set out by the Academy and providing a different history of the French tradition that tended to establish the current darlings of the Salon as interlopers rather than legitimate successors to "la grande peinture."

Of course, such historical shows had a prestige (especially when they had a hint of oppositional politics) that regular commercial exhibitions could not have. Martinet appeared to promote a school, not the interests of particular artists. And in conjunction with these historical shows Martinet pioneered a number of innovative practices. He extended the offering of special exhibitions beyond the limited season that surrounded the exhibition of the Salon, holding small, changing exhibitions independent of gallery stock. Perhaps most importantly, with the exhibition of French masters in Parisian collections, Martinet introduced the use of an exhibition catalogue (by Philippe Burty) that established provenances and certified authenticity for the works exhibited.[18] Such a catalogue strongly resembled the new brand of museum catalogues, as a scholarly document, even though in effect the catalogue served the interests of the marketplace. Martinet used this exhibition and other comparable, if less ambitious, shows to establish a standard of aesthetic criteria, a reading of the history of French painting at odds with the contemporary academic tradition—the gallery space was used in effect in the manner of a museum exhibition. The success of such exhibitions can be measured by the serious criticism they received. Such criticism also shows us how the appearance of commerce could be overridden by the nobility and historical character of an exhibition.

Martinet was unable to keep up these standards. His own exhibitions had raised the expectations of his audience beyond the capacity of any individual gallery to sustain over a period of time. Failing to produce consistently historical shows of great interest, Martinet's gallery could only be seen for its commercial character. The Salon still remained the place where the value of a contemporary artist's work was established. With the reinstitution of annual Salons a "Salon des debuts" lost its institutional rationale. The last significant manifestation of Martinet's was an exhibition the dealer did not control, the great 1864 retrospective for Eugène Delacroix. Held

after the auction of the artist's studio, the exhibition was explicitly honorary rather than commercial.

Side by side and repeatedly overlapping with the efforts of dealers such as Martinet were the relatively novel artists' societies that became fashionable in the 1860s. These societies were characterized by an intimate relationship between artists and particular dealers. They were devoted to the promotion of art, but unlike the *Kunstvereine* and the Art-Unions, the new societies were directed at elite, not popular audiences and were composed of an elite contingent of artists. Martinet's Société nationale des beaux-arts, formed in 1860, was a union of approximately 200 artists, including many of the leading painters of France, conceived neither as an oppositional party nor a jury-free *indépendants*. It took as its honorary president the French Minister of State and was to be presumably an ennobling, exclusive alternative to the Salon. The society held concerts and served drinks.

The Société nationale was only one of a number of such organization formed in these years.[19] The dealer Francis Petit had his own society, the Cercle de l'union artistique, while the print publisher Alfred Cadart joined with the printmaker Félix Braquemond to found the Société des aquafortistes.[20] Cadart's society was particularly influential for later artist-run institutions (Braquemond has been much undervalued as a player in the *Kunstpolitik* of Paris from the 1860s to the 1890s). The printmakers showed in Cadart's gallery. In addition, they collaborated to produce prints after the paintings of many artists who belonged to the "realist" school—from Corot to Manet. Cadart also brought out his own art magazine, the first effort by a dealer to enlist criticism directly in service of the commercial goals of his gallery. Martinet soon followed Cadart in publishing his own journal; twice Durand-Ruel attempted the same. However, none of these efforts were very long-lived.

Théodore Rousseau, who had agitated since the early 1830s for an alternative artist exhibition society, a society that would function as a serious place to see art and make sales, was a leading figure in the Société nationale. And yet, in advance of the society's first (and last) group exhibition in 1864, Rousseau withdrew, citing his reasons in a letter to Théophile Gautier, one of the society's leaders.

> Last year I said to Martinet that he would end up by making us run a café, and it seems to me that's where we are now. That's what it is we have: painting with music and with grog. We would have dancing and flowers; we could write on our banner: "Here the five senses are charmed," and my word, we would conquer the public. Because, indeed, it would require the

public to be an enemy to its own pleasure not to enter our rooms; but do you believe that the dignity of art would in this manner truly remain intact? . . . We, who are finally, then, painters, are giving concerts and balls and offering refreshments. We are painters with an almanac in our belts, like merchants of beef, in order not to miss any provincial fair.[21]

Instead of catering to the *amateur*, Martinet used the semi-official status of his gallery and its location on the boulevard to court the *flâneur*, hence the resemblance to a café with its diverse and transient audience. Alfred Sensier, Rousseau's biographer, patron, and sometime speculator in his paintings, attributed the artist's resignation not to the structural deficiencies of the Société nationale, but rather to the problem of promoting art generally. All Rousseau wanted, Sensier wrote in 1872, was "to work, to exhibit, and to sustain the doctrine by a journal, that was his program and that was all."[22] But Martinet (and all the other dealer-backed artist exhibition societies of the 1860s, save possibly Cadart's) had no program. Edmond Bazire later described Martinet's gallery as "a preface to the official Salon. An eclectic exhibition, without *parti pris*, where all the schools are represented, the audacious as well as the routine."[23]

Dealer-artist organizations were commercially viable at the beginning of the sixties when the Salon was still biennial and its juries obstructive. But they failed to mount a serious challenge to its preeminence, if only because they were too closely tied to a dealer to achieve the desired image of independence. Ernest Chesneau, a conservative critic who tended to reflect the state's position in the arts, attacked the Société nationale for offering in effect an inadequate or underhanded way of earning one's reputation. In a review of one of the society's last exhibitions in the winter of 1863, Chesneau noted the absence of many of the founding artists in the organization, concluding that their desertion was a sign that whereas "the boulevard des Italiens (Martinet's) is their sales agency . . . at the Champs Elysees (the Salon) they are going to seek their titles of honor, to establish or confirm their reputations before the general public."[24] Offering entertainments rather than artistic programs and lacking aesthetic coherence, their single reason for existence became the simple need for exhibition opportunities. Not surprisingly, the Société nationale quickly wilted after the reforms of 1863.

For subsequent artist organizations the Société nationale offered an effective example of the publicity potential, the public visibility of a group—usually arranged with dealer support—that could generate an aura of independence from the Salon without sacrificing in the process the quality of

the art represented. Signifying elitism against the egalitarian model of the Refusés, these artist organizations became in the last quarter of the century the dominant mode for the publication of pictures in Paris. They rendered irrelevant the first two tracks of institutional change, Salon reform and the Refusés.[25] In the short term, broadened admission policies and the return to the annual Salon temporarily reduced the pressure for alternative exhibition locales. The Salon juries of the late Second Empire and the Third Republic were never again so stringent as they were between 1855 and 1863. But in the long term, the precedents established in the 1860s were never forgotten as greater access to the Salon, combined with foreign competition and an increasing number of *exempts*, led inevitably to diminished prospects for young artists to advance through the system. As Duret's letter to Pissarro attests, the Société nationale offered different messages. For an artist such as Manet, who never joined his friends in exhibiting outside the Salon, independent exhibitions were still to be regarded as inadequate, perhaps even unprofessional. Conversely, for Pissarro and others, the opposite conclusion was reached: independence plus ideological coherence could win over the marketplace, without sacrificing one's artistic integrity.

The Impressionist "expositions particulières" of the 1870s and 1880s seemingly realized Rousseau's dream of a society run by artists, independent of all outside sponsorship, and with no intentions but to exhibit, to sell, and to promote the aesthetic values of the exhibitors through a periodical. (Their organ would be *L'Impressionniste*, which appeared for the better part of 1877.) Less obvious was the manner in which the unprogrammatic, institutionally unspecific quality of Rousseau's ambition equally characterized the Impressionists's goals. The "radicalism" of the Impressionists' efforts would be manifested only over time, from exhibition to exhibition, in a dialogue of internal adjustments and external pressures. Almost without foresight, the founding members of the Société anonyme formed a coterie that in the public eye resembled a permanent exhibition society. With the repetition of exhibitions, their efforts passed from being only one in a long succession of shows of the Refusés type, to become a prototype for the Secessions of the 1890s. In the process, willy-nilly perhaps, the Impressionists became the first institutionally delineated avant-garde.

<div style="text-align:center">

THE IMPRESSIONIST EXHIBITIONS AND THE

RHETORIC OF INDEPENDENCE

</div>

The virulence of the negative criticism that greeted the Impressionist exhibitions was said in the early histories of modernism to be so strong and so

widespread that for three quarters of a century it was popularly understood as univocal. If today we read the competing discourses within French art criticism to reflect a full spectrum of political and aesthetic agendas, for the founding mythologies of modernism there existed only this one voice. The binary opposition it proposed between an unrelentingly hostile and laughing crowd, supported by an equally complicit press, and the heroism of advanced artists was indelibly etched within the discourses of modernism in texts such as Zola's *L'Oeuvre* (1886). Zola vividly "recreated" that quintessential art exhibition in which modernism reputedly made its debut: the first Salon des Refusés in 1863.

> Tempered to a certain tactfulness at the entrance to the exhibition, the laughter became louder and louder the farther one went: in the third room the women were no longer trying to stifle their mirth in their handkerchiefs, and the men's guffaws roared out from their bellies, unrestrained. It was the wild hilarity of a crowd that had come purposely to find fun, gradually working itself up, shrieking with amusement over nothing, stirred to as much amusement by what was beautiful as by what was hateful or grotesque.[26]

Zola wrote with the understanding that this laughter, the artist's sacrifice to the crowd, was only the opening gambit in an inevitable trajectory that would lead to the apotheosis of the artist.[27] The Pennells rehearsed this same formula in their tale of the martyrdom of Whistler. Laughter was the artist's price for immortality. By risking the spectacle and comedy of the non-juried, non-academically certified public exhibition, the Impressionist Exhibitions were defined by that ruling topos of nineteenth-century art criticism: that any exhibition, legitimate or not, was prey to the mob, the crowd, who went either to laugh or to gaze at acres of nude bodies. The caricatures of Daumier and others condescended to that public and underlined the difference between them and the real art audience belonging to the milieu of the *amateur* (already sited in the commercial gallery, and, also, significantly, subject to the laudatory representations of Daumier).

As a practical matter, no artist invited laughter (at least not until this century); and as for eventual vindication, that was a matter of contention as late as the second half of the 1880s. To be laughed at was the antithesis of the drive to achieve a professional status for the artist outside the certifying rubric of the academies and their exhibition institutions. For artists who hoped to achieve a professional identity, whose only institutional alternative was a Salon des Refusés, the Impressionist exhibitions came to suggest the promise of opportunity and of an elite showcase for their art. Essentially democratic exhibitions such as the Refusés offered little to the serious artist.

The Impressionists sought to distance themselves from this unflattering precedent. The founding rules of the "Société anonyme coopérative à personnel et capital vériables des artistes peintres, sculpteurs, graveurs, etc." contained provisions that the exhibitors would not show in the Salon and that they would stage their exhibitions roughly a month before the Salon (and shortly after artists were required to submit their work to the Salon jury), thereby deferring the perception that their exhibition belonged to the jury's "refusés."[28]

The pragmatic considerations that informed the Impressionist exhibitions were lost to their subsequent construction within a narrative that stripped the historical complexities, the aesthetic and ideological diversity, from this "bande" of intransigents. With the establishment of the term *impressionnistes* in 1876 over that of *intransigeants* (which described an institutional, not aesthetic revolt) the two figures of independence and innovation were permanently intertwined. In the subsequent modernist reading of their exhibitions, it was as if the one figured the other—out of independence arises innovation, and conversely, innovation inevitably engenders independence. Political factors and motivations were collapsed into aesthetic considerations, and aesthetics into politics. Independence from what, like innovation against what, represented a less-important question in the later discourses of modernism than the mere citing of its occurrence. How to master the status of independence and how to be new were more essential than the consideration of the consequences that might derive from these acquisitions. Beginning in the 1890s, the independence of the *intransigeants* would be stripped of any hint of the Commune or other dangerous political and social ideas in favor of merely signifying the site (the trial by ordeal) that defined the great artist(s) against the crowd. Innovation likewise was sanctified not as the destruction of past artistic traditions, but their reconstitution in modern form at the hands of the artist-genius.

Reduced to a monolithic, heroic, institutional alternative to a singularly repressive regime, the idea of an independent exhibition resonated more deeply, for a much longer period of time, than any individual work displayed in the Impressionists' shows. Comparatively few people attended them (especially from outside Paris) and the criticism, particularly the unfavorable press reviews, was for the most part ephemeral. One measure of their transitory character, how quickly the Impressionist exhibitions passed into a mythic history, was Félix Fénéon's request to Camille Pissarro in September 1886 to provide the critic with as much information about these exhibitions as possible for an article he was preparing for *L'Art moderne*, which eventually found its way into the pamphlet, *Les Impressionnistes en*

1886.[29] Pissarro's reply listed not only each of the exhibitions by date and location, he provided Fénéon with the participants (and defectors) at a number of them (he also included the one-person exhibitions held for Monet, Renoir, and Pissarro within this list). Fénéon's inquiry, of course, was merely performing good historiography, but it speaks to Fénéon's need to fix historically what had thus far been only advanced under the rubric of tendentious criticism.

Fénéon's (and Pissarro's) historicizing project, like those that came after, was a significant advance over the feuilleton criticism, causing not only Impressionism's opponents to fall silent, but also fusing the diversity of views that greeted the original exhibitions into that "chorus of laughter" that is the topos of modernism's hagiographies. What lasted in the public imagination and ruled art discourse by the fin de siècle were representations such as those in *L'Oeuvre*. We should remark how even as early as 1886 Zola found it permissible to conflate the 1863 Refusés with the Impressionist shows. What the artists had been so concerned to pry apart, Zola reunited and thereby created an enduring confusion between the politics of the Refusés and that of the Impressionists. Not surprisingly, in the early literature on Impressionism produced outside France, critics and historians had difficulty getting the date of the first show right—1863 and 1873 were the errors of choice.[30]

Subsequent independent exhibition societies such as the Belgian Les XX or the Central European Secessions took over this collective project of sacrifice and redemption. If tendentious exhibitions won out over exhibitions of heterogeneous "quality" (a matter contested right through the end of the century) it was because critics—and audiences—were substantially more interested in special exhibitions, especially if they possessed an historical character. *Parti pris*, particularly when historically placed, was simply more readily classified and digested by art critics and by the public. Exhibitions of "tendencies" were more sensational, more controversial, and more entertaining than "democratic," contemporary "appendages" to the Salons.[31] The paradigm also permitted artists to band together as a group in the name of politics, not commerce. They could thereby mask the elitist nature of their organizations and their potential business advantages.

The Impressionist exhibitions taught other institutional lessons. They allowed artists within an elite format a new means of access to the public, either through official or semi-official sponsorship (as in the Secessions) or via commercial galleries, which came to see group shows as an occasion to gain press attention, and particularly to promote the visibility of the gallery. They also served as a convenient arena in which to identify within the

group the most marketable individuals. The group in turn, acting as its own jury, could aim to improve the quality or at least the compatibility of their fellow exhibitors and to reduce their numbers. Finally, only from group exhibitions could the claim for historical importance be derived, as the bearers of a particular style in the evolution of modern styles. Yet also from the group, individual artists would emerge who could be exhibited by dealers in isolation and who could acquire the attributes of "leader" or "father" or "founding figure." In the 1890s European artists witnessed just that process of canonization by which Manet especially (despite his tangential connection to the Impressionist exhibitions) was singled out as chief revolutionary, *chef d'école*, and a great temperament, great artist, even old master among the modern masters of the French tradition. Manet's final reward was the enshrinement in the national, contemporary art museum, itself a nineteenth-century invention. The overriding lesson was simple: the Impressionist exhibitions accomplished for the contemporary art market the fusion of the discourse on temperament with the politicized reception of écoles.

The Impressionists were not the first to stage such a story. Their success might not have been possible if there had not been a prior école that they were then said to supersede: the École de 1830. The Barbizon painters, however, never purported to represent something "new" in the history of French art; their originality was invariably tied by them and their supporters to the nature they painted.[32] But within the histories of Impressionism (and individual masters), particularly in the treatment of Manet as the protoimpressionist paragon at the Refusés, a new history of art was said to have begun. Manet and the Impressionists announced a radical rupture with the past, ending four hundred years of representational art.

Of course, no one was aware in 1863, nor in 1874, that such a break had occurred. Nor was it perhaps even a part of the mentality that led to the founding of the Salon des Indépendants in 1884 and the construction of a "Neo-Impressionism." At least until that moment—and that moment would arrive for different audiences at different times after 1884—Neo-Impressionism at its most radical formulation was understood only as realism in the most extreme form. Fénéon's justly famous article "Le Neo-Impressionnisme" (1887), which put the term Néo-Impressionnisme into currency also represented it as Impressionism in possession of "rigorous technique."[33] But unquestionably, sometime in the mid-1880s, in Parisian artist circles, Impressionism was breached.

Subsequently, critics and historians described or defended that breaching of the Impressionist paradigm (and naturalism as its literary form)

under many names: Neo-Impressionism, symbolism, *Neu-Idealismus*, Post-Impressionism. And with the destruction of the Impressionist orthodoxy —again occurring at different times and under many different contexts— Impressionism itself was understood as a break with the past and a new beginning (one now already transgressed and transformed by whatever the art of the present was said to be). Richard Muther concluded in 1894 that "the battle for the liberation of modern art" had ended with the exhibition of Monet's *Haystacks* in 1891.[34] "The painters of the nineteenth century are no longer imitators, but have become makers of a new thing, "enlargers of the empire." The Impressionists were "the Jacobins of the revolution in art which has since been accomplished throughout all Europe."

The views of this young German art historian spoke for many cultured Europeans outside the artist enclaves of Paris who came to believe that Impressionism was synonymous with modernist art, or even with the experience of modernity itself. So great was that identification, that once established it took a very long time to break down. One need only remember that Charles Morice, the poet, critic, and collaborator of Paul Gauguin, deferred the "death" of Impressionism until 1905.[35] (1905 is another magic date of rupture, the year of the "fauves" debut at the Salon des Indépendants, the year the Klimtgruppe broke away from the Vienna Secession, the year the Künstlergruppe Brücke formed in Dresden. If 1863 gave birth to "Impressionism" in 1905 Impressionism as a totalizing world view was cast aside and a host of new modernisms rushed in to take its place.)

What was "modern" in Impressionism was never statically defined. It mutated in concert with the definitions of modernism. At times, certainly, the *modernité* of Impressionism seemed for some critics to embody the Baudelairean description of "le transitoire, le fugitif, le contingent." At others, it was no more than the obligation to paint "plein air," usually a very loosely defined enterprise, and "modern life." These tasks could be and were undertaken just as serviceably by an artist employing conventional academic standards for the purpose of satisfying even the most conservative among the Salon's audience. The closest the painters themselves came to a concerted aesthetic vision may be found in a letter written by Edgar Degas to his friend James Tissot to try to get him to exhibit with the group by making an appeal on ideological grounds. "The realist movement no longer needs to fight with the others, it already is, it *exists*, it must show itself as *something distinct*, there must be a *salon of realists*."[36] His call to follow the realist banner is easily misinterpreted. Realism suggested and still suggests a political ideology closely linked to the life and work of Gustave Courbet.[37] But so general was its use by 1874 that this linkage had greatly blurred.

Degas actively supported artists for inclusion in the Impressionist shows who were only nominally connected to progressive painting. And Degas shared little of Courbet's political opinions. Tissot, who declined Degas' invitation, had just begun to create paintings that combined the attention to detail, line, and finish worthy of Meissonier with subjects drawn from modern life. Painting everything from boating parties to boulevards, Tissot fulfilled Baudelaire's vision of a painting of modern life, but in a style and sensibility the poet condemned in his *Salon* of 1859.[38]

The confusion of political and aesthetic realism was only deepened by the likes of Paul Alexis, the socialist art critic, intimate friend of Paul Cézanne, a writer closely connected to all the Impressionists. In one of the first notices of the society's ambitions, Alexis described the Impressionists as constituting more than "just a small clique. They intend to represent interests, not tendencies, and hope all serious artists will join them."[39] (Thirty years later E. L. Kirchner employed almost the identical phrasing in his "Program" for the Brücke.) Interest here is a euphemism for the party politics and hegemony of the Salon juries; tendencies stood for aesthetic issues. There were many who like Alexis wished to see as a political rejection of the Salon any attempt at independent exhibitions. In the aftermath of the Commune such exhibitions could hardly help but resonate politically.[40]

It was perhaps precisely to deflect such political associations that the first exhibition was widely inclusive, encompassing even some artists with Salon reputations. It was also a tactical decision to broaden the appeal of their exhibition and perhaps to diffuse some of the anticipated criticism.[41] (The Brücke took a similar tack when they enlisted Cuno Amiet and Axel Gallén-Kallela for their early exhibitions. Their prestige as international moderns was more important than their aesthetic/ideological affiliations.) Where Alexis saw organized dissent, most reviewers of the first exhibition ignored the various "fellow travelers" to concentrate their attention on the core of the Impressionist artists—a pattern repeated in the subsequent exhibitions. Critics generally saw the show espousing a specific aesthetic tendency and criticized the very inclusion of artists the Impressionists brought in to render their exhibition palatable.

Nonetheless, the "what" of Impressionism deferred to the rhetoric of innovation, the transgression of established tastes, and the disruption of the ruling institutions of art, as it had with the prior blackballing of painters such as Rousseau in the 1830s or the Refusés in 1863. Within the popular, stereotypical consumption of Impressionism, aesthetic subtleties were sacrificed to the dynamics of their rejection. For example, in 1895, Jean Bernac,

on the occasion of the Caillebotte bequest to the Musée Luxembourg, wrote a series of articles on the subject for the English *Art Journal*. Having been rebuffed by the Salon jury of 1874, he wrote, the Impressionists

> took up their abode in close proximity [sic] to that official building, and the reception that awaited them has become historical. People went there to laugh, to exclaim, to brandish protesting umbrellas at these canvases, that were then held to be revolutionary. . . . The critics of the day, with few exceptions, with ignorance that equalled their confiding readers, saluted this new art with paragraphs that smelt of powder and caught fire as they came into contact with the reader. . . . But the exaggeration had been too violent for a reaction not to set in. This ensued, and the excessive animosity which had victimized this "avant-garde" of new painters, procured for them substantial friendships on the part of some intelligent amateurs, dealers, art critics and painters of undetermined views—amongst them Caillebotte.[42]

This formula, essentially unchanged, was advanced almost ten years later by Wynford Dewhurst. As a preface to what was essentially a collection of monographic, surprisingly uncanonical studies on the various Impressionists, Dewhurst wrote an heroic sociology of their travails.

> In 1874 a small exhibition was organised, and held, from April 15 to May 15, at the galleries of M. Nadar, 35 Boulevard des Capucines. . . . From every point of view, except that of art, the exhibition was a failure. The press attacked it with exceptional virulence, the public kept away. The artists were lampooned in idiotic cartoons, and branded as traitors who were disloyal to the artistic traditions of their country.[43]

After describing the "heroic courage, faith, and self-confidence" of the Impressionists Dewhurst recounts their "ordeal," the risks taken by Durand-Ruel, the failed auctions, and continued hostile criticism. Then follows their vindication.

> M. Geffroy refers to these exhibitions as battle-fields. Campaigns cannot last for ever, and victory had at last crowned the Impressionists. To-day these artists are honoured and decorated, their works hang in public galleries over the whole world. It may be said that we are all Impressionists now. . . . The difficulty of Hanging Committees will be, not to hide away Impressionist work to the least damage of its surroundings, but to hang the anecdotal, moral, and all canvases of like *genre*, in such obscure corners as will give the least offence to their moribund and conservative creators.[44]

The historical complexity of Dewhurst's claim that "we are all Impressionists now" I will defer for the moment. What I wish to emphasize here is that it was normative for French and British criticism between 1895 and 1905 to employ this parallel construction of rejection and redemption, an assertion of a field conquered and an entirely new world view set in place.

By the time Dewhurst wrote his book the Impressionists had achieved the museum, via the subscription for Manet's *Olympia* for the Louvre in the early 1890s and the acceptance and eventual exhibition of the Caillebotte collection (with the *Olympia*) at the Musée Luxembourg in 1897. The rhetoric of innovation was therefore by necessity conjoined in the nineties, particularly among the French apologists for Impressionism, to the demand that this art stand for the great tradition of French painting rather than its antithesis. As with every art work's final interment in the museum, Manet and the Impressionists were stripped of controversy and proclaimed transcendent masters. Within this new frame, innovation was understood as the criterion of all great art; the appeal now was not just to Duret's enlightened connoisseur, but to the general public. Thus the tribulations of the Impressionists, the passage from innovation through rejection and subsequent redemption, was already understood to be a closed narrative. Marshalled as a modernist cliche in service of the canonization of the Impressionists vis-à-vis the museum, its explanatory power served the next generation and the generation after that as the primary model for the construction of a professional identity within the context of a "group endeavour."

Who belonged to the Impressionist canon, that is, who were the professional Impressionists within the group exhibitions, expanded and contracted within the course of the exhibition history, depending on the aesthetic or political agenda of the artist, critic, dealer, or historian, for whom such distinctions mattered.[45] But with the "final" exhibition in 1886, the question of canonical consensus ceased to be an internal matter, to be decided among the group itself as it struggled to create exhibitions, but an external factor. At that point a significant breach occurred between those who sought an all inclusive definition of Impressionism (Dewhurst's "we are all Impressionists now") and those—arising primarily within the commercial galleries—for whom an exclusionary understanding was, if at one level historically justified, at another level, for commercial reasons, highly desired.

Consider, again, the example of Lecomte's *L'Art Impressionniste* which Durand-Ruel published in 1892.[46] Its most salient feature was the attempt to absolve Manet and the Impressionists of all controversy. Lecomte was a young playwright, a friend of Fénéon, and an intimate of the anarchist circle

around the periodical *La Cravache*. His closest connection among the Impressionists was Pissarro. As with Fénéon and Gustave Geffroy (to whom he dedicated this book) he readily put his critical services in the hands of dealers, writing, for example, a preface for the Pissarro retrospective held at Durand-Ruel's in 1892. And like them, Lecomte revealed very little of his political views as he took his readers on a virtual stroll through Durand-Ruel's apartments. Mediated by the elegance of Durand-Ruel's quarters and the blanket admiration handed out to all of his pictures, Lecomte stripped them of political import, and showed very little interest, in fact, in their subjects.

> No properly educated artist today contests the glory of Manet: soon it will receive official consecration in the Louvre. Parallel to it, the reputations of MM. Degas, Monet, Pissarro and Renoir has been duly installed and men of taste appreciate the talent of M. Sisley, of Miss Cassatt, of Mme. Morizot [sic]. In the most respectable galleries Impressionist paintings are placed next to the masterpieces of past time. The education of the public has slowly matured.[11–12]

Manet was described in largely formal terms, save only for a peculiar digression on the *Olympia*, occasioned, obviously not by the Durand-Ruel collection but by the recent controversy over the admission of the picture to the Louvre, which had only recently, and somewhat unsatisfactorily for the supporters of the artist, been concluded.

> These errand-girls, these girls of the studio or of the street, heedless of feigned modesty, audaciously carry their blackguardism (*canaillerie*), expressed in their provocative walk, their liberally displayed throats . . . the rebellion of their hair, which above all is stated in the audacity of their gaze and the call of their mouths.[49–50]

Lecomte's slip into eroticism was not reinserted into the qualities of the artist's originality. He only observed Manet's willingness to paint themes that possessed what one could call a Baudelairian modernity. This break in an otherwise seamless formalist exposition exposes the generally unreflective, commercial subservience of his book. Like his many predecessors, Lecomte connected the Impressionists to the École de 1830 in order to complain about how long it took to "convince the buyers of the excellence of the new technique." In a familiar refrain, he reconstituted the audience for Impressionism as *acheteurs*.

As for the reputation of this core of painters that Lecomte took so manifestly for granted, we must remember that Henri Matisse, who began his

career in the studio of Gustave Moreau and who exhibited in the "progressive" Salon of the Société nationale des beaux-arts, was unfamiliar with the Impressionists's work until the Caillebotte bequest entered the Luxembourg. As a typical, if brilliant aspiring artist in the 1890s, his ignorance is telling. If Lecomte upheld a canon that was still widely unacceptable, or otherwise ill-defined, he also created within that canon a hierarchy of importance that came perhaps as a direct response to Durand-Ruel's own judgments. He helped shape the canon along the lines determined by Durand-Ruel's tastes: absent were Cézanne, Caillebotte, and Guillaumin. The book corresponds, indeed, to the slide in critical and market interest in Caillebotte and Guillaumin (not to be resurrected until the 1970s) and marks too the separation of Cézanne's reputation from Impressionism (which would be turned into commercial reality by Ambroise Vollard's wholesale commitment to Cézanne begun in 1895). Lecomte may have also shared Durand-Ruel's views when he relegated Sisley and the women painters to a second tier of importance. His only unusual departure from the norm of the Impressionist canon was Lecomte's removal of Manet from his popular role as the initiator of Impressionism in order to describe *plein air* as a group accomplishment.

Next to Lecomte's panegyric, Geffroy's nearly contemporary "Histoire de l'Impressionnisme," reads as a sober history of the movement.[47] More than Lecomte, Geffroy introduced a wider domestic and international audience to the Impressionists. Geffroy, a romance novelist and professional critic of the art world, moved in more established literary circles than Lecomte. Instead of a close relationship with Pissarro, the anarchist, Geffroy became the friend and chief critical supporter of Monet, providing the artist, for example, with an introduction to his retrospective at Georges Petit's gallery in 1889. Yet if he reflected an "establishment," if liberal position on contemporary art, he nonetheless employed many of the same techniques as Lecomte. Like Lecomte his essays on the Impressionists were situated between criticism and historical writing, simultaneously polemical and taking the issue or the art at hand as something resolved, historically determined to be of intrinsic worth. He gave a new note to the genealogy of Impressionism by arguing that

> today, the École de 1830 is classic, its paintings are *recherchées*, and covered in gold, and, by a bizarre turn of events, one moreover vulgar and habitual enough to history, it is in the name of this École of 1830 that one would bar the road to Impressionism. It is in its name that Impressionism is combatted, that one wants to assign it to a secondary place.[6–7]

Geffroy provided the standard list of heroes, incorporating Ingres into this litany to accompany Courbet, Millet, Corot, Boudin, etc., and then adding in a new, historically minded turn, Turner and the Japanese.

His version of Impressionist aesthetics was almost entirely concerned with its empiricism. According to Geffroy the Impressionists "wanted a tabula rasa, and a sincere rebeginning." Geffroy also "neutralized" and generalized this evolution, making it a process in common with all great art. Manet, for example, worked with "logical intelligence" by refusing to follow the "precepts of the Institut and the paintings of the masters." Geffroy did not deny the importance of Manet's choice of subjects, he called the artist "a perspicacious and refined observer of Parisian existence." But like Lecomte he lifted Manet above scandal.

> The shouts and laughter did not prevent the Olympia, the strangely nervous and delicate girl, of thin limbs and exhausted flesh, to say in its own language, one of the phrases of an eternal poem of the flesh. The painter of this *Olympia*, of the intimate conversation in the *Conservatory*, of the boaters of *Argenteuil*, will certainly remain as one of the most informed and most explicit historians of Parisian life in the nineteenth century.[140–41]

Manet the historian or reporter is a far cry from the revolutionary. Geffroy asked if Manet's unique contribution to contemporary art was in fact due to

> this new vision, this exact observation of the luminous surface that bathes all things, which triumphs today in the private exhibitions in the Salons, which imposes itself even in the official ateliers, in the loges of the École, in the halls patronized by the Academy and by the State?[141]

The originality of the "new vision" of Manet and the other leading Impressionists is the constituent ingredient for the seemingly paradoxical counterclaim, "we are all Impressionists now." Both revolutionary and museumbound, a double movement forward and backward in the history of art, the rhetoric of innovation requires both a break and an ever-greater investment in the past.

THE IMPRESSIONIST EXHIBITION OF 1876 AND THE EMERGING COMMERCIAL CRITIQUE

John Rewald's homogeneous account of the "chaotic evidence" of the Impressionist exhibitions offered in his seminal *The History of Impressionism* suppressed what might be called the homographic aspects of these events,

the perpetual confusion of one discourse for another based on surface sim-
ilarities, as in politics for aesthetics. Conversely, the recent corrective to
Rewald's history, the 1985 show that sought to reconstruct each of the eight
Impressionist exhibitions, *The New Painting: Impressionism 1874–1986*, sub-
stituted heterogeneity for homogeneity. Leaving aside the question as to
whether the exhibition itself perpetuated rather than redefined the Impres-
sionist canon—as critics of the exhibition have claimed—the catalogue for
the show, with a separate author for each exhibition, offered strikingly
synchronic readings that grounded each within its critical reception and in
varying degrees within the social and *Kunstpolitik* circumstances of the
day.[48] In the process, however, a diachronic understanding of the exhibi-
tions as an institution within the larger cultural life of French art was largely
excluded.

Only two essays spoke in a fundamental manner to the institutional issues
posed by the Impressionist exhibitions: Hollis Clayson's critique of the
second exhibition in 1876 and Martha Ward's on the final show in 1886.
Clayson's essay argued that the critics viewed the exhibition largely accord-
ing to the political position of the respective journal.[49] The left-wing jour-
nals were more consistently in favor of the Impressionists' enterprise than
those to their right. Moreover, she demonstrated that none of the critics she
surveyed, regardless of their political persuasion, had any real difficulty in
distinguishing what we would understand to be the canonical Impression-
ists from the artists brought on board to confer by their conventionality and
certain public reputation a more favorable reception for their enterprise.
Clayson believed that what was most notable about their reviews was the
inability to see the commercial expediency behind the Impressionists' deci-
sion to include artists who could hardly be identified with the core group on
aesthetic grounds. Clearly, the work itself and the agreement among the
painters involved had already largely shaped the main players (rightly or
wrongly) and defined the supporting cast. The Impressionist canon was not
profoundly altered through the fin de siècle and beyond, except perhaps on
the insistent exclusion of Guillaumin and Caillebotte and the ambivalent
positioning, unquestionably on the basis of gender, of Cassatt and Morisot.
Second, the will to mythicize the Impressionists was with the group from
the beginning. By discounting material considerations, the notion of an
heroic group effort was already in place, to be elaborated and refined in
subsequent decades.

The fundamental importance of the second Impressionist exhibition (al-
though it abandoned the organizational title of the Société anonyme) was
that it was to be received, as Clayson points out, as if it were the first—

because it was this exhibition that announced the permanent character of the association, something no other French circle of painters had managed to create.[50] Even though their original organization had fallen apart after the first show (Pissarro had defected to a rival, but inconsequential and quickly forgotten artists' society) and they were to continue to work in significantly different directions, all the while the public persisted in seeing them as a whole. In effect, the society's only form of existence was the exhibition itself and the criticism that supported it. And this exhibition, the one that occasioned some of the finest contemporary criticism, opened in the rooms of Durand-Ruel.[51] They took a chance in exhibiting there. The decision was probably forced on them by a shortage of funds with which to rent an alternative space. But it publicly declared the affiliation between these artists and the dealer, a fact that was frequently acknowledged in the criticism. Without a name for the group, the society could only be identified to the readers by the gallery—a reference customarily shunned in criticism of group exhibitions outside the Salon—as had almost always been the case with the Martinet shows.[52] So strong, however, was the aesthetic identity of the exhibitors in the public mind that they avoided any suggestions in the press that their exhibition was simply a disguised form of a dealer's stable of artists.

On the same day the Impressionists' exhibition opened, Manet chose to hold an open studio, motivated by the Salon jury's nearly unanimous rejection of his two entries. Since his exhibition drew large crowds and attracted significant press attention, the two shows tended to get reviewed together, as two manifestations of a single école. They acquired a common identity, independent of their exhibition locales. This identity also transcended differences in style and subject matter.

In 1874 the critical texts had been ruled by the politics of the exhibition. In 1876 a theoretical structure for the work at exhibition was laid out.[53] The key essays were Edmond Duranty's *La Nouvelle Peinture*, Stéphane Mallarmé's "The Impressionists and Edouard Manet," and Émile Zola's "Lettres de Paris. Deux Expositions d'Art au Mois de Mai," which the novelist wrote for a Russian newspaper. Duranty's was the longest and the most historically minded and the only one of the three available to Parisian audiences, and thus unquestionably the most immediately influential.[54] His vision of the new painting was largely filtered through his involvement with realism twenty years before and through his friendship with Degas. The essay projected a theoretical coherence to Impressionism based on the earlier doctrines of realism, modified by the new interest in *plein air* and urban themes. The artist who most lived up to Duranty's conception of the

101

new painting was, by virtue of his social themes, Degas. Duranty gave a less attentive, though still insightful interpretation of the aesthetic innovations of contemporary landscape painting, and so on, but due to the limited narrative interests of such pictures, Duranty's arguments tended to lose their force.

Duranty grounded his Impressionist "theory" in art politics, addressing his essay directly to the Impressionists' conservative opponents, the members of the Institut and the professors at the École. He responded to Eugène Fromentin's observations contained in a section of his essays on seventeenth-century painting that had been published in 1876 in the *Revue des Deux-Mondes*, in which the orientalist painter despaired over the decline of history painting and the triumph of the French landscape tradition.[55] Duranty answered Fromentin's critique by trying to explain the impoverishment of history painting inside the École. He specifically distinguished the École and the Institut from the rival schools of contemporary painting gathered around artists such as Gérôme, around military artists such as Meissonier and Detaille, around painters of fashionable life such as Fortuny. Each, in a sense, represented a brand of contemporary realism that Duranty dismissed out of hand. He directed his opposition to the official institutions of French art, which Duranty believed were still the only place for the formation of authentic painting. By making the École the opposition rather than the Salon, Duranty staked the legitimacy of the "new painting" on the lost legitimacy of the old. In one sweep he cast aside the artists who dominated the Salon and who led the rival art schools and thus who dominated the art politics of France. He argued, perhaps following Degas' views, that Ingres could be claimed among the fathers of the new painting.[56]

It was a brilliant critical manoeuver, representing the first round in the struggle to wrest legitimacy away from the leading officially sanctioned artists of the day. Duranty claimed for the Impressionists their place as the rightful heirs to Ingres and Flandrin, to Courbet and Corot and Chintreuil —the latter two artists having but recently died and "canonized" in the galleries of the École—and to Millet, whose reputation was soaring. Duranty even saw the new art as the beginning of the fulfillment of aesthetic ideals set out by Diderot in his *Salon* of 1765. To bring his genealogical view of art criticism into the present, Duranty added that "the serious contemporary art criticism is realist, affecting the most varied terms and techniques"[479]. In short, both serious contemporary art and criticism subscribed to the realist doctrine and were the logical successors to the classical and Romantic schools of French art.

Mallarmé's essay on the Impressionists and Manet is a less significant text only because it came out in an English publication and never entered the developing French discourse on Impressionism.[57] Mallarmé's essay, nonetheless, defined a number of critical topoi that soon formed the standard interpretation of both Manet and the Impressionists. He developed an historical argument that began with Romanticism, and unlike Duranty, passed through realism, and then became in "one of those unexpected crises which appear in art" a style of painting that possessed "a peculiar quality outside mere Realism"[29]. Mallarmé went beyond Duranty in another way, by analyzing Manet's career in evolutionary terms. Not only does art evolve towards some greater good, but so does, at least, this artist. He cited a list of paintings beginning with *Le Déjeuner sur l'herbe* (Musée d'Orsay, Paris) through pictures such as *The Execution of Maximilien* (Kunsthalle, Mannheim), ending with the 1876 Salon rejection, *Le Ligne* (Barnes Foundation, Merion, PA).

> these are the pictures which step by step have marked each round in the ladder scaled by this bold innovator, and which have led him to the point achieved in his truly marvelous work . . . *Le Ligne*—a work which makes a date in a lifetime perhaps, but certainly one in the history of art.[32]

The idea of an individual artist moving towards an abstract goal of greater naturalism or greater truth would be, obviously, an important model for the later avant-gardes. It cast the whole effort of Manet and the Impressionists as an artistic form of research, implicitly paralleling modern science. It was a research after truth (in nature) rather than relying on preconceived formulae of art. It was finally the very nature of Manet's studio "retrospective" that encouraged Mallarmé to produce within the oeuvre a model of generation and maturation, the significance of which I will describe in the next chapter.

Mallarmé made no attempt to explain the scandalous nature of the artist's early work. He called attention only to the qualities of its execution and its historical place. By putting a domestic scene painting like *Le Ligne* at the summit of Manet's career, he celebrated the less complicated, potentially much less offensive "Impressionist" pictures over the aggressive and problematic work of the 1860s. This preference for the later Manet persisted in French criticism until at least after the First World War, especially since this work lent itself more readily to a formalist critique and to the representation of Manet as the "father" of Impressionism.

Mallarmé also most emphatically located Manet at the head of the impressionists, considering the artist by far the most powerful figure. He even

raised for the first time (among friendly critics) the reproach against Monet and the other landscapists for their "wonderfully rapid execution" which lead many to suspect that "such light productions might be multiplied *ad infinitum*" (a gentle accusation here, but one that Zola in particular would repeat much more sharply against them). The poet went on to say that it would be "a merely commercial misunderstanding, from which, doubtless, these artists will have still to suffer"[30].

Zola's article was the most institutionally directed of the three and like Mallarmé he addressed a foreign public.[58] His review considered both the Salon and the opposition. Beginning with the observation, by now routine, regarding the mediocrity of the Salon and the dictatorial attitudes of its juries, Zola largely blamed the State for encouraging these problems. He believed only two choices were possible to affect meaningful Salon reform. Either the government should reinstate the despotic control of the Academy (an impossibility) or open the Salon entirely, abandoning the system of recompenses and simply offering the Salon as it already clearly was, an annual market for art, which Zola styled "le bazar de beau"[948]. The latter possibility would also not occur, however, because of the "vanity" of artists and "despite our revolutions we are a nation of aristocrats; we like to be placed apart, above the crowd, with a certificate of genius stuck to the middle of our backs"[949]. In describing the official Salon, Zola mourned the absence of artists to replace Delacroix and Ingres. "These giants have left no inheritors and we still wait for the geniuses of the future"[953]. When he turned to Manet and the Impressionists Zola made it clear by implication that they too did not embody this genius.

Manet at least acted like a great man by inviting the press and the public to his studio after he had been turned away by the jury. Zola claimed that over 10,000 people entered Manet's studio, a great success since "one could be no more occupied with an artist than if he exhibited his paintings in the Salon"[967]. Finally, he closed with the statement that Manet "is a naturalist. An analyst. He knows neither how to sing nor how to philosophize. He knows how to paint, and that is all, and it is a gift so rare that it has sufficed to make Manet the most original artist of the last twenty years"[968]. It's an odd tribute. Zola stripped Manet's work of its social dimensions, leaving behind only formal practice—far from the novelist's own ambitions in literature. He stopped short of calling Manet a genius, for genius as he knew it was recognizable only in an art of ideas. This same evaluation Zola conferred on all the Impressionists.

One last voice is worth considering in the reviews of the 1876 exhibition. Castagnary, who had written a *Salon* in 1876, concluded his review of the

state exhibition by praising the Impressionist school, which he already saw was making itself felt in the Salon. Castagnary believed that it was still necessary that the Impressionists "should be in the Salon to confirm by their presence the accomplished evolution (in the painting of *la lumière* and *la vérité*) and to give it its full importance."[59] This is another reminder of the continuing prestige of the Salon, even among those who wished the Impressionists well—and it is a prejudice that continued to reflect on the ability of the Impressionists to command a large market.

If Castagnary still insisted the need to prove oneself within the Salon, and if Zola was adamant that Manet and the Impressionists revealed an insufficiency of temperament that would signify the genius of the future (writing about Caillebotte he decried the artist's too academic manner: "the photograph of reality which is not modified by the original imprint of an artistic talent is a pitiable thing"), the most sophisticated criticism of 1876 claimed Impressionism to constitute a new kind of realism, announcing a break equivalent to the rise of Romanticism.[60] In their separate ways, Duranty, Mallarmé, and Zola each placed Manet and the Impressionists as the logical successors to the French tradition. Duranty and Mallarmé both viewed their creations as symptomatic of the new society and culture of the bourgeoisie. Duranty exulted in the Impressionists' bridging the distance between the studio and the street, foretelling of a new, popular urban art (defined within the vocabulary of realism). Mallarmé spoke of the new art as paralleling the "participation of a hitherto ignored people in the political life of France."[61] Historical rupture, the inevitable product of modern life, the genealogical turn that would recover Ingres from the Academy, these were the formulae of 1876 that would be worked and reworked in subsequent theoretical elaborations, and never fundamentally challenged. If Impressionism was not constituted precisely as a theoretical practice, that is, one possessing uniform aesthetic procedures or a unified ideological attitude toward the subjects represented, from this point onward a theoretical understanding of the horizon of methods, attitudes toward nature, and toward contemporary life, etc. was in place.

Starting from the *intransigeants* of 1874 and passing through the theoretical elaborations of "Impressionism" in 1876 to the self-styled Impressionists at exhibition in 1877, the politics of individuals banding together in the name of exhibition reform increasingly submitted to the discourse of theory, the advancement of Impressionism as a blanket "ism," a unified opposition of present art against all former manners of art making. Mallarmé announced this institutional division in 1874 in defense of Manet, when in his famous phrase he reduced the vote of the Salon jury to just one factor:

"this is a painting, or that is not a painting."[62] This all or nothing proposition meant that individual works of art had to conform to a general theory of painting (articulated in 1876). Painting begins in this sense to be understood as a proposition within a theory, as opposed to the earlier understanding, expressed by Zola, but also generally within the discourse surrounding the École de 1830, of painting as a proposition within a temperament. Thus, seemingly paradoxically, throughout the course of the Impressionist exhibitions in the 1870s the discourse of temperament circulated simultaneously with the discourse of theory. When the hero-artist within the theory was named—usually Manet after 1876—painting was advanced as a product of a temperament. But the historical claims on behalf of that temperament are henceforth argued from Impressionist theory. If at the end of the Impressionist exhibitions, Impressionist theory seemed to give way to transcendental temperament (at home in the museum), it was just that theory that served as the justifying argument for holding a retrospective in praise of a temperament.

■ CHAPTER FOUR ■

The Retrospective

THE RETROSPECTIVE PARADIGM

For most of the nineteenth century the special exhibition held in the galleries of an art dealer, whether it was of a group or of an individual, carried the burden of appearing too commercial, its historical interest too insufficient to mask its self-interest.[1] As Pissarro wrote his son after Durand-Ruel gave a one-man retrospective to Monet in 1883:

> Monet's show, which is marvelous, has not made a penny. A poor idea to have one-man shows. The newspapers, knowing that a dealer is behind it, do not breathe a word, they speak of the frightful canvases on the rue Vivienne, the Cercle St. Arnaud, etc.[2]

What irritated the artist was not just that the press stayed away from this kind of exhibition—a not fully warranted assertion—but that publicity did attend the shows of such private artist-patron societies as the Cercle St. Arnaud, or the Cercle artistique et littéraire, or the Union artistique, many of which had been in existence since the 1860s.[3] Their exhibitions, even though they were usually managed by dealers such as Petit, offered the acceptable Salon favorites in a package of gentility which an overtly commercial exhibition could not hope to match.[4] Durand-Ruel, for example, showed a collection of seventy paintings and studies by Théodore Rousseau in 1867 at the Union artistique timed to coincide with the Exposition Universelle. The Union both mitigated the commercial character of the exhibition and provided sufficient exhibition space for so large a show. Moreover, such societies automatically received significant press attention even after prolonged negative criticism of their exhibitions.[5]

Despite the social resistance to "expositions particulières" devoted to individual artists which forced Durand-Ruel's thinly veiled diversion, they became perforce one of the dominant institutions of the fin de siècle. The Durand-Ruel/Cercle exhibition of Rousseau in fact signaled the inroads private exhibitions had already begun to make in the Paris cultural fabric by the 1860s. That Durand-Ruel was able with some success to exploit Rousseau's "apotheosis" at the 1867 Exposition Universelle, to show the work of a living artist held entirely in commercial hands for commercial purposes,

was an important precedent for the one-man exhibitions of the 1880s. "Expositions particulières" also grew in eminence as the indirect result of both imperial and republican state policies that had pursued cultural consensus in the visual arts and had downplayed the role of écoles in French art in favor of the promotion of great individuals. These government efforts were inevitably undermined by the decline of "la grande peinture" and the absence of heroes. But the evaporation of the academic tradition's ability to produce the genius of the future coincided with the discovery that the decorum prohibiting self-promotion within the context of a commercial gallery could be overridden if the notion of a one-man show was closely allied to group exhibitions that offered a single aesthetic and ideological front (e.g., the Impressionists). That is, the force of an école—or, as I argued in the previous chapter, by virtue of theory's support of temperament—fulfilled the public expectation that a "school" or a "movement" naturally generates leaders, and that from leaders masters or "geniuses" emerge to carry on the canonical tradition of great art. While the original group exhibitions of the Impressionists were imbedded in the political, social, and cultural circumstances of their era, their eventual trajectory into one-man retrospectives represented an ahistorical, but institutionally comprehensible, turn in the construction of their careers and the careers of all artists who followed their example.

This recognition developed slowly. The one-person exhibition for a living artist could not readily command the political qualities of independence that helped the Impressionists' group shows overcome the appearance of commercialism. The right to such an exhibition had been traditionally conferred only when there existed some public consensus that the artist deserved this honor. So the historical process that validated the Impressionists as an "ism" institutionally coerced later artists to align themselves with a "movement." By the 1890s to be a member of a society, attached to some kind of aesthetic system, counted for more than the individual works of art displayed therein, and for much more than newspaper reviews of ephemeral influence.

Even as late as the first decade of this century, Durand-Ruel believed that while exhibitions such as the Rousseau retrospective might establish an artist's reputation, they "are prejudicial for sales." Durand-Ruel reminds us of how experimental, how fragile, an institution the retrospective was until the very end of the century.

When one shows, completely naively, the greatest masterpieces in quantity, there is a great chance not to sell anything. The visitors are content to

admire and then to go elsewhere to buy objects much less beautiful, at higher prices, because they are better presented.[6]

Although these large exhibitions gathered wide-spread public attention, the tendency was to treat them, as Durand-Ruel says, as something akin to a museum, to look, but not to buy. Collectors, too, had to be educated away from the preference for the latest Salon painting, for the newest work, in fact, by any artist, over their older work. Realizing this fact "much too late," as Durand-Ruel says in his "Mémoires," the dealer had many notable failures with his exhibitions, the most prominent among them the 1878 exhibition of the École de 1830, held in conjunction with that year's Exposition Universelle—which received remarkably little critical attention and produced less in sales—and the 1905 exhibition of Impressionist paintings in London—equally ignored, and equally a commercial failure.[7] Durand-Ruel appears to have forgotten that the great collection of Barbizon and Impressionist paintings that he took with him to New York in 1886 turned the tide on the commercial fortunes of the Impressionists. And the gallery's one-man retrospectives held in 1883 and the many more offered in the 1890s were well-received and resulted in significant sales. I would argue that if Durand-Ruel, even after witnessing the commercial triumph of the Barbizon painters and the Impressionists, still held reservations about the commercial viability of the independent, historically minded exhibition, it was because the retrospective had grown up in the space between the competing forces of the markets for contemporary and old master art.

In the *Kunstpolitik* of the nineteenth century, artists repeatedly resisted the incorporation of historical shows within the framework of either the Salon or international exhibitions. Many believed, realistically or not, that the old-master market represented direct competition for contemporary artists. In the aftermath of a quarrel over the employment of a Centennial exhibition at the Exposition Universelle of 1889, the minister of culture, Antonin Proust, characterized the position of the leader of the opposition, William Bouguereau, as arising from the fear that such an exhibition would either be "useless or even mischievous to the interests of our contemporary artists. He feared that the dead might do harm to the living."[8] Even within an artist's own oeuvre, it was commonly believed that the buying public preferred new art to older work. The historical retrospectives, which attempted to represent a career or a succession of careers of artists, obviously put both the old and the new on display. They invited comparisons, which, on the positive side, implied a continuity between masterpieces of the past and the new art, or, far more rarely, on the negative side, exposed the recent

LIVERPOOL JOHN MOORES UNIVERSITY
LEARNING SERVICES

work of an artist or group of artists to an unfavorable comparison with earlier art (as one might recall from Bouguereau's rueful self-analysis). The resistance to the retrospective as an institution (both by dealers and artists alike) was overcome when such exhibitions could be shown to have directly influenced the market fortunes of the work of a dead artist and when the retrospective could be used to align younger artists either to dead modernist masters or their elder, living contemporaries.

Retrospectives were enabled by, were eventually unthinkable without, commercial galleries, particularly those such as Durand-Ruel's that had displayed a protracted commitment to an artist throughout their career (or conversely, as with Vollard, who made substantial lot purchases of an artist's work—e.g., Cézanne—which then could be exhibited as a survey of the oeuvre). These great dealer collections, backed by the archives and the personal relationship between dealers and their *amateurs*, made the planning of any significant retrospective after 1880 unimaginable without the active support of dealers. In turn, the dealers, who had usually long speculated on these artists in the auction houses, were only too eager to provide ample access to their art to the organizers of the retrospectives. In some cases, the retrospectives provided the occasion to assemble an ad hoc catalogue raisonné as an accompanying exhibition catalogue. The most ambitious of these shows, by virtue of their inclusiveness, served as the foundation for determining provenances and providing the stamp of authenticity on a work of art, a bench mark in the life of a painting's provenance, that in an age of rampant forgeries had significant commercial value.

In this way, the retrospectives were closely linked to the monograph, which although not inherently a modernist phenomenon played a significant role in elevating modernist artists over their popular rivals in the Salons. Biographical monographs had long been the customary formulae both for art historical writing and for contemporary notices for exhibitions and for auction catalogues. Modernism's special claim to the monograph lay in its discourse of martyrdom so frequently rehearsed and in the manner in which they codified the artist's role within a specific "evolution" of recent art. It began, as I believe Nicholas Green has correctly argued, with the linking of the personality or temperament of Barbizon landscape painters to nature itself.[9] These biographies exploited the ubiquitous practice of combining anecdotal information, letters, diaries, and exhibition history. As art criticism, these monographs have an explanatory power that stands halfway between *Kunstwissenschaft* and hearsay. Since there still existed few formal or rhetorical devices for describing either the intentions or the effects of landscape painting, the Barbizon painters were read by their apologists in

the 1860s and 1870s through this anecdotal archive, so that temperament was effectively inscribed in the nature the Barbizon artists painted. The greatness of their paintings were discovered in the greatness of their personalities—and in the case of artists such as Rousseau or Millet, greatness was measured as well by the obstacles they had to overcome to remain true to their "natures."

Obviously these rhetorical structures paved the way for the reception of the Impressionists as landscape painters. And at the historical moment that the significance of Impressionism was being contested in the daily press, the École de 1830 were canonized in elaborate biographies, now ever more frequently accompanied by catalogue raisonnés—which in themselves reflected the needs of the Hôtel Drouot and its *experts* to determine authenticity. The number of forged Corots on the market, for example, has become legendary. Thus, the catalogue raisonné joined the monograph and the exhibition catalogue as a necessary tool and as an important weapon in the debate over historical primacy and the determination of the canonical figures of nineteenth-century French art. Indeed, the number and the accuracy of the catalogue raisonnés for late nineteenth-century French artists is extraordinary when compared with all other artists in different eras and geographical regions. The high prices being paid today for even minor works by the Impressionists and Post-Impressionists have been assisted by the documentary apparatus established in these years.

The retrospectives rarely created an artist's reputation—these credentials were generally long established, at least in theory, by an often limited circle of patrons and critics (as well as by the speculative market). Rather, they confirmed those reputations on a heretofore unimagined public scale—introducing artists to audiences very often unacquainted with much of the artist's work. While it might be difficult to measure with any precision the impact of the retrospectives held by the Salon d'Automne and the Indépendants in the first decade of this century, there is surely an important interrelationship between the extraordinary burst of creativity in modernist art and the revival of artists who for over a decade had been submerged in the marketplace. Thus we have the spectacle, not only of van Gogh and Seurat directly inspiring younger artists, but also Manet and Ingres, who, as equal beneficiaries of these post-1900 revivals, played as much a role in the development of a Picasso as did the Post-Impressionists.

After 1900 the retrospective was widely and self-consciously employed as a weapon to redress the exclusions of the past, to rewrite history, to construct a canonical history of modernist artists as a sequence of great individuals in the evolution of modern art. In the process, retrospectives con-

111

structed their own genealogy, a tradition of vindicated masters, stretching back to Courbet's self-arranged retrospective at the Exposition Universelle of 1855. In the writing of history the retrospectives announced a fundamentally elitist view of the development of modern art, the history of great male artists that lives on today. Externally the retrospectives insisted on an evolutionary model of modernism as a succession of great individuals. The discourse of the retrospectives was in superlatives—could it be otherwise? —inevitably raising the artist from the ranks of realism or Impressionism or symbolism to transcendent master. Except for the authentication of works of art, the retrospectives were by nature uncritical, concerned only with laying out a biography of genius, punctuated by master works. In the process, retrospectives served, and continue to serve, to destroy the actual historicity of an artist's career. Works of art are treated in retrospectives in relation to each other rather than externally to other art, to the cultural, social, and political issues that helped to form the artist's horizon of beliefs.

The retrospectives operated on the principle of exclusion rather than inclusion, focusing attention only on the work of art as an isolated entity within the personal development of the artist. They developed an evolutionary, biographical model of the artist, in which significant episodes in the early career or life of the artist bore some significant relation to the mature work. At best, this personal passage from early to mature to late could be argued to parallel a larger cultural passage, a succession of styles, say, from realism, to Impressionism, to a kind of Post-Impressionism that the career of an artist such as Monet might be said to entail. Internally the value of an artist's work could be measured by the internal progress of the master toward originality, while externally that same value could be measured against the development of modernism. In this way, the retrospectives historicized, but decontextualized, an artist's career; they created an oeuvre rather than a succession of single pictures or sculptures. They encouraged the construction of paradigmatic early, middle, and late "chapters" in an artist's life. Within this sensibility one also sees the fascination among fin-de-siècle art historians for the late work of artists.[10] An artist's work ceased simply to be a succession of Rembrandts, but became an early, middle, or late Rembrandt, often with commercial values attached.

Durand-Ruel, then, was being somewhat disingenuous when he called such shows "prejudicial to sales." For no one understood better than Durand-Ruel that the retrospective could be used decisively to develop the taste for a particular kind of art, that retrospectives could form the basis for establishing an alternative canon of artists to that offered by the Academy and the Salon. Through their essentially historicizing character, the retro-

spectives challenged the institutional hegemony of the Salon medal win-
ners. The retrospectives thus reaped the rewards of more than a half-
century of speculation at the Hôtel Drouot. Although a retrospective could
never guarantee the absolute value of an artist's work at auction, they
contributed substantially to freeing the dependency of the market value of a
particular artist on the fluctuations of current auction prices. They estab-
lished a signpost (even if inevitably relative) of an artist's value. For the basic
assumption underlying all retrospectives from those staged at the Exposi-
tion Universelle of 1855 onward was that only "great" artists could and
would be so honored.

The rapid rise in the use of the one-man show was such that already by the
first decade of this century artists increasingly came to assume that this kind
of exhibition was not merely an opportunity to "publish" their work, but
was a significant signpost of their market status, and, therefore, increasingly
their due. As the institution developed the role of public consensus for
retrospectives was abrogated, first by dealers, then by artists's societies, in
the name of artists for whom heretofore no public consensus had existed.

The Forging of the Ideological Retrospective

The retrospective was not inherently promotional of modernist art and
values—probably the majority of retrospectives before 1900 (and in France,
many of them afterwards) promoted individuals who one now calls *pompier*
or at best *juste milieu* artists. By themselves the retrospectives meant noth-
ing, but when used to legitimize and to historicize modernist artists they
assumed an unrivalled place in the historical and commercial construction
of modernism.

The retrospective as an institution seems to have had its origins in a series
of ad hoc innovations, without the implications of such a practice being
fully grasped by the retrospectives' organizers until much later. Retrospec-
tives grew out of two distinct exhibition practices: the habit of dealers to
show collections of an artist's work, most often the artist's most recent
work, and the custom of holding exhibitions—usually officially sponsored
—that followed on an artist's death and commemoratively surveyed the
artist's entire oeuvre. On occasion, as in the Courbet retrospectives of 1855
and 1867 and the Manet retrospectives of 1867 and 1876, artists mounted
their own exhibitions. More commonly artists (like their dealers) promoted
individual paintings, sending them on tour, most notably as Géricault did
with his *Raft of Medusa* in England in 1820 and Manet his *Execution of*

Maximilien in America at the end of the 1860s. Or exhibitions were held under state sponsorship to show works of art made on public, or more rarely, private commissions. Paul Baudry, for example, was given a show at the École des Beaux-Arts in 1874 of his decorations for the new Opéra. And in 1883 the state gave the rooms of the Orangerie in the Tuileries for an exhibition of Baudry's mural decorations commissioned by the American industrialist William H. Vanderbilt.

The Courbet and the Manet self-arranged exhibitions, in fact, were more unique than is often allowed, because of the wide-spread reservations held by artists, dealers, and critics alike that shows of individual, living artists, regardless of whether they were merely collections or "retrospectives," lacked propriety, revealing the unseemly appearance of self-promotion. For example, when in 1862 the dealer Ennemond Blanc offered Millet a large-scale, one-man exhibition at Martinet's gallery, Alfred Sensier dissuaded the artist from embarking on the project. He recommended that Millet exhibit instead small collections of paintings, etc., which could be frequently changed throughout the cycle of the exhibition season.[11] Intimacy and interest, Sensier obviously felt, generated by freshly displayed work, would be commercially more viable than a large historical overview of the artist's production. (Remarkably, Millet was not given a state retrospective until twelve years after his death in 1875.[12] By that time Millet had already been established as one of France's greatest painters through the enormous prices his work garnered in the marketplace.) On the other hand, it was a common practice for artists to show their work in their own studios—Manet's second retrospective in 1876 was such a showing, remarkable mostly for the number of visitors and the nature of the critical response it generated.[13]

One might have expected the retrospective to be forged in the commercial galleries as an adjunct to the "dealer-critic" system. Instead, it was only indirectly tied to the dealers, mediated by the public auctions over which they presided as experts. In fact, the retrospective only matured as an institution when it acquired the official gloss of the state. When elevated to the halls of the École des Beaux-Arts, retrospectives acquired the semi-official, semi-commercial capacity of the commemorative show. Only the memorializing of artists such as Delacroix, Rousseau, and Daumier, who remained outside the pale of officially sanctioned art, would require the services of a private gallery. Conversely, however, living artists could expect retrospective-size showings of their work only in commercial galleries until the end of the 1880s. These were surprisingly rare and "retrospective"

only insofar as they might display a large body of the artist's work, but never with the intention of providing a full overview.

In the absence of commercial willingness to undertake one-man exhibitions, Courbet and Manet's retrospectives are of interest precisely because of their public character. As privately arranged and financed pavilions put up in conjunction with official art exhibitions, their shows operated institutionally more as extensions of the display of an artist's work in his studio than as programmatic, historical surveys. Surprisingly, Courbet's first retrospective was the most programmatic, and hence, the most exceptional of artist-arranged exhibitions until the end of the century. Held on the pretext that two of his enormous paintings, *The Burial at Ornans* and *The Artist's Studio*, had been rejected by the Exposition's jury (they accepted eleven others), Courbet decided to show, in addition to the works on official display, a collection of paintings that spanned the prior seven years of the artist's life.[14] Not coincidentally, this span encompassed the 1848 Revolution, Napoleon III's coup d'état, and the establishment of the Second Empire. The exhibition thus mirrored both the artist's career and the immediate political history of France—an intention that already in fact had been allegorized in *The Artist's Studio*. The unprecedented scale on which Courbet showed his work—in a circus-like pavilion across from the Exposition Universelle—took its "retrospective" character as much from politics as from the desire to lay out a personal artistic evolution. Yet in the process Courbet asserted the value of a career of production over individual paintings, and thereby set an important precedent for retrospectives that would follow.

Courbet was self-conscious about using retrospectives to establish his uniqueness, his difference, from the typical exhibitors at the Salon. In a letter to his patron, Alfred Bruyas, Courbet gave a highly colored account of an interview with the *superintendant* of the Fine Arts Administration, the Comte Nieuwerkerke, regarding a possible special commission for a painting for the Exposition Universelle. Courbet reported that he told Nieuwerkerke that

[I] asked one thing from him, that he leave art free in his Exposition and not maintain an army of 3,000 artists with a budget of 300,000 francs against me. I continued by telling him that I was the sole judge of my painting, that I was not only a painter but also a man, that I painted not to make art for art's sake but to gain my intellectual freedom, and that I had succeeded through studying tradition in breaking away from it, that I alone

of all contemporary French artists had the power to render and translate in
an original fashion both my personality and my society.[15]

This discourse on originality named as the enemy of art not only the
government of Napoleon III but also that proletarian army of 3,000 artists.
Courbet made no claim, as other, later artists would, to a specific genealogy
of great masters as his artistic forebearers. Still, the elitist claims for his
uniqueness, whatever might have been his current "republican" politics,
were unparalleled in the nineteenth century.[16] And yet the radical pretense
of Courbet's exhibition worked to mask the issue of self-promotion. De-
spite the pavilion's obvious display of self-interest, one critic wrote that
Courbet's "works would certainly have attracted a lot of attention at the
Universal Exposition but he ought to be consoled for submitting in his turn
to the fate which, not so very long ago, was that of Eugène Delacroix, of
Decamps, of Théodore Rousseau, of Diaz and of other great painters unani-
mously celebrated today."[17] In this way, Courbet was admitted by some into
the category of the "genius of the future."

Courbet, of course, neither invented the discourse on originality nor the
institution of the retrospective to celebrate one's historical uniqueness. But
the lesson of both the state's commemorative exhibitions and Courbet's
private pavilion was that the retrospective could be a powerful tool in the
historical legitimization of previously disenfranchised art, and that the
myth of the neglected genius, whether real or invented, could serve any
artist. I have already quoted Duret's defense of the Impressionists in 1878
on the basis of their commercial desirability versus their popular neglect
and his translation of the group model into a celebration of the transcen-
dent artist recognizable only to the *amateur*.[18] The Duret example points to
another central feature of the early retrospective. Most often they were
used as posthumous, memorial exhibitions, and, consequently, as in the case
of the Manet retrospective at the École, were closely tied to the auction
house. They usually preceded the sale of the artist's private collection for the
benefit of the heirs. Consequently, most nineteenth-century retrospectives
—at least before the 1880s—had an altruistic character. That altruism was
more than just the beneficial function of the (usually) subsequent auction,
but also arose in the face of a public accustomed to appreciating and buying
recent art, not works dating from ten, twenty, thirty years before. Older art
was still insufficiently seasoned to qualify as old master work. And for an
audience weaned on the sensations of the Salon, the work lacked the allure
of the new.

Retrospectives after Courbet's were rarely explicitly conceived as ideo-

logical platforms (except when arranged by the artists themselves), and yet, from the moment that Courbet's retrospective came to be widely viewed as an implicit rejection of the policies of Napoleon III, they acquired an ideological cast. This cloak of politics was precisely what prevented Courbet's self-arranged enterprise from appearing to be a commercial gambit by the artist. By comparison, the state-arranged retrospectives in 1855 that Courbet rejected were meant to signify tolerance—they included artists outside the "classicist" tradition of Ingres (e.g., Delacroix, and the less well known Alexandre-Gabriel Decamps and Horace Vernet)—and to be "democratic," to make only a claim about the general quality of French art and civilization through the celebration of individual masters rather than an école that might represent special interests, as, for example, the academic tradition.[19] These retrospectives consequently could be received as eclectic and apolitical, since the Exposition aimed to smooth over the traditional rivalries of academicism and Romanticism. Or rather, they were ideological insofar as they were intended to demonstrate the state's liberalism manifested in its arts policies. In 1855 it was easier for the state to group Delacroix with Ingres than to speak to the divisions between "academicians" and "independents"; their collective exhibitions and those given to Decamps, etc. exemplified "la grande peinture" as a theoretical totality.

Napoleon III's ambition for the 1855 Exposition to celebrate the greatest French artists was virtually abandoned in subsequent Expositions until 1889. For a variety of reasons, political, economic, and aesthetic, the Exposition of 1867 gave no true retrospectives.[20] On that occasion, critics of the Exposition heralded the imminent demise of history painting. Charles Blanc, as much a spokesperson for the state as any critic, wrote that "one sees it clearly today: twelve years have sufficed for us to become disinterested in the *grande peinture*."[21] The absence of such painting was the obverse side of the often-stated desire among critics and public officials alike to find a movement, a style, a personality that could represent a viable successor to the French tradition. Thus, one of the most remarkable features of the sanctioning process of subsequent retrospectives was that it was lent very often to artists who did not necessarily belong to the Academy and the Institut, but who were generally thought to be outsiders in the French art world. Although the retrospective was not invented in order to celebrate the neglected genius, in France this particular alliance achieved tremendous force, if only because of the oppositional parties created by the stringent and self-interested Salon juries.

A remarkable string of memorial retrospectives caused by the coincidental deaths of many notable members of the French art world gave the

retrospective continued vitality. The following list (possibly incomplete) of major commemorative exhibitions between the 1855 Exposition and the Manet retrospective at the École National des Beaux-Arts in 1883—the last significant modernist painter to be honored at the École—is instructive of the development of the retrospective.

Palais des Beaux-Arts, *Exposition des Oeuvres Paul Delaroche*, 1857.[22]

26 boulevard des Italiens, *Oeuvres d'Ary Scheffer exposées au profit de la caisse de secours de l'association des artistes peintres, sculpteurs, architectes et dessinateurs*, 1859.[23]

Galerie Martinet, 26 boulevard des Italiens, *Ingres*, 1861.[24]

Société Nationale des Beaux-Arts, 26 boulevard des Italiens, *Exposition des oeuvres d'Eugène Delacroix*, 1864.[25]

École Impériale des Beaux-Arts, *Exposition des oeuvres d'Hippolyte Flandrin*, 1865.[26]

École Impériale des Beaux-Arts, *Exposition de tableaux, études peintres, dessins et croquis de J.-A.-D. Ingres*, 1867.[27]

Cercle artistique de la rue de Choiseul, *Exposition des Etudes Peintes de Théodore Rousseau*, 1867.[28]

École Impériale des Beaux-Arts, *Paul Huet, notice biographique et critique*, 1869.

École Nationale des Beaux-Arts, *Tableaux et dessins d'Edouard Bertin*, 1872.

École Nationale des Beaux-Arts, *Exposition des Oeuvres de Regnault*, 1872.[29]

École Nationale des Beaux-Arts, *Exposition des oeuvres de Prud'hon au profit de sa fille*, 1874.

École Nationale des Beaux-Arts, *Tableaux, études et dessins de Chintreuil*, 1874.

École Nationale des Beaux-Arts, *Oeuvres de Antoine-Louis Barye*, 1875.[30]

École Nationale des Beaux-Arts, *Exposition de Oeuvres de Corot*, 1875.[31]

École Nationale des Beaux-Arts, *Exposition des Oeuvres de Pils*, 1876.

École Nationale des Beaux-Arts, *Exposition des Oeuvres de Eugène Fromentin*, 1877.

École Nationale des Beaux-Arts, *Exposition des Oeuvres de N. Diaz de la Peña*, 1877.[32]

École Nationale des Beaux-Arts, *Exposition des Oeuvres de Léon Belly*, 1878.

Galerie Durand-Ruel, *Exposition de Honoré Daumier*, 1878.[33]

Palais de l'Industrie, *Thomas Couture*, 1880.[34]

École Nationale des Beaux-Arts, *Exposition des Oeuvres de Gustave Courbet*, 1882.

École Nationale des Beaux-Arts, *Exposition des Oeuvres de Manet*, 1884.

(The Martinet 1861 Ingres show was probably quite small, consisting largely of drawings. The artist, of course, was still alive. The year of Millet's death, 1875, there was a small show of the artist's drawings from a private collection, the proceeds of the exhibition going to the artist's family.[35])

Historical coincidence played a remarkable role in lending importance to the retrospective as an institution. As it happened, many of the leading protagonists of the Academy, the men who dominated the Salon juries, were often long-lived; there was little turnover among the leading academicians from the 1860s to the end of the century and beyond. Conversely, every year saw the death of one more member of the École de 1830, as well as the premature deaths of Courbet and Manet. By the time the first of the prominent academicians began to die off, the crowds of French and American collectors involved in the market for Barbizon and Impressionist painting rendered the École des Beaux-Arts retrospectives relatively insignificant affairs—much publicized as official exhibitions continued to be, but bearing much less influence on the market fortunes of the memorialized artists. As retrospective succeeded retrospective, the artists who were so enshrined had been or could be portrayed as "refusés." This sequence of retrospectives constituted an institutionalization of an alternative history of nineteenth-century French art. In the 1890s, when the histories of modern French art began to be written, it was these artists who progressively came to the fore at the expense both of the Academy and the contemporary luminaries of the Salon. It was mostly these artists who were represented in that widely influential and last retrospective of the century in Paris in 1900, the Exposition Centennale.

The historical force of the retrospective exhibition was enhanced by the many biographical essays written by the leading critics of the day, and routinely published alongside the exhibition, essays that often led to the production of catalogue raisonnés of the artists. Philippe Burty introduced the auction catalogue for Delacroix (but not for the retrospective), as well as the Rousseau and Corot catalogues. Louis Gonse, later editor of the *Gazette des beaux-arts*, wrote the Fromentin catalogue, Jules Claretie the Diaz, Champfleury the Daumier, and so on. Despite the variety of authors the biographical notes have much the same eulogistic tone that functioned both as the usually first attempt at the biography of the artist and as an apology for the work, thereby weaving historical significance with criticism. The catalogues contributed to the developing definition of the history of nineteenth-century French art as the history of great male artists in a logical historical evolution. On occasion the exhibition (and auction) were accompanied by book-length biographies; this became increasingly the

fashion in the 1870s. Albert de La Fizelière brought out *La Vie et l'oeuvre de Chintreuil* in the year of the artist's death.[36] Although for political reasons Courbet was not given a state retrospective until 1877, five years after his death, in 1878 two books appeared on the artist, by the Belgian novelist and critic Camille Lemonnier and by the Comte d'Ideville, and a book-length article by Paul Mantz in the *Gazette des beaux-arts*.[37]

Even as memorial retrospectives became commonplace at the École and in the showrooms of dealers, at the Exposition Universelle in 1878 it was widely claimed that there were no masters to be celebrated by retrospectives. Of the many distinguished artists memorialized at the École in the 1870s, none found a significant place at the 1878 Exposition. Only ten Corots, nine Daubignys, and three Isabeys represented the École de 1830. There were no Delacroixs, Millets, Rousseaus, Decamps, Bayres, Troyons, etc. Instead of a show of nineteenth-century French art, or even of a decentennial, the Exposition offered an historical exhibition of pre-modern French art and artifacts.

Ironically, this exhibition put the term *rétrospective* into common parlance. The retrospective consisted primarily of objets d'art, and of these primarily medieval and Renaissance works belonging to French collectors. Such an historical exhibition in France had first been attempted in 1867, but it was only in 1878 that it was offered as a replacement for "retrospectives" of contemporary artists. Moreover, the Exposition set the fashion in the following decades for numerous European municipalities to hold "rétrospectives," devoted primarily—but often not exclusively—to the "ancient" art of their geographical region. In 1880 alone there were no less than four such exhibitions held in Turin, Düsseldorf, Brussels, and Le Mans.[38] The works displayed often were a hodgepodge, but some, most notably Düsseldorf's exhibition, attempted to arrange a precise, historically defined overview of cultural artifacts in their region, organizing the exhibition into four parts: the Middle Ages, Renaissance, Baroque, and rococo.[39] In Brussels, perhaps unique for the era, the "rétrospective" was best fulfilled through a painting section devoted to an overview of Belgian art from neoclassicism to the present.[40]

The fashion for "rétrospectives" also reflected the rising tide of historical consciousness that characterizes the last half of the century. In the construction of the history of art, and more particularly, the history of painting, Britain led the way. Beginning with the great Manchester exhibition of 1857, the British art establishment, led by such figures as Henry Cole and Charles Eastlake, grew increasingly interested in holding special exhibitions of Old Master paintings, particularly those belonging to private collectors.[41] By contrast, the French, like the rest of Europe, hardly followed

suit until the 1880s. Beginning in 1867, for example, the Royal Academy sponsored a regular series of winter "loan" exhibitions that generally combined Old Master paintings from private collections with works by recently deceased British artists. As Louis Gonse remarked about one such exhibition in 1882, the Royal Academy was able to draw upon an unrivalled plenitude of first-rate painting in private hands in Britain.[42] This exhibition, which was typical of these shows, contained 275 works, and consisted largely of eighteenth- and early nineteenth-century English painting, and was supplemented primarily by seventeenth-century Dutch, Flemish, Spanish, and French pictures.

The continental "rétrospectives" that followed the Exposition Universelle of 1878, if not generally blessed with high-quality paintings, brought many other kinds of historical artifacts to public view. It is curious, then, that in 1878 the Exposition officials were content to hold their "rétrospective" of art belonging to the ancien régime, when they could have had at their disposal some remarkable French collections of nineteenth-century French painting.[43] Durand-Ruel emphatically demonstrated this point when he arranged his private exhibition of the École de 1830, which, tellingly, was titled *Exposition rétrospective de tableaux et dessins de maîtres modernes*.[44] Drawing on the best from many French collections, Durand-Ruel exhibited a total of 380 paintings, of which could be counted 88 Corots, 61 Millets, 33 Rousseaus, 32 Delacroixs, and numerous other paintings by such artists as Fromentin, who died the year before (nine pictures), and a very important collection of Courbets (thirty paintings). This remarkable overview of recent French painting inspired, according to Durand-Ruel, Antonin Proust's idea to stage a comparable retrospective in 1889 to celebrate the centennial of the French Revolution.[45] Durand-Ruel could not help but also observe that his show far surpassed the official exhibition in 1889 "en importance et en beauté."[46] Inexplicably—an historical show containing truly important works from the immediate and more distant past ought to prove a critical and popular success—the show received little press attention and few visitors. Still, Durand-Ruel believed that the show set the stage for the general escalation in the prices for the École de 1830.

If one artist emerged out of 1878 with a new historical reputation it was Courbet—rehabilitated after the disastrous events of the Commune and the Vendôme column affair.[47] The first act of this process was the depoliticization of the artist. One biographer, Henri d'Ideville, wrote that year

if we have a deep admiration for Courbet the painter . . . (if) we place (him) in the ranks of the greatest artists of our century, we must admit with no less sincerity that Courbet, as a philosopher, as a moralist, and as a

politician, seems to have been a simple idiot. . . . Politics has nothing to do with art.[48]

This was not a novel assertion. Already in the 1870s the growing appreciation of Courbet's landscape paintings as the true quality work of the artist asserted his style over the radical content of his figure painting.[49] Stripping politics from art as a necessary process in identifying genius was a widely employed tactic, applied not only to vindicate Courbet, but the whole Romantic school and, subsequently, Manet and the Impressionists.

The Durand-Ruel show certainly played an important step in the elevation of Courbet to the canon of great French artists; but it was also of such quality and organization as to define clearly and for the first time many younger members of the developing canon of nineteenth-century French painting. For what Durand-Ruel announced historically in his exhibition of 1878 was confirmed by the marketplace in the 1880s. Such reviews as Eugène Montrosier's in *L'Art*, a magazine hostile to Impressionism, indicates how volatile the exhibition was and the status that apparently reaccrued to the dealer because of it.

Without the courageous initiative of M. Durand-Ruel, without the disinterestedness of the *amateurs*, our foreign audiences would suppose that nineteenth century France had lost respect for the great painters and admiration for great art. How is it that this important collection does not have the place of honor at the Champs de Mars?[50]

In the face of the neglect by the organizers of the Exposition Universelle, Montrosier launched into a martyrology:

you have marched intrepidly towards the future, elbowing the crowd, jumping the abysses, climbing the mountains . . . Oh martyrs! you are exemplar and you will be the salvation.[51]

Even without official sanctioning, the enthusiasm for the École de 1830 had finally become international. These artists gave further currency to the standard line of contemporary neglect and the great artist's eventual vindication by posterity. The books that glorified Delacroix and the rest of the École de 1830 that poured out in the late seventies and early eighties are too numerous to cite here. But among them were such notable examples in the Delacroix literature as Alfred Robaut's monumental, innovative *Oeuvre complète* (1885), and two editions of Delacroix's letters published in 1877 and 1878, the last edited by Philippe Burty.[52] The letters themselves presented a formidable discourse against the values of the leaders of the Salon.

These works were joined with other texts celebrating the École de 1830 such as Burty's *Maîtres et petit maîtres* (1877), Ernest Chesneau's *Peintres et statuaires Romantiques* (1880), and Théophile Silvestre's newly expanded edition of his *Les Artistes Français* (1878).[53] Together with Durand-Ruel's exhibition, this developing discourse marked the ideological and historical gulf between this art and the practices of the contemporary Salon.

The move by French commercial galleries in the early 1880s to hold one-man, often retrospective, exhibitions for living artists may well have been inspired by the example offered by London dealers and exhibition societies. In the 1870s and early 1880s Whistler made a considerable reputation for himself largely through his privately arranged exhibitions of his art (although these were essentially one-man shows, not retrospectives). Whistler's exhibitions in turn may have encouraged other British artists to explore the utility of the institution. No shows were more important than those of George Frederick Watts', "England's Michelangelo." In 1877 at the newly opened Grosvenor Gallery, Watts was given a room of his own.[54] Three years later, in 1880, the Manchester industrialist and one of Watts' most important patrons, Charles Rickards, decided to hold an exhibition at the Manchester Institution of some fifty-six Watts works from his own collection.[55] The exhibition was so well received that Sir Coutts Lindsay, the Grosvenor's proprietor, then decided to give Watts, in what was characterized as a "bold, not to say audacious experiment," a one-man show. Whistler, of course, was also one of Sir Coutts' mainstays—and his various attempts at one-man exhibitions were hardly unknown to him. But the Watts exhibition was distinct from the Whistler shows, for it was to be a true retrospective that covered forty-odd years of the painter's work through more than two hundred works. *The Times* called the show unique, for its exclusivity and for the fact that it showed an artist's work in his own lifetime and

> rendered as complete as possible with his assistance. For once, owing to private enterprise, the life-work of a great artist has been brought together before the light has faded from his eyes and the speech from his lips, and writers and picture-lovers have an opportunity of paying that homage to the living which is but too generally reserved for the dead.[56]

The exhibition was very well received and was rewarded with international press attention. Subsequently, a rich young American, Mary Gertrude Mead, inspired by the seven paintings by Watts' exhibited at Georges Petit's Société internationale in 1883, convinced the artist to allow her to bring a

collection of more than fifty paintings to New York, where it was shown to over a half a million visitors between October 1884 and September 1885.[57] In the meantime, the Grosvenor staged another retrospective for Lawrence Alma-Tadema. The exhibition contained 287 works surveying his entire career. Although the reviews were more mixed than had been Watts', it is generally agreed that the exhibition "permanently" fixed the artist's reputation as one of the two or three great painters in Britain.[58] These retrospectives came at the height of the Grosvenor's reputation, both as a center for art and for fashionable London. Even though the Grosvenor subsequently offered no further retrospectives for living artists—in imitation of the winter exhibitions of the Royal Academy, but with far greater exclusivity, the Grosvenor gave winter retrospectives to Reynolds in 1884, to Gainsborough in 1885, and to van Dyck in 1887—it had demonstrated the utility of these exhibitions. Both Watts and Alma-Tadema, already stars in the British art world, were elevated to the rank of geniuses in the wake of their retrospectives.

The French, whose awareness of British practices were never higher than in the early 1880s, quickly absorbed the lessons offered by the Grosvenor, both in Petit's Société internationale which duplicated the luxuriousness of the Grosvenor's interiors, and by the retrospective, which Durand-Ruel, Petit, and the newly established firm of Bernheim Jeune all experimented with in the 1880s. The recently established Union centrale des Arts décoratifs, which had close official connections, led the way in 1883 with its Baudry exhibition of the Vanderbilt murals and by a showing, albeit not precisely retrospective, of decorative work by James Tissot.[59] The Galerie Sedelmeyer also gave Tissot a much-publicized exhibition in 1885 of his paintings forming the series "La Femme à Paris," which included a widely diverse collection of watercolors, engravings, and enamels cloisonné.[60] Jean-François Raffaëlli, who had shown with the Impressionists, had a one-man retrospective (self- arranged?) of almost 150 paintings in March-April 1884.[61] That summer Petit gave Ernest Meissonier a retrospective to celebrate fifty years of the artist's work.[62] In 1887 Durand-Ruel held a different kind of retrospective for Puvis de Chavannes, a show of the many studies for or "reductions" after his public murals and photographs of the various projects.[63]

If the practice of giving large shows or truly retrospective exhibitions (as in the case of Meissonier) gathered force in the mid-1880s in the art market, it also must be put in the context of the continued insistence on the part of the French government to ensure some form of quality control over the Salon system, to discover among its huge mass of exhibitors the most note-

worthy artists and to highlight them. Two different solutions were pro-
posed. One, tried in 1880, to much criticism, was the practice of providing a
significant number of rooms to a small class of artists who had previously
been awarded the status of *hors concours* (that is, artists who could only
compete for the grand medal of honor or cross), which allowed them to
hang their work on a single line and ordered alphabetically by artist.[64] This
reform, installed by the new minister of fine arts, Henri Edmond Turquet,
proved extraordinarily controversial—Zola devoted much of his Salon re-
view of that year to a critique of this effort. The second experiment, which
also proved abortive, was to establish a special triennial exhibition of the
best art shown at the Salon in the past three years. In the reforms announced
in 1878 that eventually ceded complete control over the Salon to a newly
formed society of artists, the state planned to hold its first triennial in 1881,
which for a variety of reasons never took place. The project was revived in
1882, emphatically recast as an "exposition nationale," even though foreign
artists such as Hans Makart and Lawrence Alma-Tadema figured promi-
nently in the exhibition, and opened in September 1883 (timed well away
from the annual Salon). Intended to celebrate the best work of the previous
five years in a relatively exclusive setting of 800 paintings and 300 sculp-
tures, the exhibition proved not exclusive enough. The Exposition Nation-
ale, however, anticipated the controversy over the Exposition Universelle
of 1889, which again represented an effort by the state to exhibit alongside
Salon regulars a special exhibition celebrating the best of French (and other
European art) while granting the prize-winning artists *exempts* status at
subsequent Salons. The drive to produce elite exhibitions within the Salon
system repeatedly failed, and with the exception of the Centennial exhibi-
tions at the Expositions Universelle of 1889 and 1900, this role passed
entirely to the commercial galleries.

THE IMPRESSIONIST CADRE VERSUS THE IMPRESSIONIST HERO

The one-man shows given to the leading Impressionists beginning circa
1880, followed eventually by true retrospectives, marked the fundamental
crack in the Impressionists' "rhetoric of independence." By the end of the
seventies the internal conflicts that divided the Impressionists increasingly
concerned the question of the defense of the "purity" of the movement, who
could belong for what reasons. Since there was never a consensus over
membership or the criteria for membership, each exhibition had to be
hammered together. Renoir's defection to the Salon in 1879 followed by

Monet's in 1880 was taken as an admission that the independent artist exhibition did not work as a vehicle for getting oneself published (though some like Burty would criticize Monet for thinking that the Salon was any better a place to make one's reputation).[65] Monet explained to Duret that by returning to the Salon it would help him do business "especially with Petit, once I have forced the door of the Salon. But it is not my taste to do this. It is really unfortunate that the press and the public have taken so little seriously our small exhibitions, preferring instead the official bazaar."[66] Even before Petit bought his first Monet in 1880 the Impressionists' group identity was progressively undermined by the growing interest among dealers in some of its members.

In June 1879, the publisher Georges Charpentier gave a small one-man show to Renoir in the rooms adjacent to those of his magazine *La Vie moderne*, at 7 boulevard des Italiens. Renoir had become close to the family and had painted the widely praised portrait of Mme. Charpentier and her children now in the Metropolitan Museum. The following April Charpentier organized a small exhibition of recent works by Manet. Then in June he showed a collection of Monets, composed of work primarily from the previous two years.[67] The interview given by Monet to Émile Taboureaux for *La Vie moderne* implied that his exhibition was held to counter the unfavorable press that the earlier Impressionist exhibitions aroused.[68] The magazine also reported that the exhibition was a great success and that most of the paintings had sold on the first day.[69] The press attention that greeted these exhibitions was, as usual, marginal compared to the reviews of the Salons or even of the Impressionist exhibition held in April 1880. Yet, despite financial difficulties encountered by Monet due to the collapse of the stock market in the early 1880s and Durand-Ruel's subsequent shaky finances, this exhibition marked an important passage in the financial security of the artist, as well as firmly establishing his reputation vis-à-vis the group character of Impressionism.

Charpentier did not pursue this project—the "gallery" gave only one more one-man show and a single retrospective, to Eva Gonzalès, who was memorialized in the wake of her sudden death in 1885.[70] (Charpentier remained, of course, an important publisher of books that defended modernist art, such as Duret's *Critique d'Avant-Garde*.) The Charpentier exhibitions indicated a tentative change in the exhibition climate for artists who had been associated with the Impressionist shows. The Impressionist exhibitions of 1880 and 1881 were dominated by Degas and those artists he brought into the Impressionist circle, including Forain, Levert, Raffaëlli, Rouart, Tillot, Vidal, and Zandomeneghi. Although other "canonical" Im-

pressionists exhibited at either one or both of these exhibitions—Pissarro, Caillebotte, Cassatt, and Morisot—the exhibitions sharply contrasted from the boldly "ideological" and aesthetically "coherent" exhibitions of the 1870s, and were largely received by the press as disorganized and diffuse. Some even argued for the "death" of Impressionism.[71] By contrast, the reputation of individual Impressionists, especially Monet and Renoir, their public visibility, and economic viability, was greater than it had ever been. And they had begun to attract the interest of other prominent dealers besides Durand-Ruel.

As market interests grew, Durand-Ruel countered with increasing investments in the Impressionists. With the financial backing of Jules Feder, director of the Union Générale bank, Durand-Ruel was able to make significant purchases of the Impressionists (along with the École de Barbizon). In 1881 he signed Monet to a contract for 22 small paintings at 500 francs a piece. He also acquired some twenty-odd works by Sisley. Although in 1882 the Union Générale failed and Durand-Ruel's financial resources were seriously jeopardized, he continued to invest heavily in the Impressionists. Motivated by the need to sell as well as to acquire, Durand-Ruel for the first time took an active role in the organization of an Impressionist group exhibition, virtually forcing the participation of Monet and Renoir, who could not prevent the dealer from exhibiting works from his considerable stock.[72] The split in the Impressionist ranks, engendered largely by Degas' earlier invitations which had widened the Impressionists' ranks, resulted in the absence of Degas and Cassatt. Significantly, this dealer exhibition most resembled the Impressionist exhibitions of the 1870s. Monet and Renoir were both adamant on the exclusive character of the show, hoping only to have the core artists represented. Renoir also wished to disassociate himself from the taint of radicalism he felt was represented by the presence of Pissarro and Gauguin. If the exhibition was less than absolutely exclusive, it nonetheless moved in the direction of a handful of canonical masters. This sense was reinforced the following year, when, in lieu of an Impressionist group exhibition, Durand-Ruel gave one-man shows to Boudin, Monet, Renoir, Pissarro, and Sisley. Although perhaps inspired by the Charpentier exhibitions, these shows differed substantially by virtue of the fact that they represented a true retrospective of the artist's work, rather than a collection of recent paintings.

Monet's exhibition in March 1883 contained fifty-six paintings dating from the mid-1860s to his most recent work. The paintings were described as "well-spaced" and the general critical reaction was favorable. Pissarro originally thought Monet's show a great success.[73] Monet, however, de-

scribed the exhibition as a "flop," for he sold no paintings, and blamed Durand-Ruel, citing a lack of publicity (the show was not reviewed by a number of important publications) and bad hanging. Nonetheless, Monet garnered favorable reviews from a number of important sources, most notably from Alfred de Lostalot, published in the *Gazette des beaux-arts* (which reproduced two drawings by the artist after his paintings), as well from Burty in the *La République française*, Geffroy in *La Justice*, and Silvestre in *La Vie moderne*.[74] Absent, however, were reviews by the dominant critics of the era, such as Albert Wolff, whose judgments were widely taken to represent an important critical rite of passage toward official recognition.

Pissarro, in nervous anticipation of his own exhibition, came to the conclusion I began with: that a one-man show was a bad idea.[75] At about the same time, Pissarro cautioned his son to be discreet about mentioning the family's association with Durand-Ruel to an English dealer because "people are rather envious of him."[76] Pissarro's warning was a reaction to a nascent, competitive awareness of Durand-Ruel's shrewd business practices regarding both the Barbizon painters and the Impressionists—even during the bad times of the early 1880s (when Durand-Ruel was said to have been a million francs in debt). In retrospect, the artist was being unduly cautious. Durand-Ruel's aggressive activity on behalf of the Impressionists and the fact that their paintings were offered at high prices, despite Monet's pessimistic assessment of his own show, demonstrate a steady advance in prices, both from the dealer and at auction. Pissarro's paintings were then selling for the substantial price of 1,200 francs apiece.[77] Durand-Ruel also renewed his efforts to show the Impressionists abroad, holding exhibitions of their work in London and Berlin, both of which were widely reviewed. According to Pissarro, the Berlin exhibition was a "sensation." It in fact caused a scandal, especially when Adolf Menzel, the dean of Berlin artists, completely rejected the new painting. His disparaging remarks caused *Le Figaro*, a previously unsympathetic paper to the Impressionist cause, to come patriotically to their defense.[78]

The growing legitimacy of Impressionist painting coincided with the defection of Monet and Renoir to Petit's and their desire to separate themselves from the radical image fostered by the group Impressionist exhibitions. Durand-Ruel eventually wooed Monet at least partly back into his stable, so that the more serious defection was these artists' withdrawal from the Impressionist exhibitions. Their absence put fundamental stress on the internal coherence of the Impressionist exhibitions that steadily mounted during the eighties, so that by their "last" exhibition in 1886 the Impressionists found themselves defending their "independence" and group identity as much from the dealers as from the Salon.

Monet and Renoir had virtually become members of the *juste milieu* in their pursuit of society connections and wealthy clients (if not official honors). Monet, in particular, the beneficiary of a competition among Durand-Ruel, Boussod et Valadon (whose modern branch was then run by the perspicacious Théo van Gogh), and Petit, was able to dictate terms to his dealers as never before, and to climb through them up the professional ladder in the Parisian art world. Contrast their assertion of professional identity with the always radical Pissarro. In 1886 (at the height of Monet and Renoir's involvement with Petit), in response to an inquiry from Joseph Durand-Ruel to provide an explanation for his Neo-Impressionist paintings and to provide a brief biographical statement, Pissarro offered a schematic chronology of places he had lived and who he had studied with up to 1855. "Quant au reste de mon histoire de peintre elle se rattache au groupe impressionniste."[79] This is in contrast too to Monet's own sense of self-importance, and the desire by the artist to reconstruct his biography away from that of the Impressionists, notably manifested in an interview the artist gave in 1889 in *Gil Blas*.[80]

Although marketing Monet followed the already growing tendency for dealers to isolate artists as they marketed them abroad, the painter probably pushed his dealers farther than they had been willing to go. In 1888 Monet, through the agency of Renoir, proposed to Petit that a "group" exhibition of "impressionists" be held that would consist only of himself, Renoir, Rodin, and Whistler.[81] By this date, Rodin was already regarded as one of the great masters of sculpture, a member of the committee of the Salon des Artistes français, a member of the jury for the Exposition Universelle of 1889, and of the Belgian Les XX. Whistler, too, had been the president of the Society of British Artists, and though still controversial in some circles, was widely regarded as among the most important of contemporary British artists.[82] Monet's show was a demonstrable manifestation of the effort by the artist and Renoir to move into the elite circle represented by these established "moderns." Although the project was not realized—Renoir exhibited with other Impressionists at Durand-Ruel's in 1888 and Monet showed twice at Boussod et Valadon, one show subsequently going on to London to be shown by the Goupil (Boussod et Valadon) branch there—it led directly to another proposal, probably advanced by Monet, to hold a two-man retrospective, himself and Rodin, timed in conjunction with the Exposition Universelle, at Georges Petit's, where as he put it in a letter to Durand-Ruel, his work would be seen by the "foreign public."[83] Despite some rough periods in the organization of the exhibition, the show was mounted to great critical success.[84] Rodin showed 36 sculptures including the *Bourgeois de Calais*, exhibited for the first time in its completed state. Monet displayed

145 paintings representing work from 1864 to 1889. The exhibition cata-
logue contained essays by Octave Mirbeau on Monet and Gustave Geffroy
on Rodin.

In planning his exhibition Monet may well have recalled the precedents
set by Courbet and Manet. They, however, never realized Monet's success
at achieving the stamp of "official" approval, for the Monet-Rodin exhibi-
tion was widely treated as a virtual adjunct to the Exposition. Even if Rodin
tended to dominate the criticism (fitted to his already official status in
France), the rewards for both artists were immediate. For example, Théo
van Gogh was subsequently able to sell a Monet to an American collector
for 9,000 francs.[85] The American amateur artist and collector Lilla Cabot
Perry let it be known among her American friends that Monet's paintings
could be had for $500 a picture.[86] And the Belgian publisher, entrepreneur,
and business agent behind Les XX, Octave Maus, published a glowing
account of Monet in *L'Art moderne*.

> All Paris files in front of his landscapes, his marines, his figure paintings and
> the newspapers that never had anything but sarcasms and jokes at the
> expense of the inventor of 'impressionism' glorify him as one of the most
> illustrious of men. It could be that the day will come when one of his
> paintings, being placed on auction, someone will cry out «Vive la France!»
> if some Antonin Proust of the next generation saves it from the rapacity of
> the Yankees.[87]

The reference is to the Secrétan auction, which took place in Petit's gallery
just before the Monet-Rodin exhibition, at which Proust outbid the Ameri-
can dealer James Sutton for Millet's *Angelus*. Yet no such Proust was to be
found in France, when, throughout the 1890s, Impressionist paintings
streamed out of France through the agency of Durand-Ruel and many other
dealers into the hands of American collectors.

As Stephen Z. Levine notes in his study of Monet's critics, this exhibition
not only marked the end of the artist's struggle to establish his reputation,
but also represented the terminus of Monet's participation in group exhibi-
tions.[88] Henceforth, Monet only showed in one-man exhibitions, if at all,
and these shows remained normally outside the province of the typical
reviewer (who continued to cover only official and group exhibitions).[89] It
hardly mattered for Monet, since his buying audience increasingly were
Americans (joined later by the Germans and the Swiss) who, when they
came to Paris, made it a point of visiting the galleries of dealers such as
Durand-Ruel (who in the 1890s made the Baedeker guide book—including
instructions for how to visit the dealer's private collection). What was true
of Monet became generally true for the rest of the Impressionists.

Durand-Ruel certainly must have measured the effectiveness of the Monet-Rodin exhibit and henceforth chose, with few exceptions, to show the Impressionists in the format of the one-man exhibition. And as a rule they had a retrospective character. At the same time, the literature on the individual Impressionists increasingly became uncritically laudatory. In place of the random journalistic criticism of the past, as Levine observes, Monet's French critics would be henceforth primarily his friends. Although public resistance persisted in Paris through the next decade, Impressionism was only seriously contested abroad, and there confined really only to Germany.

THE IDEOLOGICAL RETROSPECTIVE

A flurry of one-man exhibitions, often with catalogues, preceded and immediately followed the Exposition Universelle of 1889. Boussod et Valadon gave numerous exhibitions to Monet, Pissarro, and others, while Durand-Ruel and Petit joined in. In the 1890s Durand-Ruel showed Monet in May 1891 (Haystacks), in March 1892 (Poplars), and in May 1895 (Rouen Cathedral). Petit also showed Monet in 1898. Pissarro and Renoir were given major retrospectives at Durand-Ruel's in 1892. In the wake of these commercially successful exhibitions there was a general dispersion of the institution as a norm in dealer practices. These one-man exhibitions are notable, too, for producing catalogues, which in turn were now frequently and sometimes elaborately illustrated.

With the exponential growth in group and one-man exhibitions, the gallery season that at the start of the 1890s began in December and ran through the end of May or June, expanded by the end of the decade to become virtually year-round (excluding August). The forum for these exhibitions remained the annual shows of specific societies, such as those of the Peintres-graveurs français, the Aquarellistes français, the Pastellistes français, and so on, and the still relatively infrequent one-man exhibitions of artists that occasioned lengthy reviews. And correspondingly, especially at the beginning of the 1890s, the two galleries to receive the most press attention were Georges Petit (allied with the former) and Durand-Ruel (with the latter). Although there were many other smaller one-man exhibitions given to artists now as famous as Jules Chéret or as obscure as Charles Jacque or Antonio de La Gandara—both shown by Durand-Ruel—there was a notable falling off in critical interest in their shows. In other words, the Impressionists, whose fame had been assured in the 1880s, were treated in the 1890s as central figures in the French tradition. Other contemporary

painters, even when supported by the most prestigious modern gallery in Paris, remained essentially nameless. (At the same time, the ambition to breech the threshold of Petit's or Durand-Ruel's led some artists to form ephemeral exhibition societies, often with such impossible names as the "Inquiets" who showed at Petit's in February 1893 or the group "L'Eclectique" who also showed at Petit's in March 1894.[90])

Tracing the development of the one-man show in the gallery system is more readily done than following its history in the course of group exhibitions. It never occurred to the Impressionists to hold a retrospective of one of their members or of an older artist, a Daubigny perhaps, someone they could claim as a forefather. In 1864 the Martinet-backed Société nationale des beaux-arts sponsored the Delacroix retrospective in lieu of an official retrospective for the artist. This was, however, an extraordinary step, not repeated by an independent artist society until after 1890. The first of these must have been the posthumous retrospective given in 1891 to Albert Dubois-Pillet by the society he helped to found and lead, the Indépendants. This collection contained 63 numbers, forming a section of the regular exhibition. In this, too, it was unique (imitating as it did the earlier retrospectives given at the Paris Expositions Universelle). The same year the Indépendants gave a small, but hardly retrospective-like posthumous showing of van Gogh (10 numbers, which was about the same as most exhibitors), which was nevertheless treated in the press as a special exhibition. The next year, in the wake of Seurat's death, retrospective-style shows (all comparatively small) were held at the gallery of *La Revue blanche*, at the Indépendants, and in Brussels at Les XX. Émile Bernard also arranged a retrospective held probably in April of 1892 of twelve paintings by van Gogh at the Galerie Le Barc de Boutteville. The retrospectives given these three leading modernist painters of the 1880s were each the product of their tragic deaths, rather than harbingers of common practices of galleries and independent artist societies. For the remainder of the 1890s the Indépendants took a back seat to the commercial galleries in the business of holding retrospectives.

On the other hand, special exhibitions became increasingly common in galleries sponsored either by periodicals or by small artist groups or a confederation of the two. In 1888 the magazine *La Revue indépendante* gave small exhibitions to Maximilien Luce (August 1886) and Dubois-Pillet (September-October 1886).[91] On occasion *La Revue blanche* staged artist exhibitions (like that of van Gogh). But perhaps the most influential of all these magazine-managed exhibition societies (if we disregard the preeminence of the Belgian La Libre Esthétique) was *La Plume*. The literary

journal styled itself an aesthetically independent magazine, offering space to a variety of competing literary styles as well as to diverse philosophical, political, and religious ideas. It devoted issues to such subjects as aristocratism, anarchism, and religious mysticism. Its art critics, led by Charles Saunier and the artist-critic Alphonse Germain, were sympathetic to the latest in contemporary art and reasonably informed about the most progressive art then being made in Paris. Beginning in 1892 the magazine ran a regular column highlighting individual artists (rarely, however, were these young artists the leaders among the "avant-garde"). It was a small step from here to founding an exhibition society, originally conceived of as exhibitions of "Salon de la Plume," but then given the umbrella title of the Salon des Cents, named for the roughly hundred artists, architects, etc. who were subscribers to and participants in its exhibitions.[92] The Salon des Cent was publicized as an "exposition permanente," with the intention of devoting their gallery space at 31 rue Bonaparte, to a constantly changing exhibition of its membership. Their idea may have been directly inspired by the opening the month before of the "Néo-impressionnistes" at 20 rue Laffitte, led by the chief figures from the Indépendants and the Neo-Impressionist group: Henri-Edmond Cross, Lucien Pissarro, Hippolyte Petitjean, Luce, Léo Gausson, Paul Signac, and Théo van Rysselberghe.[93] Subsequently this locale was the site of regular exhibitions of these and affiliated artists in single and group exhibitions. Among the most remarkable of the 1890s retrospective exhibitions was the one given to James Ensor in the winter of 1898–99, which was in turn accompanied by a book on Ensor published by *La Plume*. The interrelationship between exhibitions and critical exegesis reached new heights with these celebratory exhibitions of *La Plume*.[94]

The close ties between the artist exhibition societies (and their retrospectives) and progressive literary magazines may have been partly responsible for the increasingly ideological character of the retrospective. Since the middle of the 1880s the French literary modernists had been fragmented into a number of competing schools, all stemming from, but repudiating, Zolaesque naturalism. Whether under the banner of *symbolisme* or *décadence* or a host of other names, in literary circles it had become customary to view modernism as a group of competing forces, all claiming their novelty, their last word for French literature. This habit of mind they translated into the world of fine arts, seeing the manifestations of Impressionism, Neo-Impressionism, symbolism, and idealism as comparable phenomena to the literary world. In September 1891 *La Plume* devoted a special issue to what it called "Peintres novateurs" which was subdivided into the ranks of "Chromo-luminaristes"—Seurat, Signac, Dubois-Pillet, Luce, Lucien Pissarro, and

Charles Angrand—"néo-traditionnistes"—Gauguin, van Gogh, Bernard, Maurice Denis, Paul Sérusier, and Pierre Bonnard—and "indépendants"—Cézanne, Séon, Louis Anquetin, Camille Pissarro, and Émile Schuffenecker. However unwieldy, and indeed arbitrary, these categorizations were, they reflected an impulse to fractionalize modernism into wholly distinct camps. In the wake of the deaths of van Gogh, Dubois-Pillet, and Seurat, and the virtual disappearance from the Parisian art world of Gauguin, Bernard, and Cézanne, the force of these divisions could not be sustained and the importance of all these artists tended to dissolve into the general economy of the 1890s art world. While much admired among a handful of collectors, most remained unknown outside a small circle of fellow artists, critics, and collectors.

What we do not know about either the special exhibitions of journals such as *La Plume* or the regular one-man shows staged at Durand-Ruel's, Vollard's, or Bernheim Jeune's, or at a growing host of smaller competitors, was the precise commercial success of these shows. The fragmentation of the Parisian art world into a variety of independent exhibition societies, the duelling Salons, and the dealer-sponsored show of groups and individuals, make the Parisian art market too complex to reduce to simple historical formulae by which to rate "winners" and "losers." Just winning a one-man exhibition (or even a succession of such shows) from a dealer, for example, was no guarantee of the eventual reputation of the artist. Perhaps there is no more paradigmatic an artist, who received overwhelming dealer support but who was subsequently all but forgotten, than René Seyssaud. Each spring from 1901 on Seyssaud received retrospective-size exhibitions from Bernheim-Jeune—then Paris's most prestigious gallery of contemporary art—all to little avail. If Josse and Gaston Bernheim were mistaken about Seyssaud, their willingness to give him, as later to the Nabis, the Fauves, and Matisse, in particular, sizable exhibitions (50 plus works were not uncommon) is evidence of how central these types of exhibitions became. The strength of this practice is reflected in the early exhibition career of Picasso. After showing at the Exposition Universelle in 1900 Picasso refrained from showing at a public or group exhibition society until the middle of the First World War. Vollard showed Picasso in the summer of 1901 in a two-person show, which contained no fewer than sixty-five works by the young artist.[95] Although the artist went through another four years of considerable poverty, he never stopped exhibiting at galleries such as Vollard's and Berthe Weill's and, of course, was eventually rewarded for his perseverance. On the other hand, the scant critical attention paid to Picasso's work until after 1907 is another reflection of the continued resistance by magazine editors

to covering commercial exhibitions. This not only led to Picasso virtually bursting on the public stage after 1910 under the banner of Cubism, but it also explains the curious fact that Picasso was probably more familiar to the general art public outside Paris than inside. Daniel-Henry Kahnweiler freely shipped his Picassos abroad to any gallery or exhibition society that wished to show them.

Two factors may have been at work in the remarkable effervescence of one-man and retrospective exhibitions after 1900. The first was the Centennale of the Exposition Universelle of 1900, which cemented the canonical reputations of the Impressionists and introduced them to international audiences on a scale never before witnessed. At the same time, the successors to the Impressionists, widely familiar in progressive art circles in Paris, were conspicuously absent at the Exposition. Their places were taken by the artists who showed at the "Decennnale," the ten-year retrospective of Salon art. The later retrospectives at the Salon d'Automne and the Indépendants had, therefore, an obviously polemical, compensatory role.

The rehabilitation process for the generation of 1890 began with Vollard's Cézanne and van Gogh shows in 1895 and was carried on through the many subsequent commercial retrospectives for the Post-Impressionists given in Paris and elsewhere. But international currency only came with the entry of the Salon d'Automne in the Parisian art market in 1903.[96] Its successes were in sharp contrast to the Indépendants exhibitions of the 1890s, whose lustre as the primary locale of "independent" art was overshadowed by the Salons of the Société nationale—where, for example, Matisse and his friends made their professional debuts. Unable to attract a foreign audience—after 1889, the Indépendants ceased to be reviewed in German art criticism—its leading participants sought out alternative exhibition locales such as the Neo-Impressionist gallery that opened in 1893. Contributing to the prolonged dormancy of the Indépendants was its egalitarian bylaws (excepting its hanging committee), which permitted the showing of young and marginal artists without jury review; the Indépendants was therefore not credited with being a serious professional organization until after 1900.[97] This dramatic revitalization coincided with its removal in 1901 from what were often provisional quarters into a permanent slot at the Grand Palais. With the presence of the Nabis, the Neo-Impressionists, and of Cézanne—beginning with the 1899 exhibition—the Indépendants resumed something of the importance for modernist art it had held in the second half of the 1880s.[98]

Even then, the contrast between the Indépendants and the new Salon d'Automne was profound. Paul Jamot, writing for the *Gazette des beaux-arts*,

described the Salon d'Automne in 1906 as the "third society, coming after the old Société des Artists français and the aristocratic Société Nationale."[99] Where the state would only very rarely—and only after 1900—buy from the Indépendants exhibitions, from its inception the Salon d'Automne received regular state purchases. It employed a relatively stringent jury review process and thereby attracted artists who previously showed at the Société nationale. The bellwether of its reputation was its press coverage; the *Gazette des beaux-arts*, which never reviewed the Indépendants (confining those reviews to its supplement, the *Chronique des arts*), prominently featured the Salon d'Automne beginning with its second exhibition in 1904. This same attention was shown from abroad; the German art press prominently covered successive exhibition of the Salon d'Automne, often in spite of the sharply unfavorable reviews they garnered.

If the Salon d'Automne was said to represent a third Salon, in practice it was an entirely different institution, and one that got its bite, its notoriety in the popular press, through its close collaboration with the Parisian art market. The Salon d'Automne's practice of holding major retrospectives side by side with its regular exhibitions, retrospectives of artists heretofore largely unknown to most of the European art public, dramatically enhanced its reputation.[100] These shows, in turn, were fueled by the coincidental death of a number of modernist artists: Lautrec, Pissarro, Gauguin, and Cézanne. But they also introduced the wider public to long-dead painters such as van Gogh and Seurat. This was immediately reflected in the work of younger artists, such as Picasso, whose aesthetic development in the first decade of this century was punctuated by the successive impacts of these exhibitions.

In effect, the Salon d'Automne took over the commemorative role of the École des Beaux-Arts retrospectives. By virtue of the high public visibility of "official" exhibition societies—which still earned far higher press attention, and public attendance, than private exhibitions—the exhibitions of the Salon d'Automne elevated the artists so honored to a new stature. The Paris Centennale had subtly altered the nature of contemporary retrospectives by foregrounding the historical context of an artist's work. After 1900 a new standard for retrospectives arose that placed artists within a continuum of great artists, but also asserted the progressive evolution of the avant-garde tradition.

Simultaneously, post-1900 retrospectives, whether public or private, were thoroughly enmeshed in speculation. The example of the Impressionists again is of great significance. After 1900 Impressionist prices skyrocketed. Manets in particular often sold for more than 100,000 francs, and

the prices earned by Monet, Degas, Pissarro, and some others were comparably, if not identically, high. Their success unquestionably stimulated dealers to hunt for younger masters to patronize. Picasso and the Fauves were given one-man shows, and, as in the case of Matisse, retrospectives—his first was in 1910—at increasingly earlier ages.[101] Modern artists were subsequently able to imitate what previously had been only the privilege of the Salon luminaries, to show both in group exhibitions, at the Salon d'Automne or the Indépendants, and privately, with dealers such as Bernheim Jeune or the smaller, but important galleries of Sagot or Druet (joined later by Kahnweiler). Yet their very success in private commercial exhibitions helped to undermine the idea of group exhibitions in the same format—this institution faded most rapidly in Paris, though eventually it permeated other art centers such as Berlin and Vienna. In sharp contrast to the 1890s, group shows in Paris after 1900 occurred primarily in public exhibitions.

One final observation on the retrospective. As they became increasingly common, they acquired an international character. Picasso's reputation abroad was achieved by the close alliance of his dealer Kahnweiler with German dealers, particularly the Düsseldorf-based gallery of Alfred Flechtheim. This was, however, but a late fruition of what was a common practice between French and Central European art galleries. Once a Parisian dealer had taken the trouble to gather together a collection of an artist's work, a good portion of the show was often sent on the road. The newer galleries such as Druet and Kahnweiler took an independent path in exporting French modernism abroad, but they followed in the wake of Durand-Ruel, Vollard, and Bernheim Jeune.[102] It was a tragic irony that the international modernist art market, particularly between France and Central Europe, matured in an era of virulent nationalism that produced the events of August 1914.

The Juste Milieu International

AESTHETICISM AND THE JUSTE MILIEU

JAMES MCNEILL WHISTLER died a famous man. The honorary exhibition committee for his retrospective exhibition included the French and American ambassadors to England, many of the most important museum directors and art officials in Western Europe and the United States, as well as royalty and society notables.[1] The foreign artists on the committee were Albert Besnard, Jacques-Émile Blanche, Eugène Carrière, and John Singer Sargent. The sponsoring organization was the London-based International Society of Sculptors, Painters & Gravers, over which Whistler had presided and whose current president was Auguste Rodin. This representation of officials and celebrity artists lined up to honor Whistler speaks to his stature in late nineteenth-century European culture, a reputation that is difficult for us now to appreciate. The American art and literary critic, William C. Brownell, wrote of Whistler in 1879 that he was "perhaps the most typical *painter* and the most absolute artist of his time" while in 1897 one Viennese Secessionist still ranked Whistler as the most modern artist in Europe.[2]

And yet, Whistler has had only the most marginal of roles in most histories of modernism. His exalted international reputation came in the face of failings widely observed in his own lifetime by foes and friends alike. For over twenty years Whistler's name was synonymous with Impressionism in Britain, but even his most devoted followers were anxious to disentangle the "Master" from this appellation.[3] Today, Whistler is a figure in the origins of Impressionism owing only to the sensation caused by the *White Girl* (National Gallery, Washington) at the first Salon des Refusés. The artist is not included in the recent anthology, *World Impressionism*, despite the encyclopedic embrace of artists promised by its title.[4] If Whistler's reputation has settled anywhere, it is with symbolism, despite Whistler's open hostility to the literary decadence practiced by such writers as his former protégé, Oscar Wilde.[5] One hardly need mention that Whistler has been excluded from the histories of nineteenth-century English art and that he has usually been granted only perfunctory stature in histories of American art.

Whistler's past and present reputations embody the fate of an entire class of artists, who, during the fin de siècle, were admired as the greatest and

most modern artists of their generation, but whose reputations subsequently and precipitately declined. Their chief historical importance might be said to constitute a negative. Witness the often quoted phrase of the critic Henry Houssaye, written in 1883: "Impressionism receives every form of sarcasm when it takes the names Manet, Monet, Renoir, Caillebotte, Degas; every honor when it is called Bastien-Lepage, Duez, Gervex . . . Jean Béraud."[6] The ability of these latter artists to offer the semblance of modernity with the accessibility, the narrative and pictorial coherence of the academic tradition, shaped the personality of the fin-de-siècle international art world.

That there was a *juste milieu* located between *pompier* artists such as Bouguereau and the core Impressionists was unproblematically recognized at the time. As a useful term of historical description, however, the *juste milieu* has proved controversial, at least since Albert Boime first extended the phrase from its original usage to describe painting that reconciled classicism to Romanticism in the days of Louis-Philippe to the era of the Third Republic.[7] The "compromise movement" of the 1880s Boime discovered in the effort to reconcile the Impressionist palette to academic legibility. Boime contended that "their solution appealed to the administration of the Third Republic, and many of these artists distinguished themselves through large-scale wall decoration."[8] Boime's *juste milieu* has subsequently been contested both for taking its original application out of context to describe a certain type of art made in the July Monarchy, and for the degree to which he assumes the *juste milieu* won official sanction in the Third Republic.[9] But there can be no question that in Paris in the 1880s there did exist an artistic "center," whose leading artists were easily identifiable by both French and foreign observers. And because these artists made their careers within the context of the Salon they had attained at least quasi-official approval. When Wynford Dewhurst said "we are all Impressionists now" he was but articulating the depth and breadth of the dispersion of the Impressionist palette and thematics on an unprecedented international scale.

Boime's brief analysis most misleads by overlooking the wide aesthetic possibilities present under the institutional umbrella of the *juste milieu*, and the international dimensions of the enterprise. On the one hand, the Impressionist "style" flowed to many genres and its subjects were adaptable to a variety of purposes. But equally important was the role the *juste milieu* played in response to the democratization of art audiences and the production of an artist proletariat. For, as I intend to argue, the *juste milieu* was more the political manifestation of the struggle over markets than an aes-

thetic "movement." They represent the effort to construct an artistic elite outside a bankrupt Salon and Academy without, however, rejecting the professional ambitions previously enshrined in and certified by those institutions. To locate an artistic center in "official" culture, while it might describe those *juste milieu* artists who were awarded public commissions, fundamentally lacks explanatory power in an international context.[10]

Manufacturing a new "ism" for late nineteenth-century art first allows for the separation of these artists from the way they have often been seen, as modernists, as *Jung-Kunst*, as Impressionists. More importantly, it assists the definition of the space between arguments regarding the commercialism and corruption of the academic system and the presumed radical negation of that system propounded by the European modernists, that is, between the unauthentic, academic tradition and authentic modernism. Arguments, therefore, about the *juste milieu* are inevitably arguments about commercialism and authenticity and what constitutes criteria for either term. For example, Renoir compared to Jules Bastien-Lepage in 1882 would have appeared to almost every observer as "modern" vis-à-vis his *juste milieu* rival. But when Renoir showed his *Les Baigneuses* (Philadelphia Museum of Art) at the Galerie Georges Petit in 1887, he sacrificed his modernist credentials, provoking Pissarro to remark that "I do understand what he is trying to do, it is proper not to stand still, but he chose to concentrate on line, his figures are all separate entities, detached from one another without regard for color."[11] Pissarro could not help but see Renoir's affinities to the typical efforts of the *juste milieu*. In crossing this definite, but unarticulated line between modernist and *juste milieu* Renoir was vulnerable to the accusation that he had sacrificed the authenticity of his work for commercial gain. The British critic, Charles W. Furse, described just such a boundary in 1892 when he wrote

> readers of modern art criticism are probably familiar with the use of the term impressionism. It is one of the commonest in the art jargon of the day and bears with it the peculiar advantage of being, to most people, a mere phrase, utterly unintelligible, and consequently suggestive of high culture. . . . it has come to be a title differentiating the work of those painters who are striving after an expression of their artistic individuality from those who look upon art as a commodity, the supply of which is consequent on the demand.[12]

The *juste milieu* understood as a tool, and not an "entity" or a "movement," allows for a new perspective from which to view fin-de-siècle art politics and the game of establishing an artist's "modernist" or "qualitative" creden-

tials. This leads to an understanding of how the expansion or contraction of the definition of Impressionism (vis-à-vis the *juste milieu*) represented a corresponding widening or delimiting of the granting of authenticity versus commercialism in contemporary art.

To describe a rise and fall of a *juste milieu* also articulates developments in fin-de-siècle art institutions in a manner that conventional accounts of the rise of modernism do not permit. The *Kunstpolitik* of the *juste milieu* is contained within a history of those quintessential art institutions of the 1890s, the Société nationale des beaux-arts and the international Secessionist phenomenon. The demonstrable decline after 1900 of the reputations of the *juste milieu* may also tell us much about the formation of the Impressionist canon, a canon that explicitly excluded the *juste milieu* and in so doing destroyed those artists' cultural and market value. The destruction of the *juste milieu* paradoxically marked the moment when Impressionism's co-equality with modernism was torn apart. In challenging the naturalist position of their "fathers," the Post-Impressionists also laid claim to their exclusive right to be the "sons." In the process, the *juste milieu* were no longer able to claim to be the true, authentic inheritors of a living Impressionist tradition.

The contemporary obscurity of many of the figures of the international *juste milieu* and the concomitant historical limbo they occupy may be traced first to the fact that as a class of artists they were unbounded by habits of style. Rather than forging distinct Impressionist-based criteria by which to determine *juste milieu* membership, it is more useful to recognize the manner in which they accommodated eclecticism or aesthetic pluralism as long as this art fulfilled a never-well-defined *modernité* of vision. They were drawn as a rule to the pastoral naturalism of Millet and the urban naturalism of Manet, but they also embraced anti-naturalist artists. Their justification for pluralism was to argue for the preeminence of quality over style.

To this *juste milieu* international I would name artists as diverse as the American painters Sargent and Gari Melchers, the Germans Liebermann and Fritz von Uhde, French painters such as Ernest-Ange Duez, Alfred Roll, Albert Besnard, and Henri Gervex, Scandinavian artists Anders Zorn and Peder Krøyer, Italians Giovanni Boldini, Giuseppe de Nittis, and the Italo-Swiss painter Giovanni Segantini, the Spaniards Raimundo de Madrazo and Joaquin Sorolla, and from the Lowlands painters such as Alfred Stevens and Émile Claus.[13] This list might also include sculptors Auguste Rodin, Constantin Meunier, and Max Klinger—they shared this class' social and ideological affiliations—but for the fact that while they had innumerable sculptors to their aesthetic "right," there were none to their "left."[14] One

might quarrel over the admissibility or exclusion of this or that artist, but the amorphous character of the *juste milieu* is in an important sense one of its constituent features. Finally, who now remembers Duez or Roll? The foreign artists on this list enjoy today considerably greater prestige, essentially as modernists, than do their French brethren. For it has been impossible to erect their reputations as Impressionists under the immediate shadow of Monet and Degas. By contrast, a Liebermann or a Sargent have managed to wear the garb of Impressionist modernism in their respective national art histories still mostly denied to the Duezs and Rolls of French art. This observation leads to another: the tendency in revisionist art history to rediscover "lost" Impressionists repeats the confusions of the 1880s and 1890s. Our understanding of the art of this era would be better served by examining how and why they got "lost" than to restore their Impressionist badges.

Confronted by the *juste milieu*'s eclecticism, especially in matters of style, it is easy to overlook their internal cultural and institutional coherence. They were united by their social position, by an elaborate network of acquaintances and friendships, by their celebration of artistic "temperament," and by a network of exhibition institutions and their related publicity machines. Whistler, for example, occupied a central place within the international cast of characters cited above. He knew many of these artists personally and, from the 1880s onward, showed alongside them in international exhibitions everywhere from Berlin to Venice, from Paris to Pittsburgh. The intimacy of these relationships suggests that the *juste milieu* international is best described as a brotherhood of master artists. They did not seek the radical independence of the Impressionists; their position as the dominant figures in fin-de-siècle art may be traced to their ability to command both the official legitimacy conferred on Salon and Royal Academy medalists—which they all were—and to take advantage of a restructured market for contemporary art. Their commercial success was such that many lived like princes. The extravagance of their studios, the fashionableness of their dress, their reputations as wits and men-about-town, all were a far cry from the bohemianism of their youth or the image of neglect and suffering that adheres to the idea of the avant-garde.

Because of their aesthetic liberalism (and despite their institutional elitism) the *juste milieu*, in contrast to the Impressionists and Post-Impressionists and their apologists, failed either to forge for themselves, or to have made for them, a canonical genealogy that placed their art within a historically determinist history of art. Although they rejected the academic, literalist, and narrative character of the dominant artists of the mid-Victorian age,

English painters such as Frith and Millais, or the French *pompiers* Gérôme and Bouguereau, they offered little in the way of an explicit alternative to these artists. The aesthetic pluralism—characterized in Whistler's case by his love of Japanese art and his insistent attempt to draw together Velázquez and Hokusai into a common canon of great artists—made any systematic defense of a canon of art nearly impossible. It was not, of course, that such art is inherently irreconcilable, it was that Whistler and his contemporaries did not trouble much with how they were to be reconciled. Whistler's early, obvious attempts to bring the two traditions together in the second half of the 1860s were mercifully abandoned by the artist soon after. The incipient eclecticism and ahistoricism of the *juste milieu* found these artists attempting precarious reconciliations not only between the Orient and the West, but between the "masterpieces" of the past and the modern tendencies in art. Whistler's ceaseless glorification of Velázquez, to whom he liked to compare himself (and in that purely Whistler manner, quite favorably), was as conservative an affiliation in its own way as his friend Albert Moore's neoclassical idylls. The *juste milieu*'s place within the history of these varied traditions would forever remain unresolved.

The elevation of quality over style was fundamentally articulated in Whistler's "Ten O'Clock" lecture delivered and published in 1883.[15] I take Whistler's lecture to constitute an opening "manifesto" for the *juste milieu*, just as Liebermann's lectures delivered in defense of the Berlin Secession in the first decade of this century mark the end of their era. The "Ten O'Clock" was more than what is usually described as a translation of French *l'art pour l'art* doctrine into English; it was a fundamental reaction against both the notions of the idea of progress and the inverse doctrine of aestheticism and degeneration in art ("it is false, this teaching of decay. . . . Art is limited to the infinite, and beginning there cannot progress"[154–55])—both were fundamental positions for the 1890s symbolists—against the pedagogical value of art (art "is selfishly occupied with her own perfection only—having no desire to teach"[136]), against the view that art mirrors the quality of a culture or a civilization ("there never was an artistic period. There never was an Art-loving nation"[139]). For Whistler art simply is.

Whistler was also, obviously, profoundly anti-Ruskinian in temperament, so that a large share of the "Ten O'Clock" was devoted to a critique of nature and its primacy in art. Championing art's superiority to and independence from nature, Whistler displaced the touchstone of aesthetic judgment to the intuition of the artist. Having laid out the tenet that art is mastered only by a few, regardless of their era or environment, Whistler then attacked the connoisseurs and the critics. "The Dilettante," he wrote,

"stalks abroad. The amateur is loosed. The voice of the aesthete is heard in the land, and catastrophe is upon us"[152]. In the new industrial world "the taste of the tradesman supplanted the science of the artist. . . . And the artist's occupation was gone, and the manufacturer and the huckster took his place"[142]. Yet the "Ten O'Clock" lecture offered no alternative criterion to the language of contemporary criticism by which to judge the huckster from the master other than the surety of Whistler's own opinion.

Like Whistler, the *juste milieu* came to believe that they worked exclusively to maintain the highest standards of art against the contemporary impoverishment of popular tastes and the traditional fare at the Salon or the Royal Academy or the European and American equivalents, professing no vested interest except the calling of "art." And because the *juste milieu* claimed individuality as the utmost standard for quality—and who was more individual, or indeed more idiosyncratic, than Whistler?—they consistently asserted art's independence from the material and ideological conflicts of the day, whether it be between naturalism and academicism, or between Impressionism and symbolism. The qualities of art for these men transcended style, just as great artists transcended movements.

If not precisely united by style, they were in another sense united by technique. The *juste milieu* generally employed a facture that destroyed contours and broke up the literal surface of their paintings. The presence of the "touch" reflected the performing bravado of the artist. Rodin's sculptures, likewise, were famous for the fluidity and complexity of their surfaces, the tell-tale traces of the artist's hand at work. Demonstrably modeled and often heavily worked, their surfaces were read like records of the artist-genius at work. Not surprisingly the artistic heroes of the era were led by Velázquez, Hals, and Rembrandt, and among their near contemporaries, Édouard Manet.

Evoking Manet, the paradigmatic modernist, here may seem confusing, if not paradoxical. Yet it is one of the most important aspects of the posthumous reception history of Manet that throughout the 1880s (and for much of the nineties) the artist was claimed in Paris for the *juste milieu*, rather than for the radical moderns. Manet's exhibition committee for his 1884 retrospective at the École des Beaux-Arts had among the painters none of the Impressionists, but rather Gervex, Guillemet, de Nittis, Roll, and Stevens. And when Monet and Sargent organized in 1890 the subscription to purchase Manet's *Olympia* (Musée d'Orsay, Paris) for the Louvre, the list of subscribers testifies both to the claim of Manet for the *juste milieu* and to the blurring of the lines between *juste milieu* and Impressionist. Among the list of contributing artists, dealers, collectors, and dignitaries one finds

the familiar names of modernists such as Degas and Mallarmé, but also Boldini and Helleu, Béraud and Roll, Besnard and Alexander Harrison.[16]

When the Impressionists received their validation in the Salon in the mid-1880s and at the exhibitions of Petit and Durand-Ruel, the market began to treat them as they would treat a Bouguereau or a Béraud. Their entry into the market inevitably furthered the confusion among the public between "authentic" Impressionism and the art of the *juste milieu*. Manet's fate in particular was a galvanizing point in the consumption of Impressionism outside the circle of dealers. Manet received a second class medal at the Salon of 1881 and was awarded the same year the Legion d'Honneur. Already ill, he painted only one more major canvas, *The Bar at the Folies-Bergère* (Courtauld Collection, London) before his death in 1883. His official acceptance had to be engineered during the brief political triumph of his old friend, the liberal politician Léon Gambetta. However, what was only grudgingly accepted in 1881 was institutionalized after his death with the École exhibition and subsequent auction. Both events received international press attention, and some considered the auction as a notable success.

Not everyone greeted the apotheosis of Manet with enthusiasm. Pissarro reacted with disgust over the state's enshrinement of Manet. Observing that Manet had a petty side, Pissarro wrote to his son that he found it ironic, but tragically appropriate, that

> (Théodore) Duret, (Antonin) Proust . . . could think of nothing better than to ask the worst officials, Manet's inveterate enemies, to join the organizing committee, and give an official stamp to the ceremony. All the bourgeois gentlemen will be there . . . all those who loved and defended the great artist: shocking! —Even (Henri) Fantin-Latour, who, it appears, claims that Manet in his last years had degenerated to such a point that he hoped to change his style through contact with those dilettantes who produce more noise than art! That's pretty strong, but not surprising![17]

Pissarro's belief that the claims of the *juste milieu* on Manet's legacy were explicitly grounded in their denial of the value of Impressionism may be understood in the context of the artist's own fears of marginality in the wake of the disintegration of the Impressionist exhibitions. For a member of the *juste milieu*, Manet's retrospective appeared in an entirely different light. Jacques-Émile Blanche, then a young painter and friend of Manet, was a quintessential *juste milieu* artist. In his review of Manet's posthumous retrospective Blanche professed to be appalled by the wholesale adulation of Manet, but drew very different conclusions than Pissarro from the event.

How many (there are) of these men who believe that they have assisted in his proper triumph, who imagine that they have participated directly in and had foreseen from the beginning his fortune! All those who have served up Manet as the head of an école, who have made him, through an historical error, the first Impressionist, all the realists, the naturalists, men of vague letters who don't know and don't want to understand, all proclaim that this collection of paintings, once booed, now in a way officially sanctioned, is the consecration of their diverse systems. It is the last blow against the Academy! say some. More than studio work! Long live *plein air*! Long live liberty! say others.[18]

It is difficult to imagine a more clear expression of the struggle to control the interpretation of Manet's art. Pissarro saw Manet as the basis for the new painting. Blanche described Manet as a virtual painter's painter, lifted above history. Blanche concluded with the observation that Manet's art was only for those "to whom he appears as he is, outside of all systems, of all theories; it is only to them that his true force is revealed."[19]

Too little appreciation is given today to the role virtuosity played as a standard in late nineteenth-century aesthetics. Manet's paintings, with their obvious surface presence of paint, the literal declaration of the artist as the maker of the image through the virtuoso working of the surface, enacted a lesson greater than realism. His painted surfaces fulfilled the expectation of the connoisseur for the personal touch of the artist. This expectation had been enshrined in France by at least fifty years of Salon criticism and was exported from there in the 1880s to every major western art center. Besides the theatrical and the pleasing, and especially the sensational, character of a painting's subject, *amateurs* had been educated also to expect the discernment of a skilled hand, to judge a painting finally not by what is painted, but how it is painted, that is, to read the paint as the material manifestation of the genius of the master.

The taste for the bravura performance that united Manet to the *juste milieu* was articulated most strongly in the one genre that characterized the *juste milieu* over all others: the society portrait—to which Manet himself was drawn in the second half of the 1870s. Gerald Reitlinger has noted that between the 1870s and the 1920s the auction market was dominated by portraits and that around 1900 the highest prices at auction were earned, not by Renaissance or Baroque painters, but largely by eighteenth-century English portrait painters.[20] Seventy to one hundred thousand pounds were paid for works by artists such as Gainsborough, Romney, and Reynolds, as well as for lesser artists Hoppner and Raeburn. These prices were pushed

up by an apparently insatiable American demand; its industrial nouveau riche sought to buy up a fictional ancestry to line the walls of their newly constructed Tudor mansions. In 1896 Mrs. Gardner tried to buy Gainsborough's *Blue Boy* from the Duke of Westminster for 40,000 pounds.[21] By comparison she is said to have spent only about 20,000 pounds for Titian's *The Rape of Europa*.[22] English portrait painting is rich in the bravura performance, inheriting as it did the tour de force legacy of Rubens and Van Dyck. The same class of client who bought Romneys were as likely to purchase Sargent and it was probably no coincidence that most of the leading painters of the *juste milieu*, including Whistler, Sargent, Liebermann, Boldini, and Zorn (to cite only a few) were all notable portraitists, painting the aristocracy and the nouveau riche from London and Paris to New York and Chicago.

This sensibility encouraged the subordination of the subjects and the variety of social and political contexts to which any specific work by a *juste milieu* artist might refer to the ruling qualities of artistic execution, even if there were no criteria to define quality within these demonstrative surfaces. The success of the *juste milieu* lay in their ability to satisfy the demand for worked surfaces so long, however, as it did not undermine the other criteria of legibility, narrative and spatial coherency (not to mention the "pleasing" and "sensational" subjects). Whereas the Impressionists continued to be widely perceived as "bizarre" for their dissolution of form through the task of capturing optical sensations with touches of paint, in essentials, that is in the treatment of the body and the organization of narrative elements, the *juste milieu* were just as legible as that of the academicians. Only in the inessential, the peripheral, the backgrounds of land and sky, did the *juste milieu* turn vaporous. Hence the betrayal of Renoir's *Les Baigneuses* of 1887, which forged an uneasy reconciliation between academic line in the treatment of the bathers and an Impressionist environment.

The *juste milieu* exercised a self-legitimization process. They themselves determined what art, including theirs, did or did not matter. This doctrine functioned as a remarkably flexible ideological gatekeeper for the *juste milieu*, allowing them to embrace different styles and artists from different nations while at the same time preserving an elite distinction between themselves and the proletariat of artists. And they passed this sensibility on to Secessionism. Liebermann would later argue on behalf of the Berlin Secession that the organization's exclusive interest was the exhibition of great art and that such art was the product of great individuals working in their own distinct styles. Thus for Liebermann "there is no determined norm for what art is, taste alone decides; the continual reevaluation of art:

what is today laughed at we see tomorrow as astonishing and admirable."[23] No doubt Liebermann believed this, but he spoke here from deep within the romantic discourse of the neglected artist and the transcendent qualities of art.

The *juste milieu* condemned the commercialism of the academy and Salon exhibitions, but none were more commercial than they in exploiting personal advantage through their elite exhibitions. Thus it was that in the 1890s when they came to control their own exhibition organizations, the *juste milieu* were able to construct in the name of quality temples of art, ostensibly dedicated to the worship of art, but with sales made at the door. Werner Hofmann once observed that this "theory of ubiquitous superart, an aesthetic substitute religion with the exhibition as one of its temples, requires an unlimited consumption of art and art tailored wholly to the consumer. . . . Art is sanctified and made a disposable object in the same breath."[24] The paradox of art being held simultaneously as a transcendent entity while serving the marketplace, rendering unproblematic the relationship between the work of art and the buyer, is at the crux of Whistler's own paradoxical position in the history of modern art.

It is difficult to speak of the "origins" of the *juste milieu*. Since such artists did not "band together" until after they were already famous, there is no sense of an invention of a movement. Their allegiance to one another was a matter of circumstance rather than intention. Nonetheless, if the *juste milieu* may be said to possess a communal attitude toward technique and certain expectations about what an artist is and does, then in the same vein it is possible to locate the *juste milieu* within a *Kunstpolitik* engendered by the Impressionist exhibitions, that is, in France. The eventual dominance of the *juste milieu* over the French art world was rooted in their occupation of the aesthetic and institutional example set by the Impressionists, that is, their style and modern subject matter and their independent exhibition practices with the concomitant commercial gallery allegiances that the Impressionists forged in the seventies and early eighties.

According to Zola the *juste milieu* swept into great notoriety with the Salon of 1880.[25] The American critic, Henry Bacon, in his book *Parisian Art and Artists* (1880), was also able to lay out the French contingent of the *juste milieu* with considerable accuracy, while at the same time expressing marked hostility to the canonical Impressionists.[26] Bacon identified among the leading young artists who had made their reputations in the Salon, Stevens, Duez, Bastien-Lepage, Gervex, Carolus Duran, Jean Béraud, de Nittis, Madrazo, Egusquiza, Munkácsy, Sargent, and Edelfelt. Even before

1880 a general brightening of Salon canvases had been widely observed, particularly in reference to such sensational paintings as Gervex's *Rolla*, 1877, or Duez's *Splendour and Misery*, 1874—which Bacon described as being "after the manner of the Impressionist school, yet with more detail and 'finish' "[27]—and which explored the same world of the contemporary demi-monde as did the Impressionists.

All the French painters and many of the foreign artists named by Bacon were students of academicians such as Alexandre Cabanel and Isidore Pils; each had won at least second class medals at the Salon of 1879 or in subsequent years. Bastien-Lepage, Carolus Duran, Duez, and Roll were all awarded the Legion of Honor. Despite their official accolades most of these same artists came to be perceived in the 1880s as the chief constituents of the reform party within the official institutions of the French art world, a process that I will trace in the second half of this chapter. The *juste milieu* as *Kunstpolitiker* represented the class of artists who made the transition from an academic, officially condoned art system to Secessionist-style, artist organizations. They would thus offer an important institutional legacy to the next generation of modernists, even while their ambition to create an independent, professional class of artists proved abortive.

Indeed, the *juste milieu*'s importance for the art market is that they demonstrated how one could use the official legitimacy conferred on Salon and Royal Academy medalists in order to take advantage of an increasingly international and socially diverse art audience. More timid than Durand-Ruel, the other major Parisian galleries still looked to the Salon to guarantee public visibility and economic value. The *juste milieu* were able to carry the banner of modernity without insisting upon the radical independence of the Impressionists, which is why Degas was reportedly to have said about Albert Besnard, "he flies with our wings."[28] Those "wings" were composed of more than the question of style. The Impressionists labored throughout the 1870s to establish the veneer of independence that would place their art above commercial concerns, whereas the *juste milieu*, outside the Impressionist coterie, and more importantly, outside Paris, were able to appear immediately and simply as internationally recognized "masters." Joris Huysmans, then a realist disciple of Zola, noted in his review of the 1880 Impressionist exhibition the public's inability to make a distinction between the Impressionists and the *juste milieu*.

> The public that once convulsed with laughter when the intransigents first exhibited . . . now walk peacefully through the exhibition rooms. They are still frightened and irritated by certain works whose newness confuses

them, being quite unaware of the unfathomable abyss which separates M. Degas and M. Caillebotte's concept of the modern and the fabrications of MM. Bastien-Lepage and Henri Gervex.[29]

Although Huysmans scorned the crowd, in fact the same difficulty was clearly felt in the Impressionist ranks. Degas in particular was notorious for inviting artists to exhibit with the Impressionists who might more properly be conceived of as *juste milieu*. In a famous letter to Pissarro in 1881 Caille-botte complained about Degas' nominees.

> In 1878 Zandomineghi, Bracquemond, Mme. Bracquemond; in 1879 Raffaëlli . . . and others. What a fighting squad in the great cause of realism!!!![30]

To Caillebotte, the true Impressionists were himself, Pissarro, Monet, Re-noir, Sisley, Morisot, Cassatt, Cézanne, Guillaumin, and perhaps Gauguin (as well as the now-obscure artist Frédéric Cordey). Degas' painters, includ-ing artists such as the Comte Lepic and Alphonse Legros, professor at London's Slade school, were very near to the *juste milieu* in the Salon.

ZOLA ON THE JUSTE MILIEU AND THE "CRISIS" OF IMPRESSIONISM

Zola was the sharpest observer of the challenge the *juste milieu* made to the Impressionists' public identity. In the 1880s Zola had drifted away from the artists whom he defended in his youth, so that when Monet and John Singer Sargent asked Zola to join in the subscription for the *Olympia*, the novelist refused. In his defense Zola observed that *amateurs* had syndicated to raise the prices of the painter and that he believed that Manet ought to enter the Louvre under the "full national recognition of his talent" and not as a gift that smells of the "coterie" and of "publicity seeking." "I have defended Manet enough with my pen not to fear the reproach of anyone who would market his glory."[31] Zola's reply to Monet has recently been described by an eminent French art historian as "bizarre."[32] Zola's refusal is incomprehensi-ble in light of Manet's obvious historical importance and the worthiness of Monet's cause.

How did Zola come to such a "bizarre" view of the exploitation of Manet for profit? Was Zola's much-maligned withdrawal from the Impressionist circle a consequence of a failure of vision or an expression of his now bourgeois lifestyle (in the wake of his highly successful novels)? Or was it, as

Anita Brookner has argued, the logical result of his identity as a journalist and the changing ambitions of a novelist that led to his disaffection?[33] As it has often been observed, by the 1880s Zola was no longer an insider in the art world and his knowledge of it largely now came second hand. But of the truthfulness of this knowledge Zola was undoubtedly convinced. With characteristic integrity, Zola strove to keep the critical practice separate from the art trade—in marked contrast to Duret, Burty, and the other agents of dealers.

As Brookner argues, Zola championed the cause of his artists for social rather than for artistic reasons. The Salon and the other forms of official state control over the artists were Zola's real opponents. With the entrance of Manet and his friends into the Salon in the late 1870s and early 1880s the struggle was over for Zola. In the previously cited reviews for the Russian newspaper which began in 1875 and ran through the Salon of 1879, and which were collectively published in France in 1881, Zola sharply pointed out the limitations in his friends' work and developed the dual themes that appear in the remainder of his art criticism: the inability of the Impressionists to produce a man of genius capable of painting masterpieces in the grand tradition of French art (now dead), and an analysis of Impressionism as representing fundamentally a transitional style.[34] What Zola saw in the wake of the Impressionist exhibitions was the manner in which Impressionist paintings were coming to be consumed, not for their subjects, but for their technique. The progressive rationale of Manet's art had been stripped away by the success of the new generation of *juste milieu* artists, who used Manet's techniques and those of the Impressionists, who took up the themes of modern life, but in both senses in a way that pandered to the popular tastes of the Salon. If the forms could be abused in this way, then the revolutionary project of Impressionism was substantially implicated. This is a different crisis of Impressionism than art historians generally have described. It was not the dissolution of the objective world by the Impressionist facture that was at stake, but the dissolution of the Impressionist claim to be independent.

Zola's novel *L'Oeuvre* (1886), which reputedly caused the breakup of the friendship between the novelist and his childhood friend, Cézanne, also articulated the unravelling of the Impressionist identity in the 1880s.[35] From the beginning, *L'Oeuvre* was perceived by Zola's huge international audience to be an account of the rise (and fall) of Impressionism, and offered a non-fictional account of the Impressionist "doctrine."[36] The main theme of the *L'Oeuvre* was familiar to nineteenth-century French literature. Critics have often connected the work to the Goncourts' *Manette Salomon*

(1867) and to Balzac's story *Le-Chef-d'Oeuvre inconnu* (1837), not to mention the wide variety of now forgotten stories and novels about the unrealized genius and the fatal undermining of art by women. The usual verdict is that it represents one of the novelist's least successful efforts.

The novel portrays the career of the *plein air* painter, Claude Lantier, set against the background of the history and theory of Impressionism. Lantier is a frustrated and ultimately futile genius, reputedly based on Cézanne's personality and personal history. However, the public initially received Lantier as a pseudonym for Manet. Cézanne was unknown for another fourteen years, and Zola, of course, was remembered as the ardent defender of Manet.[37] Consequently, *L'Oeuvre* was largely responsible for Manet's reputation, particularly in Germany, as *the* Impressionist artist. Since the novel preceded in most cases the international art audience's acquaintance with Manet's work, the artist, through Zola's characterization, was endowed with the qualities of Zola's naturalism and political radicalism—qualities from which Manet's *juste milieu* supporters, such as Fantin-Latour and Blanche, were most anxious to disentangle the artist's reputation. The final irony was, of course, that by the time *L'Oeuvre* was published the novelist had already become deeply disenchanted with Impressionism.

Zola used *L'Oeuvre* to describe the Impressionist "movement" from two vantages, that of the 1860s and that of the 1880s. He collapsed the problems posed by the expanding commercial art market in the eighties with the institutional rebellion of the Salon des Refusés of 1863. The novel looks forward to a future of merchandized art and the progressive isolation of true talents. Presumably this commercial crisis was embodied in Zola himself through the character of Pierre Sandoz, a recently successful author, but one whose success had brought with it self-doubt. Sandoz' fortune is contrasted with Lantier's failure, his eventual suicide, as if an admission that the painter was too much an artist and not enough a professional. For it is also true that inasmuch as Zola looked forward to a genius of the future he had no model, referring vaguely back only to Delacroix and Courbet. His idealized version of the great artist as a tragic persona was at odds with the man who sacrifices some of his artistic integrity in order to survive. How to reconcile the tragic hero and the compromising professional the novel leaves unresolved.

Manet is divided into two psyches in *L'Oeuvre*. He is the crazy, failed genius Lantier, who creates *Plein air*, the most ridiculed painting at the Salon des Refusés, and Bongrand, the modernist—or is it *juste milieu?*—artist, whose years of struggle are behind him, who has had his masterpiece but fears his ability to sustain the same level of artistic quality, who, in

Zola's words, never lived up to the potential of his first great painting. Bongrand has often been compared to Courbet, but Zola noted in his "Ébauche" for the novel that he was to be "un Manet très chic, un Flaubert plutôt."[38] For Zola Manet was both the unrealized, unfairly maligned artist whom he defended in his youth and the arrived artist, aristocratic, accomplished, the man decorated by the state.

Besides a rather typological and unremarkable investigation into the nature of artistic genius, the novel is about the struggle over the institutions of art, about the impact of the market on the production of art. In his art criticism Zola had always been more concerned with the analyses of institutions than of specific works of art, posing the problem of naturalism in painting far more often as an institutional struggle than a battle over style.[39] At the end of the "Ébauche," Zola dwelt on the element of "ma bande," the grouping of artists who had come to "Paris à conquérir and à la fin, la débâcle de la bande" in the face of the demands of everyday life.[40] Zola made the Impressionists into this "bande," used what he understood to be their theories of painting and projected on to them the need for a leader, "*une génie pour être réalisée*" (Zola's emphasis). Lantier was to be that painter and he failed. Seemingly paradoxically Lantier was turned against the Impressionists.

> Claude rose against their hasty work, the painting made in two hours, the sketch which satisfies, the premature sale of Monet . . . all of the bad side of the group with its rivalries. And yet, the undeniable role, the Salons changed by this current, the departure from the movement by Claude, the vulgarization by the Gervexes, the invasion by the cunning members of the École.[41]

Zola created a character in *L'Oeuvre* modeled on Gervex who reaps institutional and financial rewards by selling out his art to the fashionable. Fagerolles is an essential companion to Lantier—his reverse persona. In this Zola and Duret were alike. They defended the artist through the language of denial. The great artist cannot have an audience. Zola's image of the Impressionist *debâcle* was sketched out in a few phrases: "Fauning (*platitude*) of the painters before the administration. Dependency (*protégé*). The distribution of rewards."

Zola was condemned by the painters for his reservations over their work and has since then often been condemned from the vantage of the simple historical assurance that he was wrong, that he failed to see the merit of Impressionism. Yet, Zola's criticism is compelling for its marked contrast to the now solidifying canonization of these artists, for denying this mythic

language, for insisting from the end of the 1870s through his last writing on Manet and the Impressionists (1896) that there had to be more to art than its facture and its use of *plein air*.[42] Zola ought to be read less for his aesthetic pronouncements upon Impressionism than for his institutional under- standing of the consequences of the growing public awareness and accep- tance of the Impressionists—which can be found in his art criticism as early as 1877. Zola's principal arguments were that Manet failed to live up to his early promise, despite his great influence on French art; that Impressionism had failed to produce masterpieces that could be compared to the best work of Ingres, Delacroix, and Courbet; that Monet was guilty of being so much in haste to earn a living that he refrained from translating the power of his "sketches" into large, significant work; that the independent Impressionist exhibitions, while not entirely unhelpful, had failed to replace the necessity of exhibiting and earning one's reputation at the Salon; and, finally, that the Impressionist style and subject matter had taken ever greater possession of the Salon so that by his despairing review of the Salons of 1896 the triumph of Impressionism had produced a sea of bad art. The ideological and aes- thetic force of the Impressionists as an "avant-garde" had dissolved in their commercial exploitation.

THE JUSTE MILIEU IN POWER

If the Impressionists changed the style of art, but did not finally reform its institutions, from another position one may say that the *juste milieu* was responsible for precisely the opposite effect. Essentially styleless, they were the principal agents (and beneficiaries) of a transformed institutional cli- mate for artists in the last years of the nineteenth century. The activities of Petit and his international cast of artists requires that they be set against Salon politics that developed out of the reforms of 1874, and which eventu- ally led to the founding of the Société nationale des beaux-arts in 1891. As a class, the *juste milieu* believed both in the immutability, the permanent, transcendent character of art, but also in social progress. They, more than any other segment of the artist community, may justly be said to be the art world's representatives to late nineteenth-century liberal culture. Political liberalism, especially with its assumption to power in the 1860s and 1870s, represented a half-way point between the aristocracy and absolutism of the previous century and the mass parties of the next. European liberals neces- sarily shared power with the older elites, but at the same time became allied with the growing industrial base of their respective societies. Yet to hold on

to their power within a parliamentary context, the liberals ironically re-
sorted to restricting parliamentary franchises.

The artists of the *juste milieu* strikingly repeated this scenario. While
their patrons were drawn largely from the new industrial class, the artists
often moved in aristocratic circles or at least aspired to the cultivation of the
aristocracy and aristocratic culture against the perceived cultural poverty of
the nouveau riche. At the same time it was characteristic of their profes-
sional ambitions that the *juste milieu* advocated self-rule among artists,
which inevitably invited greater democratic structure to their societies.
The *juste milieu* thus came to lead the opposition to the strangle-hold still
held over their respective art worlds by the European academies. And yet,
what most distinguishes their exhibitions, especially as they evolved in the
Central European Secessions, was their restriction of membership. So like
their political brethren, they would be swept aside by modernists far less
democratic in vision than they, more exclusionary in practice, and often
profoundly anti-modernist in their social and political beliefs.[43] Con-
versely, under pressure from the ever-growing proletariat of artists, the *juste
milieu* as they were institutionalized in the Secessions crumbled in the first
decade of this century.

The *juste milieu* carried out their quixotic project against the background
of institutional reform, which in France had been a mainstay of Salon
Kunstpolitik since the Second Empire. The cultural ministers of the Third
Republic tried to fine tune their predecessors' adaptations in the Salon and
Academic system, but, much to the chagrin of many progressive artists, did
little to alter the essential character of Salon politics and its power struc-
ture. Just as 1863 marked a crisis in Salon politics, so too 1873 proved
cathartic when another Salon des Refusés had proved necessary. The fol-
lowing year, systematic reforms, carried out under the administration of
Philippe de Chennevières-Pointel, were initiated in the Salon manage-
ment. There was a general reorganization of the cultural ministry into a
Bureau of Fine Arts. It decided state purchases and commissions, the loca-
tion of these works, and the decoration of government buildings and public
spaces. It also continued to supervise the École and to award scholarships
and prizes. There were new and more elaborate adjustments and readjust-
ments of classes of medals, both in grade and in number.

The first Salon under this new regime held in 1874 contained 1,852
paintings by slightly over 1,000 artists.[44] The painting jury consisted of
fifteen artists selected by 176 voting members (that is, members of the
Institut de France, those holding the Légion d'Honneur, Salon medalists,
and Prix de Rome winners). The top five artists in the vote were Léon

Bonnat, J.-J. Henner, J.-N. Robert-Fleury, Fromentin, and Cabanel. The only "modernist" painter of any kind to receive a significant number of votes was the landscape painter, Charles Daubigny. Among the artists who placed works in the Salon, just under a third (320 painters) were not required to submit their work to the jury. There were 126 exempt artists and 194 *hors concours*.[45] Those painters who listed themselves as pupils of a master cited seven artists far more frequently than all the rest (by order of frequency): Léon Cogniet (well over 75 painters), Cabanel (over 50), Charles Gleyre (over 40), Gérôme, Paul Delaroche, M.-M. Drolling, and François Picot. (Of these artists only Cabanel and Gérôme were active in 1874.) The most frequently cited painter we now count among the moderns was Camille Corot with 17. What is evident from these figures is the domination over the Salon, even after years of reform efforts, by a small fraction of artists. They continued to exert through the juries and through the École Nationale des Beaux-Arts and the teaching ateliers considerable influence on contemporary painting.

Cogniet, a *juste milieu* painter of the 1830s, created a devoted following of students. As a master of the pastiche and formula history paintings, Cogniet educated a generation of artists who were to form a formidable coterie in Salon politics, insofar as they might share similar views on art. Moreover, the dominance of the conservative minority would last essentially unchanged until 1890 in part because of the longevity of the careers of the artists who controlled the Salon in 1874. Of the 1874 jury, only one died before 1887 and many lived into or even passed the first decade of this century. Bonnat, the leading vote getter of 1874, in 1910 was the head of the École Nationale des Beaux-Arts and the president of the French Council on Museums.[46]

Given the entrenched position of the academicians, the next step in Salon reform was the attempt to loosen the Academy's hold over the Salon, to democratize the system by granting artists greater self-determination. In 1863 in light of the controversy over the Salon des Refusés Chennevières first proposed the creation of a society of artists whose membership would be drawn from medal, prize, or state honor winners. A full outline of his proposal, complete with 200 signatures by prominent artists, including Millet and Manet, was presented to the then minister of Beaux-Arts, Maurice Richard, on the eve of the Franco-Prussian War. Interest in the project was revived in 1874 and argued over for another six years (the idea of artists running their own Salon was tainted with the air of the Commune) to be finally adopted at the end of 1880. The Société des artistes français replaced the Academy in the supervision and the jurying of the Salons.[47] In

Zola's words this decision turned the art world upside down and "unleashed all the dogs of politics."[48]

The Salon of 1881 was the first to be juried by the new society headed by Georges Lafenestre, *inspecteur des Beaux-Arts*. This Salon was in essence the culmination of a century-long effort at reform. Yet the "liberation" of the Salon was no cure for its commercialism nor did it solve the problem of too many artists competing for too few rewards. Far from it. By the late 1880s, to almost every observer the Salon appeared more commercial than ever. And the sheer weight of the numbers of artists competing for admission eventually forced, in 1890, the creation of a second, "reformed" Salon, the Société nationale des beaux-arts. The purpose of these state-imposed reforms had been, of course, fairness. The belief was that if artists chose their own jury out of their membership the bitter denunciations over favoritism and partisanship would go away. The majority would rule. The reality of the situation however was that the reforms of the seventies were put to a severe test by the ever-increasing number of exhibiting artists. The Salon of 1888 had the largest number of works exhibited in Paris during the nineteenth century: 3586 (excluding the unjuried Salon of 1848, which had 5,181 exhibits). In the passing out of rewards, it was inevitable that deep disagreements would arise.

Competition began in the art schools. The dissolution of the old Salon and the decline in the preeminence of the École des Beaux-Arts began with the decision by the state in 1875 to grant all artists the right, regardless of where in Paris they received their training, to participate in the Salon competitions. This opened competition with the École to numerous independent studios. When in 1878 it was decided to cede control over all aspects of the annual Salon to the artists, the professors at the Académie Julian's, which by this time had numerous studios around the city, possessed a disproportionate share of power, which they used to help control the juries of the Salons, etc. The reforms that opened access to the Salon to artists who had not passed through the École resulted in the unintended rule by professors of the competing official and unofficial art schools over the Salon. The English novelist and essayist George Moore wrote a highly colored, but nonetheless revealing account of the break up of the old Salon, which occurred in 1890. He described this schism in the Paris art world unsympathetically as the triumph of Julian's.[49] Moore described Rodolphe Julian in 1891 as

the most notorious and powerful personage in the Paris art world, whose studios are in every quarter of the town, almost as numerous as *braiseries*,

whose pupils, in the past and present, are numbered in the thousands, fear and hatred of whom have occasioned irreparable schism in *La Société des Artistes Français*, dividing it in twain.[183]

Even if we do not accept Julian as chief agent provocateur, Julian's schools eventually did overwhelm the École. Who did not study at Julian's at the end of the nineteenth century?

Julian's has often been portrayed as a sort of modernist school, representing a general improvement on the instruction of the École. Yet in reality, especially during the second half of the 1880s, Julian's was the bastion of the old school. A great many of the faculty taught at both the École and at Julian's. Julian, who began his career as a wrestling promoter, opened his art school in 1868, but the studio remained small until 1872 when Julian enlisted as instructors Jules Lefebvre and Gustave Boulanger. Lefebvre had been a recent Legion of Honor winner and was known for his portraits. Boulanger was a close friend of Gérôme and had exhibited primarily orientalist and history paintings. He won his Legion of Honor in 1865. They were, in short, among the most preeminent official painters in France. In addition to hiring prominent teachers Julian instituted a tradition of awarding small cash prizes and medals each month for the best student's work. This scheme neatly reproduced the official ladder of the Salon and extended its awards scheme to the lowest level of the artist proletariat.

Moore argued that Julian's influence over the French art world came to the fore in 1881 at the artist-controlled Salon. Anyone who had ever exhibited at the Salon had the right to vote for its jury. According to Moore, numerous franchised voters were only marginally artists and the system was further plagued by reputed ballot stuffing. As a result "the Salon had not enjoyed democracy more than three years when it came to be noticed that the best places were occupied by pictures painted by *les élèves de Julian*, and that a large proportion of the medals were distributed among them"[191]. Moore's view is supported by the fact that through the first two years of the artist-run Salon the Grand Medal of Honor was awarded to Paul Baudry and Puvis de Chavannes in succession, both artists by then of such stature as to be above party politics. But by 1883 no majority was found. Lefebvre himself gained only 180 of the 186 votes necessary. The same was true in 1884. The obvious deep divisions within the ranks of the Salon could not be ignored. In 1885 the rules were changed so that the winner could be determined by a relative rather than an absolute majority. The first two thus medalled were Bouguereau and Lefebvre.[50]

Within three years after the establishment of the artist-run Salon the

tensions within the leadership led the state to define more precisely the Salon's governing body. In an edict dated 12 May 1883 the government recognized a newly organized Société des artistes français, in order to distinguish the government-sponsored organization clearly from the older, less clearly defined society of artists founded in the 1840s, the Société des peintres, sculpteurs, graveurs. As it happened this older society was then led by Bouguereau, who was also the leading instructor at Julian's. The importance of this older society may be measured in the fact that in 1886 its total income was 191,300 francs annually, its expenses 188,897 francs, and that it paid out 85,694 francs in artists' pensions.[51] Though its annual income was less than a third of the newly formed Société des artistes français it still represented very significant numbers.[52] It was consequently a formidable institution of entrenched power, an alliance between a venerable artist organization and the new art schools that rivaled the École in prestige. So if Julian's was an important conduit for foreign artists to participate in the Parisian art world, thereby earning it some of its future "modernist" gloss, it was also the embodiment of the forces of entrenched power, of reaction. Precisely because of Julian's democratic power base, because it represented the interests of a very significant portion of the art proletariat, it became the focus of resistance to the reforms of the state and the way the Exposition Universelle of 1889 had been managed.

When the state ceded control over the Salon, it reserved from the artists' control the selection of the French contingent at the Expositions Universelle. The state also sought an additional "quality control" measure in the unsuccessful establishment of a "Triennial" exhibition, to be composed of the "best" art exhibited during the past three Salons. Jules Ferry, the Minister of Fine Arts, stated at the opening of the Salon of 1881 that "the annual Salon must be allowed to the artists to get before the public. It is an absolute necessity to them. The Triennial Salon will represent the art of France."[53] Only one such exhibition was held, in 1883. The second, scheduled for 1886, was cancelled under pressure from the artist community. But the friction between the state and the artists' Salon would persist over the matter of the Expositions Universelle. The creation of the Société nationale des beaux-arts indeed was a direct product of the controversy over the Exposition Universelle of 1889.

What first grated on the artist community was that the art section, now in marked contrast to the Salon, was ruled by an appointed government minister, Antonin Proust, rather than by artists. Proust, moreover, was well-known to be sympathetic to artists anathematized by the old guard, particularly Manet, for whom he arranged a small retrospective at the

Exposition. When one considers the publicly asserted reasons for the establishment of a rival Salon on the Champs de Mars, the motives for this "secession" strike surprisingly consistent themes with later Central European Secessions. The new Salon defended the principle of foreign exhibitors against popular local opposition, principally in the name of quality over quantity. Proust in his account of the schism emphasized the degree of jealousy and personal power at stake in the debate over the centennial exhibition of 1889 and Bouguereau's fear in particular that the revival of the dead would prove "useless or even mischievous."[54] Although tactful in his account of the origins of the schism, Proust generally confirms Moore's version, without, however, attributing to Julian's a role in these events. Proust did accept partial responsibility for the schism because, as he said, he set up a jury of "absolute impartiality" for the Exposition, which in turn awarded many medals and other honors to foreign artists. However, Proust believed that the refusal of exemptions for medal winners at the Exposition was "at bottom simply an excuse to cover their annoyance at not having been allowed absolute control of the department of Fine Arts in the Exhibition of 1889.[55] Perhaps to forestall criticism, Proust engaged J.-L.-E. Meissonier, the distinguished, conservative military painter, to form the jury."[56]

The government also held out the stipulation that the various medals and awards given at the Exposition would apply to the Paris Salon in future years. This meant that the *exempts* and *hors concours* given to foreign artists would result in their non-juried admission to any future Salon. This had been the custom of previous Parisian international exhibitions. Nonetheless, the leading professors at Julian's rebelled. According to Moore's statistics, in the nine years of the artist-managed Salon 1586 *hors concours* and *exempts* had been awarded. Add the awards to foreign artists at the Exposition and the number rose to 2079. If everyone took advantage of their privilege the freely admitted would exceed in size the largest Salon on record. Meissonier countered by arguing that many exempted artists do not exhibit at every Salon, that in fact, only 875 had done so in the Salon of 1887. Foreigners were even less likely to exhibit due to the transportation costs, the lack of state sponsorship, etc. Meissonier was shouted down. Out of the Executive Committee that led the Société, to which fifty artists were elected every three years, nine resigned: Meissonier, Puvis de Chavannes, Carolus Duran, Duez, Dagnan-Bouveret, Gervex, Roll, and a now-obscure artist by the name of Walter. Meissonier, as quoted by Moore, made the parting remark that it was deplorable that artists could not rise above

the interests of particular groups and societies . . . [and that] there is a sentiment of patriotism which, after the triumph of the Universal Exhibition, ought to overrule all, and that France by no faction of her children should seek to diminish the value of the awards that foreigners received thankfully at our hands with public acknowledgment.[195–96]

Although there were only nine signatories to this "secession," as soon as it was announced that this elite group was forming a new society "some fifty or sixty eminent painters"[196] joined the fledgling organization.

Both Moore and another analyst of the schism in the Paris art community, Charles Virmaitre, advanced the theory that at the heart of the controversy was the French fetish for medals, and specifically, for the power not only to receive them but to award them.[57] Even this medal fetish we should understand as an embodiment of the struggle over markets and over the control of what is considered valuable art. Bouguereau's fear of the potential rivalry of the art exhibited at the Centennale exhibition is extraordinary, yet understandable in light of the fact that though his fortune was assured, his reputation was a fragile construct and the threat of Manet, especially Manet as the endpoint of a linear progression of artists that did not include Bouguereau, which the Centennale exhibition embodied, represented not only a challenge to Bouguereau's pupils, but to his personal legacy to French painting.

The exhibitions of the Société nationale des beaux-arts, led symbolically by the figure of Puvis, represented the fundamental institutional victory of the *juste milieu*. Blanche, Gervex, Roll, and other painters of similar ilk, dominated the exhibitions on the Champs de Mars in the 1890s and through this institution gained international reputations. The Société nationale played a significant role, too, in defining the international "modernist" elite, who, as in the case of Germany, were also to be the leaders of their local Secessions. Liebermann was a regular exhibitor on the Champs de Mars until 1897. Walter Leistikow, who co-founded the Berlin Secession with Liebermann, exhibited at the Nationale from 1894 through 1896. Other notable German representatives at the Nationale exhibitions were Franz Skarbina, Uhde, Gotthard Kuehl, Fritz Thaulow, Max Slevogt, and Dora Hitz, all future Berlin Secessionists, and Klinger, who after Böcklin was regarded as Germany's finest artist. Among the other prominent foreign exhibitors one can count the Scandinavians Zorn and Krøyer, the Belgians Jean Delville, Léon Frédéric, Evenepoel, and Leempoels, the Americans Alexander Harrison, J. Alden Weir, Whistler, Sargent, H. H.

Robinson, William Glackens, Robert Henri, and Childe Hassam. Numerous other moderately progressive artists from many nations participated. Among the French artists who rose to international prominence in part because of the Société nationale were Béraud, Duez, Carrière, Lhermitte, Raffaëlli, and even Maurice Denis, who migrated from Nabis aestheticism and mysticism to an intensely colored, academically grounded, and hence mainstream painting. Occasionally "progressive" painters also found shelter in the society, most notably Alfred Sisley, who was a regular exhibitor (the only canonical Impressionist to exhibit with them). Artists such as Denis, Aman-Jean, and Anquetin, who belonged until the early 1890s to Parisian modernist circles, were reconciled to the cultural establishment and became professionalized members of the art community by showing at the Nationale. Of course, the Nationale subsequently became famous for launching future modernists, most notably Matisse, who first exhibited with them in 1897, his friend Henri Manguin, and the Czech artist, Franz Kupka. The Nationale was also considered progressive for its promotion of the decorative arts, making significant space for art nouveau designers and graphic artists such as Louis Tiffany, Gall, and Grasset. Cementing the ties between the literary culture of *La Plume* and the Nationale was the architecture section led by Frantz Jourdain and Hector Guimard. The Salon d'Automne became in a manner of speaking Jourdain's personal secession from the Secession.

We ought not be surprised that the luminaries of the Nationale were (besides the Impressionists) the most frequently discussed artists of the nineties, not only in Paris, but in Central Europe, Britain, and the United States. Because the new Salon quickly won governmental support it was given the kind of press attention and cultural cachet no other artist organization outside the old Salon had ever been given in Paris. And because the Nationale managed to preserve the international flavour of its exhibitions throughout much of its existence, as well as something of the quality of an elite exhibition—that is, between 1890 and 1899 the number of paintings shown fluctuated from the low of 910 in 1890 to a high of 1492 in 1899, which is a small figure compared to the 3,000-on-average works shown at the old Salon—these artists acquired an international audience and standing otherwise impossible to attain. They were the chief beneficiaries of the art criticism produced by the new generation of art periodicals of the era, such as *The Studio*, *Pan*, and numerous others, which served to introduce these paradigms of high culture to an ever broader audience. And these artists were almost de rigueur at the many international art exhibitions, owing to the international connections achieved by the Nationale.

Just as the international competition engendered the crisis in the Paris art community that split the Salon, international exhibitions of art would both be a cause behind virtually all the Secessions that emerged in the 1890s and the chief conduit for the spread of the *juste milieu* across Europe and America. No decade was more dominated by international art exhibition. Indeed, they virtually embodied in the fine arts the culture of fin-de-siècle Europe and America. It is unfortunate that the development of these shows has never been studied.[58] Clearly they do not duplicate the World's Fairs in London (1851), Paris (1855, 1867, 1878, 1889, and 1900), Vienna (1873), Philadelphia (1876), Chicago (1893), and a few lesser expositions in other European cities. There, though art was often given a privileged place—as, for example, in the 1878 Paris exhibition, where the giant iron and glass exhibition hall, constructed in concentric ovals, had as its center the fine arts—the World's Fairs on the Paris and London models were intended to wed the fine arts to industrial production. They were designed to elevate the standards of taste and to establish, if possible, the cultural and technical superiority of the host nation or even host city over its foreign competitors. The international exhibitions of art, by contrast, were primarily extensions of the local, official "Salons"—the Paris Salon was unusual for being by nature international—with the addition of a foreign contingent. Such was the case of Munich, which decided in 1869 to hold international exhibitions every ten years to supplement the annual state-sponsored exhibitions, which was realized once in 1879. Other cities gradually joined in. Vienna held an international exhibition of fine arts in the spring of 1882.[59] Berlin's first international exhibition was not organized until 1891.[60] And it was only then that Berlin began to be perceived as a player in the world of fine arts.

The typical international exhibition of the 1890s was devoted exclusively to the fine arts and invited other nations to participate in either publicly or privately curated group shows. The greater the exhibition the larger the number of foreign exhibitors. In Germany alone, international art exhibitions were held annually or biennially in the 1890s in Munich, Berlin, Stuttgart and Dresden (with other smaller cities holding at least one such show). There were comparable exhibitions in Paris, Vienna, Stockholm, Budapest, and many other European cities. The most enduring of all these is Venice's Biennale, which was established at the height of this fashion in 1895 (see the appendix for a list of the most significant international exhibitions).

The international exhibitions played a complex role in stimulating Secessionism and spreading European modernism. They served to establish the

kind of international artist, who would often be roughly identified with the French *juste milieu*, at its most modern, but who was more likely to be an enormously successful artist at home, and able to carry this success abroad. The waning of the international exhibition after 1904—the St. Louis World's Fair produced far more cultural conflict than it displayed notable cultural artifacts—led to the substitution of a new type of show, beginning with the 1909 Cologne Sonderbund exhibition and refined through its subsequent and ever-more ambitious shows, continuing through Fry's Post-Impressionist shows at the Grafton Galleries, and culminating in the 1913 Berlin Herbstsalon and the New York Armory Show. These were exhibitions at once retrospective and profoundly polemical, without state-sponsorship, and held with the intention to circumvent utterly the rule of official tastes.

Until then, one major consequence of the spread of international exhibitions was the persistence of the impression that Salon or academic artists represented the best or even all that was being produced in a specific country. It is true that one found on rare occasions a small contingent of Impressionist pictures at such exhibitions, but they had negligible impact (for example, on German tastes) until the end of the 1890s. Impressionism would not occupy a truly significant place at such exhibitions until after the 1900 Exposition Universelle, which established Impressionism for the first time as lying at the center of the French tradition. The same international cast of artists appear in exhibitions in Munich, in Vienna, in Paris, and so on. Many of these artists were Secessionists, such as Liebermann in Berlin, Uhde and Böcklin in Munich, Klimt in Vienna, Blanche and Carrière in Paris. That many were not modernists, or were at most intermediaries between the most modernist styles of the time and the typical Salon fare, reflect exactly the same aesthetic composition as the Secessions. This *juste milieu* was at the outset mistaken for the most modern art in Europe. In Berlin, artists such as Besnard and Cottet were called Impressionists. Symbolism was represented not by Gauguin, but by Léon Frédéric.

Consider for example the first exhibition of the Vienna Secession, which was held in the converted rooms of the Gartenbau in the spring of 1898. The Viennese art critic and apologist for the Secession, Ludwig Hevesi, enthusiastically described the show as containing "some of the greatest living artists, who for Vienna had hardly existed, [and who] fill here entire walls, even rooms."[61] Yet these artists represent a virtual role call of the *juste milieu*. French artists were represented by Roll, Besnard, Carrière, Henri Martin, Dagnan-Bouveret, Raffaëlli, Aman-Jean, Lhermitte, Pierre Lagarde, and A. Berton. The Belgians were represented by Frédéric, Laer-

mans, and Khnopff, the "Dutch" by the American Gari Melchers, the Scandinavians, Thaulow, Krøyer and Liljefors, the English and Americans, Harrison, Whistler, Shannon, Sargent, Swan, Muhrmann, Walton, Lavery, Strang, Fowler, Brough, Fromuth, Italy by Segantini, the Germans by Klinger, Kuehl, Kalckreuth, Dettmann, Stuck, Mackensen, Erler, J. Exter and Zügel. The sculptors were Rodin, Bartholomé, Charpentier, Carabin, and Constantin Meunier.

The exhibition record of one of these artists at the Vienna Secession illustrates both the visibility and success offered by this international network of exhibitions. Gari Melchers was born in Detroit in 1860.[62] His father was a German expatriate who had made a national reputation for himself as a sculptor. He was educated in Europe, first at the Düsseldorf Academy and then at the Académie Julian, where he was a student of Gustave Boulanger and Lefebvre. He then enrolled in the Ecole des Beaux-Arts and subsequently showed in the Salon of 1882. In 1884 Melchers took up residence in the Dutch fishing village of Edmond aan Zee, which would become the locus of his work and where he would often reside for the rest of his life. In 1886 he won an honorable mention at the Paris Salon and a gold medal at the Amsterdam "Exhibition of Living Masters." These prizes were followed by a first class gold medal at the 1888 Internationale Kunst-Ausstellung in Munich and a third-class gold medal at the Paris Salon. In 1889 he won the grand prize for the American contingent at the Exposition Universelle in Paris. In 1891 he took the medal of honor at the Internationale Kunst-Ausstellung in Berlin. In 1892 he received the gold medal at the Philadelphia Art Club and the Order of Saint Michael of Bavaria, 4th Class from Munich (this was subsequently upgraded in 1895 to Knight of the Order of Saint Michael and in 1902 to the Royal Order of Saint Michael). He was on the jury of the Chicago World's Columbian Exposition in 1893 and in 1894 took the Medal of Honor at Antwerp's Exposition Universelle. In 1895 he was made Chevalier of the Legion of Honor, France. A shower of medals and honors followed. In 1900 he was given an entire gallery at the Große Berliner Kunst-Ausstellung, named Academician by the National Academy of Design, New York in 1906, member of the Royal Society of the Arts, Brussels, and member of the Institut of France in 1908. The awards continued to mount right through the outbreak of the First World War (between 1909 and 1915 he was professor of art at the Grand Ducal Academy of Fine Arts in Weimar).

This extensive recital of honors provides a valuable insight into the international flavor of the official art world. Melcher's career, while extraordinary successful, marks the typical professional path taken by most of the

notable artists of the fin de siècle. And it was artists like Melchers who sat on official committees and juries during the first rush of the European avant-gardes. As an artist, Melchers blended an Impressionist palette to the genre subjects of Dagnan-Bouveret and Liebermann. During the late nineties his work reflected some of the stylization of international symbolism. After 1900 his themes and open facture return to Impressionism, but now infused with the sensibility of the Nabis, in particular Pierre Bonnard. He was never "avant-garde" but always on the edge of what was most modern in a particular era. But his deft combination of modernity and traditional themes and academic drawing allowed him to reap such universal institutional awards. Like Melchers, the vast majority of the artists represented at the Vienna Secession in 1898 developed their careers along traditional, official lines. It was only in their maturity, as already notable artists, many with international reputations, that they took the decision to secede.

Secessionism

THE SECESSIONIST IDEAL AND THE MUNICH SECESSION

THE Central European Secessions constituted a unique historical moment when artists attempted to shape themselves as a professional class, as legitimate members of an expanding middle class culture, alongside other residents of professionalism such as doctors, lawyers, and university professors.[1] In the face of the academies' century-long intransigence toward aesthetic and institutional rivals the Secessionists sought to create an independent alternative, but no less prestigious, to the identity of the academician. Although customarily the Secessions are viewed as institutional expressions of modernism, it is more useful to see them as products of a far wider crisis in the organizational effectiveness of the traditional educational and exhibition societies of the nineteenth-century art world. Secessionist-like artist societies were, in fact, deployed over a far greater geographical range than is usually granted, circling the globe from Moscow to Tokyo. The literature on Secessionism has tended to make heroes of the artists, to defend their modernity, and to assert the aesthetic value of the work they exhibited, albeit with a sense of their "inferiority" vis-à-vis French modernism.[2] Secessions are read in this manner as "avant-garde" organizations. Almost the opposite was true. Despite the coincidence of the rise of Secessionism with important changes in aesthetic norms that we associate with the expansion of modernism in the visual arts, the Secessions were not inherently the cause nor even the most important vehicle for aesthetic modernism. It is true that Secessionism was portrayed in contemporary criticism and in the statements of the Secessionists themselves as the revolt of the young against the old, radicals against conservatives, modernists against academicians, the disenfranchised against vested interests. But these assertions need to be weighed against the observation that the Munich Secession, to take the earliest example, represented little aesthetic innovation, much less possessed the stylistic coherence or shared ideological ambition that one associates with avant-garde movements. It had its original talents, such as Franz Stuck, but neither Stuck's originality nor the rejection of his work by his conservative contemporaries was to be a reason for his

active role in seceding from Munich's venerable Künstlergenossenschaft. The same could be said of the membership of the Société nationale.

Embedded between the Secessionist image and its everyday expression was an internally contradictory institutional message. Secessionism's aesthetics and politics were formed within an atmosphere that was not only willing, but insisted upon politicizing the Secessions, to extend their mission beyond artistic reform to general societal reform. As organized opposition to state-supported art institutions in their respective cities, the Secessions often occupied the loci for more than art-world dissent, becoming prominent oppositional symbols to a variety of state policies stretching beyond the arts into social mores, censorship legislation, and more wide ranging political issues. This was particularly true of the Berlin Secession, which seemed to offer a direct reproach to the regime of Wilhelm II.[3] Yet, the actual "politics" of Secessionism is best considered as reformist. Only rarely, as was the case with Vienna's, did a Secession defend an explicitly coherent ideological and aesthetic position.

The very name Secessionism signifies the division of official art societies which led to the founding of the rival Paris Salons. Compared to the ideologically and aesthetically radical image of the Parisian Indépendants, the Nationale's ambition to acquire state sponsorship aspired to public approbation, to have the society recognized as the equivalent of, if not superior to, the older society. To secede is not to negate, to cancel out, the older institution or the art it fostered—as would be the perennial modernist paradigm. If it dismissed the old, the Nationale, like the Secessions after it, still sought to find a place alongside their former comrades. This was institutionally expressed by the state's immediate granting to the Nationale of official recognition and an exhibition pavilion on the Champs-de-Mars to exhibit its wares. After 1900 some Central European Secessions attempted a more fully independent course, to build their own exhibition galleries and to acquire professional management, a legal advisor or a commercial advisor or both (the Berlin Secession also had its literary advisor). As contemporary criticism demonstrates, however, even the Berlin Secession's exhibitions were received in comparison to, not in place of, reviews of the older Große Berliner Kunstausstellungen.

Their need for professional help compromised from their inception the independence of the later Secessions. A leitmotif of the Secessions would be their ever-deepening involvement with art dealers. Nor did the Secessions escape the politics of public financing. In many cases, the Secessions still looked to local or regional governments for assistance to erect their buildings or to underwrite their exhibitions, or even to buy their works. Lastly,

the Secessions' leadership was consistently composed of many of the most prominent artists of the day, who were well connected to social, cultural, and political elites within their respective communities. Their oppositional image was not, therefore, set against, but depended upon, the local ruling elite. As a rule they expected public acceptance rather than courted confrontation.

When *Kunstchronik* announced in its 14 April 1892 issue the split in the Künstlergenossenschaft, the reporter assumed that the seceding artists "had the intention to found an international society in the manner of the Société nationale des beaux-arts in Paris, and to include only really prominent artists."[4] The Secessionists offered the same reasons for the divorce as those that split the Parisian artist community, reflecting above all the single greatest pressure on fin-de-siècle artists, the competition for publics. The international art exhibitions had encouraged a substantial increase in art production and a steady internationalization of the art world. The *juste milieu* accumulated considerable personal wealth catering to an international clientele. But the same system capable of producing princes also turned out many more proletarians. Some months before the official opening of the first Munich exhibition of the Secession (July 1893), Hans Eduard Berlepsch-Valendas, an architect, critic, and founding member of the Secession, described the other side of the international art world from Munich's perspective.[5] He observed that the byproduct of the annual exhibitions—which had only been instituted in 1888—and the many regional art schools was an ever-growing number of exhibitors at the Glaspalast, Munich's exhibition hall. Local artists were irritated by the fact that the majority of exhibitors were foreign artists. Six hundred sixty-one German artists exhibited 1258 works, while non-Germans represented 706 exhibitors displaying 1876 works. Among the German contingent Munich artists made up just 393 members. A disproportionate share of medals were going to artists living outside Germany and art sales were, alarmingly, following this same trend. And despite the Glaspalast's internationalism, Berlepsch argued, it had failed to raise the level of art in Munich, or the level of quality of state purchases. Berlepsch noted that the Munich museums failed to acquire works by artists of the caliber of Courbet, Diaz, Rousseau, Corot, or Daubigny, but paid 5,000 DM for a painting by an artist named Raffet. In other words, the internationalism had not led to a public more-informed about contemporary artists at home and abroad, but merely offered market wares for uncritical admiration and acquisition. Berlepsch warned of a coming "workers' strike" in the art community (plans for the Secession had been underway since early April 1892). The state would learn

that "the respect one renders to foreigners is above all also due to those who belong to one's own house." What that "respect" would consist of Berlepsch did not say, but the implication is that native artists of some standing should be accorded the same privileges as esteemed foreign guests, that they should not have to compete with the mass of exhibitors for space and favorable hangings. The Munich Secession responded to the growth of Munich's art proletariat by insisting that its exhibitions serve quality over quantity. It would continue to support internationalism, but there too it would attempt to upgrade the quality of the foreign guests, to make them truly "representative" of the best of foreign art. Thus the two key terms in the *Kunstchronik* report were the international qualities of the society and the insistence on including "only really prominent artists."

In a brief, but important essay on the Munich Secession, Renate Heise has noted the intensity of the debate, especially in the daily press, that was generated by the prospect of Secessionism.[6] The establishment of the Munich Secession appeared to many as a conspiracy, since it coincided with a press war between the liberal newspaper, the *Münchener Neueste Nachrichten*, published by Georg Hirth, and the conservative newspaper, the *Allgemeine Zeitung*. Both papers published almost daily reports on the various ramifications of the split in the Munich art community. On the issue of international representation at Munich's annual art exhibition, the *Allgemeine Zeitung* stated in an editorial of 21 June 1891 that "Munich should be above all for Munich artists and not for other artists and art movements."[7] Conversely, the *Münchener Neueste Nachrichten*, through the activities of its feuilleton editor, Fritz von Ostini, and the liberal outlook of Hirth, vigorously supported internationalism. The paper allied itself with those figures inside Munich's Künstlergenossenschaft, most interested in expanding foreign participation in the annual shows, particularly Fritz von Uhde, the chair of both the painting and the entire exhibition jury for the 1891 Glaspalast exhibition (which was the notorious exhibition recounted by Berlepsch that exhibited more foreign than domestic artists), and Adolf Paulus, the business manager of the Künstlergenossenschaft.

A non-internationalist, non-elitist reading of the Secessions cannot account for their emergence as part of the social and cultural mainstream of their respective societies. The Secessions put into common currency in Central Europe the idea of the elite exhibition, a display of a comparative handful of works of art (100 or 200 paintings and sculptures) compared to the 4,000 or so exhibited at most annual state exhibitions. Modeled after the commercial gallery show, the artist-run elite pretended to the values of the old academies. As the architectural critic (and later Nazi ideologue) Paul

170

Schultze-Naumburg wrote in 1896: "Without question, the most important thing primarily owed to Secessionism is the form of the small elite exhibition, since it was first introduced through this association and since for at least the foreseeable future it will likely remain the single most valuable contribution to exhibitions."[8] Exhibitions devoted to only the most prominent, international artists constituted a radical program certainly, but not a kind of artistic radicalism. As George Moore wrote in 1891 in defense of the Nationale, "in art the democratic is always reactionary."[9]

Paradoxically, then, the Secessions came to represent a powerfully antidemocratic force within the *Kunstpolitik* of the era. They asserted a professional class of artists against a rank and file proletariat who were led largely by academicians. Defending their policies of exclusivity and internationalism the Secessions claimed to put art over politics, quality over quantity. They therefore turned to an international elite of artists as bearers of the standard of quality to be preferred over the production of "lesser," local artists. But as in Berlepsch's comments regarding the exhibition of the "finest" artists, both foreign and domestic, there was little effort to define the criteria for quality the Secessions so emphatically announced. Consequently, the first exhibitions of the Secessions, like the *juste milieu* they represented, were by and large heterogeneous, undoctrinaire, essentially pluralist, and ahistorical in outlook.

Since the Secessions were not deliberately constituted against the idea of public works, they sought to achieve a precarious balance between the private market and the rewards of official commissions. How fragile this balance was may be seen in the context of the Vienna Secession, where Klimt, as head of the Secession, was embroiled in controversy in the first years of the century over his University-ceiling decorations: their celebration of irrationalism and the mutability of life were at odds with the rational materialism professed by the University. Comparable conflicts between public and private concerns were articulated in two extraordinary sculptures exhibited at the Secession in 1901 and 1902, Rodin's *Burghers of Calais* and Klinger's *Beethoven Denkmal*, respectively. Rodin's sculpture, although publicly commissioned, symbolized by the controversy it aroused the divorce between the essentially private vision of the artist and the demands of public sculpture. Klinger's homage to Beethoven, though a monumental sculpture, was not done on commission; was not, in reality, a public sculpture. It was as much a privately conceived work of art as the paintings on display in the other Secession exhibitions. (Eventually it was purchased for the Dresden state collections.) What I am suggesting is that by identifying with the commercial market, the Secessions declared an independence from

official and public sensibilities, but at the same time did not wish to forestall their chances at earning public commissions.

We ought also not overlook the intimate organizational links between the Secessions and the commercial galleries. The elite among the Secessionist elite would exhibit simultaneously with the Secessions and in a gallery. This too made the Secessions a natural bridge to the market, which offered fewer, but more lucrative opportunities for artists. The Secessions inadvertently encouraged a commercial structuring of artistic identity that led elites to form perpetually within elites. As in Paris, where Petit's Société internationale introduced to the public the artists who would later rule the Nationale, so too in Central Europe a close relationship existed between the various dealer-supported exhibitions of groups and of single artists. The Nationale was the most forceful exemplar for the Secessions. But the smaller dealer-sited exhibition societies (e.g., the Rose + Croix, the Salon des Cent, and so on), which were lodged half-way between commercial galleries and officially sponsored exhibitions, also had their Central European equivalents.

One important if unexpected result of sharing their institutional platform with the art market was manifested in the role the Secessions played in facilitating the ever-growing dialogue between radical French modernism (which existed only in the art galleries and the mostly ignored Indépendants) and the Central European art community. In the course of a decade of Secessionism one sees the passage in German art from naturalism to symbolism and from symbolism to Impressionism. The Secessions built a climate for European modernism that dealers, left to themselves, may not have been able to do, or at least do so rapidly. The Secessions possessed from the beginning an aura of disinterestedness, so that not only their own art but also that of the most advanced French painters could be viewed not merely as *Sensationsbilder* but as authentic works of art. In effect, the Secessions acted as a buffer between the apparent commercial atmosphere of the annual "Kunstmarkten" and the assumed nobility of the artistic enterprise. They preserved the distance between the world of goods and the world of art.

In her recent book, *The Munich Secession*, Maria Makela recounts how the Künstlergenossenschaft entrusted the 1891 juries to convinced internationalists because of an on-going rivalry between Munich and Berlin, especially in the wake of Berlin's plans to produce an annual, or perhaps biennial, international exhibitions.[10] These Große Berliner Kunstausstellungen were controlled by the director of the Akademie der Künste and president

of the Verein Berliner Künstler, Anton von Werner. Under Werner's ener-
getic leadership the heretofore minor Berlin academy exhibitions were
transformed into ever-larger affairs, eventually with national and interna-
tional pretensions. When the Berlin Künstlerverein suggested in 1891 that
Munich and Berlin should hold their international shows on alternate years
(Munich foregoing an international exhibition in 1892), the Munich artist
community saw this as a direct threat to Munich's artistic preeminence (and
of course a further example of the Prussianization of Germany). Yet Munich
artists received more than they bargained for when Uhde's juries produced
an exhibition in which Munich artists represented less than a quarter of the
exhibitors. When it was also observed that in addition to an unusually large
share of medals going to foreign artists, the works sold from the exhibition
were dominated by foreigners, there was a general revolt in the community.
That summer, the *Münchener Neueste Nachrichten* published three succes-
sive articles on the mismanagement of the Künstlergenossenschaft's exhibi-
tion.[11] The articles attacked the society's president Eugen von Stieler and
its secretary Karl Albert Baur, accusing them of deliberately underpubliciz-
ing the exhibition in order to sabotage the show because they objected to its
extremely large foreign contingent. The exhibition had not attracted nearly
as many visitors as had been anticipated and proved a serious financial
failure. Hirth was sued for libel and lost.[12]

Hirth's articles were nonetheless representative of the prevailing view
among progressive artists and critics that limited foreign representation at
the Glaspalast led to limited interest in its exhibitions both from elsewhere
in Germany and abroad, which in turn contributed to declining revenues.
The articles proposed (and not for the first time by the *Münchener Neueste
Nachrichten*) that an independent Verein be established and that the state
should fund it. When reforms were instituted in the Künstlergenossen-
schaft, essentially eliminating the control over the selection of foreign
exhibitors by either the jury or by the business management (i.e., Paulus),
the *Allgemeine Zeitung* was quick to call for the dismissal of Paulus from the
society. It was this dismissal (in addition to the jury reforms) that touched
off the Secession. Divisions between the new society and the old, between
the liberal newspaper and the conservative, between the "young" and the
"old" (Hirth had something to do with emphasizing this last division with
the publication of his cultural journal *Jugend* in 1896 and the illustrated
satirical magazine *Simplicissimus* that made fun both of Prussianism and the
established powers of Bavaria's social and cultural life) colored from the
beginning the institutional activities of the Munich Secession.

Before the first exhibition of the Munich Secession occurred in their own

locale in 1893 the leadership, largely through the assistance of Paulus, had arranged to exhibit their "Stammtisch" group, which they called the "XXIV" (in imitation of Berlin's own "Eleven") at the Berlin gallery of Edouard Schulte. They included Bruno Piglhein, Hugo von Habermann, Keller, Uhde, Benno Becker, Corinth, and other notables. The Munich Secession also began negotiating with the exhibition committee of the Große Berliner Kunstausstellung. The Secession asked for its own jury, its own rooms, and its own hanging committee, and, by a narrow vote, got them. And they even brought with them their own foreign artists. In addition, both the cities of Frankfurt and Dresden offered exhibition space for the Secession in exchange for a long-term commitment from the society to exhibit there. Indeed, it was the pressure of these rival cities—joined later, secretly, by Berlin—that eventually forced the Munich city government and then the Bavarian state into negotiating with the Secession, providing first land, then money, then, later, state purchases.[13] The institutional success of the Secession was matched by its commercial fortunes. Its leadership was able to exhibit at Schulte's for many years under the umbrella of the "XXIV." The commercial attractiveness of the Secessionists was such that in 1894 Ludwig Gutbier, proprietor of the Kunstsalon Ernst Arnold, announced that he was opening a branch of his operations in Dresden's Altmarkt devoted exclusively to the exhibition and sale of the Munich Secessionists. Singly and as a group, the Secessionists were in great demand by every regional exhibition society in Central Europe.

An essay by the Berlin critic, Otto Mittelberg, who reviewed the first Schulte exhibition of the "XXIV" for the progressive literary journal the *Freie Bühne*, demonstrates the characteristic fusion of the institutional and political elements of Secessionism.[14] The main purpose of the review was not to admire the aesthetic worth of the exhibitors' work, but to point out the essential, and what he believed was the necessary, elitist character of their organization.

> The artists' strife which now breaks out everywhere has in its first line a social side—ideals limp far behind. Above all in Munich it concerns whether the exhibitions should be for—besides the artists of first rank—artists of middle rank or for foreigners, whether it is right to exhibit many paintings of less worth from Munich or few and only good pictures, not coming, however from Munich.[201]

This conflict over exhibition opportunities could not be resolved by the government, however, because of the new role held in German art politics by the commercial gallery. (In Munich, the opposition of city and state

officials to the Secession was less ideological than motivated by the concern that a divided art community would undermine the city's preeminent place in German art.) Mittelberg maintained that the art dealers had already taken over the exhibition responsibilities that formerly had been the role of the local *Staat* exhibitions and the various *Kunstvereine.* "Already some art dealers give to single artists, to groups, to whole schools, the right to be 'single representatives' in the room"[202]. In short, the commercial gallery had replaced what was believed to be the more altruistic, and certainly more nationalistic, *Kunstvereine.*[15] And that the process of fragmentation, encouraged by the dealers, was virtually inevitable.

The developing custom of exclusive representation through commercial exhibitions undermined the official exhibitions. Convinced of the permanence of this commercial reality, Mittelberg argued that the positive aspects of Secessionist-like organizations lay in their ability to overcome two principal obstacles to the aspiring artist, the dealer, who in isolation takes advantage of the artist, and his own fellow artists, "who in this autonomy see ever greater arrogance"[203].

> No one has understood original artists less and has persecuted them more than their comrades. It silences even delightful artists whose work has been rejected, so that heretofore nothing has been known of them. But one sees from the tale of suffering by Böcklin, Feuerbach, Thoma, the French Impressionists, and many others that these are not so much artists who "understand something about art" as they are, in their totality, the custodians of respectable mediocrity.[ibid.]

This is a telling remark. Not only is it a subtle reply to the critics of the Munich Secession, but the author for the first time cites a litany of great, suffering German "modernist" artists, and even more remarkably, allies them with the Impressionists (even though one may doubt whether Mittelberg was personally familiar with their art). For Mittelberg, the economic and cultural elitism fostered by the artist organization was the best means by which artists could control their own destiny. Those who did not understand why the Munich Secession wanted its own rooms, its own jury, and its own sales office in the Große Berliner Kunstausstellung mistakenly believed that under the flag of Secessionism "young painters remove their daring creations from the testing eyes of the older generation. This is fundamentally wrong"[204]. In fact, the leaders were neither young nor needed to avoid the examination of their peers. It was a matter of having a "free hand," though this might separate artists "into an aristocracy and a proletariat"[ibid.]. Even so, Mittelberg believed that the request for official,

separate exhibition space at the Berlin annual should not be regarded as a bad precedent for Berlin but should be welcomed. He suggested, in effect, that the Secession was the modern replacement for the *Kunstverein*, that it served to elevate art above the marketplace and above the *Kunstproletariat*, for the sole purpose of improving the quality of contemporary art.

The limitations of its "liberal" program, however, were apparent even at the first Munich exhibition. Otto Julius Bierbaum, the critic and play-wright, reviewed the two Munich societies' exhibitions in 1893 in his book *Aus beiden Lagern*.[16] Bierbaum was not the dispassionate, unbiased observer that the book appeared to claim he was. The same year that he published this "even-handed" review of the two societies' exhibitions, he was enlisted by the Secession to write an introduction to a collection of photogravures after Secessionist work.[17] Bierbaum was also to become the founding co-editor of *Pan* (1895), which was widely perceived as the most-modern art journal of its kind anywhere in Europe—though its editorial policies would betray an artistic elitism more strongly than an aesthetic radicalism. So in this context, *Aus beiden Lagern* represented as much an apologetic for the Secession as a critique of their enterprise.

Bierbaum was emphatic in his belief that the Secession did not represent a struggle between idealism and "brutal reality" (i.e., naturalism). Instead, he argued that the Secession represented no real "new direction." The society was composed of great individual artists, who inherently followed their own course. Moreover, for Bierbaum the aesthetic divisions that might arise between naturalism and idealism are dissolved by the individual personalities of the great artists gathered together at the Munich Secession. Consequently, the difference between the Secession exhibition and that of the Glaspalast in 1893 rested in the fact that "the Secession's exhibition although quantitatively still much too rich, is a much stronger and finer small collection, in which the relationship between the good and the aver-age is much better defined."[13–14] Conversely he saw the Glaspalast as an overwhelming mass of wares that obscured the quality works that were still to be found in the exhibition if one had the diligence to search for them. So, on average the "difference between the two enemy camps lay in the fact that at the Glaspalast the masses represent the old *Schablone* [kitsch], while the majority [of exhibitors] in the Prinzregentenstraße [site of the Secession pavilion] belong to the new and the newest"[15].

The Secession's commonality was not a matter of style but instead lay in their politically liberal opposition to the conservatively entrenched artists.

Art cannot be the monopoly of a *Verein*. . . . In art especially the man is the strongest who stands alone. . . . *Künstlervereinigungen* have for this

176

reason . . . only to do with *Kunstpolitik* and have no purely artistic signifi-
cance.[19]

That Bierbaum and many others repeatedly pointed out that artists were
neither diminished nor strengthened by their involvement in *Kunstpolitik*
was but another sign of their effort to detach these artists and their work
from commercial interests. Bierbaum also pointed out that the issue of
internationalism, the principal cause behind the division of the art commu-
nity, had resulted ironically in both camps admitting important foreign
artists. From the point of view of these invitations, neither exhibition was
more "advanced" than the other. At the Künstlergenossenschaft's show
Watts, Burne-Jones, and Alma-Tadema were exhibited. And the sensation of
this exhibition was the Dutch symbolist painter, Jan Toorop, and his paint-
ing *The Three Brides*. At the Secession were Herbert Herkomer, Dagnan-
Bouveret, and representatives of the Glasgow school of painting—and a
very small collection of Monets.[18] (The really radical exhibition that year
belonged to a private gallery in Munich that showed Edvard Munch.[19])

Symbolism was perhaps better represented at the Künstlergenossen-
schaft and naturalism/Impressionism at the Secession, but the overall im-
pression left by the two exhibitions is that the Secession was virtually ten-
dency free. Of course, this view remained at odds with the other perception,
that the Secession represented *junge Kunst*. In the essay Bierbaum wrote for
the Secession publication, he defended the Secession's internationalism
against the view that it posed a threat to German culture, remarkably
anticipating the much later Expressionist apologies written after 1910:

> if we must confer on foreigners, especially the French, the credit for having
> performed the chief labor of producing the modern technique [that cap-
> tures] external reality, so we ought to declare without national prejudice
> that for the soulful [seelische] fulfillment of modern art with poetic con-
> tent, the richest buds, flowers, and fruit are to be found on German soil.[20]

In this view, efforts at elite exhibitions, etc., were designed only to purify
German art, to reveal its essential character in the face of its foreign
competitors.

The success of the Munich Secession in the art market outweighed even
its political prestige. The first Munich exhibition of the society was a great
fiscal success. On the first Sunday alone it attracted 4,000 visitors. It covered
all its expenses through admissions and sold one fifth of the total number of
works displayed, approximately fifty paintings and sculptures.[21] The
second exhibition sold about 100 works of art for approximately 220,000
DM.[22] Although it was hotly debated inside the art community and in

government circles, the state then agreed to purchase art from the Secession as well as from the Glaspalast and the city gave financial support to both societies. On the other hand, the government subvention of the Secession led to the weakening of the aims of the organization. In its opening manifestoes the Secession claimed it was above party interests and that its elite exhibition would simply cultivate the great art personalities of the age. But who was to say who those personalities were? What quickly happened was that the established leadership of the Secession became its own vested interest. It proved not to be more tolerant of younger artists than had the Künstlergenossenschaft.

Already between the first local exhibition of the Munich Secession and the second the society managed to produce its own "secession." Many of the best artists in the Secession, including Corinth, Otto Eckmann, Carl Strathmann, Hans Olde, Peter Behrens, Max Slevogt, Wilhelm Trübner, and other representatives of the Munich Jugendstil movement withdrew from the Secession to form their own, even more elite exhibition society under the name Freie Vereinigung.[23] In the absence of exhibition space at the Secession pavilion and without a convenient Munich dealer in Munich with whom to show, the new group approached the Künstlergenossenschaft for a separate room at the Glaspalast, which, remarkably, they were granted (the Künstlergenossenschaft may have wanted to demonstrate that they were as liberal or more so than their Secession rivals). The Freie Vereinigung proposed that their section of the Glaspalast should be arranged without statutes, without juries (that is, by invitation only), and that it would be international. Their show, however, was generally reviled by the press and by the public, catechized for their "society megalomania." The members were individually blackballed by the Secessionists, who refused to associate with them. And yet, the difficulties of the Freie Vereinigung in Munich served as a springboard for a group exhibition at the Kunstsalon Gurlitt in May 1894, opening even before the Glaspalast exhibition.[24] Gurlitt gave them a second exhibition in 1895, which, following the Secessionist pattern, included their own foreign guests—among them Toorop, the Danish painter J. F. Willumsen, and the Finnish artist and later member of the Brücke, Gallén-Kallela.[25]

Perhaps in answer to the Freie Vereinigung's exclusivity, the Munich Secession strongly cut back on the number of works displayed in their second exhibition. This action was warmly greeted by the reviewer for *Die Kunst für Alle*, Georg Voß. He praised the strong jury that had decided to make the Secession "not a bazaar, but an academy of new art, an elite group, which represents only the most worthy within its ranks."[26] And because this

Secession exhibition was dominated by Munich artists, Voß also praised its "powerful, self-conscious feeling of nationalism." The Secessionists more than stood up to their international comrades through their "creations of a true Germanic artistic spirit." Voß' intention was to argue that the Secession's internationalism was in no way unpatriotic, that it did not interfere with the Germanic quality of its native artists. It merely eliminated mediocrity. Eventually, however, successive shows of the Munich Secession, though always smaller than the exhibitions of the Künstlergenossenschaft, presented a pool of talent progressively diminished by average artists. Qualitatively, the Secession became nearly indistinguishable from the Künstlergenossenschaft. Indeed, beginning in 1897, the Munich Secession again exhibited at the Glaspalast, thereby becoming little more than the largest of what had become numerous independent groups on display.

The Secessionist idea meanwhile spread quickly throughout Germany. In the spring of 1893 a Düsseldorf group, "St. Lukas," was given its first exhibition at Schulte's branch gallery in that city (the gallery would show the "St. Lukas" group annually for many years).[27] Schulte also sent their second exhibition to his Berlin gallery in 1894 where it was sympathetically greeted by most critics. In the winter of 1894 a new Verein bildender Künstler Dresdens, which took its name from the Munich Secession, held its first exhibition in the Lichtenbergschen Kunstsalon. This society had about fifty members and exhibited 119 works by 35 artists. The most notable artists in the group were the future Neo-Impressionist and Berlin Secessionist Paul Baum, and the symbolist landscape painters, Karl Mediz and Emilie Mediz-Pelikan.[28] The Dresden Secession joined with Munich's for an exhibition in Vienna at the Künstlerhaus in January 1895.[29]

By 1895, Secessionism had become widely familiar and increasingly acceptable as a normal part of German artistic life. That year the "St. Lukas" club was joined at Schulte's in Düsseldorf by a local "Freie Vereinigung." And the Munich Secession showed again at the Große Berliner Kunstausstellung. Jaro Springer, the Berlin critic for *Die Kunst für Alle*, even complained that the Secession exhibition was not very special because it introduced no new groups with radically new work.[30] And yet, despite the intermingling of talented artists between the Künstlergenossenschaft and the Secession, the popular impression remained that there were great enduring differences between the two venues. In reality, the Künstlergenossenschaft's juries seem to have gone out of their way to cultivate disgruntled Secessionists and Vereinigung artists.[31] At the 1895 exhibition of the Glaspalast, the Worpswede artist Fritz Mackensen and the Russian realist Ilya Repin were given first class medals, while Corinth, Eckmann, and the

Arts and Crafts leader, Walter Crane, all received second class medals.[32] And Böcklin, everyone's choice for Germany's greatest artist, exhibited in both places.

The early success of the Secessions in fostering commercial demand led to ever-raised expectations for artistic novelty that later Secessionist exhibitions generally failed to meet. For example, Springer dismissed the 1896 Berlin exhibition of the Eleven with the observation that the show was "more quiet and more harmless than before."[33] Karl Voll in his review for *Die Kunst für Alle* of the V. Internationale Kunstausstellung of the Munich Secession wrote that "we receive the impression here that the new German art has become tame."[34] Critical reviews notwithstanding, the Secessions continued to demonstrate the commercial power of independent artist organizations, especially those that could suggest a political or aesthetic program. Characteristically, the Düsseldorf Freie Vereinigung was given the right to exhibit in the 1896 Glaspalast exhibition as an independent body with its own jury. Those not in a society had to compete individually before the Munich jury (clearly giving any society an enormous advantage).[35] And in 1897 the Prince Regent of Bavaria granted the Munich Secession the right to exhibit at that year's Glaspalast exhibition and provided for its guaranteed participation every four years (which was quickly extended to an annual basis). He also gave the society permanent exhibition rooms in the Kunst- und Industrieausstellungsgebäude directly opposite the Glyptothek on the Königsplatz (while transferring the Künstlergenossenschaft's "permanent exhibition" site to the former National-Museum on the Maximilianstraße).[36] This changeover in exhibition locales and the destruction of the Secession pavilion on the Prinzregenten-Straße occurred in 1898. More than ever before the Secession functioned as an official society at the physical and psychological center of Munich's cultural life. The new exhibition rooms offered more space and permitted larger group exhibitions, while the society continued to sponsor small group and individual artist exhibitions during the winter months. Following this trend, in 1899 the Dresden Secession agreed to exhibit together with its local Künstlergenossenschaft (though with separate juries).[37]

The regional states, just as had so often been the case in Paris, encouraged the further fragmentation and "secessionization" of the art communities of all the major German-speaking cities of Central Europe by its subventions of various Secessions large and small. Official policy was abetted by the commercial galleries, which, still generally unwilling to risk large-scale, one-person shows, became ever more eager to support groups that might represent certain (marketable) tendencies. The splintering of the

Künstlergenossenschaften and the Secessions allowed artists to stand in ever-greater contrast to the anonymous exhibitors at the Glaspalast or the Große Berliner Kunstausstellung. The proliferation of societies continued to accelerate as the century drew to a close. In 1897 a society calling itself the Luitpold-Gruppe, named after its headquarters, was granted its place (and jury) within Munich's VII. Internationale Kunstausstellung. In Berlin two new societies were hosted by Schulte's: the Vereinigung 1897, led by the future Secessionist Fritz Klimsch, the academic painter Karl Ziegler, and nine others, and the November-Vereinigung, which represented a more distinguished group, including the future Berlin Secessionists, Trübner, Curt Herrmann, and Phillip Franck. This group was sufficiently organized to include its own guest artists. In the first year they showed Raffaelli and the French poster artist Billotte. Also in 1897 the Ausstellungsverband Münchener Künstler was established with the express purpose of sending traveling exhibitions of Munich artists around Germany. The society sponsored two series of travelling shows in the exhibition season of 1897–98. The first went to Augsburg, Hannover, Berlin, Magdeburg, Leipzig, and ended in Halle. The collection consisted of approximately 130 works of art. The second cycle began in Wiesbaden in January 1898 and was organized by Trübner. Obviously these circulating exhibitions represented a fundamental precedent for the traveling shows of the later Neue Künstlervereinigung Münchens and Der blaue Reiter between 1909 and 1912. Even the pattern of cities is remarkably similar.

In 1898 a "Ring" formed in Munich that managed an exhibition at the Leipziger Kunstverein.[38] At the Glaspalast itself another independent artist group, which essentially constituted the illustrators for Hirth's *Jugend*, were given a collective exhibition. The 1899 exhibition of the *Jugend* artists at the Glaspalast even earned a fully illustrated, feature article in *Die Kunst für Alle*.[39] The artists who were primarily painters in the group, led by Fritz Erler, Walter Püttner, and Leo Putz broke away from the Jugendgruppe in 1900 to form the heart of yet another society under the name of "G" and which was also given its own rooms in the Glaspalast from 1900 until the organization, which came to be renamed Scholle, translated roughly as "Native Soil," dissolved in 1911.[40] The artists of Scholle represented a mix of Jugendstil graphics style, symbolism, and an evolving *juste milieu* form of Impressionism, wrapped, however, in a nationalist cloak that would seem to deny the very modernity the group advocated. Modern and yet non-modern, Scholle was a peculiarly German form of the *juste milieu*, which arrived much later there than elsewhere, and which largely attempted to reconcile the aesthetics and subject matter of the symbolist nineties with

181

the style and sensibility of the French imports that after 1900 showed up with increasing frequency in Munich's public and private exhibitions. The Scholle enjoyed for the first decade of this century a considerable reputation, being invited by the Vienna Secession to exhibit in its own room at their thirteenth exhibition in 1902.

THE VIENNA SECESSION

With official recognition and subvention the Secessions lost their ideological "stigma," and hence a market virtue of belonging to a "socialist/artistic" international. Their success at professionalizing and thus normalizing their artistic identities did not, however, relieve them of the burden of appearing like the academicians, to act above the interests of money. Unwittingly, the Secessions thus served as the quintessential transitional institution between public and private patronage. They hurried the collapse of the art academies as the chief gatekeeper for public patronage and helped to prepare the way for the dominance of commercial galleries and the avant-gardes those galleries helped to create. This path was followed by virtually all the Secessions, but the paradigmatic representative of the rise and fall of Secessionism in Europe was unquestionably the Vienna Secession.[41] In 1897 a group of artists led by Klimt announced its divorce from the older exhibition society of the Künstlerhaus on the basis of three tenets. They wished to bring the Viennese art world into intimate contact with the "progressive developments" of art abroad, to create exhibitions on a "purely artistic" basis, free of market considerations, and to promote modern art at every level of society, but especially among official circles of the Hapsburg Empire.[42] Seven years later, in 1905, Klimt walked out of the Secession, followed by virtually the same group of artists, and exhibited at the Galerie Miethke, which had as its artistic director, Carl Moll, who was, after Klimt, the most prominent organizing force behind the original Secession. With this secession from the Secession the institution ceased to play a "progressive" role in contemporary art in the Empire.

As in the case of Munich, the Vienna Secession maintained from the start that it did not wish to politicize the Viennese art world. As reported in the pages of *Die Kunst für Alle*, the Secession "did not want to become a fighting party."[43] The Secession argued, just as the Munich Secessionists had, that it merely wished to promote quality over quantity. It also wanted to base its activities on an international community of artists.[44] And it was to be, above all, without *parti pris*. It wanted only to liberate artists from depen-

dency on dealers and the "publishing" limitations of an annual "Salon," by providing more frequent exhibitions of greater variety. The Secession's freedom from the art market was asserted most forcefully by Hermann Bahr, who became one of the leading apologists for the Secession. He argued that the Secession arose not out of conflicts over aesthetics, but over the issue of art versus business. The old Künstlergenossenschaft, he said, "would like to be manufacturers, we want to be painters. That's the whole controversy. Business or art, that is the question of our Secession."[45] Like the Munich Secessionists, after a period of controversy the Viennese group quickly found government support. And, of course, the organizational statutes underline the obvious: in exchange for a 10 percent commission, the membership were free to use the exhibitions to sell their work.

In the seven years under Klimt's leadership, the Vienna Secession made three fundamental contributions to the *Kunstpolitik* of fin-de-siècle Europe. First and foremost, it contributed dramatic innovations in exhibition practices. Unlike the other Secessions, the Viennese society had a large, active membership of architects and designers, from Josef Olbrich who designed the Secession's building to Josef Hoffmann, Kolomon Moser, and others who worked on the interior decor. They thus were able to display art in a "museum-like" setting never seen before. Indeed, to invoke the museum does injustice to the Secession's shows, for no museum in the world had yet developed so sophisticated a decor, and especially not for special one-time exhibitions. The exhibition format employed by the Secession had been worked out in commercial galleries in the prior two decades: widely spaced, single rows of pictures, often artfully set against an elaborate decor. Perhaps the Secession's most famous installation was the one in 1902 held in honor of Klinger's *Beethoven*. Hoffmann designed the interior setting and Klimt painted a decorative frieze on the theme of Beethoven's music. The effect was a *Gesamtkunstwerk*, in which commerce was subsumed to the ideal of art. Such jewel-like settings made the Secessionist exhibitions look less like commercial shows than like small museums of contemporary art—with sales made at the door.

Carl Schorske has argued that the Vienna Secessionists aimed to "show modern man his true face," quoting the architect Otto Wagner.[46] If we allow for the ambiguity of this assertion (since both Wagner and Klimt couched their modernity in the vocabulary of classicism) the sense of ideological mission constituted the second principal contribution of the Secession. No other Secession demonstrated such a coherent ideology, expressed both in its exhibitions and in the writings and graphics of its extraordinary journal *Ver Sacrum*. The Vienna Secession enjoyed the distinction of being

lead by an unusually like-minded group of artists. Operating in a far smaller art community than Munich's, they were able to maintain a dictatorial control over their exhibitions unmatched by other Secessions. It is true that they often gave exhibition space to more conventional artists in their membership. Yet, because of the frequency of their exhibitions (in the six years between 1897 and 1903 they staged fourteen large-scale exhibitions), they were far more effective in subordinating the general interests of the membership to highly specialized projects, particularly to historical and one-man exhibitions.

As the Secession put forth an aesthetic and ideological program it virtually invented itself. Each succeeding exhibition until 1905 tended to clarify rather than to dilute—as in the case of Munich—the society's aesthetic orientation. And of all the Secessions Vienna's was most closely tied to the decorative arts movement, with intimate connections between its membership and that of the Wiener Werkstätte. In its commitment to Jugendstil, both in its exhibitions and through *Ver Sacrum*, and in its early ambition to merge the fine arts with the decorative arts under the umbrella of architecture into a *Gesamtkunstwerk*, the Vienna Secession stood, as did no other German society, for a particular kind of modernity, which at the time of its foundation made it the most radical art organization anywhere. Despite their ambition to appear without *parti pris*, adherents such as Bahr insisted on an ideological character arguing that "unsere Secession ist . . . ein agitatorischer Verein."[47]

The actual politics of this "agitation" was inevitably many-sided. There were those who followed Klimt and emphasized the cultural search for identity through sexual exploration. Still, the most basic political vocabulary to which most modernist artists, including Klimt, subscribed was the generic championing of the new, of the young, against the old. "Jung" at the time of the Secessions was never used to distinguish a Courbet or the Barbizon painters from the academicians, nor essentially the Impressionists from the realists. Before the fin de siècle there was an insufficient sense of the developmental model of culture—of a specific culture—for such attributes to have potent meaning. It was only at the end of the century that the model was sufficiently established to lend its attributes to an expanding definition of contemporary art that would eventually coalesce in the idea of the avant-garde.

In Schorske's description of the Secession's goals, his discussion of Secessionist "Jung-Kunst" as a "revolt of the plebs" is the most paradoxical.[48] In the first issue of *Ver Sacrum* the Secession's intentions were declared: "We recognize no distinction between high and low art, between art for the rich

and art for the poor. Art is a universal good."[49] Yet it is difficult to imagine Klimt, Wagner, and Rudolf von Alt as plebs. If the Secession indeed was an Oedipal revolt of the sons against the fathers, the sons already represented the cultural establishment of Vienna and the revolt was not in the name of some form of plebian democracy, but rather a plutocracy.[50] Indeed, the Secession lived out its existence in virtual isolation from the social realities of the Austro-Hungarian Empire. The concentration of intellectuals in Vienna created a hot-house atmosphere that, if not entirely isolated from the rest of the empire, was distant from it. More to the point, the Secession in action divided the rich from the poor. The Secession was deeply committed to the cultural outlook of the international *juste milieu*. Its foreign membership was dominated by *juste milieu* artists such as Besnard, Burne-Jones, Lhermitte, and Hans Olde. And the Secession owed to the *juste milieu* the desire to depoliticize and decontextualize the work of art—which prepared their art, consciously or not, for the marketplace. If the Secession constructed a temple to art, it was an exclusive one. If it brought art to the people through their magazine *Ver Sacrum*, it was in expensive editions. If it was not so clear that painting was higher than the other arts, the trend was certainly away from the *Gesamtkunstwerk* as the years passed. After 1900, the version of modernity promised by the decorative arts movement was challenged on one side by the developing industrial aesthetic of the German Werkbund and on the other side by a picture market that extolled the individual painting, the individual artist, against the *Gesamtkunstwerk* ideal. And as the Secessionists came into contact with Parisian Post-Impressionist painting, what constituted modernity was radically reversed.

The third principal contribution of the Vienna Secession was its institutionalization of the concept of the temple of art. Schorske quoted Josef Olbrich's description of the Secession as an asylum from the pressures of modern life, "a temple which would offer the art-lover a quiet, elegant place of refuge."[51] This ambition derives its novelty from the scale on which it was realized by the Secession, since providing a refuge for the art lover had long been the selling point of the commercial gallery exhibition. In this light, the Secession was less an alternative to the local Künstlergenossenschaft than to the *Kunstsalons*. The Secessions first established the precedent in this part of Europe for independent exhibitions that were endowed with apparent public, rather than private, interests.

As long as the Secession remained effectively under the control of Klimt and his friends, it offered a convenient refuge for their art, free of jury review or the approval of a dealer. But when the Secession produced its own *Kunstproletariat*, who did not share the exclusive ambitions of its leadership,

they left to exhibit in the marketplace. This "dealer secession" was long in the making, beginning with the leadership's extraordinary ambition to send Klimt's controversial University paintings as the virtual representative of Austrian art to the St. Louis World's Fair in 1904. Yet the society was finally torn apart over the attempt to affiliate the Secession with the Kunstsalon Miethke, whose artistic advisor was Carl Moll and whose business advisor was Paul Bacher, a jeweler by profession and a close friend of Klimt.[52] Moll resigned from the Secession to take over the management of the Galerie Miethke. But when the gallery ran into financial difficulties, Klimt had Bacher step in. As part of the restructuring of the gallery, they apparently hoped to relocate its commercial operations in the rooms of the Secession building, and to have it operate as the business agent for the Secession. Seemingly paradoxically, it was the "painter" wing of the Secession, led by Josef Engelhart, who balked at the visible commercialization of the Secession.

The revolt of the painters against the so-called "Stilkunst" artists led many to believe that this break in the Secession was due to factors having nothing to do with commercial considerations. Berthe Zuckerkandl, who reported the breakup of the Vienna Secession in the pages of *Die Kunst für Alle*, believed that the division transcended the issue of Moll's activities on behalf of Miethke's, arguing that the two camps represented, on the one hand, those who favored the *Gesamtkunstwerk* (the Klimt circle) and those who advanced the fine arts alone.[53] This residual body of Secessionists was regarded as "impressionists," a term that even in this context represented that homogenization of Impressionism that I have identified with the *juste milieu*. Whatever the ideological considerations were behind their "secession," Klimt, Moll, and their allies were assured access to Vienna's finest commercial galleries, but at the price of their work ceasing to have a public forum, being now entirely oriented toward the picture market. Their only institutional products (besides the efforts of the Wiener Werkstätte) were the great Kunstschauen of 1908 and 1909, which Klimt would later explicitly claim was not the product of a Genossenschaft, nor a Vereinigung, nor a Bund.[54]

These Kunstschauen were, for all their ambition, the embodiment of the paradox of the Vienna Secession. The first Kunstschau was a virtual celebration of Jugendstil and the *Gesamtkunstwerk*.[55] Although there were paintings in the exhibition, notably a large collection of Klimts, the show was dominated by the decorative arts and architecture. In the programmatic introduction to the exhibition catalogue Klimt observed that "we know full well that the exhibition is in no way the ideal form for making contact between the artist and the public. The carrying out of large scale

public art commissions, for example would for us serve this purpose infi-
nitely better."[56] The absence of such commissions he attributed (for ap-
pearance sake certainly) to the state's preoccupation with economic and
political affairs. Here Klimt perhaps indirectly referred to the conflict over
the University murals, which had proved too controversial for the sponsors
and were ultimately rejected. It was also a curious admission of the prefer-
ence for non-commercial motivations for art over those offered by the
exhibition.

In 1908 the Klimt group appeared to stand for "Stilkunst." But the
second exhibition, entirely devoted to the visual arts, celebrated the Eu-
ropean picture market in contemporary Post-Impressionist art as no prior
Viennese exhibition had done.[57] Introducing the latest in French modern-
ism, from the Post-Impressionist figures of van Gogh and Gauguin to the
Nabis and the Fauves, as well as a new generation of Austrian and German
artists, most notably Egon Schiele and Oskar Kokoschka, the 1909
Kunstschau marked the end of Viennese Secessionism as a progressive
institution. Henceforth, modernist art in Vienna would be exclusively me-
diated by the commercial galleries.

The success of the Secessions led to their acquisition of considerable
institutional stature, which in turn, as in the case of Munich, quickly as-
sumed as conservative an identity as the institutions they had originally
sought to replace (i.e., that vested interests, particularly on the part of the
general body of the membership, would overwhelm whatever aesthetic or
ideological concerns first informed the goals of the group's leadership).
More often, as in Vienna, the most talented artists within such societies
eventually would find themselves at odds with the body of the membership
and would in turn secede from the group. Since these secessions from the
Secessions involved an even greater elite character than their parent soci-
ety, often composed of only a handful of artists, they lacked the resources
that would permit the building of yet another "official" organization. In-
stead, they usually seceded to the commercial galleries, which emerged
from the process as the most elite repository for art among any of the
current institutions. These last Secessions were also the most free; they
constituted what we now generally view as the arena for avant-gardism in
Central Europe.

THE BERLIN SECESSION

Berlin offers the paradigmatic example of the allegiance between Secessio-
nism and the commercial gallery, which bred an ever-greater elitism and a

corresponding increase in the radicality of the art displayed in both institutions. The Secession was uniquely suited to Berlin's cultural life. Although it only became a reality in 1899 (very late as Secessions went), after repeated calls for such a society, we should attribute this delay neither to a lack of pretexts nor to the degree of state opposition. When the Secession was finally announced, instead of provoking a general controversy, it was warmly welcomed (except by the kaiser, Werner, and their cohorts). The Secession found immediate support among fashionable society, and more importantly, financial support from some of Berlin's leading bankers, industrialists, and from Berlin's cultural establishment (particularly Wilhelm von Bode and Hugo von Tschudi). Despite, or perhaps because of, the continued existence of the older Verein, controlled by Werner, it was the Berlin Secession's exhibitions that were the most widely reviewed, and reviewed by far the most favorably.

In 1898, when the jury of the Große Berliner Kunstausstellung rejected a Leistikow landscape, Secessionism finally took hold. This refusal appears to have been little more than a ready pretext for the Secession; it hardly compares to the *Gesamtkunstwerk* ideals that motivated the Viennese, nor does it reflect the struggle in exhibition politics between nationalism and internationalism, between a *Kunstproletariat* and an elite that tore apart the Munich art community. Indeed, the Berlin Secession was not a "secession" at all, as the term was understood by the Munich and Vienna Secessionists. The Berlin Secessionists only banded together to have their own jury and rooms within the pavilion of the Große Berliner Kunstausstellung, in the manner of the Düsseldorf Freie Vereinigung and the Munich Luitpold-Gruppe.[58] Here Werner proved to be the catalyst, by rejecting the idea that an elite group of Berlin artists could exhibit separately at the Berlin annual. He forced the Secession to redefine itself, to provide for its own space, its own by-laws, its own fund-raising.[59]

That process of self-invention has tended to obscure the fact that the Berlin Secession, as expressed in its first exhibition, was not an aesthetically radical society. Among its exhibitors after all was Adolf Menzel. There were no non-German artists at the exhibition except for the "Germanicized" Swiss Böcklin and Hodler. Representatives of the Munich Secession, the Luitpold-Gruppe, and Secessionists from Dresden and Karlsruhe joined the Berlin artists to compose the exhibition. The show was applauded by the public and the critics not for the novelty of its exhibits but because Berlin had now finally received its own Secession. The biggest controversy was excited by the presence of Menzel, an inclusion that the artist initially denied having given his permission for, but which the very old artist later turned out to have simply forgotten.

Despite an undistinguished exhibition pavilion (made fun of by critics and by the exhibitors alike), despite the costs of erecting the building, and despite, or perhaps because of, the opposition of cultural and political conservatives led by the kaiser, the society emerged from the first exhibition with a surplus of 33,000 DM.[60] Richard Mortimer's review of the show for *Die Kunst für Alle* was typical of the restrained praise given the exhibition. He acknowledged that Berlin had achieved what most other German cities already possessed: two exhibitions. He characterized the older society, Werner's Verein Berliner Künstler, as standing "for what over how, and that what lays essentially in the expression of monarchical feelings."[61] By contrast, the new society "has the face of all Secession exhibitions," especially in its support of foreign art. Implied in Mortimer's remarks is the "political" character of Secessionism, a suggestion of its anti-monarchical, anti-authoritarian position which was always present in the society's years of struggle with Werner over the artistic leadership of Berlin. The rather inexplicable assertion that the exhibition supported foreign art, considering the absence of foreign artists at the first exhibition, is but another reflection of the fact that Secessionism, publicly construed, meant internationalism, even though a considerable portion of its membership did not agree with this goal. This conception of the Secession was supported by Liebermann's opening address, which declared that the exhibition did not serve some nationalist purpose, as he described it, a *Kirchturmspolitik*, and that the Secession expected in the future to include foreign artists.[62]

Those foreign guests would be dominated by modernist French painters. And its domestic membership would include most of the best artists to emerge in the nineties. Consequently, the Berlin Secession has always been portrayed as a modernist movement, a heroic enterprise that passed through the fire of opposition posed by Werner and the kaiser. Its goals have largely been characterized as altruistic, serving only "true" art (i.e., French and German Impressionism) against academicism and national chauvinism. While it is true that modernism was present at the Secession and that its opponents were deeply reactionary, one must question such typical assertions as those of Nicolaas Teeuwisse, who recently characterized the Secession's intention to offer "a free, democratic forum where new talent of various characteristics could be expressed. This tolerant, free conception of art was expressed by Max Liebermann [in his opening address to the first Secession]."[63] In reality, the Secession was never free or democratic, nor was it particularly supportive of younger talent. It depended upon its jury to cull the best from a relatively small and exclusive membership. Liebermann in that opening statement was careful to assert that only the best German art in limited numbers was on display. The heterodoxy

with which Liebermann defined the expression of artistic talent was not a democratic impulse. The elitism of the society was institutionally reflected in the relatively stable character, following some initial purges of conservative members, of its leadership from 1899 to 1910. That leadership in turn dominated the society's exhibitions (reflected especially in the press reviews). The tension between the artists and their management (after 1901, Paul Cassirer) broke into the open in 1910, when the society lost its cohesion through factional disputes that ran along both political and aesthetic lines. But for the first ten years of its existence the strands of real power were in the hands of comparatively few individuals. Lovis Corinth later asserted about the character of the Secession circa 1902, following the purge of its conservative members, that

> no one really knew how the executive committee intended to carry on. Everyone thought: "Cassirer will see to it." Because Cassirer himself told me with his customary frankness that "Actually the Secession is guided by Leistikow and me—even Liebermann doesn't really have anything to say about it."[64]

To see, then, the society as a democratic, non-commercial institution is to miss the real point about this and all the Secessions; their fundamental ambition was to control the market in their own image, and the significant, and in the case of Berlin, the guiding leadership, of art dealers. The Secessions may have had the best of motives, but if ideals led, self-interest followed. And self-interest, though publicly denied, was the defining character of Secessionist *Kunstpolitik*.

The *Protokolle* of the Secession, a diary of the meetings held from 19 January 1899 to 25 March 1899, indicates the areas in which the new society patterned itself after the structure and practices of older Secessions.[65] The new society established direct contacts with the Munich Secession, with the Luitpold-Gruppe, with the Karlsrüher Künstlerbund, and with the Dresden Secession.[66] Because of Werner's vigorous opposition, the Secession, unlike these other societies, could never count on state purchases, subsidized exhibitions, or exhibition quarters. Unlike the Vienna Secession, the Berlin artists were forced to build their own gallery. But the absence of state subvention gave the Berlin Secession a dynamism that no other comparable institution of its time possessed. Because the responsibilities for operating the society's business affairs were to be greater than most of the Secessions, the Verein took the fateful step in March 1899 of enlisting Paul and Bruno Cassirer to run their business affairs.[67] The invitation was reluctantly made; many of the more conservative members of the society feared the conse-

quence of having the Secession managed by dealers. In the end, however, they ceded more power to the Cassirers than any other such society had given to its business managers (with the important exception of Octave Maus' virtual control over Les XX and the Libre Esthétique in Brussels). The Berlin Secession thus entered into the art market in such a way as to transform Berlin into a centralized, international locus for contemporary art on a scale only surpassed by Paris.

The decision to bring the Cassirers into the organization appears to have been Liebermann's. He was the society's president, its most prominent artist, and its initial source of prestige and cohesiveness. He was as close to an art prince as Berlin had produced (if we also include Menzel—who the society honored as a senior member). By 1899 Liebermann was substantially well-off. His dinner parties were attended by the elite of fashionable Berlin. His family house and studio was located at the heart of imperial Berlin, literally attached to the Brandenburg Gate at no. 7 Pariser Platz. In 1905, a popular Who's Who of official Berlin listed Liebermann as the only artist in the "Tout Berlin" section.[68] Counting Berlin's museum leadership among his friends, an intimate of the great industrial families of Rathenau and Arnhold, and banking families such as that of Julius Stern (whose portrait he painted), the Mendelssohns, and so on, Liebermann was in a position to bankroll the society's early endeavors through the support of his connections. Liebermann was the Secession.

Liebermann had changed dealers from Schulte to the Cassirers as soon as their gallery was established, and he was to act as artistic adviser to the cousins. Liebermann also helped to form the Cassirers' aesthetic tastes and to establish their international contacts. Conversely, this close business and personal relationship blurred the distinction between the gallery and the society. The gallery would show most of the society's leadership and the society would in turn show most of the international artists handled by the gallery. If Liebermann was the Secession, he quickly turned over the management of the society not only to the dealers but also to his friend Leistikow. Although less francophile than Liebermann, and not himself an immediate beneficiary of the Cassirers' patronage, Leistikow initially advocated the participation of the cousins more vigorously even than Liebermann.[69] Of the two artists Leistikow was by far the most impulsive and the most energetic. He pushed the Secession to take on a more radical character than most of its established leadership were inclined to do. Liebermann, as Corinth observed, privately took a back seat to Leistikow and Paul Cassirer, even while remaining the Secession's figurehead.

The Cassirers, apparently on the advice of both Liebermann and

191

Leistikow, asked the Secession's leadership for much more than the society was willing to grant them: they wanted the title of Secession Secretariat to be printed with their names on all Secession publications and correspondence. More importantly, they wanted the right to sit on juries. In exchange, they would give up commissions on sales below 50,000 DM for a regular stipend to cover their expenses.[70] Reading between the lines, it seems clear that the Cassirers wanted the publicity benefits that would accrue to their association with the Secession. They also wanted to exert some quality control over the exhibited works while regularizing and institutionalizing their affiliation. To some degree, this meant that the Secession would be run nearly as an extension of their own business.

The Cassirers' place in the Secession's leadership came at the expense of another businessman, Georg Malkowsky, editor and publisher of *Deutsche Kunst*, who in the early days of the society had been promised the position. The society had already granted him the right to print the society's catalogues, "substantial commissions on all sales," and the exclusive sale of *Deutsche Kunst* in the gallery's business room. In exchange for modernizing the conservative magazine, *Deutsche Kunst*, following the example of *Ver Sacrum*, would be the official organ of the society.[71] It took protracted negotiations to release the Secession from these obligations—and it would not mount its own magazine, although Bruno Cassirer's *Kunst und Künstler* served after 1904 as the unofficial organ of the Secession.

Peter Paret has pointed out the marked contrast between Malkowsky's attempt to impose a monopoly style on the Secession to the much less mercantile, decidedly more international position of the Cassirers. Paret did not, however, examine the Cassirers' possible motives for their policy, tacitly assuming a liberal altruism on the cousins' part. It is clear that Malkowsky's business practices were conservative and unimaginative. He had no real desire to control the quality of his product nor guide the direction of the Secession's exhibitions. He simply wanted to rake as much profit off the top as possible through a monopoly of both publicity and trade. By contrast, whatever the nobility of the dealers' intentions, their demands show a strong business practicality. The Cassirers desired the Secession to be qualitatively as rich as possible, to do in fact what the Munich Secession had failed to accomplish, to exhibit only the best of contemporary art. As their first exhibitions in their own gallery demonstrated, that "best" was to be found among artists heretofore largely unseen at the international exhibitions.

Leistikow's advocacy of the Cassirers was such that he moved that the society accept their demands out of hand, and said that if the society's

membership resisted, the leadership should immediately resign (knowing full well that it was the leadership that gave the society its identity, prestige, and contacts).[72] The conservative elements of the Secession balked at granting the Cassirers their terms, perhaps for two reasons. On the one hand, there was dissension inside the society as to whether it would serve national or international interests. In the March 16 minutes of the *Protokolle* Engel, Herrmann, Klimsch, and Frenzel objected to the Cassirers' suggestion that foreign artists should be included in the second exhibition of the Secession in 1900, on the grounds that the Secession should be a "specifically German exhibition."[73] The Cassirers' gallery had already demonstrated its determined internationalism. On the other hand, there was a concern over the commercialization of the Secession, or rather, over the power that the dealers might enjoy through their intimate relationship with the society.[74] After much debate a compromise was struck when it was agreed that the Cassirers would have the same rights as Paulus in Munich. But, as Paret has observed, they informally received much more than their Munich compatriot. They won all their demands and were even allowed to figure prominently in photographs of the Secession's leadership, albeit usually standing at the periphery of the gathered artists.[75]

It is because the Secession was neither free nor democratic that its dealer connections brought accusations of conspiracy and a lack of patriotism. Each subsequent exhibition defined more clearly the elitism and the internationalism of the Secession. The second exhibition, for example, was notable for its large foreign contingent led by Monet, Renoir, Pissarro, and three Vuillards (then handled by the Galerie Bernheim Jeune). Each exhibition brought increased press attention, so that only in the most conservative cultural journals did reviews of the Secession exhibitions not move reviews of the Große Berliner Kunstausstellung to the back pages. By the second exhibition, *Die Kunst für Alle* devoted an entire issue to the show, written by Hans Rosenhagen, who, in his previous role as editor of the magazine *Das Atelier*, had consistently attacked Werner's dominant role in Berlin's cultural life.[76] The review was lavish with illustrations, including eighteen pages of photographs of works in the exhibition. Rosenhagen asserted that the first exhibition was really only an improvised affair (this was patently not true) and that its only real purpose was to prepare the Secessionist ideal in Berlin, realized now in the second exhibition. The second exhibition featured 414 works (including drawings and watercolors, etc.), which gave the impression that the society had achieved, more than any of its Secessionist rivals, the promise of the elite exhibition devoted to the finest (or at least, the most famous) artists in Europe. Compared to Berlin's open embrace of

Impressionism, the decision to exhibit a contingent of Impressionist pictures shown in Munich that year at the Glaspalast one critic dismissed as "art speculation," and not the demonstration of "an organic use of taste."[77] And yet even Rosenhagen's version of the Secessionist "ideal" represents more an apology for the *juste milieu* than for modernism. What he admired in the new German art was the reconciliation of the German symbolist/idealist tradition and Impressionism, embodied for him in Corinth's *Salomé with the Head of John the Baptist*, which he admired for its bright and rich palette and yet a technique of almost "academic bravura."[78]

The Berlin Secession (alongside the exhibitions of Paul Cassirer) introduced radical work, and radically different work, to Berlin audiences without much of a frame of reference with which to absorb them. One finds in the Secessionist apologies a precarious attempt to find a unifying principle for contemporary art in the face of widely diverse art. Liebermann opened the third exhibition of the Secession with the argument that "when we assembled these works of art we wished that the public contemplate them, not according to an academic ideal of beauty, but according to the power with which the artist embodied that which appeared beautiful to *him* [Liebermann's emphasis]."[79] Renoir's *Woman with an Umbrella* and Monet's *Portrait of Camille*, shown at the third exhibition, Rosenhagen described as masterpieces.[80] But despite the prestige now accorded Impressionism, Liebermann insisted on the independence of the society from any tendency. In defending this ambition Liebermann described the "classic" qualities found jointly in Böcklin, the Dutch painters Josef Israels and Jacob Maris, and the French Pissarro, Renoir, and Monet. When one remembers that also on display were five van Goghs alongside sixteen Leibls, six Hans Thomas, and a miscellaneous collection of contemporary German painting of all aesthetic stripes, the blurring of the differences, so obviously there, was bewildering, not only to the Secessionists, but to their audience.

The arch-conservative, cultural polemicist Momme Nissen, who was a protégé of Julius Langbehn (famous for his 1890 nationalist polemic *Rembrandt als Erzieher*) and friend of Hans Thoma, described the contemporary situation of art in Berlin in 1902 in an article entitled "Berliner Konservative Malerei." To the growing influence of the Secession in Berlin's cultural life, manifested, for example, in Rosenhagen's championing of Berlin as the new art capital of Germany in his 1902 article "Die Niedergang Münchens als Kunststadt," Nissen replied

the highly prized speed of travel of the Berlin artwagon in the international express train, with its locomotives: Manet, Monet, Degas, and the *Moritmaler* Munch, has weakened more than strengthened the pulling power

and motive force of the Prussian rolling art stock. The rise of Berlin as an art city can never succeed through even so effective imports, but only through inner artistic growth. The fostering of Berlin as an art bourse is no fostering of Berlin as an art city. The Berlin Secession each years offers one of the best art dealer salons [Kunsthändlersalon]—no more and no less.[81]

The perception of the Secession as just another agency of the international art market was reinforced by the fifth (1902) and the seventh (1903) exhibitions. Munch dominated the fifth exhibition with his picture cycle, *The Frieze of Life* (the show also saw six Manets and the first participation of Kandinsky).[82]

The impact of work such as Munch's was enhanced by the radical decrease in the number of exhibitors (by one fourth). This scaling back coincided with an apparent purge by, or secession from, the society—it is not entirely clear which—that resulted in the departure of sixteen of the society's most conventional artists, including two of its founders. They were replaced on the guiding board by the former members of the Munich Freie Vereinigung, Slevogt and Corinth, and by the Berlin sculptor, long patronized by Cassirer, August Gall. The leadership was further expanded to include Trübner and the sculptor Louis Tuaillon. Since Slevogt, Corinth, and Trübner were all part of Cassirer's stable of artists, the leadership was bound more than ever to the gallery. The squeezing down of the exhibition size also led directly to conflicts with Secessionists from other cities, for the Secessionists' gallery now offered little space for outside guests. This intra-Secessionist conflict in turn rebounded on the controversy over Berlin's claims to supremacy over Munich. The contrast between the Munich and the Berlin Secessions could not have been more sharp. What was still "modern" about the Munich artists was their tradition of Jugendstil graphics. Berlin countered, not so much with their own aesthetic, but with that of their imports, and the vitality of their commercial market. The move to Berlin by Corinth, Trübner, and Slevogt, like the later emigration of the Brücke, owed to the prospects of Berlin's art market and Secessionist organizations. Even Kandinsky, always based in Munich, found his principal German audience in Berlin.

The Secession's opponents saw each exhibition as a specific ideological statement, an assertion of non-German art over German, extreme modernism over classical German values. At worst, when not describing the products of the Secession as dealer wares, they were explained away as mere fashions. Rosenhagen in his review of the fifth exhibition noted how Germans still perceived Secessionism as a temporary fashion, despite its ten-year history.

The significance of the Secessions, Berlin's like all the others, depends upon their staging of good, selective art exhibitions in which, through their small settings, individual works of art and individual artists come better to attention than in the exhibitions of the non-secessionists. . . . Quality is, in this case, to be counted only through limitations and strong oversight, because art, good art, cannot be produced in mass.[83]

Because of the qualitative work of this Secession Rosenhagen asserted that

this exhibition is once more thoroughly secessionistic, because it understands the will to new goals, because it once more permits the revival in the belief of the forward movement of German art. The Berlin Secession this year ceased to be a *Künstlervereinigung* of only local significance.[84]

Rosenhagen's defense of the Secession, however, simply turned the prior arguments of the Munich and Vienna Secessions to new ends.

The exhibition of French modernism at the Secession reached its high water mark of the decade in 1903. The spring exhibition, its seventh show, contained four Manets, three from local collections and one belonging to Durand-Ruel, three Cézannes, nine Toulouse-Lautrecs, two Rodins, two Monets, three Pissarros, a van Gogh, a Gauguin, a Vuillard, and four Bonnards.[85] Except for a Monet, three Manets, and the Cézannes, they were all listed for sale. The following year, in the midst of what would be the enormously important and divisive debate over the German contingent to the St. Louis World's Fair, in a fit of nationalist sentiment, or out of defensiveness, the exhibition was devoted largely to German Secessionists, including fifty-one works by Munich Secessionists.[86] Foreign contributions belonged more to the international *juste milieu* than to the "avant-garde." They included paintings by Besnard, Cottet, Krøyer, Lavery, etc. The upsurge in German nationalism among the Secessions reflected in this 1904 show can be directly traced to the attacks made on them by conservative critics. Those who supported the old Allgemeine Deutsche Kunstgenossenschaft as the national representative body for German artists—led by the kaiser—argued that Secessionism from the beginning was slavishly devoted to Parisian interests, that in the name of international art the Secessions had imported a flood of French art and gave up in return their own individuality and traditions. There was much discussion in this period of German art becoming more competitive in foreign markets, especially in France. This rather naive view of increasing German market shares at the expense of the French was based on the belief that German art offered equal worth to French art (a comparison usually made on the basis of the art on

display in the two Parisian Salons). In their view, the Secessionist artists were merely imitating French fashions. The Secessions, they argued, claimed unconvincingly to represent new directions. Foreign buyers, however, would not be deceived and would buy the French originals. Consequently the German market in America had diminished rapidly in the last twenty years. Internationalism, they held, meant that "whoever visits a Secession exhibition today will find French, Dutch, English, Scottish, Pompeian, and even Japanese imitations, but few works that exhibit the singularly German outlook. . . . Who could doubt with which pictures the American market can be conquered!"[87] The goal of presenting a *Heimatkunst* to the world at the St. Louis World's Fair produced a dismal, miscellaneous collection of academic artists, half-amateurs, and assorted representatives of serious, but explicitly nationalist painters, such as the Scholle.

The institutional response to the kaiser and the Allgemeine Deutsche Kunstgenossenschaft was the formation of the German Künstlerbund, which represented the collective organization of the Reich's regional Secessions, initially in hopes of exhibiting together in St. Louis, and then as an independent, national exhibition society devoted to modernist, but German art. The symbolic parallel to the foundation of the Künstlerbund was the development of the nearly universal habit of spelling "Secession" with a "z" as if to insist on a Germanic reading of the word. In Berlin the influence of Paul Cassirer for the moment waned and his public profile considerably lowered—hence the conservative 1904 exhibition. Then in 1905 the Berlin Secession's spring exhibition was deferred altogether in favor of a collective exhibition of the Künstlerbund. In subsequent years the Künstlerbund exhibited at a variety of commercial and official institutions, although it never had its own exhibition locale (what city could it have been in?).

There was always something artificial about the Künstlerbund. Its main purpose, to represent the Secessions abroad, was never again required, because St. Louis' Fair proved to be the last of this size to be held until after the war. Indeed, the international exhibitions (as official representations of national culture) fell rapidly into decline—just as the unofficial international shows, such as Vienna's Kunstschau and Cologne's Sonderbund rose in significance. At best the Künstlerbund was a solution to the conflicts among the Secessions over the size of guest contingents at their respective exhibitions. Between 1903 and 1906 the Künstlerbund was at the center stage in opposition to the kaiser and Werner over the World's Fair, but from 1906 on it ceased to be an important institution insofar as it reflected exhibitions that mattered to the public. Subtly, but profoundly, the German

art world changed after the Secessions' struggle with the kaiser. The Künstlerbund was the last great exercise of Secessionism in Germany, of German artists trying to control their own market in the face of state approbation on one side and the conflict with the Künstlergenossenschaften on the other. Ironically, even though the Künstlerbund was self-styled a radical opposition party to the Künstlergenossenschaften, it represented the established leadership of German artists, all belonging to the generation that came to public prominence in the late 1880s and 1890s, men such as Liebermann, Uhde, and Trübner, all at least in their forties and at the height of their careers.[88] After 1905, the commercial system upon which the Berlin Secession depended gave room to artists, both foreign and domestic, that the Secessions themselves, even Berlin's, increasingly sought to exclude. While a Kandinsky or an Emil Nolde occasionally exhibited with the Künstlerbund, it neither established nor fostered their careers. That only came about when they organized their own independent societies (much smaller than the original Secessions), like the Brücke, which never attempted to build their own galleries or to have their own juries, in the conventional sense, depending exclusively upon dealers to make their enterprises work.

The Berlin Secession returned to its international posture in 1906, but it was a far more limited commitment than before 1904. It still preserved its unique character, especially when Paul Cassirer returned to his prominent place in its leadership. Fueled by Cassirer's gallery and a renewed collaboration with Parisian dealers, the Secession continued to show selected examples of the latest art from Paris. At the same time, Liebermann continued to defend, in his addresses to the Secession, the "classic" character of the foreign art the society showed. In 1910 the Secession once again fell apart, torn by aesthetic and ideological strife, by its inflexibility in the face of a bewildering new array of foreign and domestic modernist art, and by the territorial need to preserve the market for its own wares. Out of the Secession emerged a Freie Vereinigung, an *indépendants*, which, however, asserted only a negligible presence in the Berlin art world in the few remaining years before the world war. The other, and far more notable, product of the Secession was the brief efflorescence of the Neue Secession, a society of young German artists led by the Brücke painter, Max Pechstein. Characteristically, this society found its home in a commercial gallery. The Neue Secession managed to achieve only a handful of exhibitions, with none more important than its first. Upon significant changes in the management policies of the Berlin Secession, the key leaders, including Pechstein, resumed exhibiting with the older society. Nonetheless, the extraordinary elevation

of Paul Cassirer to the presidency of the Secession in late 1912 was overshadowed—like the collapse of the Neue Secession—by a new commercial gallery and publishing house run by Herwarth Walden under the title of *Der Sturm*.[89] The most important characteristic of the Der Sturm exhibitions was no longer their group character, but the pride of place given to a small, very select group of individuals patronized by Walden. Der Sturm was thus simultaneously Secessionistic, in its attitude of ideological coherence, and commercial. It embarked on by far the most radical agenda of exhibitions yet seen in Berlin, giving space to the blaue Reiter and the Italian futurists in rapid succession, holding retrospectives for Alexander Archipenko and Kandinsky, among others, and organizing in the fall of 1913 the Erste Deutsche Herbstsalon (which was also the last), the most radical display of contemporary art held before the First World War. Der Sturm, however, was no longer an artists' society. Despite periodic efforts to revive the ideal, Der Sturm represented the end of Secessionism in Europe. From then on, Berlin's art world was to be dominated by independently acting commercial galleries.

The Secessions represented a fragile compromise between the various European states and their leading artists, a power sharing in which the artists determined their own membership, selected their own works of art, and decided whom to honor with retrospectives. The respective governments usually offered some funding or provided exhibition space alongside the older Salon (and its European equivalents). The state received in turn some ideological capital: an image of fairness and the desire to encourage the art of all aesthetic persuasions. The Secessions were rewarded in turn by becoming the chief resource for the government's representatives at the international art shows. This did not put an end to the strife. The exhibitions of the Secessions were the occasion for constant conflict among the artist community, where factions fought over the right to be represented, and between artists and the various sponsoring governments over much the same issue.

The Secessions went beyond the international exhibitions and introduced their audiences to an alternative view of French art hitherto almost unknown outside small avant-gardist circles in Paris. They presented them, not as radical oddities, but as constituent elements in a historically certified progression of French art. And they were to announce the flood of Impressionist and Post-Impressionist pictures that would sweep the Central European market in the next decade. Most of the "modernist" exhibition societies of the fin-de-siècle era that held retrospectives sought to stake

their own claims to the past, to place their own art within a historicizing discourse on the necessary progress of art, which, of course, lead through the work of their own membership. The Secessions, housed in palaces dedicated to anti-commercialism, staged such retrospectives with all the ceremony of a museum. When exhibited in the Secessions works by Cézanne, van Gogh, or Gauguin were treated not as objects for sale (though some indeed could be bought) but as museum pieces. Considering that there had yet to exist any museum in the world willing to sponsor this kind of exhibition, this practice was remarkable. In fact, museum shows have their origins in these semi-commercial arrangements.

The compromise between the Secessions' museum-like presentation and the marketplace was brief. Fear of foreign competition, the conservative political opposition, and the demands of their own community of artists over exhibition policies and privileges, all eventually undermined the institution. Just as the Secessions formed a kind of rump parliament against the older Salons, there were to be secessions within the Secessions. Thus, the evolution of the Secessions follows the path from the Salon to the Secession and from the Secession to the commercial gallery-sponsored exhibition. In this sense, the achievements of the Secessionists were ephemeral. In the last years before the outbreak of the First World War other career paths were found that proved more sensational, perhaps even more lucrative, but which in the end led to the cessation of independence and self-rule at the hands of more experienced managers of the market, the art dealers.

The Rise of the Impressionist *Weltanschauung*

A PREHISTORY OF IMPRESSIONISM IN CENTRAL EUROPE

THE SECESSIONS had been organized to name what was "authentic" and to assign a hierarchy of value to the artistic production of fin-de-siècle Europe. They regulated the intellectual and physical circulation of art by the selection and segregation of contemporary art objects and by the incorporation of historicist arguments that supported what was segregated. How was it, then, that the Secessions came to lose control of these things? I have already argued that the pressure from below, the conflict between an artist proletariat and the Secessions' elites, led to their fragmentation, and, for some, eventual dissolution. But the Secessions were not merely exhibition institutions. When they enjoyed their greatest prominence the Secessions carried the standard of modernist culture for their respective societies. Their "authenticity" depended on their identification with the new or the *Jung* against the old, a proposition that over a period of time inevitably became insupportable. As institutions the Secessions persevered after their historical claims on the new evaporated, but their place at the head of the modernist army was overtaken either early (as with the Munich Secession) or rather later (as with the Berlin Secession).

Second, the Secessions encouraged fragmentation and increased institutional elitism within the artist community. And by eliciting direct dealer management of their affairs, the Secessions prepared the way for the hegemony of commercial galleries over artistic life. Third, the Secessionists as *juste milieu* artists effectively helped postpone an interest in modernist French art in Central Europe until after 1900, but paradoxically they then became principal agents in the distribution network of the international modernist art market.[1] That the Secessionists eventually betrayed themselves—or at least the interests of the plurality of their respective memberships—should be understood as the inevitable expression of their historicist identity. The Secessionists perceived their proper role to be the heirs of Impressionism, to be representatives, in fact, of a pan-European Impressionist *Weltanschauung*. The genealogy of modernist masters they assisted in importing from France (and the works of art brought in by art

dealers as something more than visual aids in support of this genealogy) was logically to conclude with themselves.

In this chapter I survey the construction of this *Weltanschauung*, while in the next, in reference to Meier-Graefe's work, I will look at the origins of its dismantling under the guise of what popularly came to be known as Post-Impressionism. It is, however, an artificial distinction. Most Central Europeans experienced the arrival of French Impressionism and Post-Impressionism virtually together and every manifestation of French modernism was subsumed under the singular label of Impressionism until events around 1905 finally pried them apart. Also, when I speak of symbolism or neoidealism in this chapter, it is not to describe a Post-Impressionist art, but rather an anti-Impressionism, one which did not see itself growing out of, but arising instead in opposition to, Impressionism, which was broadly defined as naturalism. In the 1890s public awareness of the now-canonical "Post-Impressionists" was slight. There were those artists and critics who knew enough in the early 1890s to attempt to link a Gauguin, say, to the anti-Impressionist literature and philosophy of a Strindberg or a Nietzsche. But these sites of linkage were largely ephemeral, personal, and usually internalized, so that for the general art public, whether in Central Europe or even in France, symbolism could be spoken of without reference to a van Gogh or Gauguin. Indeed, for these artists to matter, Impressionism, not in the guise of literary naturalism, but as itself, had first to matter.

From the beginning of the 1880s to the end of the century impressionism was universally described in Central Europe through the writings of Émile Zola.[2] If a canonical Impressionist was invoked by a German critic at all, it was almost always Manet, perceived through the work of the 1870s—a reputation derived from the artist's association with Zola, and from the claims made by the *juste milieu* of Manet as the "father of us all."[3] Moreover, Zola's fame was never greater than in the second half of the 1880s, coinciding in turn with the political understanding of naturalism in Germany as the cultural wing of trade unionism and the Socialist Labor Party.[4]

For example, a literary critic, Fritz Bley, reviewed the posthumous Manet retrospective at the École des Beaux-Arts in 1884 for Germany's most prestigious art history journal, the *Zeitschrift für bildende Kunst*. There he described both Manet and Zola as "pedants of smut and triviality."[5] Distressed that Manet's "followers" had managed to get this *Kunstrevolutionär* a retrospective at the École, the bastion of the "saints" of the French school, Bley concluded that Paris was a world of vanity markets where "even the maddest can achieve power and influence" [241].[6] Manet was a virus, a

symbol of a social contagion: the corruption of German culture by prole-
tarianism and the effeminate French.[7] Reading Manet, and particularly
Manet's "personality," through Zola, Bley imitated the strategies and the
vitriol of Zola's sharpest German critics. As a literary historian has written,
Zola was portrayed in early German criticism "as a brutal, egotistical, and
envious critic, a 'climber' who was trying to fight his way into the lime-light
without due regard for his colleagues. He sought also, they believed, to
achieve popularity by sensual and sensational subjects and treatments."[8] So,
too, Bley described Manet as an elite painter, an egoist, and a painter of
sensations. It was all for the sake of idolatry that Manet painted the *Olym-
pia*.[9] Without evidence, he characterized Manet as the "darling" of the
Salons and his retrospective as the last step in Manet's rise to popularity
with the sensation-seeking, frivolous, fashion world of Paris.

Throughout the 1880s, German critics were all too willing to link a
"revolutionary," literary naturalism to Manet's "Impressionism." Richard
Graul, the *Zeitschrift für bildende Kunst*'s Paris correspondent, denounced
Manet's paintings at the 1889 Exposition Universelle: "It is neither today's
blockheads, nor the craze to amaze through unusual color or light effects,
that Manet throws into so unfavorable a light at the retrospective: it is much
more the childishness of his execution, the roguishness of his trivial in-
trigues, which lowers the worth of his work to a vile grade of artistic
understanding."[10]

And yet, Zola and his novels quickly made remarkable inroads in German
popular taste. By the end of the 1880s, literary naturalism enjoyed an
intense, albeit brief triumph. This was not without effect for the visual arts.
In 1887 the middle-brow *Die Kunst für Alle* published a ground-breaking
article by Hermann Helferich (an alias for Emil Heilbut), "Studie über den
Naturalismus und Max Liebermann," which begins by casting Liebermann
under the sway of Zola. The essay opens with an extract from *Germinal*
(1885).[11] Helferich portrayed both the novelist—in place of the immoral,
cynical writer—and Liebermann as lovers of humanity. Liebermann
treated the realities of contemporary life in a powerful, virile manner,
following in the tradition laid out by Barbizon painting and Millet in par-
ticular.[12] Helferich even used the term *Impressionismus* instead of the Ger-
man *Eindruck* [impression] to characterize Liebermann's art—and thereby
ensured the linkage of Liebermann to Impressionism thereafter.[13] The
article represented so much an about-face on the prevailing views on Zola
and naturalism that Helferich's editor, Friedrich Pecht, printed a dis-
claimer, reserving some unspecified disagreements with the brash, young
critic [214].

Pecht's own appraisal of "Impressionism," published in August 1887, supported the view of Zola's early critics that art ought to paint "the inner life of man through the representation of external appearance."[14] If Zola was a weak servant to his facts, Pecht held that the "Impressionists" also sacrificed to nature aesthetic decisions that produced a kind of passive *Reflex-Malerei*. The nearer art came to science the more passive and uncreative the artist. But for Impressionists Pecht had only German examples in mind, namely Uhde and Liebermann.[15] And he closed out his essay with this admonishment: "the adoption of such fashions by the Germans would be more unfortunate than useful"[339]. *Reflex-Malerei*, the identification of Impressionist painting with the social realism of Zola's novels, the ascription of French modernism to the culture of fashionable Paris, these are the three principal tropes of *Pleinairismus*.

The tentative arguments in favor of *Pleinairismus* advanced by critics such as Helferich were soon drowned out by the anti-naturalist reaction that set in circa 1890.[16] Surveying contemporary painting in 1894 the prominent German art historian Karl Woermann concluded that there were two camps, what he held to be the two "faces" of his time, one whose concern was to represent "nature," the other the "imagination."[17] Since the imaginative artists were posed as newer than the natural painters, the place of Impressionism (read as naturalism) as a radically modern art was entangled in a confusion of public perceptions. Art was to be both true to nature and to the social experience of everyman, but it must also celebrate the elite individual reinforced by the mythic paradigm of Friedrich Nietzsche's *Zarusthrustra*. The significance of Nietzsche had only been impressed upon German readers in 1890 through the work of the Danish literary critic Georg Brandes and his published lectures on the philosopher.[18] "Respectable" art historians such as Woermann found themselves joining forces with such radical polemicists as Julius Langbehn, the self-styled *Rembrandtdeutscher*, each looking for a post-naturalist painting that would return art to its transcendent place. Langbehn found that art, like many of his contemporaries, in the paintings of Arnold Böcklin.

Langbehn's *Rembrandt als Erzieher* (1890) symbolized the rise of neoidealism—the term came into common usage in 1890—in the new German art and literature.[19] As a cataloguer of the German *Weltanschauung*, Langbehn enumerated many of the key issues that occupied German intellectuals right through the outbreak of the First World War. Langbehn loosely grounded his radical cultural pessimism in Nietzsche, lashing out at the "decadence" of contemporary German cultural life.[20] He especially denounced Germany's official culture represented by the academies and

universities. They had become too specialized and cultivated the small man rather than the great individual. So too had the rise of liberal democracy led to a general leveling of society: the triumph of the mass man over the individual. Naturalism was to be considered as the artistic parallel to the atomization of knowledge in modern science.

The extraordinary success of Langbehn's book (it went through innumerable reprintings) had less to do with its arguments than its resonance with the anxieties of a culture that had recently undergone the traumatic effects of national unification and rapid industrialization. It served to precipitate the anti-naturalist, anti-democratic values in art (and society) that were to define the position of most German artists and intellectuals in the 1890s. For reasons that transcended rightist ideologies, Langbehn's book sparked a generation in revolt against the authority of the academies, universities, and other cultural institutions of the Reich. The emotional, rather than reasoned, character of Langbehn's critique simultaneously fed both cultural pessimism and nationalist fervor. The cultural left used Langbehn's anti-modernist, anti-science, and elitist rhetoric as positions from which to repudiate German academies and universities in the name of liberal reform. The German right looked forward to the great artistic personality who would reveal the true German *Kultur* under the layers of corrupting civilization and thereby fulfill the demand for a *Heimatkunst* (many nominated Böcklin for this task). And even the Secessionists looked to the artist who would be European-bounded, believing that "true" art and artists inevitably transcend party interests, national chauvinism, the petty politics of exhibition rights, in short, *Kunstpolitik*.

How much changed in so short a time—and the confusions these dramatic changes inevitably entailed—may be measured by the work of the Viennese critic, Hermann Bahr. In 1890 Bahr published a series of essays under the title *Zur Kritik der Moderne* that identified the modern with naturalism.[21] A year later, however, Bahr produced *Die Ueberwindung der Naturalismus* which claimed to document its fall.[22] The hero of the first book was Ibsen; of the second, Strindberg. In *Die Ueberwindung* Bahr employed a dichotomy between young and old culture and between what he called an old and a new psychology. Although Bahr used the term "Neu-Idealismus" to describe the new sensibility, his set of reference points, particularly in regard to contemporary painting, did not match the usage of neoidealism as it was to be employed in German art criticism throughout the 1890s.[23]

Bahr contrasted traditional painting with a new *Nervenkunst* (he avoided the term Impressionism). The traditional artist would paint a blue table

under yellow sunlight so that the table remained wholly blue and the light wholly yellow. The *Nervenkünstler*, the artist who paints with his nerves, would represent, without conscious control, and by the means of an optical realism, the true mixing of yellow and blue, leaving the viewer to sort out the results.[24] The enforced subjectivity of this experience stood for the new psychology against the old paradigm of naturalist objectivity. Bahr elided unconscious, objective observation on the part of the painter with the subjectivity of the implied response, linking an image of the Impressionist as the detached, scientific, and passive observer with a counter image of the subjectivity and relativity of vision. Bahr chose Albert Besnard to embody *Nervenkunst*—a logical selection if we recall that Besnard, as a member of the international *juste milieu*, enjoyed a considerable reputation as a progressive artist among those showing at the Paris Salons and at the international exhibitions.[25] Thus Besnard came to be seen in Germany, without apparent paradox, as both an Impressionist and a neoidealist.[26]

Bahr's positivist, progressive view of culture shared with Langbehn's reactionary text the simplistic use of psychologisms to describe complex social and cultural experiences. *Nervenkunst* could thus be easily subverted by critics hostile to aesthetic modernism. In a book perhaps even more sensational than Langbehn's, *Entartung* (1892) [Degeneration], the Viennese physician and literary jack-of-all-trades, Max Nordau, used Besnard's paintings to describe Impressionism as the manifestation of a hyperstimulated, diseased mentality.[27] A cosmopolitan Jew, a liberal (he had once called Zola the greatest writer of the nineteenth century), and a Zionist—he was a close friend of Theodor Herzl—Nordau moved freely between the critique of social degeneration and the degenerative individual.[28] The overstimulus of contemporary life produced the symptoms of "fatigue and exhaustion." In turn these symptoms bred the aesthetic fashions that were "manifestations of degeneration and hysteria."[29] Nordau's *Nervenkunst* was the negative consequence of mental illness and physiological disorders.[30] Turning Bahr's account on its head, Nordau argued that the audience for modern art suffers from the same disorders as the artists who make the work.[31] In a rare reference to a modernist artist—Nordau had as little knowledge of contemporary French art as Bahr—he observed that "the violet pictures of Manet and his school . . . spring from no actually observable aspect of nature, but from a subjective view due to the condition of the nerves"[25]. Nordau's book played to an almost entirely different audience than Bahr's.[32] But his influence was greater and he helped to keep the

question of healthy versus degenerate art alive in both pro and anti-modernist tracts for the next half century.

That Besnard was the exemplary Impressionist for both Bahr and Nordau illustrates an essential, overriding fact: Central Europeans saw the canonical Impressionists only at two small exhibitions at Berlin's Galerie Gurlitt in 1882 and 1883 and then virtually not at all for fifteen years. Gurlitt chose to cultivate other artists, particularly Böcklin and Klinger, for the remainder of his short career.[33] As one critic put it, "there is only one Böcklin and Gurlitt is his prophet."[34] The art critics Julius Elias and Hermann Uhde-Bernays both remember exhibitions organized by the Galerie Durand-Ruel, under Elias' stimulation, beginning in 1892 at the hotel "Kaiserhof".[35] But Charles Durand-Ruel subsequently maintained that the first two exhibitions sponsored by his gallery in Berlin only took place in 1897— the first was a show devoted primarily to the École de 1830, the second to the Impressionists.[36] Meier-Graefe also recalled the presence of Impressionist paintings in the Berlin gallery of Hermann Pächter throughout the nineties, but we have no corroborating evidence for what the dealer actually had on display or when.[37] Elsewhere, Vienna saw a large contingent of the École de 1830 and some paintings by Manet at the World's Fair of 1873 (supervised by Paul Durand-Ruel); but neither Manet nor the Impressionists were present at the next international exhibition in Vienna in 1894. In Munich, in 1891, a small contingent of Manets, Monets, and Sisleys were shown at the Glaspalast to little comment.[38] Similarly in 1896, the Munich Secession displayed a landscape by Sisley and one by Pissarro, which received only passing attention.

The ignorance of Impressionist painting extended to those who travelled to Paris.[39] German artists were far more likely to visit the exhibitions of the rival Salons or perhaps sensational shows such as those of the Rose + Croix, than to search out Durand-Ruel's gallery or the Indépendants for the latest tendencies in French art. Walter Leistikow, for example, published an article in 1893 in the *Freie Bühne*—then Germany's most advanced cultural periodical—under the title "Moderne Kunst in Paris" that claimed to discover the growing dominance of foreign art in Paris, comparable to the triumph of Wagner over French music, a demonstration, in fact, of the decline of contemporary French art.[40] Despite his friendship with Liebermann, who we know had a direct knowledge of French Impressionism since the mid-1880s, Leistikow was unable to name a single important (by our conception of the canon) modern artist then working in Paris. For

Leistikow, Whistler still represented the most modern in modern art. It was this mentality that explains why most German critics thought that the leading Impressionists in 1893 were the Scots.[41] In fact, between 1884 and 1894, when Muther's *Geschichte der Malerei im XIX. Jahrhundert* appeared, only one brief, unillustrated article, written on Monet by Helferich for the *Freie Bühne* (1890), treated Impressionism through one of its canonical representatives.[42]

If the art public at large was generally ignorant of canonical Impressionism before 1895, the cultural elite were not. There existed two principal, and quite small, collections of French Impressionism in Germany—both in Berlin—in the 1880s and 1890s, one belonging to the Russian-born lawyer Carl Bernstein and his wife Félicie, and one to Liebermann.[43] Their social circles included the young Meier-Graefe, Alfred Lichtwark, then the most energetic museum director in Germany, presiding over the Hamburger Kunsthalle, Wilhelm von Bode, director of the Berlin museums, Tschudi, named director of the National-Galerie in 1896, Friedrich Lippmann, the director of the Prussian print and drawing collection, and Woldemar von Seidlitz, eventual director of the Dresden Royal collections.[44] Outside the art historical community such luminaries as Theodor Mommsen, Germany's most famous historian, and Ernst Curtius, its best literary historian, frequented the Bernstein residence.[45] Not all these men were immediately convinced of Impressionism's worth, but their early acquaintance paved the way for their later patronage. Their academic training and the fact that many brought a museological perspective to Impressionism also ensured that they would approach this art from outside the terrain of art criticism, as an historical phenomenon fully deserving their attention. In effect they and a few other critics, publishers, and dealers came to stage a sort of palace revolution, forging from above a taste for Impressionism among the German art public.

The fact that the "Impressionist revolution" was sponsored by Germany's cultural elite may be less surprising than the stimulus it received from an apparent natural enemy, the reform movement in the decorative arts. The international enthusiasm for the decorative arts in the 1890s brought together an extraordinary, influential circle of museum men, critics, art historians, and art dealers, many of whom around 1900 shifted allegiances from championing the decorative arts to celebrating modernist painting and sculpture. The *Gesamtkunstwerk* ideals of the decorative arts movement, which proposed an equalized relationship with the high art traditions, proved in realization to be as elitist as its high art brethren. The

migration was not from low to high, but along the same plane. The institutional relationships that serviced the promotion of the decorative arts passed easily over into the promotion of high modernist art.

The key player in this complex historical event was unquestionably the former Belgian Neo-Impressionist painter, architect, and pioneer of art nouveau design, Henry van de Velde.[46] The first thread of van de Velde's connections with Central European cultural elites came with his meeting of Julius Meier-Graefe at an exhibition of Les XX in Brussels in 1891. Meier-Graefe, in turn, brought the German born, but Parisian residing publisher, dealer, and expert in *japonisme*, Siegfried Bing to Brussels in 1895; there they saw van de Velde's significant collection of Neo-Impressionist art (and a van Gogh drawing) and met the literary and artistic avant-garde around Octave Maus' La Libre Esthétique.[47] They were particularly impressed by a venture organized by Edmond Picard (coeditor of *L'Art moderne*), a Maison d'Art, in which paintings and sculptures were exhibited alongside the decorative arts in a total aesthetic environment. Bing decided to organize his own "maison d'art," the celebrated Salon de l'art nouveau, which like Picard, showed modernist painting alongside art nouveau designs.[48]

Soon van de Velde came to know most of the leading collectors, intellectuals, and industrialists who were to support modernism in Central Europe. In 1896 Seidlitz approached Bing about contributing designs to the 1897 Dresden International.[49] Among the furniture and other pieces lent by Bing (almost all of which were designed by van de Velde) only one was credited to the architect, the rest passed under Bing's name. Despite the dealer's proprietary action, van de Velde's role was quickly discovered: "The day after the opening of the exhibition I was suddenly famous in Germany."[50] Subsequently, van de Velde and the Belgian sculptor Constantin Meunier travelled to Berlin, where through the agency of Curt Herrmann, a young Berlin artist already working in a Neo-Impressionist manner (he had shown with La Libre Esthétique), they met Corinth, Slevogt, Leo von König, Georg Kolbe, as well as Paul Cassirer, and the editor of *Das Atelier*, Hans Rosenhagen. On the invitation of Liebermann, the Belgians sat down to dinner with some forty persons belonging to the elite of Berlin's cultural establishment, including Bode, Tschudi, and Lippmann.[51] An unexpected fruit of van de Velde's German connections lay in his knowledge of van Gogh; he knew Théo van Gogh's widow, Johanna. On his honeymoon in 1897 van de Velde visited Mme. van Gogh in Bussom. Later, he assisted Paul Cassirer in obtaining from Johanna eighteen pictures by the artist for Cassirer's first German exhibition in the winter of 1901.[52]

Perhaps van de Velde's most significant German relationship was with the

Baron Eberhard von Bodenhausen. An art collector and a member of *Pan*'s editorial board, the baron was also, in collaboration with Count Morton Douglas, the owner of the patent for the condensed milk product, *Tropon*, for which van de Velde did the publicity and packaging designs.[53] Bodenhausen in turn put up the capital behind van de Velde's Brussel's workshop, the "Société van de Velde." The publication of large extracts of Paul Signac's essay *D'Eugène Delacroix au néo-impressionnisme* in *Pan* in 1898, like the numerous Neo-Impressionist exhibitions in Germany that followed—including the one Paula Becker saw at Keller & Reiner—owed to the sort of connections that existed between Bodenhausen and van de Velde.[54] Neo-Impressionism and art nouveau had long been institutionally joined in Brussels at the exhibitions of Les XX and La Libre Esthétique. In the mid-1890s some Neo-Impressionist painters made considerable reputations for themselves as mural artists working in the context of art nouveau-styled buildings, as in the collaborations between the Belgian painter Théo van Rysselberghe and the architect Victor Horta.[55] The taste for Neo-Impressionism among a comparatively small circle of Germany's cultural elite that van de Velde helped to encourage was expressed in books both Meier-Graefe and Harry Graf Kessler wrote in its defense.[56] Even Rainer Maria Rilke made his debut as an art critic in connection with the first Neo-Impressionist exhibition at Keller & Reiners in 1898—it was perhaps the best essay on Neo-Impressionism to appear before the war.[57]

It was also through Bodenhausen that van de Velde met Harry Kessler— Bodenhausen had recommended van de Velde for the redecoration of Kessler's Berlin apartment. Kessler was one of the most highly placed members of Berlin society. His father, a very close friend of Bismarck, had his son educated at Oxford. After his father's death, Harry had lived with his mother in Paris before finally settling in Berlin. According to van de Velde, in 1898 Kessler already possessed by German standards a dazzling collection of modern art, one that included a "van Gogh, a Cézanne, a Renoir, a Vuillard, two Bonnards, a Maurice Denis, a series of watercolors by Ludwig von Hofmann, and the great painting *Les Poseuse* [Barnes Foundation, Merion, PA] by Seurat."[58] Kessler and Bodenhausen were also, notably, intimates of Vollard's gallery, where undoubtedly they derived their early appreciation for Cézanne and the Nabis.[59]

Through Kessler, van de Velde won the design for the Nietzsche-Archiv in Weimar, a project supervised by the count and Elizabeth Förster-Nietzsche, the philosopher's sister.[60] This commission eventually led the Großherzog Ernst Ludwig of Weimar to name van de Velde the director of the Weimar Kunstgewerbeschule; Kessler meanwhile became director of

Weimar's museums in 1902. Weimar was soon a leading center for modern-
ism in the empire, rivalled only by Berlin and Karl Ernst Osthaus' Folkwang
Museum in Hagen. For a number of years Edvard Munch resided in
Weimar as a guest of Kessler. Although Kessler's residence there was com-
paratively brief—he was forced out of office over a scandal caused by an
exhibition of Rodin drawings in 1906—the museum continued to exhibit
the most radical contemporary art, domestic and foreign.

Van de Velde also went to work for Osthaus, designing among other
projects the Folkwang's interior.[61] At the time of their first meeting Ost-
haus was 25, the son of a wealthy banker. Convinced of the need to create a
contemporary museum of art for his native city of Hagen, Osthaus learned
of van de Velde's work in the pages of *Dekorative Kunst* and asked the
architect to design the interior of the "Folkwang."[62] Van de Velde built his
patron's house, which became an important meeting place for all those
interested in the new arts. In the Osthaus circle were Bodenhausen,
Friedrich Deneken, the director of the Krefeld museum, the Hagen indus-
trialist Theodor Springmann, and the Heilbronn manufacturer, primarily
of silverware, Peter Bruckmann (later an important participant in the Ger-
man Werkbund).[63] Although the Folkwang did not open to the public until
1902 Osthaus began collecting for his museum as early as 1898. That year
he travelled to Tunisia to acquire tapestries, pottery, and folk wares with the
idea of establishing a museum of Islamic art; at the time his tastes in Eu-
ropean art were confined to Düsseldorf landscape painting. Osthaus' ac-
quaintance with van de Velde changed the young man's tastes. Van de Velde
encouraged Osthaus to acquire works by Renoir, van Gogh, Cézanne, and
the Neo-Impressionists, and he introduced the collector to Vollard and
Cassirer. After a period of apprenticeship under van de Velde's taste, Ost-
haus followed his own path. He sought out Matisse in 1905, buying his first
painting from the artist in 1907; in 1906 Osthaus approached Cézanne in
Aix-en-Provence.[64]

Not only did Osthaus display this rich collection of French modernist
painting, he annually arranged cycles of exhibitions by contemporary art-
ists and designers, from the Rhineland, or elsewhere in Germany, or from
abroad. The Folkwang also gave small retrospectives to painters such as van
Gogh. As a consequence both Hagen and Weimar became necessary stops
for travelling exhibitions of contemporary art so that the Expressionist
societies of the Brücke, the Neue Künstlervereinigung Münchens, and the
blaue Reiter all showed there, often more than once. In addition, Deneken's
museum in Krefeld played an active role in showing contemporary art and
frequently joined the other two cities on the tour.[65] Constrained by the

small size of his museum and in lieu of major purchases, Deneken staged frequent special exhibitions, showing many of the same artists and groups as Osthaus. Between them they made the Rhineland, already the most industrialized and the most politically liberal region of the empire, a sympathetic milieu for modernist art, which led to the founding of the Sonderbund and the great Sonderbund exhibition of Post-Impressionism in 1912.[66]

The volte-face of Impressionist identity in Central Europe thus came about under the leadership of a circle of Secessionists, dealers, art critics and historians, and museum men, who eventually espoused Impressionism against the dominance of the anti-rationalism and cultural chauvinism of neoidealism. Yet it was also true that as the Impressionist *Weltanschauung* was constructed it incorporated much of the neoidealist rhetoric, particularly the Nietzschean-inspired figure of the transcendent great individual. Indeed, what is so fascinating about the importation of French Impressionism is this shift of the attributes of the heroic master, from the nomination of Böcklin, to that of Manet. This transference required separating Impressionism from literary naturalism and the de-politicizing of its content, a process largely accomplished by appeal to the emergent techniques and new-found social prestige of German art historiography.

RICHARD MUTHER'S *GESCHICHTE DER MALEREI IM XIX. JAHRHUNDERT*

The first landmark in the construction of the Impressionist *Weltanschauung* was Richard Muther's *Geschichte der Malerei im XIX. Jahrhundert*, a book that both introduced Impressionism to German-language audiences on a mass scale and underlined the condition of Impressionist theory (as naturalist doctrine) without, however, the evidence of Impressionist painting.[67] Muther's three-volume history of nineteenth-century painting has an importance for the history of modernist discourse that transcends its multitude of limitations. As a professor of art history first in Munich and later in Breslau, Muther's personal prestige masked the essentially polemical nature of his history. Not only did the *Geschichte* provide the first historical account of Impressionism in German, it offered a model of historical argumentation that was taken up time and again by subsequent apologists for modernism. In addition, it was the most inclusive history of nineteenth-century art ever written—twice the size of the slightly later account of German nineteenth-century art, published by the most widely respected historian of "contemporary" art, Cornelius Gurlitt (the dealer's brother),

Die deutsche Kunst des neunzehnten Jahrhunderts.[68] And unlike Gurlitt, Muther placed German painting within a truly international context. The steel-engraved illustrations numbering well over a thousand remain a valuable visual resource for late nineteenth-century tastes.

At the center of the *Geschichte* Muther placed three tenets as the chief accomplishments of modern painting: naturalism in art, independence in *Kunstpolitik*, and the overthrow of the academies. While these themes were already cliches in French modernist art criticism, they were largely new to German discourse and had not been invested anywhere with the kind of historical authority Muther brought to this book. Muther also opened new ground in art historical writing through his advocacy of *l'art pour l'art* as the chief manifestation of nineteenth-century art, an argument he then cast as contiguous to the intentions of the great artists from the Renaissance and the Baroque [I: 170]. According to Muther, this tradition was interrupted in the eighteenth and early nineteenth centuries by those misguided artists and their publics who desired the socialization of painting and pleasing narratives to the detriment of the pure values of painting. "Only . . . when people had again apprehended art as such—as a piece of nature interpreted by the artist's eye—did all that was literary, historical, sentimental, geographical, all that narrated and played upon words, and these just sufficiently well coloured to be intelligible, fall into the second rank"[I: 171–72]. Finally, for the first time in an ostensibly art historical work, Muther cast the modern as a breakthrough, an overthrow of academic conventions and mass tastes, and gave Manet the leading role.

> Manet's achievement, as it requires to be understood—as the last issue of our struggle to see nature without mediation and to be true to our own perception—denotes the final, decisive word in the great fight for the liberty of modern art. When Manet promulgated the doctrine that every tradition of the schools, even with regard to colour, which came between the artist and nature was to be discarded, he consummated the complete ruin of academic convention. [I: 201–202]

The first volume established a "pre-history" of naturalism in Romanticism. In the sections "The Legacy of the Eighteenth Century" and "The Legacy of German Romanticism" Muther laid out the variety of national schools, beginning with their origins in the eighteenth century. There are significant lacunae (Caspar David Friedrich had yet to be restored to his central place in German Romantic painting), and other major artists were treated only in passing. As representatives of Munich's post-Nazarene idealism, Peter Cornelius and Wilhelm Kaulbach were given the same space as

Géricault, Delacroix, and Ingres combined. On occasions like these the narration was tipped in favor of German artists of the stature of Alfred Rethel or Moritz von Schwind. And yet, overall, Muther's progressive model of naturalistic studies overwhelmed the idealists and Biedermeier artists of the first volume. The third section, which bears the title "The Victory of the Moderns" and comprises all of the second volume, traced a coherent stylistic evolution from the Romantics through the rise of naturalism, represented especially in the work of Millet, Courbet, Menzel, Ford Madox Brown, and culminating in Manet and the Impressionists. "Géricault, Delacroix, Courbet and Manet, widely as they differ from one another, are links in one chain of evolution"[I: 73].

Like Bley and Helferich before him, Muther's sense of Manet's ideological and aesthetic ambitions was shaped by his reading of Zola's novels and art criticism, although he hoped to revise this relationship by demonstrating Manet's influence on the novelist: "The artistic ideas of Claude Lantier (the hero of *L'Oeuvre*) were given to Zola by his friend Edouard Manet, the father of Impressionism, and in that way the creator of the newest form of art" [II: 719]. This assertion caused a Dutch correspondent to write Zola about Muther's book, complaining that the German author knew nothing about French art and specifically did not know the role Cézanne played in Zola's portrait of Claude.[69] These deficiencies, in fact, make all the more remarkable Muther's selection of Manet, an artist without a known body of work in Germany, as the pivotal point in the restoration of painting to its true self, and in opposition to some of the most cherished beliefs of German culture.[70] Indeed, Muther judged other artists by the qualities found in modernist French painting. He wrote of one of the most admired of near contemporary German painters, Wilhelm Leibl, that the artist was "the greatest *maître peintre* that Germany has had in the course of the century"[II: 656]. The French phrase was essential. It subsumed the German artist under a French umbrella and did so with considerable sophistication.

> To avoid exaggerated characterization, to avoid the expression of anything divided into *rôles*, he [Leibl] consistently painted people employed in the least exciting occupations, peasants reading a newspaper, sitting in church, or examining a gun. Pains are taken to avoid the slightest movement of the figures. Whilst all his predecessors were romance-writers, Leibl is a painter. His themes—simple scenes of everyday life—are a matter of indifference; the beauty of his pictures lies in their technique. . . . Leibl's mystery, which of itself resulted in an astonishing truth to nature, lay in seizing an impression as quickly as possible, taking hold of the reality

rightly at the first glance, and transferring the colours to his canvas with decision and sureness, in clear accord with the hues of the original.[II: 657]

It is an astonishing portrait of a German artist cast within a French discourse. And as if to leave no doubt as to the primacy of the French, Muther observed in passing that if Trübner's work could somehow be combined with Leibl's it "would contain the same total power as Courbet had in France"[II: 664].

The tendentiousness and timeliness of Muther's history is manifest in his reprinting, almost in full, of Sâr Joséphin Peladan's preface to the first exhibition catalogue of the Rose + Croix, held at Durand-Ruel's gallery only two years before (in 1892). The self-confident image of the progress of Western civilization manifested in naturalism—the preeminent rule of science and of instrumental reason—that occupied the first four sections of his history suddenly came into conflict with fin-de-siècle decadence. Inevitably, the *Geschichte* mirrored the dramatic cultural shift of the previous five years.

Caught between naturalism and the anti-naturalist doctrines of the 1890s Muther repeated the internal contradictions of the work of his model, Georg Brandes. Brandes was the most dominant literary critic in Europe in the 1890s, pioneering the reputations, among others, of the Russian novelists.[71] In 1883 Brandes brought out a series of essays under the title *Det moderne Gjennembruds Maend* [Men of the Modern Breakthrough]. Elaborated through his subsequent books, especially *Hovedstromninger i det 19de aarhundredes Litteratur* [Main Currents in Nineteenth-Century Literature], the first volume of which appeared in German translation in 1886 with a complete second German edition appearing in 1892, and lectures on such figures as Dostoevski, Strindberg, and of course, Nietzsche, Brandes transformed the word "modern" from the description of the recent or the contemporary into an ideological rallying point.[72] His conception of a "modern breakthrough" and of "modern minds" meant essentially the arrival of naturalism in European literature, led foremost by Ibsen. Brandes' influence was most strongly felt in Germany, whose intellectuals and literati developed a sense of the modern that was markedly different from a French, or more specifically, a Baudelairean *modernité*.[73] Above all, Brandes' work was unprecedented for linking the literary schools of France, Britain, Russia, Belgium, and the various Scandinavian countries to a single developmental history of nineteenth-century literature composed of parallel "currents" and united under the "modern" sensibility. And yet, just as Brandes superintended the internationalization of naturalism in the late

1880s, he was also primarily responsible for introducing Strindberg and Nietzsche to Europe.[74] His review of Langbehn's book in the *Freie Bühne* likewise dramatically assisted the popularity of the *Rembrandtdeutscher*.[75] For all its shortcomings, Brandes admired Langbehn's celebration of the individual. And finally, his conversion to post-naturalism acquired a personal note when he became related by marriage in 1887 to Gauguin, his brother marrying Mette Gauguin's sister.

Muther's *Geschichte* tried to make sense of the watershed of 1890. Muther sought to justify neoidealism within his evolutionary model of the rise of naturalism by transferring the psychologisms of Bahr and Nordau's treatment of Impressionism to the idealists. Muther saw neoidealism as an extension of naturalism, satisfying that aspect of Western culture, the interior life of the individual, not touched by the positivism and societal concerns of naturalist doctrine.

> After Courbet's doctrine of the *vérité vraie* had been supplemented by the addition that the representation of any portion of reality only became art through the temperament brought to bear upon it, and that the essential element in art was not any document in its photographic platitude, but the man who used it as a vehicle of expression, it was already possible to lay stress altogether upon personality, splendid in itself, and of itself creating all. For what is reality? We know nothing of it. Our mental impressions are all that we know. . . . Naturalism was no longer looked upon as the aim of art, but as "the sound training-school" from which to rise into far-off realms of fantastic creation.[III: 551]

The final volume was thus equally divided between those direct heirs to naturalism I have called the *juste milieu* and those artists concerned with the "most fantastic visions of the soul, mysticism of colour and mysticism of thought"[I: 204]. Section four, "The Painters of Life," was too inclusive to conform strictly to my catalogue of *juste milieu* artists, but it represents essentially those artists to be seen at every international art exhibition in Europe in the early 1890s.[76] In the final section, "The New Idealists," Muther was compelled to acknowledge as the most modern the neoidealists, in a book that in every other respect had championed naturalism.

The heroes of his last volume were Bastien-Lepage, Puvis de Chavannes, Gustave Moreau, and Besnard, and their international equivalents. Missing were Cézanne, van Gogh, Gauguin, the Nabis, and all the members of the Belgian avant-garde (save Ferdinand Khnopff, who was already well-known on the international exhibition circuit).[77] Despite the sensational tour the year before of the work of Munch, the artist was left out of Muther's survey

of contemporary Norwegian art. In poster art, Toulouse-Lautrec was passed over in favor of Chéret, Willette, and Forain. That is, Muther did not yet know the artists who would a generation later most matter. Instead, Muther took as contemporary the Impressionists and their successors the *juste milieu* and the exhibitors at shows such as Peladan's Rose + Croix.

Like Brandes, Muther attempted to write an international and evolution-ary history of contemporary art. But unlike Brandes, Muther's heroes are led by the French. And unlike Brandes, Muther wanted to reconcile natural-ism to *l'art pour l'art*, to formalize, and inevitably, to decontextualize much of the art he treated. This may have been an indirect legacy of French art criticism which so frequently made such formalist and apolitical arguments to defend painters such as Manet.[78] Or it may have been the growing resonance of the theories of Konrad Fiedler and the sculptor Adolf Hildebrand—see my discussion in chapter 8—if one recalls Fiedler's maxim that "interest in art begins only at the moment when interest in literary content vanishes."[79] Or Muther may have borrowed from both. Muther, however, was never rigorously formalist, just as his model of the evolutionary development of naturalism was far from being the unitary march of a singular aesthetic vision. His encyclopedic ambitions were often at odds with the larger narrative concerning the rise of naturalism and continually subverted each other, confusing Muther's central arguments, and in the end, I believe, blunted the impact of his book on German audiences.[80] But by comparison, most "historiographic" accounts of nineteenth-century art written before 1900 were but collections of biographies—confined to one nation or école—which began with some general remarks about the aesthetic virtues of the artist (taken generally in isolation) and closed by demonstrating how at the artist's death those vir-tues were acknowledged by rewards, memorials, sales, etc.

The chief force of Muther's book lay in its pretensions to objective history, to its elevated form of critical writing, and to the prestige and social rank of the author. Muther anticipated the historical closures of subsequent modernist histories, and he initiated the process in which the new French imports were introduced to the Central European public with a substantial body of historical and critical literature already firmly in place, having taken the high ground of history. Modernism's opponents, conversely, however powerful their voices in the regional and national parliaments, were largely confined in critical discourse to the writers for the daily newspapers, to the conservative and entrenched critics of the popular art magazines such as *Die Kunst für Alle*, and the authors of ephemeral pamphlets. When the export of modern French painting to Germany began after 1897 Impressionism's

defenders would seek to put a formal gloss on the artists' work while simultaneously declaring the Impressionists' naturalism the fundamental and overriding concern of nineteenth-century art. The evolutionary model employed by Muther would be repeated again and again, even as the modernist canon would continue to gel. Zola's defense of Manet would not be forgotten, but its exegesis would rapidly become more sophisticated and more historically accurate.

If we can speak of a work so ambitious as Muther's *Geschichte* as tentative, we might better understand the embryonic state of his evolutionary model and Fiedlerian formalism which simultaneously stripped the subject of works of art of interest and asserted the primacy of the artist's personality in the representation of nature. The sense of the modern as a singular, evolutionary development had yet to set in. Seidlitz, for example, wrote a short book in 1897 under the prophetic title *Der Entwicklung der modernen Malerei*.[81] The development he described was in reality tripartite, and somewhat improbably arranged, a curious mirror to contemporary art as it then appeared to one of Central Europe's most informed observers. The first development was in color, beginning with Delacroix and ending with Bastien-Lepage (!). Here was a clear expression of the *juste milieu* as inheritors of the Impressionist tradition. The second strand was naturalism, understood in terms of its subject matter which encompassed Courbet and Liebermann. The last was *Gedankenmalerei* (philosophical painting), a synonym for neo-idealism, that had its origins in the English Pre-Raphaelites and was currently most manifest in the work of German artists such as Klinger, Böcklin, Stuck, and Ludwig von Hofmann. The impression conveyed by both Muther and Seidlitz's books was that this *Gedankenmalerei* was the most modern form of contemporary art.

And yet already by 1896 a certain anti-idealist reaction was observable in Berlin, particularly through the influential voice of Jaro Springer, son of the Leipzig art historian Anton Springer. In a review of the exhibition of the "Elf" at Schultes' in 1896, Springer repudiated the neoidealists in the group (save Klinger and Hofmann) in the name of naturalism.[82] This trend was undoubtedly spurred by the increasing presence of pictures by the canonical Impressionists in Central Europe. What could be more dramatic testimony of the sudden change than the assertion by Karl Voll, Munich correspondent *Die Kunst für Alle*, that Monet's *Hill Party* (possibly Wildenstein #274 or #276) was "the masterpiece of the [1897] Glaspalast exhibition"?[83] (Telling, too, is the fact that the Monet was shown in the "retrospektive Abteilung" of the international alongside paintings by Hals, Hobbema, Potter, Cuyp, Gainsborough, Reynolds, Turner, Constable, Delacroix, Corot,

Daubigny, and others.) To service this new interest Durand-Ruel sent a small collection of Impressionist paintings to Hamburg's international in 1895 and another to Vienna's in 1898.[84] The Dresden international received its first contingent of Impressionists in 1897.[85] Most significant of all was the pilgrimage made by Hugo von Tschudi to Paris, with Liebermann acting as his cicerone, in order to acquire from Durand-Ruel Impressionist paintings for the National-Galerie.[86] Tschudi's collection, including Manet's wonderful *Dans La Serre* and Cézanne's *Moulin sur la couleuve, à Pontoise* (Venturi, #324), was installed in 1898.[87] Characteristically, the Cézanne was acquired before the artist had been theoretically explicated either in Germany or in France.[88] Under pressure from the openings of the Caillebotte collection at the Musée Luxembourg and the Tschudi collection at the National-Galerie, neoidealism was toppled from its preeminent position and a new, more exclusive history of nineteenth-century art began to emerge.[89]

THE PARIS CENTENNALE OF 1900

The landmark event in the international triumph of Impressionism would prove to be the uninspired, yet widely celebrated Centennale of French painting from 1789 to 1889 held in conjunction with the Paris Exposition Universelle of 1900.[90] The Centennale was the chief attraction for the German critics who flocked to Paris to see the Exposition and it was universally offered as evidence that the Impressionists belonged at the center of modern French art. And the Centennale finally divorced (for most German critics at least) the Impressionists from their French Salon and *juste milieu* competitors.

This "apotheosis" was hardly intended by the Centennale's planners. Although the organizers made no explicit claims regarding their selection criteria, the Centennale was no more exclusionary (ideologically) than the rest of the exhibits at the Exposition. The organizers embraced the *pompier* artists along with the *juste milieu* and the intransigents. French officials were reluctant to dispense with the academic tradition, while the *juste milieu* leadership at the Société nationale were as powerfully entrenched as the academicians of the old Salon. Alongside the Ingres, Delacroixs, and other expected master painters from the first half of the century, one found not only Monet and Gauguin but Gérôme and Gervex. In the face of this apparent heterogeneity, the lack of ideological groupings (or "isms"), the often minor pictures that represented famous artists, and the famous pic-

tures by what we now take as minor artists, the exhibition was still perceived—particularly by the Germans—as forming a uniform and coherent history of nineteenth-century French art. The simple act of inclusion brought the former intransigents into the "official" history of nineteenth-century art (and incidentally, finally vindicated their dealer, Durand-Ruel).[91] In such company, the Henners, the Regnaults, and even the Bastien-Lepages were overwhelmed. The show effectively rewrote the last volume of Muther's history.

Franco-German relations, if not good, had at least improved significantly since the last fair in 1889—if the memories of Verdun had not entirely faded, they had become part of a distant past.[92] It was widely observed that the English and many other nationalities were rather poorly represented among the visitors, but that the Germans were everywhere. Even for those who stayed home there was a unprecedented flood of publications on the Exposition.[93] Most German art critics viewed the Centennale exhibition as the Exposition's centerpiece, and its most admirable aspect. Given the rivalry between the two nations it is not surprising that German critics used the Centennale to grant Paris' claim as the capital of nineteenth-century culture, while arguing that everything else at the Exposition—that is, the Paris of today, not of yesterday—suffered by comparison. They imagined that the days of Paris' hegemony over architecture and the visual arts might be drawing to a close.

René Binet's monumental arrangement of buildings on axis with the Pont Alexandre III was meant both to complement and replace the Eiffel Tower as the focal point of modern Paris. When joined with the famous pavilion of Siegfried Bing's Maison de l'art nouveau, one would expect both the conception and the architecture of the exhibition to be widely praised.[94] Yet after its closing, in contrast to all its predecessors, the show had only "isolated defenders."[95] Friedrich Naumann, the liberal Protestant critic, essayist and editor of *Die Hilfe* (founded in 1895), and future co-founder of the German Werkbund (1907), a man who was by disposition pro-French and who had frequently argued for the need to break down the traditional animosity between France and Germany, felt that the fair was simply excessive. Naumann argued that the Eiffel Tower was still the dominant architectural form at the exhibition and that there was too much fluff to the French exhibits.[96] So too the Decennale, or Decennale as it was popularly known, suffered by comparison to the Centennale. The Decennale showed more than three thousand works by Salon notables dating from 1889 to 1899. Any artists who once sat on the jury of either Salon was permitted to exhibit

eight works *hors concours*. The result was a numbing glut. Surveying the Decennale one German critic declared that "the great age of French painting is over."[97]

The combination of the apotheosis of Impressionism and the decline of French art was taken up by Muther in a lengthy review of the Centennale, reprinted in book form as *Ein Jahrhundert Französischer Malerei*.[98] Compared to his earlier compendium, this latter, now exclusively French version of nineteenth-century art underlines the notable changes German perceptions of Impressionism had undergone in the subsequent six years. Muther agreed with Naumann that whereas in 1889 the exhibition displayed significant architectural advances, notably the Eiffel Tower, the design of the 1900 fair was abysmal. For Muther the exhibition did not acknowledge the best of contemporary architects and designers, referring specifically to van de Velde and choosing to ignore Bing's *L'Art Nouveau* pavilion. He phrased this deficiency by referring to Zola's characters in *L'Oeuvre*: "Instead of Claude Lantier, the Fagerolles triumphed"[7]. It was a veiled opposition between Manet and the *juste milieu*, between, in effect, the Centennale and the Decentennale. Muther described the Decennale as a show that "teaches nothing about what will come, but it gives an overview of what was"[8]. Even the Centennale was marred by the extensive borrowing of works from provincial museums and private collections, rather than relying on the great Parisian collections. He concluded, nevertheless, that the exhibition, especially for the art historian, made known artists barely heard of before and shed new light on many others.

In some respects the ordering of Muther's review resembled his earlier history. He began with the end of the rococo and traced modernism to its "conclusion" in what he called "Der Sieg der Linie," carried out by artists such as Puvis. "The further development of French painting was that the influence of Manet more and more receded and instead of him Moreau and Puvis de Chavannes became the leading stars"[286]. Muther also credited Moreau with reviving the interest in the art of the old masters, which he believed had been forgotten in the time of the Impressionists, a revival, however, that put Old Master paintings in the context of the new Impressionist vision. He further cited the influences of Wagner, Maeterlinck, and d'Annunzio on modern French art. Despite this endgame of the victory of line over color (which Meier-Graefe would turn on its head in his *Entwicklungsgeschichte*), the body of Muther's text, like the Centennale itself, celebrated the Impressionists at the expense of the generation of the nineties represented at the Decennale.[99] Besnard, Muther wrote, "was perhaps

overvalued from his first appearance, because one knew him before his predecessors"[232]. Muther adjusted the reputations of Boldini, Bastien-Lepage, Roll, and so on. The academicians fared worse: Muther described Bouguereau as "the public's painter in the worst sense, (who) has hindered by his characterless softness and weak technique [flauen Fachheit] the understanding for real art—even as it still does today"[129].

Because Muther saw the Impressionists succeeded by artists such as Puvis and Moreau, the aberrations to his system, e.g., Cézanne and Seurat, had to be treated simply as extensions of the Impressionist aesthetic.[100] He remained entirely unaware of any break within modernist aesthetics between the generation of the 1860s and that of the 1880s. In the six years since his monumental survey, Muther had more proficiently mastered the symbolist aesthetic and the literary and musical references that informed it. But as the exhibition showed, and which Muther only reiterated, the radical successors to the Impressionists remained obscure to the general art public. With the exception of Cézanne, who was present as an Impressionist, the major Post-Impressionist painters were only nominally present in single works by Seurat and Gauguin, and were entirely absent at the Decennale, which even excluded Monet. The Neo-Impressionists were brought into the orbit of Impressionism merely as the logical consequences of the investigation of pure light. Muther viewed Neo-Impressionism as the refinement of some of Impressionism's principles, but not an original art. The unification of all modernist French art under the umbrella of Impressionism—even Moreau and Puvis were treated as alternative, but linked, lines of development along the same evolutionary path—was hardly the exclusive doing of Muther; even in most Parisian artist circles Impressionism now signified modernism.

More importantly, as Muther became better acquainted with the pictures themselves, rather than with the French critical interpretations of them, he was more ready to abandon his literary models. Zola, Huysmans, and the Goncourts all gave way to the representation of Impressionism as the equivalent of modern science. For Muther the École de 1830 were lyricists while "The Impressionists are scholars. Not as dreamers but as researchers they view Nature, seeking like chemists to give learned analyses of light to landscape painting and to determine the components of the sun's rays"[205]. On the other hand, Muther now took this "scientism" to be the chief weakness among the landscape painters, where there was too little of the "Persönlichkeitsnote." Muther condemned the absence of "seelische Stimmung" and "Begeisterung," that is, the intellectual and spiritual voice in painting [208]. From this observation Muther drew broad conclusions

about the state of French society and culture. The Impressionists had played a specific historical role, but that was now fulfilled: they had mastered objective appearance. Since the Impressionist challenge to art was clearly over and its lessons learned, Muther concluded that the Centennale underlined what the Exposition Universelle generally demonstrated, the exhaustion of French culture and the general decline in the state of French painting and sculpture. Paradoxically, if the lessons of Impressionism had already been mastered, the real influence of this art had just barely begun in Germany (if Muther could now distinguish the French *juste milieu* from the Impressionists, he drew no such distinction for artists such as Liebermann and Leibl).

Although Muther still held to a neoidealist critique of naturalism, there were now other German writers willing to defend Impressionism against neoidealism and no longer under the guise of naturalism. Tschudi's review of the Centennale for *Die Kunst für Alle* articulated this new understanding of Impressionism.[101] What gave Tschudi's article particular force was the semi-official gloss he cast over the Impressionists from his position as the director of the National-Galerie. Tschudi wrote firmly within the conventions of the traditional exhibition review. Every artist, every picture was accorded a certain space. Yet even with these limitations, Tschudi surpassed Muther in distinguishing the canon of Impressionist masters from the *juste milieu*. He described Bastien-Lepage, for example, as "a tame popularizer of pleinairism," who combined the new qualities of light with "a mixture of sentimentality for the masses"[112]. Conversely, "the pictures of the Impressionists filled an entire room, which with the wall of paintings by Manet formed the highlight of the Centennale"[108]. Moreover, Tschudi valued this art so highly that "for the first time since the days of Velázquez and Rembrandt, in pleinairism and Impressionism has arisen something new and great"[108].[102]

The historical expectations that Muther and Tschudi held for the Centennale showed in their mutual disappointment that the exhibition fell far short of their goals (fundamentally through the general absence of paintings from the Louvre and Luxembourg collections, including the Caillebotte gift). The primacy of history was an obvious reflection of the German academic sensibility, but it also indicated how German critical discourse would now continually refer to Impressionism as a predetermined, historical constant. Tschudi imagined the show as an exhibition of the best that nineteenth-century French art had to offer, an "exhibition that would not be an illustration of the history of French artists, but a monu-

mental art history, written by the works of the masters themselves."
Tschudi found the juxtaposition of "greater" with "lesser" artists, such as
Manet with Bastien-Lepage, self-defeating.

Regardless of the exhibition's limitations, certain aspects impressed
Tschudi. He not only saw (again) the *Déjeuner sur l'herbe* (which he de-
scribed as "in no way among [Manet's] best work"), he was able to view
such later work as the *Déjeuner dans l'Atelier*—that he would later buy for
Munich—and the *Bar at the Folies-Bergère*, along with nine other paintings.
Like Muther, Tschudi refused to treat the content of Manet's pictures,
seeing in them all the drive towards naturalism. To this socially informed
term of the 1880s, however, Tschudi gave a universalist, non-social reading.

> Naturalism is a goal without means. Indeed, one can say the goal will be
> reached with certainty in proportion to how unnatural are the means. . . .
> From century to century, sometimes from decade to decade naturalism
> plants its goals higher and forces art to create new means of expression, the
> more fine and spiritual they become, the more refined the problems
> are.[107]

Tschudi concluded the first part of his review with the thought, stated
almost in passing, that the striving after nature embodied in Impressionism
held a greater richness than the paintings of fantasy—that is, neoidealism.
"Certainly the knowledge of such nature impressions and the creation of
the signs through which they are transmitted to us are a far greater act of
fantasy than anything a so-called soulful (Gemüts), fantasy art may of-
fer"[108]. In other words, the craft of illusionism, as it had reached a new
level of sophistication in Impressionism, required a greater participatory
engagement from the viewer. Tschudi offered in a remarkable rewording of
the arguments advanced in favor of the Impressionism in the 1870s. Here
the connoisseur was evoked in an explicit market discourse. Yet, on another
level, his argument was similarly involved with enlightened versus popular
perception, where the degree of difficulty falls just short of being an artistic
end unto itself. As a counter-demonstration, Tschudi devoted his harshest
criticism to Moreau, whom he described as having the properties of "ster-
ility and antiquated values. His drawing is poor, above all without life, the
color willful and without essential fineness. He is a fantasist without
fantasy"[114–15].

Tschudi's opposition to neoidealism—only some German exponents
such as Böcklin and Hans Thoma were spared criticism—anticipates the
virulent controversy Meier-Graefe provoked with *Der Fall Böcklin* in 1905.
Like Meier-Graefe, he found something more than science in Impression-

ism; when Impressionist pictures began to be imported into Central Europe, the discourse on *Reflex-Malerei* was replaced by one concerned with the ennobling of form through the great temperament—a complex equation drawn from popular and Nietzschean ideas. The original German critics of *plein air* emphasized its (radical) political aspects (or, on occasion, derisively about its lack of them). The new discourse, in order to counteract the prevailing representation of Impressionism in political terms, emphasized the aesthetic dimensions of the art, seeking to historicize the work as the inevitable consequence of evolving artistic issues. The new German critics of Impressionism played down the political readings of French modernism by following, perhaps unwittingly, comparable French criticism that had defended the Impressionists by stripping away their social concerns and any hint of political radicalism their work might suggest. They strengthened temperament into an architecture of genius and thereby laid the intellectual foundations for the reception of Expressionism.

This historicizing and formalist effort could of course be used for very different causes. Since Impressionism was increasingly seen after 1900 as synonymous with modernism, its proprietorship was also increasingly contested. Wynford Dewhurst maintained in 1904 that "those Englishmen who are taunted with following the methods of the French Impressionists, sneered at for imitating a foreign style, are in reality but practicing their own, for the French artists simply developed a style which was British in its conception."[103] As strained, and as defensive an argument as this is, it is but one sign that the German *impressionistische Weltanschauung* was by necessity—historical and political—constructed against the grain of nationalist arguments. Not surprisingly, French apologists in particular increasingly took up a nationalist defense of Impressionism in the face of its legitimization abroad. André Mellerio, for example, published a small polemical tract, *L'Exposition de 1900 et L'Impressionnisme*, that in general agreed with the German critics in regard to the Centennale: that the Impressionists were still too marginalized and that it was still necessary to correct the prevailing misconceptions as to what and who really constituted Impressionism; he provided his readers with a bibliography (the first of its kind).[104] Mellerio used the usual cliches: Impressionism was vindication of the free personality of the artist in the face of academicism, a movement united in sympathy with the prior struggles of the École de 1830 against the Academy, and characterized by the research into the effects of light realized in a technique that employed a palette of pure colors and the division of tones.[105] But the chief thrust of his polemic was to argue that at a time when

French prestige, political, industrial, and commercial, was waning abroad, it was necessary to privilege the great artists that France had produced in recent years. Taking Rodin's self-arranged retrospective at the 1900 Exposition as his exemplar—but also recalling Durand-Ruel's retrospectives for the Impressionists in the early 1890s—he called for the housing of a great retrospective devoted to Impressionism. It was an event unrealized in his lifetime.

After the 1900 Exposition, the escalating prices for Impressionist paintings and its increasingly diverse foreign patronage forced a reconsideration of Impressionism at home. Two kinds of literature emerged, the sober historical efforts of insiders such as Théodore Duret, who, beginning with *Histoire de Édouard Manet et de son oeuvre* (1902), produced a series of books that attempted to consolidate the Impressionists' historical importance inside the French tradition, and the work of new converts to the Impressionist banner who sought to enlist Impressionism to their own causes.[106] Duret registered the mirroring effect of international attention when he justified Manet by noting that his paintings "have now entered the museums or have taken their place in the great collections of Europe and America"[79]. In Duret's conservative construction Manet was—as indeed he had always been—respectable because his art arose from a deep respect for tradition: "No one admired more than he the true modern masters, Ingres, Delacroix, Courbet. No one studied more than he the old masters for whom he sensed an affinity"[87]. Stressing the social neutrality of Manet's vision, Duret attempted to strip his pictures of scandal: in *Nana* Manet rendered "one of the aspects of the life of pleasure . . . but by the aid of an artifice so simple and so tranquil that it seemed to have nothing of the offensive"[179–80].

Camille Mauclair was an "historian" of the second type. For most of the 1890s Mauclair had been a spokesman for "symbolist" painting and literature. But after 1900 he transformed himself into an (unlikely) apologist for Impressionism.[107] The price of such an abrupt change of taste is manifest in such books as *The French Impressionists (1860–1900)* [1903], which demonstrate neither factual accuracy nor trenchant critique.[108] Mauclair did not know the modernist tradition he claimed to represent, and appeared unashamed about not knowing it. Yet it was of course just such careless texts that established Impressionism as normative. It appeared in English in the Duckworth and Dutton series The Popular Library of Art, whose small format and relatively inexpensive prices embraced the widest possible audience.[109] Like all the early, popular histories of Impressionism (and against the grain of the series format of great artists in which they appeared), Mauclair treated Impressionism as an organic movement, sacrificing indi-

vidual differences and qualities to a group aesthetic. His history was a cliched account of the Impressionists' martyrdom, their exclusion from the Salons, and the lack of official rewards. He invited his readers, for example, to visit "the public galleries of Durand-Ruel's" instead of the Luxembourg Museum where the Caillebotte collection was "very badly shown" and anyway composed of inferior early work compared to the "beautiful productions which followed"[xvii]. But his sense of the movement's significance was not created by taste, nor by sympathy, nor by real knowledge, but by a widely acknowledged public discourse that incontrovertibly asserted their greatness. Like Duret, Mauclair detached technique from its content and identified whatever content Impressionist pictures may have had with the simple desire to paint modern life; as a result, he described Impressionism in a way that just as easily embodied the art of the *juste milieu*.

Mauclair's nationalism was more strident than Mellerio's or Duret's. He proposed that one benefit of Impressionism's overthrow of the academic tradition was that it disposed of something "of very mixed origin and very little French. Its principles are the same by which the academic art of nearly all the official schools of Europe is governed"[8]. Conversely, Impressionism was the "logical return to the very spirit of these traditions"[4] embodied in artists such as Chardin, Watteau, Georges de la Tour, Largillière, Fragonard, etc. In *De Watteau à Whistler* (1905)—a book which incidentally, but not surprisingly, was dedicated to Alfred Roll—Mauclair returned to the argument that the "classics" of the French tradition were not the "néogrecs."[110] He proudly championed "the école of Watteau, Chardin, Fragonard, those of Delacroix and of Corot; and finally those of Courbet, Manet and Monet. Here is my classicism"[37]. The French, Mauclair wrote, had their music dictated by Wagner, their theater by Ibsen, their moral ideas by Nietzsche and Tolstoy. But in painting, France taught Europe. Mauclair's curious genealogy for authentic contemporary art culminated in Whistler, joined by Roll, Besnard, Paul Helleu, and the like. Mauclair's arguments for an alternative French tradition, of course, ran exactly counter to the emerging German impressionist *Weltanschauung*, while also preserving the connection between the *juste milieu* and the canonical Impressionists that German historians would set aside.

Die Impressionistische Weltanschauung

In 1902 Tschudi published a short monograph, *Edouard Manet*, which, while contributing little that was not already available to German readers,

made an important contribution to the Impressionist *Weltanschauung*.[111] Neither a history nor a monograph as such, Tschudi's essay was criticism cast within a historical frame.[112] Early German writers on Manet and the Impressionists were far less interested in getting the details of the story right than in establishing the overriding meaning of Impressionism. Tschudi had long been convinced of Manet's seminal role in the development of modern painting. In *Manet* he continued the project outlined in his review of the Centennale: to place the artist in the largest historical context, whose work in effect paralleled the inventions of quattrocento Italian painting. Tschudi drew a parallel between the discovery of linear perspective and *plein air* painting as the two key turning points in the art of painting. If *plein air* was historically momentous, Tschudi put Manet's contribution in a new light, separating the artist from the Impressionists. Tschudi had already suggested in his essay on the Centennale that Manet's naturalism was not to be found in the command of representation, but as he would now put it, in "the totality of appearance."[113] Tschudi believed that too great an emphasis had been placed on *plein air*, as if that alone would guarantee great art, when, in fact, as the *juste milieu* demonstrated, it could and would serve academic purposes. Linear perspective and *plein air* were technical innovations, not guarantors of great art.

Manet's genius rested not in his technique, but his temperament. "Manet's temperament is thoroughly painterly: he sees always and only as a painter"[44]. Temperament, of course, could mean many things. For Tschudi it was the pleasure of representation; he united the pleasure of the connoisseur with the vision of the great artist:

> For those whose spirit seeks stimulation, who longs for poetic inspiration, will be sent away empty by Manet. However, for an eye that desires the painterly, his painting provides an ever new source of pure artistic pleasure. As they are derived from the joy of appearance, they therefore want only through their appearance to make joy.[45]

Tschudi's formula recalls not only Zola's much cited phrase: "une oeuvre d'art est un coin de la nature vu à travers un tempérament," but also Duret's claim that it takes the enlightened connoisseur to perceive the great artist. Compared to Duranty's remarks in *La Nouvelle Peinture*, one can see both how far and how little the critical language had developed, especially as translated into German. Much of Duranty's defense of Impressionism had been formulated within an historical lineage. Some twenty-five years later Tschudi took that lineage for granted. Yet Tschudi cast the historical legitimacy of Impressionism in a far wider frame; where Duranty had only

argued that "serious contemporary art criticism is realist," Tschudi argued that the ambition of all truly great art was profoundly naturalist. Insisting on a fundamental difference between Impressionism and photographic realism and on the primacy of the artist's temperament, Tschudi's reading of Impressionism overturned the still widespread view of Impressionism as *Reflex-Malerei*. Tschudi took the freedom from nature as the true measure of artistic sensibility. By stressing the importance of the non-narrative qualities of Manet and the sheer pleasure of looking offered by his pictures, Tschudi also rejected the neoidealism of his contemporaries. He articulated a position that saw formalism as the basis for a secular humanist understanding of art.

The continued development of the Impressionist *Weltanschauung* was stimulated by the growing number of exhibitions that either included the Impressionists or was devoted exclusively to them.[114] The Berlin Secession and the Cassirers' gallery had of course brought a notable, if small, collection of modernist French paintings to the capital. But the Impressionists became increasingly de rigueur at most international exhibitions, whether in Munich, Dresden, Hamburg, or Vienna. The bellwether exhibition occurred, surprisingly, in Prague in 1902, when the Secessionist society, Mánes, devoted a retrospective to Rodin.[115] It was the second biggest show—his 1900 retrospective at the Paris Exposition Universelle was the first—held in the artist's lifetime.[116] The 84 sculptures and some 300 drawings inspired the apotheosis of the sculptor in Central Europe.[117]

Like other *juste milieu* artists Rodin was popularly taken to be an Impressionist—an opinion Rainer Maria Rilke took pains to refute in his 1903 essay on the artist.[118] Georg Simmel, Berlin's leading sociologist and cultural philosopher, certainly saw Rodin as an Impressionist in an article written on the sculptor in the wake of the Mánes exhibition.[119] There Simmel laid out the fundamental elements of a new understanding of Impressionism, one which would have important implications for German aesthetics, particularly for the development of Expressionist critical discourse. Although Simmel had been denied a professorship at the University of Berlin, undoubtedly out of anti-semitism, he was a widely influential scholar, having just brought out his book *Philosophie des Geldes* (1900).[120] Simmel gave Rodin an unparalleled position in modern art because he believed that Rodin's "be-souling" of stone was a more complicated task than posed by other media, an obstacle that had prevented sculpture from advancing as an art since the days of Michelangelo. Sculpture was therefore a "specifically unmodern art." But Rodin, Simmel argued, was able to ac-

complish this "be-souling" through his self-conscious operation between two ruling principles, naturalism and conventionalism—terms that could be understood as standing for Impressionism and academicism.

> Naturalism and conventionalism are only the artistic reflexes of the two assaults of the nineteenth century: nature and history. Both threatened to suffocate the free, self-possessed personality. The one because its mechanistic values subjugated the soul to blind force, like the falling stone and the budding stem. The other, because it made the soul into a naked intersection of social fashions and its entire production dissolved into a management of a type of inheritance.[233]

Rodin's great contribution was to overcome conventionalism without falling into the trap of a materialist naturalism. Simmel believed that it was the nature of great art to unite the form and content of the visible world in a manner missing in life. While the unity posed in this dualism is possessed by all master works, modern art has gone furthest in recognizing and emphasizing the contribution of the individual. Rodin, especially in his stone pieces where the body remains embedded in the block, created a situation for the beholder in which "a minimum of objective reality . . . sets free a maximum of self-expression"[236–37]. The beholder, through the stimulus of fantasy, is asked to complete the work.[121] As the cultivation of the individual is one of the great benefits of urban life, so too does the individual artist rise above all conflicts to represent the essential truths of human experience.

What Simmel did for Rodin was only a more strongly articulated form of what Tschudi had claimed for Manet. One may discover in both writers arguments for a French non-narrative, seemingly objective, urbanist nomenclature fused with the Nietzschean individualism that strikingly anticipates the Expressionist rhetoric of the succeeding decade. Both saw Impressionism as the product of this deep polarity of experience between the objective and the subjective, and between content and form. In perhaps his single most influential essay, "The Metropolis and Mental Life," published in the wake of the Vienna Secession's 1903 Impressionist retrospective, Simmel explicitly tied Impressionism to the (positive) condition of urban life that stimulated all aspects of personal and emotional life.[122] Through the conditions of the modern money economy and the phenomenon of the metropolis, Simmel observed a fundamental and accelerating opposition between objective and subjective culture. In this struggle between the objective culture of modern industrial society and the rise of individualism, Simmel found the constituent elements of modernity. For Simmel, Impres-

sionism was a postnaturalist art, which transcended the "mere" materialism of naturalism by reconciling the material world to the soul, the deep experience of the artist. Art, he believed, was best equipped to reconcile these opposing forces. The greatness of the artist might be said to be measured by how subjective experience is given objective form—as Rodin produced timeless images of the transitory, the fugitive, and the contingent.

Simmel, at least indirectly, countered the view of modern life offered by Nordau's *Entartung* to celebrate life in the *Großstadt*. Simmel agreed that the metropolis offered "an intensification of nervous stimulation," the impersonality and isolation of urban life, but also argued that it had stimulated the rise of personal independence on the one hand and the elaboration of individuality as a subject on the other. "The carrier of man's values is no longer the 'general human being' in every individual, but rather man's qualitative uniqueness and irreplaceability"[423]. Where Ferdinand Tönnies, Simmel's closest predecessor in German sociology, had unfavorably contrasted modern society with older communal cultures, Simmel argued that the city lead to conditions which on the surface seemed negative, but that stimulated the maximum in personal freedom. Simmel characterized the response of the individual to urban life through such traits as hyperstimulation, impersonal social relations, enhanced mental activity, and a blasé or cool, detached, we would now call ironic, attitude. The *Großstadt* led to the proliferation of cultural facilities, offering heretofore unimagined opportunities for self-exploration and growth.

In this light it is notable that the views of Simmel and other contemporary German apologists for Impressionism hardly differed from the aesthetic position of such moderate conservatives as Ferdinand Avenarius. Through the editorial policies of his journal *Der Kunstwart*, Avenarius argued that all art was an expression of the artist's personality.[123] Like Simmel, he believed that art's chief function was the completion of the aesthetic and ethical education of the non-artist (that is, the traditional German concept of *Bildung*). The ethical convictions of the artist, in Avenarius' view, were colored by his national heritage. As a corollary to this national identity, great art was the product of a mentally, physically, and morally healthy personality. Avenarius' conservatism is discovered in his still deep commitment to narrative subjects. He could not, like the advocates of Impressionism, find in the manner of representation alone sufficient moral value.

Even Simmel's praise of urban modernity was not without reservations; institutional advances in science and technology had not necessarily led to comparable personal advances in reference to "spirituality, delicacy, and idealism." Yet, urban experience acts as a catalyst to inspire the desire for

personal change, for the improvement of the everyday life of the individual. The dualism of Simmel's conception of the city was embedded in the contemporary cultural circumstances of imperial Berlin. The subtlety of his paradoxical cultural outlook resonated against the expanding reading of French Impressionism—those who wanted to go beyond Impressionism understood either as mere formalism or as the visual correspondent to literary naturalism. Simmel defended the positive need for objective experience and yet called for its transcendence, a transcendence he found in Rodin, but one similar to what Tschudi, Meier-Graefe, and others, found in Manet.

The 1903 Vienna Impressionist retrospective inspired the first open declaration of an "impressionistische Weltanschauung" in an essay by Karl Scheffler.[124] Scheffler, future editor of *Kunst und Künstler*, not only described Impressionism as "the characteristic artistic manifestation of the present," but also the direct reflection of modern social conditions. Although he did not claim Impressionism to have an absolute primacy over all other forms of contemporary art, he suggested that it possessed, like all other *Weltanschauungen*, a specific social dimension—urbanism and industrialism—and described Impressionism, moreover, as an *Anschauungsform* of atheism. Scheffler advanced the view that Impressionism arose in Paris precisely because of that city's revolutionary history, which had rejected Catholicism, and thus at least the overt trappings of spiritualism, that it had "travelled" to Belgium, because it was the most industrialized nation on the continent, and that it was now finally finding a home in Germany, due to its recent industrialization, its social conflicts, and the Protestant heritage of northern Germany.[125] He explicitly termed Impressionism a non-Jewish art form—which is interesting because there was no more famous Jewish painter than Liebermann—because it lacked the "spiritual Jewish nature." If it were not spiritual, like Simmel he understood Impressionism to be the transformation of "objective" vision through the powerful personality. Impressionism was the product of absolutely free individuals, who "humanize, socialize, and render proletarian their themes." Surveying Central European art in 1903, Scheffler concluded that there were two great masters, Böcklin, whose art stood for the ideal and the dream, and Manet, who represented the modern, materialist spirit. He chose to condemn Böcklin and his followers, arguing that the Böcklins at the National-Galerie could not stand up to the Rembrandts there, whereas Manet did not suffer from the comparison. The *Stilkünstler* "made god-like the depicted story, but from the outset they do it with a borrowed *Anschauungsform* and an untrue aesthetic, whereas the Impressionists' aesthetic

is original and free"[147]. In Scheffler's essay, the strands of naturalism (in the "nihilism," the materialism, and the political independence of the Impressionists) came together with the radical individualism in art—in a precarious dance of opposing world views.

In November 1903 the *Zeitschrift für bildende Kunst* published an article by Ferdinand Laban, "Im Zwanzigsten Jahre Nach Manets Tode," which surveyed how far the German art public had come in appreciating the French master.[126] Laban was trained as a philosopher; he was an early admirer of Nietzsche, and of Schopenhauer. At the time of the *Zeitschrift* article Laban was the chief librarian of Berlin's museums. Laban read Manet's reception history as a close parallel of Nietzsche's. He recounted his own initiation into the wonders of Manet as a paradigm for a generation of intellectuals. In the 1870s and 1880s Manet was little known in Laban's native city of Vienna. Though he was, he said, a frequent visitor to the 1873 World's Fair in Vienna he did not recall seeing the Manet exhibited there (*Le Liseur*, Rouart #35). Instead, he recalled the general lightening of palettes exemplified by the exhibition, what he then saw as radical art and those he now called minor artists who worked in an academicized *plein air* style [26]. Even the publication of Zola's *L'Oeuvre* made no impression on Laban, knowing too little, he wrote, to connect Lantier to Manet [sic]. His first acquaintance with the artist's work came, then, with Muther's *Geschichte*. But, as he said, the illustrations offered too little for the reader to see Manet's qualities. This he first grasped in 1896 when he saw *Dans La Serre*, a discovery for him comparable to his first reading of Nietzsche. He shared this revelation with the "great and the greatest art historians and most well-informed collectors" [27] in Central Europe. As many before him, Laban believed that it was an attribute of Manet's genius that he had been ignored for so long. And he compared Manet to Rembrandt and Dürer, artists who like Manet were surrounded by less-talented successors. "They are the trails to the comets of great artists." Manet made an "elementary breakthrough" that represented the "total development of modern man"[28]. Without disparaging Degas and Monet, "Manet is in this circle, the manly, the robust, who in the highest productive sense, is its Columbus"[29]. Quoting Tschudi: "Manet stands not only at the beginning of modern painting, he stands also as its greatest master."[127] So much did he identify Manet with the modern, that Laban turned the usual comparison to Old Master painting on its head. So radically original was the French artist, it would be impossible to find a fitting place to hang *Dans La Serre* among the paintings of Berlin's Altes Museum, whereas Böcklin's masterpieces would fit in without any trouble. Following the now-established view, Laban dated

Manet's principal contribution to modern art in the work after 1870, seen as the artist's ability to paint nature directly, unfiltered by artistic conventions. As others before him, Laban compared Manet to the natural scientist.

In much of the remainder of his article, Laban reviewed Fritz Bley's essay published twenty years before.[128] Laban pointed out how far German art audiences had come since then. Linking Manet to Goya, the Spanish master who "stands at the beginning of modern times . . . like a Vulcan"[33], he declared them both to be aristocratic artists, and asserted, without irony, that "Nature is aristocratic!"[34]. Laban saw Manet like Nietzsche as a neglected genius, towering over his times through his ability to visualize the present and anticipate the future. Laban made no effort to reconcile the *flâneur* image of Manet with the anti-urbanism that Simmel found in Nietzsche. And there was very little in Laban's essay to pin Manet's genius to: *plein air*, the break with tradition, the great temperament, these cliches he marshalled self-confidently, uncritically, in defense of Manet's towering achievement. Emil Heilbut reviewed Laban's essay in *Kunst und Künstler*, and while he noted the perhaps excessive hero worship and the too-sharply-drawn division between Manet and Old Master painting and between Manet and the Impressionists, he cited almost every passage approvingly.[129] The acquisition of Manets by German collectors and museums now began in full force.

Ultimately, the creation of the Impressionist *Weltanschauung* was as much an expression, albeit paradoxical, of Secessionism in Central Europe, as it derived from the art market or art criticism. Without the assistance of the Secessions, which provided an altruistic cover for the introduction of French modernism, the resistance to "dealer conspiracies" would have been altogether more formidable. The Secessions aspired to signify their own modernity by claiming the French Impressionists as their "fathers." But that process not only initiated a completely different generation of "sons" than the Secessionists had anticipated, the "fathers" threatened their own position in the Central European art world. The founding of the German Künstlerbund in 1904 was more than a declaration of independence against the artistic interventionism of the kaiser and his agents over who would represent Germany at the St. Louis World's Fair. The Künstlerbund signified the underlying unease with the market for French modernism it had helped to create. The Künstlerbund hoped to be both modern and wholly German. Only a few years later the German Expressionists aspired to the same.

Der Fall Meier-Graefe

MEIER-GRAEFE'S *Entwicklungsgeschichte der modernen Malerei* was a landmark in the construction of the Impressionist *Weltanschauung*, advocating both cultural heterodoxy and internationalism.[1] But because Meier-Graefe insisted on setting the historical record straight by admitting only certain artists as the originating Impressionists, and their heirs, the book created a homeodoxy. The more canonical Impressionism became, the more French it was. In his hands modernism nearly became an exclusively French property. In a comparable paradox, no book did more to announce the arrival of French Post-Impressionism in the European art world. It was not his intention: he would have had the development of modern painting end in 1904 with the Nabis and the Neo-Impressionists. He came to believe that the art of the Fauves, the Expressionists, and the Cubists were produced not by great temperaments, but by an excess of theory.

The contradictions posed by Meier-Graefe's art criticism expressed both his temperament and his simultaneous activities as a writer, a critic, an entrepreneur, and a dealer. Meier-Graefe's life and work represents the full matrix of the art market, the politics of cultural reception and identity, and the modernist historiography this book has sought to describe.[2] His career was shaped under the competing demands of the fin de siècle: the decorative arts movement, Impressionism, and Post-Impressionism. The attempt to reconcile these traditions produced a peculiarly heterogeneous art criticism. At times, his writing is historical, at times merely descriptive, then again nakedly polemical. His style varied from precise, often telling phrasing, to a self-consciously poetic, abstract, virtually untranslatable German. As a manipulator of received ideas Meier-Graefe recalls Lévi-Strauss' description of the mythic practices of the "bricoleur":

> He interrogates all the heterogeneous objects of which his treasury is composed to discover what each of them could "signify" and so contribute to the definition of a set which has yet to materialize but which will ultimately differ from the instrumental set only in the internal disposition of its parts. . . . The elements which the "bricoleur" collects and uses are

235

"pre-constrained" like the constitutive units of myth, the possible combinations of which are restricted by the fact that they are drawn from the language where they already possess a sense which sets a limit on their freedom of manoeuvre.[3]

The "bricoleur" may be opposed to the Western scientist or engineer "who is always trying to make his way out of and go beyond the constraints imposed by a particular state of civilization while the 'bricoleur' by inclination or necessity always remains within them" [19]. Without straining the analogy, Lévi-Strauss' terminology offers some insight into Meier- Graefe's incessant, retrospective consumption of predetermined givens of French modernism and modernist art criticism, endlessly rearranged to elucidate meaning. I want to cast the positive agency of Meier-Graefe's art criticism within this retrospective mode, to see his eventual conservatism as the logical product of a man less accustomed to working through new ideas than refashioning and re-presenting a predetermined critical tradition for an audience heretofore unschooled in this literature.

Like most of the individuals responsible for introducing French modernism to Central Europe, Meier-Graefe was the product of an ascendent merchant class and both belonged to the cultural elite and remained something of a social outsider. Born in 1867, his father was a leading developer of the German iron industry. He briefly studied engineering in Munich and Zürich, but aspired to be a writer. Perhaps yielding to family pressure he enrolled in Berlin's university in 1890, where he took courses in philosophy and sociology with the young Simmel, history with Heinrich von Treitschke, what we might now call anthropology with Moritz Lazarus, political science/economics from Adolph Wagner, and art history from Hermann Grimm. Financially independent, Meier-Graefe flirted with university life and his time there was brief. His first novella was published in 1890; his first novel in 1893; and two more appeared in 1895.

Like Nietzsche before him, Meier-Graefe came to see himself as an opponent of the German academic system (an opposition no doubt encouraged by the fact that as a Jew he would have faced an endlessly obstructed path through the echelons of the German university system). In 1872 Nietzsche accused university professors of persuading the German public that the German victory over the French was not only a triumph of power but a triumph of culture over decadence.[4] Meier-Graefe rephrased Nietzsche when he wrote in the *Entwicklungsgeschichte* that the "revival of painting in Germany" can be traced "to the exhibition of the Frenchmen in

Munich in 1869 and . . . that the halt in its development was due to the break in our relations with French art almost as soon as they were formed" [II: 517].

Meier-Graefe therefore chose a type of art criticism that defined itself in opposition to much of conventional German art history, including the work of both Grimm and Muther.[5] In 1902 he condemned the art historical community for its consistent failure to see the value of modernist art.

> Baudelaire, Zola, Astruc and we must also include Théophile Gautier, the defenders of the new art: four poets. Where are the scholars of art? . . . [How] curious it is that our brother scholars, so few of whom are truly called to their profession, always refuse to acknowledge the great events of history.[6]

Where Muther sought to be inclusive and as factually informative as possible, Meier-Graefe was less interested in specific works of art or in the careers of artists than he was in erecting an exclusive teleology for modernist art.

If his role as an oppositional writer had already begun to emerge in the early 1890s, it was an equal measure of his personal connections that in 1894 at the age of 27 Meier-Graefe managed to become co-editor of the luxury, cultural journal *Pan*. And it is just as characteristic that he was forced out of *Pan* a year later, along with its literary editors Otto Julius Bierbaum and Richard Dehmel, in a controversy initiated by Meier-Graefe's intention to publish a lithograph by Toulouse-Lautrec but which turned on the question as to whether *Pan*'s editorial policy would be national or international.[7] Perhaps this incident played a role in Meier-Graefe's alienation from official German culture; leaving *Pan* he settled in Paris, where, in close connection with Bing's L'Art Nouveau, he devoted himself to the decorative arts.[8]

At this juncture Meier-Graefe's career as an art critic held little promise. He wrote his first essay on modernist painting in 1894 for a volume devoted to Edvard Munch which was edited by the Polish writer Stanislaw Przybyszewski.[9] Its publication came in the aftermath of the Munch-Affair, the exhibition of Munch's paintings at the Verein Berliner Künstler in 1892— an exhibition that marked an important chapter in the history of Secessionism in Berlin.[10] Meier-Graefe took up Munch as a noble cause and expressed his enthusiasm in immediate, practical terms. He is credited with having arranged a successful exhibition of Munch's paintings in Berlin in 1893, another show at Bing's L'Art Nouveau gallery in Paris, and another in Brussels at Octave Maus' La Libre Esthétique.[11] And he published a suite of prints by the artist in 1895.[12] Of all the contributors to the Przybyszewski

volume, Meier-Graefe was the most self-consciously literary. Przybyszew-ski wrote, for example, about Munch's "naked individuality" and described his art as the "creative work of a somnambulant, transcendental conscious-ness," constructing for Munch's art an anti-naturalist, primitivist the-matics, whereas Meier-Graefe provided a kind of criticism more closely allied to John Ruskin than to the "progressive," "formalist" art criticism he would come to imitate; he put into poetic description the stories he discov-ered in Munch's paintings.

The changes wrought by his Paris years are palpable. In an essay written on Manet six years later for *Die Kunst für Alle*—illustrated with thirteen reproductions provided by Durand-Ruel—Meier-Graefe chose not to ar-gue Manet's "position" through aesthetics, but through the artist's market successes.[13] Following an exhibition of Manet's work at the Cassirers' (with pictures provided by Durand-Ruel, including the *Déjeuner sur l'herbe*), "Die Stellung Edouard Manet" ushered in a new era in German criticism of French modernist painting, offering as it does a heretofore unseen match between word and image. Noting the enormous escalation in Manet's prices, particularly among American patrons, he observed that the larger paintings were now selling for over 100,000 francs while "the smallest sketch by Manet today has the price which in the artist's lifetime he asked for his most beautiful pictures" [58]. Where others might have seen this price escalation for a largely unknown artist as a sign of dealer conspiracies, Meier-Graefe argued that such "rehabilitations" characterized the age; he compared the revaluation of Manet to that of Rembrandt and Vermeer (and Manet's own example as a key element in the rediscovery and reevaluation of Goya). Here the connoisseur/buyer replaced public sentiment in deter-mining great art, the same argument Duret employed in 1884. If, however, an artist's worth was to be vindicated by higher prices, the reverse could be as easily said: that Manet was the product of a symptomatic overvaluation of art, a product of fashion undisciplined by "authentic" cultural values. The Manet literature in Germany was haunted, like no other artist, by the price list. Meier-Graefe's own 1912 monograph on the artist was concerned throughout the text and in an extensive appendix with the provenances of the artist's works, complete with prices and notations of their rapid escalation.

Beyond the defining agency of the market, Meier-Graefe largely deter-mined Manet's position through the artist's use of the past. Comparing Manet to Goya and Velázquez, he eschewed the criterion of *plein air*, be-coming the first German critic to privilege Manet's paintings from the 1860s. Using what would subsequently be a signature device—the elevation

of one artist's reputation at the expense of another—he erected Manet's stature as genius on the body of Whistler's. He invited the reader to compare Whistler's *Portrait of Paganini* [sic] with Manet's *Victorine Meurend in the Costume of an Espada* (Rouart #48): "Whistler appears great, because he has attained simplicity through fabulous means, whereas Manet appears simple, because he is great" [64].[14] He dispatched the paradigmatic artist of the *juste milieu* to the dustbin of history.

The difference between the essays signifies Meier-Graefe's personal and cultural emigration. In 1894, he travelled to Paris and London for what was perhaps the most formative experience of his life. There he met Lautrec, William Morris, and Oscar Wilde. Not only did he become one of Lautrec's foremost German apologists, but Lautrec's art offered an image of modernity heretofore outside the horizon of German art. From Morris came a confirming interest in the international decorative arts movement. But the contact with Wilde was the most rich for the aspiring critic. Wilde the art critic offered Meier-Graefe much more than a philosophy of "decadence."[15]

The enfant terrible of the decadent movement, Wilde wrote remarkably modernist, formalist treatises on the nature of art and art criticism. Eventually Meier-Graefe would come to imitate not only Wilde's *l'art pour l'art* formalism, but also his conception of the art of criticism.[16] In his 1890 dialogue, "The Critic as Artist," Wilde saw art criticism as much the product of temperament as great art.[17] The critic resembles the artist as a producer of creative activity, an activity, indeed, independent of the artist's intentions. Roger Fry, in a 1928 review of an English edition of Meier-Graefe's monograph on Cézanne, perhaps unintentionally identified the debt owed to Wilde when he wrote

> Professor Meier-Graefe considers the critic's task to be itself a kind of artistic creation. His aim has been to use language not so much for analysis, for precise discrimination of values, and for exposition as for the evocation by means of words of a feeling as nearly as possible corresponding to that provided by the artist's work.[18]

It is a mistake to conclude as Fry does that Meier-Graefe hoped to match the intentional emotions of the artist, but there is little doubt that the interpretive artistry of Meier-Graefe, in evidence throughout his career, was derived from the conception of criticism as a form of artistic creation.

Meier-Graefe learned from Wilde to see the value of a painting ultimately in the painting itself. Wilde argued that "while a poet can be pictorial or not, as he chooses, the painter must be pictorial always. For a painter

is limited, not to what he sees in nature, but to what upon canvas may be seen" [152]. In passages that echo Nietzsche, Wilde also advocated aesthetics as a higher condition than ethics. "Even a colour-sense is more important, in the development of the individual, than a sense of right and wrong" [221]. From this aesthetic position Wilde believed that criticism could take on social responsibilities not normally understood to be within a critic's domain.

> Criticism will annihilate race-prejudices, by insisting upon the unity of the human mind in the variety of its forms. If we are tempted to make war upon another nation, we shall remember that we are seeking to destroy an element of our own culture, and possibly its most important element [219].

This theme of trans-national aesthetic commonality was both a product of the internationalist mood of the 1890s and an agent in the theoretical articulation of modernity. It stood in marked opposition to the still profoundly influential doctrines of Hippolyte Taine, who factored cultural production in terms of race, milieu, and era.[19] Wilde also sanctioned the tendentiousness that subsequently characterized most modernist art criticism and historiography and which so often united a critique of the theories of painting with the critique of cultures that produced them. "A critic cannot be fair in the ordinary sense of the word. It is only about things that do not interest one that one can give a really unbiased opinion, which is no doubt the reason why an unbiased opinion is always absolutely worthless" [195].

Wilde denounced naturalism in contemporary painting. He employed the decorative arts movement as a critical lever to make a particularly compelling defense of the formal characteristics of art, a kind of implicit doctrine of significant form that would resonate throughout Meier-Graefe's later criticism.

> By the deliberate rejection of Nature as the ideal of beauty, as well as the imitative method of the ordinary painter, decorative art not merely prepares the soul for the reception of true imaginative work, but develops in it that sense of form which is the basis of creative no less than of critical achievement. For the real artist is he who proceeds, not from feeling to form, but from form to thought and passion [206–7].

Like his contemporary exponents of the English decorative arts, Walter Crane and Lewis Day, Wilde understood the decorative arts to possess a formal grammar as applicable to the most simple design problems as to the most "elevated" concerns of art.[20]

An involvement with the decorative arts may have similarly enabled Meier-Graefe's abandonment of a literary-infused art criticism. From the moment he settled in Paris his career as a novelist all but dried up and a new orientation toward art and business emerged. Meier-Graefe carried into his enthusiasm for the decorative arts the internationalist perspective advocated by Wilde. Both Meier-Graefe and Bing's understanding of art nouveau stressed an independence from French nationalist arguments.[21] In his most programmatic statement from these years, "Wohin treiben wir?" [Where are we drifting?], Bing wrote that the decorative arts in France had declined since the French Revolution and called for the rediscovery of design principles that had been organic to the evolution of French decorative arts in the *ancien régime*, and held that these principles were, in fact, universally valid. A modern style was less important than, in Bing's words, "the necessity in the creation of a commodity, to create the fundamental nature of the thing in such a way as to respect the means of manufacture."[22]

Bing, however, eventually capitulated to the nationalist-inspired resistance to German encroachments in design and the organization of industrial production, and came to produce increasingly French and increasingly elitist decorative objects, exemplified by his pavilion at the 1900 Exposition Universelle. Meier-Graefe, on the other hand, continued to insist on the necessary internationalism of the decorative arts, on the need to tailor the production of designs to the requirements of mass production so that such objects could reach the largest audience at the lowest possible prices. He advocated treating the production and sale of the decorative arts as commercial objects, so that, as he wrote, "one no longer finds a good lamp in an art shop, but in a lamp store."[23] That frank commercialism carried over into his appreciation of Manet. For a modernist critic he was unusually insistent upon seeing the dependency of modernist painting on the art market.

In 1897 Meier-Graefe began publishing the journal *Dekorative Kunst*, modeled on the English periodical *Studio*. Its explicit internationalism was confirmed by the publication the following year of a French edition, *L'Art décoratif*.[24] In 1899 he gave up his editorship in order to open in Paris La Maison Moderne, for which van de Velde designed the interiors and facade. He intended to model his business after the Munich and Viennese *Werkstätten*, to form an alliance of artists to create designs explicitly for production in quantity. He published a catalogue of the firm's designs and offered on-site decorative consultations. Not surprisingly, La Maison Moderne came under fire as a German import and a threat to French cultural traditions.[25] Although it survived until 1904, the firm eventually cost Meier-

Graefe his family inheritance; he was forced to liquidate his stock at auction at half its value.

At the zenith of Meier-Graefe's involvement with the decorative arts, modernist painting began to make important inroads in his tastes. He had, of course, become well-versed in the Parisian art market and knew who mattered. And he began to write art criticism from Paris for Maximilien Harden's *Die Zukunft* and for Hans Rosenhagen's *Das Atelier*. This taste found its way into La Maison Moderne, where alongside the decorative arts he exhibited paintings by the Impressionists and Post-Impressionists, including the Nabis, and sculptures by Rodin, Meunier, and George Minne.[26] A sign of Meier-Graefe's apparent crash course in French modernism may be found in a portfolio of original prints (woodcuts, lithographs, dry points, and etchings) he published at about this time under the title *Germinal*. Included were works by Peter Behrens, Degas, Bonnard, Gauguin, van Gogh, Renoir, van Rysselberghe, and Jan Toorop, but also twelve other artists representing a mix of modernists and Salon celebrities.[27]

In a strange article published in 1902 in *Die Zukunft* Meier-Graefe began to distance himself from art nouveau by quoting a list of leading contemporary artists such as Rodin, Degas, Sisley, Renoir, and Liebermann, all of whom he said repudiated its tenets.[28] This period of ambivalence constitutes Meier-Graefe's most interesting moment as a critic. Torn between his commitment to art nouveau and his intensifying love of contemporary painting, Meier-Graefe sought a difficult reconciliation between the two.[29] Meier-Graefe was far more committed than Wilde to the social aspect of the decorative arts, to the ambition to put good design in the hands of the widest possible public and to integrate art more fully into everyday life. This was difficult to reconcile with his historicist, essentially unintegrated conception of the social value of painting and sculpture, that is, the interest of the fine arts lay in part in the determination of the artist/genius behind the work and the isolated particularity of the masterpiece—a position obviously opposed to the relative anonymity of the decorative artist and his utilitarian products.

ENTWICKLUNGSGESCHICHTE DER MODERNEN MALEREI

Prophetically forward-looking, Meier-Graefe's *Entwicklungsgeschichte* was, as Alfred Flechtheim recalled at the end of his life, the most significant

modernist history of the era.[30] Flechtheim quoted an obituary written for Meier-Graefe by his close friend, the painter Leo von König.

> It was as if the spring wind had flung the windows open and fresh air had penetrated the musty studios. This book was an achievement full of new starting points for future art historians. The first to realize this were we artists for whom it was a vital experience. Facts were expressed in it which until then we had but vaguely perceived in our subconscious mind. Today, since one art tendency has followed another in rapid succession, this has been forgotten. Meier-Graefe may have written more mature and better books than this *Entwicklungsgeschichte*—later he himself became overinvolved—but never again has a book of his been more stimulating [107].

The book's origins lay in a series of essays published in 1899–1900 under the collective title "Beiträge zu einer modernen Aesthetik," and represented an attempt to unify modernist painting with the decorative arts.[31] In a revised form, they reappear as introductory chapters to the *Entwicklungsgeschichte*. Meier-Graefe opened the "Beiträge" with a defense of the "new" in art as a necessary reflection of modern life. At the same time, he indicted the exaggerated position of painting and sculpture in contemporary culture. Meier-Graefe looked back to prior societies (e.g., the Renaissance) that had an integrated conception of these media, when a prince or a merchant might value a painting no more than a table or a chair.[32] He then described the rise of the autonomous work of art and its growing commodification in the nineteenth century, referring, among other examples, to Durand-Ruel's profiteering in the Impressionist market. He likewise condemned the great fin-de-siècle collectors: "The most notorious vices are not so grotesquely irrational as this mania for hoarding, which, owing to its apparent innocuousness, has not yet been diagnosed as a mental illness" [89]. To reach the new mass market for culture, to raise cultural experience generally, a partnership with industry was required, so that designs would be made that "identify artistic value with utilitarian qualities" [91].

Over the course of the six-part essay his passion for painting overwhelmed the argument for artistic integration. Calling for a unified sense of line and color as the basis for a modern monumental art (announced by the work of van Gogh), Meier-Graefe presented little more than a history of the rise of easel painting and the collapse of monumental decorative painting.

Meier-Graefe brought to his history a comparative method (prefigured

243

in the Manet/Whistler contrast of the year before) which created broad contrasts between national styles, between monumental and easel painting, and between color and line, based on an empathetic experience of form. There was little room for reconciliations. What in Heinrich Wölfflin's work was nuanced and constantly in a state of revision, Meier-Graefe solidified in the most broad identifications of style and national, racial, and individual personality.[33] Meier-Graefe gave as the subtitle to the *Entwicklungsgeschichte*: "Vergleichende Betrachtung der bildenden Künste, als Beitrag zu einer neuen Aesthetik" [Comparative analysis of the visual arts as a contribution toward a new aesthetic]. He lacked, however, the precision of Wölfflin's standards; he must have been aware how little his approach stood up to scrutiny as a precise method. The subtitle was dropped from later editions.

Meier-Graefe's comparisons were as dramatic as possible—what L. D. Ettlinger once called his "Aunt Sallys"—ensuring the plausibility of his opinions without having to entertain the many variables to his interpretations.[34] Naturally, it was just such comparisons that so roused the passions of his contemporaries. Take, for example, the section that surveyed German painting in the nineteenth century. There he argued that "since Dürer there has been no German painter and even in its golden age, the essential in German art was almost always more draftsmanship than of a painterly kind" [IV: 219]. Moreover: "The German is a musician, a poet, he is always less as a painter." And: "German art has never left the Gothic behind. Its deepest, most singular characteristic remained gothic" [IV, 221].

> It is therefore no wonder that this fundamentally German tendency toward the color-hating, pure draftsmanship-espousing classicism has constantly arisen. . . . How painterly David's masterly M. Recamier appears next to Carsten's paper trifles [IV, 223].

In the fifth installment of the "Beiträge," Meier-Graefe doled out praise for such famous Central European artists as Makart, Feuerbach, Böcklin, Lenbach, Stuck, and Klinger. But the installment ends with a panegyric on Millet, the intensity of which effectively eclipses the German masters. Meier-Graefe did not yet go so far as to ascribe the deficiencies of German painting to larger cultural and social deficiencies. But it is already clear that Meier-Graefe had come to measure German art by a French standard. When in the next and final installment Millet's chief descendent turned out to be van Gogh, the Dutchman is read through the lens of French painting.

What is immediately striking about the passages on van Gogh is that they preceded by a year or more the introduction of his pictures in Germany.

This came to be another characteristic motif of Meier-Graefe's criticism: to describe foreign exemplars of contemporary painting as if they were already deeply familiar to Central European audiences, and were, for that matter, internationally acknowledged geniuses. Cézanne he identified, without explanation, as van Gogh's "Meister" and compared at length the qualities of a Cézanne still life with that of a van Gogh [VI: 210], though only perhaps two or three people among his German readers would have then been capable of recreating these types of pictures in their minds. Meier-Graefe continually defined himself by appearing to "one-up" his contemporaries, to be more knowledgeable, more enlightened than they.

Meier-Graefe cast the appearance of van Gogh as a recipe for future decorative painting, as the embodiment of the unification of line and color, in the frame of cultural conflict. He described van Gogh as a nihilist destroyer of past art and culture:

> van Gogh in the house of the peaceful bourgeois is like the bomb in the pocket of the police chief. Van Gogh is an anarchist; he is an anarchist because his paintings are anarchistic [VI: 214].

Meier-Graefe's van Gogh was an idiosyncratic instrument for the destruction of the old cultural order.[35] Improbably, he confined van Gogh's anarchism to the formal properties of his work—he is nothing but a painter. Compared to van Gogh an artist like Munch was nothing but a painter of ideas (Gedanken), who sacrificed the purely aesthetic qualities of his pictures. Van Gogh, on the strength of his artistic temperament, embodied the deep humanist values out of which a new culture might be forged. The first signs of his legacy were to be discovered in the Nabis; Meier-Graefe named Ranson, Sérusier, and Bonnard.

The sense of the dangerousness of contemporary painting to bourgeois values posed in the "Beiträge" was carried over into another book that anticipated the *Entwicklungsgeschichte*: *Manet und sein Kreis* (1902).[36] This pamphlet was published in the popular format of Richard Muther's Kunst series, and undoubtedly had the widest circulation of any of Meier-Graefe's work to date. It was a notable departure from the conventional literature on Impressionism, for, above all, Meier-Graefe asserted that Manet was not merely the forerunner and co-conspirator of the Impressionists, but rather, by placing Degas and Monet emphatically under Manet, that Impressionism was less a group effort than a refinement of advances first affected by Manet.[37]

Compared to Tschudi's subtle and relatively unpointed essay on Manet, Meier-Graefe's book was archly polemical. The critique he later imposed

on Böcklin in *Der Fall Böcklin* appears here in an embryonic stage. Like the later text *Manet* was as much a *Kulturkritik* as it was art criticism. He began with the observation that Germans

> have still only a cool appreciation for Victor Hugo and we prefer the complications of the Richard Wagner school to the simplicity of Bach, the pure lyricism of Mozart, and the depth of Beethoven. The wish for objectivity has taken possession of our aesthetic desires; we wish art to be as pure and concentrated as possible and prefer the apparatus with which it is rendered the more blunt it is, like the librettos of Italian operas, because it allows us to get quicker to the content of the thing so defined. This timidity before the romantic, intoxicated by frivolous wine, has made the appreciation of Delacroix dangerous[2].

The argument borrows from Wilde: the danger of Delacroix rests in the intoxication of his formal arrangements, not his "content."

This unexpected citation of Delacroix (whose German reputation was still to be fashioned) is a reprise of his introduction of van Gogh and Cézanne in the "Beiträge."[38] More importantly, it signalled Meier-Graefe's decision to read Manet, however improbably, in light of Signac's *L'Eugène Delacroix au néo-impressionnisme*, a book that had made Delacroix the technical starting point for modernist painting. Signac's pamphlet appeared at a moment when the ambition to write a unified developmental history of art, understood through an evolution of form, and conceived independently of social circumstances, can be discovered within the German art historical community in the writings of the Vienna circle, led by Franz Wickhoff and Alois Riegl.[39] If this new history was to be more than a biography of great artists, if it was to represent evolutionary progress—the Hegelian tendencies that saturated all German art historiography—it required a common ground found in the developmental history of style.[40] A "scientific" discourse that might treat works of art independent of biography, social circumstance, or the artist's intentions was consequently ruled by theory, an autonomous, organic evolution. As German art history began to see itself as a *Kunstwissenschaft*, it internalized scientific positivism, and thereby took over some of the problematics of its procedures.[41] Gaston Bachelard argued that scientific observation

> is always polemical; it either validates or invalidates a previous thesis, a preliminary schema, a level of observation . . . it orders appearance into a hierarchy. . . . When we go from observation to experimentation, the

polemical character of knowledge will naturally be even clearer. Phenomena must now be carefully selected, filtered, purified; they must be cast in the mold of scientific instruments and produced at the level of these instruments. Now, instruments are just materialized theories. The phenomena that come out of them bear on all sides the mark of theory.[42]

There could be no better match for a post-Wölfflinian *Kunstwissenschaft* than the system offered in *D'Eugène Delacroix*. Reducing the development of nineteenth-century art to investigations of the physical properties of light, reproduced via oil paint, Signac offered an extraordinarily exclusive, experimental model of art, that, as so many later unfriendly critics complained, turned painting into "materialized theories."

The historiographic polemic of *D'Eugène Delacroix* defined the concept of modernity in the spirit of scientific research. In the hands of Meier-Graefe and other apologists, the claim to the advance of knowledge, art as a series of investigations, as an enterprise of research, lent modernism a coherent, inevitable legitimacy that would resonate both with artists who subsequently came to compose "systems" for their enterprise (the famous "isms" of the first two decades of this century) and art historians, particularly those under the sway of the Wölfflinian model of competing stylistic (and cultural) paradigms announced in *Renaissance and Baroque*.

Meier-Graefe, however, was no art historian: he incorporated the lessons of formalism on one hand and Signac's theoretical, rather than biographically based, history of modernism on the other, to create what can only be described as a reductive parallel to the art historiography advanced by the Vienna school. Clearly Meier-Graefe was far less interested in Signac's technical account than he was in Signac's model of historical succession based on a succession of "firsts" within a perceived evolution of formal developments. Signac's text offered Meier-Graefe the possibility of considering the entire history of western painting as a technical and stylistic evolution. Thus, paradoxically, Meier-Graefe's subsequent writing would be ruled by the dual obedience to subjective statements of quality and a transcendent objective criteria, shaped by the history of art.

Indeed, Meier-Graefe's subscription to a doctrine of significant form, one in which social values are conveyed entirely in formal terms, represented the intersection between the nascent formalism, the anti-decadent, anti-literary, strain of French art criticism of the 1890s and the work of Wölfflin and subsequent German art historiography.[43] German scholars invested formal descriptions with sweeping cultural implications both for the description of period styles and for the creation of cultural paradigms.

An idiosyncratic, but nonetheless symptomatic book of the allegiance of modernist discourse and art historical writing is the English critic R. A. M. Stevenson's *Velasquez* (1895).[44] Stevenson, like Meier-Graefe, was a popularizer rather than a scholar, and like Meier-Graefe he joined a formalist analysis of the artist's work to a largely unself-conscious appraisal of Velázquez' genius and temperament in order to promote a realist understanding of art against the then-dominant taste for neoidealist painting. Stevenson first put into practice what many of Impressionism's apologists had suggested: that its stylistic traits could and should be traced back at least to Velázquez. Making no pretense to contributing new information regarding the Spanish master—he tells the reader that his facts are derived from Carl Justi's seminal *Diego Velazquez und sein Jahrhundert*—nor new iconographic or symbolic analyses of his paintings, Stevenson rather considered Velázquez under such topic headings as "The Dignity of Technique," "The Composition of Velasquez," "His Colour," and "His Modelling and Brushwork," closing the book with a chapter on "The Lessons of Impressionism."[45] One passage gives the book's tenor:

> The great idealist of Italy [Michelangelo] was admirable, but he is dead, his work is done, and when it was doing it was at least based on matter, on anatomy, on the laws of decoration. There is a modern idealist whose whole cause seems to be hatred of matter, of the truth, of the visible, of the real, and a consequent craving for the spiritual, the non-material. That this man should choose painting or sculpture, the most material, the most tied to representation of the arts seems indeed a non-sense. . . . This temperament is ruinous to the artist. He neglects the material base of art, despises drawing and modelling, and sacrifices the conquest of nature as readily as a faddist, the well-being of a great empire to his dreams [114–15].

Stevenson turned Velázquez into an Impressionist, who united the observation of reality with the emotional, intuitive decisions of the painter, who sought "a truth of general aspect." This conjunction of formalist description, *l'art pour l'art* aestheticism, a historicist sensibility, and the apotheosis of artistic temperament had a fin-de-siècle currency that reached from Stevenson to Tschudi, Simmel, and Meier-Graefe, offering a reconciliation between the objective concerns of naturalism and the emotional, introspective demands of great artists.

Also contributing substantially to the new German art criticism were the aesthetic theories of the circle of the philosopher Konrad Fiedler, the sculptor Adolf Hildebrand, and the painter Hans von Marées. It is sufficient for my purposes to reduce the aesthetic systems offered by Fiedler and

Hildebrand to two principal elements of their aesthetics (shared and partly inspired by the views of Marées) that bear on the developing formalism of the fin de siècle: the upholding of Renaissance art (i.e., tradition) as a standard for contemporary art, yet conversely, understanding this tradition outside conventional aesthetics, which concerned the nature of beauty.[46]

Their influence on German art criticism began in 1893 with the publication of Hildebrand's *Das Problem der Form in den bildenden Künsten*, a book that put a new emphasis on art as a problem of form and of art history as the history of forms.[47] Fiedler's first important essays date from the late 1870s, but his work exerted its greatest influence only after the philosopher's death in 1895, occasioned both by the prestige of Hildebrand's book and by the publication of his collected works.[48] Lionello Venturi, borrowing from Benedetto Croce, once described Fiedler as the founder of a "science of art," a doctrine that Croce called "pure visibility."[49] Within Fiedler's view, art was not subservient to nature, but obeyed its own internal laws of visibility. He argued that some aspects of experience are only knowable through sight and only expressible through art. "The content of a work of visual art that can be grasped conceptually and expressed in verbal terms does not represent the artistic substance which owes its existence to the creative powers of the artist" [11]. Meier-Graefe learned from Fiedler, as he had from Wilde, the conception of the primacy of artistic form over subject matter. Yet he would not follow Fiedler in the radical conviction that art must be entirely detached from its social circumstances, that it must be treated as one would philosophical ideas.[50] Perhaps Meier-Graefe followed the course of his Berlin teacher Hermann Grimm when he placed transcendent value in the individual agency of the artist.[51] In any case, he remained consonant with Wilde's view that great art was a product both of a great temperament and a culture to support it.

Tschudi had been content with a comparative discussion of the inventions of *plein air* held up against the inventions of linear perspective and Italian Renaissance painting. Meier-Graefe, however, sought in *Manet und sein Kreis* to trace a specific line of technical influences from one artist to another across the centuries. He grounded Delacroix, for example, in technical lessons derived from Constable, from Rubens, and from the Venetians. By defining French modernism in this way, Meier-Graefe separated Manet from Zola far more radically than had Tschudi. What was essential to Manet and his friends, he argued, was entirely alien to the literary ambitions of much of contemporary painting in the 1890s. If great art was still the expression of a great soul, a kind of Nietzschean *Übermensch*, whose

LIVERPOOL JOHN MOORES UNIVERSITY
LEARNING SERVICES

greatness was naturally unattractive to the crowd, then "the painter of the *Barque of Dante* would have had difficulty remaining popular; he was never so. His gesture is distasteful to the great masses; to the better public of the Louvre it is fatal. He had the misfortune to have a soul" [5]. Like Tschudi Meier-Graefe joined the formal qualities of the art to the inner workings of the psyche. It was a way of thinking that allowed one to get around the normative German definition of Impressionism as a heightened naturalism. Manet's art was not the naturalism of the bullfight or of the bourgeois individual "but life overall; that is, the power, the organism, which lives independently . . . (Manet) despite all of this was a million times more proud, more aristocratic, more precise than the classicists. More precise because his criterion contained something—: that was the new" [13]. This strikingly vitalist reading of culture stood in place of the need to articulate what the new, in fact, was. Meier-Graefe only suggested that it was French, non-narrative, and based on the principles of *plein air*. After these vague categories, his definitions were elastic, allowing him to mix easily the work of disparate artists such as Manet and Cézanne, treating them unproblematically as a group.

Meier-Graefe's peculiar conception of artistic "circles" first appear in *Manet und sein Kreis*. They suggest the tendency of some contemporary German art historians writing on the Renaissance to ascribe schools or circles of painting to each important artist. In the *Entwicklungsgeschichte*, Millet has in his circle van Gogh, Giovanni Segantini, and the sculptor Constantin Meunier.[52] The device intrinsically argued for a continuity between the "influence" of Millet, first announced in the "Beiträge," and the nature of a circle. A great artist presides over each circle; his commanding presence saturates the work of the artists who follow in his wake. This had the effect of presenting the development of modern art as a progression of movements, led by a master, rather than a succession of individual artists. It also allowed for the simultaneous positioning of great artists as transcendent individuals who effectively rupture the course of art history. The great artist announces and demarcates a general cultural and stylistic development to be refined and expanded upon in the (relative) anonymity of the circles. The suspension between personalities and an abstract, developmental history of style exactly reproduced the tension in modernist discourse between the God-like artist, whose genius depends on an absolutely independent originality, and the inevitable course of art history to which personalities must be subsumed.

How Meier-Graefe positioned artists in these circles reveals much about their current public position in Paris. For example, in *Manet und sein Kreis*

he placed Cézanne with Manet's "circle" as his most important follower. This illustrates the emerging knowledge of the biographical connections between Cézanne and Zola and Manet, and conversely, reflects Cézanne's current position among the Nabis and among the intimates of Vollard's gallery on the Rue Laffitte. From Cézanne, Meier-Graefe claimed, stemmed the paintings of Bonnard and Vuillard, artists "upon whom the greatest hopes are set by contemporary France" [32]. Handing the Nabis the mantel of heirs to Cézanne granted them a stature still contested in Paris. Meier-Graefe also repeatedly compared Cézanne stylistically and biographically to the other two still great unknowns of Parisian modernism, Gauguin and van Gogh. Meier-Graefe still only partially grasped their role in the development of contemporary French painting. He grouped them all under the banner of Impressionism: the section on Cézanne and his "followers" was followed by chapters on Degas and Monet.

In another contribution to Muther's Kunst series, *Der moderne Impressionismus* (1903), Meier-Graefe was even less concerned with an orthodox reading of Impressionism than in *Manet und sein Kreis*.[53] Indeed, it constituted an attempt to account for a "post" Impressionism without acknowledging a break. Its four chapters were titled: "Die Neoimpressionisten," "Der Impressionismus Japans," "Toulouse-Lautrec," and "Paul Gauguin." In the discussion of the Neo-Impressionists Meier-Graefe was not concerned to write a history or a biographical monograph; again he assumed his reader's prior acquaintanceship with the major works by the artists. His overriding intention, reflecting his still on-going commercial activities with La Maison Moderne, was to integrate Neo-Impressionism with architecture at the level of theory. His principal example was van Rysselberghe and the use of his paintings as decors for domestic interiors designed by Victor Horta. The "Impressionism of Japan" proved to be a short history of the Western reception of Japanese prints and some brief appraisals of some printmakers—and as schematic as the Japanese print section in the Vienna Impressionist exhibition held that same year.[54] More novel was Meier-Graefe's treatment of Lautrec, who had died the year before and was consequently the recent beneficiary of retrospectives at La Libre Esthéthique and at Durand-Ruel's. Meier-Graefe's text reads like an obituary, yet is a surprisingly expressivist account of Lautrec's art. The Paris retrospective made "a colossal impression of monstrous beauty, with which one could time and again ask whether this modern art, which has so much to say, is not capable of outlasting all the other creations of our spirit" [46].

The biggest surprise of *Der moderne Impressionismus* for the Central European reader would certainly have been the chapter on Gauguin, which

strikingly recalls the way Manet had been treated by German writers five or ten years before. His sole presence in Germany in 1903 was confined to two paintings shown at the Vienna retrospective and one picture owned by Karl Osthaus, *Contes Barbares* (Wildenstein, *Gauguin*, no. 625). Gauguin had not made Muther's history of the nineteenth century and was only marginally represented at the Centennale. Instead, Gauguin was in the hands of Parisian dealers and a handful of collectors. Unable to provide illustrations of the artist's work, Meier-Graefe made much of Gauguin's obscurity.

He began by comparing Gauguin's orientalism to Degas' and Whistler's, and praised Gauguin as an artist of the highest stature: "there are small pastels by him from the 1880s which have a color magic of the most refined kind and an objectivity of line that one can put next to Degas' best, and one can buy them, if one is able to find them, for as many ten franc notes as one pays in thousands for a Degas" [49]. Gauguin, however, is more decorative, but also more "cosmic" than Degas, "a premature child of the times, a tragic representative of a period of transition, who must be sacrificed in order that others may build upon his example" [50]. But he gave his readers very little real information: he had Cézanne painting with van Gogh and Gauguin in Brittany (an association first advanced in the "Beiträge"), a marriage of convenience if not of fact to underline their artistic brotherhood.

The most telling passages, rather, concern the artist's primitivism.[55] Gauguin found new sources of beauty in the art of "so-called primitive peoples," in Assyrian sculpture and African bronzes, among other things [52]. He was a painter of the natural man, who found beauty in the free movement of the body in dance and in mime; the body was in harmony with the rhythms of the natural world before it had been disguised by clothes. As a natural man Gauguin "struggles half unconsciously for abstract art, but his whole apparatus reaches only for the old goals. He does not even know the new goals" [51]. Meier-Graefe detected in Gauguin's childlike primitivism the danger of "decadence." Yet "Gauguin is never less ill than when he is wholly himself, and it appears to me impossible, if one does not want to develop an idea of illness à la Nordau, to deny an appearance of healthiness, which is still above all the capability of expressing oneself personally and at the same time aesthetically" [54].

In this reading of Gauguin Meier-Graefe offered a new understanding of Impressionism that transcended the naturalist reproduction of reality. Gauguin's trip to Tahiti "was a rest from religion, or better, from a far busier time. He wished to bring his environment into steady, outward agreement with his inner world" [52]. The inner world of Meier-Graefe's formulation,

standing under the umbrella of "der moderne Impressionismus," is sharply opposed to the dominant German reading of Impressionism and foreshadows the rhetoric of the Expressionists. A tragic hero, a child, a European savage, Meier-Graefe announced most of the future figures of Gauguin's mythologies. Tellingly, *Der moderne Impressionismus* closes with the warning that

> since the Impressionists in France have had their say, there have occurred things in painting of which most German painters have still not the slightest dream of. These things are not merely of a national character, no less than the research of Pasteur or the balloon experiments of Santos Dumont belong exclusively to the French sphere of interest. One paints differently since Manet and Monet. Certain facts which still persist in Munich are no longer endured in Europe [64].

Leaving aside the dubious assertion that all Europe, save Germany, had come to work within a *post*Impressionist heritage, *Der moderne Impressionismus* exemplifies Meier-Graefe's ambition to remodel German culture in step with French modernism. The imprecision of Meier-Graefe's language, the inadequacy of his knowledge, the lack of the paintings, demonstrates the critic's rush to judgment. He was simply compelled to be the first harbinger of the new art. Only in Germany did a critic say, as Meier-Graefe did in 1903, that Impressionism was old hat.

When the *Entwicklungsgeschichte* appeared in 1904 its novelty and its influence rested not so much on the presentation of Manet and the Impressionists—this was an increasingly familiar story—but on how for the first time the Post-Impressionists are fleshed out (with accompanying illustrations), a feat heretofore without parallel. Nor were there any studies to rival the overall completeness of his survey, nor the order and passion of his arguments. Of the book's three volumes (the third was devoted to plates—many stemming from Durand-Ruel) the most influential volume was certainly the first. Its three sections "The Struggle for Painting," "The Four Pillars of Modern Painting," and "Color and Composition in France," put into prose what had been pictorially advanced at the 1903 Vienna retrospective: how the grand tradition of painting was passed down from the Renaissance largely via the French tradition to the Impressionists. For the first time a modernist art history traced its genealogy through Constable and Turner, Delacroix, Daumier, Corot, Millet, Courbet to embrace the "four pillars": Manet, Cézanne, Degas, and Renoir.[56] The third section continued the story from Monet through the Neo-Impressionists, to what

Meier-Graefe idiosyncratically discovered as "color" in modern sculpture, again beginning as early as Jean Goujon and then brought into the present via Rodin and Medardo Rosso. The "composition" aspect of modern art Meier-Graefe organized around a tradition stemming from Ingres through Puvis, and which included artists as diverse as Fantin-Latour, Redon, and Denis. He concluded this section with Gauguin and the circle of Pont-Aven, thereby implicitly and explicitly linking color and form. No space remained for the French *juste milieu*, much less academic and Salon artists.

Unique to Meier-Graefe's history was his recognition that modern art presented problems for the historian different from the art that preceded it. Meier-Graefe combined, as no German art critic or historian before him, an extensive knowledge of French literature and art criticism. If he owed much to Fiedler and Wilde, his approach was far more elastic than theirs' and his knowledge of international modernism far more informed. His chapter on Seurat, for example, discussed not only Seurat's technique but his academic education and his theoretical and scientific sources. On Gauguin Meier-Graefe was able to quote from *Noa Noa* (not translated into German until 1908) and remarked

> the poem adapts itself to our language, and the colorful episodes, whose names with their wealth of vowels, serve our pleasure in splendor, without forcing us into exotic forms. The spirit is European: nothing, indeed, speaks here more decisively for the European than Gauguin's flight from Europe [I: 376].

In order to get all his masters to fit into his synthetic account (and in harmony with his circles) the book has some surprising results. Van Gogh (in Millet's circle) arrives in the text before Manet. And Cézanne, no longer in Manet's circle, now heads his own, presiding over the Nabis. The elevation of Cézanne and the Nabis to the grand French tradition added the latest link in a long chain of stylistic development; because Meier-Graefe viewed modernism as a new application of old laws, he stood apart from German critics such as Ferdinand Laban, for whom Manet represented an extreme break with the past.

Unlike most apologists for Impressionism, Meier-Graefe was not content to uphold Impressionism within the standards set by the great art of the past. As one historian has argued, Meier-Graefe's intention was the reverse.[57] He made Impressionism the normative standard by which all Western art was to be judged. Whether Meier-Graefe was aware that he was employing such a standard is an open question since he rationalized the perceived qualities of Impressionism into what he called an "organic" sys-

tem and gave it the authority of a "logical" historical development, one which presumably could generate successors.

> What we must . . . recognize is that Manet is painting and Böcklin is something else. This something may be loftier, it may appear to us Germans more Germanic, and it may furnish the poetical for the poets; from the artistic side it may also have its value as the stimulant for the decorative: but with the typical art that we admire as painting, not only because it is beautiful, but because it is a living part of ourselves, it has nothing to do [I: 152].

This of an artist who only a few years before had been compared to Michelangelo! For Meier-Graefe, Manet's radicalism was his Frenchness, his upholding of the great tradition of art largely lost to Germans, instead of a radicality of technique. Accordingly, Manet's naturalism was something profoundly different than the views of his contemporaries. He emphasized the fragmentary quality of Manet's work, the quality of each elemental stroke of paint, the refusal of Manet to engage in anecdotal or narrative conventions. He wrote, for example, of *Nana* that

> it is difficult to imagine anything more pungent in the shallowest sense than this boudoir-scene, from which Zola's novel has taken every possible element of ambiguity. And nothing could be greater, the most pious Mantegna is not more worthy of honor, than this coquettish beast in corsets and lace petticoats. This is the true naturalism, which like Nature itself, reveals the wonders of creation in the lowest things, and Zola's phrase, which became its gospel, is only true if we take the "coin de la nature" for as little and the "temperament" for as much as possible [I: 154].

Not naturalism but Manet's French soul dominated his reading, a lack of which he used to condemn Böcklin.

However, the narrative model so forcefully presented in the first volume begins to unravel in the second. The first part, and the book's fourth section, "Die Kunst in Deutschland," offered an unprecedented revision of recent German painting, a small list of heroes (which in the first edition excluded even Adolf Menzel) whose work was measured by their degree of acceptance or rejection of French modernist aesthetic principles. They are Marées, Leibl, Trübner, and Liebermann. There are also the negative heroes: Anselm Feuerbach, Hildebrand, Klinger, and Böcklin. While he was not without substantial praise for the first three, he presented them all as unrealized artists. None was so unrealized as was Böcklin, whose specific artistic failures were as much a product of the culture in which he worked as

his own. Meier-Graefe's belief, expressed in the "Beiträge," that German art never had much to do with painting, that it was linear and ideational, rather than sensual, realist, and painterly (all French qualities), now was cast in a far more public, and more historicizing frame. Characteristically, about Feuerbach he wrote

> amid all the sentimental ugliness and triviality, the bombast of false patriotism, and ill-constructed tags from the classics, we long for a quiet spot. . . . Feuerbach opens before us a great and spacious garden, not indeed, completely beautiful, for there is no sunlight and no flowers to be seen [II: 412].

Those closest in spirit to Impressionism fared the best, especially Liebermann.

> The masses who stand behind Liebermann are the new Berlin. . . . Liebermann symbolizes Berlin . . . the Berlin which still has no traditions, which has hardly a sense of place, which with its emperor, its soldiers, and the many-sided bourgeois drawn from every state in the empire, seems an amorphous body, yet with mighty aspirations [II: 525–26].

Yet he implied that Liebermann could never be as good as Manet, because Liebermann was a product of an immature culture whereas Manet was heir to a great cultural tradition. Those German painters who did not compare to this French tradition, Meier-Graefe largely treated with silence—except for Böcklin.

The next section, "The Struggle for Style," moved from a discussion of the decorative sculpture of the Belgian George Minne to English Pre-Raphaelite painting and the rise of the Arts and Crafts movement. Written at the moment just before Post-Impressionist painting was to occupy the cultural space of a collapsing decorative arts tradition, the closing sections devoted to "Ornamentation," "The New Vienna," "The Generation of 1890," and "German Aesthetics from Goethe to Nietzsche"—which largely concerned the problem of integrating the qualities of painting into the architectonic—were already out of date and did not survive later editions of the book.[58] In 1904 he continued to struggle to harmonize this 1890s aesthetic sensibility to the modernist paradigms laid out in the other parts of the book, to make, in fact, the history of French modernism serve the history of the decorative arts movement. But it was an argument increasingly compromised by the failure of art nouveau and by the steady inroads modernist painting was making in Central Europe.

DER FALL BÖCKLIN

Fritz Stern has argued that the German search for culture was a "revolution against modernity."[59] But for Meier-Graefe the opposite was true. It was in the name of modernity that Meier-Graefe rejected not the masses of whom he expected nothing but the German cultural elites. It was for this elite audience that Meier-Graefe assumed his role as a *Kulturkritiker*. The *Entwicklungsgeschichte* was intended to initiate Germans into the necessary cultural sensitivity before what he called "an organic culture" could be created. In the chapter "Aubrey Beardsley und sein Kreis" he defined the role of the great artist within this cultural sensitivity.

> Not until we have learned to understand Beardsley or Dostoevski or Manet as we understand Bismarck, shall we have *Kultur*. Whether it is a painter or a statesman or anyone else is not especially in question: they have our age at their fingertips, each in the manner peculiar to himself, so that to limit our acquaintance to only one alone would necessarily distort our understanding [II: 607].

We are very far now from Scheffler's portrayal of Impressionism as a radical, socialist, atheistic approach to the visual arts. Meier-Graefe's idea of cultural reform took the approach of a kind of pedagogical connoisseurship, not very different from Wilde's. Politically centrist and culturally radical, the critic's responsibility was to educate the public into a new taste, to acquire knowledge of what were the truly significant aspects of modern European culture. Time and again in the early histories of modernism Meier-Graefe's approach would be taken up, if in different forms and for different artists.

In these days, all of Meier-Graefe's ideas were interlocking. Out of the *Entwicklungsgeschichte*, for example, would come his life-long interest in Marées as well as a book on the young Menzel. Clearly the chapter on Böcklin in the *Entwicklungsgeschichte* announced the major themes that made such a dramatic impression when they appeared in isolation in *Der Fall Böcklin*.[60] Yet Meier-Graefe's critics reacted to each new book as a fresh blow struck in the conflict between modernists and their rivals. This is to say that the arguments advanced in *Der Fall Böcklin* largely reiterated the cultural theories of the *Entwicklungsgeschichte*. Thus, it proved controversial less for its specific denunciation of Böcklin as an artist than for its larger attack on German culture. In rejecting Böcklin, Meier-Graefe went against the views of many of his contemporaries. Although he was certainly the

most shrill voice raised on behalf of modernism in his generation, his views usually conformed to his more centrist friends and contemporaries, such as Ferdinand Avenarius in his *Der Kunstwerk* or Heilbut in his *Kunst und Künstler*. These liberal, progressive individuals and institutions had the common ambition to assert a new, modern German identity through art and design that would carry over into all aspects of everyday life. Maximilian Harden, the editor of *Die Zukunft* and a man whom Meier-Graefe lavishly praised at the end of the *Entwicklungsgeschichte*, admired Böcklin for creating a new mythology and for possessing a quality of poetry comparable to Goethe's.[61] Harden's standards, however, were anathema to his friend, who argued against such a "poetic" or literary appreciation of art. In his condemnation of German militarism, materialism, and imperial ambitions Meier-Graefe insisted on a formalist discourse, or a doctrine of significant form, that in effect anticipated Le Corbusier's famous phrase, "architecture or revolution."[62]

In *Der Fall Wagner* (1888) Nietzsche rejected Wagner's aesthetics revolving around the personality of the artist. The authority, the presence, of the artist obscured or covered over the qualities of the music. Nietzsche maintained that the truth in music was found in composers such as Bizet who was "without counterfeit. Without the lie of the great style."[63] Meier-Graefe similarly chose to reject Böcklin on the grounds that he had overwhelmed the values of his art through his overriding personality. He attacked the painter for a deficiency of *Einheit* (the gestalt that Tschudi had also found in Manet). *Einheit* was a formal unity of line and color. Meier-Graefe claimed to have grounded his conception of *Einheit*, understood outside a narrative content, in the theories of Fiedler, but *Einheit* was also close to such contemporary definitions as Maurice Denis' view of French classicism, where he equated the unity of a painting with a cultural unity.[64] Where Nietzsche said that Bizet created a musician's music, Meier-Graefe said as much of Impressionism; it was, in Fiedler's sense, pure painting.

As he laid it out in the second volume of the *Entwicklungsgeschichte* artistic unity was found primarily in two forms: monumental art where the work is united with its surroundings (e.g., the Ravenna mosaics) and easel painting, isolated from its surroundings, reflecting the fragmentation of modern culture. The critic accused Böcklin of transgressing the proper limitations of each by attempting to make out of easel painting a monumental art. Only modern French art could lead to a modern monumental form because it was characterized by flat planes that could be tied organically to the wall (here he cites paintings such as Gauguin's). Böcklin by contrast tried to achieve monumentality not through style but through subject matter. This was his

"lie of the great style." Nietzsche's attack on Wagner's excesses were made parallel to the excesses of Böcklin, which led to unintentional comic results.

To the false prophets of Böcklin and Wagner, Meier-Graefe contrasted an aesthetic position taken directly from Fiedler's conception of artistic truth. Meier-Graefe saw the great artist as the social outsider, but also one who is able to see his own age with a clarity not given to the masses. Whereas modern mass society sought a self-confirming art (Böcklin), Meier-Graefe described Manet's art in the *Entwicklungsgeschichte* as

> great in itself, because all it touches develops into the strongest expression of its manner, because everything it sees is seen with such unapproachable certainty that our consciousness reposes in the shadow of a consciousness of one stronger, greater, and richer [than ourselves]. The marvel is that this something greater lives among us, with us, in us, without seducing us by objective symbolism [I: 154].

Neither scientific rationalism, nor formalist materialism, Meier-Graefe advocated a form of nature philosophy united with a Nietzschean view of the *Uebermensch*. This vision of the great artist runs through much of Meier-Graefe's writing and linked the critic to a Post-Impressionist aesthetic.

For Meier-Graefe, modern French art possessed a language not only of greater artistic worth than those of Böcklin's *Gedanken* pictures, it owned a far greater moral authority. Meier-Graefe's old friend, the poet Richard Dehmel, once described Böcklin as a Nietzschean hero. Meier-Graefe, speaking of Monet, but addressing all the Impressionists in relation to Nietzsche, argued that they

> have give us back normal vision. It is not their originality but their healthiness that raises them above the abstract significance of every purely artistic activity of our times, and gives them a halo no less radiant than the aureole that encircles Nietzsche's head [I: 219].

Meier-Graefe united Impressionism and Post-Impressionism under one roof, which amounted to the French cultural tradition as he understood it. This tradition of great personalities acted according to certain laws of formal development and experimentation that simply and decisively excluded Böcklin and all that he stood for.

The aftermath of the publication of *Der Fall Böcklin* took two distinct forms. First, Böcklin's reputation suffered permanent injury and though many continued to write about the artist and to collect his paintings, he was never to be taken as seriously again.[65] Conversely, the book resulted in

reviving a heated debate over the virtues of German culture versus French culture. The battle was joined by Henry Thode, professor of Renaissance art at the University of Heidelberg and a friend of the symbolist painter Hans Thoma. Thode brought out a book, based on lectures given to thunderous applause at Heidelberg, called *Böcklin und Thoma*, which attacked Meier-Graefe both for his defense of Impressionism and for his repudiation of Böcklin and German culture.[66] He began by seeing Meier-Graefe as a representative of a "great party" headquartered in Berlin. Thode identified this party as a well-organized, if small clique, centered around art dealers, who, he said, had established themselves alongside the *Kunstvereine* and the old artist exhibition societies. This party was supported by "art historians and critics, writers who champion modern art out of a conviction we do not question, but frequently with the fanatical delusion that the newest is the best."[67] Thode hardly invented this argument, but he was among the first to see an intimate relationship between the market and the critics and historians. Thode argued that painting was more than sensual pleasure, that it had to appeal to the intellect. He attacked *l'art pour l'art* as morally and aesthetically bankrupt and promoted German idealism.

The sensation caused by Thode's lectures at Heidelberg caused an exchange of letters in the *Frankfurter Zeitung* between Liebermann and Hans Thoma, the latter prompted by Momme Nissen to attack Liebermann.[68] Eventually the exchange turned to Liebermann and Thode. Liebermann accused Thode of anti-semitism, of poor scholarship, and of a complete ignorance of modern art. Thoma replied by characterizing Liebermann, Meier-Graefe, and the Berlin Secession as promoters of "reheated cabbage as the laws of art," and as champions of a French fad against the German *Geist*. Stripped of the personal slanders, the debate rested essentially on the question of whether the Secession represented a foreign fashion imposed by dealers on the German public.

It is worth noting that this attack, like many that followed, came from the periphery, even if that periphery was an art historian from Heidelberg. By 1905 the apologists for Impressionism already occupied center stage in the German publishing houses and in the galleries of Berlin, Dresden, and, increasingly, Munich. Thode's book characteristically was printed by an insignificant publishing house. And despite the enthusiastic response it received not only from the students at Heidelberg but from around the country, this opposition did nothing to stem the tide. If anything, it merely served to clarify and unify the modernist position in Germany. The pro-modernists were quick to point out that France had offered the same opposition to the Impressionists in the 1870s and 1880s, which was now at last in

the process of being overcome. It was a matter of the "enlightened" versus the "philistines," with the "enlightened" holding most of the principal strands of power within German cultural institutions. On one side Tschudi and Meier-Graefe articulated an interpretation of French modernism that sought to ennoble formalism and to downplay both the subject and the partisan character of art. The opposition took the view of Impressionism as a radical materialism, that debased German cultural values in the name of market gains.

Meier-Graefe's career took a pronounced turn after 1905. He assisted in planning the 1906 *Die deutsche Jahrhundert-Ausstellung* held at Berlin's National-Galerie.[69] This collaborative project brought Germany's museum elite together to present a history of nineteenth-century German painting that would accomplish what the Paris Centennale had failed to do: to visually write a cogent history of art using the best available work as exemplars. If Meier-Graefe had been solely responsible for *Die deutsche Jahrhundert-Ausstellung* it might have been less egalitarian, more consistently "modern" in its selection of artists (Böcklin was given considerable place at the show). But representing as it does a panoply of Central European painting from 1775 to 1875 (it embraced Vienna and the *Römer Deutschen*, the Nazarenes through the Swiss painter Böcklin), the exhibition celebrated no revolutions nor centennials of revolutions, neither the beginning of the Prussian state as a Central European power nor the *Reichsgründung*. Conceived in art historical terms to embrace classicism through Romanticism to realism, the exhibition gathered together some of Central Europe's best pictures from its most important museums. Most notably, it dramatically revived the reputations of both Casper David Friedrich and Marées.

For Meier-Graefe's part, the show realized his ambition to discover an authentic culture after the false culture of Wilhelmine Germany. While the academicians of Munich and Düsseldorf were included, their presence was far from dominant. Meier-Graefe's participation in the show also announced the end of his commitment to the newest trends in art. Henceforth his critical gaze would always be retrospective. The exhibition confirmed Meier-Graefe's interest in Marées, who as a muralist and a theorist seemingly fulfilled much of what Meier-Graefe had argued for a grand style. His subsequent devotion to Marées marked the end of his fresh involvement with contemporary French painting.

Because the dominant characteristic of the German reception of French Impressionism was its mediation by a significant portion of the nation's

cultural elite, it ought not to be surprising that Impressionism was presented in Germany not only as an historicist *fait accompli*, something that did not need to be argued about, but also something fundamentally synonymous with the modern world itself. Yet the anxiety of influence this *Weltanschauung* produced far transcended aesthetic issues. The Brücke artist, Ernst Ludwig Kirchner, in the face of obvious evidence to the contrary, found it necessary to assert in 1913 that his work was "uninfluenced by contemporary movements of cubism, futurism, etc."[70] In the controversy centered around Vinnen's pamphlet *Ein Protest deutscher Künstler*, one of the leitmotives of the German response to French modernism was the reaction to the speculative market it fed upon and the historical/museological institutions that supported that market, particularly embodied in the acquisition in 1910 by the recently revivified museum in Mannheim of Manet's *The Execution of Maximilien* for the extraordinary price of 90,000 marks. Vinnen's protest, however, should be understood merely as the codification of what was in fact a long-standing popular sentiment, inside and outside the art community, that predated and persisted long after his polemic. *Ein Protest deutscher Künstler* voiced the same arguments about the interrelationship between fashion, criticism, and dealer-contrived conspiracies that the Nazis used to justify their repression of modernism twenty-five years later. What Hitler and his agents shared with Vinnen was not simply a distaste for Post-Impressionist art, the non-naturalistic styles, or even the beliefs it might be said to represent. In Germany the question of modern art would never be separate from the aggregate art institutions, the commercial galleries, the museums, the journals, the critics, and the historians who all came to the defense of French modernism.

In 1905 the generation of 1890, with Meier-Graefe as one of their most vocal spokesmen, found themselves no longer identified with the emerging avant-gardes, but defended their art and beliefs against new paradigms. The debate was joined between modernism and their opponents and among modernists and increasingly it took the form of nationalism versus internationalism. Yet how unsuited these polarized arguments were to the complex social conditions they so summarily described. How ironic it was that the apologists for the newest avant-gardes so frequently marshalled nationalist rhetoric on behalf of artists whose stature and livelihood depended upon their international commercial connections. How ironic, too, that French chauvinism found its strongest voice in the books published by Meier-Graefe, who not only aroused nationalist ardor among Impressionism's opponents back in Germany, but offered a sort of inverted nationalism for all his readers. Preaching a doctrine of intolerance, Meier-Graefe over-

threw the Impressionist *Weltanschauung* to argue all things French against Germany: not only did France possess better, more profound art, it was the inevitable product of French culture. His alienated internationalism earned him the lasting hatred of the German right. At the Degenerate Art exhibition in Munich in 1937 Meier-Graefe's portrait hung in the entrance hall.

And yet Meier-Graefe was no friend to the artists the Nazis pilloried. He withdrew from the organization committee of the 1912 Sonderbund exhibition because the newest artists that were to be included he is said to have described as makers of "flammable products."[71] And in 1913 in the essay "Wo treiben wir?" [Where are we drifting?] he attributed the latest manifestations of contemporary art to materialism and the art market.[72] In selecting the title, as in the case of *Der Fall Böcklin*, Meier-Graefe remembered the much earlier polemic of Siegfried Bing. Evoking Bing, Meier-Graefe returned to the problem of the economic underpinnings of the modernist art market. In perhaps its most memorable passage he wrote "how simple is the business of making art today! We will soon no longer have artists, only business people, just as we already today have really no connoisseurs [Liebhaber], but just dealers" [45]. Consistent with the themes in *Der Fall Böcklin* Meier-Graefe attributed the decline in contemporary culture, not exclusively to a circle of dealers, but to a society that values soldiers and ships more than art [50]. The generation that followed Meier-Graefe's did not share this sense of cultural alienation—the Brücke artists never went to Paris and would not admit to a debt to Parisian modernism, even when it was manifestly obvious. Yet it was their art that burned under the Third Reich.

1905

\mathbf{A}s late as 1905 what Impressionism was, as a technique and as a so-
cial *Anschauung*, was still obviously very much subject to debate. The limits
of the canonical Impressionists' prestige may be measured in part by the
commercial failure of Durand-Ruel's huge Impressionist exhibition in Lon-
don in 1905, as well as by the failure of Impressionism to win more than a
narrow audience of collectors in Paris. In France, modernist painting would
never be a state-sponsored export; despite the prestige the Impressionists
lent to French culture, official juries still sent abroad a predictable stable of
Salon artists.

And yet a momentous change had occurred. Consider Matisse's igno-
rance of Impressionist painting until the display of the Caillebotte collec-
tion, his almost simultaneous acquisition of a painting by Cézanne, and his
subsequent fall from favor with the Nationale's leadership as he began to
incorporate the lessons of Impressionism into his work. Significant, too, was
Matisse's subsequent association with Signac, which drew the artist into
the circle around the Indépendants. Matisse's passage from a respectable,
mainstream career into a participant in the Neo-Impressionist-led Indé-
pendants followed in close step with the renewal of a culture of painting in
post-1900 Paris.

That culture announced itself in Paris by ironically presiding over the
funeral of Impressionism. Charles Morice, poet, disciple of Mallarmé,
friend and collaborator of Gauguin, and art critic, published a circular some
weeks before the opening of the 1905 Salon d'Automne in the *Mercure de
France* framed around the question: Was impressionism dead?[1] And if so,
was it possible to revive it? His respondents were to measure the aesthetic
worth of Whistler, Gauguin, and Fantin-Latour, all recently deceased, and,
more tellingly, tell what they thought of Cézanne. Finally, he posed the
question: "Should the artist expect anything from nature or ask of it only
the plastic means to realize the idea within himself?" Morice received
numerous replies, some quite long, printed over three issues of the *Mercure*.
Most respondents were relatively minor artists, or major artists who have
since slipped from history; artists one would have liked to have heard from,
Matisse for instance, either were not asked or did not respond. Despite
these limitations, the replies do indicate a profound shift in sensibility, a

recognition that indeed modern art was no longer merely an extension of Impressionism.[2]

Suddenly modernist painting (and modernist discourses) mattered more and mattered in a way it hadn't since the 1880s. In 1905 the Fauves, the wild beasts of young French painting, "debuted" at the Salon d'Automne.[3] The year of their ascendancy coincided with the great retrospectives at the Indépendants for Seurat and van Gogh and at the Salon d'Automne for Ingres and Manet. In Central Europe the Brücke was founded in Dresden and the Vienna Secession fissured over the question of one member's ties to a commercial gallery.

In 1905 the international art market began to be perceived as a benefit not only to the Impressionists, but to another generation of artists, either in fact or symbolically younger, and positioned in opposition to Impressionism itself. In Berlin, for example, in the wake of Cassirer's second, larger exhibition of Cézanne in May 1904, Hans Rosenhagen not only asserted that the painter was one of the strongest artists of the nineteenth century, but that when he was placed side by side with the Impressionists at the 1900 Centennale, "Manet appeared next to him elegant, Monet decadent, Sisley sweet, and Pissarro almost weak."[4] A year later Cassirer showed a collection of Cézanne portraits, followed by portraits by Edvard Munch. Rosenhagen again concluded that "it is unfortunate for the Norwegian artist that shortly before, work of van Gogh was shown here and that between his last exhibition and this one portraits by Cézanne were to be seen in the same place."[5] Munch, *der modernsten Künstler* a few years previously, was now unfavorably compared to what appeared to Germans as a new generation of artists (despite the actual age of the painters compared). What counts is this: at the same moment that young French painters and critics were rediscovering Cézanne, so too were the Germans.

The same holds true for van Gogh. Cassirer showed van Gogh in 1904 and twice in 1905.[6] And in 1904 the Munich Kunstverein held the little known exhibition of van Gogh and Gauguin.[7] The summer of 1905 brought the great Amsterdam retrospective for the artist at the Stedelijk Museum.[8] In 1906 the Galerie Miethke in Vienna gave the artist an exhibition with 45 pictures in its catalogue. There was another show in Rotterdam that year of 65 pictures. In 1908 Bernheim Jeune showed 100 paintings that surveyed van Gogh's entire career. Simultaneously, the Galerie Druet in Paris showed 35 of the artist's works. The Bernheim show traveled to the Kunsthandel C.M. van Gogh in Amsterdam in September 1908, supplemented by another 25 works. In a reduced form this show went on to Brakls Modernen Kunsthandlung in Munich and closed at the Kunstsalon Richter

in Dresden, where once again about 100 paintings were shown.[9] The success of van Gogh in Germany may be measured by the 1912 Sonderbund exhibition in Cologne where no less than 108 paintings and 16 drawings were shown. Fully one third belonged to German collectors.[10]

These market pressures from abroad obviously challenged Impressionism's exclusive claim on modernist identity. They were abetted by the emergence of new "avant-gardes"—a term in reference to modernist painting that had just entered general use.[11] This is what sent Morice looking for explanations for the death of Impressionism. The appearance of Matisse and his friends at the Indépendants exhibition in 1905 called for new theoretical and historical explanations for contemporary painting, explanations that challenged the heretofore seamless whole of modernism.

The anti-naturalist liberties taken by the Nabis and the early work of the Fauves, staged before an international public attending the exhibitions of both the Indépendants and the Salon d'Automne, suddenly showed the Impressionists by contrast to be "classical." Karl Eugen Schmidt's review of the 1904 Salon d'Automne exhibition for *Kunstchronik*—the same review that denounced Durand-Ruel's "circle of dealers"—saw Manet in the company of artists such as the Nabis as "an old, moldy, ossified classicist and academician, a fossilized professor compared to these Titans, who vomit where the master spit, who yell where he spoke, who sneer where he smiled."[12] Not only did Schmidt describe the newest art as "Avantgarde," he also saw works like Matisse's sculptures striking the same blow "against Impressionism [in sculpture] that his paintings have struck against Impressionist painting."[13] It is indicative of how internationalized the audience for French modernism had become that this hostile, but well-informed observer put Auguste Maillol, Denis, Matisse, and the other younger Parisian avant-gardists "gegen den Impressionismus" [against Impressionism] a year before Morice's circular.

Although scholars universally agree that the Impressionist paradigm had been ruptured in the second half of the 1880s, transgressed by the canonical Post-Impressionists, why did the end of Impressionism become universally apparent only in 1905, and not, say, in 1890? What had happened to French Post-Impressionism that it so belatedly manifested itself to redefine Impressionism as classic, and to demand the restitution of painting as theory? Where were the canonical Post-Impressionists in the 1890s? There were the obvious circumstances of untimely death and voluntary exile. Van Gogh died in 1890; Seurat and Albert Dubois-Pillet (an essential player in the Indépendants) in 1891. Cézanne was long entrenched in the south of France—as Mellerio wrote in 1896: "Still living, one speaks of him as one

does of the dead."[14] Gauguin left for Tahiti in 1891 and although he returned for some months in 1893–94 he was soon back in the South Seas to stay. Bernard settled in Cairo in 1893 where he remained until 1904.

Of less obvious significance were the death in 1892 of the symbolist critic, Gabriel-Albert Aurier, and the departure in 1893 of Félix Fénéon, the defender of the Neo-Impressionists—and perhaps the best art critic of his era—from the field of art criticism.[15] Remy de Gourmont lamented in 1898, "since the new era we have had only two art critics, Aurier and Fénéon: one is dead, the other is silent."[16] After the brilliant emotionalism of Aurier's advocacy of artists such as van Gogh and Gauguin, and the unparalleled lucidity and perceptiveness of Fénéon, the Post-Impressionists were largely treated by critics of a markedly lower caliber, such as Mauclair or Geffroy. Indeed, despite a warm article on Cézanne by Geffroy and an introduction to his first exhibition catalogue at Vollard's in 1895, Cézanne dismissed the critic as "that vulgar Geffroy."[17] Pissarro, writing to his son about Geffroy's intense admiration for Eugène Carrière and what Pissarro perceived as the "flop" of Carrière's retrospective at Bing's in 1896, declared that "Geffroy has no judgment!"[18] Pissarro thought so little of Mauclair that he complained that he "is ill informed like most of those critics who understand nothing."[19]

Aurier did not live long enough to establish a coherent historical identity for a Post-Impressionist painting. In 1891 he invited his readers to consider Gauguin under a potpourri of categories: symbolist, synthetist, or ideist—this easy confusion of terms such as neoidealism, idealism, symbolism, and synthétisme was preserved throughout the 1890s.[20] Only the "idealists," who exhibited at the Salons, were to be excluded from the ranks of the anti-naturalists. Five years later, this heterogeneous taxonomy was revised by Mellerio in his pamphlet *Le Mouvement idéaliste en peinture* (1896).[21] Now it was under the banner of idealist painting that Mellerio discovered four distinct modernist camps, plus a collection of unclassifiable "independents". When Aurier was alive, *symbolisme* could still be readily identified with a small group of artists led by Gauguin and the art colony of Pont-Aven. But the idealist or symbolist painting that dominated international exhibitions of contemporary painting in the 1890s was a far cry from the kind of art Aurier and Gauguin imagined. This "public" symbolism had critics such as Mauclair as spokesmen. In 1897 Mauclair declared symbolism virtually extinct and then set out to give its genealogy, incorporating Wagnerianism, the English Pre-Raphaelites, Whistler, Moreau, Odilon Redon, and Felicien Rops, but excluding such artists as van Gogh, Gauguin, Bernard, and Paul Sérusier.[22]

Mellerio's pamphlet therefore constitutes an abortive attempt to reconstruct an aesthetic phenomenon that had in effect disappeared from the Parisian stage. Mellerio grouped his discussion around four "pillars": Puvis, Moreau, Redon, and Gauguin, and included as a subset within their ranks the still largely unknown Cézanne and van Gogh. He explicitly suppressed the literary and religious aspects of idealist painting—attacking the exhibitions of the Rose + Crois as a "great deception"—in favor of the formalist, individualist, and increasingly naturalist understanding of modernism. *Le Mouvement idéaliste*, indeed, is chiefly of interest for its exclusionary strictures; it did little more than to place certain artists on the modernist bus and to throw off the rest.

The basic question remains, why was it still left to Mellerio to recreate in 1896 an avant-garde around "idealism" (blithely ignored by Mauclair a year later) that Aurier had thought self-evident in 1891? Among possible answers one might begin with the nature of modernist exhibitions and markets. In the 1880s the Impressionists had been firmly and relatively coherently represented at their self-arranged exhibitions and at Durand-Ruel's, and the Neo-Impressionists at the Indépendants. In the following decade, the Impressionists, the symbolists, the artists showing with the Rose + Crois, the Nabis, and the Neo-Impressionists all competed for public attention in alternative exhibition societies and dealer showrooms alike. This apparent pluralism defied easy historical description—especially in an era still accustomed to seeing Impressionism as the most modern of art forms. Professional heterogeneity may also have played a role. Many artists found work in advertising, in the decorative arts, in book illustration, and so on, blurring the contours of the high-art tradition. Consider that modernist artists before and after the nineties were far less multifaceted in their approach to media; their professional identity was to a much greater degree located in the practice of being a painter or a sculptor. The professional heterogeneity of the nineties matched the aesthetic eclecticism of the *juste milieu*.[23] A weakened Salon system and the collapse in the prestige of the academic tradition also offered few sites of resistance against which an avant-garde might define itself, since not even Impressionism constituted an orthodoxy in the 1890s. Finally, perhaps it was simply that both as state policy and within commerce the action was elsewhere: as we have seen in Meier-Graefe's career, the promotion of decorative arts reform simply overwhelmed other aesthetic issues. Thus, the general collapse of international art nouveau between 1900 and 1904 quite literally cleared the way for a return to painting. An institution such as the Salon d'Automne made a

show of integrating all the arts, but especially in its early, decisive years, the overriding emphasis was on painting, and its chief agent, the retrospective.

Compared to the tenuous, polymorphous identity achieved by Impressionism over the prior two decades, the Post-Impressionists at the post-1900 retrospectives and their immediate successors (the Fauves, Cubists, etc.) were instantly isolated by both foreign and Parisian observers alike from the mass of exhibitors. Why? Because the selection process had already taken place through the filter of the commercial galleries, for in a very short number of years Matisse, Picasso, and a handful of others had advanced up from minor galleries such as Berthe Weill's to Paris' leading commercial showrooms.[24] Divorced from the confusing circumstances of the Salons and the Indépendants, these artists sprung from the head of Zeus, as it were, readymade.

The growing competition (and collaboration) between the Parisian galleries and a new generation of German dealers also stimulated the search for new artists, and new art organizations, thereby forging ever more intimate links between French galleries and the international market to the east. When the galleries began to export these younger artists abroad, Central European audiences generally knew who they were, what they were, knew too the degree of scandal they had already caused in Paris. And because the modernist art institutions had evolved considerably since the *Jahrhundertwende*, a Matisse had almost as much a chance of being seen first in Moscow or Berlin as in Paris.

Theory too played an important role in the resurrection of modernist painting after 1900. The first of the Post-Impressionist revivals belonged to Neo-Impressionism, whose great attraction and seductive force was its historicism, its position as a "néo," as a refinement of a previous artistic expression, its status, as it were, as the logical outcome of certain aesthetic ideas. Attractive, too, were its pretensions to scientific procedures, to a system of artistic knowledge that was researched, developed, articulated, refined, and progressively expandable. Signac, as I have argued, was perhaps the first modernist artist to theorize his aesthetic project in light of a linear, developmental history of modern art and put into international currency a modernist genealogy entirely unencumbered by academicians and the *juste milieu*.

But theory had its costs. As Alfred Flechtheim recalled late in life, at the great 1900 retrospective for Seurat that Fénéon organized at *La Revue blanche* the artist's prices "were still very low. The only sales were *La Parade*

and *La Rade de Grandcamp* which went to MM. Josse and Gaston Bernheim, the only dealers then bold enough to buy a Seurat, for a few hundred francs apiece."[25] Maurice Denis' remarks in 1909 concerning Seurat suggest why the authority of Neo-Impressionism over the post-1900 Parisian art world would prove widespread, yet shallow.

> It was the excess of this anarchy [on the part of the generation of 1890] which brought about, as a reaction, the spirit for system and the taste for theories. Seurat was the first who tried to substitute a self-conscious working method for this more or less imaginative improvisation after nature. He tried to introduce some order, to create the new doctrine everyone was waiting for.[26]

In Denis' view, the immediate virtue of doctrine was nonetheless detrimental to great art. Denis, as much as a Tschudi or a Meier-Graefe, believed that a great temperament necessarily brings the "exaltation of the individual sensibility" to his art. Even Seurat shared this anxiety of originality. Secretive in matters of technique, and jealous of his position as the "inventor" of Neo-Impressionism, Seurat had difficulty in transcending his own "system."[27] For a very long time, Seurat would not be allowed to belong to a lineage that included Manet, van Gogh, Gauguin, and Cézanne.

Because Neo-Impressionism was sustained by the institutional bastion of a rejuvenated Indépendants and by the personal generosity and patronage of Signac, it continued to hold sway not only over the Fauves early on in their careers, but over younger artists such as Delaunay, Gleizes, and Metzinger, for whom the attractions of the Neo-Impressionist system were internalized in the search for new systems of art after 1910. Before 1914 the "science" of color was never far from the center of avant-gardist debate over systems. And yet, shortly after the apex of its influence, c. 1904–05, Neo-Impressionism became subordinate to the figure of Cézanne. No other artist of the generation of 1890 so addressed the issue of discovering "the plastic means within oneself." It was left to Cézanne to reconcile the seeming aporiae of the avant-gardes: between temperament and system.

Cézanne's Post-Impressionist reputation may be reckoned to begin with Vollard's first showing of the artist in 1895, but for the next ten years and beyond the question of Cézanne's identity as an Impressionist or as a Post-Impressionist was continually contested. One painted testimony to Cézanne's reputation stands out, if only for its strangeness. In the winter of 1900–1901 Denis painted an *Hommage à Cézanne* (Paris, Musée d'Orsay), representing a cramped room of Vollard's gallery on the rue Laffitte in which the Nabis are grouped around a Cézanne on an easel. Flanking the

easel was Odilon Redon on the left and on the right Denis, and as if to symbolize the dealer's support for the artist, standing behind the easel, Vollard. The other artists are (from left to right) Vuillard, Sérusier, Ranson, Roussel, and Bonnard. Also included in his picture were Denis' wife and one critic, Mellerio. This statement of ideological coherence—these are the Nabis and they honor Redon, a father figure among symbolist painters, honoring Cézanne—is oddly wrong, or at least wrong from the perspective of subsequent modernist historiography.

First, the date of execution—the winter of 1900–1901—is a surprise. Why then? Why not in 1895 in the wake of Vollard's exhibitions of Cézanne? Or in 1897 when Denis showed with Bonnard, Henri Gabriel Ibels, Georges Lacombe, Ranson, Roussel, Sérusier, Vallotton, and Vuillard at Vollard's? Or much later, say in 1904, when Cézanne's reputation had grown to a new pitch with the publication of Bernard's conversations with the artist in the conservative periodical *L'Occident*?[28] Then there is the matter of Vollard's shop. Citing such a picture on a dealer's premises, even if a direct tribute to Vollard's patronage, is unprecedented in this genre. The painting precisely anticipates the image of the dealer behind the group that so many of modernism's opponents decried. As if to underline the difference between the semi-private world of the gallery and the public art world Denis showed the painting at the Nationale—the bastion of the *juste milieu*. In a letter to his friend André Gide Denis claimed the public laughed at his picture: but why was he surprised? The setting he chose for his *Hommage* could hardly have been expected to be more hospitable.[29] The truth is, to be noticed at all among the 3,000 plus works of art housed by the Nationale was an accomplishment.

The Nabis would not now be our legatees to the lessons of Cézanne (but in 1900 Matisse, Picasso, and the rest did not know they would require Cézanne's teaching). It would, in fact, be a mistake to see Denis' picture as a declaration of radical intentions, something akin to Henri Fantin-Latour's *Hommage à Delacroix* (1864) upon which Denis based his homage. Where Fantin had hoped to depict the "bande" of realists, of writers, critics, and artists, who were to capture the future, Denis' ambition was entirely retrospective. By 1900 the group identity of these artists was extremely tenuous. Most recent art historiography on the Nabis terminate their narratives around 1897 or 1898.[30] However arbitrary that terminus might be, one fact stands out: Denis was an anti-Dreyfusard, his Nabis colleagues were not. Although his position on Dreyfus did not lead to any immediate alienation from the Nabis circle, it marked an irrevocable schism between Denis and his modernist friends, even if, for a time, they remained united in their

shared faith in modernist painting. In 1901, Denis showed both with the Nationale and the Indépendants, but subsequently drew ever closer to the world of the Nationale and of official Paris. Vallotton's *Five Painters* (1903, Kunstmuseum, Winterthur) provides a hint of the fissuring of Denis' affiliation with the Nabis—as well perhaps as constituting a pictorial payback for Vallotton's omission from the artists recorded in Denis' *Hommage*. Denis' place among the Nabis (the other four were Vallotton, Bonnard, Vuillard, and Roussel) was taken by the unlikely figure of Charles Cottet.

In addition to the great ideological stresses of the moment, Denis' *Hommage* speaks to the insertion of market consciousness in the theory and practice of the post-1900 avant-gardes. Consider the centrality of Cézanne's still life, the one that formerly belonged to Gauguin. In Fantin's *Hommage à Delacroix* it was the man and not a representative object from Delacroix's oeuvre that received Fantin's homage, just as in the slightly later group portraits such as *The Atelier at the Batignolles* (1870, Paris: Musée d'Orsay) the painters and not the paintings declare themselves. The change shifts the target of admiration from the great temperament to a technical demonstration. Only Courbet's *Studio* offers a comparable insistence on the work of art, a landscape that acts as a metaphorical presentation of nature as the source of art (as well as a prophetic testimony to how Courbet would subsequently earn his livelihood). The location of Courbet's paintings like the people he imagines from his life to populate his studio are both private and fictive. As he wrote to Champfleury, "it is the moral and physical tale of my studio It is how I see society with its concerns and its passions; it is the world that comes to me to be painted."[31] Since still life was not a favored genre of the Nabis, at least not yet, and never of Denis, what in particular did the still life signify to them?—neither the world nor the personality. If Cézanne is here declared the "master of us all" what then, in 1900, was he the master of? In what way, after all, does the technique with which Denis executed his homage, correspond to, or engage in, the "lessons" of Cézanne?

In the fall of 1897 Denis was in Florence, intoxicated with Renaissance painting, and working on a portrait in the manner of Piero della Francesca. His return to the techniques of Renaissance painting and his repudiation of the flat, decorative manner announces a classicism quite at odds stylistically with Cézanne's project. The conversion to a monumental, if coloristically high-keyed, painting that rules his later work provided the ideological undertone to his *Hommage*. Denis admired Cézanne as a master, soon he would discern the "classical" qualities of Cézanne's art. But these were the judgments of the critic in Denis, not the artist. Because Denis's *Hommage*

no longer belongs to the private space of the studio, because it no longer testifies to a personal way of seeing things—the artist he admires practices an art almost wholly unlike his own—it located Cézanne within a larger, essential public defense of both the artist's commercial value and the aesthetic ambitions he might inspire. Cézanne *and* Vollard *and* the Nabis are all held up for public consumption and approval.

Between the *Hommage* and Cézanne's death in 1906, the definitions of classicism spiraled out simply to embrace the French modernist temperament. The rising nationalist rhetoric, which made all German art Gothic and expressionist, made French painting classic. What did it mean when on the occasion of the 1905 Salon d'Automne Mauclair called Manet classic and Ingres realist?[32] Such terms clearly were as much arguments about market shares as arguments about style; to be "classic" was to be placed beyond dispute. At best, the classical Cézanne signified another ideal: the equilibrium between naturalist observation or systems of working and subjective temperament. As Denis wrote in 1907:

> The art of Cézanne showed the way to substitute reflexion for empiricism without sacrificing the essential rôle of sensibility. Thus, for instance, instead of the chronometric notation of appearances, he was able to hold the emotion of the moment even while he elaborated almost to excess, in a calculated and intentional effort, his studies after nature.[33]

However clear Denis was in his own mind about the classical, in effect he presented classicism as the "just equilibrium between nature and style" [279]. This reconciliation of symbolist subjectivity and naturalist objectivity was a harmony of opposites that in reality was open to whatever set of artists and ideologies were convenient to the author/artist. If Cézanne was the single father to the post-1900 avant-gardes, he had innumerable sons, whose art often bore little resemblance to each other, from Denis, Bernard, and Vallotton's neoclassical figures (their new objectivity in classical guise) to Matisse and Derain, to Picasso and Braque. As Denis himself observed in 1909, Apollinaire was employing classicism to describe the proto-Cubist paintings of Braque.[34]

In the autumn of 1905, as "wild beasts" at the Salon d'Automne, the Fauves were caught between the discourse of "scientific" Neo-Impressionism, painting as a pre-established system with rules of procedure, and the discourse of temperament, read by opposing critics as the self-indulgent disregard for the rules of art, an opinion derived paradoxically from their pursuit of theory. Mauclair, for example, accused Matisse, Camoin, and others of confusing originality with excess.[35] Conversely, he con-

demned the Salon d'Automne generally for fostering "anti-virtuosity," an accusation that has as its standard the premium placed by the *juste milieu* on just such virtuosity.[36] Mauclair believed the artists of the Salon d'Automne made their paintings not according to the subjective, intuitive response by a great temperament to the stimuli of nature, but according to a pre-conceived plan, according to theory—even though the paintings themselves when considered stylistically gave every indication of spontaneity. The claims against anti-virtuosity would have been better directed against Denis' own "neoclassical" paintings, or comparable works by Bernard—now in his neoclassic stage, or Vallotton. That is, the same terms and the same cliches were directed at different targets, for not only was the new generation defined in 1905, but the old underwent fundamental redefinition: Mauclair's arguments about anti-virtuosity were as much targeted at Denis' and Vallotton's surfaceless neoclassicism as at the "excesses" of the Fauves.

Here is another defining paradox of the era: Denis and Bernard were politically more conservative than Mauclair, and more, not less nationalist in their rhetoric. When Zola published "J'Accuse" early in 1898 Denis wrote from Rome to Vuillard condemning the novelist, and more particularly, *La Revue blanche* for its support of Dreyfus.[37] Denis flirted with the views of the conservative philosopher Charles Maurras and his *Action française*, which since the Dreyfus affair had mobilized the French right against the perceived enemies of national disunity and cultural decadence in the name of the pre-Revolutionary monarchy, the Church, and the army. But they employed the classical to describe a post-naturalist, that is, Post-Impressionist painting. This seeming inversion of political and aesthetic positions is even more in evidence in a direct attack on Denis published by Mauclair in January 1905.[38] As a pro-Dreyfusard, Mauclair accused Denis of undue nationalist rhetoric, lumping him together with Peladan and Jacques-Émile Blanche, and as Denis himself wrote, "of conspiring against Modern Art."[39]

If Mauclair's political target was clear enough, what he meant by modern art is less certain, but it adheres to a concept of the great Impressionist individuals—a *juste milieu* celebration of transcendent temperaments passed down from the Impressionists to Roll, Besnard, and so on. His predecessors represent a litany of "republican" anti-academicians and the realists. Conversely, Denis' notion of modernity embraced Cézanne, van Gogh, Gauguin, and even Seurat within his compass, although with the caveat that their contribution to modern painting required further resolution in the Italian Renaissance tradition—which in this context is an inter-

nationalist argument compared to Mauclair's distinctly nationalist geneal-
ogy. As if to toss away the challenge proffered by Mauclair, in his review of
the Salon d'Automne, Denis wrote that "the influence of Whistler is
over."[40] And yet, finally, astonishingly, Denis held up Albert Besnard
against those who like Matisse suffer from an "excess of theory," arguing
that in 15 years some paintings of Besnard will have their place in the
museum while the work of these contemporary "novateurs" will have lost
their prestige [196]. Denis, like Meier-Graefe, could not take modernist
painting beyond the Nabis. He closed his review of Matisse therefore with
the admonition: "soyen objectifs!"[202].

Terms such as "temperament" and "originality," "systems" and "avant-
gardes," these code-words for post-1900 Parisian modernism, staked out
absolute positions which from our perspective are clearly relative and tran-
sitory, enflamed by the struggle over markets, over the claims to authen-
ticity and to identity that obsessed the era. These criteria were inevitably
elusive. Responding to the Fauves at the Salon d'Automne, Denis argued for
the real, but not too real, the decorative, but not the abstract, temperament,
but not the anarchic pursuit of originality, originality, but not the excesses
of theory brought on by too great an adherence to a system of art, avant-
garde but without sacrificing tradition.

I said the Fauves were caught between systems and temperaments, but I
should add that it was precisely because they occupied both terrains that
they succeeded so well, both as makers of *Sensationsbilder* for the excitement
of the Salon audience and among the *amateurs*. The Fauves, like the Impres-
sionists before them, were defined by the critics, perceived at once to repre-
sent something (system) that challenged the contemporary paradigm of art
(Impressionism). But they were also greeted, or at least worried about, as
temperaments. The respect accorded Matisse, even by critics such as Denis
who rejected his work, is striking. Additionally, the Fauves as a group
achieved their identity through an exhibition society, just as the Impres-
sionists before them. Significantly, Matisse was the president of the hanging
committee of the 1905 Indépendants and a leader among the organizers of
the Salon d'Automne. And as German art critics recognized, the Salon
d'Automne operated very much like a Secession; it had the same kind of
public visibility, the same claims to artistic independence, but also the same
official sanctions. Dealer involvement, too, was as essential to its retrospec-
tives as it was in Central Europe. Perhaps only in one area did the Salon
d'Automne differ significantly from the Secessions, and this more by degree
than by kind, and that was the dominance of the commercial galleries that
fed the Salon d'Automne, but also competed with it. Commercial retrospec-

tives of the Post-Impressionists—such as Seurat's in 1900—preceded those of the Salon d'Automne. Some artists, Picasso for instance, bypassed the public art exhibition altogether. This division between public and "private" exhibitions is most strikingly found in Cubism, or between what I would call public and private Cubism. Through the Salons artists such as Fernand Léger, the Duchamp brothers, Le Fauconnier, Albert Gleizes, Jean Metzinger, Robert and Sonia Delaunay, and many others, held the public stage, while everyone realized—at least outside of Paris—that it was at Kahnweiler's and in Picasso's and Braque's studios that the "pioneers" of Cubism were really to be found.[41]

The very fact that internal quarrels that opposed naturalist systems to classical temperaments soon became public quarrels indicates aesthetic modernism's newly won public visibility and centrality to the post-1900 Parisian art world. And if politics divided what was, after all, still a very small circle of modernist painters and critics, it did not prevent the artists from finding the same dealers to represent them. How characteristic it was that for all the much publicized quarrels, Denis would show in late November, early December 1904 at the newly established Galerie Druet, to be immediately followed by a show of that arch-anarchist and apostle of system, Paul Signac! No matter. There were exclusive contracts to sign and foreign clients waiting. Following the honored example of the Impressionists' success with their American and German patrons, the Fauves, the Nabis, and the Neo-Impressionists may not have won the hearts and minds of the vast majority of the Parisian art public, but there was no need.

LIVERPOOL JOHN MOORES UNIVERSITY
Aldham Robarts L.R.C.
TEL. 051 231 3701/3634

Appendix

This (undoubtedly partial) list of international art exhibitions begins in 1888, when Munich's annual exposition became a permanently international annual. After 1900 the number of international shows markedly droped off and only the most significant have been included.

Munich	1888	Internationale Kunstausstellung, Königl. Glaspalast
Amsterdam	1888	
Munich	1889	Internationale Kunstausstellung
Paris	1889	Exposition Universelle
Berlin	1891	Große Berliner Kunst-Ausstellung
Munich	1891	Jahresausstellung von Kunstwerken von aller Nationen
Stuttgart	1891	Die erste Internationale Gemälde-Ausstellung
Munich	1892	Internationale Kunstausstellung, Glaspalast
Chicago	1893	The Columbian Exposition
Munich	1893	Glaspalast and Secession
Antwerp	1894	Exposition Universelle
Brussels	1894	Exposition Internationale de Société des Beaux-Arts (held annually thereafter)
Hamburg	1894	
Munich	1894	Glaspalast and Secession
Vienna	1894	III. Internationalen Kunst-Ausstellung im Künstlerhaus
Berlin	1895	Große Berliner Kunstausstellung (henceforward international)
Hamburg	1895	
Munich	1895	Glaspalast and Secession
Venice	1895	Biennale
Budapest	1895–96	Winterausstellung
Berlin	1896	Internationale Jubiläums-Kunstausstellung
Munich	1896	Glaspalast and Secession
Pittsburgh	1896	The Pittsburgh International Exhibition of Contemporary Painting, Carnegie Institute (held annually thereafter)
Stuttgart	1896	Internationale Gemälde-Ausstellung
Vienna	1896	Jahresausstellung im Wiener Künstlerhause
Copenhagen	1897	Internationale Kunstudstilling
Dresden	1897	Internationale Kunstausstellung
Krefeld	1897	Internationale Kunstausstellung

Munich	1897	Glaspalast
Stockholm	1897	Allmänna Konst-och Industriutställingen
Venice	1897	Biennale
Barcelona	1898	Exposición internacional de arte
Krefeld	1898	Internationale Kunstausstellung
Munich	1898	Glaspalast
London	1898	First exhibition of International Society of Sculptors, Painters and Gravers
Vienna	1898	Jubeljahr Kunst-Ausstellung
Berlin	1899	Große Berliner Kunst-Ausstellung
Dresden	1899	Internationale Kunstausstellung
London	1899	International Society
Munich	1899	Glaspalast
Venice	1899	Biennale
St. Petersburg	1899	
Berlin	1900	Secession and Große Berliner Kunst-Ausstellung
Munich	1900	Glaspalast
Paris	1900	Exposition Universelle
Vienna	1900	
Berlin	1901	Secession and Große Berliner Kunst-Ausstellung
Buffalo	1901	Pan-American Exposition
Dresden	1901	4. Internationale Kunst-Ausstellung
Glasgow	1901	International Exhibition
Munich	1901	Glaspalast
Berlin	1902	Secession
Munich	1902	Glaspalast
Berlin	1903	Secession
Munich	1903	Glaspalast
Berlin	1904	Secession
Munich	1904	Glaspalast
St. Louis	1904	Louisiana Purchase Exposition

Notes

INTRODUCTION

1. See the exhibition catalogue, *Entwicklung des Impressionismus in Malerei und Plastik. XVI. Ausstellung der Vereinigung bildender Künstler Oesterreichs* (Vienna: Secession, 17 January-3 February 1903). See also Ludwig Hevesi, "Sezession. Eine Ausstellung des Impressionismus," "Edouard Manet und seine Leute," and "Die Nach-Impressionisten," reprinted in *Acht Jahre Sezession (März 1897-Juni 1905) Kritik-Polemik-Chronik* (Vienna: Carl Konegen, 1906), 404–17, and H. [Emil Heilbut], "Die Impressionistenausstellung der Wiener Secession," *Kunst und Künstler* 1 (February-March 1903): 169–207. Heilbut's essay appeared in expanded form as *Die Impressionisten* (Berlin: Bruno Cassirer, 1903).

2. Durand-Ruel probably purchased these paintings at the Choquet auction in 1899. See John Rewald, *Cézanne and America* (Princeton: Princeton University Press, 1989), 34 and note 7, 49–50.

3. J. Meier-Graefe, *Entwicklungsgeschichte der modernen Kunst* (Stuttgart: Julius Hoffmann, 1904). The book was translated into English under the title *Modern Art. Being a Contribution to a New System of Aesthetics* (London: W. Heinemann, 1908) and appeared in a second revised German edition (Munich: R. Piper, 1915), and in numerous subsequent editions. In the *Entwicklungsgeschichte* Meier-Graefe treated Impressionism as the latest, historically necessary development in the history of the "colorist," "Romantic" wing of Western art.

4. The phrase "genius of the future" was coined by Émile Zola and around which Anita Brookner casts her study of French art criticism since Diderot, *Genius of the Future* (London and New York: Phaidon, 1971).

5. The "rediscovery" of El Greco was sudden and yet was prepared for by scholarly work of some two decades. The reevaluation began in 1886 with an informal study by Manuel B. Cossío; his major monograph, however, only appeared in 1908. Even before Cossío's book reached press, El Grecos began to appear in international exhibitions. Meier-Graefe himself contributed substantially to the artist's reputation with his *Spanische Reise* (Berlin: B. Cassirer, 1910), in which he claimed El Greco to be superior to Velázquez. See Jonathan Brown, "El Greco, the Man and the Myths," in *El Greco of Toledo* (Boston: Little, Brown, and Co., 1982), 15–33, and Francis Haskell, *Rediscoveries in Art* (Ithaca: Cornell University Press, 1976), 175–77.

6. See, for example, E. M. Butler, *The Tyranny of Greece Over Germany* (Cambridge: Cambridge University Press, 1935).

7. J. Meier-Graefe, *Der Fall Böcklin und die Lehre von den Einheiten* (Stuttgart and Munich: J. Hoffmann and R. Piper, 1905).

8. This translation is by M.-A. von Lüttichau, "*Entartete Kunst*, Munich 1937," in *"Degenerate Art" The Fate of the Avant-Garde in Germany*, ed. Stephanie Barron (Los Angeles: Los Angeles County Museum of Art, 1991), 80.

9. R. Muther, *Die Geschichte der Malerei im XIX. Jahrhundert*, 3 vols. (Munich: G. Hirth, 1893–1894).

10. A typical example is an exhibition organized by the Kunstsalon Gurlitt in Berlin in 1889 which referred to Fritz von Uhde, Max Liebermann, and other prominent Berlin artists as *Hellmaler*, a Germanization of *plein air* painting. See Georg Voß, "(Berlin)," *Die Kunst für Alle* 4 (1 February 1889): 128. For a survey of the early German writing on "Hellmalerei," *plein air*, and *Impressionismus*, see Josef Kern, *Impressionismus im Wilhelminischen Deutschland* (Würzburg: Königshausen u. Neumann, 1989), app. 3, 383–443.

11. However, even in 1903 the Secession's chief critical apologist described this art in his review of the show as "Nach-Impressionismus." See L. Hevesi, "Die Nach-Impressionisten," in *Acht Jahre Sezession*, 412–17.

12. One need only refer to the virulent nationalism of the Italian Futurists or to the racial nationalism espoused in the Cubist polemics of Jean Metzinger and Albert Gleizes.

13. See, for example, Evelyn Gutbrod, *Die Rezeption des Impressionismus in Deutschland 1880–1910* (Stuttgart: W. Kohlhammer, 1980); Dominik Bartmann, *Anton von Werner* (Berlin: Deutscher Verlag für Kunstwissenschaft, 1984); Lukas Gloor, *Von Böcklin zu Cézanne. Die Rezeption des französischen Impressionismus in der deutschen Schweiz* (Bern, Frankfurt a. M.: Peter Lang, 1986); and Nicolaas Teeuwisse, *Vom Salon zur Secession* (Berlin: Deutscher Verlag für Kunstwissenschaft, 1986). See also the special issue, "Sammler der Frühen Moderne in Berlin," *Zeitschrift des deutschen Vereins für Kunstwissenschaft* 42:3 (1988).

14. I am guilty here of creating a greater Germany, for the Central European art world I describe, and for which I tend to use "Germany" and "Central Europe" interchangeably, had three centers of gravity—Berlin, Munich, and Vienna—and a constellation of lesser, but still important cities.

15. Other countries, like Russia and Switzerland, played important, but secondary roles in the international expansion of the modernist art market. Their patterns of promoting and collecting modernist art tend to parallel, rather than to be in advance of the Germans.

16. P. Bourdieu, *Outline of a Theory of Practice*, trans. Richard Nice (Cambridge and N.Y.: Cambridge University Press, 1977), 72ff.

17. R. Jensen, "The Avant-Garde and the Trade in Art," *Art Journal* 47 (Winter 1988): 360–67.

18. See P. Bürger, *Theory of the Avant-Garde*, trans. Michael Shaw (Minneapolis: University of Minnesota Press, 1984). I agree, however, with Bürger's general principal which distinguishes "aesthetic modernism" from avant-gardism as legitimately different historical entities.

19. I explored this thesis in "Selling Martyrdom," *Art in America* 80 (April 1992): 138–45, 175.

20. N. Broude, ed., *World Impressionism* (New York: Abrams, 1990), 10.

21. L. Corinth, *Selbstbiographie* (Leipzig: J. Hirzel, 1926), 89.

22. Meier-Graefe, *Entwicklungsgeschichte* (1915), 2:324. This translation is by Kenworth Moffett, *Meier-Graefe as Art Critic* (Munich: Prestel, 1973), 137.

23. R. Fry, "J. S. Sargent," reprinted in *Transformations* (Garden City, N.Y.: Doubleday, 1956), 170.

24. S. Cheney, *A Primer of Modern Art* (New York: Boni & Liveright, 1924), 3.

25. Art & Language, "Blue Poles," *Art-Language* 5 (March 1985): 40.

26. M. Pleynet, *Painting and System*, trans. Sima N. Godfrey (Chicago: University of Chicago Press, 1984), 7.

27. Ibid., 13.

28. T. de Duve, *Pictorial Nominalism. On Marcel Duchamp's Passage from Painting to the Readymade*, trans. Dana Polan (Minneapolis: University of Minnesota Press, 1991), 66.

CHAPTER 1

1. T. Duret, *Les Peintres Impressionnistes Claude Monet, Sisley, C. Pissarro, Renoir, Berthe Morisot* (Paris: H. Heymann and J. Perois, 1878), reprinted in *Les Ecrivains devant l'impressionnisme*, ed. Denys Riout (Paris: Macula, 1989), 210–29. The brochure was also reprinted with notable changes in *Critique d'Avant-Garde* (Paris: G. Charpentier, 1885), 57–89. The figure of the art of the future (traced in French criticism from Diderot to Huysmans) is the subject of Anita Brookner's *The Genius of the Future* (London and New York: Phaidon, 1971). For a largely uncritical survey of Duret's commercial activities, see Anne Distel, *Impressionism: The First Collectors* (New York: Abrams, 1990), 57–71.

2. *Les Écrivains devant l'impressionnisme*, 211–12.

3. Duret's introduction to the Manet auction catalogue is reprinted in his *Critique d'Avant-Garde*, 125–28.

4. This subject has been explored at length by Patricia Mainardi, *The End of the Salon* (Cambridge: University of Cambridge Press, 1993).

5. My translation is taken from the French version of the Dutch exhibition catalogue reprinted by the reviewer H. V., "L'Exposition Van Gogh in Amsterdam," *L'Art moderne* 13 (1 January 1893): 12–13.

6. F. J. Mather, *Modern Painting. A Study of Tendencies* (New York: Henry Holt, 1927), 114–15.

7. Bouguereau's interview was published in the newspaper *L'Eclair* (9 May 1891), cited in translation by Louise d'Argencourt, "Bouguereau and the Art Market in France," in *William Bouguereau 1825–1905* (Montreal: Museum of Fine Arts, 1984). I also owe the following account of Bouguereau's market to d'Argencourt's essay and to Robert Isaacson, "Collecting Bouguereau in England and America," from the same exhibition catalogue as well as his *William-Adolphe Bouguereau* (New York: The New York Cultural Center, 1975).

8. P. G. Hamerton, *Painting in France after the Decline of Classicism* (Boston: Roberts Brothers, 1895), 16–18.

9. Duret, *Les Peintres Impressionnistes*, 212.

10. Ibid., 224.

11. This translation is from R. Muther, *The History of Modern Painting*, trans. Ernest Dowson, George Greene, and Arthur Hillier (London: Henry & Co., 1895), 1:415–16. All subsequent page references and translations are from this edition. It is a generally faithful translation, although the English version is more profusely illustrated, and while reprinting many of the illustrations in the German edition, many are missing, supplemented by others.

12. The modernist artist is a professional in the same sense as a doctor or a lawyer in nineteenth-century terms by being "a producer of special services (who) sought to constitute *and control* a market for their expertise." On nineteenth-century professions and professionalization, see Magali Sarfatti Larson, *The Rise of Professionalism. A Sociological Analysis* (Berkeley and Los Angeles: University of California Press, 1977).

13. For an analysis of the new audiences for art generated by the Salon, see Thomas Crow, *Painters and Public Life* (New Haven and London: Yale University Press, 1985).

14. Hamerton's review of the Salon of 1863 and the accompanying Salon des Refusés extolled the ideal character of both institutions. He believed that the "refusés" ought to be permanently institutionalized, for in his words, "every picture refused by the jury may also be published, if the artist desires it, in an exhibition close to the Salon, and as well lighted, being separated from the Salon only as the different rooms of the Salon itself are separated from each other. The real separation is that of honour, not locality, nor even notoriety. A rejected picture enjoys precisely the same publicity as an accepted one." See P. G. Hamerton, "The Salon of 1863," *The Fine Arts Quarterly Review* 1 (October 1863): 225–62.

15. On the history of the Academy, see Henri Delaborde, *L'Académie des Beaux-Arts depuis la fondation de L'Institut de France* (Paris: Plon, 1891).

16. The most accessible account of the academic system of rewards, etc., is Clara H. Stranahan, *A History of French Painting* (New York: Charles Scribner's Sons, 1888). See also Jacques Lethève, *Daily Life of French Artists in the Nineteenth Century*, trans. H. Paddon (New York: Praeger, 1972) and Lois Marie Fink, *American Art at the Nineteenth-Century Paris Salons* (New York and Washington: National Museum of American Art and Cambridge University Press, 1990).

17. G. Semper, "Wissenschaft, Industrie, und Kunst," first published in 1852, reprinted in *The Four Elements of Architecture and Other Writings*, trans. H. F. Mallgrave and W. Herrmann (Cambridge: Cambridge University Press, 1989), 130–67.

18. G. Reitlinger, *The Economics of Taste* (London: Barrie and Rockliff, 1961), 1:175–206.

19. For a useful account of the Paris Salon artists and their studios, see John Milner, *The Studios of Paris* (New Haven and London: Yale University Press, 1988).

20. On the dominance of these academicians, see Milner, *The Studios of Paris*, 9–11.

21. See Maurice Hamel, "Société Nationale des Beaux-Arts," "Société des Artistes Francais," "Les Salons de 1914. La Sculpture," *Les Arts* 148–150 (April, May, June 1914): 1–13, 17–32, 1–13.

22. For a brief biography of Manzi, see *Degas Letters*, ed. Marcel Guerin (Oxford: Bruno Cassirer, 1947), 266, note to letter #121.

23. A long extract of Delécluze's Salon is reprinted in translation in *The Art of All Nations, 1850–1873*, ed. Elizabeth Gilmore Holt (Garden City, New York: Anchor, 1981), 9. Nicos Hadjinicolaou has pointed to the persistence of this attitude in Delécluze's criticism since the beginning of the 1830s in his "Art in a Period of Social Upheaval. French Art Criticism and Problems of Change in 1831," *Oxford Art Journal* 6 (1984): 29–37. Hadjinicolaou's article and the other published excerpt from his dissertation, "The Status of the Artist in France During the First Half of the 19th Century," *Block* 9 (November 1983), confirm the stability of this negative criticism and the continued ability of the critic to seek positive appraisals of art and artists in a situation he tells the reader is overwhelmingly decayed.

24. Delécluze, *Salon de 1850*, 10.

25. The literature on either the Art-Unions or the central European *Kunstvereine* is small. Two useful sources are Maybelle Mann, *The American Art-Union* (Washington: Collage, Inc., 1977) and York Langenstein, *Der Münchner Kunstverein im 19. Jahrhundert* (Munich: Kommissionsverlag UNI, 1983). Perhaps the study that takes the widest perspective on the Art-Unions, yet is confined to America, is Neil Harris, *The Artist in American Society* (New York: George Braziller, 1966).

26. Taylor was also instrumental in founding four other "self-help" societies, over which he presided for nineteen years: l'Association des artistes dramatiques (1840); Artistes musiciens (1843); Inventeurs et artistes industriels (1849); and Membres de l'enseignement (1859). See É. Maingot, *Le Baron Taylor* (Paris: E. De Bocaerd, 1963) and J. Plazaola, *Le Baron Taylor* (Paris: Fondation Taylor, 1989).

27. For a brief description of the history and organization of the Bazar Bonne-Nouvelle exhibition, see *The Triumph of Art for the Public*, ed. Elizabeth G. Holt (Garden City, New York: Anchor, 1979), 448–53. Baron Taylor's choice of the Bonne-Nouvelle was probably inspired by the earlier success there of the Galerie Artistique, which had operated "une salle ouverte," a kind of "refusé" in 1843. According to William Hauptmann, "Juries, Protests, and Counter-Exhibitions Before 1850," *Art Bulletin* (March 1985): 95–109, esp. 105–6 and note 106, it was "an enormously popular gallery," that had been famous also for an 1842 exhibition of Raphael paintings.

28. L. Rosenthal, *Du Romantisme au Réalisme* (Paris, 1914); repr. ed., intro. Michael Marrinan (Paris: Macula, 1987), 39.

29. See, for example, Edmond and Jules de Goncourt's *La Peinture à l'Exposition de 1855* (Paris, 1855). Excerpted and reprinted in translation in Holt, ed., *The Art of All Nations*, 132–43. The Goncourts concluded that landscape painting had become the only living genre of the nineteenth century.

30. R. Eitelberger von Edelberg, *Briefe über die moderne Kunst Frankreiche bei*

Gelegenheit der Pariser Ausstellung 1855 (Vienna: Beurtheilungs-Commission, 1857). A partial translation may be found in Holt, ed., *The Art of All Nations*, 118–31, esp. 124–25.

31. J.-A.-D. Ingres, letter to the Commission Permanente des Beaux-Arts, reprinted in H. Lapausze, *Ingres, sa vie et son oeuvre* (Paris: G. Petit, 1911), 401–2. The English translation is from *Neoclassicism and Romanticism 1750–1850*, ed. Lorenz Eitner (Englewood Cliffs, New Jersey: Prentice-Hall, 1970), 2: 138.

32. Albert Boime regarded the actions of the 1850s as generally repressive, efforts to impose Imperial ideology on the art world. See his "The Teaching Reforms of 1863 and the Origins of Modernism in France," *Art Quarterly* 1 (Autumn 1977): 1–39.

33. This was part of a general systematization of the medal system. One could not receive the Legion of Honor until one had taken medals at every level of the system, i.e., the third, second, and first class medals. For an overview of Salon and instruction reform, see Stranahan, *History of French Painting*, 264–65 and 267.

34. In the decree of November 13, 1863, which Charles Blanc described as "une révolution dans le monde des arts," the École des Beaux-Arts was removed permanently from the control of the Academy and placed in the hands of the government. See Charles Blanc, *Ingres* (Paris: Jules Renouard, 1870), 208. The Academy no longer controlled the Prix de Rome, the prize for historical landscape was abolished, the eligibility for the Grand Prix was limited to 25 years and younger, the directorship of the École, elected by the faculty, was established, and the École itself was reorganized with the intent of improving the quality of instruction, and in one notable area, the creation of instruction in painting technique, extending the traditional course of Academic teaching.

35. A thorough history of the Académie Julian still needs to be written, but see Catherine Fehrer, *The Julian Academy. Paris 1868–1939* (New York: Shepherd Gallery, 1989).

36. See the discussion of the French reception of foreign artists in Fink, *American Art at the Nineteenth-Century Paris Salons.*

37. See Patricia Mainardi, "The Double Exhibition in Nineteenth-Century France," *Art Journal* 48 (Spring 1989): 23–28.

38. For the fiasco that was the first Triennial in 1883 see Mainardi, *The End of the Salon*, 91–118.

39. For the relationship of the great expositions to the development of French art in 1855 and 1867 see Patricia Mainardi, *Art and Politics of the Second Empire* (New Haven and London: Yale University Press, 1987). See also Elaine Wauquiez, "Académisme et modernité," in *Le Livre des expositions universelles 1851–1889* (Paris: Union Centrale des Arts Décoratifs, 1983), 245–56. For the institutional phenomenon, see Paul Greenhalgh, *Ephemeral Vistas: Expositions Universelles, Great Exhibitions and World's Fairs, 1851–1939* (Manchester: Manchester University Press, 1986). For the American use of the international fair, see Robert W. Rydell, *All the World's a Fair: Visions of Empire at American International Expositions, 1876–1916* (Chicago: University of Chicago Press, 1984).

40. L. d'Argencourt, "Bouguereau and the Art Market in France," describes not only the adjustment that Bouguereau made in his style under market pressures, but the character of his patronage, one which in fact can hardly be distinguished from the patronage of Barbizon painting.

41. Durand became Durand-Ruel upon his marriage to the daughter of his employer at the *papeterie* they owned on the rue Saint-Jacques. I will refer to the father as Durand and to the son as Durand-Ruel. See P. Durand-Ruel, "Mémoires," in *Les Archives de l'Impressionnisme*, ed. Lionello Venturi (Paris and New York: Durand-Ruel, 1939), 2:143–220.

42. D'Argencourt, "Bouguereau and the Art Market," 99–100. On Durand-Ruel's taste for Merle and the reshaping of Bouguereau, see Linda Whiteley, "Accounting for Tastes," *Oxford Art Journal* 2 (April 1979): 25–28.

43. D'Argencourt, "Bouguereau and the Art Market," 101.

44. On the early history of the American art dealers, see Harris, *The Artist in American Society*, 254–82.

45. See A. Boime, "Entrepreneurial Patronage in Nineteenth-Century France," in *Enterprise and Entrepreneurs in Nineteenth- and Twentieth-Century France*, ed. Edward Carter et al. (Baltimore and London: Johns Hopkins University Press, 1976), 331–50.

46. See Jeremy Maas, *Gambart, Prince of the Victorian Art World* (London: Barrie & Jenkins, 1975), upon which this discussion of Gambart is based.

47. In 1862, for example, Gambart commissioned three paintings on the theme "The Streets of London" from Frith. As part of the contract, Frith sold the copyright, the original sketches, all possible subsequent sketches in return for ten thousand pounds. See Frith, *My Autobiography and Reminiscences*, 7th ed. (London: Richard Bentley and Son, 1889), 227–28.

48. Rosenthal, *Du Romantisme au réalisme*, 25.

49. R. Fry, "The Artist in the Great State," in *Socialism and the Great State*, ed. H. G. Wells et al. (New York and London: Harper & Brothers, 1912), 249–72, esp. 254.

50. Michael Marrinan (note 28 above) points out, however, the immediate political context of Rosenthal's book, the general current of nationalism in the immediate pre-war era, which tended to nationalize (and de-Europeanize) his treatment of Romanticism.

51. On the problem of the relationship between political and artistic avant-gardism, see F. Haskell, "Art and the Language of Politics," *Journal of European Studies* 4 (1974): 215–32.

52. Quoted in A. Tabarant, *Manet et ses oeuvres* (Paris: Gallimard, 1947), 138.

53. P. Signac, unpublished manuscript written c. 1900 and excerpted in translation by Eugenia W. Herbert, *The Artist and Social Reform. France and Belgium, 1885–1898* (New Haven: Yale University Press, 1961), 190, note 38.

54. A considerable literature now exists on this subject. See especially Peter Paret, *The Berlin Secession* (Cambridge: Harvard University Press, 1980).

55. The attraction of the École de 1830 may have been heightened by the

contemporary preference in older art for Dutch seventeenth-century painting and even for eighteenth-century French painting (that was not of the neo-classical variety) among the "entrepreneur-patrons" of mid-century France. See Boime, "Entrepreneurial Patronage," 142.

56. Edward Villiers, [untitled], *The Art Amateur* 10 (March 1884): 109.

57. N. Green, "Dealing in Temperaments: Economic Transformation of the Artistic Field in France during the Second Half of the Nineteenth Century," *Art History* 10 (March 1987): 59–78, esp., 70. The consumption of the Barbizon painters as natural temperaments was further articulated in Green's *The Spectacle of Nature: Landscape and Bourgeois Culture in Nineteenth Century France* (Manchester: Manchester University Press, 1990).

58. W. C. Brownell, "Whistler in Painting and Etching," *Scribner's Monthly* 18 (August 1879): 486–90, 493–95. The essay has been reprinted in Robin Spencer, ed., *Whistler. A Retrospective* (New York: Hugh Lauter Levin, 1989), 147–51, esp. 148–49.

59. On the artist's exhibition practices, see David Park Curry, "Total Control: Whistler at an Exhibition," *Studies in the History of Art* 19 (1987): 67–82, and R. Spencer, "Whistler's First One-Man Exhibition Reconstructed," in *The Documented Image*, ed. Gabriel P. Weisberg et al. (Syracuse: Syracuse University Press, 1987), 27–50.

60. In a letter dated 28 February 1883, Pissarro responded to his son's description of Whistler's 1883 exhibition at the Fine Arts Gallery of his Venetian etchings. "I should say that for the room white and yellow is a charming combination. The fact is that we ourselves made the first experiments in colors: the room in which I showed was lilac, bordered with canary yellow. But we poor little rejected painters lack the means to carry out our concepts of decoration. As for urging Durand-Ruel to hold an exhibition in a hall decorated by us, it would, I think, be wasted breath. You saw how I fought with him for white frames, and finally I had to abandon the idea." Reprinted in *Letters to His Son Lucien*, 3rd rev. ed., ed. Lucien Pissarro and John Rewald (Santa Barbara and Salt Lake City: Peregrine Smith, 1981), 5–6. In a letter to Lucien dated 24 April 1883, Pissarro noted that while Durand-Ruel showed his paintings in London in white frames, he would not do so in Paris, concluding that "Yes, Whistler is right, here is another convention which must be demolished" (12). See also Martha Ward, "Impressionist Installations and Private Exhibitions," *Art Bulletin* 73 (December 1991): 599–622, for a discussion of the differences between Whistler's and the Impressionists' exhibitions.

61. Curry in "Total Control," 81, note #29, cites a writer in the *British Times* (1 March 1883) who argued that Whistler's exhibitions were "not particularly original, for many of us have seen the same kind of idea carried out in houses of the nobility, but it is something quite new for a public art gallery."

62. Prior to Whistler's 1874 show, the artist probably collaborated with Charles Deschamps, who managed Durand-Ruel's London *Society of French Artists*, which since 1871 had occupied the rooms of the Old German Gallery, 168 Bond Street.

See Spencer, "Whistler's First One-Man Exhibition," 36–39. Deschamps' and Whistler's catalogues were similar in design; Whistler also had helped to arrange his pictures when shown at Deschamps'. And in 1873 Whistler showed with Durand-Ruel. The connection is an important one. Clearly Whistler learned from Durand-Ruel the value of a few well-placed, well-hung works of art. What Whistler may have taught Durand-Ruel in turn was the value of the overall exhibition environment, the attention to details from the artistically manufactured letters of invitation to the decoration of the walls.

63. For a reading of the general relationship between modernism and the exhibition locale, see Brian O'Doherty, *Inside the White Cube. The Ideology of the Gallery Space* (Santa Monica and San Francisco: Lapis Press, 1986). Martha Ward in "Impressionist Installations" argued that against the theoretical reductiveness that ascribes as a general condition of modernism its autonomy, the "autonomous" work of art arose from an ideological/political contest in the 1880s over where and how works of art were to be seen, a point that we have hardly begun to consider.

64. Anonymous, "The Grosvenor Gallery," *Magazine of Art* 1 (1878): 50–51.

65. H. Blackburn, "A 'Symphony' in Pall Mall," *Pictorial World* (13 June 1874), reprinted in Spencer, ed., *Whistler. A Retrospective*, 109–10.

66. Anonymous, "Art Gossip," *Lady's Pictorial* (24 February 1883), reprinted in Spencer, ed., *Whistler. A Retrospective*, 199–200.

67. See E. R. and J. Pennell, *The Life of James McNeill Whistler* (Philadelphia: J. B. Lippencott, 1908), 1:310. "The prints, fifty-one in number, included several London subjects. He decorated the gallery in a scheme of white and yellow. The wall was white with yellow hangings, the floor was covered with pale yellow matting and the couches with pale yellow serge. The few light, cane-bottomed chairs were painted yellow. There were yellow flowers in yellow pots, a white and yellow livery for the door attendant, and white and yellow Butterflies in paper and silk for his friends. It was remembered that, at the private view, Whistler wore yellow socks just showing now and then above his low shoes and that the young assistants wore yellow neckties. He prepared the catalogue, its brown paper cover, form and size now established, and after each title he printed a quotation from the critics in the past. 'Out of their own mouths shall ye judge them' was the motto on his title-page."

68. This passage comes from a slightly revised later edition of the Pennells' biography (London: William Heinemann, 1911), 218.

69. Anonymous [A Foreign Resident], "Actors, Actresses, Etc. in Society," reprinted in *Society in London*, third ed. (London: Chatto and Windus, 1885), 315–17.

70. Ibid.

71. Ibid.

72. W. Sickert, "Impressionism—True and False," *The Pall Mall Gazette* (2 February 1889), reprinted in Spencer, ed., *Whistler. A Retrospective*, 256–57.

73. See Colleen Denney, "Exhibition Reforms and Systems: The Grosvenor Gallery, 1877–1890" (Ph.D. diss., University of Minnesota, 1990). However, I disagree with her characterization of the Grosvenor as an "avant-garde" or even

essentially modernist institution. See also Michele Archambault, "The Grosvenor Gallery, 1877–1890" (Ph.D. diss., Courtauld Institute of Art, London, 1978) and Barrie Bullen, "The Palace of Art: Sir Coutts Lindsay and the Grosvenor Gallery," *Apollo* 102 (1975): 352–57.

74. See, for example, J. Comyns Carr, "La Grosvenor Gallery," *L'Art* 3 (1877): 265–73.

75. Burne-Jones exhibited eight paintings at the Grosvenor in 1877 and continued to show there (with rare exceptions) throughout the 1880s. See *Memorials of Edward Burne-Jones (1868–1898)*, 4th ed., ed. George Burne-Jones (London: Macmillan and Co., 1912), 2:70ff.

76. Agnes D. Atkinson, "The Grosvenor Gallery," *The Portfolio* 8 (1877): 97–99.

77. Ruskin, incidentally, objected to the idea of hanging an artist's work together in one place, arguing that "it is unwise to exhibit in too close a sequence the monotony of their virtues, and the obstinacy of their faults." Quoted in Burne-Jones, ed., *Memorials*, 2:76–77.

78. H. James, "Picture Season in London, 1877," in *The Painter's Eye*, ed. J. L. Sweeney (London: Rupert Hart-Davis, 1955), 130–51, esp. 139. The review was originally published in *Galaxy* (August 1877).

79. See, for example, Théodore Duret, "Expositions de la Royal Academy et de la Grosvenor Gallery," *Gazette des beaux-arts* 23 (1881): 549–56.

80. Five francs admission, for example, is what Georges Petit charged visitors to his 1883 exhibition "100 Chef d'Oeuvres." See the letter from William Walters to George Lucas dated June 13, 1883, reprinted in *The Diary of George A. Lucas: An American Art Agent in Paris, 1857–1909*, ed. Lilian M. C. Randall (Princeton: Princeton University Press, 1979), 1:13. The one mark admission price was standard for exhibitions held by Paul Cassirer (among others) in Berlin after 1900. See also Ward, "Impressionist Installations."

81. On the rise of the museums, especially in France, see Daniel J. Sherman, *Worthy Monuments* (Cambridge: Harvard University Press, 1989) and for a discussion of the varied representations of art galleries, see Georg Friedrich Koch, *Die Kunstausstellung* (Berlin: Walter de Gruyter, 1967).

CHAPTER 2

1. See Haskell, "Art and the Language of Politics" (chap. 1, n. 51), 232.

2. H. and C. White, *Canvases and Careers* (New York: John Wiley and Sons, 1965).

3. Ibid., 94.

4. An essential, if general, discussion of the auction houses and the dealers is to be found in Green, "Dealing in Temperaments" (chap. 1, n. 57). For what the Hôtel Drouot was like in 1860 (in a typical comparison with the British form of auction), see René Gersaint, "Des Ventes publiques d'objets d'art, à Paris et à Londres,"

Gazette des beaux-arts 7 (15 September 1860): 362–66, which criticizes the French monopolistic system for encouraging undue expenses and favors the "free" English system, where anyone anywhere may hold an art auction, and for the reply (in defense of the French system), P. Burty, "Des Ventes publiques d'objets d'art, a Paris et a Londres," *Gazette des beaux-arts* 8 (15 October 1860): 92–100.

5. Durand-Ruel, "Mémoires" (chap. 1, n. 41), 163.

6. The first journal *La Revue internationale de l'art et de la curiosité* was founded in 1869 and was brought to an end by the outbreak of the Franco-Prussian War. The second, *L'Art dans les Deux Mondes*, was equally ephemeral, appearing only in 1891.

7. In addition to Durand-Ruel's "Mémoires," for the early history of the firm, see Whiteley, "Accounting for Tastes" (chap. 1, n. 42).

8. Durand-Ruel, "Mémoires," 164.

9. Théodore Rousseau, for example, even at the age of 49, that is, as late as 1861, had secured neither his fortune nor his reputation.

10. Étienne Moreau-Nélaton, *Millet raconté par lui-même* (Paris: Henri Laurens, 1921), 2:71–74, reproduces the contract and gives substantial information about the circumstances surrounding the agreement.

11. Ibid., 2:12. This information comes from Millet's letters to Sensier, dated 26 October and 3 November 1866. Moreau-Nélaton described the offer as a "mirage."

12. Durand-Ruel, "Mémoires," 165–66. The total yield of the Rousseau auction was 160,000 francs.

13. In 1872 Durand-Ruel bought at the Carlin auction Millet's *Parc à moutons au clair de lune* for 20,000 francs and sold it two months later for 40,000 francs. See the letters from Sensier to Millet (30 April and 12 July 1872) in Moreau-Nélaton, *Millet,* 3:85.

14. The last painting officially belonged to Sensier and was in his collection when auctioned following his death in 1877.

15. The figure of 5,000 pounds was given by Julia Cartwright, *Jean-François Millet* (London and New York: Sonnenschein and Macmillan, 1910), 362.

16. Durand-Ruel, "Mémoires," 184.

17. The timing of the Gavet exhibition was obviously intended to exploit the common jump in prices occasioned by the death of an artist. A few years before, Gavet had attempted to convince the painter to give him an exclusive contract for all the artist's pastels. And prior to the pastel auction, Gavet held an exhibition organized by Francis Petit, *Dessins de Millet provenant de la Collection de M. G. et Exposés au Profit de la Famille de l'Artiste*, in the dealer's gallery on the rue Saint-Georges, no. 7 (6 April-6 May 1875). The admission fees went to the family but not the sales receipts. See L. D., *L'Art* 1 (1875): 359 and 381.

18. L. Hevesi, *Altkunst-Neukunst Wien 1894–1908* (Vienna: Carl Konegen, 1909), 206.

19. K. E. Schmidt, "Der Pariser Herbstsalon," *Kunstchronik* 16 (4 November 1904): 54–58, esp. 55.

20. L. Venturi quotes from a short declaration by Durand-Ruel of his business principles published in the *Revue internationale de l'art et de la curiosité* (December 1869) in *Les Archives de l'Impressionnisme* (chap. 1, n. 41), 1:17–18.

21. For example, Durand-Ruel began his "Mémoires" by noting that "D'ailleurs dans la carrière commerciale de mes parents, comme dans la mienne, les questions d'argent ont toujours été négligées presque à l'excès. Nous avions d'autres préoccupations plus élevées et plus intéressantes, mais qui, mal heureusement, n'enrichissent pas" [145]. Durand-Ruel also thought it necessary to insist that his father, an employee of his mother in a stationary shop, did not marry her for her property, nor she for his business acumen, though these things they certainly had.

22. W. Dewhurst, *Impressionist Painting. Its Genesis and Development* (London: George Newnes, 1904), 34. This appraisal, interestingly, forced Dewhurst into a rather curious denial. He continued: "Certainly he speculated upon a large scale. . . . [On the occasion of the Manet lot purchases] the whole Impressionist camp went wild with joy under the mistaken idea that their millennium had arrived. They had many years to wait. Both the pictures and the capital were locked up for a considerable time. The public had yet to be educated and the few amateurs who bought Impressionist work could select examples in abundance from the artists' easels."

23. J. Elias, "Paul Durand-Ruel," *Kunst und Künstler* 10 (November 1911): 105–7, esp. 105.

24. Ibid.

25. A. Alexandre, "Durand-Ruel. Bild und Geschichte eines Kunsthändler," *Pan* 2 (16 November 1911): 115–122, esp. 115.

26. Katherine Cassatt to Alexander Cassatt (19 September 1881), in *Cassatt and Her Circle. Selected Letters*, ed. Nancy Mowell Mathews (New York: Cross River Press, 1984), 162–63.

27. Robert Cassatt to Alexander Cassatt (25 May 1883) in ibid., 166–67.

28. Robin Lenman, "Painters, Patronage and the Art Market in Germany 1850–1914," *Past and Present* 123 (May 1989): 109–40, relates Marc's "gleeful" account to Herwarth Walden of Hans Goltz being beaten up by a disgruntled American client as exemplary of Kandinsky's and Marc's attitudes toward Thannhauser, Brakl, and Goltz.

29. See, for example, in order of publication, François Daulte, *Auguste Renoir. Catalogue raisonné de l'oeuvre peint*. Vol. 1: *Figures 1860–1890* (Lausanne: Durand-Ruel, 1971); Daniel Wildenstein, *Claude Monet: Biographie et catalogue raisonné*, 4 vols (Paris and Lausanne: La Bibliothèque des arts, 1974–1985); Denis Rouart and Daniel Wildenstein, *Manet. Catalogue raisonné*, 2 vols (Paris: La Bibliothèque des arts, 1975); Robert Fernier, *La Vie et l'Oeuvre de Gustave Courbet*, 2 vols (Paris: La Bibliothèque des arts, 1977–1978); Marie Berhaut, *Caillebotte, sa vie et son oeuvre* (Paris: La Bibliothèque des arts, 1978).

30. H. v. Tschudi, *Edouard Manet* (Berlin: Bruno Cassirer, 1902).

31. Similarly, Durand-Ruel's collector/dealer friends such as the opera baritone

and collector, Jean-Baptiste Faure, assisted in providing loans for public exhibitions. See Anthea Callen, "Faure and Manet," *Gazette des beaux-arts* 83 (March 1974): 157–78, esp. 170–73. The dealer also recalled that when he fled to England during the Franco-Prussian war, he was able to set up shop not only with his own collection, but also with collections from friendly French *amateurs* such as Faure, Goldschmidt, "et quelques autres." Durand-Ruel, "Mémoires," 176.

32. G. Lecomte, *L'Art Impressionniste, d'après de collection privée de M. Durand-Ruel* (Paris: Chamerot et Renouard, 1892), 259–60. In a copy of Lecomte's book now in Doe Library, University of California, Berkeley, it was Durand-Ruel, not Lecomte, who autographed the book for a California client. No doubt the dealer not only paid for the book's production but used it to promote his collection (public and private) with clients.

33. *Baedeker's Paris und Umgebungen*, 15th rev. German ed. (Leipzig: Karl Baedeker, 1900), 258.

34. See Rouart and Wildenstein, *Manet, son vie et son oeuvres* 1:cat. nos. 122 and 231.

35. See Wildenstein, *Monet*, 2:cat. nos. 725, 1070, 1108, 1160, 1168, and 3:cat. nos. 1203 and 1266.

36. On Lucas' role in exporting the École de 1830 and Salon notables see *The Diary of George A. Lucas* (chap. 1, n. 80).

37. E. Zola, "Ébauche," for *L'Oeuvre*, reprinted in *Les Oeuvres Complètes*, vol. 31 (Paris: Bernourd, 1928), 409–17.

38. Ibid., 421.

39. A sociology of American patronage of European art has yet to be written. The most important books recently devoted to American collecting of European modernism have been notably uncritical on this point [e.g., Frances Weitzenhoffer, *The Havemeyers. Impressionism Comes to America* (New York: Abrams, 1986) and Rewald, *Cézanne and America* (intro., n. 2)].

40. On the Moreau-Nélaton and Camondo gifts to the Louvre, see R. Koechlin et al., "La donation Etienne Moreau-Nélaton," *Bulletin de la Société de l'histoire de l'art français* (1927): 118–52, and Musée National du Louvre, *Catalogue de la Collection Isaac de Camondo* (Paris, n. d.).

41. On Count Doria's collecting activities, see Distel, *Impressionism: The First Collectors* (chap. 1, n. 1), 171–74.

42. See the German account of this sale in *Die Kunst für Alle* 3 (1 March 1888): 174.

43. See *Die Kunst für Alle* 3 (1 April 1888): 210.

44. See, for example, Alfred de Lostalot, "Exposition internationale de Peinture, dans la galerie de M. Georges Petit," *Gazette des beaux-arts* 25 (June 1882): 602–7.

45. The catalogues for this society have been reprinted under the title *Expositions of Modern European Art* in the series *Modern Art in Paris*, ed. T. Reff (New York and London: Garland, 1981).

46. See, for example, the multiple records in *The Diary of George A. Lucas* of

Lucas' dealings with Madrazo, de Nittis, Bouguereau, Gérôme, and similar artists, in conjunction with or as an intermediary for Walters and Vanderbilt among others.

47. Monet to Durand-Ruel dated 23 December 1882 (letter no. 305), reprinted in Wildenstein, *Monet*, 2: 222.

48. On this exhibition, see Joel Isaacson, "The Painters Called Impressionists," in *The New Painting. Impressionism 1874–1886* (San Francisco: Fine Arts Museums of San Francisco, 1986), 373–93.

49. See the introduction to *Exposition internationale de peinture*, deuxième année (Paris: Galerie Georges Petit, 1883), in *Expositions of Modern European Art*.

50. M. Cassatt to Alexander Cassatt (14 October 1883), in *Cassatt and Her Circle*, 172–73.

51. See Monet's letter to Durand-Ruel (letter no. 170) in Wildenstein, *Monet*, 2:642.

52. For the critical response to Monet's exhibitions with Petit, see Steven Z. Levine, *Monet and His Critics* (New York and London: Garland, 1976), 62–66 and 75–88.

53. M. Ward, in her essay on the last "official" exhibition in 1886, "The Rhetoric of Independence and Innovation," in *The New Painting*, 421–42, remarks on the increasing inability of the Impressionists to project an image of ideological and commercial independence, but does not trace this situation into the events of the following year. Rewald, noting the absence of Degas from the Petit exhibition, still managed to say that "of the impressionist painters, only Monet, Renoir, Morisot and Pissarro were represented." See *Letters to His Son Lucien* (chap. 1, n. 60), 104, n. 1. And yet this "only" represented the vast majority of the canonical Impressionists. Clearly, the fact that it was neither sponsored by Durand-Ruel nor independent has caused its exclusion from the list of Impressionist exhibitions.

54. Letter to Lucien (14 April 1887) in *Letters To His Son Lucien*, 104.

55. On the history of Les XX, see Jane Block, *Les XX and Belgian Avant-Gardism 1868–1894* (Ann Arbor: UMI Research Press, 1984) and Madeleine Octave Maus, *Trente Années de lutte pour l'art* (Brussels: Librairie L'Oiseau Bleu, 1926).

56. Letter to Lucien (3 December 1886) in *Letters to His Son Lucien*, 82–83.

57. On the Swiss reception of French modernism, see Lukas Gloor, *Von Böcklin zu Cézanne. Die Rezeption des französischen Impressionismus in der deutschen Schweiz* (Bern, Frankfurt a.M.: Peter Lang, 1986).

58. This exhibition was reviewed in *Kunstchronik* 12 (31 January 1901): 220–21. See also the review of the first exhibition of the Neo-Impressionists at Keller & Reiner's in 1898: A.R. (Adolf Rosenberg) "Sammlungen und Ausstellungen," *Kunstchronik* 10 (8 December 1898): 57–58.

59. Letter dated 26 January 1901, reprinted in *Paula Modersohn-Becker, The Letters and Journals*, ed. Günter Busch and Liselotte von Reinken (New York: Taplinger, 1983), 237–38.

60. For an overview of the German art market, see Lenman, "Painters, Patronage and the Art Market."

61. See *Die Kunst für Alle* 15 (15 February 1900): 238.

62. For example, in the spring of 1900 the Kalckreuth exhibition was seen both at Dresden at the Emil Richter Kunstsalon in March and in Berlin at Bruno and Paul Cassirers in May. See *Die Kunst für Alle* 15 (15 April 1900): 331, and (1 June 1900): 404.

63. The Galerie L. Richard-Abenheimer in Frankfurt is a typical example of a gallery that had traditionally been devoted exclusively to antiquities and the occasional old picture, but which in this new commercial climate began to speculate in contemporary painting. In the fall of 1900 it exhibited a seascape by Boudin, a "Flachlandschaft" by Sisley, and an unindentifiable Monet. See *Die Kunst für Alle* 16 (15 February 1900): 238.

64. H. E. W., *Die Kunst für Alle* 16 (15 December 1900): 146. The review noted that although the gallery had existed since 1821, it had only just been modeled over into a modern art gallery, devoted to paintings and interior designs.

65. Ibid.

66. See Andrea Grösslein, *Die internationalen Kunstausstellungen der Münchner Künstlergenossenschaft im Glaspalast in München von 1869 bis 1888* (Munich: Stadtarchiv, 1987).

67. See Horst Ludwig, *Kunst, Geld und Politik um 1900 in München* (Berlin: Gebr. Mann, 1986) and R. Lenman, "Politics and Culture: The State and the Avant-Garde in Munich 1886–1914," in *Society and Politics in Wilhelmine Germany*, ed. Richard J. Evans (London: Croom Helm, 1978), 90–111. See also Peter Jelavich, *Munich and Theatrical Modernism* (Cambridge: Harvard University Press, 1985) and Maria Makela, *The Munich Secession* (Princeton: Princeton University Press, 1990).

68. H. Rosenhagen, "Münchens Niedergang als Kunststadt," *Der Tag* 143 (13 April 1901): 1–3, and 145 (14 April 1901): 1–2.

69. In the autumn of 1900 the Kunstsalon Jacques Caspar was added to the Berlin list. Caspar expanded his small publishing house to include the sale of contemporary art, particularly contemporary prints. See *Kunstchronik* 12 (29 November 1900): 105. In its first exhibition he showed everything from Reynolds to Corot to Ludwig von Hofmann. In 1902 the Kunstsalon Rabl was opened. See *Die Kunst für Alle* 18 (1 November 1902): 27.

70. See E. K[estner]., "Von Ausstellungen und Sammlungen," *Die Kunst für Alle* 15 (1 April 1900): 308.

71. See the unsigned review of the exhibition in *Die Kunst für Alle* 5 (1 June 1890): 271, which provides what is certainly a partial, but indicative list of the artists represented.

72. Paret, *The Berlin Secession* (chap. 1, n. 54), 16. Werner attempted to provide a real social safety net for artists taking the form of insurance and pension programs. And "as chairman of the national association and of the Verein Berliner Künstler, he was demonstratively antielitist. He believed in the rule of the majority, whose sound judgment—like that of the German people as a whole—might, he thought, occasionally be swayed in matters of art, but would always reassert itself."

73. Another reason for the late arrival of Secessionism in Berlin is that its art community, compared to Munich's, was small. Fewer artists competed not only at the Große Berliner Kunstausstellung, but also at the commercial galleries.

74. Besides Cassirer's own view on his career published under the title "Kunst und Kunsthandel" in *Pan* 1 (16 May 1911): 457–69, and (1 July 1911): 558–73, see the brief biography by Wolfgang Freiherr von Löhneysen, "Paul Cassirer— Beschreibung eines Phänomens," in *Imprimatur. Ein Jahrbuch für Bücherfreunde* 7 (1972): 153–80, and Peter Letkemann, Klaus P. Mader, and Günter Wollschlaeger, "Cassirer und Co. Ein Beitrag zur Berliner Kunst-und Kulturgeschichte," *Mitteilungen des Vereins für die Geschichte Berlins* 69 (January 1973): 233–44.

75. The commercial viability of English portraiture in Berlin was confirmed a few years later when Schulte collaborated with Sedelmeyer in Paris to show a large collection. See *Die Kunst für Alle* 18 (1 June 1903): 410, for a brief review. Moreover, in 1906 the Galerie Gurlitt held a large show of eighteenth- and nineteenth-century English landscapes. See *Die Kunst für Alle* 21 (1 February 1906): 209. In 1907 Cassirer came back with a large, if miscellaneous collection of English painting from Reynolds to Turner. See *Die Kunst für Alle* 22 (15 May 1907): 386–88.

76. See the reviews in *Die Kunst für Alle* 19 (15 December 1903): 151–52, and 23 (1 July 1908): 452–54.

77. On Cassirer's commercial activities on behalf on individual Secessionists, see Verena Tafel, "Paul Cassirer als Vermittler deutscher impressionistischer Kunst in Berlin. Zum Stand der Forschung," *Zeitschrift des deutschen Vereins für Kunstwissenschaft* 42:3 (1988): 31–46.

78. Wildenstein, *Monet*, 4:35, cites a letter from the Durand-Ruel archive (4 August 1902) addressed to the gallery Hermes & Co. in Frankfurt that states that "M. Cassirer est la correspondant de la galerie pour tout l'Allemagne." The Durand-Ruel archive preserves an extensive correspondence between the two firms during these years.

79. The cited exhibitions were reviewed in *Die Kunst für Alle* 17 (1 December 1901): 115–16; 19 (15 April 1904): 237–41; 21 (1 March 1906): 257–58; and 22 (1 November 1906): 72.

80. This collection of twelve paintings all belonged to Durand-Ruel. On this show see Rewald, *Cézanne and America*, 49–50, 37 n.7.

81. For a complete discussion of the van Gogh-Cassirer relationship and exhibition history, see Walter Feilchenfeldt, *Vincent van Gogh & Paul Cassirer, Berlin: the reception of van Gogh in Germany from 1901 to 1914* (Zwolle: Cahier Vincent, 1988). See also Ron Manheim's review of the book in *Jong Holland* 5 (1989): 32–37, and his "The 'Germanic' van Gogh: a case study of cultural annexation," *Simiolus* 19:4 (1989): 277–88.

82. The watercolor show must have been composed of many works from the exhibition held in Paris at Bernheim Jeune (17–29 June 1907). For a list of works, see Donald E. Gordon, *Modern Art Exhibitions* (Munich: Prestel, 1974), 2:218–19.

83. J. Laforgue, "Impressionismus," *Kunst und Künstler* 3 (September 1905): 501–6.

84. H. Matisse, "Notizen eines Malers," *Kunst und Künstler* 7 (May 1909): 335–47.

85. h.r. (Hans Rosenhagen), "Ausstellungen und Sammlungen," *Die Kunst für Alle* 17 (1 July 1902): 450.

86. See Tafel, "Paul Cassirer als Vermittler."

87. P. Drey, *Der Kunstmarkt: Eine Studie über die wirtschaftliche Verwertung des Bildes* (Stuttgart: Union Deutsche Verlagsgesellschaft, 1910) and H. Floerke, *Studien zur niederländischen Kunst- und Kulturgeschichte* (Munich and Leipzig: Georg Müller, 1905), esp. 85–119.

88. C. Vinnen, *Ein Protest deutscher Künstler* (Jena: Eugen Diederichs, 1911).

89. See note 74 above.

90. The conversion between francs and marks is inevitably imprecise. My calculations are based on the money table published as the frontispiece to *Baedeker's Northern Germany* (Leipzig: Karl Baedeker, 1910).

91. Galerie Heinemann, *Manet-Monet Ausstellung* (January 1907). The annotated catalogue belongs to the library of the Zentralinstitut für Kunstgeschichte, Munich.

92. See, for example, Meier-Graefe's celebratory appendix, "Manet auf dem Kunstmarkt," in *Edouard Manet* (Munich: Piper, 1912), 310 ff.

CHAPTER 3

1. *Im Kampf um die Kunst. Die Antwort auf den Protest deutscher Künstler* (Munich: R. Piper, 1911).

2. For a useful critique, see F. Orton and G. Pollock, "Les Données Bretonnantes: La Prairie de Répresentation," *Art History* 3 (September 1980): 317.

3. The Duret letter to Pissaro is quoted in translation in John Rewald, *The History of Impressionism*, 4th rev. ed. (New York: Museum of Modern Art, 1973), 310. The original letter is in Lionello Venturi and Ludovic Rudolphe Pissarro, eds., *Pissarro, son art, son oeuvre* (Paris: P. Rosenberg, 1939), 1:33–34.

4. This is Rewald's view in *The History of Impressionism*, 311, and also Durand-Ruel's testimony in his "Mémoires" (chap. 1, n. 41), 197–99.

5. On Durand-Ruel's increasing interest in and control of Courbet's market, see Anne Wagner, "Courbet's Landscape Paintings and Their Market," *Art History* 4 (December 1981): 410–31. From 1871 onward Durand-Ruel was Courbet's principal agent, holding for the artist the most important paintings not already in private collections. Among them were the *The Artist's Studio* (Musée du Louvre, Paris) and the *Burial at Ornans* (Musée du Louvre). Durand-Ruel arranged to send these and many other Courbets to the 1873 Vienna World's Fair as part of the French contingent. See Durand-Ruel, "Mémoires," 186.

6. Durand-Ruel, "Mémoires," 189–97.

7. These figures are presented by Ralph Shikes and Paula Harper, *Pissarro, His Life and Works* (New York: Horizon Press, 1980), 103–37.

8. Durand-Ruel, "Mémoires," 178–79.

9. E. Manet to Berthe Morisot, reprinted in *The Correspondence of Berthe Morisot*, ed. Denis Rouart and trans. B. Hubbard (New York: George Wittenborn, 1957), 81.

10. See *The Diary of George A. Lucas* (chap. 1, n. 80), 2:265, for the entry dated 1 April 1868 where Avery's offer and refusal was noted. See also the slightly later purchase by Lucas of a Rousseau drawing at an auction of the artist's work mediated by Petit (27 April 1868), 2:267.

10. E. Manet to Berthe Morisot, reprinted in *The Correspondence of Berthe Morisot*, ed. Denis Rouart and trans. B. Hubbard (New York: George Wittenborn, 1957), 81.

11. A similar case was made by Paul Tucker, "The First Impressionist Exhibition in Context," in *The New Painting. Impressionism 1874–1886* (chap. 2, n. 48), 93–117, who argued from Pissarro's perspective that the artist realized that he and his friends had achieved "some financial stability" and "could see a market developing outside the official realm."

12. International relationships, whether artistic or institutional, have never been properly studied and here is no exception. But see Marcia Pointen's enlightening essay, "'Voisins et Alliés': The French Critics' View of the English Contribution to the Beaux-Arts Section of the Exposition Universelle in 1855," in *Saloni, Gallerie, Musei e Loro Influenza sullo Suiluppo dell'Arte dei Secoli XIX e XX*, ed. F. Haskell (Bologna: Editrice CLUEB, 1979), 115–22. Pointen argues that the fact that the British contributions were largely from private collections while the French were owned by the state or more frequently, by the artists themselves meant that French critics were unable to face the fact that the English system was more successful than the French.

13. See, for example, Hamerton, "The Salon of 1863" (chap. 1, n. 14), 228.

14. I owe this citation to Jon Whiteley, "Exhibitions of Contemporary Painting in London and Paris, 1760–1860," in *Saloni, Gallerie, Musei*, 69–87, esp. 69, where he quotes the critic C. Lenorment, *Les Artistes Contemporains*, vol. 1 (Paris, 1833), 187.

15. See Lorne Huston, "Le Salon et les expositions d'art: réflexions à partier de l'expérience de Louis Martinet (1861–1865)," *Gazette des beaux-arts* 116 (July-August 1990): 45–50. See also the brief biography of Martinet in *The Art of All Nations* (chap. 1, n. 23), 378–84; Thieme-Becker, *Lexicon des Künstlers* 24 (1930), 167, and *Chronique des arts* (1895): 16, for an obituary. Martinet's business was located at 26 boulevard des Italiens in the vast rooms belonging to Richard Wallace, the marquess of Hertford. Wallace was renowned for his love of eighteenth-century French painting and decorative arts. He also served as a juror for the 1855 Exposition Universelle. For a discussion of Wallace and his collection, see the Wallace Collection Catalogues, *Pictures and Drawings* (London, 1928), esp. xii-xvi. The

stature of Martinet's enterprise is reflected in an observation made by Hamerton in 1863 (chap. 1, n. 14): "There are only two regular exhibitions in Paris, one called the Salon, hitherto biennial, but henceforth to be annual, and a permanent exhibition on the Boulevard des Italiens, where the pictures are constantly changing, so as to induce the same visitors to go there about once a month" [227–28].

16. Martinet was a practicing artist (he exhibited in the Salons as late as 1882) who became by chance well-placed in society as a result of an incident during the 1848 Revolution, when as a lieutenant in the National Guard he rescued the duchesse d'Orleans, the comte de Paris, and the duc de Nemours. Constant patronage followed. Under the Second Empire he was given a job in the Ministry of Beaux-Arts, organized Parisian fêtes, and participated in the organization of the Exposition Universelle in 1855. In 1860, he was an "Inspecteur des beaux-arts." To open his gallery he had to obtain permission from his minister, the comte Walewski.

17. Delacroix was the special beneficiary and emblematic figure of Martinet's exhibitions, sparking the enthusiasm of young artists such as Monet (in response to the show of eighteen paintings by the artist in the 1860 exhibition) and critics such as Baudelaire—see his celebration of the *Death of Sardanapalus* (Musée du Louvre) exhibited at Martinet's in 1862. See Monet to Boudin, 20 February [1860], in Wildenstein, *Monet*, 1:419–20, and C. Baudelaire, [Exposition Martinet], *Revue Anecdotique* (January 1862), reprinted in *Écrits esthétiques* (Paris: Union Générale d'Éditions, 1986), 409–11. See also the exhibition catalogue for Martinet's show in the summer of 1860, *Tableaux de l'École Française Ancienne, tirés de collections d'amateurs*. The show contained over 100 drawings and over 200 paintings, primarily loans from wealthy collectors. Among the extraordinary paintings in the collection were Claude Lorrain's *Le Matin* from the Rothschild collection, Louis LeNain's *Les Buveurs* from the La Caze collection, and nine Watteaus, including *Le Rendez-Vous de chasse* from the de Morney collection, *Giles* (La Caze), and *L'Amour badin* (Wallace collection). The significance of this exhibition is discussed by Haskell, *Rediscoveries in Art* (intro., n. 5), 165–66 and 209 n.40.

18. Burty wrote the catalogue for the 1860 exhibition of French masters. A recent addition as the sales and auctions editor to the staff of the *Gazette des beaux-arts*, Burty perhaps as no other nineteenth-century critic was to work in service of the art market, combining the qualities of art expert, critic, and entrepreneur. His catalogue was no ordinary affair. As Charles Blanc noted in an unusual, perhaps unprecedented review of an exhibition catalogue ("Catalogue des tableaux de l'Ecole Française, tirés de collections d'amateurs par Ph. Burty," *Gazette des beaux-arts* 8 [October 1860]: 61–62), "the catalogue was an innovation in its genre." Gone, according to Blanc, were the "dry nomenclatures of the masters and a vague indication of the subjects." In its place Burty wrote a descriptive catalogue that placed each work with "its certificates of origin, its passport of voyage through the collections and sales," authenticated by "illustrious amateurs and serious experts." In short, Burty began the practice of placing provenances into exhibition catalogues (at least insofar as Blanc was aware), making the catalogue a scholarly document. The cata-

logue, moreover, closely resembled the kind of catalogues that only a few years before had begun to be written about museum collections, as, for example, the collection of London's National Gallery. The National Gallery celebrated its new home on Trafalgar Square (finished in 1838) with an elaborate illustrated guide: *The National Gallery of Pictures by the Great Masters* (London, 1840). Each illustration was accompanied by a biographical, and often surprisingly critical, catalogue entry that also gave the donor or the purchase source and the size of the picture. Otherwise no provenances were generally given unless the painting came from some famous source such as the Borghese Gallery. This in turn provided the basis for such museum guides as Felix Summerly's [Henry Cole] *Hand-Book for the National Gallery* (London: George Bell, 1843). This edition was illustrated with woodcuts by the famous Linnell family; the accompanying descriptions were historical, anecdotal, and frequently included provenances that often provided prices various collectors (as well as the National Gallery) had paid for the work. But since the Martinet exhibition was not a museum collection, such a catalogue would also serve to certify the exhibited paintings for the marketplace, should they once again find themselves there (as many did).

19. Only one of these has been substantially documented, Cadart's "Société des aquafortistes." See Janine Bailly-Herzberg, *L'Eau-forte de peintre au xix siècle. La Société des aquafortistes, 1862, 1867* (Paris: L. Laget, 1972).

20. On the Cercle de l'union artistique, see Charles Yriarte, *Les Cercles de Paris* (Paris: Dupray de La Mahéne, 1864), 215–48. For the rise of "Cercles" or elite men's clubs in France, see Maurice Agulhon, *Le Cercle dans la France bourgeoise: 1810–1848* (Paris: A. Colin, 1977).

21. T. Rousseau to Théophile Gautier (4 February 1864), first published in Alfred Sensier, *Souvenirs de Th. Rousseau* (Paris: Durand-Ruel, 1872), 298, and recently reprinted under the title *Lettre à Théophile Gautier* (Caen: L'Échoppe, 1989).

22. Sensier, *Souvenirs de Th. Rousseau*, 301. Ironically, Rousseau's ambition, as seen through the eyes of Sensier, might almost have been the statement of the later program of Paul Durand-Ruel. Sensier's interpretation of Rousseau's denunciation had to have been colored by Sensier's own position, as a collaborator of Durand-Ruel's, as an *amateur*, and as a small dealer in his own right. (His essay on Rousseau was first published in Durand-Ruel's journal and then later published as a book, again under the aegis of the dealer.) Sensier had acquired a very considerable collection of Barbizon painting which he would sell to Durand-Ruel in the 1870s. The dealer would have drawn the same distinctions as Sensier, and like Sensier he must have shared the same conviction about the function of the artist and his relationship to the commercial gallery: that there could be purity in exhibiting and propagating a "doctrine" that would not subvert the dignity of art and that could be kept separate from commerce, without limiting commerce. The problem was to find the proper form.

23. E. Bazire, *Manet* (Paris: A. Quentin, 1884), 35.

24. E. Chesneau review published in *L'Artiste* (15 February 1863) and reprinted in translation in *The Art of All Nations* (chap. 1, n. 23), 385.

25. Albert Boime, "The Salon des Refusés and the Evolution of Modern Art," *Art Quarterly* 32 (Winter 1969): 411–26, argued that the Salon des Refusés was the institutional origin of the Impressionist exhibitions, but I believe that this view overlooks their fundamental difference: the exclusive Impressionist shows versus the inclusive *refusés*. Artists jurying artists without *parti pris* and with a sense of exclusive quality: this was the ideal for an independent exhibition society, which, of course, no group ever managed to live up to. For a convincing rebuttal to Boime, see J.-P. Bouillon, "Sociétés d'artistes et institutions officielles dans la seconde moitié du XIXe siècle," *Romantisme* 54 (1986): 89–113.

26. Émile Zola, *The Masterpiece*, trans. Katherine Woods (New York: Howell and Soskin, 1946), 160.

27. On the mythic dichotomy between the individual and the crowd in Zola's novels, see Naomi Schor, *Zola's Crowds* (Baltimore: Johns Hopkins University Press, 1978).

28. The rules of the society were published under the heading of the statutes of the Société Anonyme Coopérative, in *Chronique des arts et de la curiosité* (17 January 1874). No doubt motivated by his "socialist belief in smaller collectives," Pissarro played an instrumental role in establishing the structure of the Société anonyme, which he based on a baker's union in his native town of Pontoise. The Société anonyme was to have a life of ten years. Its exhibitions would be jury-free and without recompenses, devoted exclusively to the sale of works. And it declared the intention to found an art journal. The ambitions of its artists were clearly stated by the uniformly high prices they asked for their work (compared to what they had been getting). See Tucker, "The First Impressionist Exhibition," 106.

29. See Pissarro's letter to Fénéon (8 September 1886) in *Correspondance de Camille Pissarro 1886–1890*, vol. 2, ed. Janine Bailly-Herzberg (Paris: Editions du Valhermeil, 1986), 67–68, letter 350. See also Joan Halperin's discussion of this exchange in *Félix Fénéon, oeuvres plus que complètes*, 2 vols. (Geneva: Droz, 1970), esp. 1:xv.

30. For example, Muther in *Die Geschichte der Malerei im XIX. Jahrhundert* had the Impressionists' first exhibition in 1871.

31. See Carol Armstrong, *Odd Man Out* (Chicago: University of Chicago Press, 1991), esp. chapter one, "Degas, the Odd Man Out: The Impressionist Exhibitions," 21–72, for a nuanced reading of Degas' resistance to commercialism both in the domain of the Salon and the Impressionist exhibitions, and his idiosyncratic take on the idea that to "make or sell to a public is to 'prostitute' one's art and one's self" [72]. At the same time, Armstrong argues, Degas exploited the visibility offered by the group exhibitions, armored by a surrounding coterie of more conservative artists, to appear both radical and safe, unique and yet not too challenging.

32. On the construction of Nature within the reception of the Barbizon painters, see Green, *The Spectacle of Nature* (chap. 1, n. 57).

33. See F. Fénéon, "Le Néo-Impressionnisme," *L'Art moderne* (1 May 1887): 138–392, reprinted in *Oeuvres plus que complètes*, 1:71–76, esp. 72.

34. Muther, *The History of Modern Painting* (chap. 1, n. 11), 2:771.

35. See C. Morice, "Enquête sur les tendances actuelles des arts plastiques," *Mercure de France* 56 (1 August 1905): 346–59; (15 August 1905): 438–55; and 57 (1 September 1905): 61–85.

36. (Degas' emphasis.) Degas to Tissot, [Friday] 1874, in *Degas Letters* (chap. 1, n. 22), 38–39.

37. See Champfleury's codification of realism in *Le Réalisme* (Paris: Michel Lévy frères, 1857). See also the anthology of Champfleury's art criticism edited by Geneviève and Jean Lacambre under the title *Le Réalisme* (Paris: Hermann, 1973).

38. Baudelaire denounced artists like Meissonier for panderings to public taste through their photographic realism. See Baudelaire, "Salon de 1857," in *Écrits esthétique*, 279–359, esp. 283–85.

39. Quoted in Tucker, "The First Impressionist Exhibition," 104.

40. See Stephen F. Eisenman, "The Intransigent Artist or How the Impressionists Got Their Name," in *The New Painting*, 51–60.

41. The show contained 165 numbers by 30 painters. See *Société Anonyme. Première Exposition* (Paris, 1874). The catalogue has been frequently reproduced, most recently in *The New Painting*, 118–123. In size it resembled the typical size of an exhibition that preceded auctions.

42. J. Bernac, "The Caillebotte Bequest to the Luxembourg, *Art Journal* (August 1895): 230–32, esp. 230–31; (October 1895): 308–10; (November 1895): 358–61.

43. Dewhurst, *Impressionist Painting* (chap. 2, n. 22), 34–35.

44. Ibid., 35.

45. For example, Dewhurst provided a canonical list that amounted to Monet, Pissarro, Renoir, and Sisley. The additional artists Dewhurst singled out as notable Impressionists reflect the fin-de-siècle understanding of who then constituted canonical Impressionism. Yet the names still surprise. The chapter devoted to "some younger impressionists" detailed the work of Eugène Carrière, Auguste Pointelin, and Maxine Maufra. The Impressionist "realists" were Raffaëlli, Degas, and Toulouse-Lautrec; its "women painters" were Morisot, Cassatt, Bracquemond, Gonzalès. As representatives of "La Peinture Claire": Émile Claus, Le Sidaner, Albert Besnard, and Didier-Pouget. The Americans were Whistler, Alexander Harrison, and Childe Hassam, and the single German representative, Liebermann.

46. Lecomte, *L'Art Impressionnistes* (chap. 2, n. 32). See also Martha Ward's discussion of this book in "Impressionist Exhibitions" (chap. 1, n. 60), 618.

47. G. Geffroy, "Histoire de l'Impressionnisme," *La Vie artistique*, 3rd. series (Paris: E. Dentu, 1894), 1–299.

48. See especially the reviews by Kathleen Adler, *Art History* 9 (September 1986): 376–80; Carol Armstrong, *Art Journal* 46 (Fall 1987): 239–43; John House, *Burlington* 128 (September 1986): 704–5; and Gabriel P. Weisberg, *Arts* 60 (March 1986): 72–74.

49. H. Clayson, "A Failed Attempt," in *The New Painting*, 145–59.

50. Ibid., 145.

51. Was Manet's decision to open his studio at the same time as the Impressionist

exhibition a coincidence? It served to abet the affiliation of Manet with the other Impressionists and brought his name into the discussions of the dissenting group in most of the criticism.

52. It is worth noting that an affiliation with a dealer could still generate hostility by critics, as in the case of *L'Art*, whose editorial policy was hostile to Impressionism, but which took the occasion of the first (and last?) exhibition of the *L'Union* to outline its exhibition policy. While it noted the society's independence from the Salon it also observed that the society was independent from dealers who worked for the interests of their stable of artists. See T. Chasreul, "Première Exposition de «L'Union»," *L'Art* 3 (1877): 203.

53. Clayson believes, "A Failed Attempt," 145, following the Whites' argument, that the exhibitors did not want controversy. "They hoped to make money and to win critical and public approval." Yet the Impressionists were always unwilling to pay the costs necessary for respectability, which they could have had. Again, Duret's advice to Pissarro that he moderate his style was studiously ignored by the artist.

54. E. Duranty, *La Nouvelle Peinture - A propos du groupe d'artists qui expose dans les galeries Durand-Ruel* (Paris: E. Dentu, 1876). Duranty's text has been reprinted in *The New Painting* in the original (477–84) and in translation (37–50). The citations are from the reprinted original, but the translations are mine.

55. Fromentin, interestingly, was himself rebuffed by the Academy as a painter *and* as a writer—in the latter case he lost out to Charles Blanc in an appointment to the Academy. His essays were reprinted in book form as *Les Maître d'autrefois*. These essays have been translated as *The Masters of Past Time* (London: Phaidon, 1960). See H. Gerson's brief introduction to the English edition (vii-xiii).

56. Duranty, *La Nouvelle Peinture*, 499, asserted that "Ingres est ses principaux élèves admiraient Courbet; Flandrin encourageait beaucoup cet autre peintre (Alphonse Legros) maintenant fix en Angleterre."

57. S. Mallarmé, "The Impressionists and Edouard Manet," *The Art Monthly Review* 1 (30 September 1876): 117–22. The essay is reprinted in *The New Painting*, 27–35, from which the citations come.

58. E. Zola, "Lettres de Paris. Deux Expositions d'Art au Mois de Mai," *La Messager de l'Europe* (June 1876). The Zola article is reprinted in *Oeuvres Complètes*, vol. 12, ed. Henri Mitterand (Paris: Cercle du Livre Precieux, 1966), 946–71. I prefer this translation from the Russian to those published in *Mon Salon. Manet. Écrits sur l'art* (Paris: Garnier-Flammarion, 1960).

59. Quoted from the pages of *Siècle* by Gustave Geffroy in *Claude Monet, sa vie, son oeuvre* (Paris: G. Crès, 1924), 1:97.

60. Zola, "Lettres de Paris," 970.

61. Mallarmé, "The Impressionists and Edouard Manet," 33.

62. S. Mallarmé, "Le Jury de peinture pour 1874 et M. Manet," *La Renaissance littéraire et artistique* 3 (12 April 1874) 155–57. Reprinted in *Les Écrivains devant l'impressionnisme* (chap. 1, n. 1), 82–88. See de Duve, *Pictorial Nominalism* (intro., n. 28), 86–87, for his use of Mallarmé's phrase as a turning point in modernist rhetoric,

the logic of a reductive, binary opposition that informed the subsequent history of the avant-gardes.

Chapter 4

1. The commercial art exhibition as an institution deserves much more study. See Ekkehard Mai, *Expositionen: Geschichte und Kritik des Ausstellungswesens* (Munich: Deutscher Kunstverlag, 1986) and the brief, but useful essay by Georg Friedrich Koch, "Ausgestellte Kunst wird Ausstellungskunst: Wandlungen der Präsentation von Kunst im 20. Jahrhundert," in Elisabeth Liskar, ed., *Der Zugang zum Kunstwerk: Schatzkammer, Salon, Ausstellung, Museum* 25th. International Congress for Art History, Vienna, 1983, vol. 4 (Vienna, Cologne, Graz: Hermann Böhlaus, 1986), 147–59.

2. C. Pissarro to Lucien Pissarro, letter dated 15 March 1883, reprinted in *Letters to his Son Lucien* (chap. 1, n. 60), 8. I use the term "one-man show" quite self-consciously to indicate the vast predominance of men figured in such exhibitions and also to imply the role these exhibitions played in constructing a male canon of modernist masters. For a discussion of Durand-Ruel's 1883 retrospectives and the context in which they were staged, see Ward, "Impressionist Installations" (chap. 1, n. 60), esp. 616–17.

3. Very little work has been done on these patronage clubs (which must resemble in spirit if not in deed the German *Kunstvereine*). The Cercle de l'union artistique, or the Cercle des Mirlitons as it was later popularly known, was established in 1860 as a club composed of members of society and from the various arts—including no less than the young Degas. In its early years Francis Petit worked closely with the Cercle, providing the society with pictures from his stock and from the collection of other dealers and speculators. See Philippe Burty, "L'Exposition du Cercle de la rue de Choiseul et de la Société nationale des Beaux-Arts," *Gazette des beaux-arts* 12 (1 April 1864): 366–72; Yriarte, *Les Cercles de Paris* (chap. 3, n. 20), 215–48; and Sophie Monneret, *L'Impressionnisme et son époque. Dictionnaire international* (Paris: Bouquins, 1978), 2:209. See also Tamar Garb, "Revising the Revisionists: The Formation of the Union des Femmes Peintres et Sculpteurs," *Art Journal* 48 (spring 1989): 63–70.

4. In 1888, the Cercle de l'union artistique chose to show at Georges Petit's. Félix Fénéon, writing for *La Revue indépendante* 7 (March 1888): 478–87, described them as "laureats of the Palais de l'Industrie, the favorites of New York collectors, the *institutaires* of today and tomorrow—MM. Bonnat, Elie Delaunay, Jules Lefebvre, Clairin, Duran, Delort, Fr. Flameng, Jacquet, Maehard, Bouguereau, Guillaume Dubufe, Lecomte de Nouy (sic)" as well as some "sous-officiers": Berne-Bellecour, Detaille, Dupray, Aimé Morot, Jacques Blanche, Roll, Cazin, Benjamin Constant, Gérôme. Fénéon's review is reprinted in *Oeuvres plus que complètes* (chap. 3, n. 29), 1:100–101.

5. See, for example, Alfred Lostalot's dismissal of the Cercle artistique de la rue Volney, *Chronique des arts* (24 January 1891): 27, as being an exhibition completely

without importance. Nonetheless, each year the Cercle rue Volney would be reviewed or their exhibition at least acknowledged in the *Chronique*.

6. Durand-Ruel, "Mémoires" (chap. 1, n. 41), 174–75.

7. The 1878 exhibition deserves closer study than it has received. For the 1905 exhibition, see John Rewald, "Depressionist Days of the Impressionists," reprinted in *Studies in Impressionism*, ed. Irene Gordon and Frances Weitzenhoffer (New York: Abrams, 1976), 203–8, and the reprinting of the contemporary criticism of the exhibition in *Impressionists in England. The Critical Reception*, ed. Kate Flint (London: Routledge & Kegan Paul, 1984), 193–225.

8. Antonin Proust, *The Salon of 1891*, trans. Henry Bacon (Paris and Boston: Goupil, Estes, & Lauriat, 1891), 28. See my discussion of this dispute in relation to the foundation of the Société nationale des beaux-arts in chapter five below.

9. See Green, "Dealing in Temperaments" (chap. 1, n. 57).

10. One of the more interesting expressions of this concern for late styles is to be found in Richard Hamann's *Impressionismus in Leben und Kunst* (1907), 2nd ed. (Marburg a. d. Lahn: Kunstgeschichtlichen Seminars, 1923). Hamann linked Impressionism as a *Weltanschauung* to Impressionism as a kind of emotional-psychological condition, consequently describing as Impressionist "Der Alterstil Rembrandts, Goethes, Beethovens." Although as Catherine Soussloff, "Old Age and Old-Age Style in the 'Lives' of Artists: Gianlorenzo Bernini," *Art Bulletin* 46 (summer 1987): 115–21, has argued, the topos of an old-age style has had a long history, the concept of *Alterstil* as an art historical term appears to have been invented precisely at the fin de siècle. See Julius Held, "Commentary," *Art Bulletin* 46 (summer 1987): 127–33.

11. Moreau-Nélaton, *Millet* (chap. 2, n. 10), 2:105.

12. See essay by Paul Mantz in *Catalogue descriptif des peintres aquarelles, pastels . . . de J.F. Millet réunis à l'Ecole des Beaux-arts* (Paris: Quantin, 1887).

13. The sense that Manet conquered the Salon that year in absentia (via his studio show) is amusingly portrayed by the cartoonist Gill in *L'Eclipse* (14 May 1876). He depicts Manet bursting through a page of Salon caricatures labeled "Les Triomphateurs du Salon." Manet's caption reads "le triomphe de L'absence." The cartoon is reproduced in *Les Écrivains devant l'impressionnisme*, 80.

14. The following account is indebted to Patricia Mainardi's *Art and Politics of the Second Empire* (New Haven: Yale University Press, 1987).

15. Mainardi, *Art and Politics*, 58, reprints the letter in which Courbet described to his chief patron Alfred Bruyas an encounter between the artist and the *Directeur des beaux-arts* in 1854, regarding an offer to commission from Courbet a painting for the great Exposition.

16. One might acknowledge a certain tongue in cheek in Courbet's self-aggrandizing report to his client and friend, but such remarks are not discordant with the general manner in which Courbet sought to present himself to the world.

17. Anonymous review in *La Revue universelle des arts*, cited by Mainardi, *Art and Politics*, 92–93.

18. See chapter 1 above.

19. Patricia Mainardi, "The Political Origins of Modernism," *Art Journal* 44 (spring 1985): 13, defines eclecticism in the terms of 1855 as a showing of individual careers versus a school of art. "Although artists had held such shows earlier, the ideology of the individual retrospective exhibition was an innovation of 1855. It is itself a modernist tool, for it emphasizes the development of an individual self-referential style. In the traditional 'School,' in contrast, the artist's individuality is subsumed in the artists of shared concerns. This is pointed up by the Academy's unsuccessful counterproposal for the 1855 exhibition; namely, a show to demonstrate the development of the French School in the nineteenth century, which it saw as synonymous with history painting by Academicians. Prince Napoleon described these two contradictory proposals as a show of artists (the eclectic model) and a show of works (the Academic model)."

20. See P. Minardi, "The Death of History Painting in France, 1867," *Gazette des beaux-arts* 100 (December 1982): 219–26. She interprets part of the impoverished character of the show to the shock generated by the recent deaths of Ingres and others. Minardi does not, however, discuss the abandonment of history painting already widely observed in the criticism of the 1855 exhibition.

21. Charles Blanc, "Exposition Universelle de 1867," *Le Temps* (15 May 1867): 12.

22. See *Exposition des oeuvres de Paul Delaroche. Explication des tableaux, dessins, aquarelles et gravures exposés au Palais des Beaux-Arts* (Paris: imp. Ch. de Mourgues, 1857).

23. See *Catalogue des oeuvres de Ary Scheffer exposés 26, Boulevard des Italiens* (Paris: J. Claye, 1859).

24. No catalogue, I believe, survives for this exhibition.

25. See *Exposition des oeuvres d'Eugène Delacroix*, preface d'Arpentigny (Paris: J. Claye, 1864).

26. See *Exposition des oeuvres d'Hippolyte Flandrin à l'Ecole impériale des Beaux-Arts* (Paris: Siège de l'Association des artistes peintres, sculpteurs, architectes, graveurs et dessinateurs, 1865).

27. *Catalogue des tableaux, études peintes, dessins et croquis de J.A.D. Ingres. Exposés dans les galerie du Palais de l'école imperiale des beaux-arts* (Paris: École impériale des beaux-arts, 1867).

28. See *Notice des études peintes par M. Théodore Rousseau exposés au cercle des arts*, notice by Ph. Burty (Paris: J. Claye, 1867).

29. See *Oeuvres de Henri Regnault exposés à l'Ecole des beaux-arts*, notice by Théophile Gautier (Paris: J. Claye, 1872).

30. See *Catalogue des oeuvres de Antoine Bayre*, preface A. Genevay (Paris: École des beaux-arts, 1875).

31. *Exposition de l'Oeuvre de Corot*, biographical notice by P. Burty (Paris: École nationale des beaux-arts, 1875).

32. *Exposition des oeuvres de N. Diaz de la Peña*, biographical notice by Jules Claretie (Paris: J. Claye, 1877). This exhibition is unusual having as its sponsor the

old Association des artistes peintres, sculpteurs, architectes, graveurs et des-sinateurs, with Baron Taylor as one of the presidents of the organizing committee. The baron was also one of the sponsoring presidents of the Corot retrospective.

33. See *Exposition des peintures et dessins de H. Daumier*, biographical notice by Champfleury (Paris: Gauthier-Villars, 1878).

34. See *Catalogue des oeuvres de Th. Couture exposés au palais du l'industrie*, preface by Roger Ballu (Paris: A. Quantin, 1880).

35. See *Catalogue des dessins de Millet provenant de la collection de M. G. et exposés au profit de la famille de l'artiste* (Paris: Imprimerie Renou, Maulde et Cock, 1875).

36. Albert de La Fizelière, *La Vie et l'Oeuvre de Chintreuil* (Paris: Cadart, 1874).

37. C. Lemonnier, *Gustave Courbet et son oeuvre* (Paris: Ed. Lemerre, 1878); Henri d'Ideville, *Gustave Courbet, notes et documents sur sa vie et son oeuvre*, (Paris, 1878); and P. Mantz, "Gustave Courbet," *Gazette des beaux-arts* 17 (June 1878): 514–27, 18 (July 1878): 17–30, and (September 1878): 371–84. The posthumous literature on Courbet is reviewed by Jean-Pierre Sanchez, "La Critique de Courbet et la critique du réalisme entre 1880 et 1890," *Histoire et Critique des Arts* 4–5 (May 1978): 76–83.

38. Three of these exhibitions were thought worthy of reviews by the *Gazette des beaux-arts*. See Louis Gonse, "Exposition rétrospective de Turin," *Gazette des beaux-arts* 22 (July 1880): 71–93; Henry Havard, "Rétrospective Bruxelles," *Gazette des beaux-arts* 22 (October 1880): 333–48; Camille Lemonnier, "L'Art Belge à l'exposi-tion historique de Bruxelles," *Gazette des beaux-arts* 23 (January 1881): 57–64; and Alfred Darcel, "Exposition rétrospective de Dusseldorf," *Gazette des beaux-arts* 23 (January 1881): 15–32.

39. See Darcel, "Exposition rétrospective de Dusseldorf," 16.

40. See Lemonnier, "L'Art Belge," 58.

41. On the Manchester exhibition, see John Steegman, *Consort of Taste 1830–1870* (London: Sidgwick and Jackson, 1950), chapter X, 233–56, and Haskell, *Redis-coveries in Art* (intro., n. 5), 157–60. Haskell's marvelous book, unfortunately, stops in 1860. The contrast between Britain and France, the proliferation of historical exhibitions in international competition, the linkage between specific exhibitions of Old Masters and corresponding historiography that evolved between 1860 and 1900 deserve far more substantial treatment than I can give here.

42. L. Gonse, "Exposition de maîtres anciens à la «Royal Academy», de Lon-dres," *Gazette des beaux-arts* 25 (March 1882): 288–91.

43. The Exposition did offer another "rétrospective" of sorts, a collection of Japanese art for which the collector Émile Guimet lent a considerable body of work. See the entry dated 11 July 1878 in *The Diary of George A. Lucas* (chap. 1, n. 80), 458. Lucas described the show that he visited as a "Japanese retrospective."

44. *Exposition rétrospective de tableaux et dessins de maîtres modernes* (Paris: Galeries Durand-Ruel, July 15-October 1, 1878).

45. Durand-Ruel, "Mémoires," 208–9.

46. Ibid.

47. For a discussion of his rehabilitation see Linda Nochlin, "The De-Politicization of Gustave Courbet: Transformation and Rehabilitation under the Third Republic," *October* 22 (fall 1982): 65–77. The process that led to Courbet's "canonization" in 1889 as a legitimate heir to the French school was defined by Nochlin as consisting of three tasks: 1.) separating the artist from his politics; 2.) firmly attaching the artist to nature by privileging the later landscapes over the figure paintings; 3.) transforming Courbet into a great artist by inserting him into an uninterrupted tradition of great art. Yet this tripartite line of criticism is consistent with the consumption of a large number of artists who were eventually to form the canonical French modernist masters.

48. d'Ideville, *Gustave Courbet, notes et documents* (note 38 above). The translation is by Nochlin, "The De-Politicization of Courbet," 68.

49. See Wagner, "Courbet's Landscape Paintings and Their Market" (chap. 3, n. 5), 410–31.

50. Montrosier, "Exposition de Tableaux et Dessins des Maitres Modernes," *L'Art* 4 (1878): 19–23.

51. Ibid., 23.

52. Alfred Robaut, *L'oeuvre complet de Eugène Delacroix* (Paris: Charavay frères, 1885). Besides Robaut there was the catalogue raisonné of the artist by Ad. Moreau, *Eugène Delacroix et son oeuvre* (Paris: Jouaust, 1873).

53. Chesneau, *Peintres et Statuaires Romantiques*, (Paris: Charavay Frères, 1880); Burty, *Maîtres et petits maîtres*, (Paris: G. Charpentier, 1877); Silvestre, *Les Artistes Français*, (Paris: G. Charpentier, 1878), reprint of the 1855–56 edition (Paris: E. Blanchard).

54. See my discussion of the Grosvenor Gallery in chapter 1 above. And see Paula Gillett, *Worlds of Art. Painters in Victorian Society* (New Brunswick: Rutgers University Press, 1990), especially chapter seven, "Art Publics in Late-Victorian England."

55. Watts himself had expressed in a letter to his patron almost seven years before the belief that "the best way to create interest in a more solemn and serious character of art would be to get together a sufficient number of pictures of the class, and exhibit them all together." Letter cited without date in M.S. Watts, *George Frederic Watts* (London: MacMillan, 1912), 2:3–4.

56. *The Times* review (undated) quoted in Wilfred Blunt, *'England's Michelangelo'* (London: Hamish Hamilton, 1975), 146.

57. Ibid., 152.

58. For a brief discussion of this exhibition, see Christopher Wood, *Olympian Dreamers. Victorian Classical Painters* (London: Constable, 1983), 115–16.

59. See Charles Ephrussi, "Exposition des oeuvres de M. Paul Baudry," *Gazette des beaux-arts* 26 (August 1882): 132–44, and *Exposition des oeuvres de M. J.-J. Tissot* (Paris: A. Quantin, 1883). The first exhibition was allowed to be staged at the Orangerie in the Tuileries, the second at the Palais de l'Industrie.

60. *Exposition J.-J. Tissot* (Paris: Galerie Sedelmeyer, 19 April 15 June 1885).

61. See Alfred de Lostalot, "Expositions diverses à Paris: Oeuvres de M. J.-F. Raffaelli," *Gazette des beaux-arts* 29 (April 1884): 334–42.

62. See André Michel, "Exposition des oeuvres de M. Meissonier," *Gazette des beaux-arts* 30 (July 1884): 5–18.

63. *Exposition de Tableaux, pastels, dessins par M. Puvis de Chavannes* preface by Roger-Ballu (Paris: Galeries Durand-Ruel, 20 Nov. 20-Dec. 1887).

64. As Zola noted in his review of this Salon, this reform had the unexpected consequence, however, of exposing *hors concours* artists, whose work was either outmoded or weak, to a strongly heightened public scrutiny. See E. Zola, "Le Naturalisme au Salon," *Le Voltaire* (18–22 June 1880), reprinted in *Mon Salon. Manet* (chap. 3, n. 58), 325–52.

65. P. Burty, "Exposition des oeuvres des artistes indépendants, *La Republique française* (10 April 1880). Burty particularly wondered why Monet would exchange an exhibition environment where all the paintings were hung on one line for the top row of the Salon.

66. Monet to Duret dated 8 March 1880 (letter no. 173), reprinted in Wildenstein, *Monet*, 1:438.

67. Wildenstein, *Monet*, 1:112 n.848, has attempted to identify the works in the catalogue. Only one picture (not conclusively identified) dates from before 1879.

68. É. Taboureaux, "Claude Monet," *La Vie moderne* (12 July 1880): 380–82.

69. [Anonymous], "Notre Exposition: Claude Monet," *La Vie moderne* (19 June 1880): 400.

70. See *Catalogue des peintures et pastels de Eva Gonzalès*, preface by Ph. Burty (Paris: Salons de la "Vie Moderne," 1885).

71. See H. Havard, "L'exposition des artistes indépendants," *Le Siècle* (2 April 1880). The review is quoted in length in C. S. Moffett, "Disarray and Disappointment," in *The New Painting*, 293–308.

72. For a discussion of this exhibition, see Joel Isaacson, "The Painters Called Impressionists," in *The New Painting*, 373–93.

73. See C. Pissarro to Lucien Pissarro (3 March 1883), in *Correspondance de Camille Pissarro*, vol. 1, ed. Janine Bailly-Herzberg (Paris: Presses Universitaires de France, 1980), 179–80, letter 122.

74. See A. Lostalot, "Exposition des oeuvres de M. Claude Monet," *Gazette des beaux-arts* 27 (April 1883): 344–48; G. Geffroy, "Claude Monet," *La Justice* (15 March 1883), reprinted in *La Vie artistique* (Paris: E. Dentu, 1894), 3:59–60; and A. Silvestre, "Exposition de M. Claude Monet, 9 boulevard de la Madeleine," *La Vie moderne* (17 March 1883): 177. Lostalot's essay reiterated many of the themes current in Monet criticism, notably the admiration of the *amateurs* in the face of public ridicule, and the attempt to rescue the artist from his reputation as "un anarchiste de la peinture."

75. C. Pissarro to Lucien Pissarro (15 March 1883), in *Correspondance*, 1:183–84, letter 125.

76. C. Pissarro to Lucien Pissarro (3 March 1883), in *Correspondance*, 1:179–80, letter 122.

77. See C. Pissarro to Lucien Pissarro (10 November 1883), in *Correspondance*, 1:248–50, letter 188. A businessman added up the prices Durand-Ruel asked for the Pissarros at his retrospective and announced to the painter that he had 300,000 francs worth of art on the walls (much to the artist's astonishment). See the Monet letters to Durand-Ruel (3 March, 6 March, and 7 March 1883), reprinted in *Les Archives*, 1:249–52.

78. Pissarro recounts this incident to his son (10 November 1883), in *Correspondance*, 1:248–49, letter 188.

79. C. Pissarro to P. Durand-Ruel, (6 November 1886), in *Correspondance* 2: 75, letter 358.

80. Hugues Le Roux, "Silouhettes parisiennes: L'Exposition de Cl. Monet," *Gil Blas* (3 March 1889). This interview has provided subsequent Monet biographers with numerous biographical incidents, but what is more interesting here is the habit of retrospective criticism (and exhibitions) to make much of the artist's early life, as a critical formative element in the artist's later work.

81. For a discussion of this project, see Pierre Gassier, "Monet et Rodin," in *Claude Monet-Auguste Rodin* (Paris: Musée Rodin, 1989), 25–6. See also Paul Tucker, *Monet in the 90s* (Boston: Museum of Fine Arts, 1989), 51–55, for a discussion of this exhibition in relation to the development of the series paintings.

82. The British Society of Artists dated from the beginning of the century. Whistler was brought in in the early 1880s to bring new financial life—he loaned the Society five hundred pounds to pay its debts—and public visibility to the organization. For two years as a member and two more years, beginning in 1886, as its president, Whistler drew prominent artists from England and abroad into the society, most notably Alfred Stevens, Walter Sickert, and Theodore Roussel. By March of 1885 he proposed that the society limit the size of exhibits, underwrote the decoration of the society's gallery, and arranged the decoration and hanging largely by himself (characteristically, in yellow). In 1887 he persuaded Queen Victoria to grant a royal charter to the society. In the spring of 1888 he proposed that "no member of the Society should be, or should remain, a member of any other Society," and when he followed this with the proposition that no member of the Royal Society of British Artists who was a member of any other Society should serve on the Selecting or Hanging Committee, they again defeated him. He was finally forced out that summer after the society rejected his decorative schemes for the annual spring exhibition. Subsequently he said in an interview "I wanted to make the British Artists an art centre; they wanted to remain a shop." On Whistler's involvement, see the Pennells' biography (chap. 1, n. 67), 2:47–74, and Whistler, *The Gentle Art of Making Enemies* (London: Heinemann, 1890), 207.

83. C. Monet to P. Durand-Ruel dated 1 May 1889 (letter no. 969), in Wildenstein, *Monet*, 3:247. Monet worded the letter to imply that Petit had initiated the invitation, rather than the other way around (just as he did in a later letter to Duret

dated 15 May 1889 (letter no. 982), in Wildenstein, *Monet*, 3:248. Wildenstein also believes that Petit approached Monet (perhaps because of these later letters) but Gassier, "Monet et Rodin," 26, read the letter inviting Rodin to participate in the project, dated 28 February 1889 (letter no. 912), in Wildenstein, *Monet*, 3:240, differently. There Monet writes "Je reçois un mot de Petit me donnant rendez-vous samedi matin 10 heures, pour m'entendre avec lui au sujet d'une exposition à faire dans sa galerie pendant l'Exposition Universelle, *mais rein que vous et moi*. Etes-vous toujours dans cette disposition, comme vous me l'avez dit lorsque je vous en ai parlé?" It certainly sounds here as if Monet had initiated the meeting and the circumstances of the exhibition. Monet was subsequently responsible for persuading Rodin and then negotiating with Petit for the timing and financial conditions (10 percent commission for Petit and 8,000 francs a piece from Monet and Rodin for rent) of the exhibition.

84. For a discussion of the critical reaction to this exhibition, see Stephen Z. Levine, *Monet and His Critics* (New York: Garland, 1976), 95–116. The most important reviews of the exhibition are reprinted in *Monet et Rodin*, 218–38. The Musée Rodin catalogue also reproduces the original catalogue (47–69).

85. C. Pissarro to L. Pissarro (13 September 1889), in *Correspondance* 2:293–94, letter 541.

86. See Lilla Cabot Perry, "Reminiscences of Cl. Monet from 1889 to 1909," *The American Magazine of Art* 18 (March 1927): 119–25.

87. O. Maus, "Claude Monet—Auguste Rodin," *L'Art moderne* (7 July 1889): 209–11, reprinted in *Monet-Rodin*, 235–37.

88. Levine, *Monet and his Critics*, 96–98.

89. For a consideration of how Monet's new-won independence from group identity and how his one-man shows in the 1890s might have shaped the production of his late series paintings, see John House, "Time's Cycles," *Art in America* 80 (October 1992): 127–35 and 161.

90. See the notices for the two exhibition societies in *Chronique des arts* (4 February 1893): 35, and (17 March 1894): 83.

91. See C. Pissarro to L. Gausson (9 September 1888), in *Correspondance*, 2:252–53, letter 506. See especially editor's note 2.

92. The exhibition society of *La Plume* owes a clear debt to the Belgian society Les XX. But the lesson was reversed in 1894 when Les XX dissolved in favor of La Libre Esthétique, which was much less the artist organization Les XX had been and more resembled a literary and social club on the pattern of *La Plume*, subsequently holding not only art exhibitions, but literary soirées, and musical concerts.

93. This society seems originally to have exhibited in December 1892 at the l'hôtel Brébant, 32 boulevard Poissonnière. See *Chronique des arts* (8 December 1892): 289. Their status as an "exposition permanente" was announced in *Chronique des arts* (30 December 1893): 322, which described their plan to hold new exhibitions each month. However, the second formal exhibition of the society was held only the following year. See *Chronique des arts* (22 December 1894): 318.

94. The architect Frantz Jourdain was on *La Plume*'s editorial board (while his son Francis contributed articles to the magazine). He also played an instrumental role in the founding of the Salon d'Automne in 1903—he was its first president—vastly extending the scope of exhibitions offered by *La Plume* and other such small galleries in the 1890s.

95. See *Iturrino & Picasso* (Paris: Galeries Vollard, 25 June-14 July 1901). A copy of the catalogue is in the Zentralinstitut für Kunstgeschichte, Munich. See also Gordon, *Modern Art Exhibitions 1900–1916* (chap. 2, n. 82), 2:36.

96. See, for example, these exhibitions: *Georges Seurat. Oeuvres peintes et dessinées* (Paris: Revue Blanche, 19 March-5 April 1900); *Vincent van Gogh* (Paris: Bernheim Jeune, 15–31 March 1901); *Émile Besnard* (Paris: Galerie Vollard, 10–22 June 1901); *H. de Toulouse-Lautrec* (Paris: Galeries Durand-Ruel, 14–31 May 1902); *Paul Signac* (Paris: Galerie de l'Art Nouveau, June 1902); and *Paul Gauguin* (Paris: Galerie Vollard, 4–28 November 1903).

96. The basic text on the Salon d'Automne unfortunately remains Frantz Jourdain, *Le Salon d'Automne* (Paris: Les arts et le livre, 1926).

97. The revalidation of the Indépendants deserves further study. But as Roger Marx pointed out, the Indépendants exhibitions had swollen in size from its original 280 numbers in its first exhibition in 1884 to 4,269 works of art in 1905. See R. Marx, "Le Salon des Indépendants," *Chronique des arts* (1 April 1905): 99–102.

98. Cézanne also exhibited at the Indépendants in 1901 and 1902, but deserted the spring Salon in favor of the Salon d'Automne in 1904 where he was given his own room, containing thirty-one works, twenty-six belonging to Vollard, five to Durand-Ruel, and two by the collector Eugène Blot. See Jourdain, *Le Salon d'Automne*, 51. He continued to show at the Salon d'Automne until his death, and, of course, this was where his great 1907 retrospective was held.

99. P. Jamot, "Le Salon d'Automne," *Gazette des beaux-arts* 36 (1 December 1906): 456–84, esp. 456.

100. That the retrospectives were part of the organizing intentions of the Salon d'Automne is made clear in Roger Marx's article, "Le Vernissage du Salon d'Automne," *Chronique des arts* (8 October 1904): 241.

101. See *Exposition Henri-Matisse* (Paris: Bernheim Jeune, 14–22 February, 1910). The catalogue is organized chronologically, with the paintings listed by date, with most of the works being lent by collectors.

102. See, for example, the group exhibition organized with the cooperation of the Galerie Druet in 1906 that toured Germany in 1906–7, stopping at the *Kunstvereine* in Munich and Frankfurt, the Kunstsalon Ernst Arnold in Dresden, and the *Kunstvereine* in Karlsruhe and Stuttgart. The exhibition was intended as a quasi-historical survey of French Post-Impressionist painting, including pictures by Bernard, Bonnard, Denis, Gauguin, van Gogh, Matisse, Manguin, Seurat, Signac, and Vuillard among others, and stemming from the collections of commercial galleries such as Druet, Bernheim Jeune, and Vollard, as well as from private collectors.

Katalog der Ausstellung Französischer Künstler, organized by Dr. Rudolf Adelbert Meyer (Paris: Galerie E. Druet, 1906).

CHAPTER 5

1. See the catalogue for the *Memorial Exhibition of the Works of the Late J. McNeill Whistler* . . . (London: William Heinemann, 1905). The exhibition was held at the New Gallery, February-March 1905. Some of the most notable officials were Léonce Benedite from the Luxembourg Museum, Wilhelm von Bode and Hugo von Tschudi from Berlin, the directors of the Hague Gallery and the Victoria and Albert Museum, as well as museum directors from Pittsburgh, Boston, St. Louis, and Chicago. Among the other sponsors were the French Minister of Fine Arts and his Italian counterpart, as well as the director of the Pennsylvania Academy of Fine Arts.

2. William C. Brownell, "Whistler in Painting and Etching," *Scribner's Monthly* 18 (August 1879): 486–90, 493–94, 494–95. The essay has been reprinted in *Whistler. A Retrospective* (chap. 1, n. 58), 147–51. In what was characteristic of Whistler criticism, despite his high praise for the artist, Brownell thought that the classicist Albert Moore was a better painter.

3. In 1889 the English perception of Whistler as an "impressionist" was so great that Walter Sickert, who was himself then both deeply under the sway of Whistler and Edgar Degas, wrote an opinion piece for *The Pall Mall Gazette* (2 February 1889) in which he attempted to separate Whistler both from Impressionism and from his many imitators. Sickert, "Impressionism—True and False," reprinted in *Whistler. A Retrospective*, 256–57.

4. Broude, ed., *World Impressionism* (intro., n. 20).

5. See Whistler's disengagement from aestheticism in his famous "Ten O'Clock" essay. The original lecture was delivered at various locations in England in 1885 and was subsequently printed as a separate pamphlet in 1888 and reprinted in *The Gentle Art of Making Enemies* (chap. 4, n. 82), 133–59. See my discussion of it below.

6. H. Houssaye, *L'Art français depuis dix ans* (Paris: Didier, 1883), 35.

7. A. Boime, *The Academy and French Painting in the Nineteenth Century*, 2nd ed. (London and New Haven: Yale University Press, 1986), 16.

8. Ibid., 17.

9. Michael Marrinan, *Painting Politics for Louis-Philippe, Art and Ideology in Orléanist France, 1830–1848* (New Haven: Yale University Press, 1987), 206–11, argues that the *juste milieu* should be more precisely defined to describe an official art, invented in service of the ideological ambitions and needs of Louis-Philippe than as an ethereal *Zeitgeist*. He defines the *juste milieu* within the context of the "historique genre" developed under the patronage of Louis-Philippe. Less a simple, compromised, and weak-hearted synthesis of the Romantics and classics, the *juste milieu* represents a new type of painting deeply dependent on low art, on popular prints particularly. It was an art whose legibility and historical specificity and clearly

focused ideological program was directly connected to Louis-Philippe's commissions for the Musée de Versailles. P. Vaisse, "Salons, Expositions et Sociétés d'Artistes en France 1871–1914," in *Saloni, Gallerie, Musei* (chap. 3, n. 12), 141–55, has quarreled with Boime's notion that official commissions were primarily handed out by the state during the Third Republic to a *juste milieu* constituency. See also his "La Troisième République et les peintres: Recherches sur les rapports des pouvoirs publics et de la peinture en France de 1870 à 1914" (Thèse du Doctorat d'État, Université de Paris IV, 1980) and J.-P. Bouillon, "Sociétés d'artistes et institutions officielles" (chap. 3, n. 25).

10. Just such a construction—exclusively French—has been offered under the term "art officiel" by Marie-Claude Genet-Delacroix, "Vies d'artistes: Art académique, art officiel et art libre en France à la fin du XIXe siècle," *Revue d'histoire moderne et contemporaine* 33 (January-March 1986): 40–73. See also Marie-Claude Genet-Delacroix, "Esthétique officielle et art national sous la Troisième République," *Mouvement social* 131 (1985): 105–20.

11. Pissarro to Lucien (14 May 1887) in *Letters to His Son Lucien* (chap. 1, n. 60), 107–08.

12. Charles W. Furse, "Impressionism - What It Means," *Albermarle Review* 1 (August 1892): 47–51. Furse was a member of Britain's most progressive art society, the New English Art Club.

13. If I were following Marrinan's exact definition of the *juste milieu*, I might argue that the great German *juste milieu* painter was not Liebermann, but the head of the Prussian Academy, and the most powerful artist in Berlin, Anton von Werner. He would be the *juste milieu* extraordinaire for his exact and essentially popular renderings of political propagandizing history painting in the name of the legitimacy and the supremacy of Kaiser Wilhelm II and his Reich. But what characterizes the *juste milieu* of the 1880s and 1890s is that they represented a tolerated, often semi-official, yet distinctly oppositional culture.

14. Sculpture offers a special case. The deeply conservative nature of the discipline makes Rodin "avant-garde." But in his professional practices, his self-presentation to the public, even in his style, Rodin was quintessentially *juste milieu*. It is for this reason that Rosalind Krauss' essay on Rodin's reproductive practices, etc., is misguided not for her critique of "originality" but for her acceptance of Rodin as "avant-garde." See "The Originality of the Avant-Garde," reprinted in *The Originality of the Avant-Garde and Other Modernist Myths* (Cambridge, Ma.: M.I.T. Press, 1985), 151–70.

15. See note 5.

16. The final list is reprinted in Wildenstein, *Monet.* 3:255–56, document 1047.

17. Pissarro to Lucien Pissarro (28 December 1883), *Letters to His Son Lucien*, 40–43.

18. J. E. B. [Jacques-Émile Blanche], "Exposition de l'Oeuvre d'Edouard Manet à l'Ecole des Beaux-Arts," *L'Art moderne* 4 (20 January, 1884): 19–21, esp. 19.

19. Ibid., 21.

20. See Reitlinger, *The Economics of Taste* (chap. 1, n. 18), 182–97.

21. Ibid., 189.

22. Ibid., 118.

23. Liebermann, "Rede zur Eröffnung von Ausstellung der Berliner Secession," (spring 1900), reprinted in *Die Phantasie in der Malerei*, ed. G. Busch (Frankfurt: S. Fischer, 1978), 170–71.

24. W. Hofmann, *Gustav Klimt* (Greenwich, Conn.: New York Graphics Society, 1971), 15.

25. See Zola's review of the Salon of 1880, "Le Naturalisme au Salon," which first appeared in *Le Voltaire* (18 and 22 June 1880), reprinted in *Mon Salon. Manet* (chap. 3, n. 58), 325–52.

26. H. Bacon, *Parisian Art and Artists* (Boston: James R. Osgood and Company, 1880).

27. Ibid., 22.

28. Quoted without reference by John Rewald in *Letters to His Son Lucien*, 90.

29. J. Huysmans, "Expositions des Indépendants de 1880," reprinted in *L'Art Moderne* (Paris: Charpentier, 1883). The translation is from Charles Harrison and Francis Frascina, eds., *Modern Art and Modernism* (New York: Harper & Row, 1982), 48.

30. G. Caillebotte to C. Pissarro (24 January 1881), in *Caillebotte. Sa vie et son oeuvre* (chap. 2, n. 29), 245–46.

31. For a discussion by Françoise Cachin and a paraphrase of Zola's letter to Monet, see *Manet. 1831–1883*, 183. What is excised from the letter, however, is the important statement: "je me suis promis, moi écrivain, de ne jamais me mêler à ces sortes d'affaires."

32. Ibid.

33. See A. Brookner, "Zola," in *The Genius of the Future* (chap. 1, n. 1), 89–118.

34. These reviews are reprinted in Zola, *Mon Salon. Manet*, 213–242; 247–280; and 285–324.

35. See Robert J. Niess, *L'Oeuvre: Zola, Cézanne and Manet* (Ann Arbor: University of Michigan Press, 1968) for an analysis of all the possible precedents for Zola's novel as well as for an extensive discussion of the break between Cézanne and the novelist.

36. Zola's international reputation guaranteed the immediate translation of his novels. The German translation by E. Ziegler of *L'Oeuvre* was published as *Aus der Werkstatt der Kunst* (Dresden, 1886).

37. A Dutch correspondent of Zola's wrote in 1895 to the novelist concerning Muther's *Die Geschichte der Malerei*, disparaging the book for attempting a history of Impressionism (through the lens of Zola's novel) without a knowledge of Cézanne. See Niess, *L'Oeuvre*, 82.

38. This character description is drawn from Zola's notes for the novel, the "Ébauche," published in *Les Oeuvres Complètes* (chap. 2, n. 37), 414.

39. For naturalism in *L'Oeuvre* as institutionally transgressive, see Denis Hollier,

"A Room with a View on a Wall," in *Emile Zola and the Arts*, ed. Jean-Max Guieu and Alison Hilton (Washington, D.C.: George Washington University Press, 1988), 177–84.

40. Zola, "Ébauche," 417.

41. Ibid.

42. See, for example, Zola's last essay on the subject, "Peinture," *Le Figaro* (2 May 1896), reprinted in *Mon Salon. Manet*, 371–77.

43. The best discussion of nineteenth-century liberal culture in relation to fin de siècle modernism, albeit confined to the Austrian context, appears in Carl Schorske's *Fin-de-Siècle Vienna* (N.Y.: Alfred Knopf, 1980), 4–10.

44. All of the following figures are taken from the *Explication des ouvrages de peinture, sculpture, architecture, gravure et lithographie des artistes vivants, exposés au Palais des Champs-Elysées* (Paris, 1874). As elsewhere, this discussion is confined to paintings.

45. The definition of *exempt* and *hors concours* were not hard and fast throughout the nineteenth century. They were frequently modified during various reforms. On the rules for Salon exemptions, see Stranahan, *A History of French Painting* (chap. 1, n. 16). See also the specific case surrounding the Salon des Refusés in 1863, discussed by Boime in "The Salon des Refusés," (chap. 3, n. 32) and Daniel Wildenstein, "Le Salon des Refusés de 1863. Catalogue et Documents," *Gazette des beaux-arts* 66 (September 1965): 125–52.

46. On Bonnat, see Alisa Luxenberg, "Léon Bonnat (1833–1922)" (Ph.D. diss., Institute of Fine Arts, 1991).

47. For a complete account of the development of the society and his critical role in it, along with a number of interesting documents, see Philippe de Chennevières, "Les Expositions annuelles et la société des artists français," *Souvenirs d'un Directeur des Beaux-Arts*, part 4 (Paris; Au Bureau de *l'Artiste*, 1888), 69–118.

48. Zola, *The Masterpiece* (chap. 3, n. 26), 315.

49. George Moore, "Meissonier and the Salon Julian," in *Impressions and Opinions* (New York: Brentano's, 1913), 183–203. Moore's critique was first published in the *Magazine of Art* in the immediate aftermath of the schism.

50. Stranahan, *A History of French Painting*, 475.

51. Ibid., 267.

52. Ibid., 475, determined from published sources that the new society's income in 1887 was 612,202 francs.

53. Quoted in ibid., 277 n.1.

54. Proust, *The Salon of 1891* (chap. 4, n. 8), 28.

55. Ibid., 51.

56. On Meissonier's role in and motivations for the founding of the Société nationale des beaux-arts, see Constance Cain Hungerford, "Meissonier and the Founding of the Société National des Beaux-Arts," *Art Journal* 48 (spring 1989): 71–77.

57. C. Virmaitre, *Paris-Médaillé* (Paris: Léon Genonceaux, 1890).

58. For a brief overview of the institution and a selection of criticism on various international exhibitions, see part two of *The Expanding World of Art 1874–1902*, ed. Elizabeth Gilmore Holt (New Haven: Yale University Press, 1988), 171–390.

59. For a French review of the exhibition, see Jacques d'Aubais, "L'Exposition internationale des Beaux-Arts à Vienne," *Gazette des beaux-arts* 26 (July 1882): 81–88.

60. The local *Kunstverein* organized this exhibition to celebrate their fiftieth anniversary.

61. L. Hevesi, "Die Ausstellung der Sezession," reprinted in *Acht Jahre Sezession* (intro., n. 1), 12–17, esp. 14.

62. This exhibition list is recorded in the catalogue, *Gari Melchers* (St. Petersberg: Museum of Fine Arts, 1990).

CHAPTER 6

1. See my discussion, in a different format, of the Secessions in "Selling Martyrdom" (intro., n. 20).

2. A characteristic example of a defensive reading, but superbly researched history, of a Secession is Maria Makela's *The Munich Secession* (chap. 2, n. 67). Although I read it too late to use any of its material, Markus Harzenetter, *Zur Münchner Secession* (Munich: Stadtarchiv, 1992) offers a reading of the Secession much closer to mine.

3. Peter Paret has explored these various social and political ramifications in his *The Berlin Secession* (chap. 1, n. 54). See also Paret, "The Tschudi Affair," *The Journal of Modern History* 53 (December 1981): 589–618.

4. [Anonymous], "In der Münchener Künstlergenossenschaft," *Kunstchronik* 3 (14 April 1892): 362–63.

5. Berlepsch-Valendas, "Ein Wort über die Münchener Jahresausstellung," *Kunstchronik* 3 (28 January 1893): 225–32.

6. R. Heise, *Die Münchener Secession und ihre Galerie* (Munich: Stadtmuseum, 1975).

7. Quoted by Heise, *Die Münchener Secession*, 29.

8. P. Schutze-Naumburg [sic], "Die Internationale Ausstellung 1896 der Secession in München," *Die Kunst für Alle* 11 (1 July 1896): 289–93. The peculiar spelling of the author's name seems to have been adopted for essays away from his role as the editor of the visual arts and architecture section of the conservative journal *Der Kunstwart*. Under the editorship of Ferdinand Avenarius *Der Kunstwart* advocated a national ideal/realist art. See Gerhard Kratzsch, *Kunstwart und Dürerbund* (Göttigen: Vandenhoeck & Ruprecht, 1969). Schultze-Naumberg also contributed to the critical discourse on German Jugendstil and was among the founders of the German Werkbund. In 1903 he was named professor at the Kunsthochschule in Weimar. See Norbert Borrmann, *Paul Schultze-Naumberg* (Essen: Verlag Richard Bacht, 1989).

9. Moore, *Impressions and Opinions* (chap. 5, n. 49), 190.

10. See Makela, *The Munich Secession*, 45–57.

11. *Münchener Neueste Nachrichten* (14 July 1891). See also Heise, *Die Munchener Secession*, 30.

12. Makela, *The Munich Secession*, believes that the source of Hirth's charges was Uhde himself and that the artist had misrepresented his colleagues in the Künstlergenossenschaft. One wonders, however, what role Paulus played in the affair, because he more than anyone knew the business details of the society. It is hardly an accident that Paulus became the Secession's first business manager.

13. See Makela, *The Munich Secession*, 62–7, for a detailed discussion of the Secession's management of their multiple offers to win concessions from the city and state governments.

14. O. Mittelberg, "Die Secessionisten in Berlin," *Freie Bühne* 4 (1893): 201–4.

15. Mittelberg refers here to an ongoing debate in official circles about how to shore up the *Kunstvereine*, which, from its position as the dominant German art institution of the nineteenth century, had rapidly slipped into decline in the 1880s and 1890s.

16. J. O. Bierbaum, *Aus beiden Lagern. Betrachtungen, Karackteristen und Stimmungen aus dem ersten Doppel-Ausstellungsjahre in München* (Munich: Verlag on Karl Schüler, 1893).

17. J. O. Bierbaum, *Secession. Eine Sammlung von Photogravuren* (Berlin: Photographische Gesellschaft, 1893).

18. The Glasgow "Boys" entered European consciousness via the international exhibition and came to stand for many in Central Europe as the most modern contemporary representatives of Impressionism. A contributor to *Kunstchronik*, "Die Vereinigung der schottischen Künstler," 5 (16 November 1893): 72–73, visited an exhibition of the Society of Scottish Artists, for example, and described among them the "Impressionisten der Schule von Glasgow." The artists so named were John Lavery, James Guthrie, A. Walton, Grosvenor Thomas, and John Teriss. As it happened, according to one scholar, the first exhibition of Impressionist painting did not occur in Scotland until 1892. See William Hardi, *Scottish painting 1837–1939* (London: Studio Vista, 1976), 74. A representative overview of these painters as they were seen in the 1890s may be found in David Martin, *The Glasgow School of Painting* (London: George Bell & Sons, 1897). See also Roger Billcliffe, *The Glasgow Boys. The Glasgow School of Painting 1875–1895* (Philadelphia: University of Pennsylvania Press, 1985).

19. See *Die Kunst für Alle* 8 (1 September 1893): 363, with two illustrations of Munch's work.

20. Bierbaum, *Secession. Eine Sammlung von Photogravuren*, ix.

21. These figures were published in *Die Kunst für Alle* 9 (15 October 1893): 30.

22. Figures published in *Die Kunst für Alle* 10 (1 October 1894): 30.

23. See Lovis Corinth's discussion of this episode in Munich's *Kunstpolitik* in *Selbstbiographie* (intro., n. 21), 109–12.

24. See Dr. R. [Jaro Springer]'s review of the Gurlitt exhibition in *Die Kunst für*

Alle 9 (15 June 1894): 284. Springer defended Secessionism as an exhibition principle, and rejected the parallel drawn by some critics between the fragmentation of the Reich's political parties (into small parties representing special interests) with the fragmentation of the art world.

25. See J. S. [Jaro Springer], *Die Kunst für Alle* 10 (1 April 1895): 201.

26. G. Voß, "Die Ausstellung der Münchener Secession," *Die Kunst für Alle* 9 (1 July 1894): 289–94, esp. 290.

27. Characteristically, the St. Lukas group showed in 1896 at Schulte's alongside paintings by Liebermann, Stuck, Uhde, Crane, Jacob Maris, and Emile Claus. See W. von Oettingen, "St.-Lukas-Ausstellung 1896," *Die Kunst für Alle* 12 (1 February 1897): 134- 36.

28. See *Die Kunst für Alle* 10 (1 January 1895): 108.

29. Ibid. See also Gustav Schoenaich, "Die Münchener Secession in Wien," *Die Kunst für Alle* 10 (15 January 1895): 119–20. Schoenaich reported that the sensation of the exhibition for the Viennese public was Stuck, whose art would then play a major role in the developing style of the future Viennese Secessionists.

30. J. Springer, "Die 1894er Jahres-Ausstellung der Münchener Secession," *Die Kunst für Alle* 10 (1 July 1895): 289–92.

31. Although in 1895 Trübner, Slevogt, and other members of the Freie Vereinigung were reunited with the Munich Secession, artists such as Corinth and Eckmann continued to show with the Künstlergenossenschaft.

32. See *Die Kunst für Alle* 10 (1 August 1895): 332.

33. J. Springer, "Die Ausstellung der 'XI,'" *Die Kunst für Alle* 11 (15 April 1896): 211–22, esp. 212. The title of "XI" like that of the "XXIV" suggests a connection to Brussels' Les XX (although there exists no direct evidence for this). Such a connection was certainly not made by German reviewers. Yet Hans Hofstätter states that the "Zusammenschluss" of the Eleven was according to the "Vorbild der 'Vingt' in Brüssel." See his *Geschichte der europäische Jugendstilmalerei* (Cologne: Verlag M. Dumont Schauberg, 1963), 165. A characteristic contemporary example of this confusion can be found in Adolf Rosenberg's review of the Edvard Munch exhibition in Berlin in November of 1892, quoted incidentally by Hofstätter, which complains that Munch's work puts into the shade "der französische und schottische Impressionisten wie der Münchner Naturalisten" (166). One can readily contrast this ignorance with a contemporary English chronicle, this time a regular supplement to *The Magazine of Art*, "Chronicle of Art" (June 1892): xxxv, which not only reviewed the ninth exhibition of Les XX but also capably distinguished the different styles of the participants and wrote generally admiringly of them all. Such an account had no equivalent in Germany. According to the anonymous reviewer "it was supposed that to speak of a man as one of the 'XX' was to dub him impressionist. This is an utter blunder. Though neo-Impressionism has, indeed, asserted itself in the exhibitions of the Twenty, symbolism and realism also hold their own."

34. K. Voll, "Die V. Internationale Kunstausstellung der 'Münchener Secession," *Die Kunst für Alle* 13 (1 July 1891): 273–76, esp. 273.

35. See *Die Kunst für Alle* 11 (15 May 1896): 270.

36. See *Die Kunst für Alle* 11 (15 June 1896): 285.

37. See *Die Kunst für Alle* 14 (1 April 1899): 199–200.

38. See *Die Kunst für Alle* 13 (15 February 1898): 236.

39. Dr. G. H.-Ch., "Die 'Jugendgruppe' auf der Jahresausstellung im Münchener Glaspalast," *Die Kunst für Alle* 15 (1 November 1899): 49–54.

40. For a brief, uncritical account of Scholle, see Bernd Dürr, "Die Münchener Künstlergemeinschaft 'Scholle,'" in *Leo Putz 1869–1940* (Bozen: Athesia, 1980), 23–45. For an interesting contemporary description of the group, see Hans Rosenhagen, "Die Münchener Künstlervereinigung 'Scholle,'" *Die Kunst für Alle* 20 (1 June 1905): 395–406, and (15 June 1905): 419–32.

41. The Vienna Secession was the focal point of Carl Schorske's *Fin-de-Siècle Vienna* (chap. 5, n. 43), but the best account of the institution is Wolfgang Hilger, "Geschichte der 'Vereinigung Bildender Künstler Österreichs'. Secession 1897–1918," in *Die Wiener Secession. Die Vereinigung bildender Künstler 1897–1985* (Vienna, Cologne, Graz: Hermann Böhlaus, 1986), 9–66. The most significant contemporary source for the history of the Vienna Secession is Ludwig Hevesi's *Acht Jahre Sezession* (intro., n. 1).

42. This is a paraphrase of a letter written by Klimt as president of the Secession to the Künstlerhaus, notifying them of their intention to exhibit separately. The letter is reprinted in full in Christian M. Nebehay, *Gustav Klimt, Dokumentation* (Vienna: Verlag der Galerie Ch. M. Nebehay, 1969), 135.

43. V. V. [Karl von Vincenti], "Personal- und Atelier-Nachrichten," *Die Kunst für Alle* 12 (1 May 1897): 242.

44. See the "Statuten der Vereinigung bildender Künstler Oesterreichs," published in the *Katalog der I. Kunst-Ausstellung der Vereinigung bildender Künstler Oesterreichs* (Vienna: Vereinigung bildender Künstler Oesterreiches, 1898), 7–11.

45. H. Bahr, "Unserere Secession," in *Secession* (Vienna: Wiener Verlag, 1900), 8. Bahr's view of the Secession has been essentially accepted by Donald Daviau in his essay "Hermann Bahr and the Secessionist Art Movement in Vienna," in *The Turn of the Century. German Literature and Art 1890–1915*, ed. G. Chapple and H. H. Schulte (Bonn: Bouvier Verlag, 1983), 433–62. My reading of the situation is entirely opposed to Bahr's.

46. Schorske, *Fin-de-Siècle Vienna*, 215.

47. H. Bahr, "Vereinigung bildender Künstler Österreichs. Secession," *Ver Sacrum* 1 (January 1898), 8–13.

48. This characterization of the Roman *plebis* in relation to the Secession was undoubtedly suggested to Schorske by the theater director Max Burckhardt's introductory essay to the first issue of *Ver Sacrum* (January 1898): 1–2, where he wrote: "Wenn im alten Rom die Spannung, welche wirtschaftliche Gegensätze stets hervorrufen, einen gewissen Höhepunkt erreicht hatte, dann geschah es wiederholt, daß der eine Teil des Volkes hinauszog auf den Mons sacer, auf den Aventin oder das Janiculum, mit der Drohung, er werde dort im Angesichte der alten Mutterstadt und den ehrwürdigen Stadtvätern gerade vor der Nase ein zweites Rom gründen, falls man seine Wünsche nicht erfülle. Das nannte man: Secession plebis."

49. Editors' introduction, *Ver Sacrum* 1 (January 1898): 1.

50. Schorske tends to accept the generational model, the revolt of the sons against the fathers, as a kind of preexisting cultural condition, rather than the invention of the very era he describes. His book inadvertently liberates the Secession from the era's *Kunstpolitik* even as he contextualized the art within the cultural politics of fin-de-siècle Vienna. An important critique of the overidealizing of the Secession is Reinhold Heller, "Recent Scholarship on Vienna's 'Golden Age,' Gustav Klimt and Egon Schiele," *Art Bulletin* 59 (March 1977): 11–118. Heller argues for the commercial nature of the Secession and the essentially elitist ambitions of its leadership, especially Klimt.

51. Schorske, *Fin-de-Siècle Vienna*, 217.

52. The particulars of this story are still confusing, since the various parties to these events give different emphasis to different issues. Berthe Zuckerkandl, the prominent Viennese journalist and defender of the Secession, sided with the "Klimt-Gruppe," yet nonetheless gave the most systemic discussion of the relationship between Moll and the Secession in an article, "Die Spaltung der Wiener Sezession," for *Die Kunst für Alle* 20 (15 July 1905): 486–88. For another contemporary account, which viewed the split as entirely based in aesthetic conflict, see Hevesi, "Der Bruch in der Sezession," in *Acht Jahre Sezession* (intro., n.1), 502–5. See also Nebehay, *Klimt-Dokumentation*, 345–50, and Hilger, *Die Wiener Secession*, 48–50.

53. Zuckerkandl, "Die XXIII. Ausstellung der Wiener Sezession," *Die Kunst für Alle* 20 (1 July 1905): 441–49. Zuckerkandl describes the two parties as "eine Stil-Gruppe und eine realistische Gruppe. Die einen betrachten «Kunst» als Einheit, als großen dekorativen Zusammenhang architektonischer, bildnerischer und angewandter Gestaltungen; die andereren wollen von der Unterordnung, von der Harmoniesierung des Kunstwerkes mit dem Ganzen nichts wissen" (441).

54. This declaration was made in the introduction to the first *Kunstschau* and is reprinted in Nebehay, *Klimt-Dokumentation*, 394.

55. See L. Hevesi, "Kunstschau 1908," reprinted in *Altkunst-Neukunst* (chap. 2, n. 18), 311–15.

56. Nebehay, *Klimt-Dokumentation*, 394.

57. See *Katalog der internationalen Kunstschau* (Vienna: Internationale Kunstschau, 1909). A partial list of the works exhibited has been reproduced in Gordon, *Modern Art Exhibitions* (chap. 2, n. 82), 2:333–36.

58. This is the purpose given for the Secession in its brief announcement of the formation of the society in *Die Kunst für Alle* 14 (1 February 1899): 138.

59. For a thorough discussion of the founding of the Berlin Secession, see Paret, *The Berlin Secession* (chap. 1, n. 54), 59–91. For a more general discussion of the place of Secessionist politics in Berlin at the end of the nineties, see Nicolaas Teeuwisse, *Vom Salon zur Secession* (Berlin: Deutscher Verlag für Kunstwissenschaft, 1986), 241–69. See also Dominik Bartmann, *Anton von Werner* (Berlin: Deutscher Verlag für Kunstwissenschaft, 1984), 187–94.

60. This figure is given in *Die Kunst für Alle* 15 (15 December 1899): 166.

61. R. Mortimer, "Die Ausstellung der Berliner Secession," *Die Kunst für Alle* 14 (15 July 1899): 314–15.

62. Liebermann addressed each opening of the spring Secession exhibition. His lectures have been reprinted in *Die Phantasie in der Malerei* (chap. 5, n. 23), 169–87, esp. 169.

63. Teeuwisse, *Vom Salon zur Secession*, 246.

64. Corinth, *Selbstbiographie* (intro., n. 21), 150.

65. The Secession's *Protokolle der Vorstand Sitzungen der Berliner Sezession* unfortunately is only extant from 19 January 1899 to 25 March 1899. The transcript is in the Cassirer Collection I, Stanford University, Department of Special Collections, Manuscript Division.

66. 22 February 1899 minutes, *Protokolle*, unpaginated [69]. The Secession also contemplated the participation of members of the *Worpsweder Kunstkolonie*.

67. 3 March 1899 minutes, *Protokolle* [87]. Liebermann wrote a letter to Bruno and Paul Cassirer dated 10 March 1897, offering them a position similar to the business situation of Adolf Paulus with the Munich Secession. See the uncatalogued papers of the Cassirer Collection, Stanford University.

68. *Berlin und die Berliner* (Karlesruhe: J. Bielefelde Verlag, 1905), 22–23. Liebermann is joined by only one other artist, a friend of Anton von Werner, the animal painter Paul Meyerheim, but his presence, according to the guide, is due to his popularity at banquets as a comic and story teller.

69. Leistikow was exhibiting at Keller & Reiner's in 1900. See *Die Kunst für All* 15 (1 April 1900): 308, for a review of one of his exhibitions.

70. 6 March 1899, *Protokolle* [99].

71. Paret, *The Berlin Secession*, 76–78, recounts in detail the maneuvering out of the Malkowsky contract.

72. *Protokolle* [100–101].

73. 16 March 1899, *Protokolle* [143].

74. This was the chief object of discussion for a pre-meeting discussion between Frenzel, Dettmann, Engel, Herrmann, Leistikow, and Klimsch in Engel's studio on 16 March 1899. Notes were taken and recorded in the *Protokolle* [124–31].

75. See the photograph that accompanies Hans Rosenhagen's review of "Die zweite Ausstellung der Berliner Secession," *Die Kunst für Alle* 15 (15 July 1900): 459–77, esp. 466. Only five Secessionists are shown: Liebermann, Oscar Frenzel, Franz Skarbina, Otto Engel, and Bruno Cassirer. Another photograph that illustrated the first installment of Rosenhagen's review of "Die dritte Kunstausstellung der Berlin Secession," *Die Kunst für Alle* 16 (15 July 1901): 467–74, esp. 474, shows the two Cassirers in the outer circle of artists grouped around a sculpture by Fritz Klimsch (done in the manner of Rodin). The group of artists shown now included Corinth and Leistikow. Many of the same individuals are featured again, minus Bruno Cassirer, in Rosenhagen's review, "Die fünfte Ausstellung der Berliner Secession," *Die Kunst für Alle* 17 (1 July 1902): 433–43, esp. 443. Paul Cassirer (metaphorically?) stands directly behind the seated Liebermann.

NOTES TO PAGES 193-196

76. See previous note.

77. Fritz von Ostini, "Die Franzosen im Münchener Glaspalast 1901," *Die Kunst für Alle* 17 (15 October 1901): 27–34, esp. 28. His negative review came in the face of some fine landscapes by Monet, Boudin, and Sisley, as well as Manet's *Portrait of Éva Gonzalès.*

78. Rosenhagen, "Die zweite Ausstellung der Berliner Secession," 462.

79. Liebermann, *Die Phantasie*, 171.

80. The Renoir was bought for the Folkwang Museum in Hagen.

81. Momme Nissen, "Berliner Konservative Malerei (Große Ausstellung 1902)," *Die Kunst für Alle* 17 (15 August 1902): 505–7. Nissen was the only real disciple of Langbehn, the *Rembrandtdeutsche*, that is, the famous author of *Rembrandt als Erzieher*, the most wildly popular, and wild text, of *Kulturkritik* to appear in Germany in the 1890s. On Langbehn, see Fritz Stern, *The Politics of Cultural Despair* (Berkeley and Los Angeles: University of California Press, 1963), 121ff. Nissen was a portrait painter from Hamburg who met Langbehn in 1892 only a year after the publication of the "Rembrandt" book. He became a devoted disciple of Langbehn, following him even into his conversion to Catholicism. He supported Langbehn for much of his life with his earnings as a portraitist. Long after Langbehn's death (1907) Nissen published his biography *Der Rembrandtdeutsche Julius Langbehn* (Freiburg im Breisgau, 1927).

82. On Munch's *Frieze of Life* and the Secession exhibition that year, see Peter Krieger, *Edvard Munch. Der Lebensfries für Max Reinhardts Kammerspiele* (Berlin: Gebr. Mann Verlag, 1978), especially chapter one, 8–13.

83. Rosenhagen, "Die fünfte Ausstellung der Berliner Secession," 443.

84. H. Rosenhagen, "Die fünfte Ausstellung," part 2, *Die Kunst für Alle* 17 (15 July 1902): 457–60, esp. 460.

85. The Manets were *Le Banc* (Rouart #375), owned by Durand-Ruel, *Lilas blanc dans un vase de verre* (Rouart #427), and *Le Départ du bateau de Folkstone* (Rouart #147), both from the Bernstein collection, and finally a late entry, not listed in the exhibition catalogue: *Asparagus* (Rouart #357) from the Liebermann collection. The Cézannes, from circumstantial evidence, were a *Self-Portrait* (likely Venturi #290), then either in the collection of Theodor Behrens or Julius Meier-Graefe, *La Promenade* (Venturi #119), belonging to Cézanne's son, and a landscape, *Le Montagne Sainte-Victoire et le Viaduc* (Venturi #453) in the Pellerin collection and possibly sent through the cooperation of Durand-Ruel.

86. The politics of the St. Louis World's Fair and the origin of the German Künstlerbund have been extensively discussed by Paret, *The Berlin Secession*, 92–155. See also the contemporary accounts by Walter Leistikow, "Über den Deutschen Künstlerbund und die Tage in Weimar," *Die Kunst für Alle* 19 (1 February 1904): 201–5; Wilhelm Shafer, "Der deutsche Künstlerbund," *Jahrbuch der bildenden Kunst* 2 (1904): 98–99; and Harry Graf Kessler, "Der deutsche Künstlerbund," *Kunst und Künstler* 2 (February 1904): 191–96. See also Kessler, "Herr von Werner," *Kunst und Künstler* 2 (April 1904): 287–90.

87. [Anonymous], "Die Deutsche Kunstabteilung in St. Louis," *Die Kunst für Alle* 19 (15 December 1903): 144–47, esp. 147. A member of the Deutsche Kunstgenossenschaft wrote the essay.

88. This point was also made by the conservative opponents to the Secession. Carl Langhammer, a leader of Berlin's Kunstgenossenschaft, responded in an essay, "Zum Deutschen Künstlerstreit," *Die Kunst für Alle* 19 (1 May 1904): 354–59, to the Künstlerbund by arguing that "Die Künstler, die im Laufe der letzten zwölf Jahre die Sezessionen gründeten und sie noch leiten, sind zu größten Teil Herren im reiferen Mannesalter. Überall beklagt sich, opponiert und rebelliert sogar die wirkliche Jugend innerhalf der Sezessionen gegen das starre Regiment dieser leitenden Meister" (357). And as if to confirm their central place in the German art world, Trübner was named in 1904 to be the director of the *Karlsrüher Kunstakademie*. See *Kunstchronik* 16 (18 November 1904): 76. Led by Liebermann and Trübner the next ten years saw a steady stream of Secessionists into the ranks of the academicians.

89. See Maurice Godé, *Der Sturm de Herwarth Walden. L'Utopie d'un art autonome* (Nancy: Presses Universitaires de Nancy, 1990).

CHAPTER 7

1. For the reception of Impressionism in Germany see Kern, *Impressionismus im Wilhelminischen Deutschland* (intro., n. 10); Evelyn Gutbrod, *Die Rezeption des Impressionismus in Deutschland 1880–1910* (Stuttgart: W. Kohlhammer, 1980); Teeuwisse, *Vom Salon zur Secession* (intro., n. 13); Karl-Heinz and Annegrel Janda, "Max Liebermann als Kunstsammler," *Forschungen und Berichte. Staatliche Museen zu Berlin* 15 (Berlin: Akademie-Verlag, 1973), 105–49; Peter Krieger, "Max Liebermanns Impressionisten-Sammlung und ihre Bedeutung für sein Werk," in *Max Liebermann in seiner Zeit* (Berlin: National-Galerie, 1979), 60–71; and Hugo von Tschudi, "Die Sammlung Bernstein," in *Gesammelte Schriften* (Munich: R. Piper, 1912), 282ff.

2. Already by the early 1880s Zola was an international literary lion. The strongest and one of the most cruel of Zola's Rougon-Macquart novels, *L'Assommoir*, was first published in France in 1877. It was already in its 92nd French edition by 1881, only a year after its first German translation (Berlin: Freund und Jeckel, 1880), and the first of all of Zola's novels to be translated. *Nana*, which caused some scandal upon its publication in France in 1880, had a German edition by 1881 (Grossenhain: Baunert und Ronge, 1881). In 1886, when Zola brought out *L'Oeuvre*, a German edition was published in the same year [*Aus der Werkstatt der Kunst*] (Dresden: H. Minden, 1886).

3. The phrase is Matisse's, regarding Cézanne. Manet's reputation was assisted by his attention to the human figure on a large scale, which distinguished him from landscape painters such as Monet or the "miniatures" of Degas. His early, scandalous paintings, moreover, had been directly defended by Zola. In ways more difficult to define, Manet's paintings also reflected in the German view a kind of

aristocratic "masculinity." Curiously, despite the long familiarity German audiences had with the art of Courbet, Manet's painting exerted far greater authority. Unlike Courbet, Manet was cast as an exclusive, originary figure in the development of a specific style, the invention of Impressionism, and unlike Courbet, a style that could be purported to be diametrically opposed to comparable currents in German art. Courbet was perceived as a crude, proletarian revolutionary, whereas Manet clearly belonged to an altogether different class. Among the Secessionists Manet came to stand for aesthetic sophistication and internationalism.

4. For the history of the socialist movement and organized labor in Wilhelmine Germany, see Carl Schorske, *German Social Democracy 1905–1917* (New York: John Wiley & Sons, 1965). The Socialist Labor Party was reorganized at Erfurt in 1891 into the Social Democratic Party.

5. F. Bley, "Edouard Manet," *Zeitschrift für bildende Kunst* 19 (1883–84): 241–52. This article was virtually Bley's only foray into the realm of art criticism and was, remarkably, illustrated with woodcuts after Fantin-Latour's portrait of Manet (Art Institute of Chicago), Manet's own portrait of Zola (Musée d'Orsay)—an obvious choice—his portrait of *Faure as Hamlet* (Museum Folkwang, Essen), and a sketch after the *Drinker* (private collection, Chicago). This is the first time that any Manet had been reproduced in a German-language periodical and the last until Muther's *Geschichte der Malerei*.

6. If the Manet exhibition had not occurred at the École it is very doubtful a German writer would have reviewed it. Bley mistook the show for official sponsorship. Zola's participation through his introductory text to the catalogue for the exhibition further linked the writer to the artist for Bley and his German readers. It was largely against this sign of the official "consecration" of Manet and Zola's naturalism that Bley organized his attack on Manet, pursued with a virulence unusual even for the most conservative of French critics.

7. Bley was unable to distinguish Manet's art from the work of his "followers." Bley was able to name Degas, Renoir, Pissarro, and Monet "who, since the 'master's' death, has stood for the leader of Impressionism" [250], but he also named as Manet's followers those artists who awarded him his second class medal in 1881: Carolus-Duran, Cazin, Duez, Gervex, Guillemet, Henner, and Roll, among others.

8. See Winthrop H. Root, *German Criticism of Zola, 1875–1893* (New York: Columbia University Press, 1931), 31.

9. Bley quoted Baudelaire's famous letter to Manet (cited in Bazire) written in answer to a letter from the artist expressing doubts and hesitations over his art. Baudelaire encouraged the painter with the ambiguous phrase "you are the first in the decadence of your art." Bley [218] translated the passage: "Sie sind nur der Erste in der Entwicklung Ihrer Kunst." It entirely changed Baudelaire's meaning. From it Bley argued that this was an irresistible appraisal of the artist that encouraged the painter to exhibit the *Olympia* in the Salon.

10. R. Graul, "Pariser Kunstausstellung," *Zeitschrift für bildende Kunst* 24 (1889): 250–56, 279–81, and 311–13.

11. H. Helferich [Emil Heilbut], "Studie über den Naturalismus und Max Liebermann," *Die Kunst für Alle* 2 (15 April 1887): 209–14, and (1 May 1887).

12. For a discussion of this "second stage" in Zola criticism, see Root, *German Criticism*, 67–68.

13. In the rewording of the usual description of Impressionist ideology, Helferich [210] wrote "das ist der Ausgangpunkt der neuen Kunst, welche die Kunst ist, die nur die Impression durch die Nature kennt. Diese Kunst senkt sich in einer Weise in die Dinge, die über das optische Sehen hinausgreift. Den Gehalt der Dinge, ihre Eigenschaft, ihren Geruch will sie erreichen." Helferich's near mystical transport through natural vision is near to that expressed by Vincent van Gogh and indicates how far the criticism of naturalism had changed in the course of a very few years. A few years later, he used virtually the same metaphor to describe the fantasy involved in experiencing Monet's landscapes.

14. [F. Pecht], "Ueber den heutigen französischen Impressionismus," *Die Kunst für Alle* 2 (15 August 1887): 337–39.

15. He made a point especially of Uhde (ibid., 339), arguing that his work was significant despite its debt to *plein air* painting.

16. Paradoxically, the peak of Zola's popularity in Germany coincided in France and Belgium (c. 1885) with the widespread challenge to literary naturalism by symbolism. Joris Huysmans' *A rebours* was published in 1884; Jean Moréas coined the word "symbolisme" in the page of *Le Figaro* in 1886. If German literary interests fell behind comparable trends in Paris, naturalism acquired in Germany a greater fusion with political radicalism than elsewhere.

17. See K. Woermann, *Was uns die Kunstgeschichte lehrt. Einige Bemerkungen über alte, neue und neueste Malerei*, 3rd ed. (Dresden: Ehlermann, 1894).

18. G. Brandes' lectures on and correspondence with Nietzsche have been collected in *Friedrich Nietzsche*, trans. A.G. Chater (New York and London: Macmillan and Heinemann, 1909). A useful guide to the reception history of Nietzsche in Germany in the 1890s and to his contribution to the cult of the individual is R. A. Nicholls, "Beginnings of the Nietzsche Vogue in Germany," *Modern Philology* 56 (August 1958): 24–37.

19. J. Langbehn, *Rembrandt als Erzieher, von einem Deutschen* (Leipzig: C. L. Hirschfeld, 1890). About Langbehn's book, see Stern, *The Politics of Cultural Despair* (chap. 6, n. 81). The book was, as Stern observed, enthusiastically greeted by the general public and even by Rembrandt scholars. Pecht chose to review the book as the lead article in *Die Kunst für Alle* 5 (1 April 1890): 193–97. Among the numerous passages Pecht reprinted was an important section that argued that Böcklin was the true heir to Rembrandt. On neoidealism, see Arne Garborg, "Der Neu-Idealismus," *Freie Bühne* 1 (16 July 1890): 633–36, and (23 July, 1890): 660–63, and H. Helferich, "Etwas über die Neu-Idealisten," *Die Kunst für Alle* 7 (1 December 1891): 70–72, and (15 December 1891): 85–87, inspired in part by the publication of Sâr Péladan's *Salon de la Rose + Croix, Règle et Monitoire* (Paris, 1891). Helferich's review, however, concentrated on the work of Puvis, Gustave Moreau, and Albert Besnard. Though

Helferich did not dismiss the Sâr out of hand, he described him as possessing a mixture of one-sixth talent and five-sixths charlatanism [86].

20. There is no better testament of the confrontation of Nietzsche with naturalism than the publication in the naturalist journal *Freie Bühne*, a two-part essay by Paul Ernst, "Friedrich Nietzsche. Seine historisch Stellung," *Freie Bühne* 1 (4 June 1890): 489–91, and "Friedrich Nietzsche. Seine Philosophie" (11 June 1890): 516–20, which cast Nietzsche as a bourgeois decadent, whose "system of thought has no track, only loosely connected essays and aphorisms, which are more psychologically than logically related" [part 2, 56].

21. Like many writers belonging primarily to the 1890s, Hermann Bahr deserves considerable further study. For a generally non-interpretive explication of his literary criticism, see Robert E. Simmons, *Hermann Bahr as a Literary Critic: An Analysis and Exposition of His Thought* (Palo Alto: Stanford University, 1956). For a general overview of Bahr's career, see Donald G. Daviau, *Hermann Bahr* (Boston: Twayne, 1985).

22. See Andrew W. Barker, "Der 'Grosse Ueberwinder'—Hermann Bahr and the Rejection of Naturalism," *Modern Language Review* 78 (July 1983): 617–30.

23. See H. Bahr, "Die Ueberwindung des Naturalismus," in *Die Ueberwindung des Naturalismus*, ed. Gotthart Wunberg (Stuttgart: W. Kohlhammer Verlag, 1968), 89.

24. Bahr, "Die neue Psychologie," in *Ueberwindung*, 57–58.

25. Ibid., 59.

26. Bahr named one modern, Degas, knowledge of whom most surely must have come from reading Huysmans' collection of art criticism, *Certains*. See the section "Kunst und Kritik," in *Überwindung*, 64–70.

27. M. Nordau, *Entartung* (Berlin: C. Duncker, 1892). The English translation is from the second German edition (London: William Heinemann, 1895). *Entartung* had an impressive publication record. It was in its second German edition in 1893; its third in 1896. The French translation was produced in 1893 and reached five editions by 1899. There were four Italian editions before 1914. The American and English publication record is perhaps even more remarkable. First translated in 1895 there were seven New York editions by the end of the first year, by 1898 *Degeneration* had already gone into the ninth edition. The London version was only slightly less spectacular.

28. For a discussion of the relationship between modernism, nationalism, and Zionism, see Ritchie Robertson, "Nationalism and modernity: German-Jewish writers and the Zionist movement," in *Visions and Blueprints*, ed. Edward Timms and Peter Collier (Manchester: Manchester University Press, 1988), 208–20.

29. Nordau, *Entartung*, 42–43.

30. Ibid., 27.

31. "Painters who are insensitive to colour will naturally have a predilection for neutral-toned painting; and a public suffering from the same malady will find nothing objectionable in falsely-coloured pictures. But if, besides the whitewash of a

Puvis de Chavannes, obliterating all colours equally, fanatics are found for the screaming yellow, blue and red of a Besnard, this also has a cause, revealed to us by clinical science" [Ibid., 28].

32. For a review of Nordau's principal beliefs and their public reception, see P. M. Baldwin, "Liberalism, Nationalism and Degeneration: The Case of Max Nordau," *Central European History* 13 (June 1980): 99–120.

33. Gurlitt died in 1893. For a number of years the gallery declined markedly in preeminence until it was revived by his son around 1905 and soon became again perhaps second only to Paul Cassirer among contemporary art galleries in Berlin. However, in December of 1893, after his death, a small show of Impressionist pictures was shown at the gallery, which included a Degas pastel of a ballet dancer, at least two Pissarro landscapes, and a landscape each by Monet and Sisley. See R. [Hans Rosenhagen], "Französische Maler im Salon Gurlitt," *Das Atelier* 75 (December 1893): 4–5.

34. G.C., "Der neue Gurlitt'sche Kunstsalon," *Das Atelier* 50 (15 November 1892): 2–3. On Gurlitt's marketing of Böcklin, see Elizabeth Putz, "Classical Antiquity in the Painting of Arnold Böcklin" (Ph.D. diss., University of California, Berkeley, 1979).

35. See H. Uhde-Bernays, *Im Licht der Freiheit* (Wiesbach: Insel, 1947), 42, and Elias, "Paul Durand-Ruel" (chap. 2, n. 23), 106. According to Uhde-Bernays, 213–15, Elias met and became friends with Camille Pissarro in 1890 and subsequently owned a significant collection of paintings, particularly by Monet and Cézanne.

36. Cited in Teeuwisse, *Vom Salon zur Secession*, 241 and note 593. Durand-Ruel's statement is supported by the fact that only the 1897 exhibitions were reviewed. See J.S. [Jaro Springer], "Ausstellungen und Sammlungen. Berlin," *Die Kunst für Alle* (1 February 1898): 142. In 1894 three Monets were exhibited in Gurlitt's gallery in Berlin and aroused only passing notice. They may well have been paintings belonging to the Bernstein collection. See the review in *Die Kunst für Alle* 9 (1 February 1894): 142. The cited works were "The Seine near Rouen," "Hyde Park," and "Ice Breaking on the Seine."

37. See J. Meier-Graefe, "Handel und Händler," *Kunst und Künstler* 11: 1 (1912): 27–34, and "Pächter und Bing," in *Geschichten neben der Kunst* (Berlin: S. Fischer, 1933), 87–103.

38. Identification of these paintings (and who lent them) cannot be determined.

39. Of course, there were notable exceptions to this rule. We know, for example, that Harry Graf Kessler, diplomat, museum director, and cultural politician, was a frequent visitor to Vollard's gallery in the early days when it was known to few outside Parisian modernist circles such as the Nabis.

40. W. Leistikow, "Moderne Kunst in Paris," *Die Freie Bühne* 4 (1893): 802–3. He found little of worth among the French artists at the Salons of 1893, even among those exhibiting on the Champs de Mars, such as Carolus Duran, Courtois, and Roll, and preferred the American Harrison and the Belgian Claus, and concluded with the remark that "Berlin art is not the worst on the Champs-de-Mars" [803].

41. See my discussion of the Scottish "Impressionists" in chapter 6, note 18.

42. H. Helferich [Emil Heilbut], "Claude Monet," *Freie Bühne für modernes Leben* 1 (26 March 1890): 225–30. Helferich's essay may well have been occasioned by the Monet-Rodin retrospective in Paris the year before. Helferich took pains to distinguish Monet from Manet for his readers, as well as to establish Manet's credentials vis-à-vis a much more familiar artist to German audiences, Bastien-Lepage, who by comparison was "dry, without temperament, patient—academic in a certain sense" [226]. *Die Kunst für Alle* confined its coverage of French modernism to small essays harshly critical of the Indépendants exhibitions in 1886 and 1887. An anonymous critic for *Die Kunst für Alle* 1 (15 September 1886): 353, commented on the side by side hanging of pictures by the Artistes indépendants and the Société des indépendants and came to the conclusion that "Was ist schlimmer als eine Flöte?, worauf die Antwort: zwei Flöten." The second essay by Otto Brandes on the 1887 Indépendants, "Die Impressionisten in der Ausstellung der Indépendants," *Die Kunst für Alle* 2 (1 May 1887): 238, was much more informed. The critic showed a real grasp of the principles of Neo-Impressionism, which he then, however, went on to rebut.

43. Bernstein and his wife Félicie brought approximately ten minor paintings and some watercolors by Manet, Monet, Degas, Morisot, Sisley, Cassatt, and de Nittis, and perhaps some others, with them to Berlin. Their collection had been formed under the tutelage of his cousin Charles Ephrussi, the editor of the *Gazette des beaux-arts*, who was himself only a moderate admirer of the Impressionists. See Karl-Heinz and Annegrel Janda, "Max Liebermann als Kunstsammler"; Peter Krieger, "Max Liebermanns Impressionisten-Sammlung und ihre Bedeutung für sein Werk"; and Barbara Paul, "Drei Sammlungen französicher impressionistischer Kunst im kaiserlichen Berlin - Bernstein, Liebermann, Arnhold," *Zeitschrift des deutschen Vereins für Kunstwissenschaft* 42:3 (1988): 11–30.

44. A measure of the impact of the Bernstein collection may be found in an essay published by Georg Brandes in 1882, "Japanesik og impressionistik Kunst," excerpts of which have been reprinted in English translation by Rewald, *History of Impressionism* (chap. 3, n. 3), 496–98. Brandes saw the Impressionists for the first time at the Bernsteins and concluded that only de Nittis had "a future." But he also observed "the astonishment, almost consternation" of many of Berlin's artists and noted that even "the most amazed and dismayed came back after several days and asked to see the pictures once more."

45. See Krieger, "Max Liebermanns," 62.

46. Although the van de Velde literature is vast, for a good overview of his early work and aesthetic theories, see Susan Canning, "Henry van de Velde. The early career as a painter 1880–1895," in *Henry van de Velde (1863–1957). Schilderijen en tekeningen* (Antwerp: Koninklijk Museum voor Schone Kunsten, 1988), 49–94. Van de Velde's international connections have been traced in the excellent exhibition catalogue, *Henry van de Velde. Ein europäischer Künstler in seiner Zeit*, ed. Klaus-Jürgen Sembach and Birgit Schulte (Cologne: Wienand, 1992). See also van de Velde's memoirs, *Geschichte meines Lebens* (Munich: R. Piper, 1962).

47. For the relationship between Bing, Meier-Graefe, and van de Velde, see Nancy Troy, *Modernism and the Decorative Arts in France* (New Haven: Yale University Press, 1991) and Catherine Krahmer, "Über die Anfänge des Neuen Stils. Henry van de Velde - Siefried Bing - Julius Meier-Graefe," in *Henry van de Velde*, 148–64.

48. In *Geschichte meines Lebens*, 107, van de Velde dismissed Bing and Meier-Graefe's enthusiasm as uncritical, untheoretical, and motivated more by the interest of novelty and modernity than by a deep understanding of the values of the new art.

49. See Moffett, *Meier-Graefe* (intro., n. 22), 178. Seidlitz knew of Bing through the entrepreneur's exhibitions of Japanese art at the Dresden gallery of Ernst Arnold; Seidlitz admired Japanese art and had begun a significant collection for Dresden's museums. See *Geschichte meines Lebens*, 127, and also W. von Seidlitz, *Geschichte des japanischen Farbenholzschnitts* (Dresden: Gerhard Kühtmann, 1897).

50. *Geschichte meines Lebens*, 134.

51. Ibid., 135. According to van de Velde, Liebermann at that time (1897) had already begun to collect van Gogh. Perhaps this is an error of memory or perhaps Liebermann later sold these pictures. At the time of his death he owned no works by the artist. See also Karl-Heinz and Annegret Janda, "Max Liebermann als Kunstsammler."

52. See *Geschichte meines Lebens*, 89–91. See also Herta Hesse-Frielinghaus, "Folkwang 1. Teil," in *Karl Ernst Osthaus. Leben und Werk* (Recklinghausen: Verlag Aurel Bongers, 1971), 119–244, esp. 139. Feilchenfeldt *Vincent van Gogh & Paul Cassirer, Berlin* (chap. 2, n. 81), 14–15, has discovered the specific authorization given by Johanna van Gogh to send the pictures to Cassirer.

53. On his business relationship with Bodenhausen, see *Geschichte meines Lebens*, 141–43. See also Thomas Föhl, "Henry van de Velde und Eberhard von Bodenhausen. Wirtschaftliche Grundlagen der gemeinsamen Arbeit," in *Henry van de Velde*, 169–205.

54. Signac's essay first appeared in installments in *La Revue blanche* between May and July 1898 and was then published as *D'Eugène Delacroix au néo-impressionnisme* (Paris: La Revue blanche, 1899). It made its German appearance under the title, "Französische Kunst. Neo-Impressionismus," *Pan* 4 (July 1898): 55–62. A complete German edition was published in a translation by the wife of the Neo-Impressionist painter Curt Herrmann through the agency of Bodenhausen in Krefeld in 1903 and was reprinted in Berlin in 1910. The kind of institutional allegiances that brought Signac's work to German readers is expressed in *Pan*'s editorial board in 1898: Bode, Bodenhausen, Flaischlen, Richard Graul, Richard Hartleben, Ludwig von Hofmann, Karl Koepping, Kessler, Lichtwark, Liebermann, and Seidlitz. See Karl H. Salzmann, "*Pan*. Geschichte einer Zeitschrift," in *Jugendstil*, ed. Jost Hermand (Darmstadt: Wissenschaftliche Buchgesellschaft, 1971), 178–208.

55. On van Rysselberghe, see Paul Eeckhout, *Retrospektive Théo van Rysselberghe* (Gand: Musée des Beaux-Arts, 1 July-16 September 1962).

56. Meier-Graefe gave significant space to the Neo-Impressionists in his

Entwicklungsgeschichte der modernen Kunst (intro., n. 3), I:225–46, and in *Der moderne Impressionismus*. See Harry Graf Kessler, "Zum Verständnis des Neo-Impressionismus," in *Deutsche und französische Impressionisten und Neo-Impressionisten* (Weimar: Großherzoglichen Museums für Kunst und Kunstgewerbe, 1903). This essay has been reprinted in Kessler, *Künstler und Nationen* (Frankfurt a.M.: Fischer, 1988), 54–59.

57. R. M. Rilke, "Impressionisten," reprinted in *Sämtliche Werke* 5 (Frankfurt a. M.: Insel, 1987), 447–50. For contrast see the far less probing review by Richard Mortimer, "Berliner Kunstbrief," *Die Kunst für Alle* 14 (1 January 1899): 98–102, where he described the exhibition as the "höchst bizarre, aber doch sehr interessante."

58. For many years Kessler owned Seurat's *Les Poseuses* displayed in a special frame designed by van de Velde to fit Kessler's small apartment (two hidden rollers allowed the selective viewing of a narrow band of Seurat's picture). See *Geschichte meines Lebens*, 161–62. See also Alexandre Kostka, "Der Dilettant und sein Künstler. Die Beziehung Harry Graf Kessler - Henry van de Velde," in *Henry van de Velde*, 253–73.

59. See Ambroise Vollard, *Recollections of a Picture Dealer*, trans. Violet M. Mac-Donald (Boston: Little, Brown, and Co., 1936), 81ff. and 145–48.

60. On van de Velde and the Nietzsche-Archiv, as well as for the Nietzsche cult among Central European artists and intellectuals, see Jürgen Krause, *Märtyrer" und Prophet". Studien zum Nietzsche-Kult in der bildenden Kunst der Jahrhundertwende* (Berlin: de Gruyter, 1984). Van de Velde also worked with Kessler to publish a deluxe edition of Nietzsche's *Also Sprach Zarathustra*. See Jane Block, "The Insel-Verlag Zarathustra: an untold tale of art and printing," *Pantheon* 45 (1987): 129–37.

61. On Osthaus and his cultivation of the fine arts, see *Karl Ernst Osthaus. Leben und Werk*, with contributions by Herta Hesse-Freilinghaus, Walter Erban, Klaus Volprecht, Sebastian Muler, Peter Stressig, and Justus Buekschmitt. The following account is largely indebted to their essays and van de Velde's memoirs, as well as to Johan Heinrich Müller, "Die Kunstsammlungen des Folkwang 1900–1914," in *Der westdeutsche Impuls 1900–1914* (Hagen: Karl Ernst Osthaus Museum, 1984), 29–47, and Paul Vogt, *Das Museum Folkwang, Essen* (Cologne: DuMont Schauberg, 1965), 9–27.

62. The Folkwang's exterior was planned, long before Osthaus met van de Velde, by Carl Gérard, a Berlin architect, working in an academic, historicist style. See Hesse-Freilinghaus, "Folkwang 1. Teil" in *Karl Ernst Osthaus* (note 61 above), 122–23.

63. See Erben, "Karl Ernst Osthaus, Lebensweg und Gedankengut," in ibid., 41. On van de Velde's contributions to Krefeld's industrial designs, see Gerda Breuer, "Der Künstler ist seiner innersten Essenz nach glühender Individualist. Henry van de Veldes Beiträge zur Reformierung der Krefelder Industrie -Grenzen einer Gewerbeförderung durch Kunst," in *Henry van de Velde*, 206–26.

64. Osthaus purchased from Bernheim Jeune, Matisse's *Asphrodel* (1907) for

1,500 francs. The painting still hangs in the Folkwang, Essen. See Vogt, *Das Museum Folkwang, Essen*, 22.

65. On Deneken's exhibition activities in Krefeld, see Gerde Breuer, "Das Kaiser Wilhelm Museum Krefeld," in *Der westdeutsche Impuls, 1900–1914* (Krefeld: Kaiser Wilhelm Museum, 1984), 76–157.

66. See Magdalena M. Moeller, *Der Sonderbund* (Cologne: Rhineland Verlag, 1984) and *Der westdeutsche Impuls 1900–1914* (Düsseldorf: Kunstmuseum, 1984).

67. Muther, *The History of Modern Painting* (chap. 1, n. 11), I:170.

68. C. Gurlitt, *Die deutsche Kunst des Neunzehnten Jahrhunderts* (Berlin: G. Bondi, 1899).

69. Cited in Niess, *L'Oeuvre: Zola, Cézanne and Manet* (chap. 5, n. 35), 82.

70. If Muther presented Manet and the Impressionists as the "final, decisive word" in the liberty of modern art, he was hardly more informed about the victors than Pecht had been. He opened his chapter "Fiat Lux"—which occupies the center of the second volume—with a brief and substantially inaccurate account of the origins of the word "Impressionism." He had the first Impressionist exhibition in Nadar's studio in 1871, Manet's first public exhibition in 1862, the first Salon des Refusés in 1865. He believed, inaccurately, following Bley, that "the Impressionists took the Salon by storm" [II: 722].

71. Brandes' still vastly underestimated influence on contemporary art and literature in the 1890s is an intellectual scandal. For an acknowledgment of Brandes' seminal position, see the brief discussion by Malcolm Bradbury and James McFarlane, "The Name and Nature of Modernism," in *Modernism*, ed. Bradbury and McFarlane (London: Penguin, 1976), 19–56.

72. G. Brandes, *Die Hauptströmungen der Literatur des 19. Jahrhunderts* (Leipzig: H. Barsdorf, 1892).

73. The critic and novelist Eugen Wolff first used the concept of "modern" in German around 1886 in order to define literary naturalism. Naturalism was subsequently identified in German criticism with scientific positivism, social democracy, and egalitarianism, in other words, the faith in the capacity of modern knowledge and technologies to transform the world. See Wilhelm Kosch, *Deutsches Literatur-Lexikon* II (Halle: Max Niemeyer Verlag, 1930), 3116.

74. See, for example, the publication of Brandes' lectures on Nietzsche under the title "Aristokratischer Radikalismus. Eine Abhandlung über Friedrich Nietzsche," *Deutsche Rundschau* 63 (April 1890): 52–89. The essay has been translated in *Friedrich Nietzsche* 3–56.

75. G. Brandes, "Rembrandt als Erzieher," *Freie Bühne für Modernes Leben* 1 (7 May 1890): 390–92.

76. There are a few exceptions to the rule. Muther devotes an unillustrated paragraph to the Neo-Impressionists, for example, who are described as artists on the extreme left [III: 50]. But by comparison, artists such as Bastien-Lepage, L'Hermitte, Roll, and Raffaelli are discussed over numerous, illustrated pages.

77. The only other Post-Impressionists besides Seurat and Signac Muther mentions was Odilon Redon.

78. Muther's sources were relatively varied but dominated by art criticism either published in book form or book length in format. They began with Duranty's *La nouvelle peinture* and Duret's *Les peintres impressionnistes*. Notable too were Fénéon's first account of the Neo-Impressionists, *Les Impressionnistes en 1886*, Lecomte's *L'Art Impressionniste*, the first volume of Geffroy's *Le Vie artistique* (composed primarily of the critic's Salons of 1890 and 1891), and the two volumes of Joris Huysmans' criticism, *Certains* and *L'Art Moderne*. There are some surprising and puzzling additions—such as the *Catalogue illustré de l'exposition des peintures du groupe Impressionniste [sic] et Synthétiste, faite dans le local de M. Volpini au Champs de Mars* (1889), an exhibition Muther likely did not see, since he never mentioned its chief exhibitors, Gauguin, Bernard, and Schuffenecker. For Manet, the criticism was dominated by Zola's *Mes Haines* and the catalogue for the Manet retrospective. In short, what was most available to Muther and most guided his remarks were Duranty, Zola, Duret, and Lecomte.

79. K. Fiedler, *Ueber die Beurteilung von Werken der bildenden Kunst* (1876). The translation is by Henry Schaefer-Simmern, *On Judging Works of Visual Art* (Berkeley and Los Angeles: University of California Press, 1949), 11.

80. Muther's reputation ran into other troubles. In the *Geschichte*, as elsewhere, Muther frequently lifted or only subtly realtered texts written by himself or others. That Muther was a frequent plagiarizer became well-known in 1896 when Muther was exposed for borrowing extensively from others. See H. Uhde-Bernays, *Mittler und Meister* (Munich: Leibnis, 1948), 140–61. See also the strange book by Muther, *Die Muther-Hetze: Ein Beitrag zur Psychologie des Neides und der Verläumdung* (Munich and Leipzig: G. Hirth, 1896).

81. W. von Seidlitz, *Die Entwicklung der modernen Malerei* (Hamburg: A. G. Richter, 1897).

82. J. Springer, "Die Ausstellung der 'Elf,'" *Die Kunst für Alle* 11 (15 April 1896): 211–13. As a regular observer of Berlin's art world in the 1890s and as a curator in the Kgl. Kupferstich-Kabinett and professor of art history, Springer was a consistent advocate of modernism and promoter of Secessionism.

83. K. Voll, *Die Kunst für Alle* 12 (15 August 1897): 355.

84. See Ernst Zimmermann, "Die Kunstausstellung in Hamburg," *Das Atelier* 10 (May 1895): 5–6.

85. See Paul Schumann, "Dresdener Kunstausstellung," *Das Atelier* 18 (September 1897): 4–5.

86. Liebermann recounted the story in his homage to the museum director, "Hugo von Tschudi," first published in *Kunst und Künstler* in 1912 and reprinted in *Gesammelte Schriften* (Berlin: Bruno Cassirer, 1922), 155–64, esp. 159–60.

87. For the excitement generated by this installation, see Georg Gronau, "Die Neugestaltung der National-Galerie in Berlin," *Die Kunst für Alle* 13 (1 February

1898): 129–36. These acquisitions roused the ire of the kaiser, symbolically inaugurating a tumultuous curatorship that ended in Tschudi's departure in 1908. For an account of Tschudi's tenure at the National-Galerie and the 1908 controversy over his "dismissal" and "rehiring," see Paret, "The Tschudi Affair," (chap. 6, n. 3).

88. According to the Venturi provenance the Cézanne previously belonged to that *juste milieu* painter, Jacques-Émile Blanche. No doubt Tschudi understood Cézanne to be simply another Impressionist.

89. The Caillebotte collection raised considerable interest internationally. As one anonymous critic reported in the conservative English art periodical *The Artist* (April 1898): 202, "the acceptance by the Luxembourg of the Caillebotte bequest . . . constitutes if not an epoch at least a very definite date in the history of the art of this century. Firstly, because official recognition has at length been given to a school of painters which has existed outside and away from the Institute and all beaten paths; and secondly, it is a definite date because it marks the end of the struggles and battles of which this school has been the cause. Henceforth the era of struggle is closed, and these painters whether accepted as a whole or only in part, cannot but have their page in the history of art." Similar observations were made by German critics, who also dwelt at length on the controversy surrounding its admission. But it probably was not until the German public travelled to Paris for the 1900 Exposition Universelle that the newly installed Luxembourg was to exert its influence.

90. See *Catalogue Officiel illustré de L'Exposition Centennale de l'Art Français de 1800–1889* (Paris: Ludovic Baschet, 1900).

91. Muther, for one, had obviously come to know the dealer in the years following the publication of the *Geschichte der modernen Malerei*. His praise for the dealer was high. Repeatedly in the Impressionist chapter of his *Ein Jahrhundert Französischer Malerei* (Berlin: S. Fischer, 1901) Durand-Ruel was given a significant place. He was made to lead the group to England in 1870. So too was the dealer credited with a comparable historical role: "Es war genug der Mühe, all die Anregungen zu verdauen, die in diesen Werken gegeben waren, genug der Anstrengung, als Gros der kühnen Avant-garde zu folgen, und Durand-Ruel irrte nicht, als er einst die unverkäuflichen Bilder kaufte" [210]. This passage is also notable, of course, for a very early use by a German critic of the term "avant-garde," the application of which I suspect Muther learned from Duret's book by the same name, and which did not come into common currency until some time later.

92. For a discussion of the politics of the Franco-German responses to the Paris World's Fair of 1889 and the first Berlin Internationale Kunstausstellung in 1891, see Françoise Forster-Hahn, " 'La Confraternité de l'art art': Deutsch-französische Ausstellungspolitik von 1871 bis 1914," *Zeitschrift für Kunstgeschichte* 48:4 (1985): 506–36, esp. 521–32.

93. For example, see J. Meier-Graefe, *Die Weltausstellung in Paris, 1900* (Paris: F. Krüger, 1900).

94. Although the 1900 Exposition has often been taken uncritically to represent the apotheosis of l'art nouveau, contemporary criticism—and especially German criticism—was harsh. See Philippe Julian, *The Triumph of Art Nouveau. Paris Exhibition 1900*, trans. Stephen Hardman (New York: Larousse, 1974). Even Debra Silverman, in her otherwise exemplary *Art Nouveau in Fin-de-Siècle France* (Berkeley and Los Angeles: University of California Press, 1989), tends to overvalue the exhibition as the apotheosis of art nouveau. Certainly the exhibition marked its culmination in France, but it equally signalled its collapse. By concentrating on its two most widely praised features (besides the Centennale), Bing's pavilion *L'Art Nouveau* and the Rodin retrospective held under the auspices of the Exposition, Silverman overlooks the general criticism of the show. On Bing's pavilion and its reception, see Gabriel P. Weisberg, *Art Nouveau Bing. Paris Style 1900* (Washington and New York: Smithsonian Institution and Abrams, 1986), esp. 161–205.

95. See Richard Mandell, *Paris 1900. The Great World's Fair* (Toronto: University of Toronto Press, 1967), 110.

96. Friedrich Naumann, *Ausstellungsbriefe* (Berlin: Verlag der Hilfe, 1909), 52–115. See also Theodor Heuss, *Friedrich Naumann: Der Mann, Das Werk, Die Zeit*, 2nd rev. ed. (Stuttgart: Rainer Wunderlich, 1949).

97. E. N. Pascent, "Von der modernen Kunst auf der Pariser Weltausstellung," *Die Kunst für Alle* 16 (15 October 1900): 74–76. The only surviving "great artists" Pascent discovered was Puvis de Chavannes, who, he said, was just now creating his best work.

98. See note 91 above.

99. Courbet, however, who was substantially represented at the Centennale, was not given his "proper" emphasis by Muther. Perhaps it was because Muther no longer knew how to fit the artist within his historical schema. Manet is made to conquer both contemporary themes and the painting of nature and Manet now dominated Muther's whole perspective. It is Manet who embodies Zola's naturalism, as he had in Germany from the beginning. Courbet consequently is described as being related to Millet "wie Tizian zu Michelangelo oder wie Grünewald zu Dürer" [118]. Later in the text Muther managed a more extensive appreciation, but one that still tended to excise Courbet from the canonical place he enjoyed in the earlier book: "Ich halte Courbet für einen der allergrößten französischen Künstler: als Landschafter ebenso fein wie die Fontainebleauer, als Tiermaler größer denn Troyon, als Pleinairmaler (sic) beinahe so groß wie Manet" [122].

100. Muther's formalism betrayed him on this count. He argued, for example, that "what is called Impressionism is—let it not be forgotten—a technique which can be applied to any subject. Whether the subject be a virgin, or a labourer, it can be painted with divided tones, and certain living artists, like the symbolist Henri Martin, have proved it by employing this technique for the rendering of religious or philosophical subjects" [38–40].

101. H. v. Tschudi, "Die Jahrhundert-Ausstellung der französischen Kunst," *Die*

Kunst für Alle 16 (1 October 1900); (15 October 1900); and (1 November 1900). The essay is reprinted in the *Gesammelte Schriften*, from which, because of its greater accessibility, I give the following citations.

102. In this context, Durand-Ruel is singled out by Tschudi for his wisdom in buying and supporting the Impressionists.

103. Dewhurst, *Impressionist Painting* (chap. 2, n. 22), 4–5.

104. A. Mellerio, *L'Exposition de 1900 et L'Impressionnisme* (Paris: H. Floury, 1900). Mellerio's bibliography is itself a testament to the growing canonization of Impressionism: his list names Monet, Pissarro, Renoir, Degas, Cézanne, Sisley, Morisot, Guillaumin, Boudin, Caillebotte, Cassatt, and Zandomeneghi.

105. In support of this definition he cited Lecomte. Mellerio identified Monet as the incarnation of Impressionism and cast Pissarro, Renoir, and Degas in subsidiary roles. For a historical description of the Impressionist exhibitions Mellerio deferred to Geffroy's 1893 account.

106. The following quotations are cited from the second edition of T. Duret, *Histoire de Édouard Manet et de son oeuvre* (Paris: Charpentier, 1906). The essential difference between the two versions is that the latter omits the catalogue raisonné, the first for the artist and the first for a modernist French painter since Robaut's on Delacroix. Among Duret's other post-1900 writings, see the revised edition of *Histoire des peintres impressionnistes* [1878] published in Paris in 1906 and the expanded English version *Manet and the French Impressionists* (New York and London, 1910), as well as such German translations from this work as "Claude Monet und der Impressionismus," in *Kunst und Künstler* 2 (March 1904): 233–44.

107. John Rewald has described Mauclair best in his *The History of Impressionism* (chap. 3, n. 3), 611. "As an art critic of the *Mercure de France* . . . he saw in neo-impressionism a *trifling* technique, referred to Gauguin's art as *colonial*, spoke of the *gangsterism* of Lautrec, poured out his scorn for Cézanne and treated Pissarro with contempt. At the same time he admired Böcklin, Hodler, Carrière, etc. But when the painters were finally rewarded with recognition, and when most of those he had slandered had died, Mauclair did not scruple to add his voice to the general expressions of admiration."

108. C. Mauclair, *The French Impressionists (1860–1900)* (London and New York: Duckworth and Dutton, 1903). The French version was not published until a year later. Duckworth also brought out a picture book by Mauclair, *The Great French Painters and the Evolution of French Painting from 1830 to the Present Day* (London: Duckworth & Co., 1903), an anemic reflection of the Centennale, but perhaps identifiable as the first French effort to write a "modernist" history of nineteenth-century French painting. Compared to the German alternatives, or the British writer D. S. MacColl's *Nineteenth Century Art* (Glasgow: James Maclehose & Sons, 1902), Mauclair's was a thin book of cliche material. Remarkably for this late date, he confused the 1863 Salon des Refusés with the first Impressionist exhibition at Nadar's in 1874, placing a Monet "Impression" (he must have meant the now famous picture *Impression Sunrise*) at the Refusés [10].

109. This series resembles the Knackfuß artist monographs that dominated German art literature in the nineties as well as the series edited by Richard Muther, *Die Kunst*, a kind of modernist addendum to Knackfuß (which among numerous essays published Meier-Graefe's important *Manet und sein Kreis* and *Der moderne Impressionismus*. See my discussion in chapter 8). So popular was its format that it provided English translations of even simple French phrases, then a very rare phenomenon among scholarly books on French subjects. Published alongside biographies of artists such as Dürer and Millet—the latter written by Romain Rolland [!] for Duckworth's—books like Mauclair's legitimized Impressionism within its covers and by association.

110. C. Mauclair, *De Watteau à Whistler*, 2nd ed. (Paris: Bibliothèque-Charpentier, 1905; first edition E. Fasquelle, 1905).

111. H. v. Tschudi, *Edouard Manet* (Berlin: Bruno Cassirer, 1902).

112. Tschudi's essay was still a second-hand account of the origins of French modernism; he did not know more than what could be found in the Bazire biography (it is not likely on the basis of textual evidence that he knew Proust's memoirs of Manet published as "Edouard Manet inédit. Souvenirs," *La Revue blanche* 12 (1897): 125–35, 201–97, 413–27, which was not published as a book until 1913). See A. Proust, *Edouard Manet. Souvenirs* (Paris: Renouard et Laurens, 1913), which has recently been reprinted (Caen: L'Échoppe, 1988).

113. Tschudi, *Edouard Manet*, 45.

114. Tschudi argues, for example, that "just as real progress, so too is real originality only thinkable on the soil of naturalism. Nothing protects so well against becoming manneredly shallow or against the danger of falling into sympathy with foreign achievements. This is the common mistake made by all those who understand naturalism as only a photographic means of reproducing external appearance. Naturalism in art means, however, the artistic registering (Erfassen) of nature"[42].

115. The Mánes society was named for an influential Czech painter and teacher, Josef Mánes (1820–1871), and was founded in 1887. The group had as its most significant honorary members Alphonse Mucha and Franz Kupka (both residing in Paris).

116. Concerning the Prague exhibition, with supporting documents, see *Auguste Rodin—Plastik/Zeichnungen/Graphik* (Berlin, East: Staatlichen Museen zu Berlin, 1979). According to Claude Keisch's chronology of Rodin in Germany, there was already competition by 1898 among Berlin dealers over who would represent Rodin in Germany. Meier-Graefe advised Keller & Reiner and Liebermann advised the Cassirers, but neither were able to take exclusive or even significant control of Rodin's German market. Keisch also noted that the Dresden gallery of Emil Richter negotiated with Rodin and exhibited selections of his work through 1910. Keisch discovered that in 1899 Meier-Graefe had conceived of a plan to form a society that would specialize in turning out editions of Rodin bronzes, though it came to nothing. See also Ernst-Gerhard Güse, "Auguste Rodin und Deutschland," in *Auguste Rodin. Zeichnungen und Aquarelle* (Stuttgart: Verlag Gerd Hatje, 1984), 13–40.

117. Rodin's first fame in Central Europe came at the Dresden Internationale Kunstausstellung in 1897. Even earlier, Georg Treu, the curator of Dresden's sculpture collection, acquired a plaster of the *Age of Bronze* and a bronze *L'Homme au nez cassé*. At the close of the 1897 show, Treu bought a plaster *La voix intérieure* and two bronzes, a large head of Victor Hugo and a small female torso. Tschudi followed by acquiring as a gift *L'Homme et sa pensé* for the National-Galerie. Also in 1897 Roger Marx published an essay on Rodin in *Pan* (November 1897). Rarely was Rodin's work challenged in German art criticism, confined largely to the kaiser and scattered feuilleton reviewers. See J. A. Schmoll gen. Eisenwerth, *Rodin-Studien* (Munich: Prestel, 1983), 329–46. Max Nordau wrote a vituperative critique of Rodin for the Vienna *Neue Freie Presse* (2 July 1908) which has been reprinted in *Rodin* (Paris and Vienna: Musée Rodin, 1980). Rodin's triumphal success in Prague and Vienna are recounted in Jiri Mucha, *Alphonse Mucha. His Life and Art* (London: Heinemann, 1966), 253–55, and by Bertha Zuckerkandl, *Oesterreich Intim. Erinnerungen 1892– 1942* (Frankfurt, Berlin and Vienna: Propyläen, 1970).

118. R. M. Rilke, "Rodin," in *Auguste Rodin. Readings on His Life and Work*, ed. Albert Elsen and trans. Jesse Lamont and Hans Trausil (Englewood Cliffs, N.J.: Prentice-Hall, 1965), 110–44. "For erroneous as it is to see in Rodin's plastic art a kind of Impressionism, it is the multitude of precisely and boldly seized impressions that is always the great treasure from which he ultimately chooses the important and necessary, in order to comprehend his work in its perfect synthesis"[131].

119. G. Simmel, "Rodins Plastik und die Geistesrichtung der Gegenwart," *Berliner Tageblatt* (29 September 1902). The essay has been reprinted in Hannes Böhringer and Karlfried Gründer, eds., *Aesthetik und Soziologie um die Jahrhundertwende: Georg Simmel* (Frankfurt a. M.: Klostermann, 1976), 231–37.

120. For a useful overview of Simmel's ideas in relation to the concept of modernity, see David Frisby, *Fragments of Modernity* (Cambridge: MIT Press, 1988), esp. 38–108.

121. Meier-Graefe, who would later approvingly, and extensively, quote Simmel's text in his *Entwicklungsgeschichte der modernen Kunst*, believed that Simmel too readily dismissed the developments of sculpture that led up to Rodin (and which he set down at length in his own book). See Meier-Graefe, *Entwicklungsgeschichte der modernen Kunst* (intro., n. 3), 263–86. All subsequent references in the text are to the 1904 edition. The Simmel passages, with only brief paraphrases, are reprinted on 272–86. Eisenwerth has argued (*Rodin-Studien*, 317–28) that *all* of Meier-Graefe's reading of Rodin owed to Simmel's essay and that there appears to have been some tension between the critic and the sociologist over this matter. The passages directly borrowed from Simmel were excised from the subsequent editions of the book. But he reproduced unchallenged Simmel's formulation of the dualism between form and content and Rodin's role in reuniting them.

122. "The Metropolis and Mental Life" was first published in the 1903 *Jarhbuch der Gehe-Stiftung* under the collective title *Die Großstadt*. The most readable translation of Simmel's essay is by C. Wright Mills and H. H. Gerth, "The Metropolis and

Mental Life," in *The Sociology of Georg Simmel*, ed. Kurt H. Wolff (London: Collier-Macmillan, 1950), 409–24.

123. I owe this reading of Avenarius' aesthetic views to Geoffrey Perkins, *Contemporary Theory of Expressionism* (Berne and Frankfurt a. M.: Verlag Herbert Lang, 1974), 26–27.

124. K. Scheffler, "Impressionistische Weltanschauung," *Die Zukunft* 11 (24 October, 1903): 138–47. Scheffler's views on Impressionism were then incorporated into a larger social critique of contemporary art, *Die Moderne Malerei und Plastik* (Berlin: Leonhard Simion, 1904).

125. Scheffler, "Impressionistische Weltanschauung," 139.

126. F. Laban, "Im Zwanzigsten Jahre Nach Manets Tode," *Zeitschrift für bildende Kunst* 15 (November 1903): 25–35.

127. Tschudi's statement was published in the journal *Museum* 5 (1903): 35.

128. Laban concluded his essay with a bibliography of the Manet literature which although not complete is instructive of the growing acquaintance of German critics and art historians with a far more extensive body of French critical texts dating both from the artist's lifetime and posthumously.

129. E. Heilbut, "Chronik," *Kunst und Künstler* 2 (December 1903): 120–22.

CHAPTER 8

1. The *Entwicklungsgeschichte der modernen Kunst* developed over its numerous editions. The version most widely read today reflects the text as it stood in the 1920s after the critic had produced his various monographs on the Impressionists and Post-Impressionists. The first edition (1904) was far more bound up with Jugendstil, so that Meier-Graefe's first reading of French modernism is slanted towards reconciling the two traditions. In later editions, significant revisions pared away much of the decorative arts intentions of the original. All subsequent citations will come from this first edition.

2. The most systematic treatment of Meier-Graefe's career is Moffett, *Meier-Graefe as Art Critic* (intro., n. 22). For useful critical reappraisals see Ron Manheim, "Julius Meier- Graefe—'Kunstschriftsteller' zwischen Traditionsbewusstsein und Modernität," in *Altmeister moderner Kunstgeschichte*, ed. Heinrich Dilly (Berlin: Reimer, 1990), 95–116; Hans Belting, "Nachwort," in J. Meier-Graefe, *Entwicklungsgeschichte der modernen Kunst*, ed. H. Belting (Munich and Zurich: Piper, 1987), 727–57; and Henry Schumann, "Julius Meier-Graefe als Kunstkritiker," in *Julius Meier-Graefe. Kunst-Schreiberei, Essays und Kunstkritik* (Leipzig and Weimar: Gustav Kiepenheuer, 1987), 283–321. See also Meier-Graefe, *Geschichten neben der Kunst* (chap. 7, n. 37).

3. C. Levi-Strauss treats the "bricoleur" in *The Savage Mind* (Chicago: University of Chicago Press, 1966), 18.

4. For a discussion of Nietzsche's attack on the German universities, see Frederic Lilge, *The Abuse of Learning* (New York: MacMillan, 1948), 84–110.

5. Udo Kultermann, *Kunst und Wirklichkeit. Von Fiedler bis Derrida* (Munich: Scaneg, 1991), 111–28, on the other hand, has argued that in Meier-Graefe's adoration of the geniuses of art, the great personalities, he followed directly in the wake of the prejudices of Hermann Grimm.

6. J. Meier-Graefe, *Manet und sein Kreis* (Berlin: Bard, Marquardt, 1902), 131.

7. Although the exact reasons for the dismissal are still subject to conjecture, clearly nationalism (as well as Lautrec's reputation) played the dominant role. See Moffett, *Meier-Graefe as Art Critic*, 157 n. 49.

8. One may only speculate on how close a connection existed between Bing and Meier-Graefe. Weisberg, *Art Nouveau Bing. Paris Style 1900* (chap. 7, n. 94), sees them as two quite distinct actors in Parisian art nouveau. But since Meier-Graefe, as editor of *Dekorative Kunst*, consistently wrote and published reviews in favor of Bing's shop, they had to maintain a certain public distance. Yet, on occasion, Bing clearly relied on Meier-Graefe, as in the case of the Munch exhibition in 1896.

9. S. Przybyszewski, *Das Werk des Edvard Munch* (Berlin: S. Fischer, 1894). The other contributors were Franz Servaes and Willi Pastor. That Fischer was the publisher is also noteworthy, since he had already become a significant force in publishing naturalist dramas and novels, among them works by Hermann Bahr and Arno Holz, as well as managing the business affairs of *Die Freie Bühne*. On Fischer, see Peter de Mendelssohn, *S. Fischer und sein Verlag* (Frankfurt a. M.: S. Fischer, 1970), esp. 85–136.

10. See Reinhold Heller, "Affaeren Munch, Berlin, 1892–1893," *Kunst og Kultur* 52 (1969): 175–91, or the author's more accessible account in *Munch. His Life and Work* (Chicago: University of Chicago Press, 1984).

11. See Moffett, *Meier-Graefe as Art Critic*, 102. On the extensive exhibition history of Munch in Germany and elsewhere, see Lucius Grisebach, "Munch-Ausstellungen," in *Edvard Munch. Probleme-Forschungen-Thesen*, ed. Henning Bock and Günter Busch (Munich: Prestel, 1973), 239–48.

12. J. Meier-Graefe, *Acht Radierungen* (Berlin, June 1895).

13. J. Meier-Graefe, "Die Stellung Edouard Manet," *Die Kunst für Alle* 15 (1 November 1899): 58–64.

14. There is no portrait of Paganini in the catalogue raisonné by Andrew McClaren Young, Margaret McDonanald, Robin Spencer, and Hamish Miles, *The Painting of James McNeill Whistler* (New Haven: Yale University Press, 1980). Meier-Graefe may have misidentified the celebrated portrait *Arrangement in Black: Portrait of Señor Pablo de Sarasate*, 1884 (cat. no. 315, Carnegie Institute, Pittsburgh), who holds a violin.

15. As a probable homosexual himself, one may only imagine what Wilde meant to Meier-Graefe as a positive exemplar and as a cautionary example of European society's treatment of gays. The scant information we have regarding Meier-Graefe's life, the marginal number of published correspondence from one of the truly central figures in German cultural life in this era (compared especially to the extensive surviving correspondence of Rilke or even of Bodenhausen) suggests a systematic destruction of records.

16. The decadent Wilde has been a constant figure of literary criticism since at least Arthur Symons' essay, "The Decadent Movement in Literature," *Harper's New Monthly Magazine* (November 1893) and indelibly confirmed in Holbrook Jackson's *The Eighteen Nineties* (London: Pelican, 1939), first published in 1913. In Jean Pierrot's *The Decadent Imagination 1880–1900*, trans. Derek Coltman (Chicago: University of Chicago Press, 1981), Wilde is cast as a kind of intellectual precursor and bridge between the French decadents and the English aesthetic movement. These readings tend to overlook the extraordinarily modernist viewpoint of Wilde's formalist, relativist, and evolutionary conception of art.

17. O. Wilde, "The Critic As Artist," first published in *The Nineteenth Century* in 1890 and reprinted in the 1891 volume *Intentions*. The following passages are cited from *Complete Writings of Oscar Wilde* (New York: Nottingham Society, 1909), 97–224. It would take another book to trace Wilde's direct debt to Whistler, to Walter Pater, and to Thomas Carlyle.

18. R. Fry, "In Praise of Cézanne," *The Burlington Magazine* 52 (February 1928): 98–99. I owe this citation to Richard Shiff, *Cézanne and the End of Impressionism* (Chicago: University of Chicago Press, 1984), 276 n. 24.

19. On Taine, see Thomas H. Goetz, *Taine and the Fine Arts* (Madrid: Playor, 1973).

20. See, for example, Lewis F. Day, *Nature and Ornament* (London: Batsford, 1909) and Walter Crane, *Line and Form* (London: G. Bell, 1900).

21. My reading of Bing and Meier-Graefe's internationalism is indebted to Troy, *Modernism and the Decorative Arts* (chap. 7, n. 47). Troy's analysis offers a useful counterweight to the official promotion of national style in the decorative arts presented by Silverman, *Art Nouveau in Fin-de-Siècle France* (chap. 7, n. 94).

22. S. Bing, "Wohin treiben wir?," *Dekorative Kunst* 1 (1897–98): 1–3, 68–71, 173–77. Characteristically, Meier-Graefe borrowed this title, as he borrowed Nietzsche's titles, in 1913, in an essay that examined the failures of contemporary art. See note 82 below.

23. As quoted in Troy, *Modernism and the Decorative Arts*, 30.

24. The idea of a French/German correspondence was remarkable for its time. In his prospectus [*Dekorative Kunst* 2:1 (1898)] Meier-Graefe explained that the French publication would advance "das Ansehen deutscher Kunst und deutschen Gewerbes." Perhaps not coincidentally, the first number of the French edition was exclusively devoted to van de Velde. See *L'Art Décoratif* 1:1 (October 1898).

25. Troy, *Modernism and the Decorative Arts*, 45 n. 131, cites the review of Octave Mirbeau, "Art Nouveau," *Le Journal* 17 (22 December 1901): 1.

26. See Moffett, *Meier-Graefe as Art Critic*, 38.

27. Ibid., 111 n. 141, provides the complete list. The other artists were Frank Brangwyn, Carrière, Denis, Lautrec, Liebermann, Minne, Alfred Müller, Max Arthur Stremel, Vallotton, Vuillard, and Ignazio Zuluoga.

28. J. Meier-Graefe, "La Maison Moderne," *Die Zukunft* 38 (1902): 279–84.

29. The causes behind the sudden international eclipse of art nouveau have never been systematically examined. S. Tschudi Madsen, *Art Nouveau* (London: Weiden-

feld and Nicholson, 1967), 234–36, has suggested a number of possible causes (though they are not pursued in detail): the difficulty of reconciling the individualist element of art nouveau design with the problems of mass production, its elitism, the collapse of ornamentalist aesthetics under post-1900 functionalism in architecture, the desire for a new style after 1900, and the backward-looking character of art nouveau, as an anti-style rather than a productive and endlessly flexible new style. "In so far as Art Nouveau was an anti-movement, a reaction against what had gone before, it ceased to have any meaning once the stylistic chaos of the nineteenth century had been tidied up"[235].

30. See A. Flechtheim, "Postscript," in James Laver, *French Painting and the Nineteenth Century* (London: Batsford, 1937), 107.

31. J. Meier-Graefe, "Beiträge zu einer modernen Aesthetik," *Die Insel* 1 (October 1899): 65–91; (November 1899): 181–204; (January 1900): 92–105; (February 1900): 203–27; (March 1900): 351–74; and (May 1900): 199–223.

32. Meier-Graefe, "Beiträge," part 1, 74.

33. For an analysis of Wölfflin's method, see M. Podro, "Wölfflin and Classic Art," in *The Critical Historians of Art* (New Haven: Yale University Press, 1982), 98–116.

34. See L. D. Ettlinger's review of K. Moffett's *Meier-Graefe as Art Critic*, "Julius Meier-Graefe: An Embattled German Critic," *The Burlington Magazine* 117 (October 1975): 672–74.

35. In making these assertions about van Gogh's anarchism, Meier-Graefe knew full well the conventional association of Neo-Impressionism with anarchism, being personally acquainted with both Fénéon and Signac. It may have been that the image of the bomb-throwing anarchist derived fresh currency from the publication of Peter Kropotkin's *Memoiren eines russischen Revolutionërs* (Stuttgart: R. Lutz, 1899). It was introduced by the ubiquitous Georg Brandes and we know that Rainer Maria Rilke, at least, read it soon after it was published (22 November 1900). See Ingeburg Schnack, *Rainer Maria Rilke. Chronik seines Lebens und seines Werkes. Vol 1. 1875–1920* (Frankfurt a.M.: Insel, 1990), 97ff.

36. See note 6.

37. Meier-Graefe's unusual resistance to the canonization of the individual Impressionist masters in these early years is made even more emphatic by the publication of his *Impressionisten* (Munich and Leipzig: G. Hirth, 1907) which surprisingly devotes chapters to Guys (!), Manet, van Gogh, Pissarro, and Cézanne. Although Meier-Graefe later wrote monographs on Degas (1920) and Renoir (1911), he would never so honor any of the landscapists, reiterating the German predilection for the figurative Impressionists.

38. Meier-Graefe, for example, edited and translated an edition of Delacroix's writings: *Literarische Werke* (Leipzig: Insel, 1912). See Catherine Krahmer, "Meier-Graefe et Delacroix," *Revue de l'Art* 99 (1993): 60–68.

39. Wickhoff is hardly read anymore, but fortunately his essay "On the Historical Unity in the Universal Evolution in Art" in a translation by Peter Wortsman has

been reprinted in *German Essays on Art History*, ed. Gert Schiff (New York: Continuum, 1988), 165–72. See also Alois Riegl's essay "Late Roman or Oriental?," translated by Wortsman in the same volume, 173–90. And see Schiff's useful introduction, xi–lxxii. See also the discussion of Riegl in Michael Ann Holly, *Panofsky and the Foundations of Art History* (Ithaca: Cornell University Press, 1984), esp. 69–96.

40. For a discussion of the rise of the progressive stylistic model of art history in Germany, see Thomas Gaehtgens, "Les rapports de l'histoire de l'art et de l'art contemporain en Allemagne à l'époque de Wölfflin et de Meier-Graefe," *Revue de l'art* 88 (1990): 31–38. Of course, the Hegelian project of German art historiography has long been a theme in the work of E. H. Gombrich, but see in particular *In Search of Cultural History* (Oxford: Clarendon, 1969) and *The Ideas of Progress and Their Impact on Art* (New York: Cooper Union, 1971).

41. For a taxonomy of the German art historical community and its positions on modernism, see Gottfried Boehm, "Die Krise der Repräsentation. Die Kunstgeschichte und die moderne Kunst," in *Kategorien und Methoden der deutschen Kunstgeschichte 1900–1930*, ed. Lorenz Dittmann (Stuttgart: Steiner, 1985), 113–28.

42. G. Bachelard, *Le nouvel esprit scientifique* (Paris: Presses Universitaires de France, 1934). The translation is by Mary McAllester Jones, ed., *Gaston Bachelard, Subversive Humanist* (Madison: University of Wisconsin Press, 1991), 54.

43. For example, Meier-Graefe, *Manet und sein Kreis*, 18, wrote that "Weil sie ganz auf das Literarische verzichten, weil sie gesehen, nicht meditiert werden wollen, weil ihr Wesen formaler Art ist, kann die Kritik nur auf formalem Wege, indem sie auf andere Weise ähnliche Empfindungen lockt, eine vagen Begriff von ihnen geben."

44. R[obert] A[lan] M[awbray] Stevenson, *Velaszquez* (London: G. Bell, 1899). This second, revised edition from the luxury volume published by the same press in 1895, contains an additional critical catalogue. Stevenson's book was translated into German by Bodenhausen and commented favorably upon by Scheffler in *Der Deutsche und seine Kunst* (Munich: R. Piper, 1907), 55, particularly for its elevation of technique over content: "Wer sich für technische Fragen nicht interessiert, hat auch für Kunst keinen Sinn."

45. C. Justi's monograph on Velázquez was first published in English as *Diego Velazquez and his times*, trans. A. H. Keane (London: H. Grevel, 1889).

46. See A. von Hildebrand, *Das Problem der Form in den bildenen Künsten* (Strassburg, 1893) reprinted in *Gesammelte Schriften zur Kunst* (Cologne: Westdeutscher Verlag, 1969). Hildebrand participated in the English translation of *Das Problem der Form*, trans. and rev. Max Meyer and Robert Morris Ogden under the title *The Problem of Form in Painting and Sculpture* (New York: G. E. Stechert, 1932).

47. My discussion necessarily begs the question of how much Hildebrand, as a popularizer of Fiedler's ideas—applied to sculptural questions—changed and simplified Fiedler's work. But clearly Meier-Graefe embraced all three men, devoting a chapter to Hildebrand in the *Entwicklungsgeschichte*, and dedicating to Fiedler his

monumental *Hans von Marées. Sein Leben und sein Werk*, 3 vols. (Munich and Leipzig: R. Piper, 1909–10).

48. See K. Fiedler, *Schriften über Kunst*, ed. Hans Marbach (Leipzig: S. Hirzel, 1896).

49. See L. Venturi, *History of Art Criticism*, trans. Charles Marriott (New York: E. P. Dutton, 1964), 275. The first English edition dates from 1936. Croce's ideas on "pure visibility" are contained in his *Estetica* (1902). See Michael Podro, "The Parallel of Linguistic and Visual Formulation in the Writing of Konrad Fiedler," in *Studi di esthetica* 19 (Turin: Filosophia, 1961).

50. See M. Podro's brief, but useful discussion of Fiedler's relationship to Wölfflin in *The Critical Historians of Art*, 110–12.

51. Udo Kultermann in *Kunst und Wirklichkeit*, 122, argues for the significance of Grimm's work for Meier-Graefe and for their mutual dependence on Carlyle's conception of the "great man."

52. Meier-Graefe's reason for placing van Gogh where he does is based on a letter from the artist to his brother in which he declared his greater debt to Millet and Delacroix than the Impressionists. A subsequent tension arises between Meier-Graefe's description of the artist as a volcanic creator, struggling to preserve the healthiness of art even as his personality crumbled, while he is also portrayed as one of the progenitors of the modern painting for the home. Meier-Graefe stressed at the end of his essay the decorative effects of the artist's work and noted his influence on contemporary decorative painters such as the Nabis and van de Velde (when he still painted).

53. J. Meier-Graefe, *Der moderne Impressionismus* (Berlin: J. Bard, 1903).

54. Just how schematic is clear by comparing the essay to von Seidlitz, *Geschichte des japanischen Farbenholzschnitts* (chap. 7, n. 49).

55. At the time Meier-Graefe wrote *Der moderne Impressionismus* he appears to have not yet read *Noa Noa*, nor was he much informed about the details of the artist's life. In the *Entwicklungsgeschichte* the discussion of Gauguin's primitivism and the traditional and ancient sources for his work largely gave way to biographical description, to the famous exchange of letters between Gauguin and Strindberg, to the conception of tribal culture laid out in *Noa Noa*.

56. Meier-Graefe, *Entwicklungsgeschichte*, 1:269.

57. Alfred Hentzen, "Postscript," in Moffett, *Meier-Graefe as Art Critic*, 203.

58. The exception is the 1908 English edition, *Modern Art* (intro., n. 3), which preserves most of the material on the decorative arts (although some of Meier-Graefe's theoretical chapters, among them a closing panegyric on Goethe and Nietzsche were not included).

59. F. Stern, "Introduction," in *The Politics of Cultural Despair* (chap. 6, n. 81), xi–xxx.

60. Meier-Graefe, *Der Fall Böcklin* (intro. n. 7).

61. See M. Harden, *Köpfe* (Berlin: Erich Reiss Verlag, 1911), 316.

62. See Le Corbusier, *Vers une architecture* (Paris, Crès et Cie, 1923).

63. The translation is from Walter Kaufmann, *The Birth of Tragedy and the Case of Wagner* (New York: Random House, 1967), 157.

64. Theodore Reff, "Cézanne and Poussin," *Journal of the Warburg and Courtauld Institutes* 23 (1960): 150–74, esp. 162–63, describes Denis' evolution to classicism between 1897 and circa 1900. He suggests a comparable role played by the neo-classical revival in poetry and the political influence of Maurras and his *Action française*. See also Michael Marlais, *Conservative Echoes in Fin-de-Siècle Parisian Art Criticism* (University Park, PA: Pennsylvania State University Press, 1992).

65. On the fate of Böcklin's reputation, see Elizabeth Putz, "Classical Antiquity in the Painting of Arnold Böcklin" (chap. 7, n. 34) and [as Elizabeth Tumasonis] "Böcklin's Reputation: Its Rise and Fall," *Art Criticism* 6:2 (1990): 48–71.

66. H. Thode, *Böcklin und Thoma* (Heidelberg: Carl Winters Universitätsbuchhandlung, 1905). For a full discussion of the Böcklin controversy see Paret, *The Berlin Secession* (chap. 1, n. 54), 170–82. There were over two dozen articles and pamphlets, most launched against Meier-Graefe, in this controversy.

67. *Böcklin und Thoma*, 9–10.

68. Much of the correspondence was reproduced in *Kunst und Künstler* 3 (August 1905): 484–88; (September 1905): 529–32. For an overview of this exchange, see Paret, *The Berlin Secession*, 178–80.

69. See the exhibition catalogue, *Ausstellung deutscher Kunst. Aus der Zeit von 1775–1975 in der Königlichen Nationalgalerie* (Munich: F. Bruckmann, 1906).

70. E. L. Kirchner, *Chronik der Brücke* (Berlin, 1916). This excerpt is taken from the translation by Peter Selz reprinted in H. Chipp, *Theories of Modern Art* (Berkeley and Los Angeles: University of California Press, 1974), 178.

71. L. D. Ettlinger in "Julius Meier-Graefe" refers without citation to a remark made by Meier-Graefe in 1912 that described recent painting as "Verbrennungspro-dukte."

72. J. Meier-Graefe, *Wo treiben wir? Zwei Reden über Kultur und Kunst* (Berlin: S. Fischer, 1913).

POSTSCRIPT

1. Morice, "Enquête sur les tendances actuelles des arts plastiques," (chap. 3, n. 35). Although the relationship between Morice and Gauguin has been told in many places, particularly revealing was their collaborative project *Noa Noa* as discussed by Nicholas Wadley in *«Noa Noa». Gauguin's Tahiti* (Salem, New Hampshire: Salem House, 1985), 85–107.

2. What was at stake in the death of Impressionism has been theorized by Shiff, *Cézanne and the End of Impressionism* (chap. 8, n. 18).

3. A certain fictionality resides in the conception of the Fauve debut in 1905 and the concomitant "shock of the new," since much of what might be called Fauvist painting was present at least at the exhibition of the Indépendants the previous spring. Both the debut and the shock require further examination. But see Marcel

Giry, "Le Salon des Indépendants de 1905," *L'Information d'histoire de l'art* 15 (May-June 1970): 110–14, and his "Le Salon d'Automne de 1905," *L'Information d'histoire de l'art* 13 (January-February 1968): 16–25. For the most recent appraisal of Fauvism, especially in regard to the French tradition, see James D. Herbert, *Fauve Painting: The Making of Cultural Politics* (New Haven: Yale University Press, 1992).

4. H[ans] R[osenhagen], "Von Ausstellungen und Sammlungen," *Die Kunst für Alle* 19 (1 June 1904): 401–3.

5. H[ans] R[osenhagen], "Von Ausstellungen und Sammlungen," *Die Kunst für Alle* 20 (1 February 1905): 210.

6. The van Gogh show was reviewed by Hans Rosenhagen in *Die Kunst für Alle* 20 (1 January 1905): 164–66.

7. Apparently no catalogue for this exhibition survives and the reviews are too vague to place any of the paintings. Nonetheless, it was given a half-page review in *Die Kunst für Alle* 20 (15 October 1904): 46. Almost simultaneously, the Dachau painter and theorist Adolf Hölzel selected a painting by Gauguin and van Gogh each among the illustrations for his article "Ueber künstlerische Ausdrucksmittel und deren Verhaltnis zu Natur und Bild," *Die Kunst für Alle* 20 (15 November 1904): 81–88; (1 December 1904): 106–33; (15 December 1904): 121–42. Curiously, although Hölzel discussed favorably and at length Signac's treatise he had little to say about van Gogh, Gauguin, or even Cézanne. One might understand the presence of these illustrations therefore as a reflection of the urgent desire to absorb the lessons of this alien art into the language of contemporary German art criticism. Moreover, Hölzel resembled Meier-Graefe on this important point: he placed the history of art exclusively at the level of formal development, irrespective of content. See Nina G. Parris, "Van de Velde, Obrist, Hoelzel," in *The Turn of the Century* (chap. 6, n. 45), 327–46.

8. The retrospective at the Stedelijk Museum had a catalogue of 474 numbers. See *Vincent van Gogh* (Amsterdam: Stedelijk Museum, 1905). The retrospective was reviewed by J. C. G., "Vincent van Gogh. Ausstellung in Amsterdam," *Kunstchronik* 16 (1 September 1905): 525–26. The reviewer declared "Van Gogh ist weniger ein Impressionist als ein Neo-Primitiver, der die Würzel der Dinge mit erstaunlicher Unmittelbarkeit zu enthüllen versucht hat." That is, he distinguished van Gogh from the Impressionists as altogether something new.

9. There was another van Gogh exhibition in Munich at the same time as Brakl's in the Kunstsalon Zimmermann. This show may also have consisted of pictures from the Bernheim Jeune contingent and was then rejoined for the Richter show in Dresden. The Brakl catalogue, incidentally, was in the possession of Vassily Kandinsky and is now in the collection of the Münter-Stiftung, Städtische Galerie im Lenbachhaus, Munich. The show was reviewed by Wilhelm Michel, "Münchener Bilderfrühling," *Kunstchronik* 19 (18 May 1908): 417–22.

10. This fact was observed by John Rewald, "The Posthumous Fate of Vincent van Gogh, 1890–1970," in *Studies in Post-Impressionism*, ed. Irene Gordon and Frances Weitzenhoffer (New York: Abrams, 1985), 244–54, esp. 248.

11. Schmidt, "Der Pariser Herbstsalon" (chap. 2, n. 19), 54–58, described Auguste Maillol as the newest discovery of the "*Avantgarde*" [58].

12. Ibid., 57. The year before Schmidt brought out his own history of nineteenth-century French painting as part of an unrealized series of monographs targeted at a popular audience that would survey the development of modern art in separate monographs by different authors. See K. E. Schmidt, *Französische Malerei 1800–1900* (Leipzig: E.A. Seemann, 1903). Capable of admitting, albeit in passing, the worth of Cézanne and the Nabis, Schmidt's history is more striking for the book's axis along the line of the Barbizon painters through Courbet, Manet, and the Impressionists, culminating, as with Muther, with what he called the "Dichter und Träumer." Strikingly, the academicians are removed from the general history to occupy a chapter on "Die offizielle Kunst der dritten Republik," and the *juste milieu* are confined to chapters on "Die dekorative Malerei" and "Die Bretagne": the latter comprising painters such as Charles Cottet and Lucien Simon, but not Gauguin. Schmidt was ready to conclude that the great days of French art were over and that foreign nationals figured more prominently in Parisian exhibitions than French artists.

13. Ibid., 58.

14. A. Mellerio, *Le Mouvement idéaliste en peinture* (Paris: H. Floury, 1896), 26.

15. On Aurier, see Patricia Townley Mathews, *Aurier's Symbolist Art Criticism and Theory* (Ann Arbor: UMI, 1986).

16. Cited in Joan Ungersma Halperin, *Félix Fénéon. Aesthete & Anarchist in Fin-de-Siècle Paris* (New Haven: Yale University Press, 1988), 236.

17. See J. Rewald, *Cézanne, Geffroy et Gasquet, suivi de Souvenirs sur Cézanne de Louis Aurenche et de Lettres inédites* (Paris: Quatre Chemins-Editart, 1959), 19. Rewald, however, attributes Cézanne's disenchantment with Geffroy not to the criticism, but to the artist's antisocial personality.

18. C. Pissarro to L. Pissarro (28 April 1896), in *Letters to His Son Lucien* (chap. 1, n. 60), 370.

19. C. Pissarro to L. Pissarro (22 November 1895) in *Letters to His Son Lucien* , 351.

20. See G.-Albert Aurier, "Le Symbolisme en peinture: Paul Gauguin," *Mercure de France* 2 (March 1891): 159–64.

21. See note 14.

22. C. Mauclair, "Souvenirs sur le mouvement symboliste en France 1884–1897," *La Nouvelle revue* 108 (September-October 1897): 670–93, and 109 (November-December): 79–100. Mauclair's conception of symbolism in both art and literature is closer to decadence than to Gauguin's conception of symbolism. For a useful reading of the domain of decadence in the nineties, see Pierrot, *The Decadent Imagination 1880–1900* (chap. 8, n. 16).

23. On the primacy of diversity over a unified doctrine for the 1890s, see Reinhold Heller, "Concerning Symbolism and the Structure of Surface," *Art Journal* (Summer 1985): 146–53. I disagree however with his overall model of diversity as

the chief characteristic of early modernist historiographies, in particular his reading of Meier-Graefe's *Entwicklungsgeschichte*.

24. For a particularly good description of the speculative environment for modernist painting in Paris immediately after 1900, see Michael Cowan FitzGerald, "Skin Games," *Art in America* 80 (February 1992): 70-83, 139-41.

25. Flechtheim, "Postscript" (chap. 8, n. 30), 109.

26. M. Denis, "De Gauguin et de van Gogh au classicisme," in *Théories (1890-1910): du symbolisme et de Gauguin vers un nouvel ordre classique* (Paris: Bibliothèque de l'Occident, 1912), 257.

27. On Seurat's "science" and its relation to art criticism, see especially Joan Ungersma Halperin, "Scientific Criticism and *le beau moderne* of the Age of Science," *Art Criticism* 1 (Spring 1979): 55-71. One may also recall Bernard's quarrel with Gauguin (via the latter's supporters) over who was the primary author of symbolist painting. See Vojtéch Jirat-Wasiutyski, "Émile Bernard and Paul Gauguin: The Avant-Garde and Tradition," in *Émile Bernard. 1868-1941*, ed. Mary Anne Stevens et al. (Mannheim: Städtische Kunsthalle, 1990), 48-67. These claims among the small modernist circles of Paris had their more public equivalent in the debate over Manet's versus Monet's denomination as head of the Impressionist movement, but after Gauguin's death Bernard launched a public attack on Gauguin's reputation. See E. Bernard, "Notes sur l'école dite de Pont-Aven," *Mercure de France* 47 (December 1903): 675-82, and the replies from M. Denis, "Lettre," *Mercure de France* 49 (January 1904): 186-87, and C. Morice, "Les Gauguin du Petit Palais et de la rue Laffitte," *Mercure de France* 49 (February 1904): 393-95. Bernard responded to these critiques in *Mercure de France* 49 (February 1904): 574, and (March 1904): 856.

28. E. Bernard, "Paul Cézanne," *L'Occident* 32 (July 1904): 17-30.

29. Letter to A. Gide, (23 April 1901), reprinted in M. Denis, *Journal (1884-1904)* (Paris: La Colombe, 1957), 1:168.

30. See, for example, George L. Mauner, *The Nabis: Their History and their Art, 1888-1896* (New York: Garland, 1978); Robert T. Wang, "The Graphic Art of the Nabis, 1888-1900" (Ph.D. diss., University of Pittsburgh, 1974); and Patricia Ecker Boyer, ed., *The Nabis and the Parisian Avant-Garde* (New Brunswick: Rutgers University Press, 1988).

31. G. Courbet to Champfleury [November-December 1854] in *Letters of Gustave Courbet*, ed. and trans. Petra Chu (Chicago: University of Chicago Press, 1992), 131.

32. C. Mauclair, "La peinture et la sculpture au Salon d'Automne," *L'Art decoratif* (1905): 222-40. Quoted in Giry, "Le Salon d'Automne de 1905," 20.

33. M. Denis, "Cézanne," *L'Occident* (September 1907), in *Théories*, 237-53. The translation is by Roger Fry from *The Burlington Magazine* 16 (January 1910): 207-19, and (February 1910): 275-80.

34. Denis, "De Gauguin," 259. The translation is by Susan Suleiman in *Apollinaire on Art*, ed. LeRoy C. Breunig (New York: Viking, 1972), 50-52.

35. See Giry, Le Salon d'Automne de 1905," 20.

36. See C. Mauclair, "La Crise de la laideur en peinture," in *Les Trois Crises de l'art actuel* (Paris: Bibliothèque-Charpentier, 1906), 309, and Roger Benjamin's discussion of the small format and spontaneity associated with the exhibits at the Salon d'Automne in "Fauves in the Landscape of Criticism. Metaphor and Scandal at the Salon," in *The Fauve Landscape* (New York: Abbeville, 1990), 241–66 and note 24.

37. Letter to E. Vuillard (23 November 1897), in Denis, *Journal 1884–1904*, 1:123–24.

38. C. Mauclair, "La Réaction nationaliste en art et l'ignorance de l'homme de lettres," *La Revue* 54 (15 January 1905): 151–74.

39. M. Denis, "Le Réaction nationaliste," *L'Ermitage* (15 May 1905), in *Théories*, 182.

40. M. Denis, "Le Salon d'Automne de 1905," *L'Ermitage* (15 November 1905), republished under the title "De Gauguin, de Whistler et de l'excès des théories" in *Théories*, 194.

41. The evidence from the German side for this point is very large. But witness Max Raphael's *Von Monet zu Picasso* (Munich: Delphin Verlag, 1913) which treated Picasso as the ruling spirit behind Cubism (Braque gets not even a mention).

42. See R. Fry's review of Ambroise Vollard's monograph on the artist, "Paul Cézanne" in *The Burlington Magazine* (1917), reprinted in *Vision and Design*, 4th rev. ed. (London: Chattus and Windus, 1925), 256–65.

Index

Académie des Beaux-Arts (Paris), 18–19, 23–24, 31, 50, 104, 119, 156. *See also* Salon system
Académie Julian, 31, 157–59, 160
Action français, 274
advertising, 268
aestheticism, 138–50, 240
Aesthetic Movement, British, 47
aesthetic pluralism, 141, 143
aesthetic populism, 32, 79
Agnew, Thomas, 34, 42
Agnew, William, 33
Alexandre, Arsène, 56, 58
Alexis, Paul, 94
Allgemeine Deutsche Kunstgenossenschaft, 72, 196, 197, 198
Allgemeine Zeitung, 170, 173
Alma-Tadema, Lawrence, 47, 63, 124, 125, 177
Alt, Rudolf von, 185
Alterstil, 303n.10
Aman-Jean, Edmond-François, 162, 164
amateurs, role of, 3, 8, 18, 21, 35, 55, 62, 81, 83, 87, 89, 110, 116, 122, 144, 146, 150, 275, 307n.74
American art collectors, 8, 53, 60, 61–62, 66–67, 78, 83
American art markets, 33, 53
American art museums, 8, 16
Amiet, Cuno, 94
anarchism, in painting, 38, 245
Angrand, Charles, 134
Anquetin, Louis, 134, 162
anti-rationalism, 212
Apollinaire, Guillaume, 273
Archipenko, Alexander, 199
Les Archives de l'impressionnisme (Venturi), 58
Argencourt, Louise d', 33
Armory Show. *See* New York Armory Show (1913)

Arnhold family, 191
Arnold, Ernst, 68, 71, 76, 77, 310–11n.102
art: commodification of, 10, 18, 19–22, 33–34, 241; official commissions for, 171–72; professionalization of, 23, 167, 171, 182, 268
L'Art, 122, 301n.52
art collectors: American, 8, 53, 60, 61–62, 66–67, 78, 83; Belgian, 62, 209; British, 9; and commodification of art, 20–21; German, 8, 9, 67; hoarding by, 243; Russian, 67; Swiss, 67
art criticism: development of, 27; and marketing of Impressionists, 51–52; of Oscar Wilde, 239–40; and temperament, 239. *See also* Meier-Graefe, Julius; Muther, Richard
L'Art dans les Deux Mondes, 289n.6
L'Art décoratif, 241
L'Art Impressionniste (Lecomte), 96
L'Art moderne, 90, 130
artist relief organizations, 26
artists' societies, development of, 86. *See also names of specific societies*
Art Journal, 95
Art-Language (artists' group), 14
art museums, development of, 16, 62, 80, 92, 200. *See also names of specific museums*
art nouveau, 162, 210, 241, 242, 256, 268. *See also* Jugenstil movement
Les Arts, 25
Arts and Crafts movement, 256
Art-Unions, 26, 86
Association des artistes dramatique, 283n.26
Association des artistes musiciens, 283n.26
Association des inventeurs et artistes industriels, 283n.26
Association des membres de l'enseignement, 283n.26

Association des Peintres d'histoire et de genre, Sculpteurs, Graveurs, Architectes et Dessinateurs, 26
Astruc, Zacharie, 237
Das Atelier, 193, 209, 242
Aubourg (art dealer), 60
auction market, 51, 60, 72, 83, 116, 146
Aurier, Gabriel-Albert, 267, 268
Aus beiden Lagern (Bierbaum), 176
Ausstellungsverband Münchener Künstler, 181
avant-gardism: and commodification of art, 10–11, 15, 19; definition of, 40, 142, 266; of Secessionists, 167, 184, 187
Avenarius, Ferdinand, 231, 258, 315n.8
Avery, Samuel, 83

Bachelard, Gaston, 246
Bacher, Paul, 186
Bacon, Henry, 148–49
Bahr, Hermann, 183, 184, 205–6, 216, 338n.9
Balzac, Honoré de: *Le-Chef-d'Oeuvre in-connu*, 152
Barbizon painters. *See* École de 1830 (École de Barbizon)
Barnum, P. T., 42, 45, 46
Bartholomé, Paul Albert, 165
Bastien-Lepage, Jules, 32, 41, 65, 71, 139, 140, 148, 149, 216, 218, 222, 223, 224, 327n.42
Baudelaire, Charles, 40, 93, 94, 97, 215, 237, 297n.17, 323n.9
Baudry, Paul, 63, 114, 124, 158
Baum, Paul, 70, 179
Baur, Karl Albert, 173
Bayre, Antoine-Louis, 118
Bazar Bonne-Nouvelle exhibition (1846), 26
Bazire, Edmond, 87
Beardsley, Aubrey, 13, 257
Becker, Benno, 174
Becker, Paula, 68, 210
Beethoven, Ludwig von, 246
Behrens, Peter, 178, 242
Belgian art collectors, 62, 209
Belgian art market, 33

Belly, Léon, 118
Benedite, Léonce, 311n.1
Béraud, Jean, 65, 139, 145, 148, 162
Berlepsch-Valendas, Hans Eduard, 169–70, 171
Berlin art market, 7, 67–68, 70–75, 194–95. *See also names of specific galleries and dealers*
Berlin Freie Vereinigung, 198
Berlin international exhibition (1891), 163
Berlin Künstlerverein, 173
Berlin Secession: development of, 72, 187–99; exhibitions of, 188–89, 192, 193–94, 195, 196, 197, 229, 237; ideology of, 73, 143, 147; literary advisor to, 168; politics of, 38, 168; *Protokolle* of, 190, 193; success of, 195; support for, 12, 188
Bernac, Jean, 94–95
Bernard, Émile, 132, 134, 267, 271, 273, 274, 310–11n.102
Bernatzik, Wilhelm, 4, 6
Berne-Bellecour, Etienne, 302n.4
Bernheim, Gaston and Josse, 54, 134, 270. *See also* Galerie Bernheim Jeune (Paris)
Bernstein, Carl and Félicie, 208
Bertin, Edouard, 118
Berton, Armand, 164
Besnard, Albert, 5, 65, 66, 138, 141, 145, 149, 164, 185, 196, 206, 207, 216, 221, 227, 274, 275, 300n.45
Beugniet, Adrien (art dealer), 61
Bierbaum, Otto Julius, 176–77, 237
Billotte, René, 181
Binet, René, 220
Bing, Siegfried, 209, 220, 237, 241, 263
biographies, of artists, 119–20
Bismeyer and Kraus (Düsseldorf art gallery), 69
Bizet, Georges, 258
Blanc, Charles, 117
Blanc, Ennemond, 114
Blanche, Jacques-Émile, 65, 138, 145, 146, 152, 161, 164, 274, 302n.4
Blaue Reiter, 70, 181, 199, 211
Bley, Fritz, 202–3, 214, 234
Böcklin, Arnold: reputation of, 5, 24, 68, 74, 161, 164, 175, 180, 188, 194, 204,

205, 207, 212, 218, 224, 232, 233, 244, 246, 255, 256, 257–61

Bode, Wilhelm von, 188, 208, 209, 311n.1, 328n.54

Bodenhausen, Baron Eberhard von, 210, 211, 328n.54

Boime, Albert, 34, 139, 284n.32

Boldini, Giovanni, 65, 141, 145, 147, 222

Bongrand (character), 152–53

Bonnard, Pierre, 13, 134, 166, 196, 210, 242, 245, 251, 271, 272, 310–11n.102

Bonnat, Léon, 65, 155–56, 302n.4

book illustration, 268

Boudin, Eugène-Louis, 99, 127, 293n.63, 334n.104

Bouguereau, William: *Angel of Death*, 20; in Cercle de l'union artistique, 302n.4; and commodification of art, 19–20, 21–22, 28, 32–33, 34, 35; *Dante's Hell*, 20; and foreign art students, 31; imitators of, 32; marketability of, 60, 64, 66; opposition to exhibiting Old Masters with modern artists, 109, 110, 160, 161; relationship to Impressionism, 139; reputation of, 222; in Société des peintres, sculpteurs, graveurs, 159; success of, 35, 158

Boulanger, Gustave, 158

Bourdieu, Pierre, 9

Boussod et Valadon (art gallery), 66, 129, 131

Boutet de Monvel, Louis-Maurice, 65

Bracquemond, Félix, 86, 150

Bracquemond, Mme. Marie, 150, 300n.45

Brakl (art dealer), 58, 70, 76, 77, 265

Brame, Hector-Henri, 52–53, 61

Brandes, Georg, 204, 215–16, 327n.44, 340n.35

Brangwyn, Frank, 339n.27

Braque, Georges, 273, 276

Bréton, Jules, 71

bricoleur, 235–36

British art collectors, 9

British art market, 8–9, 33, 34–35, 43–44, 123

Brookner, Anita, 151

Broude, Norma, 11–12

Brough, William, 165

Brown, Ford Madox, 214

Brown, John Lewis, 65

Brownell, William C., 41, 67, 138

Brücke. *See* Künstlergruppe Brücke (Dresden)

Bruckmann, Peter, 211

Brussels retrospective exhibition (1880), 120

Bruyas, Alfred, 115

Burckhardt, Max, 318n.48

Bureau of Fine Arts, French, 155

Bürger, Peter, 10

Burne-Jones, Edward, 47, 177, 185

Burty, Philippe, 18, 85, 119, 122, 123, 126, 128, 151

Cabanel, Alexandre, 64, 65, 149, 156

Cadart, Alfred, 86, 87

Caillebotte, Gustave, 98, 100, 105, 127, 139, 150, 334n.104

Caillebotte collection (Musée Luxembourg, Paris), 16, 60, 67, 95, 96, 98, 219, 223, 227, 264

Camoin, Charles, 273

Camondo, Count Isaac de, 62, 64

Campbell, Lady Archibald, 46

Canvases and Careers (White and White), 49

Carabin, François, 165

Carrière, Eugène, 138, 162, 164, 267, 300n.45, 339n.27

Caspar, Jacques, 293n.69

Cassatt, Alexander, 57

Cassatt, Katherine, 57

Cassatt, Mary, 57, 65, 97, 100, 127, 150, 300n.45, 327n.43, 334n.104

Cassatt, Robert, 57

Cassirer, Bruno, 70, 71, 73, 75–77, 190–93

Cassirer, Paul, 70, 211; alliance with Durand-Ruel, 55; and Berlin Secession, 75, 77, 190–93, 197, 198, 199; exhibitions by, 71, 73, 75–80, 194, 209, 229, 265; as publisher of *Pan*, 56, 79; support for Impressionists from, 81

Castagnary, Jules, 18, 38, 104–5

catalogue raisonnés, development of, 110, 111, 119, 334n.106

Cazin, J.-C., 65, 302n.4

Cellini, Benvenuto, 12
Cercle artistique de la rue de Choiseul, 118
Cercle artistique de la rue Volney, 302–3n.5
Cercle artistique et littéraire, 107
Cercle de l'union artistique (Cercle des Mirlitons), 86, 107, 301n.52
Cercle St. Arnaud, 107
Cézanne, Paul, 94; as an Indépendant, 134, 135, 245; collectors of, 210, 211, 264; death of, 136, 273; exhibitions of, 4, 74, 77, 110, 135, 196, 200, 265, 270–71, 310n.98; friendship with Zola, 151, 152, 214, 251; influence of, 251, 266–67, 270–73; *Moulin sur la couleuve, à Pontoise*, 219; and museums, 16; public recognition of, 4, 67, 76, 210; relationship to Impressionism, 6, 8, 98, 150, 222, 251, 253, 254, 268, 270, 274, 334n.104; reputation of, 245, 246, 264
Champfleury (Jules Fleury), 119, 272
Champs de Mars Salon, 160, 161, 168, 326n.40
Chardin, Jean-Baptiste-Siméon, 227
Charpentier, Georges, 126, 127, 165
Chauchard, Alfred, 62
Cheney, Sheldon, 14
Chennevières-Pointel, Philippe de, 155, 156
Chéret, Jules, 131, 217
Chesneau, Ernest, 18, 87, 123
Chicago World's Fair (1893), 163
Chintreuil, Antoine, 102, 118, 120
Christie's auction house, 45
Chromoluminaristes, 133
Chronique des arts, 136
Clairin, Georges, 302n.4
Claretie, Jules, 119
classicism, 4, 102, 139, 227, 258, 261, 272–73
Claus, Émile, 141, 300n.45, 317n.27, 326n.40
Clayson, Hollis, 100
Cogniet, Léon, 156
Cole, Henry, 120
Cologne Sonderbund exhibitions, 3, 164, 197, 212, 263, 266

commodification of art: and decorative arts movement, 241; development of, 10, 18, 19–22; and international art market, 33–34
connoisseurship, 20, 21, 143, 263
conspiracy, among art dealers, 55, 79, 193, 234, 238, 262
Constable, John, 4, 218, 249, 253
Constant, Benjamin, 302n.4
Le Corbusier (Charles-Édouard Jeanneret), 258
Corcoran, W. W., 64
Cordey, Frédéric, 150
Corinth, Lovis, 12, 70, 174, 178, 179, 190, 191, 195, 209, 317n.33; *Salomé with the Head of John the Baptist*, 194
Cornelius, Peter, 213
Corot, Jean-Baptiste-Camille: exhibitions of, 71, 118, 119, 120, 121, 156, 218; forgeries of works by, 111; marketability of, 39; mythologizing of, 56; originality of, 18, 21; photographs of works by, 71; prints of works by, 86; relationship to Impressionism, 99, 102, 253; reputation of, 227; sale of works by, 61
Cossío, Manuel B., 279n.5
Cottet, Charles, 5, 164, 196, 272
Courbet, Gustave, 14; death of, 119, 120; depicted by Zola, 153; and doctrine of *vérité vraie*, 216; exhibitions of, 44, 76, 112, 113, 114, 115–17, 118, 120, 121, 130; influence of, 226, 253; and monumental figure painting, 33; originality of, 18, 115–16; as a realist, 93–94; relationship to Impressionism, 8, 99, 102, 333n.99; reputation of, 121–22, 152, 154, 215, 227, 322–23n.3; sale of works by, 61, 82; style of, 214, 218
—works: *The Artist's Studio*, 115, 272, 295n.5; *The Burial at Ornans*, 115, 295n.5
Courtois, Gustave, 326n.40
Couture, Thomas, 118
Crane, Walter, 180, 240, 317n.27
La Cravache, 97
critic-dealer system. *See* dealer-critic system
Critique d'Avant-Garde (Duret), 126
Croce, Benedetto, 249

Cross, Henri-Edmond, 133
Cubism, 135, 235, 269, 276, 280n.12
Curtius, Ernst, 208
Cuyp, Albert, 218

Dadaism, 19
Dagnan-Bouveret, Pascal, 71, 160, 164, 166, 177
d'Annunzio, Gabriele, 221
Daubigny, Charles-François, 71, 120, 132, 156, 219
Daumier, Honoré, 28, 89, 114, 118, 119, 253
David, Jacques-Louis, 17, 25, 33, 49, 244
Day, Lewis, 240
dealer-critic system, 49–50, 51–52, 64, 114
décadence, 133, 204, 236, 239, 252
Decamps, Alexandre-Gabriel, 116, 117
decorative arts, 208–9, 235, 237, 239, 240–42, 268
Defregger, Franz von, 79, 80
Degas, Edgar: collectors of, 327n.43; and exhibition reforms, 42; exhibitions of, 25, 326n.33; marketability of, 83, 137; orientalism of, 252; published prints of, 242; and purchase of Manet's Olympia, 145; as a realist, 93–94, 101, 102; relationship to Impressionism, 8, 97, 126, 127, 139, 149, 150, 245, 253, 300n.45, 334n.104; reputation of, 194, 233, 325n.26; resistance to commercialism, 299n.31; sale of works by, 57
Degenerate Art exhibition (Munich, 1937), 263
Dehmel, Richard, 237, 259
Dekorative Kunst, 211, 241, 338n.8
Delacroix, Eugène: exhibitions of, 85–86, 114, 118, 119, 121, 132, 218, 219, 297n.17; influence of, 13, 14, 104, 226, 253, 279n.17; marketability of, 61, 62; notebooks published, 77; originality of, 18, 21, 117, 218; photographs of works by, 71; reputation of, 116, 122, 152, 154, 214, 227, 246; and Salon system, 27; state commissions by, 39; style of, 249
Delaroche, Paul, 118, 156
Delaunay, Elie, 302n.4

Delaunay, Robert, 270, 276
Delaunay, Sonia, 276
Delécluze, Étienne, 25, 26, 29–30
Delort, Charles-Edouard, 302n.4
Delville, Jean, 161
Deneken, Friedrich, 211–12
Denis, Maurice, 134, 162, 210, 254, 258, 266, 270, 271–75, 276, 310–11n.102, 339n.27; Hommage à Cézanne, 270–73
Derain, André, 273
Deschamps, Charles, 286–87n.62
Desfriches, Armand-François-Paul (Count Doria), 62
Detaille, Edouard, 102, 302n.4
Dettmann, Ludwig, 165
Die Deutsche Jahrhundert-Ausstellung (Berlin, 1906), 261
Deutsche Kunst, 192
Die Deutsche Kunst des neunzehnten Jahrhunderts (Gurlitt), 213
De Watteau à Whistler (Mauclair), 227
Dewhurst, Wynford, 56, 67, 95–96, 139, 225
Diaz de La Peña, Narcisse-Virgile, 116, 118, 119
Diderot, Denis, 102
Didier-Pouget, William, 300n.45
Dostoevski, Feodor, 215, 257
Douglas, Count Morton, 210
Dresden art market, 68–69
Dresden International Exhibition (1897), 209, 219, 336n.117
Dresden Secession, 179, 180, 188, 190
Drey, Paul, 78
Dreyfus affair, 271, 274
Druet, Eugène (art dealer), 137, 265, 276
Dubois-Pillet, Albert, 132, 133, 134, 266
Dubufe, Guillaume, 302n.4
Duchamp, Gaston, 276
Duchamp, Marcel, 276
Duez, Ernest-Ange, 65, 139, 141, 142, 148, 149, 160, 162; Splendour and Misery, 149
Dupray, Henry, 302n.4
Duran, Carolus (Charles), 65, 148, 149, 160, 302n.4, 326n.40
Durand, Jean-Marie Fortuné, 33, 49, 52
Durand-Ruel, Charles, 207

Durand-Ruel, Joseph, 129

Durand-Ruel, Paul, 86; as an archivist, 58–59; and art criticism, 77; artists represented by, 52–54, 55, 82–83, 107, 124; and exhibition reforms, 42, 107, 108–9, 110, 112, 118, 121, 226; as expert for Hôtel Drouot, 52, 58; and exporting of French paintings, 76, 78, 79, 219; as ideological dealer, 49, 51–52; Impressionist works handled by, 4, 39, 55, 56, 64, 66, 76, 82, 95, 97, 98, 101, 127–31, 196, 207, 215, 220, 243, 251, 268; personal collection of, 59–60, 130, 227; as promoter of modern art, 17, 55–56; reshaping of Bouguereau's work by, 33; success of, 67, 80; support of École de 1830, 49, 51, 52–54, 56, 82, 109, 121, 122, 207

Duranty, Edmond, 101–2, 105, 228

Dürer, Albrecht, 233, 244

Duret, Théodore, 88, 96, 126, 145, 151, 227, 228, 238; defense of Impressionists by, 18, 21, 37, 38, 77, 81–83, 116, 153, 226

Du Romantisme au réalisme (Rosenthal), 27

Düsseldorf art market, 69

Düsseldorf Freie Vereinigung, 179, 180, 188

Düsseldorf retrospective exhibition (1880), 120

Düsseldorf tradition of landscape painting, 71, 211

Duve, Thierry de, 17

Eastlake, Charles, 120

Eckmann, Otto, 178, 179, 317n.33

eclecticism, 117, 141, 142, 143, 268

"L' Eclectique," 132

École de 1830 (École de Barbizon): collectors of, 62, 83; death of members of, 119; definition of, 37, 92; Durand and Durand- Ruel's support of, 49, 51, 52–54, 56, 82, 109, 121, 122, 207; marketability of, 39, 53, 54, 60, 62, 66, 71, 109, 121, 122–23; patronage of, 33; as precursor to Impressionism, 97, 98, 203, 222, 225; ret-

rospective exhibitions of, 119, 120, 207; temperament of, 40, 106, 110–11

École de David, 49

École des Beaux-Arts (Paris), 23–24, 31, 39, 102, 114, 118, 136, 144, 155, 156, 157, 202

Edelfelt, Albert, 65, 148

Egusquiza, Rogelio de, 65, 148

Eiffel Tower, 220, 221

Eitelberger von Edelberg, Rudolf, 27–28

The Eleven (XI; Die Elf), 72, 73, 74, 174, 180, 218

Elias, Julius, 56, 58, 207

empiricism, 99

Engel, Otto, 193

Engelhart, Josef, 186

Der Entwicklung der modernen Malerei (Seidlitz), 218

Ensor, James, 133

Entartung (Nordau), 206–7, 231

Entwicklung des Impressionismus in Malerei und Plastik (1903 exhibition), 3

Die Entwicklungsgeschichte der modernen Kunst (Meier-Graefe), 4–5, 13, 221, 235, 236, 242–46, 253–56, 257–59, 328–29n.56

Ephrussi, Charles, 64, 327n.43

Erler, Fritz, 165, 181

Erste Deutsche Herbstsalon (1913), 164, 199

Espagnat, Georges d', 76

Ettlinger, L. D., 244

L' Eugène Delacroix au néo-impressionnisme (Signac), 210, 246–47

Evenepoel, Henri, 161

exhibition catalogues, development of, 85, 111, 131

Exposition Centennale (Paris, 1900), 119, 135, 136, 219–27, 261

Exposition Decennale, 220–21, 222

Exposition Nationale (Paris, 1883), 125

Exposition rétrospective de tableaux et dessins de maîtres modernes (1878), 121

Exposition Universelle (Paris): in 1855, 26, 27, 30, 39, 44, 112, 113, 115–17, 163; in 1867, 28, 30, 39, 44, 107, 117, 163; in

1878, 28, 109, 120, 121, 122, 163; in 1889, 28, 31, 109, 121, 125, 129, 131, 159, 160, 163, 203, 221; in 1900, 28, 31, 60, 67, 125, 134, 163, 164, 219, 229, 241, 332n.89

Expressionism, German, 7, 9, 13, 41, 177, 211, 225, 229, 230, 234, 235, 253

Exter, Julius, 165

Fagerolles (character), 153, 221

Der Fall Böcklin (Meier-Graefe), 5, 224, 246, 257–61

Der Fall Wagner (Nietzsche), 5, 258–59

Fantin-Latour, Henri, 145, 152, 254, 264, 271; The Atelier at the Batignolles, 272, Hommage à Delacroix, 271, 272

Faure, Jean-Baptiste, 62, 76, 79, 82, 290–91n.31

Fauves, 93, 134, 137, 187, 235, 265, 266, 269, 270, 273–76

Feder, Jules, 127

Fénéon, Félix, 90–91, 92, 96, 97, 267, 269, 302n.4, 340n.35

Ferry, Jules, 159

Feuerbach, Anselm, 175, 244, 255, 256

Fiedler, Konrad, 217, 248–49, 254, 258, 259

Le Figaro, 128, 324n.16

Fischer, Samuel, 338n.9

Flaischlen, Caesar, 328n.54

Flameng, August, 302n.4

Flandrin, Hippolyte, 102, 118

flâneur, 87

Flechtheim, Alfred, 75, 137, 242–43, 269

Floerke, Hanns, 78

Folkwang Museum (Hagen), 211

Forain, Jean-Louis, 126, 217

forgeries, 58, 110, 111

Förster-Nietzsche, Elizabeth, 210

Fortuny y Carbó, Mariano José María Bernardo, 102

Fowler, Frank, 165

Fragonard, Jean-Honoré, 227

Franck, Phillip, 181

Frankfurt art market, 69

Frankfurter Kunstverein, 76, 77, 310–11n.102

Frankfurter Zeitung, 260

Frédéric, Léon, 161, 164

Freie Bühne, 174, 207, 208, 216, 325n.20, 338n.9

French Academy. See Académie des Beaux-Arts (Paris)

French art museums, 16. See also names of specific museums

French Impressionists (1860–1900) (Mauclair), 226

Frenzel, Oscar, 193

Frick, Henry Clay, 62

Friedrich, Caspar David, 213, 261

Frith, William Powell, 35; Derby Day, 35

Fromentin, Eugène, 102, 118, 119, 121, 156

Fromuth, Charles, 165

Fry, Roger, 3, 6, 13–14, 36–37, 239

Furse, Charles W., 140

Futurism, 199, 280n.12

G (artists' society), 181

Gainsborough, Thomas, 124, 146–47, 218; Blue Boy, 147

Galerie Bernheim Jeune (Paris), 76, 78, 79, 124, 134, 137, 193, 265, 329–30n.64

Galerie Commeter (Hamburg), 69

Galerie Druet. See Druet (art dealer)

Galerie Durand-Ruel (Paris). See Durand-Ruel, Paul

Galerie Francis Petit (Paris). See Petit, Francis; Petit, Georges

Galerie Gurlitt (Berlin), 70, 71, 178, 207, 280n.10

Galerie Heinemann (Munich), 79–80

Galerie K. F. Heckel (Mannheim), 69

Galerie Le Barc de Boutteville (Paris), 132

Galerie Martinet (Paris). See Martinet, Louis

Galerie Miethke (Vienna), 54, 76, 182, 186, 265

Galerie Sedelmeyer. See Sedelmeyer (art dealer)

Gall, August, 162, 195

Gallén-Kallela, Axel, 13, 94, 178

Gambart, Ernest, 33, 34–35, 52, 85

Gambetta, Léon, 145

Gardner, Isabella Stewart, 147

Gauguin, Paul, 216, 258, 267; death of, 136; exhibitions of, 70, 187, 196, 200, 222, 265, 310–11n.102; influence of, 93; published prints of, 242; radicalism of, 127; relationship to Impressionism, 4, 13, 134, 150, 202, 219, 251–53, 254, 268, 274; reputation of, 264

—works: *Contes Barbares*, 252; *Noa Noa*, 77, 254, 342n.55

Gausson, Léo, 133

Gautier, Théophile, 86, 237

Gavet (architect), 54

Gazette des beaux-arts, 48, 63, 120, 128, 135, 136

Gedankenmalerei, 218, 245, 259

Geffroy, Gustave, 67, 95, 97, 98–99, 128, 130, 267

genius: demonstrated in retrospective exhibitions, 112; and "geniuses of the future," 4, 104, 105, 108, 116, 152, 153; versus marketability, 18–19; and politics, 122; and temperament, 40, 108, 225

The Gentle Art of Making Enemies (Whistler), 43

Gérard, Carl, 329n.62

Géricault, Théodore, 27, 71, 113, 214; *Raft of Medusa*, 113

Germain, Alphonse, 133

German art collectors, 8, 9, 67

German art museums, 16, 69, 210–11. *See also names of specific museums*

German Künstlerbund, 197–98, 234

German Socialist Labor Party, 202

German Werkbund, 185, 211, 220

Germinal (Meier-Graefe), 242

Gérôme, Léon, 24, 60, 63, 64, 66, 102, 156, 219, 302n.4

Gervex, Henri, 65, 66, 71, 139, 141, 144, 148, 153, 160, 161, 219; *Rolla*, 149

Gesamtkunstwerk, 42–43, 183, 184, 185, 186, 208

Die Geschichte der Malerei im XIX. Jahrhundert (Muther), 5, 67, 208, 212–18, 233

Gide, André, 271

Gil Blas, 129

Glackens, William, 162

Glasgow school, 177, 208

Gleizes, Albert, 170, 276, 280n.12

Gleyre, Charles, 156

Gobineau, Joseph Arthur, 68

Goethe, Johann Wolfgang von, 258

Gogh, Johanna van, 76, 209

Gogh, Théo van, 54, 66, 129, 130

Gogh, Vincent van: collectors of, 209, 210, 211, 328n.51; death of, 134, 266; exhibitions of, 4, 19, 70, 76–77, 132, 135, 136, 187, 194, 196, 200, 211, 265–66, 310–11n.102; influence of, 111, 245, 246, 251; and naturalism, 324n.13; published prints of, 242; relationship to Impressionism, 244, 245, 250, 254, 268, 274; style of, 134, 243; and symbolism, 202

Goldschmidt, Jacob, 290–91n.31

Goltz, Hans, 58, 70

Goncourt, Edmond and Jules: *Manette Salomon*, 151, 222

Gonse, Louis, 119, 121

Gonzalès, Eva, 126, 300n.45

Goujon, Jean, 254

Goupil, Adolphe, 33, 34, 52, 61, 64, 66, 129

Gourmont, Remy de, 267

Goya y Lucientes, Francisco José de, 4, 75, 234, 238

Grafton Galleries, 164

Grand Prix (Salon medal), 284n.34

Grasset, Eugène, 162

Graul, Richard, 203, 328n.54

El Greco (Doménikos Theotokópoulos), 4

Green, Nicholas, 40, 110

Grimm, Hermann, 236, 237, 249

Grosse Berliner Kunstausstellungen, 72–73, 168, 172, 174, 175, 179, 188, 193

Grossherzog Ernst Ludwig (Weimar), 210

Grosvenor Gallery (London), 47–48, 63, 123, 124

Guillaumin, Armand, 98, 100, 150, 334n.104

Guillemet, Antoine, 144

Guimard, Hector, 162

Guimet, Émile, 305n.43

Gurlitt, Cornelius, 212–13
Gurlitt, Fritz, 70, 71
Gutbier, Ludwig, 68–69, 174
Guthrie, James, 316n.18

Habermann, Hugo von, 174
Hals, Franz, 144, 218
Hamburg art market, 69
Hamburg international exhibition (1895), 219
Hamburg Kunsthalle, 69
Hamburg Kunstverein, 69
Hamerton, P. G., 20–21, 23
Harden, Maximilien, 242, 258
Harrison, Alexander, 65, 145, 161, 165, 300n.45, 326n.40
Hartleben, Richard, 328n.54
Haskell, Frances, 37, 49
Hassam, Childe, 162, 300n.45
Havemeyer, Louisine, 60, 62
Hébert, A.-A.-E., 64
Heilbut, Emil, 203, 234, 258
Heilbuth, James, 47
Heimatkunst, 197, 205
Heise, Renate, 170
Helferich, Hermann (pseud. of Emil Heilbut), 203, 204, 208, 214
Helleu, Paul, 145, 227
Hellmaler, 280n.10. See also plein air philosophy
Henner, J.-J., 156
Henri, Robert, 162
Herkomer, Herbert, 71, 177
Hermes & Co. (Frankfurt art gallery), 69, 294n.78
Herrmann, Curt, 181, 193, 209, 328n.54
Herzl, Theodor, 206
Hevesi, Ludwig, 54, 164
Hildebrand, Adolf, 217, 248–49, 255
Die Hilfe, 220
Hirth, Georg, 170, 173, 181
The History of Impressionism (Rewald), 99
history painting, demise of, 117
Hitler, Adolf, 262
Hitz, Dora, 161
Hobbema, Meindert, 218
Hodler, Ferdinand, 71, 188

Hoffmann, Josef, 183
Hofmann, Ludwig von, 71, 210, 218, 328n.54
Hofmann, Werner, 148
Hokusai, 143
Holz, Arno, 338n.9
Hölzel, Adolf, 344n.7
Hoppner, John, 146
hors concours, 125, 156, 160, 221
Horta, Victor, 210, 251
Hôtel Drouot auction house, 51, 52, 58, 60, 81, 111, 113
Houssaye, Henry, 139
Huet, Paul, 118
Hugo, Victor, 246
Huysmans, Joris, 149–50, 222, 324n.16

Ibels, Henri Gabriel, 271
Ibsen, Henrik, 205, 215, 227
idealism, 13, 176, 267–68
Ideville, Comte Henri d', 120, 121
illusionism, 224
Im Kampf um die Kunst (Vinnen), 81
Impressionism, definition of, 90. See also names of individual artists and exhibitions; Neo-Impressionism; Post-Impressionism; Secessionist painters
Impressionist exhibitions: in 1874, 92, 93–94, 101; in 1876, 99–106; in 1877, 105; in 1880, 126; in 1881, 126; in 1886, 100, 128
Impressionist Painting. Its Genesis and Development (Dewhurst), 56
Impressionist *Weltanschauung*: development of, 5, 201, 212, 227–34, 235; internationalism of, 5, 6
L' Impressionniste, 88
Les Impressionnistes en 1886 (Fénéon), 90–91
Indépendants, 132, 134–35, 168, 172, 264, 266, 268, 270, 327n.42. See also Salon des Indépendants
independence, 37–38, 40, 81, 90, 125–26, 128, 142, 149, 200, 213
individualism, 6, 12, 81, 230–31, 233
Ingres, Jean-Auguste-Dominique: exhibitions of, 26, 118, 119, 219, 265; influence of, 111, 154, 214, 226; as precursor to

Ingres, Jean-Auguste-Dominique (*cont.*)
 Impressionism, 14, 99, 102, 104, 105
 117, 254; and reform of the Salon system,
 29; style of, 273
innovation, 81, 85, 90, 94, 96, 99
"Inquiets," 132
Institut de France, 24, 30, 64, 99, 102, 155
internationalism, 5, 6, 11–12, 31, 32, 73,
 169, 177, 179, 182, 189, 193, 197, 198,
 235, 240, 241, 262, 263
International Society of Sculptors, Painters
 & Gravers, 138
intransigeants, 90, 105, 149, 220
Isabey, Eugène, 120
Israels, Josef, 63, 194

Jacque, Charles, 131
Jacquet, Gustave, 302n.4
Ein Jahrhundert Französischer Malerei
 (Muther), 221
James, Henry, 48
Jamot, Paul, 135
Japanese art, influence in Europe, 4, 45, 99,
 143, 251, 305n.43
Jourdain, Francis, 310n.94
Jourdain, Frantz, 162, 310n.94
Joyant, Maurice, 25
Jugend (cultural journal), 173, 181
Jugendgruppe, 181
Jugenstil movement, 178, 181, 184, 186,
 195. *See also* art nouveau
Julian, Rodolphe, 157–58
Jung-Kunst, 140, 184, 201
juste milieu painters: aestheticism of, 138–
 50; collapse of, 11, 15; definition of,
 139–42; description of, 37; exhibitions
 of, 4, 48, 65–66; as heirs to French Im-
 pressionism, 5, 67, 141; internationalism
 of, 11; legitimacy of, 65, 67, 113, 147–
 48, 149; marketability of, 66; member-
 ship in, 155; origins of, 148; popularity
 of, 13–14; and Secessionism, 141, 145,
 185, 201; success of, 154–66
Justi, Carl, 248
La Justice, 128

Kahnweiler, Daniel-Henry, 54, 64, 135,
 137, 276

Kaiser Wilhelm Museum (Krefeld), 211
Kalckreuth, Leopold von, 71, 165, 293n.62
Kandinsky, Vassily, 10, 58, 69, 70, 195, 198,
 199
Karlsruhe Kunstverein, 310–11n.102
Karlsrüher Künstlerbund, 190
Karlsruhe Secessionists, 188
Kaulbach, Wilhelm, 213
Keller, Albert von, 174
Keller & Reiner (Berlin art gallery), 67–75,
 210
Kessler, Harry Graf, 210–11, 326n.39,
 328n.54
Khnopff, Fernand, 71, 165, 216
Kirchner, Ernst Ludwig, 94, 262
Kirchturmspolitik, 189
Klimsch, Fritz, 181, 193
Klimt, Gustav, 3, 164, 171, 182, 183, 184,
 185, 186–87
Klimtgruppe, 93
Klinger, Max, 3, 5, 141, 161, 165, 207, 218,
 244, 255; *Beethoven Denkmal*, 171, 183
Knaus, Ludwig, 63
Koepping, Karl, 328n.54
Kokoschka, Oscar, 14, 187
Kolbe, Georg, 209
König, Leo von, 70, 209, 243
Krøyer, Peder, 65, 141, 161, 165, 196
Kuehl, Gotthard, 161, 165
Kunstchronik, 54, 169, 170, 266
Die Kunst für Alle, 69, 78, 178, 180, 181,
 182, 189, 193, 203, 217, 223, 238
Kunsthandel C.M. van Gogh (Amsterdam),
 265
Kunsthandlung Ernst Zäslein (Berlin), 70
Kunsthandlung Louis Bock & Sohns (Ham-
 burg), 69
Künstlergruppe Brücke (Dresden), 93, 94,
 178, 195, 198, 211, 262, 263, 265
Künstlerhaus (Berlin), 70
Der Kunstmarkt (Drey), 78
Kunstpolitik: definition of, 12; of German
 art dealers, 74; and independence, 37–38;
 of *juste milieu*, 141, 148, 149; of the Salon
 system, 155; of Secessionism, 171, 177,
 183, 190, 205
Kunstproletariat, 176, 185
Kunstsalon Ernst Arnold (Dresden), 174

Kunstsalon Jacques Caspar (Berlin), 293n.69

Kunstsalon Rabl (Berlin), 293n.69

Kunstsalon Ribera (Berlin), 70

Kunstsalon Zimmermann (Munich), 344n.9

Kunst und Küstler, 77–78, 192, 232, 234, 258

Kunstvereine, 8, 26, 69, 86, 175, 176, 260, 302n.3. *See also names of specific Kunstvereine*

Der Kunstwart, 231, 315n.8

Der Kunstwerk, 258

Kupka, Franz, 162, 335n.115

Laban, Ferdinand, 233–34, 254

Lacombe, Georges, 271

Laermans, Eugène, 164–65

Lafenestre, Georges, 157

La Fizelière, Albert de, 120

Laforgue, Jules, 77

La Gandara, Antonio de, 131

Lagarde, Pierre, 164

landscape painting, 33, 35, 40, 71, 102, 110–11, 222, 283n.29

Langbehn, Julius, 194, 204–5, 216

Langhammer, Carl, 322n.88

Lantier, Claude (character), 152–53, 214, 221, 233

Largillière, Nicolas de, 227

Larsson, Carl, 65

Lavery, John, 5, 165, 196, 316n.18

Lazarus, Moritz, 236

Le Caze, Baron, 21

Lecomte, Georges, 59–60, 67, 96–98

Lecomte du Noüy, Jean, 302n.4

Leempoels, Joseph, 161

Le Fauconnier, Henri, 276

Lefebvre, Jules, 158, 302n.4

Léger, Fernand, 276

Legion of Honor, 30, 149, 155, 158

Legros, Alphonse, 47, 150

Leibl, Wilhelm, 64, 194, 214–15, 223, 255

Leighton, Lord Frederick, 24, 64

Leistikow, Walter, 71, 72, 73, 161, 188, 190, 191–92, 207–8

Le Mans retrospective exhibition (1880), 120

Lemonnier, Camille, 120

LeNain, Louis, 297n.17

Lenbach, Franz von, 24, 71, 79, 244

Lepic, Comte Ludovic-Napoléon, 150

Le Sidaner, Henri, 300n.45

Levert, Jean-Baptiste, 126

Levine, Stephen Z., 130, 131

Lévi-Strauss, Claude, 235–36

Lhermitte, Leon, 162, 164, 185

liberalism, 154–55, 205

La Libre Esthétique (Brussels), 73, 132, 191, 209, 210, 237, 251, 309n.92

Lichtenbergschen Kunstsalon (Berlin), 179

Lichtwark, Alfred, 69, 208, 328n.54

Liebermann, Max, 219, 328n.54; art collection of, 208; and Berlin Secession, 143, 147–48, 161, 189–90, 191, 194, 209, 260; and the Eleven, 72; exhibitions of, 5, 65, 73, 164, 280n.10, 317n.27, 339n.27; relationship to Impressionism, 5, 141, 142, 204, 207, 223, 232, 242, 255, 256, 300n.45; reputation of, 74, 198; style of, 166, 203, 218

Liljefors, Bruno, 165

Linde, Max, 78

Lindsay, Sir Coutts, 47, 123

linear perspective, 228, 249

Lippmann, Friedrich, 208, 209

literary naturalism, 202, 203, 212, 232

London exhibitions: Crystal Palace Exhibition (1851), 32; Fine Arts Society (1883), 45; at Grosvenor Gallery, 47–48, 123, 124; Impressionist show (1905), 3, 109, 264; Post-Impressionist show (1910), 3; Post-Impressionist show (1912), 3; World's Fair (1851), 163

Lorrain, Claude, 297n.17

Lostalot, Alfred de, 128

Louvre (Paris), 21, 62, 96, 97, 144, 150, 223

Lucas, George A., 60, 83

Luce, Maximilien, 132, 133

Mackensen, Fritz, 165, 179

Madrazo, Raimundo de, 63, 65, 141, 148

Maeterlinck, Maurice, 221

Maillol, Auguste, 266

Maison d'Art, 209

Maison de l'art nouveau, 220, 221

Maison Moderne (Paris), 241–42, 251

Makart, Hans, 24, 125, 244

Makela, Maria, 172

Malkowsky, Georg, 192

Mallarmé, Stéphane, 101, 103–4, 105, 145

Manchester exhibition (1857), 120

Manchester Institution exhibition (1880), 123

Mánes (artists' society), 229

Mánes, Josef, 335n.115

Manet, Édouard: collectors of, 18, 60, 82–83, 234, 327n.43; comments on Duret, 37; death of, 119; depicted by Zola, 77, 152, 202–3, 214, 218; exhibitions of, 44, 76, 79, 88, 101, 104, 113–14, 115, 116, 118, 126, 130, 144, 145–46, 151, 159–60, 195, 196, 202, 203, 207, 224, 238, 265, 300–301n.51; imitators of, 32; influence of, 111, 141, 144, 151, 154, 213, 221, 223, 233–34, 253; marketability of, 39, 67, 71, 82–83, 96, 136, 238, 241, 290n.22; originality of, 18, 21, 99; photographs of works by, 59; politics of, 122; prints of works by, 86; relationship to Impressionism, 4, 6, 8, 11, 13, 14, 92, 96, 97, 98, 103–4, 105, 139, 217, 224, 227–29, 245, 246, 253, 254, 255, 266, 300–301n.51; reputation of, 152, 194, 202–3, 212, 213, 226, 227–29, 232, 238–39, 322–23n.3; sale of works by, 79, 80; style of, 206, 214, 249–50, 258, 259, 273; success of, 24, 96, 97, 145, 161, 233, 238; temperament of, 41–42, 92, 105, 106, 228, 234

—works: *The Bar at the Folies-Bergère*, 145, 224; *Barque of Dante*, 250; *Dans la Serre*, 79, 219, 233; *Déjeuner dans l'atelier*, 80, 224; *The Execution of Maximilian*, 79, 103, 113–14, 262; *Le bon bock*, 80; *Le Déjeuner sur l'herbe*, 103, 224, 238; *Le Ligne*, 103; *Le Liseur*, 233; *Nana*, 226, 255; *Olympia*, 96, 97, 99, 144, 150, 203; *Victorine Meurend in the Costume of an Espada*, 239; *View of Venice*, 60; *Woman Playing Guitar*, 60

Manet, Eugène, 83

Manet und sein Kreis (Meier-Graefe), 245, 249–51

Manguin, Henri, 162, 310–11n.102

Mannheim art market, 69

Mannheim Kunsthalle, 79, 262

Mantz, Paul, 120

Manzi, Michel, 25

Marc, Franz, 58

Marées, Hans von, 248–49, 255, 257, 261

Marinetti, F. T., 43

Maris, Jacob, 194, 317n.27

Martin, Pierre (called *le père*), 60

Martin, Henri, 164, 333n.100

Martinet, Louis, 59, 83–88, 101, 114, 118–19, 132

Mather, Frank, 20

Matisse, Henri: classicism of, 273; collectors of, 211; criticism of, 275; exhibitions of, 77, 134, 135, 137, 162, 266, 310–11n.102; relationship to Impressionism, 8, 97–98, 264; success of, 269

—works: *Asphrodel*, 329–30n.64

Mauclair, Camille, 226–27, 267, 268, 273–75

Maufra, Maxine, 300n.45

Maurras, Charles, 274

Maus, Octave, 73, 130, 191, 209, 237

Max, Gabriel von, 79

McColl, D. S., 67

Mead, Mary Gertrude, 123

Mediz, Karl, 179

Mediz-Pelikan, Emilie, 179

Meier-Graefe, Julius, 3, 4–5, 13, 15, 80, 207–10, 221, 224, 235–63

Meissonier, Ernest, 24, 71, 94, 102, 124, 160

Melchers, Gari, 141, 165–66

Mellerio, André, 225, 266, 267–68, 271

Mendelssohn collection, 78

Mendelssohn family, 191

Menzel, Adolf, 63, 128, 188, 191, 214, 255, 257

Mercure de France, 264

Merle, Hugues, 33

Metropolitan Museum of Art (New York), 64

Metzinger, Jean, 270, 276, 280n.12

Meunier, Constantin, 141, 165, 209, 242, 250

Millais, John Everett, 63
Millet, Jean-François: dealers for, 52–54;
 exhibitions of, 114, 119, 121, 289n.17;
 influence of, 141, 203, 214, 244, 250,
 253; marketability of, 39, 41, 52–54, 61,
 62, 83; originality of, 18, 21; photo-
 graphs of works by, 71; relationship to
 Impressionism, 99, 102; sale of works by,
 61, 62; temperament of, 111
—works: *Angelus*, 53, 61, 62, 130; *Death
 and the Woodcutter*, 53; *Man with a Hoe*,
 62; *Oedipus Taken Down from the Tree*, 53;
 Parc à moutons au clair de lune, 289n.13;
 Seated Shepherdess, 53; *Sheepfold by Moon-
 light*, 53; *The Sower*, 53
Minne, Georges, 242, 256
Mirbeau, Octave, 66, 130
Mittelberg, Otto, 174–75
Moderne Galerie/Kunsthandlung
 (Munich), 58, 70, 76, 77, 265
Der moderne Impressionismus (Meier-Graefe),
 251–53
modernism, legitimacy of, 3, 7, 113, 247
Modern Painting (Mather), 20
Modersohn, Otto, 68
Moll, Carl, 182, 186
Mommsen, Theodor, 208
Monet, Claude, 98; collectors of, 327n.43;
 and dealers, 65, 66, 82, 127, 128; devel-
 opment of, 112; and exhibition reforms,
 63–64; exhibitions of, 76, 79, 91, 107,
 126, 127–28, 129–31, 177, 193, 196, 207,
 219, 293n.63, 326nn.33, 36; imitators of,
 32; influence of, 253; influence of De-
 lacroix on, 297n.17; marketability of, 67,
 82, 83, 129, 130, 137; and purchase of
 Manet's *Olympia*, 144, 150; relationship
 to Impressionism, 6, 8, 55, 97, 139, 150,
 245, 253, 300n.45, 334nn.104, 105; repu-
 tation of, 127, 130, 194, 208, 227, 233;
 sale of works by, 60, 79; style of, 104,
 154, 194
—works: *Haystacks*, 93, 131; *Hill Party*, 218;
 Poplars, 131; *Portrait of Camille*, 194;
 Rouen Cathedral, 131
monographs, 110
monopolies, on artists, 52

Montrosier, Eugène, 122
Moore, Albert, 143, 311n.2
Moore, George, 157–58, 160–61, 171
Moréas, Jean, 324n.16
Moreau, Gustave, 16, 47, 98, 216, 221, 222,
 224, 267, 268
Moreau-Nélaton, Étienne, 62, 71
Morice, Charles, 93, 264, 266
Morisot, Berthe, 65, 97, 100, 127, 150,
 300n.45, 327n.43, 334n.104
Morot, Aimé, 302n.4
Morris, William, 30, 239
Mortimer, Richard, 189
Moser, Kolomon, 183
Le Mouvement idéaliste en peinture (Mellerio),
 267–68
Mozart, Wolfgang Amadeus, 246
Mucha, Alphonse, 335n.115
Muhrmann, Henry, 165
Müller, Alfred, 339n.27
Munch, Edvard, 13, 76, 177, 194, 195, 211,
 216, 237–38, 245, 265, 317n.33; *The
 Frieze of Life*, 195
Münchener Neueste Nachrichten, 170, 173
Munich art market, 69–70. *See also names of
 specific galleries and dealers*
Munich exhibitions, 163
Munich Freie Vereinigung, 178, 195
Munich Kunstacademie, 69
Munich Künstlergenossenschaft, 168, 169,
 170, 172, 173, 177, 178, 179
Munich Kunstverein, 70, 265, 310–11n.102
Munich Luitpold-Gruppe, 181, 188,
 190
Munich Secession: aesthetics of, 167–68;
 and Berlin Secession, 190; development
 of, 167–68, 169–70, 172–82; exhibitions
 of, 73, 77, 169, 170–71, 173–74, 175–76,
 177–79, 180, 181, 207; success of, 69,
 174, 177–78; support for, 12
Munich Werkstätte, 241
Munkácsy, Mihály, 61, 64, 148
Musée d'Orsay (Paris), 62
Musée Luxembourg (Paris), 16, 60, 66, 95,
 96, 98, 219, 223, 227, 264
Muther, Richard, 3, 5, 22, 67, 93, 208, 212–
 18, 221–23, 233, 237, 245

Nabis, 326n.39; and Cézanne, 251, 254, 271; and Denis, 271–72, 275; exhibitions of, 4, 67, 134, 135, 187, 242, 268; influence of van Gogh on, 245; relationship to Impressionism and modernism, 235, 266; reputation of, 210, 276; style of, 162, 166, 266

Nadar (Gaspar-Félix Tournachon), 95, 330n.70

Napoleon III, 36, 115, 116, 117

national cultural identity (nationalism), 5, 6, 9, 36, 137, 179, 181, 196, 205, 225, 227, 262

National-Galerie (Berlin), 16, 219, 223, 232, 261

National Gallery (London), 297–98n.18

naturalism, 5, 13, 40, 41, 92, 103, 110, 133, 141, 153, 172, 176, 202–5, 212, 213–18, 223, 224, 232–33, 240, 250

Naumann, Friedrich, 220, 221

neoclassicism, 143

neoidealism, 202, 204, 205, 212, 216, 218, 219, 223, 224, 229, 248

Neo-Impressionism, 6, 38, 66, 74, 75, 92, 133, 135, 209, 210, 211, 222, 235, 251, 253, 268, 269–70, 276

néo-traditionnistes, 134

Nervenkunst, 205–6

Neue Künstlervereinigung Münchens, 70, 181, 211

Neue Secession, 198, 199

Neu-Idealismus, 93, 205

Neumann, L. (art dealer, Munich), 71

New Painting: Impressionism 1874–1986 (exhibition), 100

New York Armory Show (1913), 3, 164

Nietzsche, Friedrich Wilhelm, 5, 202, 204, 212, 215, 216, 227, 230, 233, 234, 236, 240, 249, 258–59

Nietzsche-Archive (Weimar), 210

Nieuwerkerke, Alfred, comte de, 115

Nissen, Momme, 194, 260

Nittis, Giuseppe de, 63, 65, 141, 144, 148, 327n.43

Nolde, Emil, 198

Nordau, Max, 206–7, 216, 231, 252

La Nouvelle Peinture (Duranty), 101, 228

November-Vereinigung (Berlin), 181

L' Occident (periodical), 271

Olbrich, Josef, 183, 185

Olde, Hans, 178, 185

one-person shows. *See* retrospective exhibitions

Osthaus, Karl Ernst, 80, 211

Ostini, Fritz von, 170

Pächter, Hermann, 207

Palais de l'Industrie (Paris), 81, 118

Palais des Beaux-Arts (Paris), 118

Pall Mall Gazette (London), 47

Palmer, Mrs. Potter, 62

Pan (Cassirer), 56, 79

Pan (Meier-Graefe et al.), 162, 176, 210, 237

pan-Europeanism, 5. *See also* internationalism

Paret, Peter, 72, 192, 193

Paris art market, 7, 23, 50. *See also names of specific galleries and dealers*

Parisian Art and Artists (Bacon), 148

Paris World's Fairs. *See* Exposition Universelle (Paris)

Pastor, Willi, 338n.9

patronage system, 18, 20, 28, 36, 50, 80, 84

Paulus, Adolf, 170, 173, 193, 316n.12

Pechstein, Max, 198

Pecht, Friedrich, 203–4, 330n.70

Peladan, Sâr Joséphin, 215, 217, 274

Pellerin, Auguste, 62, 80

Pennell, Elizabeth and Joseph, 46, 47, 89

Perry, Lilla Cabot, 130

Petit, Francis, 33, 51, 60, 61, 63, 83, 86

Petit, Georges, 61–67, 98, 107, 123, 124, 126, 128, 129, 131, 140, 154, 172

Petitjean, Hippolyte, 133

Phalanx, 70

Philadelphia World's Fair (1876), 163

photographs (of paintings), 59, 71

Picard, Edmond, 209

Picasso, Pablo, 69; exhibitions of, 54, 74, 134, 137, 276; influences on, 111, 136, 273; relationship to Impressionism, 8, 269, 276; success of, 72, 134–35

Piglhein, Bruno, 174

Piloty, Carl, 24

Pils, Isidore, 118, 149

Pissarro, Camille, 107, 150, 194, 267; as an Indépendant, 134; comments on Renoir, 140; death of, 136; and exhibition reforms, 42, 63–64, 88, 299n.28; exhibitions of, 65, 66, 71, 76, 81–83, 91, 97, 127, 128, 131, 193, 196, 207, 326n.33; and list of Impressionist exhibitions, 90–91; marketability of, 83, 128, 137; opinion of Manet's canonization, 145, 146; radicalism of, 127, 129; relationship to Impressionists, 55, 97, 101, 150, 300n.45, 334n.104; success of, 83

Pissarro, Lucien, 133

plein air aesthetic (*Pleinairismus*), 5, 93, 98, 101, 152, 154, 204, 223, 225, 228, 233, 234, 238, 249, 250

Pleynet, Marcelin, 14–15, 16

La Plume, 132–34, 162

pluralism, 32, 141, 143

Pointelin, Auguste, 300n.45

pompier painters, 66, 113, 139

Pope, Alfred (art collector), 60

The Portfolio, 20

portraiture, English, 71, 75, 146–47

positivism, 6, 216, 246

Post-Impressionism: development of, 6, 15, 67, 93, 141, 202, 235, 253, 266–69; internationalism of, 6; retrospective exhibitions of, 3, 135

postmodernism, internationalism of, 11–12

Potter, Paul, 218

Prague international exhibition (1902), 229

Pre-Raphaelite painting, 218, 256, 267

A Primer of Modern Art (Cheney), 14

primitivism, 252

printmaking, 86

Prix de Rome, 23, 31, 155, 284n.34

Das Problem der Form in den bildenden Künsten (Hildebrand), 249

Ein Protest deutscher Künstler (Vinnen), 79, 262

Proust, Antonin, 62, 64, 109, 121, 130, 145, 159–60

Prud'hon, Pierre-Paul, 118

Prussian Academy, 72

Przybyszewski, Stanislaw, 237–38

pure visibility, 249

Püttner, Walter, 181

Putz, Leo, 181

Puvis de Chavannes, Pierre-Cécile, 13, 124, 158, 160, 161, 216, 221, 222, 254, 268

Raeburn, Sir Henry, 146

Raffaëlli, Jean-François, 65, 124, 126, 150, 162, 164, 181, 300n.45

Raffet, Auguste, 169

Ranson, Paul, 245, 271

Rathenau (Walter) family, 191

rationalism, 6

realism, 86, 92, 93, 101–2, 103, 106, 150, 216, 261

Redon, Odilon, 13, 254, 267, 268, 271, 331n.77

Reflex-Malerei, 204, 225, 229

Regnault, Henri, 118

Reitlinger, Gerald, 24, 146

relativism, 40

Rembrandt als Erzieher (Langbehn), 204–5, 216

Rembrandt van Rijn, 144, 223, 232, 233, 238

Renoir, Auguste: collectors of, 210, 211; exhibitions of, 65, 76, 91, 125, 126, 127, 128, 129, 131, 193, 194; marketability of, 83; published prints of, 242; relationship to Impressionism, 55, 129, 139, 140, 150, 253, 300n.45, 334n.104; reputation of, 97 —works: *Les Baigneuses*, 140, 147; *Woman with an Umbrella*, 194

Repin, Ilya, 179

representational art, 92

reproduction prints and photographs, 32

La République française, 128

Rethel, Alfred, 214

retrospective exhibitions: definition of, 120; development of, 107–13, 199–200, 226; ideological, 113–25, 131–37; list of, 118

La Revue blanche, 132, 269, 274

Revue des Deux-Mondes, 102

La Revue indépendante, 132

La Revue internationale de l'art et de la curiosité, 289n.6

Rewald, John, 99–100

Reynolds, Sir Joshua, 124, 146, 218

Ribera, Román, 65

Richard-Abenheimer, L., 69, 293n.63

Richter, Emil, 68, 76, 265

Rickards, Charles, 123

Riegl, Alois, 246

Rilke, Rainer Maria, 210, 229, 340n.35

Robaut, Alfred, 122

Robert-Fleury, J.-N., 64, 156

Robinson, H. H., 161–62

Rodin, Auguste, 3, 65, 66, 129–31, 138, 141, 144, 165, 196, 226, 229–32, 242, 254

—works: *Bourgeois de Calais*, 129; *Burghers of Calais*, 171

Roland-Holst, R. N., 19

Roll, Alfred, 65, 66, 71, 141, 142, 144, 145, 149, 160, 161, 164, 222, 227, 274, 302n.4, 326n.40

Romanticism, French, 4, 17, 27, 37, 39, 102, 103, 105, 122, 139, 213–14, 261

Romney, George, 146

Rops, Felicien, 267

Rose + Croix, 172, 207, 215, 217, 268

Rosenhagen, Hans, 70, 78, 193–96, 209, 242, 265

Rosenthal, Léon, 27, 36–37

Rosso, Medardo, 254

Rothschild, Baron, 64

Rouart, Henri, 126

Rousseau, Théodore, 108; blackballing of, 94; dealer for, 53; and exhibition reforms, 86–87, 88; exhibitions of, 107, 114, 118, 119, 121; marketability of, 39, 62, 83, 289n.9; originality of, 18; photographs of works by, 71; reputation of, 116; sale of works by, 61; temperament of, 111

Roussel, Theodore, 271, 272, 308n.82

Royal Academy (London), 23, 42, 43–44, 84, 121, 124, 142, 144

Rubens, Peter Paul, 147, 249

Ruskin, John, 30, 44, 46, 47, 238

Russian art collectors, 67

Russian art market, 280n.15

Rysselberghe, Théo van, 68, 133, 210, 242, 251

Sagot, Clovis, 137

St. Louis World's Fair (1904), 164, 186, 196, 197, 234

St. Lukas group (Düsseldorf), 179

Salon d'Autumne, 54–55, 111, 135–36, 162, 264, 265, 266, 273–76, 310n.94

Salon de la Plume, 133

Salon de L'art nouveau (Paris), 209, 237

Salon des Artistes français, 129

Salon des Cent, 133, 172

Salon des Indépendants: in 1884, 92; in 1899, 135; in 1905, 93, 111, 135, 266, 275

Salon des Refusés: in 1863, 19, 30, 36, 84, 88, 89, 91, 92, 94, 138, 152, 282n.14; in 1873, 155

Salonkünstler, 24

Salon of 1879, 125

Salon of 1880, 31, 125, 126, 148

Salon of 1881, 145, 157, 159

Salon of 1885, 31

Salon of 1887, 160

Salon of 1888, 157

Salon system: challenges to, 87, 113; collapse of, 8, 19, 268; commercial limitations of, 84; criticisms of, 25–32, 104; description of, 23–24; and establishment of French taste in art, 19, 23, 29, 50, 85, 144; and exhibition reforms, 31–32, 42, 125, 155–59; perpetuation of, 24–25, 35–36, 105, 142

Sandoz, Pierre (character), 152

Sargent, John Singer, 13–14, 65, 138, 141, 142, 144, 147, 148, 150, 161, 165

Saunier, Charles, 133

Scheffer, Ary, 85, 118

Scheffler, Karl, 232–33, 257

Schiele, Egon, 10, 187

Schmidt, Eugen, 54–55

Schmidt, Karl Eugen, 266

Schneiders Kunstsalon (Frankfurt a.M), 69

Scholle, 181–82, 197

Schopenhauer, Arthur, 233

Schorske, Carl, 183, 184, 185

Schuffenecker, Émile, 134

Schulte, Edouard, 174, 191

Schultes Kunstsalon (Berlin), 69, 71, 72, 73, 78, 174, 179, 181, 218

Schultze-Naumburg, Paul, 170–71

Schwind, Moritz von, 214

scientism, 222, 246–47, 273

Secessionist painters: and art dealers, 168, 193, 200, 201, 234; ideals of, 167, 176–77, 179, 193–94, 195; internationalism of, 5, 6, 31, 73, 167, 169, 177, 179, 182, 189, 193, 197, 198; and *juste milieu*, 141, 147, 185, 201. *See also* Berlin Secession; Dresden Secession; Munich Secession; Vienna Secession

Secrétan collection, 61, 62, 130

secular humanism, 229

Sedelmeyer (art dealer), 61, 64, 67, 124

Segantini, Giovanni, 141, 165, 250

Seidlitz, Woldemar von, 208, 209, 218, 328n.54

self-promotion, prohibition of, 108, 114, 116

Semper, Gottfried, 24

Sensationsbilder, 69, 74, 172, 275

Sensier, Alfred, 53, 87, 114, 289n.14

Séon, Alexandre, 134

Sérusier, Paul, 134, 245, 271

Servaes, Franz, 338n.9

Seurat, Georges, 6, 111, 132–34, 136, 222, 254, 265, 266, 269–70, 274, 276, 310–11n.102

—works: *La Parade*, 269; *La Rade de Grand-camp*, 270; *Les Poseuse*, 210

Seyssaud, René, 134

Shannon, Charles H., 165

Sickert, Walter, 47, 308n.82, 311n.3

Signac, Paul, 38, 133, 210, 246–47, 264, 269, 270, 276, 310–11n.102, 340n.35

Silvestre, Théophile, 123, 128

Simmel, Georg, 229–30, 231–32, 234, 236, 248

Simplicissimus (satirical magazine), 173

Sisley, Alfred, 55, 65, 71, 97, 98, 127, 150, 162, 207, 242, 293n.63, 300n.45, 326n.33, 327n.43, 334n.104

Skarbina, Franz, 161

Slevogt, Max, 161, 178, 195, 209, 317n.33

social degeneration, 206–7

social realism, 204

Société anonyme coopérative à personnel et capital vériables des artistes peintres, sculpteurs, graveurs, etc., 88, 90, 94, 100

Société des aquafortistes, 86

Société des aquarellistes français, 131

Société des artists français, 136, 156–57, 159, 286–87n.62

Société des pastellistes français, 131

Société des peintres, sculpteurs, graveurs, 159

Société des peintres-graveurs français, 131

Société des Trente-Trois, 66

Société internationale de Peinture, 63, 64–65, 66, 123, 124, 172

Société nationale des beaux-arts (Martinet), 84–88, 118, 132

Société nationale des beaux-arts (Paris), 65, 73, 98, 135, 136, 141, 154, 157, 159, 161–62, 168, 219

Société van de Velde (Brussels), 210

Society of British Artists, 129

Sorolla, Joaquin, 141

South Kensington Museum (London), 64

Springer, Anton, 218

Springer, Jaro, 179, 180, 218

Springmann, Theodor, 211

Stedelijk Museum (Amsterdam), 265

Stendhal (Marie-Henri Beyle), 37

Stern, Fritz, 257

Stern, Julius, 78, 191

Stevens, Alfred, 63, 65, 141, 144, 148, 308n.82

Stevens, Arthur, 52

Stevenson, R. A. M., 248

Stewart, W. H., 64

Stieler, Eugen von, 173

Stilkunst painters, 186, 187, 232

still life painting, 272

Strang, William, 165

Strathmann, Carl, 178

Stremel, Max Arthur, 339n.27

Strindberg, August, 202, 205, 215, 216

Stuck, Franz von, 79, 165, 167–68, 218, 244, 317nn.27, 29

Studien zur niederländischen Kunst- und Kulturgeschichte (Floerke), 78

The Studio, 162, 241

Der Sturm, 199

Stuttgart Kunstverein, 310–11n.102

style, developmental history of, 246, 247, 250, 269

Sutton, James (art dealer), 62, 130

Swan, John M., 165

Swiss art collectors, 67
Swiss art market, 280n.15
Swiss art museums, 16
symbolism, 93, 133, 138, 164, 166, 172, 177, 181, 202, 267, 268

Taboureaux, Émile, 126
Der Tag (Berlin), 70
Taine, Hippolyte, 240
Tate Gallery (London), 16
Taylor, Baron Isadore, 26, 304–5n.32
Teeuwisse, Nicolaas, 189
temperament, of artists, 40–41, 52, 81, 92, 105, 106, 108, 110–11, 142, 225, 239, 248, 249, 270, 274, 275, 276
Teriss, John, 316n.18
Thannhauser, Heinrich, 58, 70
Thaulow, Fritz, 161, 165
Thiéry, Thomy, 62
Thode, Henry, 260
Thoma, Hans, 5, 175, 194, 224, 260
Thomas, Grosvenor, 316n.18
Thomas Agnew and Sons (London and Manchester). *See* Thomas Agnew
Tiffany, Louis, 162
Tillot, Charles, 126
Times (London), 123
Tissot, James, 47, 93–94, 124
Titian: *Rape of Europa*, 147
Tolstoy, Leo, 227
Tonnies, Ferdinand, 231
Toorop, Jan, 177, 178, 242; *The Three Brides*, 177
Toulouse-Lautrec, Henri de, 13, 25, 136, 196, 217, 239, 251, 300n.45, 339n.27
Tour, Georges de la, 227
trade unionism, 202
trans-national cultural identity. *See* internationalism
Treitschke, Heinrich von, 236
Treu, Georg, 336n.117
Triennial Salon (1883), 159
Troyon, Constant, 62, 71
Trübner, Wilhelm, 71, 178, 181, 195, 198, 215, 255, 317n.33
Tschudi, Hugo von, 16, 59, 79, 80, 188, 208, 209, 219, 223–25, 227–30, 233, 245, 248–50, 258, 261, 311n.1

Tuaillon, Louis, 195
Turin retrospective exhibition (1880), 120
Turner, J. M. W., 4, 99, 218, 253
Turquet, Henri Edmond, 125
Twain, Mark, 46

Die Ueberwindung der Naturalismus (Bahr), 205
Uhde, Fritz von, 141, 161, 164, 170, 173, 174, 198, 204, 280n.10, 317n.27
Uhde-Bernays, Hermann, 207
Union centrale des Arts décoratifs, 124
urbanism (urban art), 6, 101, 105, 230–31, 232

Vallotton, Félix, 13, 271, 273, 274, 339n.27; *Five Painters*, 272
Vanderbilt, William H., 53, 63, 114, 124
Van Dyck, Sir Anthony, 124, 147
van Gogh, Vincent. *See* Gogh, Vincent van
Vasari, Giorgio, 12
Velasquez (Stevenson), 248
Velázquez, Diego Rodríguez de Silva, 4, 143, 144, 223, 238, 248
Velde, Henry van de, 75, 209–11, 221, 241
Venice Biennale, 163
Venturi, Lionello, 58, 249
Verein Berlin Künstler, 72, 189, 237
Verein bildener Künstler Dresdens, 179
Vereinigung 1897 (Berlin), 181
Vereinigung bildender Künstler Oester- reich. *See* Vienna Secession
Vermeer, Jan, 4, 62, 238; *Woman and Maid*, 62
Vernet, Horace, 117
Ver Sacrum, 183, 184, 185, 192
Vidal, Eugène, 126
La Vie moderne, 126, 128
Vienna international exhibitions: in 1882, 163; in 1894, 207; in 1898, 219
Vienna Kunstschauen (1908 and 1909), 186–87, 197
Vienna Secession: development of, 93, 182– 87, 265; and end of Impressionism, 6; ex- hibitions of, 77, 93, 164–66, 182, 183, 184, 186–87; ideology of, 183–84; Im- pressionism exhibition (1903), 3–4, 10, 13, 230, 232, 253; isolation of, 185; and

official commissions, 171; politics of, 168; and temple of art concept, 185

Vienna World's Fair (1873), 53, 163, 207, 233

Vigeland, Gustav, 13

Les Vingt (Les XX), 66, 94, 129, 130, 132, 191, 209, 210, 309n.92, 317n.33

Vinnen, Karl, 79, 80, 81, 262

Virmaitre, Charles, 161

virtuosity, 146, 274

Voll, Karl, 180, 218

Vollard, Ambroise, 54, 64, 76, 78, 98, 110, 134, 135, 210, 211, 251, 267, 270–71, 273, 326n.39

Voss, Georg, 178–79

Vuillard, Édouard, 193, 196, 210, 251, 271, 272, 274, 310–11n.102, 339n.27

Wagner, Adolph, 236

Wagner, Otto, 183, 185

Wagner, Richard, 5, 42–43, 207, 221, 227, 246, 258–59, 267

Walden, Herwarth, 75, 199

Wallace, Sir Richard (marquess of Hertford), 64, 296–97n.15

Walters, Henry, 60, 63

Walton, A., 165, 316n.18

Ward, Martha, 100

Watteau, Antoine, 21, 227, 297n.17

Watts, George Frederick, 24, 47, 123–24, 177

Wauters, Émile, 65

Weill, Berthe, 134, 269

Weimar (Germany), 210–11

Weimar Kunstgewerbeschule, 210

Weir, J. Alden, 161

Werner, Anton von, 72–73, 173, 188, 189, 190, 197, 312n.13

Whistler, James McNeill, 14; exhibitions of, 5, 42–47, 64, 65, 123, 129, 138, 161, 165; influence of, 275; orientalism of, 252; as a portraitist, 147; public reaction to, 46, 89; relationship to Impressionism, 13, 142, 143, 227, 267, 300n.45; reputation of, 13, 129, 138, 148, 208, 239, 264; temperament of, 41; "Ten O'Clock" lecture of, 143–44, 311n.5

—works: *Portrait of Paganini* (sic), 239; *White Girl*, 138

White, Cynthia and Harrison, 49–50, 51

Wickhoff, Franz, 246

Wiener Werkstätte, 184, 186, 241

Wilde, Oscar, 138, 239–42, 246, 249, 254, 257

Wilhelm II (kaiser), 168

Willette, Adolphe, 217

Willumsen, J. F., 178

Wilson, John W., 53

Winckelmann, Johann Joachim, 5

Woermann, Karl, 204

Wolff, Albert, 128

Wölfflin, Heinrich, 244, 247

World's Fairs, 163

Die XXIV (Munich), 174

Zandomeneghi, Federico, 126, 150, 334n.104

Zeitschrift für bildende Kunst, 202, 203, 233

Ziegler, Karl, 181

Zola, Émile, 78, 222; and artistic technique, 104; and artistic temperament, 41, 105, 106; defense of Impressionists by, 18, 150–54, 202–4, 237; defense of Refusés by, 91, 152; description of art dealers' hierarchy, 60–61; description of Durand-Ruel, 56, 61, 64; and "geniuses of the future," 104, 105, 152, 153, 279n.4; on Manet, 77, 152, 202–3, 214, 218; reputation of, 202, 206; review of Salon of 1880, 125, 148; review of Salon of 1881, 157; review of Salon of 1896, 154; review of second Impressionist exhibition (1876), 101, 104

—works: *Germinal*, 203; "J'Accuse," 274; *L'Assommoir*, 322n.2; *L'Oeuvre*, 60–61, 89, 91, 151–53, 214, 221, 233, 322n.2; *Nana*, 255, 322n.2

Zorn, Anders, 14, 71, 141, 147, 161

Zuckerkandl, Berthe, 186, 319n.52

Zügel, Heinrich, 165

Die Zukunft, 242, 258

Zuluoga, Ignazio, 339n.27

Zur Kritik der Moderne (Bahr), 205

LIVERPOOL JOHN MOORES UNIVERSITY
Aldham Roberts L.R.C.
TEL. 051 231 3701/3634